CREATING
THE ILLUSION

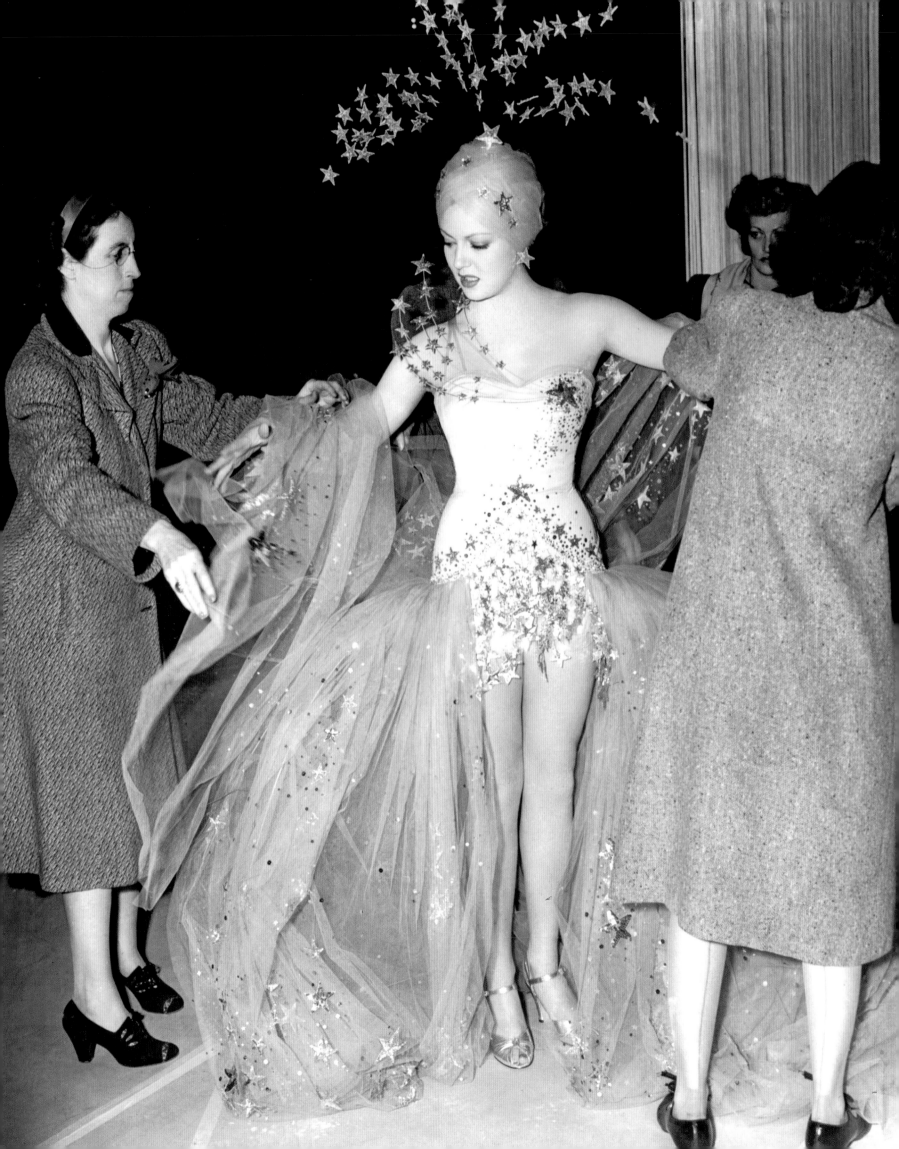

CREATING
THE ILLUSION

A FASHIONABLE HISTORY OF HOLLYWOOD COSTUME DESIGNERS

JAY JORGENSEN *AND* DONALD L. SCOGGINS

RUNNING PRESS
PHILADELPHIA · LONDON

FOR THE ALBRECHT FAMILY
—J.J.

FOR PAT, NORMA, DAVID, AND GAYLENE
—D.L.S

Page 1: The Wardrobe department at MGM.

Page 2: Lana Turner is assisted by wardrobe women for *Ziegfeld Girl* (1941).
Costume design by Adrian.

Page 5: Costume designer Jean Louis in the workroom of Columbia Pictures.

Page 6: Marlene Dietrich in *Kismet* (1944). Costume design by Irene.

© 2015 BY JAY JORGENSEN AND DONALD L. SCOGGINS

PUBLISHED BY RUNNING PRESS,
A Member of the Perseus Books Group

Books published by Running Press are available at special discounts for bulk purchases in the United States by corporations, institutions, and other organizations. For more information, please contact the Special Markets Department at the Perseus Books Group, 2300 Chestnut Street, Suite 200, Philadelphia, PA 19103, or call (800) 810-4145, ext. 5000, or e-mail special.markets@perseusbooks.com.

ISBN 978-0-7624-5661-1
Library of Congress Control Number: 2015935930

E-book ISBN 978-0-7624-5807-3

9 8 7 6 5 4 3 2 1
Digit on the right indicates the number of this printing

DESIGNED BY JENNIFER K. BEAL DAVIS
EDITED BY CINDY DE LA HOZ
Typography: Kabel, Brandon Text, Bembo, and Berthold Akzidenz Grotesque

RUNNING PRESS BOOK PUBLISHERS
2300 Chestnut Street
Philadelphia, PA 19103-4371

VISIT US ON THE WEB!
www.runningpress.com

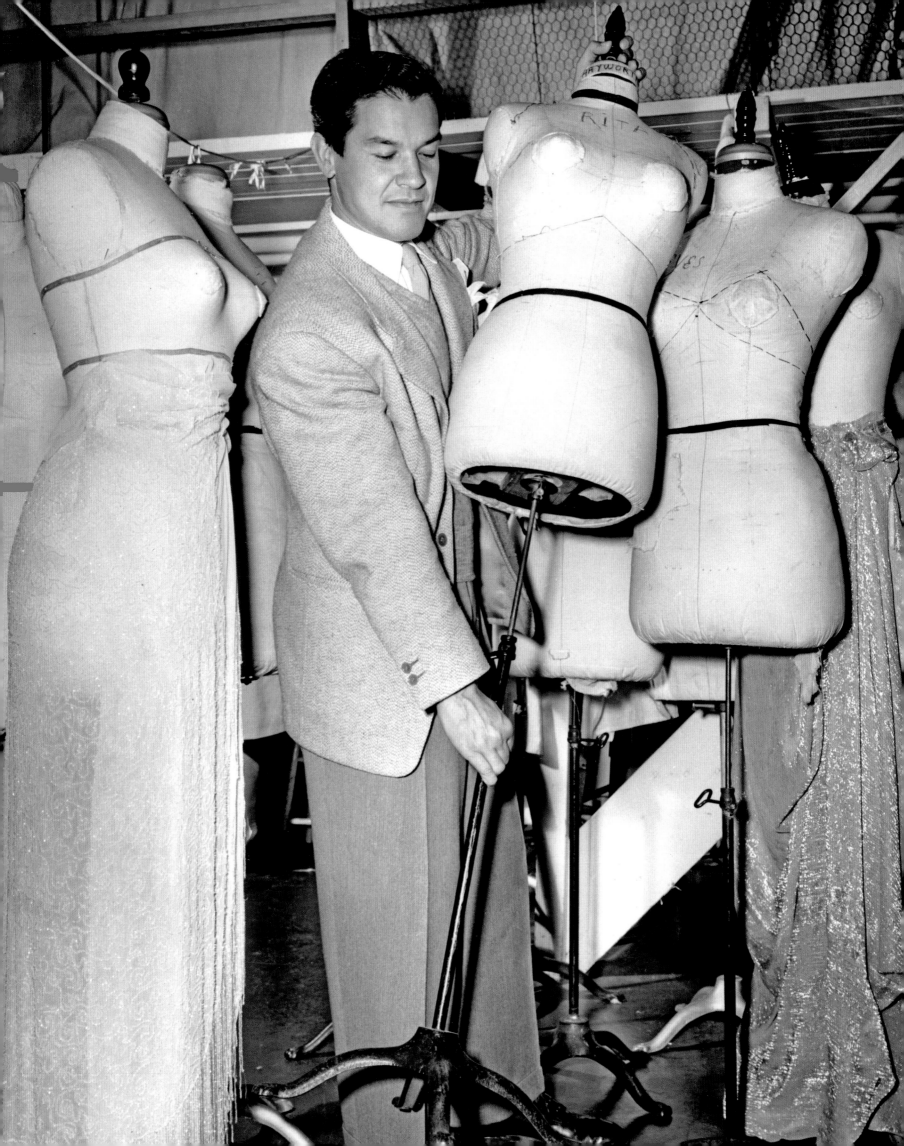

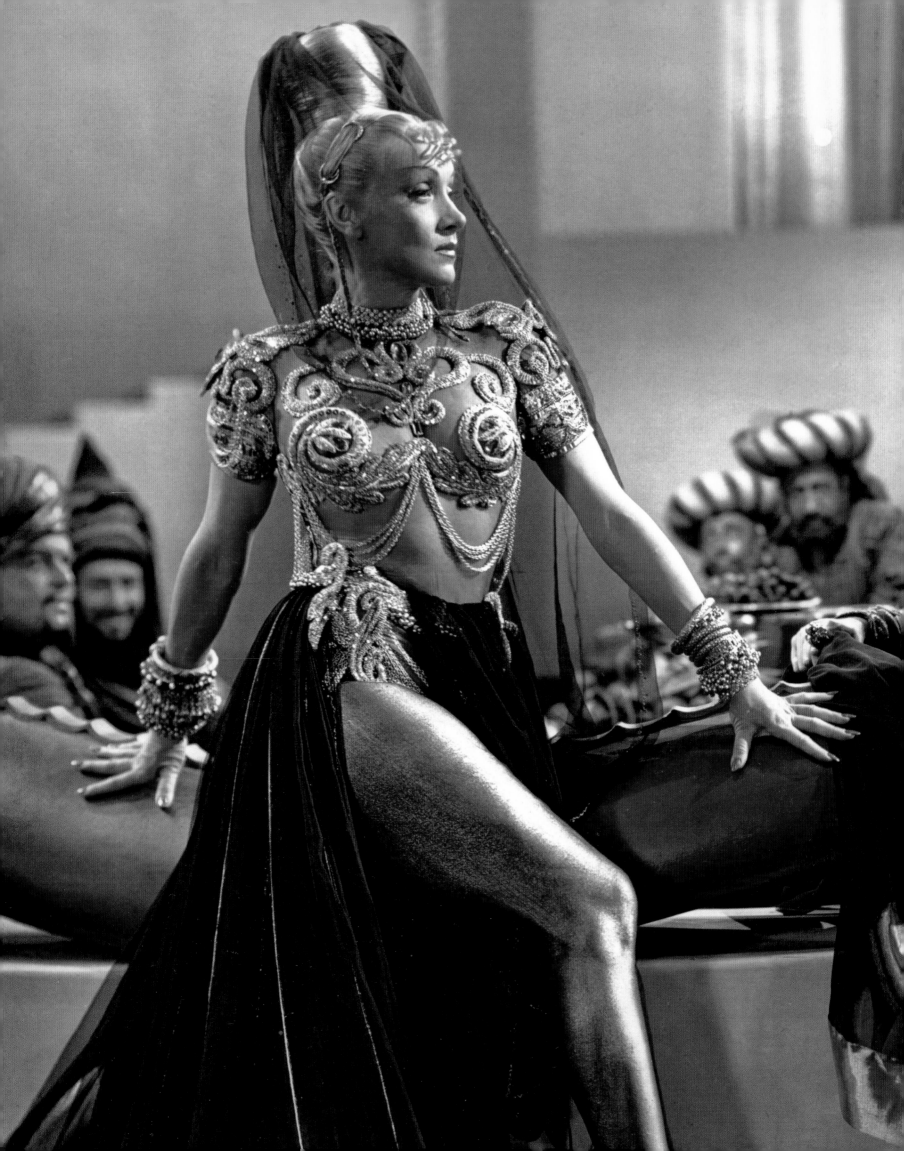

CONTENTS

FOREWORD BY ALI MacGRAW

happen to love the movies. As accidental as it was that I turned out to be a film actress, I have always adored sitting in a darkened theater, feeling myself leave my seat to float away to another projected reality. It has always been—and always will be for me—pure magic. If it soon becomes wildly popular for people to "watch films" on tiny wrist watches, I shall be crushed! I will campaign fiercely for the return of the original scope and wraparound wonder of movies as we have known them for more than a century. I want to be enraptured and transported by the entire creative scope and detail of that fabulous, contemporary art form: *Motion pictures.*

Probably because my earliest great job was working behind the camera for one of the top photographers of the 1960s, Melvin Sokolsky, I was educated early on as to just how many people it takes to create the best pictures, moving as well as still. And when I did my first big film, *Goodbye, Columbus,* I was immediately aware of (and grateful for!) the contribution of each and every member of the crew. I knew from that beginning that it is impossible for an actor to step onto the scene and be totally and solely responsible for the success of a film. I have remained in awe of the specific and huge talents of each contributor to every movie in which I acted, and this most certainly includes the costume designer.

I have always loved costume, and fashion, too . . . "dress up," I think it is called. This goes back to my childhood and continues to this day. Certainly the way we dress ourselves in real life tends to set the tone for how we present ourselves, whether deliberately or unconsciously. But what happens as an actor when we are helped by a brilliant costume designer to create a character is so major that it is impossible to overstate the help it offers. I know that some great, great actors are able to convey the nuances of the character they are portraying with virtually no assistance, but

I certainly cannot. I love the subtle, sometimes radical, feelings of change and osmosis that happen as the layers and choices of costume are presented: I instantly feel myself sinking more and more into character. The boost that this gives is indescribable, and it totally catapults the actor into the period, the mood, and the way of moving and being in the film. It is invaluable—and huge fun, too!

I am so happy that Jay Jorgensen and Donald L. Scoggins have written this incredibly thorough and readable history of the costume designers who have worked in film from the silent era to the present. *Creating the Illusion* is a veritable encyclopedia of the great talents who have costumed us actors throughout the entire history of film. Some have inspired fashion. Others have recreated historical costume with astonishing accuracy. But all have contributed enormously to the beautiful and moving dream that remains the original magic of the movies.

—ALI MacGRAW, APRIL 2015

Oscar-nominated and Golden Globe–winning actress Ali MacGraw began her career as a photographic assistant to Diana Vreeland at *Harper's Bazaar.* Miss MacGraw later worked as a model and stylist for *Vogue.* In 1969, she received critical acclaim in her first movie, *Goodbye, Columbus,* and a year later starred opposite Ryan O'Neal in *Love Story,* which remains one of the highest-grossing films in Hollywood history. She starred in *The Winds of War* (1983) and *Dynasty* (1985) on television and made her Broadway stage debut in 2006. A lifelong animal welfare advocate, Miss MacGraw lives in the hills north of Santa Fe.

OPPOSITE: Ali MacGraw in *Love Story* (1970). Costumes by Ed Brennan and Linda Howard.

INTRODUCTION

When I began collecting Hollywood costume sketches in 1992, little information was available on the costume designers. Auction companies set their prices almost entirely on the star depicted, with little thought given to the creator of the sketch. I always thought it inequitable that the careers of fashion designers spawned a large number of articles, books, and sometimes even movies; yet the lives of *costume* designers—whose work so influenced those fashion designers—remained largely undocumented. Living in Los Angeles, whenever I met someone who worked in the costume design field, I pestered them with questions about their work and the history of the industry.

I had always hoped that my friend David Chierichetti would one day write the book I wanted to read. David had written *Hollywood Costume Design* in 1976, which was the first overview of design in films. David had known many of the designers of Hollywood's Golden Age at a crucial time—when they were retired and could speak freely of the highs and lows of their careers. Over the years, he told me many of the stories that did not make it into his book. One day while we were having lunch, I asked him when he was going to finally write a book with all of those stories. "I'm never going to write another book," he said. "That will be up to you."

So I set out to write the book I always wished existed. Many questions intrigued me. What made a designer seek a career in films? What were their relationships with stars and directors? And often, why did they leave the industry midcareer?

Our story begins in 1909, when Southern California's ubiquitous sunshine and its distance from motion picture camera inventor Thomas Edison and his patent lawyers enticed producer William Selig to make films in the Edendale neighborhood of Los Angeles. Multiple movie companies soon sprang up within a stretch of several blocks along Allesandro Street, later renamed Glendale Boulevard. These early American producers put little emphasis on costume. "When motion pictures were still too young to talk, it was the privilege of the star to report to a studio garbed in her red dress, or her blue, or her white—just as she preferred," wrote *Talking Screen* magazine contributor Dorothea Hawley Cartwright in 1930. "It mattered not the least that she wore the same gown as a Tennessee mountain girl in one picture, and as a society belle in the next."

Fabled producer D. W. Griffith was among the first filmmakers to realize that relying on the actors' personal wardrobes often compromised effective storytelling and diminished a film's overall impact. On *The Birth of a Nation* (1915) and *Intolerance* (1916), he not only budgeted money to costume his players, but he also hired a designer to create costumes specifically tailored to each production. Both practices would eventually become industry standards, though early producers could not spend as lavishly as Griffith had.

Fittingly, the capital to support this phenomenal growth in wardrobe departments came from entrepreneurs who had done well in the fashion business. Eager to become Hollywood studio moguls, these investors poured their manufacturing profits into the fledgling film industry. The roll call of early studio executives reads like a fine department store's vendor list. Paramount founder Adolph Zukor had been a furrier in New York. William Fox of 20th Century-Fox fame had been a dress manufacturer. Samuel Goldwyn had worked for a glove company, and Louis B. Mayer of MGM had been an antique and button dealer. Universal's Carl Laemmle had been a haberdasher. Because of their backgrounds, these men appreciated the value of good clothing. They did not hesitate to turn their movie profits back into their wardrobe departments.

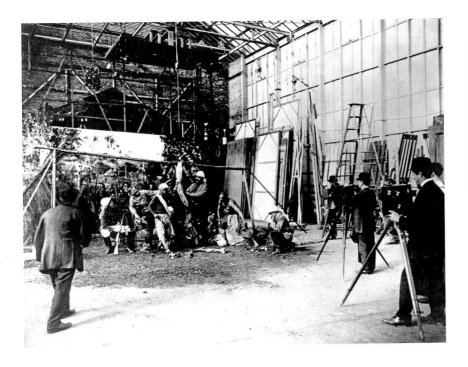

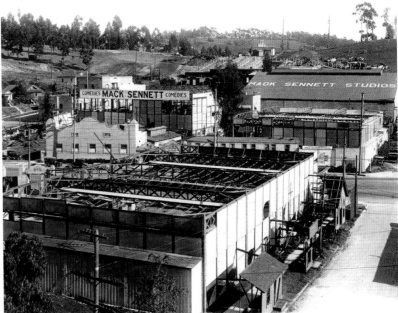

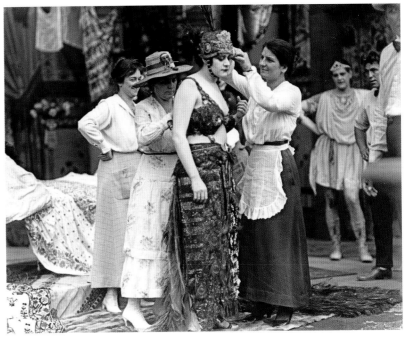

L. L. Burns, a collector of thousands of Native American artifacts, jewelry, weapons and clothing, founded Western Costume in 1912, partially in response to the ridiculous and inauthentic ways that Native Americans were being costumed in films. Indigenous wear was often just a random assemblage of beads, feathers, and furs that bore no resemblance to authentic dress. Burns quickly developed a reputation for supplying historically accurate Western wear and expanded his collection to include other periods.

For the most part, the first wave of designers and costumers hired by the studios came from theatrical backgrounds. Nepotism was also common, as many hires had a son, daughter, or husband already employed by the studio. The mothers of actresses Mildred Harris and Virginia Norden were both hired to costume Thomas Ince's films. The wife of actor Frank Farrington had begun her costuming career on Broadway before being hired by Thanhouser Company in New Rochelle, New York. But Hollywood was the Wild West, and it attracted a group of talented designers and dressmakers looking to make better lives for themselves at the dawn of the film industry. These are the stories.

In doing my research, I found that frequently studio biographies fudged many details of designers' lives, and many have come to be accepted as fact and are repeated over and over, particularly on the Internet. Some designers claimed to have worked in or owned fashion salons in Paris or New York, when records show they never even lived in those cities. More often than not, designers' generally accepted birth dates could vary widely from their official birth records. Census records often gave a very different account of the early years of some designers from what has been known.

But even census records needed to be scrutinized. Many female designers, though clearly divorced, often told census takers they were "widowed." Through intense research, every effort has been made to separate fact from fiction.

Please be advised that you will encounter stories that don't mince words, nudity, murders, suicides, vamps, and villains. After all . . . it is about the movies.

—JAY JORGENSEN, MARCH 2015

CLOCKWISE FROM TOP LEFT: An early silent film set. · Mack Sennett's studio in the Edendale section of Los Angeles. · On the set of *Cleopatra* (1917), Theda Bara's revealing costume stands in stark contrast to the modest clothing worn by wardrobe personnel.

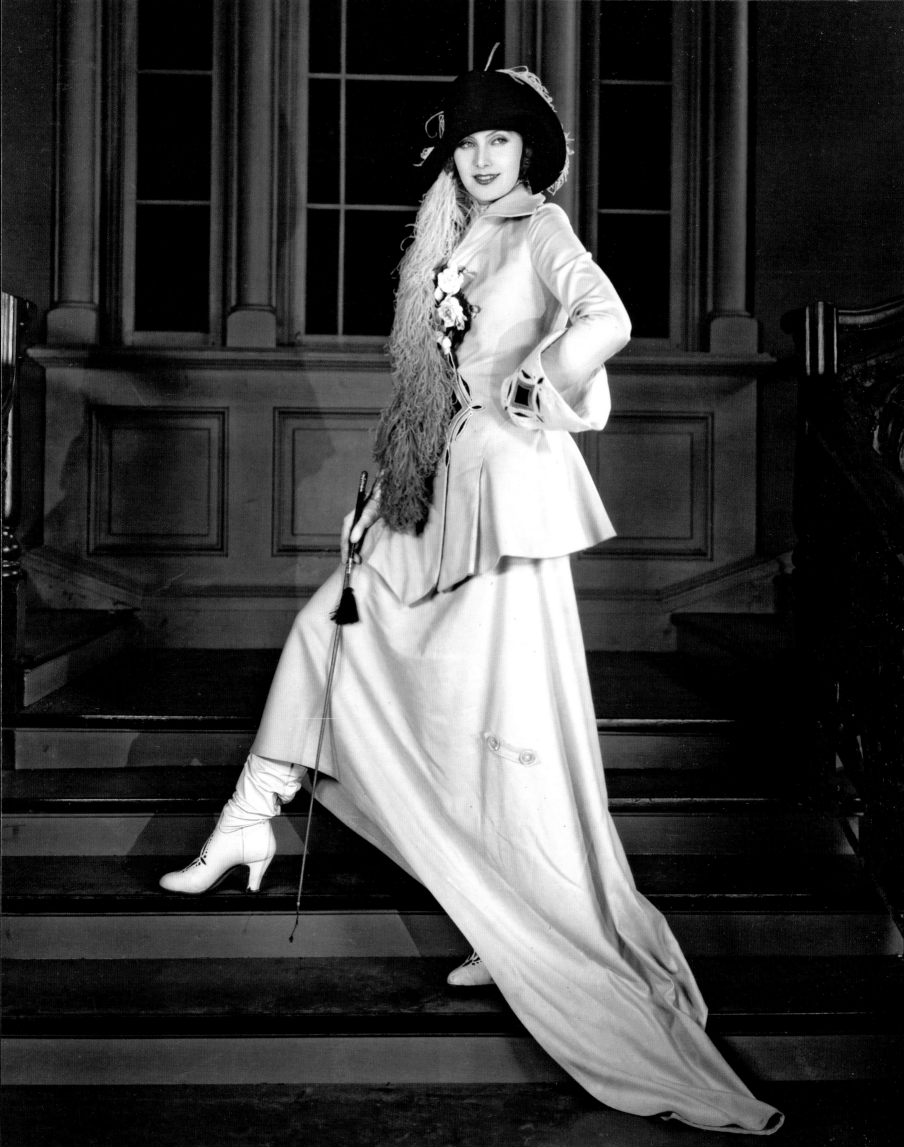

CHAPTER ONE
THE SILENT ERA

During the Silent Era, fantasy, rather than practicality, dominated costume design. In the 1910s, Hollywood regarded fashionable clothes as mere *objets d'art* that held a special allure for female moviegoers. In the 1920s, clothes became decidedly something more. Seemingly overnight, clothes transformed into statements expressing shifting societal norms for women. *The Flapper* (1920), starring Olive Thomas, perpetuated a new image for women, one of independence, one that embraced the hedonism of the Jazz Age, and thwarted the restrictions of Prohibition.

Before the institution of the 1930 production code, male moviegoers packed theaters to be titillated by flesh-revealing costumes that would be daring even by contemporary standards. Biblical epics were excellent vehicles to get stars into flimsy costumes while nominally appearing respectable. Designer Margaret Whistler's "gowns" for Betty Blythe in *The Queen of Sheba* (1921) included gossamer, see-through, breast-revealing bodices, and one ensemble comprised of ropes of pearls, and nothing else.

As the 1920s wound down, Hollywood designers made a concerted effort to make clothes that were modern, elegant, and more believable as clothing. While they were still out of the price range for the average American moviegoer, the clothes had more relevance and were more wearable than the clothes worn by "vamps" at the beginning of the decade.

OPPOSITE: Greta Garbo in *The Temptress* (1926).
Costume design by André-Ani.

SOPHIE WACHNER

In 1923, the *New York Times* referred to Clare West, Ethel Painter Chaffin, and Sophie Wachner as "three of the best known film costumers" in the nation.

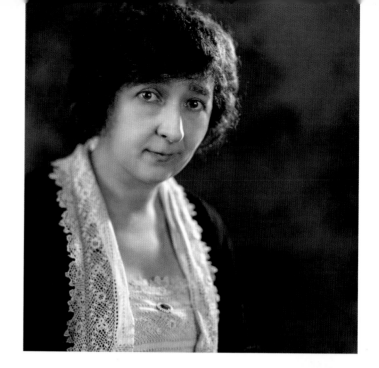

Sophie Wachner was born on November 5, 1879, to Hungarian immigrants Sigmund and Marie De Wolfe Wachner in Akron, Ohio, where her father ran a saloon. A teaching career was the natural choice for young Sophie, who grew up helping her mother raise six younger brothers and sisters. After graduating from Akron Normal Training School on June 2, 1899, Wachner was immediately hired by the Akron public schools.

In 1909, Wachner's aunt Frederica De Wolfe convinced her niece to join her in New York and design for Broadway productions. After several Broadway successes, Wachner's father, Sigmund, quit his liquor business and became the principal in the ladies' new design firm De Wolfe, Wachner & Company.

Wachner and De Wolfe designed for Broadway for nearly a decade, ending when Wachner moved to Los Angeles to become director of costumes for Goldwyn Studios in 1919. She remained at the studio until 1924, by which time it had transitioned into Metro-Goldwyn-Mayer studios.

Wachner approached designing in a unique way. "When I have informed myself thoroughly on the requirements of my particular assignment," she once said, "I relax and wait for inspiration. It usually comes to me at dinner time, when I have enjoyed a good meal and am listening to good music." She designed for more than a hundred movies during her career, including *He Who Gets Slapped* (1924) with Lon Chaney and *Lady Windermere's Fan* (1925) with Ronald Colman. Her most creative project, *Just Imagine* (1930), required Wachner and collaborators Alice O'Neill and Dolly Tree to design for humans and Martians in 1980 New York City.

Wachner would end her career at the Fox Film Corporation in 1931. She had signed a "long-term contract" with the William Fox Studio on September 17, 1928, as head of its costume department, but newly reorganized Fox Film fired her three years later. Her friend, actress Jeanette MacDonald, called it a petty cost-savings move. Ironically, Wachner had told the press a decade earlier that

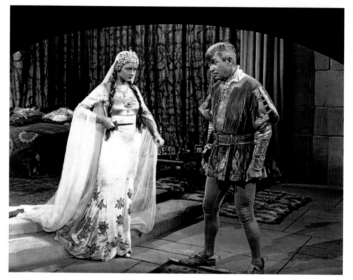

she always shopped and cared for clothing much as an economical mother of a large family. What she bought for stars she purchased with a view to cutting down and making over for lesser characters in other pictures, she said.

Whatever factors may have contributed to Wachner's ousting from Fox, they did not seem to diminish her ongoing success. She and husband Harold Powers opened their own ladies ready-to-wear shop, which they jointly operated until Harold's death on October 8, 1943. In 1936, Wachner came out of retirement from the movie business, designing for David O. Selznick's *Little Lord Fauntleroy*. She would do two more films, one in 1938 and another in 1939, both for 20th Century-Fox. Wachner died on September 13, 1960, in Los Angeles. She was eighty.

ABOVE, TOP TO BOTTOM: Sophie Wachner · Myrna Loy and Will Rogers in *A Connecticut Yankee* (1931).

OPPOSITE: A starlet in *Fox Movietone Follies of 1929*. Costume design by Sophie Wachner.

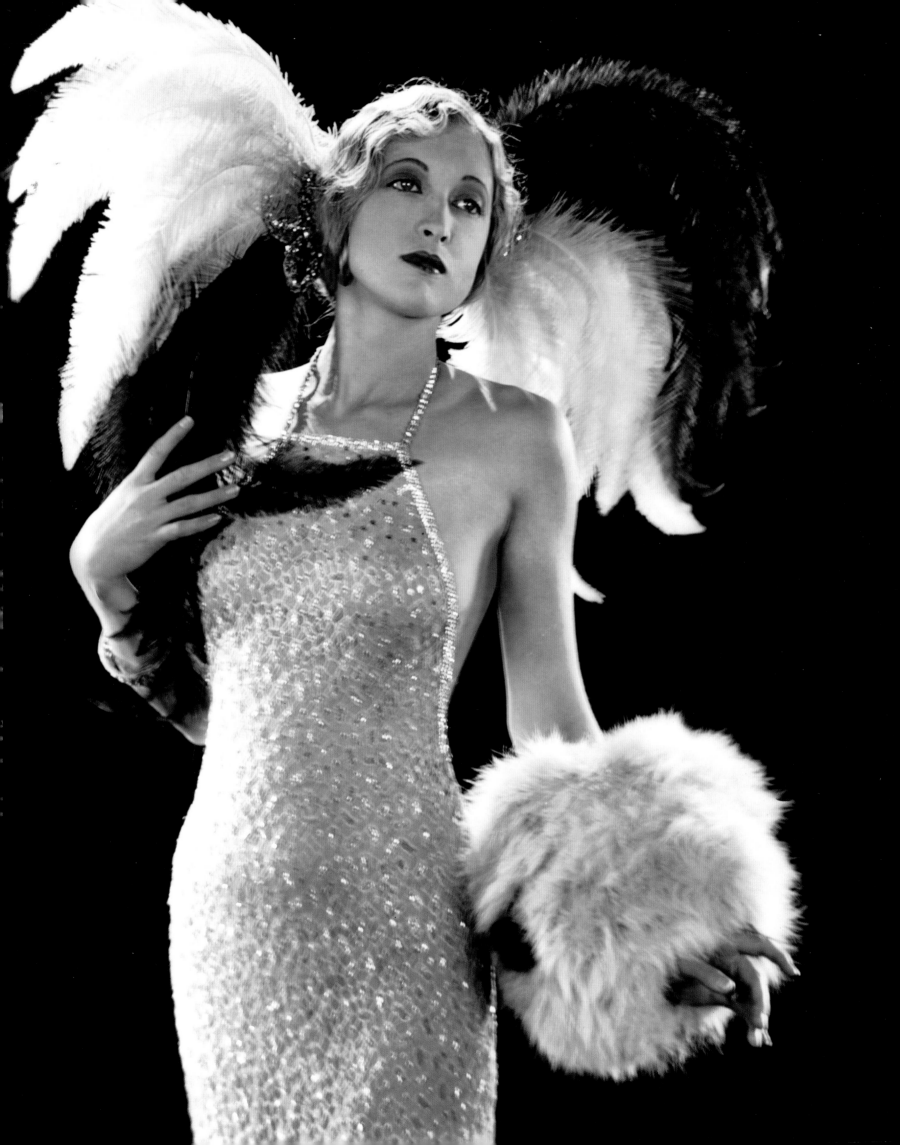

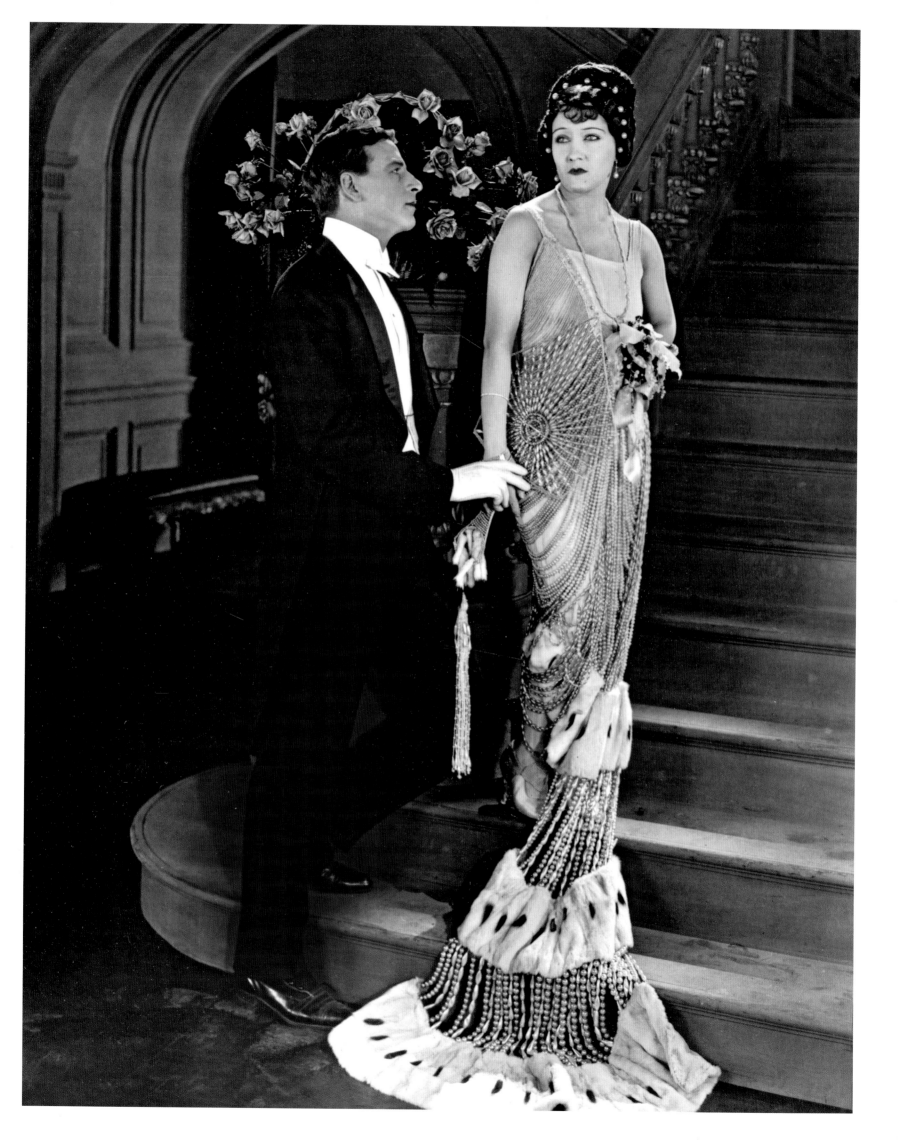

ETHEL PAINTER CHAFFIN

Another designer popular with the press, Ethel Painter Chaffin, became head of wardrobe at Famous Players-Lasky in 1919.

She was born Ethel Painter on January 14, 1885, in Pasadena, the second of two children born to Alzono and Hannah G. "Nannie" Negus Painter. Her father was a real estate agent who died when Ethel was eight years old. A year later, Nannie married Albert Royal, M.D., a Pasadena physician who had been widowed two years earlier. Ethel and her older brother, Harry Painter, both attended the prestigious private college preparatory school, Throop Polytechnic School (now Polytechnic School) in Pasadena. Ethel attended the Hopkins Art School (now San Francisco Art Institute) in San Francisco. Following a brief marriage to John S. Barber, whom she wed on May 29, 1904, Ethel returned home to Pasadena and worked as a dressmaker for a local department store.

In 1914, Ethel married George Duclos Chaffin, a fine arts merchant. She opened her own dress shop and by 1919, word of her dressmaking talents reached studio execs at Famous Players-Lasky, who hired Chaffin to head their wardrobe department. For the next six years, Chaffin designed for the studio's biggest stars, including Pola Negri, Gloria Swanson, Nita Naldi, and Bebe Daniels.

By 1923, Chaffin, along with Wachner and Clare West, had revolutionized movie costuming, at least in the eyes of the press. "These women have elevated it to the dignity of an art. And handsome salary checks attest to the importance the respective studios attach to their talents," wrote syndicate reporter Jack Jungmeyer of the trio in 1923. "Motion Picture costuming, once a slipshod and casual consideration, today is one of the most important and often the most expensive factor in movie-making."

Unlike her colleagues, Chaffin did not consider an actress's personal tastes a factor when creating a design. "I design gowns for directors rather than stars or leading women," Chaffin said in 1921, an unexpected statement for its time. "They generally have more to say about what the feminine characters in a motion picture will wear than the ladies themselves."

Chaffin moved to MGM in 1924, where she designed for Norma Shearer in *The Tower of Lies* (1925) and Marion Davies in *Lights of Old Broadway* (1925), among others. In 1925, she worked on King Vidor's production of *The Big Parade* (1925), one of the most successful and well-regarded films of the silent era. She retired from film design later that year.

During their marriage, the Chaffins took numerous trips to Europe for pleasure combined with business. George acquired art for his import business, and Ethel bought fabrics and observed European fashion trends. On one of these trips, George Chaffin died on board the R.M.S. *Carinthia* on September 3, 1927. Ethel never remarried. She spent the rest of her life in Los Angeles making gowns for private clientele. She died there on December 30, 1975.

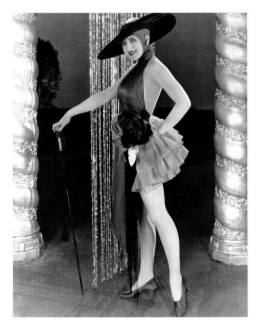 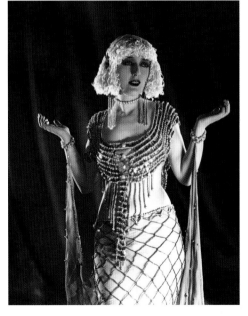

OPPOSITE: Gloria Swanson and Milton Sills in *The Great Moment* (1921).

FAR LEFT: Norma Shearer in an Ethel Painter Chaffin costume in *Pretty Ladies* (1925).

LEFT: Carmel Myers in *Ben-Hur: A Tale of the Christ* (1925). Costume design by Harold Grieve and Ethel Painter Chaffin.

CLARE WEST

One of the greatest enigmas of silent-film era costuming must be Clare West, the first individual to achieve celebrity status as a costume designer.

Appearing on the Hollywood scene in 1914 with no appreciable experience or training, West designed for the screen's biggest stars in some of the most well-regarded silent-era classics, and then seemingly vanished.

Born Clara Belle Smith on January 30, 1879, in Missouri, West was the sixth of eight children. Her parents, Abraham Chapman Smith and Jane "Jennie" Smalley married shortly after Abraham returned from serving in the Civil War. Throughout West's childhood, the Smiths eked out an existence farming in Caldwell and adjoining Clinton counties, northeast of Kansas City.

On August 24, 1898, West married salesman Otis Oscar Hunley in Missouri. The couple made their home in Billings, Montana. When the couple divorced in 1902, West was awarded custody of their only child, one-year-old Maxwell Otis Hunley. A year later, West married musician Marshall Elmer Carriere in Tulare County, California. Their first son, Leonard Carriere, arrived in 1908 in Bakersfield, California. Shortly after that, the couple moved to Missoula, Montana, where Marshall opened the Carriere School of Music. He and a business partner, Charles Freshwater, also owned and operated the Star Theater, a venue for traveling acts. Around 1912, Carriere sold his interest in the theater to Freshwater, and moved his family, which now included a third son, Lester Carriere, to Los Angeles.

Carriere and West divorced soon upon their arrival in Los Angeles. Carriere remained in town playing piano for silent movie houses. West, who had developed a penchant for sketching gowns, began selling her designs to makers of fine clothes and peddling her artistic talents to the film industry.

The details of how West actually acquired her design skills are lost. She probably learned to sew as a Missouri farm girl, and likely took note of the costumes of the various acts booked at her husband's theater in Montana. But as she gained fame as a costume designer, the press unabashedly ascribed to West a truly impressive résumé. "Madame Clare West, a trained Parisian designer and formerly head of 'The Maison Clare' in New York is now head of the Fine Arts costume department," *Motography* magazine announced in its March 11, 1916, issue. Other than the fact that West had indeed been hired by D. W. Griffith's studio, nothing else in the announcement was true. West had never lived in New York, nor had she ever left the country.

West was a savvy innovator who happened to be in the right place at the right time. In 1914, director D. W. Griffith was readying a film in Los Angeles that would make cinematic history. "Miss West had been an ardent picture fan, and the idea came to her that a unit in costuming would greatly improve a picture. She presented her dress plan to David Griffith and 'sold' him the idea so well that she was given the opportunity to costume *The Birth of a Nation* (1915)," Jean Mowat wrote in 1927 of West's entry into film design.

Based on *The Clansman*, a novel and play by Thomas Dixon Jr., *The Birth of a Nation* starred Lillian Gish, Mae Marsh, and Henry B. Walthall in a tale about family and friends divided by the Mason-Dixon Line during the Civil War. Fans today revere the film for cameraman Billy Bitzer's pioneering cinematic techniques. Sadly, the film also suffers from blatant racism. Filming took place from July to November, 1914, in the San Fernando Valley. West shared costuming duties with Robert Goldstein, who owned a costume house in Los Angeles and supplied authentic Civil War uniforms, which were still available in 1914. West dressed the prominent female stars, including Mae Marsh in a well-known tattered post-war dress. Wanting to greet her returning brother in splendor, Marsh's character, Flora, styles pieces of cotton to resemble fur accents on her dress, referred to in the intertitles as "Southern Ermine."

The Birth of a Nation made millions at the box office, despite protests at screenings organized by the National Association for the Advancement of Colored People (NAACP). Its depiction of African Americans as inferior people bent on interracial marriage

OPPOSITE: Mae Marsh inscribed this photo of herself in costume for *The Birth of a Nation* (1915) to Clare West.

For Mrs West
With best wishes
Sincerely
Mae Marsh

HARTSOOK
PHOTO
S.F. - L.A.

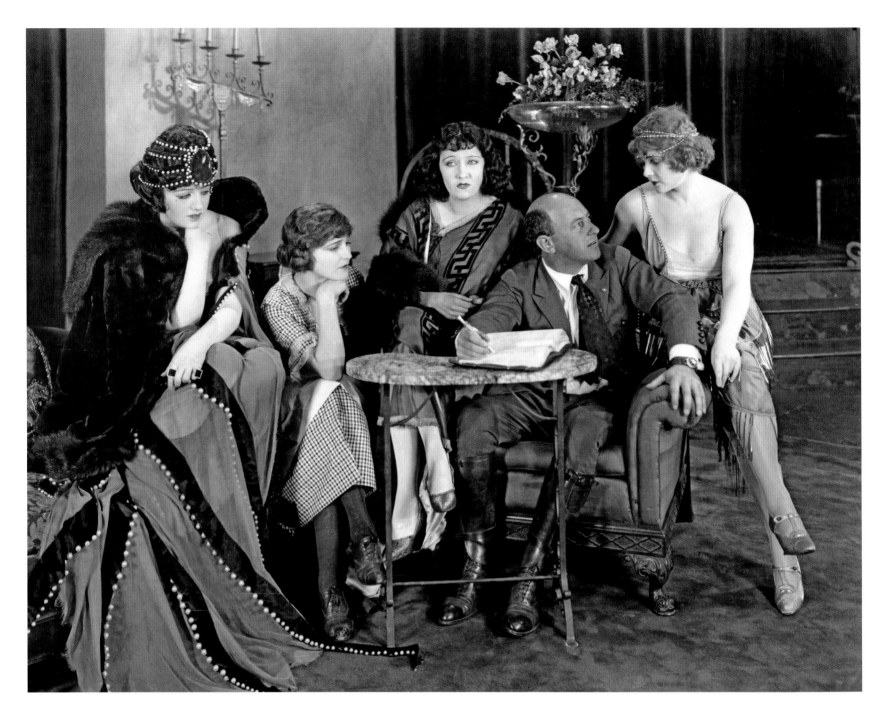

caused a reemergence of the Ku Klux Klan, which used the film as a recruiting tool in the South. Woodrow Wilson, who became the first president to screen a movie in the White House, called the film "unfortunate."

Griffith's next film, *Intolerance* (1916) was his response to the backlash, which he found painfully unfair. He again hired West. With four diverse stories—a contemporary one, a story about Jesus Christ, a depiction of the St. Bartholomew's Day Massacre of 1572, and the fall of the Babylonian empire—all intertwined in a three-and-a-half-hour epic, *Intolerance* presented huge design challenges for West. Griffith amassed scrapbooks of research for each story, including decorative objects and costumes. He strove for historical accuracy, although he allowed West to tailor her

designs somewhat to each individual actor. West's stint at Fine Arts ended after one year. Although *Intolerance* did excellent at the box office, its extravagant production costs made the film a financial failure. Griffith could not recover and closed down his studio. Nonetheless, West's years with Griffith had made her a celebrity in her own right, the first costume designer to achieve that status.

In 1918, director and showman Cecil B. DeMille hired West to oversee Famous Players-Lasky's costumes and to design for his protégée, Gloria Swanson. DeMille's early work pushed the envelope on sex and extravagance on-screen. West swathed Swanson in rich fabrics, jewels, and furs. The themes of DeMille's films included marital strife among the rich, and the subject matter was aimed at adults only. Film trade magazines, aimed

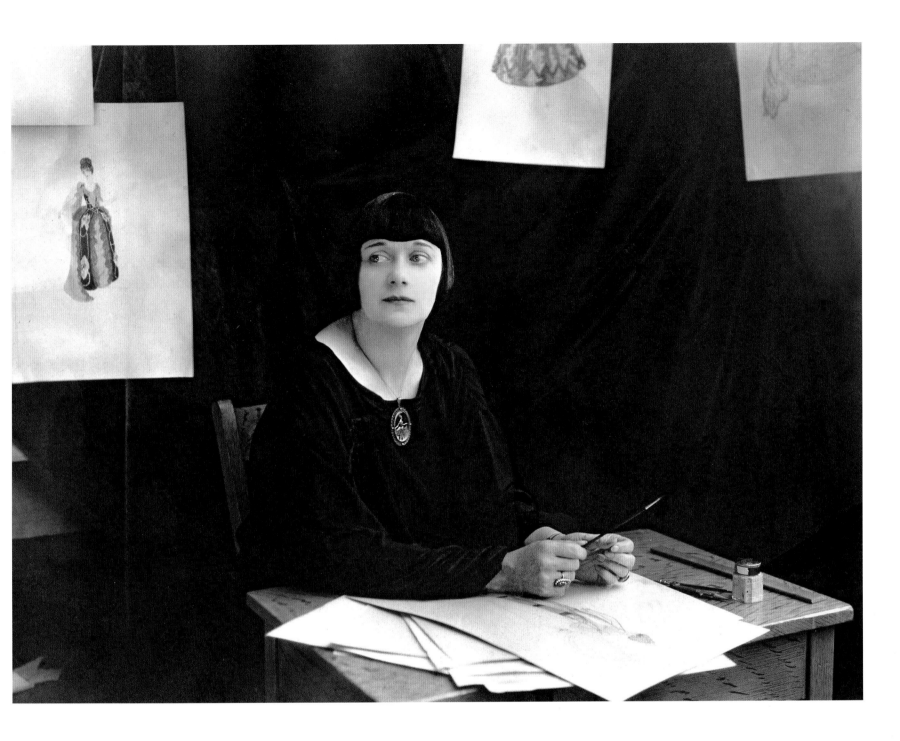

at exhibitors, began specifically mentioning West's designs for DeMille's female stars.

As West's career flourished, she developed a disinterest in her family that bordered on disdain. "If there was anything else to do other than taking care of the boys, Clare was doing it," said Clarissa Carriere Abbott, West's granddaughter by her middle son, Leonard. "She used to have some hellacious cocktail parties, with actors and actresses there," Seth Carriere, West's grandson, added.

In May 1920, West married cinematographer Paul P. Perry in San Diego. Shortly after the wedding, Margaret Tally brought suit against Perry for breaching his promise to marry her. The case never went to trial, but the Perry-West union ended two years later. When word of West's divorce hit the papers in 1922, she announced that she was "through with husbands forever and a day, or at least until 1930, by which time the model found today may have changed for the better." Apparently, West never found the hoped-for "better model" of husband, as she never married again. "I had the feeling that she thought she was above most people," Clarissa said. "She certainly was ahead of her time in her thinking. She was promiscuous, as I understand from my father, but she was also very strict."

OPPOSITE: (l-r) Bebe Daniels in the famous "octopus" dress, Agnes Ayres, Gloria Swanson, Cecil B. DeMille, and Wanda Hawley on the set of *The Affairs of Anatol* (1921).

ABOVE: Clare West

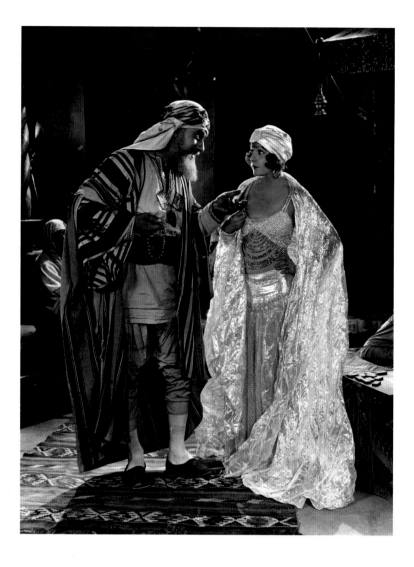

In 1921, *Photoplay* magazine devoted a full-page photograph to West's design for Bebe Daniels in *The Affairs of Anatol* (1921). Called "The Octopus Gown," West's creation of pale gray georgette included a cape of black velvet attached to the back with eight "tentacles" outlined in enormous pearls. Appearing as the vamp Satan Synne in the film, Daniels also wore a headdress of loose pearls woven into her hair. "Any man that gets within reach of those arms is never going to escape, but who would want to?" the accompanying copy said of Daniels's promotional photograph.

In January 1923, West finally made her first visit to Paris. DeMille sent her there to do research and buy fabrics for *The Ten Commandments* (1923). West used 333,000 yards of cloth to make over three thousand costumes for the production. West also used the Paris trip as an opportunity to knock European couture. Upon her return, she declared triumphantly, "I am more proud than ever of our own United States. Our designers, especially those whose work is reflected on our screen, are months ahead of those of Paris and London, and the Europeans very evidently realize it." By this

time, West's identity was so well known to the American public that she played herself in a cameo, along with thirty other stars, including Fatty Arbuckle and Mary Astor, in *Hollywood* (1923), the industry's comedic exposé of itself.

Later that year, West left Famous Players-Lasky and signed a long-term contract to head the new costume concern of Joseph M. Schenck Productions. John Considine, general manager of Schenck Productions, planned to erect a three-story building at United Studios at a cost of $100,000 to house the costume collection West would oversee. But within a year, the contract was cancelled; West instead agreed to design for actresses Constance and Norma Talmadge and for the actresses who appeared in films for their company, First National Pictures.

At this point, West seemed to be changing jobs yearly, but press interest in her remained high through 1925. For *Photoplay* readers, she gave a daring fashion forecast: "This year, evening gowns will be worn without stockings, underwear will be of black chiffon and black Chantilly lace, and milady must expose practically all of her spinal column in the evening if she is to be really in vogue." In December, West opened her own dress salon in downtown Los Angeles. Then something inexplicable happened: silence. The interviews stopped. Films for the Talmadges stopped. Everything seems to have stopped for West.

"I don't believe her store survived long," Seth Carriere said. By 1930, West was living on Spring Street in downtown Los Angeles and designing for Buffums, a chain of upscale department stores in Southern California. While Buffums traded on West's star stature, once she left the store, her visibility completely ended. "I believe she vanished intentionally," Seth said. "My father told me that she was probably bipolar. Back then they didn't realize what it was. She would spend weeks at a time sequestered in her living quarters and wouldn't come out, not even to see her children."

West's press interviews may have ended because "even though Clare wanted fame, she wanted acceptance in her field more," Clarissa said. "She wanted the approval of Cecil B. DeMille and the stars for whom she worked and knew. She didn't care a lot for the press. She told my father they were all 'consummate asses' and had contempt for news people."

In the late 1940s, West moved to Carson City, Nevada, where Clarissa remembers visiting her once-famous grandmother in 1947. "Dad hadn't seen his mother in quite a while. I was about

seven and Seth had just been born, and my parents wanted to show Clare the baby. I remember driving down her long driveway, which was surrounded by beautiful walnut trees. When we arrived Clare bent down and gave me a hug, and I loved the smell of her perfume. She wore a green top with cream-colored silk pants and offered us cold drinks. As she sat down with a cigarette in one hand and iced tea in the other, she glided on to the sofa as if she was royalty. She was very graceful, though her voice was very commanding. As I sat there drinking my lemonade, I watched her. She had auburn hair and a beautiful complexion, and golden brown eyes, which matched her hair. Her hair was bobbed with bangs, and I had never seen anyone with hair like that."

A year later, in 1948, West garnered press attention one last time, albeit unintentionally. Her live-in maid, Jennie Belle Bartlett Kniess, dressed herself in West's diamond earrings and expensive clothes, then left for Salt Lake City just ten days after West had hired her. The local newspaper reported the crime after West filed a complaint with the police. Kniess had insisted on referring to West as "mother," and in a farewell note to West said that she "would give a million dollars to have a real mother like her." Kniess was apprehended a few days later with West's possessions still in tow.

The reclusive designer never developed a close relationship with her son Leonard. "My father and Clare were close enough to talk maybe once a year by telephone," Seth said. The only emotional bridge between them was their mutual respect as artists. Leonard was a sculptor working in glass and eventually owned his own studio. In 1954, he carved glass panels depicting the history of banking and finance that still adorn the interior of J. P. Morgan Chase bank on Wilshire Boulevard in Beverly Hills. "He loved her and admired her for what she accomplished in her life," Seth said of his father and grandmother. "All he ever wanted as a young man was her acceptance. But the only time she ever expressed approval was the few times she came to see his glass art."

The second and last time Clarissa recalls seeing her grandmother was at her father's glass studio in the 1950s. West still exuded the regal air that she recalled from their first meeting. "She was so in command," Clarissa said. "But it was apparent that she appreciated my father's creative ability with glass." Leonard died in Twisp, Washington, in 2002, never receiving the maternal acceptance he craved. "He really loved Clare and was sad that he didn't get the same kind of love from her," Clarissa said. Despite

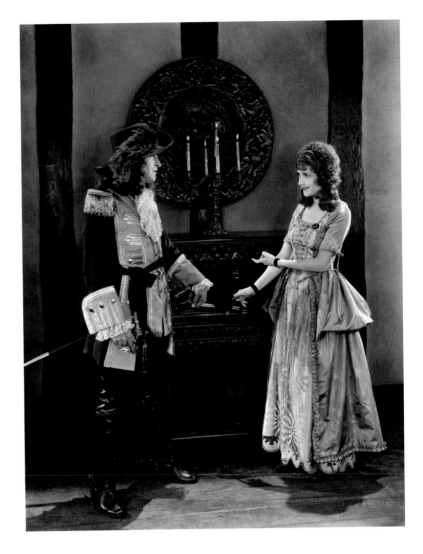

a distant relationship with his mother, West's youngest son, Lester, adopted West as his last name, though no one today knows how the designer came to choose that as her professional surname.

West spent her last years living in the Paradise Travel Trailer Park in Ontario, California, about forty miles east of Los Angeles. "She became reclusive and didn't want to be around anyone," Seth said. "She just alienated herself from society. While I was growing up, I more or less just felt sorry for the woman because she was missing out on some great kids." West died in Ontario on March 13, 1961, at the age of eighty-two.

OPPOSITE: Norma Talmadge and Hector Sarno in *The Song of Love* (1923).

ABOVE: Constance Talmadge and Conway Tearle in *The Dangerous Maid* (1923).

MARGARET WHISTLER

Unlike Wachner, Chaffin, and West, each of whom became famous on account of their costume design careers, Margaret Whistler's name was already well known to movie audiences of the 1910s before she began her design career.

She had been a featured actress in no fewer than thirty silent movies before becoming a designer for William Fox Studios in 1919. She was born Louise Margaret Pepper in Louisville, Kentucky, on July 31, 1892, and grew up in Washington, D.C., where she attended Notre Dame Academy, a Catholic girls high school. Her stage name, "Margaret Whistler," apparently had its origins in an early marriage, as Whistler referred to herself as *Mrs. Louise Margaret Whistler* in deeds and other legal documents. Claims about Whistler's pre-Hollywood career—touring with a circus in England and appearing on the vaudeville stage—seem inflated or erroneous.

Whatever led Whistler to the big screen, her path to the wardrobe department clearly followed from there. By 1915, she was designing gowns for silent film actress Cleo Madison, although Whistler acted in seven shorts herself that year. In 1916, Madison directed and starred with Whistler in *Virginia* and *To Another Woman*. Whistler designed the costumes for both movies. Around the same time, Whistler also gained notoriety as a painter. Following her last screen appearance in *A Beach Nut* (1919) with Wallace Beery, Whistler began designing gowns for William A. Fox's studio. While at Fox, she spent one year designing costumes for exotic screen siren Betty Blythe for her title role in *The Queen of Sheba* (1921), one of the most lavishly produced films of the 1920s. Directed by J. Gordon Edwards, grandfather of Blake Edwards, the precensorship-era *Sheba* featured Blythe nude or nearly nude in every scene. Although Whistler designed a total of twenty-eight "gowns" for the star, Blythe would later joke that they all would fit in one shoebox. Whistler remained a designer for the rest of her life, but her work on *Queen of Sheba* is what she is most remembered for.

As the 1920s drew to a close, Whistler married former automobile dealer Merle G. Farnsworth. By 1930, he was managing a medical laboratory. And by 1932, he left Whistler for his third wife, Myrtle Stewart, a physician from Chicago. Whistler became ill a few years later and died on August 23, 1939, in Los Angeles. She had been designing for Columbia Pictures for about two years prior to her death. She was forty-seven.

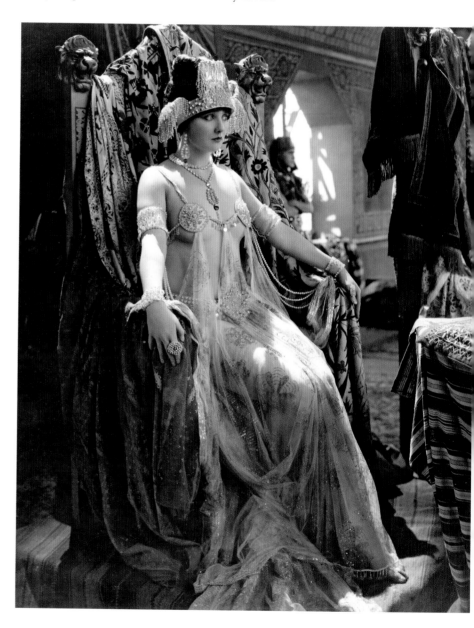

ABOVE: Betty Blythe in *The Queen of Sheba* (1921).

OPPOSITE: Fritz Leiber in *The Queen of Sheba*.

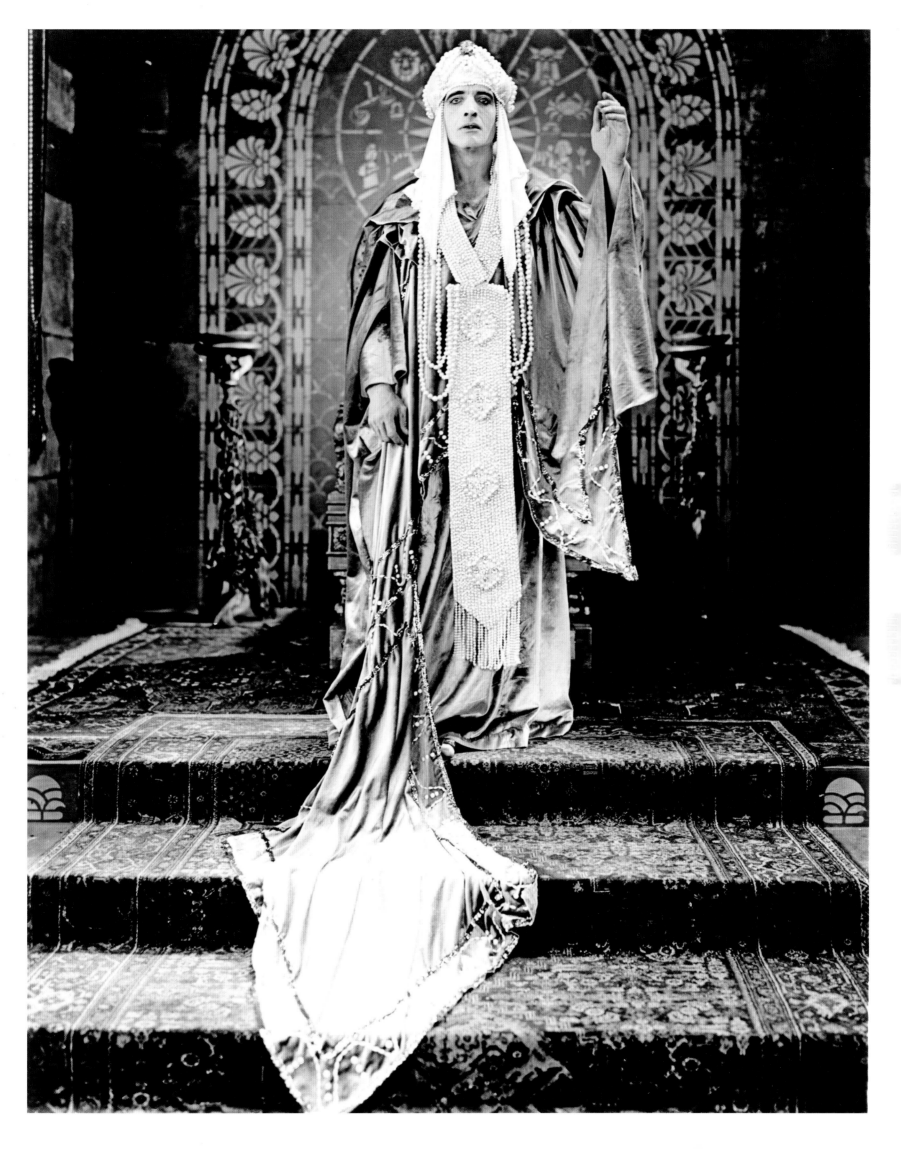

PEGGY HAMILTON

In 1917, Harry and Roy Aitken announced that Peggy Hamilton, actress-turned-designer, would be costuming players at their Triangle Film Studio. The Aitken brothers touted Hamilton as the "Lucille (sic) of the West," a reference to Lucile, Ltd., the international couture house of British designer Lady Duff-Gordon.

Hamilton had invented the title herself. She frequently compared her work as being on par with, if not superior to, that of the famed couturier. A tireless self-promoter, the future designer was born May Bedloe Armstrong on December 31, 1888, in Denver, Colorado. As a child, she moved with her parents and sister, Aurora, to Los Angeles. She took an interest in fashion as a teen and made clothes for herself and her sister. In 1916, she appeared in *The House of Mystery* under the stage name Peggy Wilson.

As a designer, Hamilton never gained the reputation of the real Lucile, though her work was arguably as detailed and beautiful. At Triangle, Hamilton costumed Gloria Swanson for her earliest screen appearances. During Hamilton's first year at the studio, movie magazines featured actresses modeling Hamilton's satin gowns, which she adorned with hand-embroidered nets of pearls, sequins, and other luxurious fabrics and furs. Her creations were especially impressive given that Triangle was not known for large wardrobe budgets. In 1917, Adolph Zukor took over the company, which had run into financial difficulties. Film production ceased in 1919, and Hamilton was out of a job. Her real contribution to the world of Hollywood fashion would begin a couple of years later, when she became editor of the *Los Angeles Times*' rotogravure fashion page. From 1921 to 1934, Hamilton reigned as the arbiter of taste. She incessantly promoted the work of California designers, including Adrian, Travis Banton, and Howard Greer, by featuring their gowns modeled by stars such as Norma Shearer and Dolores del Rio. Hamilton was not above modeling the gowns herself. "Look to Paris for our modes?" Hamilton said. "Have we no

originality of our own? During the time that I was with Triangle, I did not look at a fashion book from abroad. Our demands are different."

When she was not sharing her insights with Angelinos, Hamilton organized fashion shows at L.A.'s Biltmore Hotel and became the first promoter to stage a Hollywood fashion show in Paris. Hamilton joined the staff of *Picture-Play* magazine and wrote a monthly column on film fashions for a national audience. She also found time to occasionally design for film on a freelance basis, notably dressing Dorothy Mackaill in *Joanna* (1925). She consulted on fashion show sequences for films until 1937.

In 1931, she was given the title "Queen of Olympias of the Mythical Kingdom of Olympia" by the Los Angeles County Board of Supervisors, who declared her the official hostess of the 1932 Olympic Games in Los Angeles. The resolution noted that Hamilton had "the distinction of having placed Los Angeles and Hollywood on the map as a style center of the country." Hamilton's son, Fred Hamilton, became a television producer and director, and co-created the television series *Bonanza* (1959–73). Peggy Hamilton died on February 26, 1984, in Los Angeles.

ABOVE: Costume designer Peggy Hamilton in one of her own creations.

MADAME VIOLETTE

Though Hollywood designers did not trigger fashion crazes until the 1920s and '30s, one early designer, Madame Violette, did influence popular attitudes toward ladies' swimwear.

Producer Mack Sennett had built his Keystone studio up with great comedians like Charlie Chaplin and Mabel Normand and a group of women known as the Sennett Bathing Beauties. Normand would appear in the company's short films wearing provocative bathing costumes designed by Violet Schofield Schroeder, who went by the name Madame Violette, or sometimes Madame Violet. A 1922 Keystone press release touted, "With a competent corps of assistants, Mme. Violet designed and personally supervised the making of the entire wardrobe for every Sennett short length and feature picture." The beauties had a profound influence on the acceptance of modern swimwear, which was still sometimes seen as scandalous in the post-Victorian era.

Madame Violette worked for Keystone from 1916 to 1931, quitting just a few years before the demise of the studio. On September 29, 1921, she married a fellow Keystone employee, cinematographer George Unholz, in Los Angeles, and was sometimes credited in the press as Mrs. George Unholz. In films she was credited as Violet Schofield on *A Small Town Idol* (1921) and *The Crossroads of New York* (1922) and as Madame Violette on *Suzanna* (1923), starring Mabel Normand. After leaving Keystone, she designed sportswear. In 1969, she and her husband moved to Yucaipa, California, and she died in Redlands on January 22, 1979.

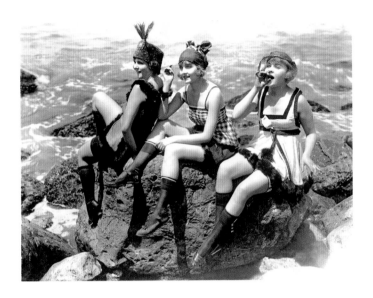

ABOVE RIGHT: The Mack Sennett Bathing Beauties

RIGHT: Madame Violette

NATACHA RAMBOVA

"Even her worst enemy has admitted the genius of Natacha," Herb Howe wrote of Natacha Rambova in 1930, "that unquenchable flame of ambition that sweeps out from her ruthlessly."

The woman known the world over by the striking Russian name was born Winifred Kimball Shaughnessy in Salt Lake City on January 19, 1897. Her father, Michael Shaughnessy, a hero of the Civil War, and her mother, Winifred Kimball, an interior decorator, separated when she was young because of Michael's heavy drinking and gambling. The elder Winifred remarried twice, first to Edgar De Wolfe, brother of interior decorator Elsie De Wolfe, and then to wealthy perfumer Richard Hudnut.

Rambova studied ballet while attending boarding school in Great Britain. She began an affair with the Russian ballet dancer Theodore Kosloff when she was only seventeen. She changed her name to Natacha Rambova to dance professionally. When her mother discovered the affair, she pursued statutory rape charges against Kosloff. Eventually, the charges were dropped and Kosloff and Rambova settled in Los Angeles, where he began acting and designing films for Cecil B. DeMille.

Rambova helped Kosloff with the designs, and he passed Rambova's work off to DeMille and others as his own. For *Billions* (1920), Kosloff submitted Rambova's designs to Alla Nazimova, which she used in the film. For Nazimova's next proposed film, *Aphrodite* (unmade), Kosloff made the mistake of sending Rambova to meet the actress instead of going himself. As Rambova made changes to the sketches in Nazimova's presence, the actress realized that they were Rambova's designs, not Kosloff's. Nazimova hired Rambova to design *Aphrodite*, sending Kosloff into a rage. When Rambova announced that she was leaving him, Kosloff shot her in the leg. Rambova never reported the incident to police to avoid any further contact with Kosloff.

In 1921, Rambova met unknown actor Rudolph Valentino while he was making *Uncharted Seas* (1921). Nazimova introduced the two because she intended to cast Valentino as Armand in *Camille* (1921). Valentino had just finished *The Four Horsemen of the Apocalypse* (1921), which would establish him as a star, but it

had not yet been released. Given the legend that their romance would spawn, Rambova and Valentino's initial meeting was disappointingly uneventful, at least for Rambova.

"I remember the first day he came on to the set, I disliked him," Rambova said. "At that time I was very serious, running about in my low-heeled shoes and taking squints at my sets and costumes. Rudie was forever telling jokes and forgetting the point of them, and I thought him plain dumb." She did not realize that she had piqued Valentino's interest. "Then it came over me suddenly one day that he was trying to please, to ingratiate himself with his absurd jokes," Rambova recalled. "'Oh, the poor child,' I thought. 'He just wants to be liked—he's lonely.' And, well, you know what sentiment leads to . . ."

Rambova had a unique personal style. She wore turbans and bangle bracelets. She favored designers like Paul Poiret. She loved fabrics that reflected light, and designs that showed off the human form. Her sets and costume designs for *Camille* embodied an art deco sensibility, which was the rage in Europe at the time. But *Camille* may have been too much of an art film. When audiences rejected it at the box office, Metro Pictures canceled Nazimova's contract. Nazimova Productions released its next feature, *A Doll's House* (1922), through United Artists. It also featured Rambova's sets and costumes.

Rambova and Nazimova's final collaboration, *Salomé* (1922), was perhaps Hollywood's first art film, as it was clearly experimental, even by today's standards. Rambova's minimalist sets looked like peculiar stage scenery. Her highly stylized costumes matched Nazimova's bizarre hairdos, which included glowing light spheres. Shirtless male actors sported nipple paint and giant bead necklaces. "The settings and composition of the scenes, devised by Natacha Rambova, correspond in a measure to the drawings by Aubrey Beardsley (in Oscar Wilde's published play); and this visual beauty, as background to the fantastic flare and vivid drama of the story,

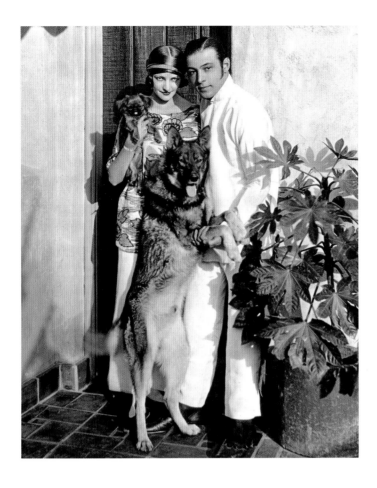

gives the Nazimova *Salomé* an added artistry," wrote the *Exhibitors Herald*. Public response was not so enthusiastic. Audiences stayed away *en masse*. The disaster ended Nazimova's career as a producer.

Valentino was charged with bigamy and jailed shortly after Rambova married him in Mexico on May 22, 1922. Although Valentino's first wife, actress Jean Acker, had obtained a divorce decree prior to the Rambova nuptials, Valentino had failed to wait the mandatory waiting period under California law before remarrying. Before the year was over, contract disputes arose between Valentino and Famous Players-Lasky, resulting in lawsuits in court, and a struggle for public sympathy in the press. When the studio successfully obtained an injunction preventing Valentino from acting for other studios, his new agent, George Ullman, suggested he and Rambova go on a dance tour, sponsored by Mineralava products, to keep the couple financially solvent. The tour was a great success. It ended with the couple marrying again, this time legally, on March 14, 1923.

Rambova became Valentino's manager, and his career seemed to suffer instantly. In *Monsieur Beaucaire* (1924), Valentino played a seventeeth-century duke. Although Rambova, George Barbier, and René Hubert designed beautiful period costumes for Valentino,

his fans did not expect or accept the star in powdered wigs and frilly ruff collars. The film flopped. Valentino's next film, *A Sainted Devil* (1924), showed a return of the Latin lover image, but script revisions caused the film to suffer. Rambova was increasingly blamed in the press for Valentino's failures.

Misstep after misstep plagued their next production, *The Hooded Falcon* (unmade), to be produced by Ritz-Carlton. Valentino tabled the project and made *Cobra* (1925) instead. Ritz-Carlton hired Adrian to costume the players, thereby minimizing Rambova's involvement. After talks failed to resolve *The Hooded Falcon* disputes, Ritz-Carlton canceled the project and Valentino's contract.

United Artists offered Valentino a contract with the stipulation that Rambova had no negotiating power, nor could she even visit the sets of his films. To placate the outraged Rambova, Ullman co-produced *What Price Beauty?* (1925), starring and written by Rambova. The film did not do well at the box office.

ABOVE LEFT: Natacha Rambova and husband Rudolph Valentino.

ABOVE RIGHT: Costume sketch by Natacha Rambova, possibly for Alla Nazimova in *Aphrodite* (never made).

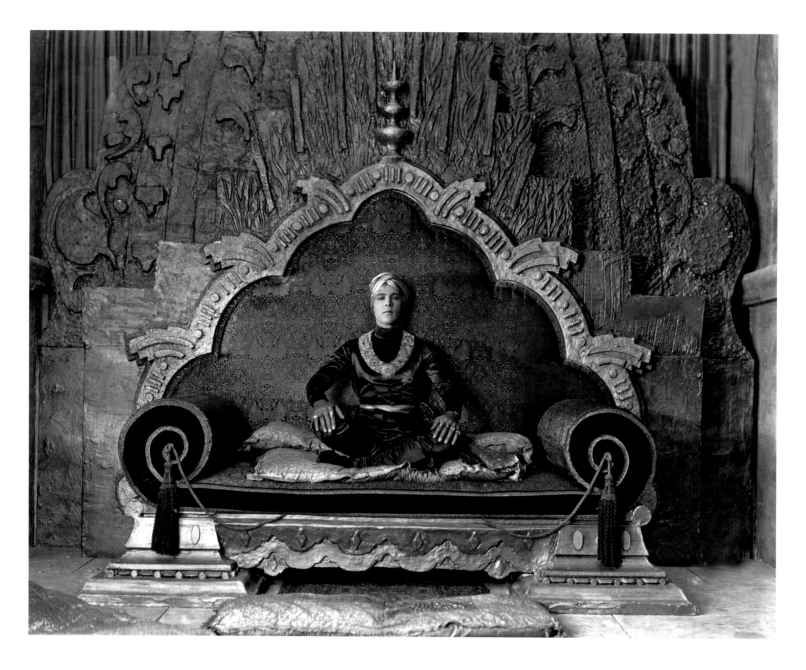

Under the strain of failed business collaborations, and because Rambova did not want to have children, Valentino and Rambova separated in 1925 and were divorced in 1926. By the time of the divorce, Valentino's next two films *The Cobra* (1925) and *The Son of the Sheik* (1926) put his career on track again.

As the Valentino divorce was being finalized, Rambova was given an opportunity to act in *Do Clothes Make the Woman?* The film, about an oil executive who tries to break up the marriage between a young inventor and his wife, was re-titled *When Love Grows Cold*, to Rambova's dismay. She was further insulted when the producer billed her as Mrs. Rudolph Valentino. Hurt and humiliated, she never worked on another film.

In August 1926, Valentino was hospitalized in New York City with appendicitis and gastric ulcers. Hearing of his grave condition, Rambova telegraphed Valentino from France. The couple exchanged telegrams, and Rambova viewed this as a reconciliation. After a brief rally, Valentino relapsed with pleurisy and died on August 23, 1926. Rambova was inconsolable and did not attend the funerals in New York or Los Angeles.

Rambova remained a pariah in Hollywood following Valentino's death. In 1927, she found some success opening a couture shop on Fifth Avenue in New York City. In 1934, she married Spanish aristocrat Alvaro de Urzaiz and moved to the island of Mallorca with him. When the Spanish Civil War broke out, Urzaiz stayed to fight, and Rambova moved to France. Rambova suffered a heart attack shortly afterward, and the couple divorced in 1939. When World War II started, Rambova returned to New York and taught classes in Egyptology and mysticism. She amassed a well-regarded collection of Far Eastern and Egyptian art. When she became ill in the early 1960s with scleroderma, brought on by years of anorexia nervosa, Rambova moved to Pasadena to be looked after by a cousin. She died there of a heart attack on June 5, 1966.

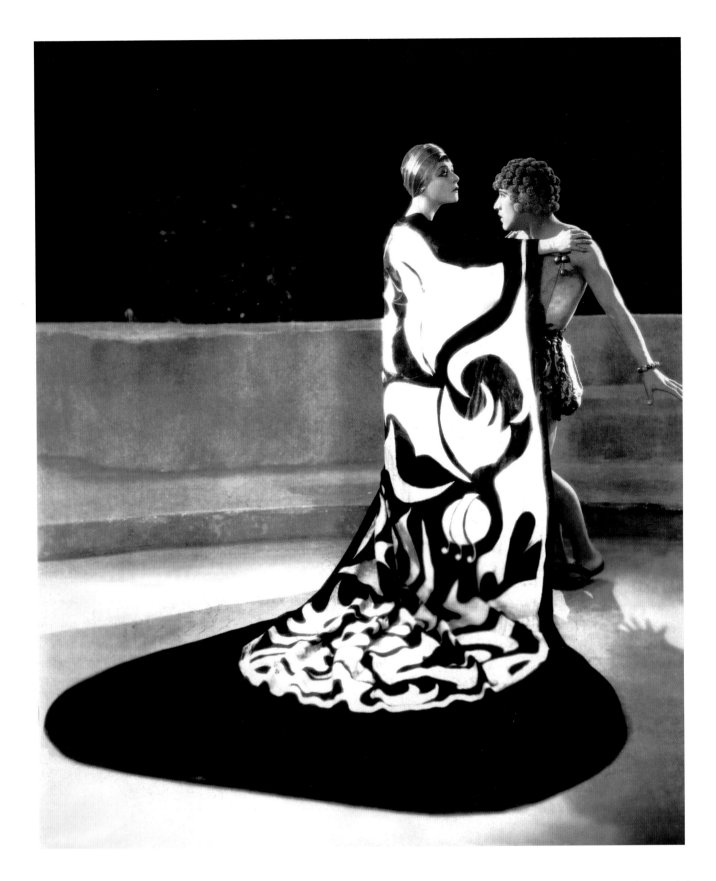

Though Rambova has been revered for her costume and set designs, and later was respected as a scholar, her legacy remains the villainess who destroyed Valentino's career. "I'm glad Rudie died when he did, while the world still adored him," Rambova said in 1930. "The death of his popularity would have been a thousand deaths to him. Of course he might have gone on, but I'm afraid today we have a realism in pictures and on the stage.

Rudie belonged to the age of romance. He brought it with him, it went with him. I think it was a climax he would have wished."

OPPOSITE: Rudolph Valentino in *The Young Rajah* (1922).

ABOVE: Alla Nazimova in *Salomé* (1922).

HOWARD GREER

Howard Kenneth Greer used to say that he "grew up on the wrong side of the social tracks." Those tracks were located in Lincoln, Nebraska.

Greer grew up there, though he was actually born in Rushville, Illinois, on April 16, 1896, to farmers Samuel and Minnie May Eyler Greer. While Greer was a toddler, a physician told Samuel to move to Nebraska to alleviate the elder Greer's chronic asthma. The family settled on the outskirts of Lincoln, where Samuel operated a greenhouse for five years. After that business failed, Samuel became a clerk for the railroad.

Minnie wanted her son to become a musician, but Greer preferred drawing and going to the theater. Greer graduated from the University of Nebraska in 1916 and turned his eyes to New York and a career as a writer. He began writing letters to the famous people he read about in *Vanity Fair*, hoping one of them might offer him a job. When Greer could not secure a loan to pay for a move to New York, he took a holiday job in the bargain basement of Miller & Paine, Lincoln's leading department store. One day, working as a window dresser, Greer was dispatched to get a strand of pearls to accessorize a display mannequin. After weeks went by without the jewelry department asking about them, Greer "liberated" the pearls as a birthday present for his mother, and replaced them with a cheap strand from Woolworth's. Greer then took the pearls back to Miller & Paine's jewelry department to have them restrung when his mother accidentally broke them. He was fired that day.

Just a short time before, Greer had written to Lady Duff-Gordon, the British dressmaker known as Lucile, asking for an interview. The weekend after Greer was fired, the British dressmaker, who had salons in Chicago, New York, London, and Paris, telegrammed back:

MEET ME IN CHICAGO THURSDAY WILL GIVE YOU DEFINITE ANSWER REPLY LUCILATION, SIGNED LADY DUFF GORDON

Greer could not believe his luck. He immediately replied:

DEATH ALONE WILL KEEP ME FROM YOU THURSDAY, SIGNED HOWARD GREER

Greer hastily made the 520-mile trip from Lincoln to Lucile's Lake Shore Drive salon in Chicago. By the time he arrived for

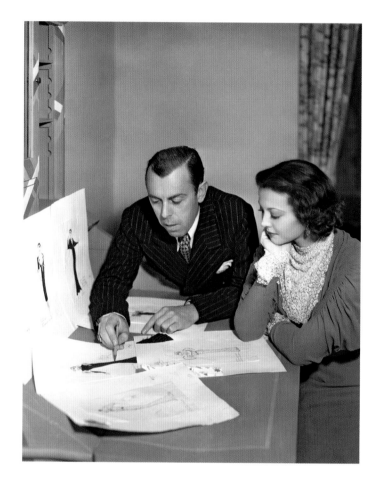

his appointment, everyone at the salon had heard about him. "Are you the one who sent that terrifying wire?" an assistant asked. "Madame can't *wait* to see what you're like!" When Greer was ushered into Lucile's salon, she silently looked him over. "You don't *look* insane," she said at last. "Naturally, everyone thought a *lunatic* had sent the telegram." Greer realized the woman was taunting him. He found out later that Lucile had not believed that a boy from Nebraska actually imagined that he had something to offer her. She had given him the interview as a joke.

Lucile asked to see Greer's sketches, which he had prepared especially for their meeting. "Dear me," she said, "what a lot you have to learn!" Notwithstanding her haughtiness, Lucile hired Greer at her Chicago salon as a sketcher-apprentice. In 1918, Lucile transferred Greer to her New York workrooms on Fifth Avenue,

but his promotion was short-lived. Like many designers of that era, Greer was forced to put his career on hold a year later, answering the call of duty in France. In 1918, he fought in the Battle of Château-Thierry under General John J. Pershing. After the war, Greer remained in France, where he reconnected with Lucile to work at her salon on the Rue Boissonade. Unfortunately, when business took Lucile from Paris, she entrusted her pet Pekingese to Greer. Greer came down with pneumonia, rendering him bedridden. Lucile returned to find that her pet had died under Greer's "care." She fired him for his negligence on the spot.

OPPOSITE: Costume designer Howard Greer with actress Sylvia Sidney.

ABOVE: Director Milton Sills inspects Colleen Moore's costume for *Flaming Youth* (1923), which helped to usher in the "flapper" look.

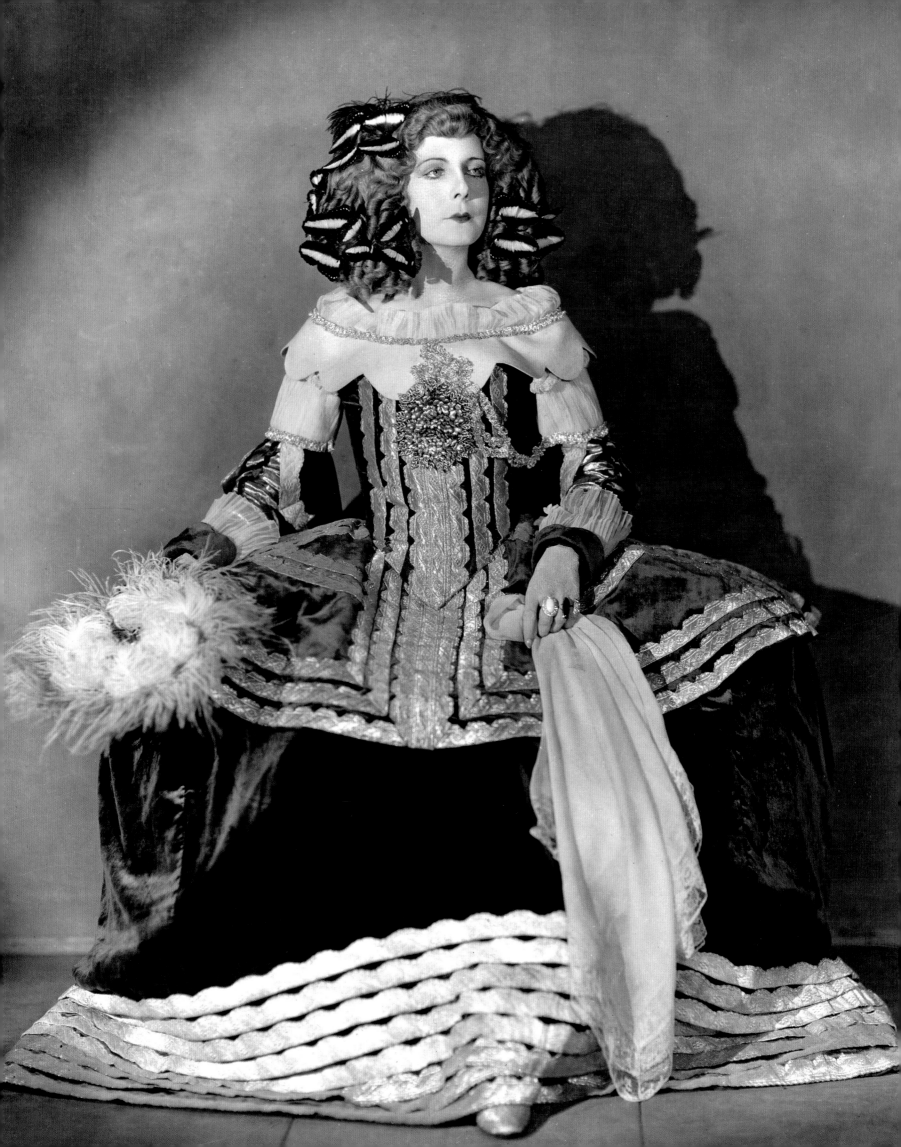

Greer returned to America, broke and dejected, in 1921. He survived at first by creating custom clothing for some of the wealthy women he had met abroad. John Murray Anderson hired Greer to design for a cabaret revue, paying him $25 a week and kept Greer on to costume his successive revue, *The Greenwich Village Follies* (1922–1923). Greer's private commissions continued to compete for his time with his costume assignments. Greer also found himself in direct competition with Gilbert Clarke, a New York designer who only sought private clientele. When Jesse Lasky of Famous Players-Lasky, offered Clarke a designing job—a position Clarke found déclassé—he suggested that the studio hire Greer instead. Clarke's strategy to eliminate his competition worked. Walter Wanger, Lasky's assistant, hired Greer for a six-week trial period at $200 a week. It was 1922.

For his first assignment, Greer dressed the temperamental Polish actress Pola Negri, who was making her first American film, *The Spanish Dancer* (1923). Greer's gowns not only pleased Negri, but his $25,000 wedding gown, featuring a pearl and crystal embroidered brocade and lamé, trimmed in ermine and sporting a fifteen-foot-long train, got plenty of press attention for the studio.

When Clare West departed Famous Players-Lasky in 1924, Greer succeeded her as head of the studio wardrobe department. Greer designed for Paramount's biggest stars including Leatrice Joy, Pola Negri, Clara Bow, Billie Dove, and Bebe Daniels.

"Much to every dressmaker's surprise, we got along famously together," Greer wrote of designer Travis Banton, who had been brought to Famous Players-Lasky to design *The Dressmaker from Paris* (1925). "Money was something new and almost unknown to both of us before, and the spending of it went to our heads." Both men were gay and both enjoyed hitting the town together.

In September 1927, Famous Players-Lasky changed its name to Paramount, and Greer, now in his fifth year of film design, reassessed his career. He had designed for some two dozen films, but now, more stars and directors were requesting Travis Banton. Greer believed Banton's clothes actually looked better on-screen than his own creations. "I have always felt my clothes depended upon a third dimension," Greer once said. "If I live another hundred years, I doubt whether I will develop a camera 'eye' and know, from its inception, whether an idea will live up to my expectations on celluloid."

Greer opened his own salon in Los Angeles on December 27, 1927, with a guest list that included Norma Talmadge, Lilyan Tashman, Vilma Bánky, Mae Murray, and Adolph Zukor.

During a visit to Greer's salon, Greta Garbo encountered Mrs. Samuel Goldwyn. After the two exchanged pleasantries, Goldwyn invited Garbo to meet Ruby Keeler, who was being fitted in another room. Keeler had not yet begun her acting career, and was then only known as the wife of Al Jolson. "But why should I meet Mrs. Jolson?" Garbo asked. Her inquiry was grounded in wariness, not arrogance, and Greer knew it. "Meeting anyone is a terrific ordeal for her," Greer said. A few minutes later, Goldwyn appeared at Garbo's fitting room and introduced her to Mrs. Jolson. "But you look exactly like your husband!" Garbo blurted out. "To this day I shall never know what she meant." Greer said.

From 1935 to 1937, Greer took two years off to live in Paris, leaving his salon in the hands of his assistant. When he returned to Hollywood, Greer resumed his custom work, as well as designing for film, including dressing Katharine Hepburn in *Bringing Up Baby* (1938) and Ginger Rogers in *Carefree* (1938).

When his old drinking buddy, Travis Banton, left Paramount, Greer took him on at the salon. "Howard didn't really need him at all, but he knew Travis was awfully depressed and worried about him," claimed gossip columnist Hedda Hopper. "Howard's manager told me he had been afraid at the time they might start tooting it up with too many cocktails and the shop would suffer, but Travis started getting offers to do some pictures again and things worked out."

Thanks to the success of his creations and the support of Hollywood, Greer was able to maintain his salon during the Depression and the war. Wartime labor shortages forced Greer to devote more time to the salon. In response to the growth of the ready-to-wear industry, Greer and his new partner, Bruce McIntosh, began designing a wholesale line in 1946, which proved profitable. At first the two produced both custom and ready-made garments, but after several years, they produced exclusively ready-to-wear items. A couple of years later, rising supply costs and a shortage of skilled labor forced Greer to close shop. Greer remained active in costuming and design until his death on April 17, 1974.

OPPOSITE: Kathlyn Williams in a Howard Greer costume in *The Spanish Dancer* (1923).

LUCIA COULTER

From 1924 through her death in 1936, Lucia Coulter was in charge of the women's character wardrobe department at MGM studios, where she was affectionately known to film stars simply as "Mother."

This unpretentious sobriquet aptly fit the elderly designer, who was known as a sympathetic listener who safeguarded the confidences troubled actresses and coworkers shared with her. She was even known to lend money to struggling actors waiting for their big break.

Coulter was born as Lucy Hays on a farm in Lincoln County, Kentucky, in December 1861. She was the only child of Patrick F. Hays and his second wife, Joanna Davidson Hays. Lucy had four older half siblings from her father's first marriage to Mary Blain Barnett, who had died on January 6, 1859.

Sometime between 1877 and 1880, the extended Hays family moved to Honey Grove, Texas, a small town in Fannin County, northeast of Dallas. While Coulter's parents and siblings, who by then were married with their own families, farmed in the surrounding area, Coulter lived in town where her husband, John William "Willie" Coulter, was a clerk at a general store. Coulter and Willie eventually had four children during the 1880s before divorcing sometime around 1890.

Coulter opened a boarding house in Denton, Texas. Being blessed with a beautiful singing voice and what she described as a "comedienne's face," Coulter obtained a dream position as a performer with the Olympia Opera Company in the mid-1890s, a relationship that would last for eight years.

Despite her success as a performer, Coulter's love of sewing—a skill she honed out of the necessity of making clothes for her four children during leaner times—drew her more and more to create costumes. By the early 1900s, she gave up the stage all together, focusing exclusively on her true passion, costuming. She left Denton and traveled with vaudeville companies, making costumes for them as they toured.

Coulter's daughter Bess met performer Orvey Jermain "Gene" Post in the early 1900s, and by 1913, they were living in Los Angeles with their son. Coulter and the rest of her adult children

moved to Hollywood, where Coulter pursued her career as a costume designer in the motion picture industry.

Perhaps because she entered her profession at an advanced age, Coulter never was offered nor sought the limelight. She could be called upon by Lon Chaney for *London After Midnight* (1927) or Lillian Gish for *La Bohème* (1926) but she was almost always assigned to character actors and bit parts. She became known as the "character designer." Glamour and high fashion did not interest her. Instead, she was drawn to period and "character"

ABOVE: Lon Chaney in a Lucia Coulter costume in *London After Midnight* (1927).

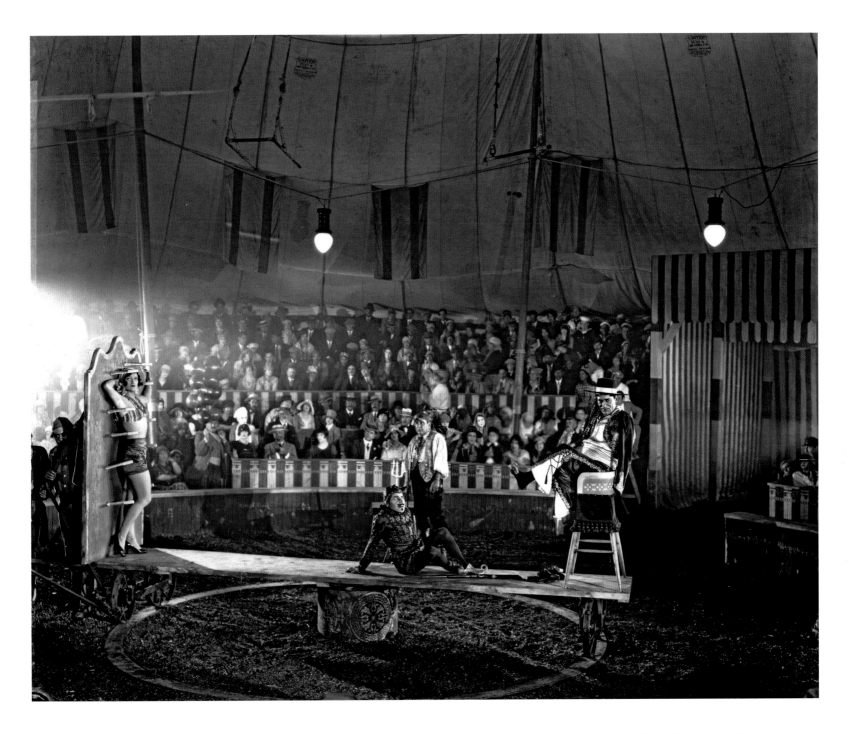

costumes, especially the old, worn, lived-in looking duds of "real" people. To achieve the needed look, she sometimes took crisp, new clothes, soaked them in coffee, rubbed them against plaster walls, and burned holes in them. She would then spend hours patching the damage that she had intentionally inflicted to achieve the historical "realness" she sought.

Coulter had nearly fifty seamstresses working under her at MGM. She claimed that during her first fifteen years at the studio, they had turned 1,750,000 yards of fabric into 135,000 costumes under her direction. Coulter personally made every costume worn by Marie Dressler, and character costumes were made under her direction for May Robson, Greta Garbo, Joan Crawford, Marion Davies, and Norma Shearer.

September 14, 1936, proved to be a fateful day for MGM studios. On that day, MGM vice president and producer Irving Thalberg died. That same day, Coulter suffered a massive heart attack. She lingered for nearly a month, with Los Angeles newspapers and daily trades periodically reporting on her condition as she lay dying. On October 24, 1936, MGM's "Mother" passed away, surrounded by her daughters, grandchildren, and great-grandchildren. She was seventy-four.

ABOVE: Lon Chaney (far right) and Joan Crawford (far left) in *The Unknown* (1927).

ERTÉ

During his 1924 annual talent scouting trip to Europe, Louis B. Mayer persuaded famous French designer Erté to come to Hollywood to work for him.

With Erté's fame already eclipsing that of the stars who would be wearing his gowns, Mayer had certainly upstaged his competitors, all of whom claimed to have the most beautifully dressed stars in Hollywood. Returning to Los Angeles, Mayer wasted no time using his famous designer's name to promote MGM's upcoming productions *Paris* and *Monte Carlo* to exhibitors.

Erté was in his early thirties when he arrived in Hollywood. He had been born Romain de Tirtoff in St. Petersburg, capital of Imperial Russia, on November 23, 1892. Erté's early interest in ballet and painting had been an anomaly to his family, which had produced career navy men for generations. Though his family never embraced Erté's desire for a career in art, his mother agreed to tolerate her son's decision if at least he agreed to be a portrait painter. Young Romain adopted the name "Erté," the French pronunciation of his initials, *RT*, to spare his family embarrassment.

After seeing Diaghilev's *Ballet Russe* perform, Erté decided to pursue costume design in Paris instead. He moved there in the winter of 1912. Nine months went by before he secured employment in a small shop on Rue Royale with the dressmaker Caroline, only to be fired one month later. Though his designs were beautiful, Caroline found them unwearable. She admonished Erté, "Follow any career except that of a dress designer." Erté took his designs to the famous couturier Paul Poiret, who saw promise in them. When the outbreak of war closed La Maison Poiret in 1914, Erté and a former Poiret dressmaker formed a partnership, selling clothes to large American retailers. During this time, Erté perfected his meticulous illustration techniques. But when a nearly fatal bout of scarlet fever forced Erté to abandon Paris to recuperate in Monte Carlo, he feared his career would die with him living so far from the creative center of France.

As he recovered, Erté submitted drawings to *Harper's Bazaar*. Publisher William Randolph Hearst offered Erté an exclusive ten-year contract with the magazine. With his newfound fame from *Harper's Bazaar*, he was commissioned in 1919 to work on the *Folies-Bergère* with the well-known costumer Max Weldy. The *Folies* was the perfect outlet for Erté's exotic designs. His success crossed the pond, and Erté's work was soon featured in the United States in portions of *Ziegfeld Follies*, George White's *Scandals*, Earl Carroll's *Vanities*, and *Greenwich Village Follies*. That same year, Cecil B. DeMille approached Erté to design for films, but Hearst persuaded the designer to sign with his Cosmopolitan Films. For Hearst, Erté designed the *Bal des Arts* sequence in *The Restless Sex* (1920), which featured a ballroom and Babylonian hanging gardens.

To induce Erté to move to Hollywood five years later, MGM created an elaborate black, white, and gray salon for him on the lot and rented a home for him and his lover, Nicholas Ourousoff. Upon his arrival, MGM's publicity machine went into high gear. By bringing Erté to Hollywood, Mayer had given the fashion-obsessed movie-going public the most celebrated creator of French fantasy design. But therein lurked a huge problem that utterly escaped the studio head: hardly any of Erté's designs translated into practical costumes; some creations actually restricted the actress's ability to move naturally.

Though his contract only required Erté to design for two films—*Paris* and *Monte Carlo*—he welcomed other work while the scripts for those films were finalized. Erté designed Aileen Pringle's gowns in *The Mystic* (1925), and contributed some costumes to *Ben-Hur* (1925) and to the ball sequence in *Dance Madness* (1926). Trouble began when he designed Lillian Gish's costumes for *La Bohème* (1926). "She objected to wearing a woolen dress I had designed for her as the impoverished Mimi in *La Bohème* and insisted on wearing silk," Erté said later. "I said that was ridiculous and she stormed off in a huff." Gish believed Erté's stylized Belle Époque costumes did not accurately convey her character's poverty to the audience. She insisted on dresses made of ragged silk. Being an established star, Gish not only had experience understanding how costumes read on-screen, but she also had the clout to get

OPPOSITE: Gwen Lee in *Bright Lights* (1925).

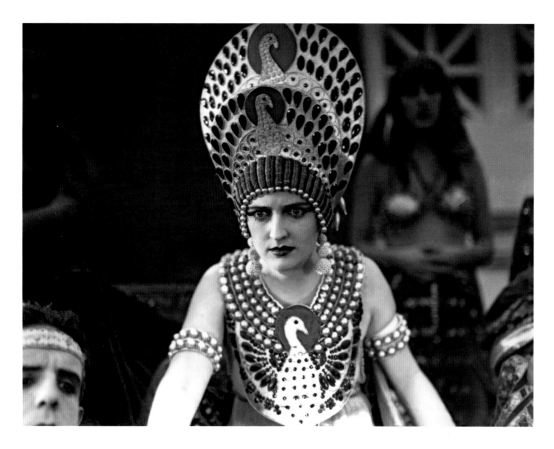

what she wanted. After she failed to convince costar Renée Adorée to boycott Erté's designs, the feud became public.

"Imagine! Miss Gish will not wear the dress of the poor 'La Bohème' unless the rags are silk lined!" Erté told *Motion Picture* magazine. Gish said later, "Monsieur was a small, dainty man, and he seemed to have designed [the costumes] for himself." Gish turned to Lucia "Mother" Coulter, who specialized in character costumes, for the distressed outfits she sought. Erté was insulted.

Though the feud frustrated Erté, it did not finish him. That final straw would come over *Paris*, the centerpiece of Mayer's initial publicity blitz that had heralded Erté's arrival at MGM the year before. The script had been reworked four times. The studio had asked Erté to design and redesign costumes and sets for each incarnation of the story. When final script approval came down, Erté was expected to ready fifty costumes in a matter of three to four weeks. Even more trying to Erté, the script presented Paris as imagined by Hollywood, rather than as the actual city Erté knew

so well. "The producers had no concept of elegance or taste," Erté said later. "The scriptwriters were ill-informed. It was fantasy, but of a damaging kind. For my work, I need to concentrate—there it was impossible. I had to leave." In November of 1925, his departure was announced.

Erté returned to France with Ourousoff and successfully designed costumes for revues, ballets, and operas. When art deco design experienced a renaissance in the 1970s, Erté found great financial success in reproducing his celebrated drawings. His celebrity status endured until the end. He died in New York on April 21, 1990, at the age of ninety-seven.

TOP, LEFT TO RIGHT: Carmel Myers in an Erté costume in *Ben-Hur: A Tale of the Christ* (1925). · Erté's unused design for Lillian Gish in *La Bohème* (1926).

OPPOSITE: Erté with Aileen Pringle wearing his design for *The Mystic* (1925).

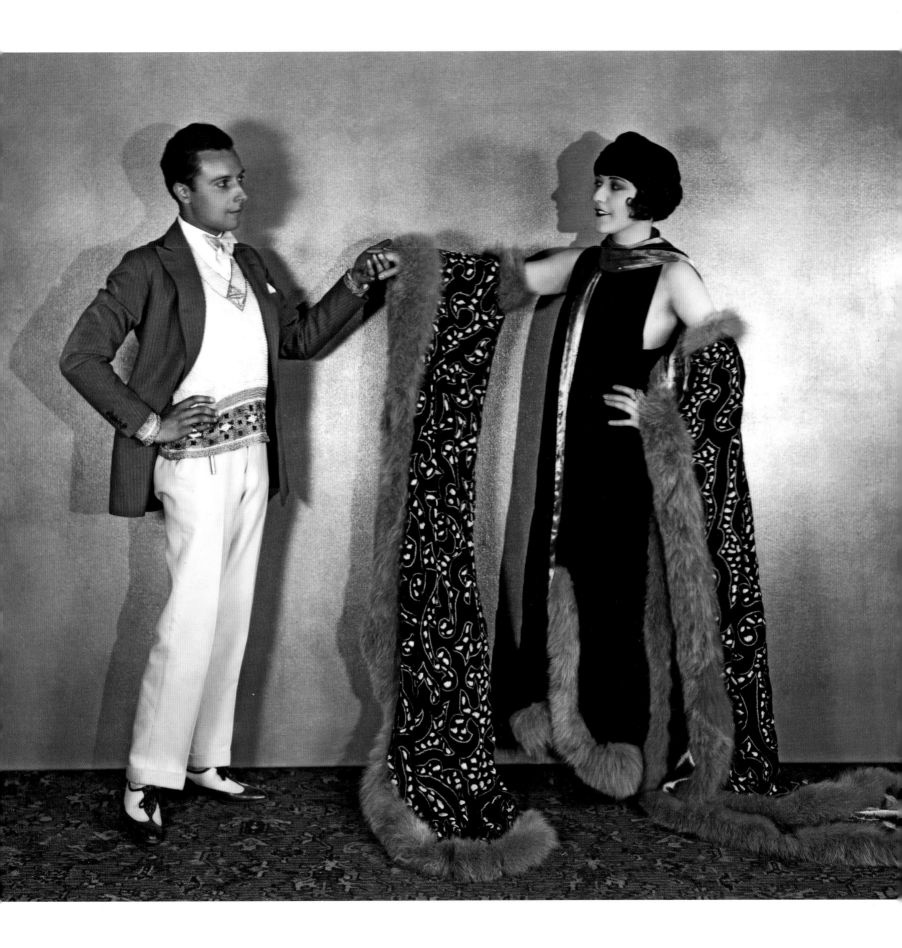

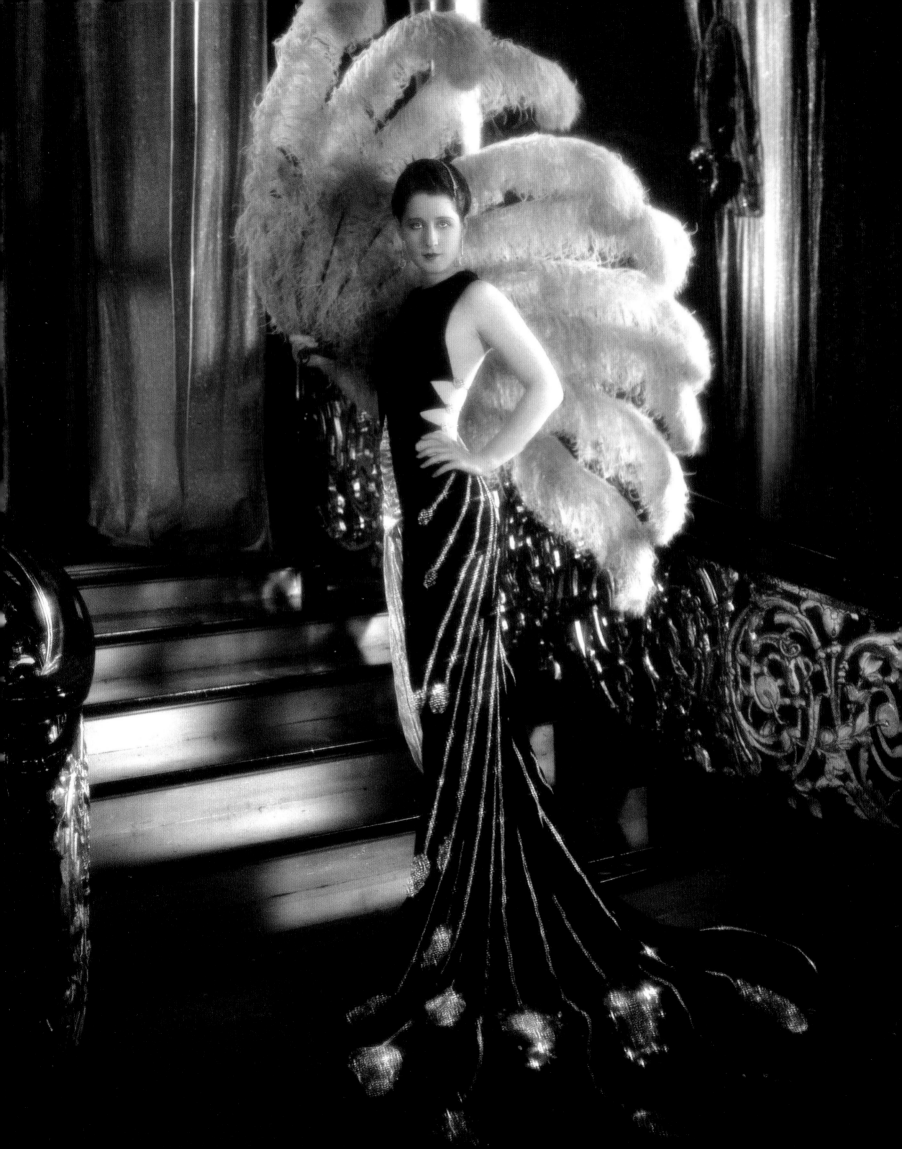

ANDRÉ-ANI

When Erté quit MGM after one year of being frustrated with the motion picture business, an Italian American young man from Oakland immediately assumed design responsibilities for *Paris* (1926), starring Joan Crawford.

But unlike Erté, André-Ani would have a long career as a costume designer, dressing Hollywood's biggest stars in more than fifty-five films before his untimely death at age fifty-one.

André-Ani first fashioned Greta Garbo as an exotic, untouchable creature when she arrived at MGM in 1925. That first year, he dressed her in *Torrent* (1926), *Flesh and the Devil* (1926), and *The Temptress* (1926). "I did have some difficulty with Greta Garbo," the designer later confessed. "She is very difficult to do things for. She has a difficult figure; she has set ideas and very foreign ones. She has innumerable dislikes. She will wear nothing that has fur, absolutely nothing. She goes in for flaunting, bizarre collars and cuffs. She likes short skirts when she should wear longer ones." Garbo's dislike of velvet particularly challenged André-Ani, who ordinarily relied on velvets, brocades, and flowing soft materials to hide an actress's imperfections.

André-Ani was born as Clement Henri Andreani on April 22, 1901, in Oakland, California, the youngest of six sons born to Italian immigrants. His parents, Massimo Andreani and Angiolina Reali, had married in Como, Italy, and immigrated to the United States in 1888. They settled in Alameda County, California, where Massimo operated a successful saloon a few blocks from the family home on 14th Street in Oakland. Tragically, Massimo suffered a stroke and died suddenly on March 8, 1903, at the age of forty-seven; André-Ani was just a month shy of his second birthday. André-Ani's mother died two months later, on May 10, 1903, leaving André-Ani and his five older brothers orphaned.

The Andreanis' maternal aunt, Quinta Reali Bardoli, took in the toddler, but was too busy caring for her own family as a single mother to be much help to her older nephews. Their parents' deaths forced the older Andreani boys to grow up quickly; some of them claimed to be adults while still minors in order to obtain employment and housing.

As if being orphaned at age two did not make young André-Ani's life difficult enough, he was short of stature and suffered from a spinal deformity that left him noticeably hunchbacked. Like his brothers, André-Ani was forced to lie about his age and enter the adult world while still a teenager. After André-Ani's talent for art began to emerge, his friends helped the promising young artist receive an art education in San Francisco. The faculty of the school was so impressed with the young man's skill that within a matter of days, he joined their ranks.

At sixteen, André-Ani became an artist for the Selectasine Serigraphics Company in San Francisco. During his time there, the company developed its "Selectasine process," a method of producing a multicolor composition using only one screen and heavy, opaque pigments. The process was patented in 1918, and dominated screen printing until the late 1930s, when multiscreen processes with thinner color layers became the method of choice. The future designer's experiences at Selectasine would serve him well later. When he could not find a fabric to meet his needs for a costume at MGM, André-Ani printed his own designs on fabric in-house.

After leaving Selectasine in 1918, André-Ani continued to work as an independent artist from the home of his aunt Quinta in Oakland. The timing of his arrival in Los Angeles is not certain. *If Marriage Fails*, released in the summer of 1925, was the first film on which he was known to have worked.

After leaving MGM in 1928, André-Ani worked for Universal, and later as a freelancer. His last movie was Hal Roach's *Vagabond*

OPPOSITE: Norma Shearer in an André-Ani costume for *Upstage* (1926).

Lady (1935), starring Robert Young. Like both of his parents, André-Ani's was fated to die young. His passing came on April 3, 1953, in his hometown of Oakland, just nineteen days shy of his fifty-second birthday.

When reflecting back on his life, André-Ani never disclosed how difficult his childhood had been. "I've always been interested in women's clothes," he once said. "I can't remember a time when I wasn't working on designs or fooling around with fabrics and scissors. I must have been born that way. And I have had a very fortunate time, really. No desperate struggles, no tale of bitter hard luck."

ABOVE: André-Ani

OPPOSITE: Norma Shearer in *The Demi-Bride* (1927).

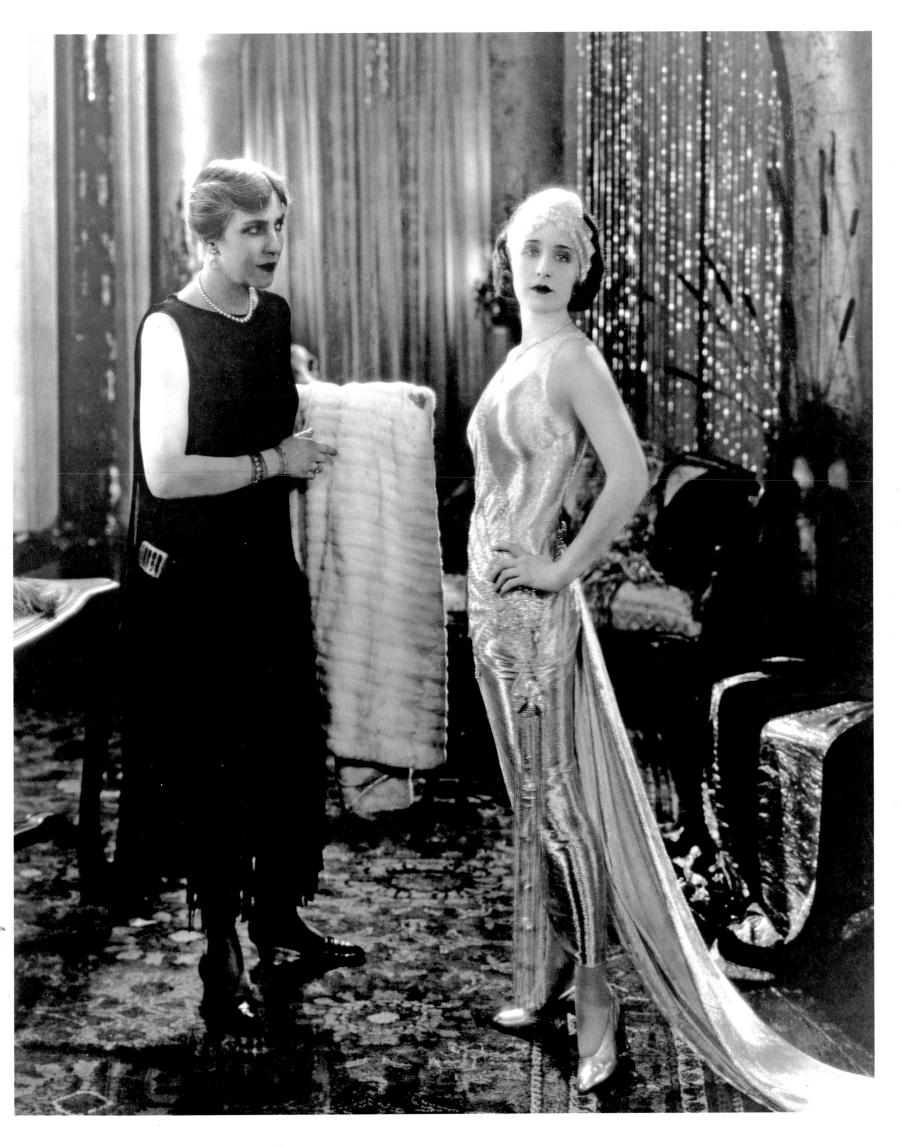

KATHLEEN KAY

"I'll be so engagingly happy and vivacious, I'll fool 'em into thinking I'm beautiful," Kathleen Kay later recalled of her decision to take the plunge into show business.

Kay started life as Sarah Kosminsky on May 19, 1891, born to German immigrants Samuel Kosminsky, a tailor, and his wife, Dora. As a young woman, Kay found work as a bookkeeper and a stenographer. Unhappy with her paycheck, she tried her hand as a performer, despite being insecure about her looks. Audiences definitely appreciated her decision. Kay traveled all over the world for seven years performing an act similar to that of Fanny Brice, until her voice gave way under the strain.

Kay returned to New York and began making the rounds in search of a specialist to repair her voice. After a year of trying various rehabilitation therapies, Kay accepted that she would never sing professionally again. With $250, she opened a dressmaking shop on Fifth Avenue with business partner Mauricia M. Weiss. The partnership did well for more than five years.

In 1921, Kay married Bernard Abrahams, an insurance salesman. They made their home in Los Angeles, where their only son, Jerome, was born in 1925. Although Kay may have relocated to California in hopes of exploring alternative treatments for her vocal cords, she soon opened another dress shop on Seventh Street in downtown Los Angeles. After gowning actress Mae Murray, her business took off. Two years later, fire destroyed her shop. Although Kay's business was short-lived, it survived long enough for her to come to the attention of William Fox. He gave the designer her first opportunity in film, designing Alma Rubens's gowns in *Gerald Cranston's Lady* (1924). Surprisingly, MGM, not Fox, offered Kay a long-term contract, likely at the urging of her patron, Mae Murray. Kay stayed at MGM for three years.

"In those days they had no air-conditioning," said Kay's son, Jerome Kay. "In the morning all the stars would come in to get their dresses, and they would begin to perspire. My mother said the wardrobe department would begin to smell like a brewery because they had been drinking champagne all night and they would perspire champagne."

During her three years at the "MGM brewery," Kay worked with a surprisingly large number of Hollywood's biggest stars, including Lon Chaney in *The Blackbird* (1926), Great Garbo in *Torrent* (1926), and Norma Shearer in *The Devil's Circus* (1926). Most of these films were collaborations with colleagues André-Ani and Maude Marsh.

When her MGM contract was up, Kay returned to Fox, overseeing a staff of one hundred seamstresses. Perhaps because she was required to devote considerable time to supervising her large staff, Kay had just three film credits during her first year at Fox, including *7th Heaven* (1927) with Janet Gaynor. Despite the fanfare surrounding her arrival at Fox, Kay's time there was brief. *Street Angel* (1928), also with Janet Gaynor, was her last Fox film. Kay was unemployed for nearly three years after the separation, not opening her own shop again until September 1930.

By 1930, she, Bernard, and Jerome were living with Bernard's brother and sister-in-law. Before the year ended, Bernard initiated what would become an acrimonious and public divorce. Kay obtained custody of Jerome and changed his last name to Kay.

In September 1930, Kay opened another dress shop on Wilshire Boulevard, called the House of Kathleen Kay. Actress

Lina Basquette financed the shop. Kay traveled to Paris to study the latest collections and to make purchases. "She could speak French like a native," Jerome said. The third time Kay opened a dress shop turned out *not* to be the charm for Kay. Within a year, Kay and Basquette were sued for non-payment of $774 worth of furs and the salon closed. Kay left Los Angeles for the East Coast, after completing the freelance project *Money Talks* (1933) with Julian Rose for British International Pictures.

"There are two stories about why my mother left California," Jerome said. "One was that my mother and father were divorced and that she didn't feel he was a good influence on me. There was another story that she had gotten together with another gentleman, and she just felt she had to get out of town. And it cost her an awful lot."

Kay first settled in Wilmington, Delaware, and then Trenton, New Jersey. She managed a retail dress shop before becoming manager of Nugent's, a retail chain. In 1945, Kay moved to Miami, Florida, where she became a successful real estate agent. That would be her last vocation. She stayed in Florida following her retirement, and died there on February 17, 1982, at the age of ninety.

OPPOSITE: Kathleen Kay was a well-known performer who turned to costume design after losing her voice.

ABOVE: Charles Farrell and Janet Gaynor in *Street Angel* (1928). Gaynor won the first Best Actress Oscar for her role.

MITCHELL LEISEN AND NATALIE VISART

She was a high-school gal pal of Cecil B. DeMille's daughter Katharine. He was the son of a Midwestern beer baron and had established himself as a Hollywood costume designer and art director.

The two met at DeMille's house during the time Leisen was collaborating with the director on *The Volga Boatman* (1926), and Visart was hanging out with the director's daughter after school.

Visart had been born Natalie Visart Schenkelberger in Chicago on April 14, 1910. Her father, Peter C. Schenkelberger, a tall, bald man with a withered left leg, was a surgeon; and her mother, Marie Gertrude Debury, was a Canadian immigrant. Visart expected to follow her father in a medical career as a nurse. But in September of 1920, her respiratory health issues prompted her father to send Visart to live in California. She met Katharine DeMille at the Hollywood School for Girls. The DeMille family befriended Visart, inviting her to spend weekends and school vacations with them.

Just before Visart's move to California, an encounter with DeMille at a dinner party had brought Leisen his first job as a costume designer, making clothes for superstar Gloria Swanson in DeMille's *Male and Female* (1919). Leisen was aggressively unqualified for the task. "DeMille approved my sketch and then told me I had to do fifty more and supervise the making of them," Leisen recalled years later. "I had never made a dress in my life and I didn't know the first thing to do. Clare West was the head of wardrobe at Lasky studio, and she wasn't about to have me making anything in her workroom. She stuck me in a little room about four by six with six seamstresses, and I sweated the whole thing out myself."

True to his reputation for extravagance, DeMille requested something startling for Swanson in the sequence, "When I Was a King of Babylon and You Were a Christian Slave." Leisen designed a gown dyed in batik—an ancient technique from Java using wax and pigments—and embroidered with pearls. The ensemble included a peacock-shaped, feathered headdress also embroidered in pearls. To give the diminutive Swanson more stature, Leisen used clogs shaped like Babylonian bulls with wings coming up the sides of Swanson's feet to hold them on. "You had to learn to think

the way he thought, in capital letters," Leisen said of DeMille. "Everything was in neon lights six feet tall: *Lust, Revenge, Sex.*"

Creating over-the-top designs to satisfy DeMille's grandiose tastes seemed like an unlikely vocation for Leisen given his beginnings as an awkward, shy child. He was born Jacob Mitchell Leisen on October 6, 1898, in Menominee, Michigan, where his father was a partner in the Leisen & Henes Brewing Company. His parents divorced while Leisen was a toddler; he was raised by his mother and stepfather in St. Louis. At age five, Leisen underwent an operation to correct a club foot that left him with a slight limp for the rest of his life. Introverted as a child, Leisen spent hours alone building models of theaters and arranging flowers. Alarmed by his atypical boyhood interests, Leisen's parents sent him to military school. It never had the desired effect, as Leisen went on to study architecture and commercial design at Washington University in St. Louis.

As an interior designer for the Chicago architectural firm of Marshall and Fox, Leisen realized some of his boyhood dreams of theatrical design by planning the interior decor of the Powers Theater and the ballroom of the Edgewater Beach Hotel. When business at the firm slowed, Leisen took a sabbatical in Hollywood, and taking the advice of his cousin, stage and film actress Kathleen Kirkham, gave films a try.

Leisen stayed in Los Angeles with family friends Ruth St. Denis and Ted Shawn, who were pioneers of modern dance. They introduced Leisen to Jeanie Macpherson, Cecil B. DeMille's valued screenwriter. Impressed with Leisen, Macpherson introduced him to her boss.

At the end of his first year, Leisen asked DeMille to put his architectural skills to use by letting him design sets. DeMille assigned Leisen to do sets for his brother, William DeMille, and set

OPPOSITE: Mary Pickford in *The Taming of the Shrew* (1929). Costume design by Mitchell Leisen.

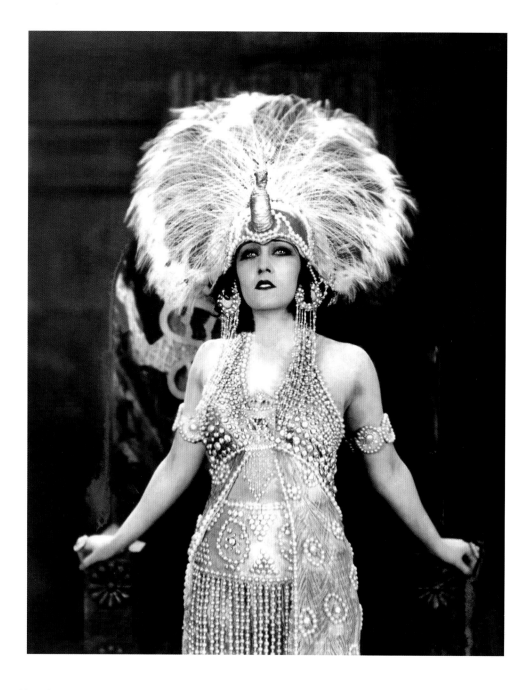

dressing for himself. After several blowups with Paul Iribe, DeMille's art director, Leisen was fired.

Leisen bounced back immediately, getting a dream job with Douglas Fairbanks. He moved into Pickfair, the home of Fairbanks and Mary Pickford, as their guest while he designed Fairbanks's wardrobe for *Robin Hood* (1922). Leisen strove for authenticity in the film, giving each soldier his own crest with matching tabard, shield, and helmet. He also styled an enormous piece of burlap to look like tapestry, which Fairbanks used to slide down to the ground from atop the castle to escape the villain.

The following year, Leisen designed *Rosita* (1923) for Mary Pickford and *The Courtship of Myles Standish* (1923), neither of which was particularly well received. Next came *The Thief of Bagdad* (1924), one of the most expensive films of the decade and the first by art director William Cameron Menzies. In a truly impressive feat, Douglas Fairbanks and Julanne Johnstone flew over a crowd of three

thousand extras on a flying carpet, suspended by just four piano wires.

In 1927, Leisen married opera singer Stella Seager, known professionally as Sandra Gahle, in a ceremony at DeMille's ranch. Although they would remain married for fifteen years, their marriage was anything but traditional. The two lived apart frequently. Gahle even lived in France for a few years studying voice. Leisen had numerous dalliances, which Gahle knew about, and did not seem to mind. Some lovers were men. Others were women. And one was Visart.

Visart was undoubtedly flattered to receive the attention of a successful older man, at least initially. Ultimately their

ABOVE: Gloria Swanson in *Male and Female* (1919).

OPPOSITE: A costume sketch by Mitchell Leisen for *Male and Female* (1919).

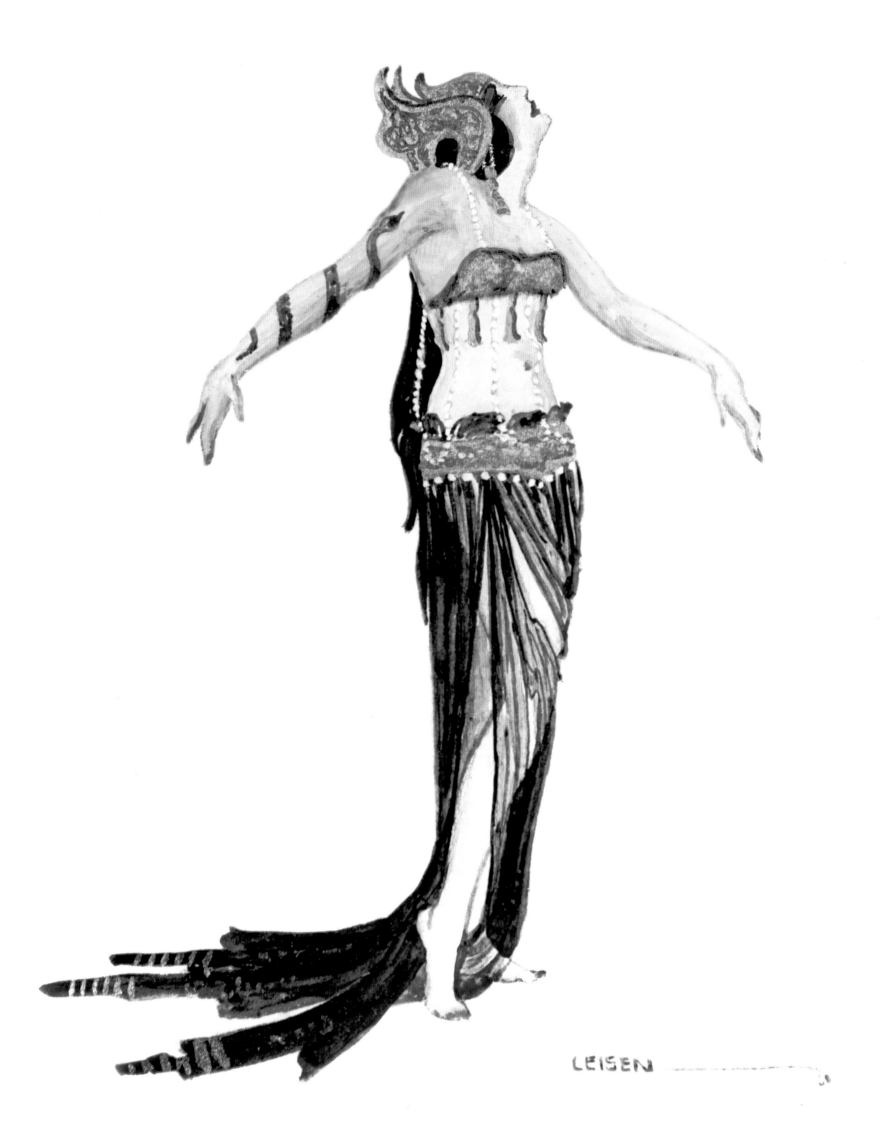

LEISEN

connection was as much cerebral as physical, according to Visart's daughter, Laurel Taylor. The two "got" each other, she said. And Leisen proved helpful to Visart's career. As he began working as a director in 1933, he positioned Visart to take his place as DeMille's costume designer. By 1936, she was assigned to costume *The Plainsman*.

Despite his marriage to Gahle, Leisen openly lived with Visart during the 1930s. He also carried on with his flying instructor, Edward Anderson. Leisen eventually made Anderson an assistant director on *The Big Broadcast of 1938*. Because the two men had an outwardly plausible non-sexual pretext for their *rendezvous*, appearance-conscious Visart tolerated the affair, which did not last. During production of *Big Broadcast*, Anderson's affections turned from Leisen to leading lady Shirley Ross. When the loss of Anderson to Ross seemed inevitable, Leisen began pursuing dancer and choreographer Billy Daniel.

The upheaval in Leisen's personal life took a toll on him. On the last night of shooting *Big Broadcast*, Leisen suffered a serious heart attack. His subsequent recovery changed him. He became cranky. And he no longer showed any discretion regarding his libido. While Visart could adjust to Leisen's cantankerous

personality shift, she could not abide him flaunting his relationship with Daniel. She left Hollywood to work for milliner Lily Dache in Paris, even though her career as DeMille's costume designer had just started to take off. Visart was not gone from Hollywood long though. As the Nazis menaced Europe, she returned to Los Angeles, where DeMille welcomed her back by hiring her to design the wardrobe for *North West Mounted Police* (1940). The war in Europe also prompted Gahle to return to the United States, settling in San Francisco, where she performed with the local opera.

Despite her misgivings, Visart resumed her affair with Leisen. He induced Barbara Stanwyck to hire her for *Meet John Doe* (1941), a collaboration that resulted in some of Visart's best work. More than fifty years later, Visart's white outfit which Stanwyck wears as her character reveals that she is in love with Gary Cooper still drew accolades for its story-telling power. Stanwyck's character "sold out so hard, so fast, so elegantly, and it's all expressed in that costume," director Michael Tolan said in 1995. "Everyone wants costume to express character transformation. That's almost too extreme a transformation, but it works because she looks so great." After *Meet John Doe*, DeMille

induced Paramount to offer Visart a contract, but she declined, telling DeMille that she was afraid that during downtime "Edith (Head) would have me picking up pins off the workroom floor." She decided to sign with producer Hunt Stromberg instead.

In late 1942, Visart found herself in the same difficult position Loretta Young had been in 1935, when she conceived Clark Gable's child on the set of *The Call of the Wild* (1935). Visart, who had worked on *The Crusades* with Young, now found herself carrying Leisen's child. Because Young had worn loose-flowing costumes in the medieval drama, made right after *Call of the Wild*, no one realized she was pregnant. "Natalie was one of the people in on the fact then that Loretta had adopted her own daughter," film historian David Chierichetti said. "So when Natalie got pregnant, it occurred to her and Mitchell that they would do the same thing." Visart would have probably preferred to marry Leisen, but she could not. Although Gahle moved to Idaho in 1942, specifically to establish residency to sue Leisen for divorce, he would not be single again until after the child's birth. Even then, because Visart was a devout Catholic, she would not be able to marry Leisen as a divorced man until the Vatican annulled his marriage to Gahle. These issues became moot when Visart miscarried.

In a cruel twist of irony, soon after the miscarriage Paramount sent Leisen the script of *To Each His Own* (1946), which recounts the story of a woman who adopts her own child. He turned it down initially, saying that it was too close to *Madame X* (1937), but in reality, it was too close to his own life. Leisen did eventually direct *To Each His Own*, for which Olivia de Havilland won an Oscar for Best Actress.

On March 30, 1946, Visart married writer Dwight Bixby Taylor, soon after meeting him at a party. He was one of the first "Talk of the Town" editors for *The New Yorker* and later a noted novelist, playwright, and screenwriter. Taylor was himself the child of famous parents, actress Laurette Taylor and producer Charles Taylor.

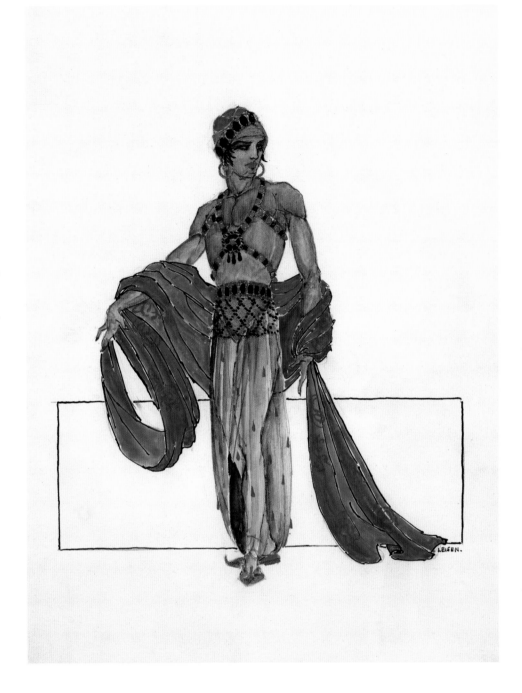

During his career, Leisen directed some of Paramount's most sparkling and witty comedies, including *Easy Living* (1937) and *Midnight* (1939). Visart and Leisen stayed in touch through the decades to come.

Leisen died of heart disease on October 28, 1972 in Woodland Hills, California. Natalie and Dwight died three months apart in 1986, both at the Motion Picture Retirement Home. Natalie died September 11 and Dwight on December 31.

OPPOSITE, LEFT TO RIGHT: Natalie Visart and Ray Milland out on the town. · An adaptation of a design for Barbara Stanwyck in *Union Pacific* (1939) by Natalie Visart.

ABOVE: Costume sketch for Douglas Fairbanks in *The Thief of Bagdad* (1924) by Mitchell Leisen.

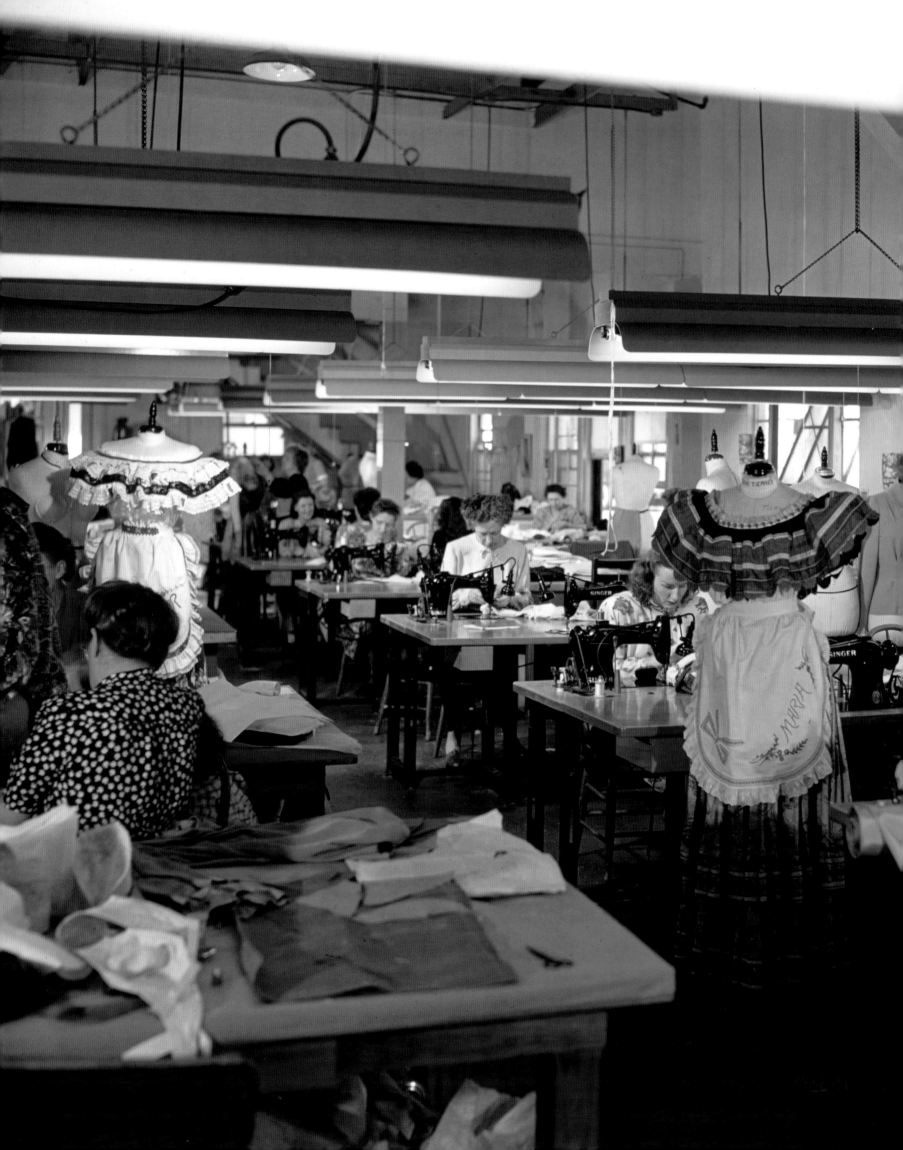

CHAPTER TWO
THE GOLDEN AGE

O n October 29, 1929, Wall Street crashed. Remorse for 1920s' excesses followed almost instantly. Guilt-ridden Americans longed for the traditions abandoned during the Jazz Age. Hemlines plummeted from the knee to the ankle, as the Great Depression ushered in a return to modesty. Hollywood had spent the 1920s using and promoting fashion for its own profit, but it had yet to become the arbiter of fashion. To combat Parisian dominance, studio publicity departments in the 1930s churned out reams of copy and photographs to fashion editors and movie magazines, extolling the talents of Hollywood designers. *Photoplay* contained monthly fashion features and sold patterns of Hollywood-inspired dresses for the movie fan to make at home.

The 1930s saw Hollywood's unregulated portrayal of nudity and sexuality on the screen come to an end. Mae West's seeming absolute enjoyment of sex and the unwillingness of her bad girl characters to repent, especially her Lady Lou character in *She Done Him Wrong* (1933), outraged community leaders. To keep government regulation at bay, film studios amended the production code in 1934, requiring all films to receive a certificate of approval before release, thereby giving the Production Code Administration real power to regulate scripts, dialogue, and costumes.

When Europe plunged into war on September 1, 1939, European film markets began closing to the United States. With the loss of ticket sales, studios reacted by implementing cost-saving measures, including drastically slashing wardrobe budgets. Wartime rationing forced further austerity on designers.

After the war, Hollywood saw a surge in ticket sales and studios achieved their largest grosses to date. But a 1948 antitrust court decision ended studio ownership of movie theaters. The loss of the profits guaranteed by the oligopoly was a major blow to the bottom line of all studios. Producers began dropping contracts of some of their biggest stars, directors, and writers and instead hired talent on a freelance basis. Costume designers also become independent contractors, moving from studio to studio, and project to project. As the Golden Age drew to a close, a final threat to Hollywood appeared more ominous than a censorship code or government antitrust suits. Television, which allow the masses to abandon theaters and enjoy entertainment in their own homes, ultimately brought the Golden Age to an end.

OPPOSITE: Workroom at 20th Century-Fox, 1940s.

COCO CHANEL

Like his colleagues, producer Samuel Goldwyn spent the early months of the Great Depression wrestling with the problem of synching film production with the whim of Parisian couturiers, including the great Coco Chanel.

"Six months after women had ceased to wear short skirts, the screen showed our most famous stars wearing skirts to their knees," Louella Parsons lamented in her column in 1931. "Where smart women of the world were wearing long, trailing frocks, the Hollywood stars were wearing extremely scanty skirts." The solution to Goldwyn became clear. If a producer wanted to stay ahead of Parisian couture houses, then he needed to put a Parisian designer on his staff. In what he surely believed was a coup to be envied by all of his rivals, Goldwyn retained the greatest couturier of his time, Coco Chanel, to design for his productions. In announcing the $1 million deal to her readers, Parsons advised them, "For the latest fashions, study United Artists pictures."

Chanel started life as Gabrielle Bonheur Chanel, the second daughter of Henri-Albert Chanel and Eugénie Jeanne Dévolles, born out of wedlock on November 17, 1884, in Saumur, France. The origin of her appellation, Coco, is anyone's guess. At times, the designer claimed her father gave her the nickname. On others, she said it was short for "coquette," the French term for a flirtatious woman. Popular gossip claims that the sobriquet had its origin in the fabulous cocaine parties Chanel allegedly threw for the Parisian elite. Though many aspects of Chanel's life are disputed, historians agree that her mother was a laundry woman and her father was a street peddler. After their mother's untimely death from tuberculosis, Chanel and her two sisters lived at a convent school, where Chanel learned to sew. After she turned eighteen, Chanel worked as a seamstress while pursuing a career as an entertainer. Her singing voice did not inspire admirers, but her beauty did. She was mistress to two men, textile heir Étienne Balsan and Captain Arthur Edward Capel, the latter of whom financed her first shops. Although Chanel initially focused on millinery, she expanded her lines to include sportswear, then *haute couture*. In 1922, she launched her iconic perfume, Chanel No. 5, retailed in department stores and shops. As her fame as a designer

grew, her creations became popular first with the Parisian elite and then crossed the Channel to Great Britain's aristocracy and royals. Beginning in 1924, Chanel also designed costumes for Sergei Diaghilev's *Russian Seasons* in collaboration with Pablo Picasso.

By the time Goldwyn met Chanel in Monte Carlo in 1931, the Chanel brand was a thriving enterprise, employing thousands of workers. Goldwyn offered Chanel $1 million, a truly extraordinary sum in those days, to design for his production company. Under their agreement, each script for a new production would be sent to Chanel, who would design the clothes from Paris. A trip to Hollywood was planned for Chanel, and Goldwyn built a custom salon for her at the United Artists studio, which was "the last word in modernistic design and appointments," one reporter noted.

Chanel arrived in Hollywood at the end of March 1931, by way of New York. The idea of a Parisian couturier designing for an American studio met with mixed responses in the press. A sense of nationalistic pride in American fashions had been on the rise, and some fashion editors were wary of being swayed by what Chanel dictated as chic. "The famous designer speaks no English," the *Pittsburgh Press* reported, "but while walking around the studio grounds following close on her heels, we passed a young flapper whose hair had the appearance of being combed with an egg beater. And from Mlle. Chanel's gestures, I gathered the startling news that bobbed hair was taboo."

Chanel herself received a dressing down in the press. "Coco Chanel was Hollywood's big disappointment when Sam Goldwyn brought her out here to design for his stars," costume designer Maybelle Manning wrote. "She had just two evening gowns—a black satin, perfectly cut, and a white satin without a flaw in its smooth flowing lines." Chanel wore them without jewels of any kind. And she wore them repeatedly. "Hollywoodites were put to it

OPPOSITE: Gloria Swanson in *Tonight or Never* (1931).

to locate her in a room because she was invariably the most simply gowned woman there," Manning continued. "The Chanel turban of jersey, the Chanel tailleur, and the Chanel neutrality of color fairly blotted her out of this vivid scene. Especially since all the local ladies wore every diamond clip they possessed in her honor."

Chanel stayed in Hollywood for fifteen days learning about motion picture production and meeting Goldwyn's production staff and the actresses for whom she would be designing. Chanel agreed to send the studio a complete collection of her seasonal fashion designs in linen at the same time she presented them in Paris. She also agreed to supply the studio with a Parisian staff experienced in converting her sketches and linen models into the finished clothes required for studio purposes. In early July 1931, Jane Courtois, Chanel's head fitter, arrived in Hollywood with Chanel's fall collection made of muslin and linen. From this collection, Goldwyn selected dresses for *The Greeks Had a Word for Them* (1932).

Next, Joe Schenck and Samuel Goldwyn bought the rights to *Tonight or Never* (1931), which had been a big hit for producer David Belasco on Broadway. Acquiring the film as a vehicle for Gloria Swanson, Schenck asked the actress to spend a month or two in Paris for fittings with Chanel while visiting Europe for the premiere of *Indiscreet* (1931). While Swanson was in Paris in August, she discovered a lump on her right breast. A doctor removed the tumor, which pathologists determined to be a milk cyst. The diagnosis meant she did not have cancer, but the cyst meant she was pregnant. Though she had married Michael Farmer earlier that month, her divorce from Henri de la Falaise had not yet become final, making the Farmer nuptials invalid. Swanson began to hatch a plan to hide her pregnancy, but she had to keep her fitting appointments with Chanel. When Swanson tried on a black satin floor-length dress for which she had been measured six weeks before, Chanel glared as the actress struggled to squeeze into the bias-cut gown unsuccessfully. Swanson tried the dress with a girdle, but the outline of the girdle showed through the form-fitting gown. "Take off the girdle and lose five pounds," Chanel ordered Swanson. "You have no right to fluctuate in the middle of fittings."

The next day, Swanson begged Chanel's corset maker to sew surgical elastic into underwear. "Impossible!" the corset maker said. But with some persuading from Swanson, the corset maker stitched together experimental panties in muslin. They showed promise, so the final version in surgical elastic was made. Swanson had to be helped into the panties by three people, but they had the slimming effect she needed. "With the lavish confidence of Harry Houdini hearing twenty padlocks snap shut, I then raised my arms to receive the black satin cut on the bias over my head," Swanson wrote in her autobiography. "It fit like a glove." Swanson did not have to keep her pregnancy secret for long. She married Farmer a second time in November 1931 as soon as she returned to the United States. Their daughter Michelle arrived the following April.

When *The Greeks Had a Word for Them* was released, the press noted Chanel's design presence in the film, but not in the way Goldwyn had hoped, despite his aggressive promotion with pre-release press materials. "All the costumes worn by Ina Claire, Joan Blondell, and Madge Evans were designed by Mlle. Gabrielle Chanel. The list of gowns includes fur coats, one of them costing $40,000, evening gowns, tailored suits, negligees, lounging pajamas, everything necessary to the pursuit of millionaires in which the three heroines indulge so skillfully," a reviewer in the *Reading Eagle* wrote. Chanel's clothes, while chic, were understated, certainly not the kind of flamboyant cinematic creations to which moviegoers had been accustomed. The ultimate disappointment for Goldwyn, though, was the failure of Chanel's wardrobe to attract audiences to his films.

Ultimately, bad scripts accounted for most of the failure of the Goldwyn-Chanel films. They ended their association that year, and Chanel designed only for a few more films—all by French filmmakers.

In 1941, Maybelle Manning recalled the Goldwyn-Chanel collaboration as part failure and part success. The couturier "missed no scathing word" in panning Hollywood styles. "[She] snipped out a few chic, plain, and worldly clothes, waved 'bon voyage,' never, she hoped, to return again," Manning wrote of Chanel's departure from Tinseltown. "Hollywood laughed with bravado, sniffed gingerly at the simple styles of the great couturier, and would have returned to their gaudy ways . . . except they didn't. The unrelenting criticism of Chanel had struck a note in their vanity-soaked souls. Like a good little mouse, every gal in Hollywood began to quietly change her type, to make a new woman of herself. To learn and know the ethics of fashionable dressing."

OPPOSITE: Coco Chanel

EDWARD STEVENSON

Tall, gangly Edward Stevenson designed the wardrobes for two of the most iconic movies released by RKO, *Citizen Kane* (1941) and *It's a Wonderful Life* (1946).

Stevenson was born on May 13, 1906, in Pocatello, Idaho. His father was a railroad superintendent. Stevenson grew up there until shortly after his father's death in 1919. He moved to Los Angeles with his widowed mother in 1922, seeking relief for a chronic respiratory ailment. He finished his schooling at Hollywood High School.

On a train trip back to Idaho, Stevenson's mother met a friend of a designer at the Robert Brunton Studio. When summer came, the friend gave a letter of introduction to Stevenson after learning the young man wanted to be a designer. He was hired as a sketch artist during his summer vacation. He also created some designs of his own, his favorite being a gown used for *The White Moth* (1924) worn by Barbara La Marr. A neighbor introduced Stevenson to designer André-Ani, who hired him as a sketch artist when André-Ani went to work for MGM in 1925. In 1927, Stevenson became an assistant designer at Fox, creating gowns for stars Janet Gaynor and Alma Rubens. In 1928, actress Louise Fazenda helped Stevenson become a contract designer with First National, designing for the Talmadge sisters. The studio was purchased by Warner Bros., and Stevenson left in 1931, after a dispute about not receiving screen credit for his work. From 1931 to 1935, Stevenson moved between Hal Roach Studios and Columbia Pictures. He also opened his own salon, Blakely House, which supplied clothes to studios.

In 1935, Stevenson worked as an assistant to Bernard Newman at RKO. When Newman returned to designing for private clientele, he recommended Stevenson as his replacement because he believed Stevenson was a better designer for the screen. "If Hollywood designers do not go off into bizarre and fantastic creations, and remain both sensible and practical, I believe that within a few years the film city will become the fashion center of the world," Stevenson told the *Los Angeles Times* in 1937. Stevenson went on to design some of RKO's best-known films, including

Gunga Din (1939), *Suspicion* (1941), *The Magnificent Ambersons* (1942), and *I Remember Mama* (1948).

After Howard Hughes bought RKO in 1949, he intended to clean house and make Howard Greer his head designer. But Ava Gardner requested Michael Woulfe for *My Forbidden Past* (1951), so Hughes kept Woulfe, but Stevenson was out. He landed at 20th Century-Fox, where Irene Dunne requested him for *The Mudlark* (1950). "He had done such a good job padding her for *I Remember Mama* (1948)," said Stevenson's friend, David Chierichetti. "For

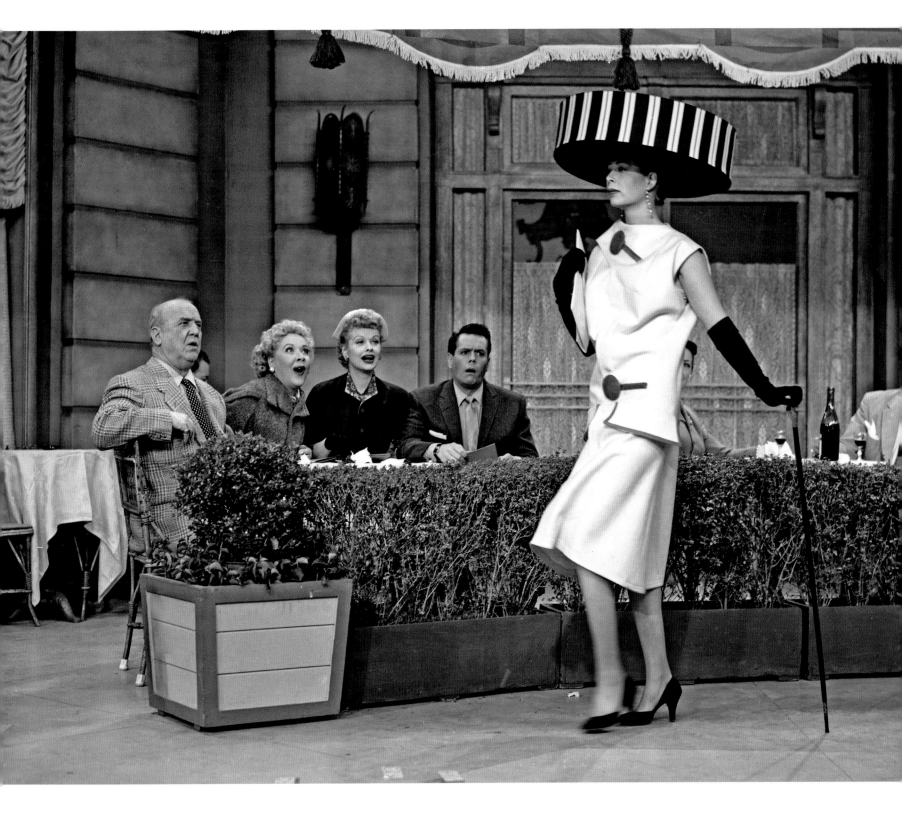

The Mudlark, he had to pad her a great deal more to play Queen Victoria."

Charles Le Maire and Stevenson co-designed *David and Bathsheba* (1951) with Susan Hayward. Le Maire designed Hayward's clothes and Stevenson designed the rest of the cast. Le Maire found Stevenson a morose, unhappy man. Le Maire felt that criticism squelched a designer's artistic expression, so he tread carefully with Stevenson. He supervised the fittings and tried to be diplomatic. But that approach did not work, and Stevenson

left Fox for Universal in 1951, first designing for *The Redhead from Wyoming* (1953) with Maureen O'Hara, with whom he had worked at RKO. After Stevenson was arrested for lewd behavior,

OPPOSITE: Edward Stevenson holds a photo of two of his creations for *I Love Lucy* (1956).

ABOVE: William Frawley, Vivian Vance, Lucille Ball, and Desi Arnaz admire an Edward Stevenson "Paris" dress in the *I Love Lucy* episode "Lucy Gets a Paris Gown" (1956).

he resigned from Universal. "When I asked Eddie why he got out of the business, he said he had a cataract operation and couldn't see well," Chierichetti said. "He did have the operation, but that was not the whole truth." Sources close with Stevenson have indicated that he struggled for years with his homosexuality, unable to reconcile his personal desires with his faith.

Stevenson assumed a low profile, designing wedding gowns in the fashion district in downtown Los Angeles. One day as Lucille Ball was headed to Desilu Studios, she saw Yvonne Wood at Western Costume and was reminded of Stevenson. He had first dressed Ball for *That Girl from Paris* (1936) at RKO. They had worked together on fourteen subsequent films. Elois Jenssen was leaving *I Love Lucy*, and Ball was interested in approaching her former film designer. "Nobody knew where Stevenson was, because Eddie was so embarrassed, he had just dropped out," Chierichetti said. "Lucy tried everything. She called Maureen O'Hara, but Maureen told her that she didn't know where he was. Lucy said she went 'the Pocatello route.' Eddie was from Pocatello, Idaho, and she got in touch with his relatives." When Ball had all but given up hope of finding Stevenson, he called. "Lucille, have you been trying to find me?" he asked sheepishly.

"Yes!" Ball said. "Get over here! I need you to design *I Love Lucy*!"

Stevenson designed for Ball not only for the remainder of *I Love Lucy*, but for *The Lucy Show* (1962–1968), and *Here's Lucy* (1968–1969). From 1960 onward, Stevenson worked exclusively for Ball. With Edith Head, Stevenson designed for the movie *The Facts of Life* (1960), which starred Ball and Bob Hope. Together the pair won the Oscar for Best Costume Design, Black and White.

On the morning of December 2, 1968, Stevenson went to the Home Silk Shop to look for fabrics for Ball. When he found something he liked, he called Desilu to run it past Ball before making the purchase. The Desilu switchboard put him on hold, and when Ball got on the line, somebody at the other end told her that Stevenson was dead. He had suffered a massive heart attack. Though he was rushed to Hollywood Receiving Hospital, he was pronounced dead on arrival. Stevenson was sixty-two.

OPPOSITE, CLOCKWISE FROM TOP LEFT: Sketch by Edward Stevenson, possibly for Mae Murray in *The Merry Widow* (1925). · Sketch by Edward Stevenson for Marilyn Miller in *Sunny* (1930). · Sketch by Edward Stevenson for Thelma Todd, 1934. · Sketch by Edward Stevenson for Barbara Stanwyck in *The Bitter Tea of General Yen* (1933).

ABOVE: Susan Hayward in *David and Bathsheba* (1951).

DOLLY TREE

Dolly Tree began life as Dorothy Marian Isbell on March 17, 1899, in Bristol, England.

She was born to Bertha Marion and Charles Edwin Isbell, a solicitor. Charles was able to provide his family a thoroughly upper-class British lifestyle. From a young age, Dorothy loved art and sketched constantly. In 1915, at the age of sixteen, Dorothy defied convention and began acting in silent films. She adopted the stage name of Dolly Tree. She acted for just three years, but landed the female lead in *Two Lancashire Lasses in London* (1916) before moving into costume design. Tree quickly became one of the leading designers for musical revues in London and the *Folies-Bergère* in Paris. By 1920, she was even well known enough in the United States to have handkerchiefs marketed with her designs in finer department stores.

In 1927, Tree arrived in New York to conquer Broadway. She took out numerous full-page ads in industry trade magazines announcing her arrival. She became the designer for Paramount Circuit and Capitol Stage shows. In 1928, she designed the costumes for Mae West's original New York stage production of *Diamond Lil*, helping West to hone her belle of the 1890s look. In 1929, she was put under contract by Winifred Sheehan to design costumes for the Fox Film Corporation. At Fox, Tree designed futuristic costumes for *Just Imagine* (1930) and dressed Jeanette MacDonald for *Annabelle's Affairs* (1931). Though Tree was originally hired as an assistant designer, she became the head of the wardrobe department when Sophie Wachner left the studio. During this period, Tree met Thomas Kimes, a handsome naval officer, and they were married in December 1932. Although the marriage would not last, it enabled Tree to become a U.S. citizen on April 24, 1936.

In 1933, Tree moved to MGM, when the studio was in its heyday under the creative influence of Irving Thalberg. Tree was given assignments that Adrian did not want or was otherwise too busy to do. Adrian kept Garbo and Crawford, but that still left the likes of Myrna Loy, Jean Harlow, and Judy Garland for

Tree. She designed for Myrna Loy in seventeen films, including *Another Thin Man* (1939). For Garland, Tree designed some of her successful musicals with Mickey Rooney, including *Babes in Arms* (1939) and *Strike Up the Band* (1940). Tree also worked on a series of films that David O. Selznick produced based on classic books, including *David Copperfield* (1935) and *A Tale of Two Cities* (1935).

In November 1940, the *Los Angeles Times* reported the demise of Tree's marriage. Tree had been willing to give up her position as one of Hollywood's leading fashion designers for marriage and a home, but it still didn't please her husband.

In 1941, Tree left MGM and returned to Fox, where she designed films for Linda Darnell and Gene Tierney. Newspapers began to speculate that Tree could be secretly married to millionaire

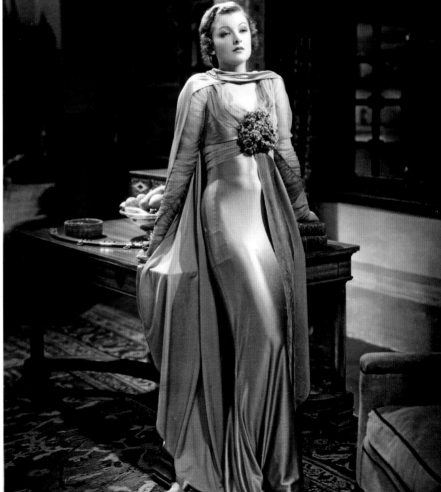

OPPOSITE: Dolly Tree

CLOCKWISE FROM ABOVE: Elizabeth Allen in *David Copperfield* (1934). · Clark Gable and Myrna Loy in *Too Hot to Handle* (1938). · Myrna Loy in *Stamboul Quest* (1934).

rancher Rex Ford. The papers were correct that Tree was secretly married, but not to Ford. Instead, she had married part-time cowboy actor Don Earl Whiteford. A tragedy brought the secret marriage to the attention of the public. In January 1942, Tree and her husband were returning to Los Angeles from Las Vegas. On a desert highway near Baker, California, Whiteford's car crossed the center line and struck an oncoming car. Lorraine Margaret Gire, a twenty-one-year-old passenger in the opposing car, was killed. Neither Tree nor Whiteford were injured. An inquest was held where Tree had to admit that she was married to Whiteford.

An additional loss befell Tree in 1942. On April 29, her father died in Beverly Hills. She left Fox later that year, and never

designed for another film. Perhaps with an inheritance from her father's estate, Tree found it unnecessary to work, or perhaps her father's death was an event from which she could not rebound emotionally. She moved to New York, and apparently never attempted to revive her Broadway design career. She died on May 17, 1962, in Long Island, at the age of sixty-three.

ABOVE LEFT: Myrna Loy costumed by Dolly Tree for *The Thin Man* (1934).

ABOVE RIGHT: A tryout costume sketch for Jean Harlow, designed by Dolly Tree.

BERNARD NEWMAN

Filming of the "Cheek to Cheek" sequence in *Top Hat* (1935) was not going well. Bernard Newman unwittingly caused a stir with a feathered gown he had created for star Ginger Rogers.

"All right, take it again," director Mark Sandrich said for the umpteenth time. The last take, like many others, had seemingly gone perfectly. Fred Astaire and Ginger Rogers had glided, whirled, and swanned flawlessly across the sparkling white Venetian set countless times. Rogers's blue shimmering satin dress, heavily trimmed in clouds of downy ostrich feathers, moved almost magically with her every step. But alas, this take, like many of the others that day, had been ruined by those majestic feathers.

"The dress was beautiful, but it was all very fine ostrich feathers," said choreographer Hermes Pan. "It moved beautifully. Fred would throw her up in the air and she'd fall back again, and then through the step, feathers would sort of drift up and fall in their face or fall in front of the camera." With another take ruined by floating feathers, Astaire was about to lose his mind.

"This damn dress . . . ," he muttered. As tensions grew, Pan and Astaire expressed their frustration through more clever means. They repenned the lyrics to Irving Berlin's now-famous "Cheek to Cheek" ditty:

"Feathers. I hate feathers.

And I hate them so I can hardly speak.

And I never find the happiness I seek,

With those chicken feathers, dancing cheek to cheek."

With some help from wardrobe staff, who attempted to attach the feathers more securely to the gown, Rogers persevered and Astaire acquiesced. The result: one of the most romantic and visually beautiful dance sequences ever committed to celluloid. Yet decades later, Astaire was still so marked by the experience that he named a chapter in his autobiography, "Feathers," which also became his nickname for his costar.

"He found that the feathers were getting all over his tuxedo, and you couldn't see them," Rogers said in a 1987 interview. "What you can see is the feathers coming off as I dance, you see them float. But you don't see them on his clothes. But he saw them on his clothes. He was furious and I guess I couldn't blame him.

But I had designed the dress and I was going to wear it, and I did."

Rogers had not exactly designed the dress. She had asked for feathers and a gown of blue "like a Monet painting," but designer Bernard Newman sketched the design and brought Rogers's idea into reality. Newman, who had been the former head designer at New York's luxury Fifth Avenue department store Bergdorf Goodman, came to RKO in 1934 to design the gowns for *Roberta* (1935), also starring Astaire and Rogers.

Newman had had a fashion sense since childhood. His mother, Augusta, had instilled it in him. "We were always poor, but always well dressed," Newman remembered. "Mother would spend her last cent for clothes. She believed in keeping up appearances and no matter whether we had anything in the pantry, we always had good clothes on our backs."

Newman was born on November 18, 1903, in Joplin, Missouri. His family moved to New York when he was just a toddler. Augusta was widowed, leaving her alone to raise Newman and his sister, Edna. She worked as a dressmaker. "I never thought I'd be one too," Newman later said. "I started out when I was old enough with a job in a factory. After I had commuted from New York to Jersey every morning for a few months, I decided that anything was better than that with the long hours and the small pay, so I got a job at a store in New York." The store was Bergdorf Goodman.

"How do you like that dress?" Herman Bergdorf asked Newman one day, as the pair stared at one of the department store's window displays.

"I don't like it at all," Newman told him. "I could design a better dress than that myself."

"All right," Bergdorf said, "go ahead and do it."

Based on the sketch Newman proceeded to produce, Bergdorf moved him to the design department. "It was the beginning of my

OVERLEAF, LEFT TO RIGHT: Fred Astaire and Ginger Rogers in *Top Hat* (1935). • Fred Astaire and Ginger Rogers in *Follow the Fleet* (1936).

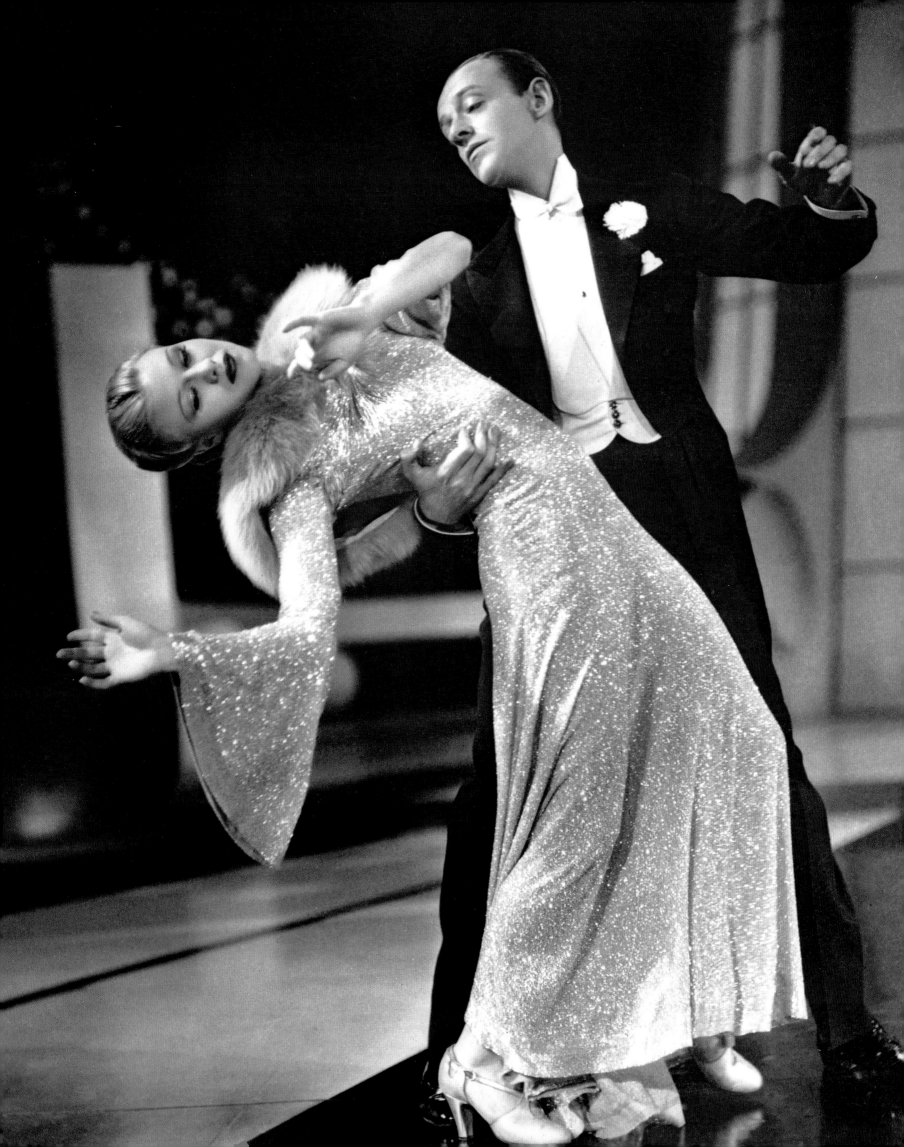

becoming a designer," Newman said, "although I had lots of other duties, such as window dressing." Newman worked at Bergdorf Goodman for twelve years, eventually being promoted to the position of head designer.

The blue feathered gown of *Top Hat* was not the only blue dress Newman created for Rogers to the consternation of Astaire. In *Follow the Fleet* (1936), Newman designed a gown covered entirely in ice-blue beading. "It was really quite a difficult dress to handle," Rogers said. "It was so heavy, it must have been thirty-five pounds." The heavy beading on the bell-shaped sleeves gave Astaire fits. "As I would whirl, I'd come around and I didn't realize it, but it would slap him in the face. Poor baby, I didn't know that was happening. When we'd stop, he said, 'Can't we do something about those sleeves?' Well, it was too late, we'd already initiated the dress into the film."

In 1935, Newman married Helen Keeler, sister of actress Ruby Keeler. Between 1933 and 1936, Newman worked on more than twenty films at RKO. During that time, he developed a hostile relationship with Walter Plunkett. Though Plunkett was also on staff at the studio, Newman kept receiving the assignments for the Astaire-Rogers films, which Plunkett resented. The dissent between Newman and Plunkett eventually reached the press. "Bernard Newman, the dress designer at RKO and Walter Plunkett, who is a ditto, are pouting," the *Rochester Journal* reported in 1936. "It seems that Bernard has always been conceded the top dress creator on that lot, but last week 'Plunky' was brought west to frock Pandro Berman's *Portrait of a Rebel* [released as *A Woman Rebels* (1936)], and now Bernard is so furious, he could quit at the drop of a stitch!"

Despite Newman's great successes with Rogers, he never reached a zenith on par with other film designers. "He was fine with Ginger Rogers, because she had a perfect figure," said film historian David Chierichetti. "But his way of designing costumes was to drape material on whoever he was designing for. This is how he worked on his retail line in New York, as well, draping material on a model until he got an idea. Then he would tell the sketch artist what to sketch. Ginger Rogers's time was too valuable, and he couldn't work that way." After designing for twenty-six films, Newman was ready to return to private clientele. He believed his sketch artist, Edward Stevenson, better understood designing for films, and Newman encouraged RKO executives to promote Stevenson as his replacement, which they did.

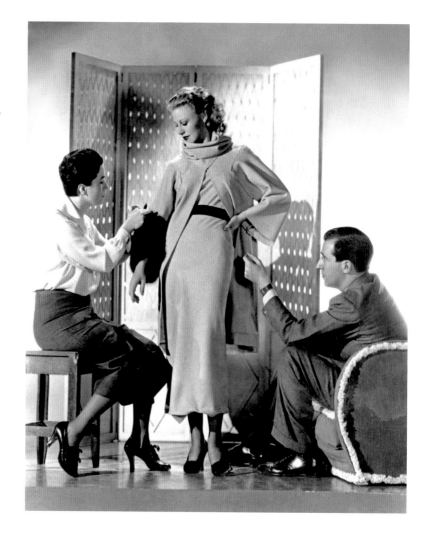

By 1938, Newman had set up shop in Beverly Hills and sold his gowns in a New York salon as well. He worked freelance for films, and returned to RKO for one assignment in 1937—a Ginger Rogers film, *Vivacious Lady*. "You know, I hate to take all this money, but my agent says I have to," Newman said in 1937. "I'd like to do certain pictures to get the experience they would give me—not for huge sums of money—but that can't be done out here. You have to get up to your neck in gravy."

Newman worked at Warner Bros. from 1946 to 1947. He did *Deception* (1946) with Bette Davis and began work on *Humoresque* (1946) with Joan Crawford. He made several changes for Crawford, but none of them worked. His designs had the misfortune of making the middle-aged star look, well, middle-aged. Sheila O'Brien was brought in to complete the project. Newman did one more picture, *Hazard* (1948) with Paulette Goddard. Newman returned to New York and went back to work as a designer for Bergdorf Goodman. He died on November 30, 1966, in New York City, aged sixty-three years.

ABOVE: Costume designer Bernard Newman (right) fits Ginger Rogers for *Roberta* (1935).

OPPOSITE: Irene Dunne in *Theodora Goes Wild* (1936).

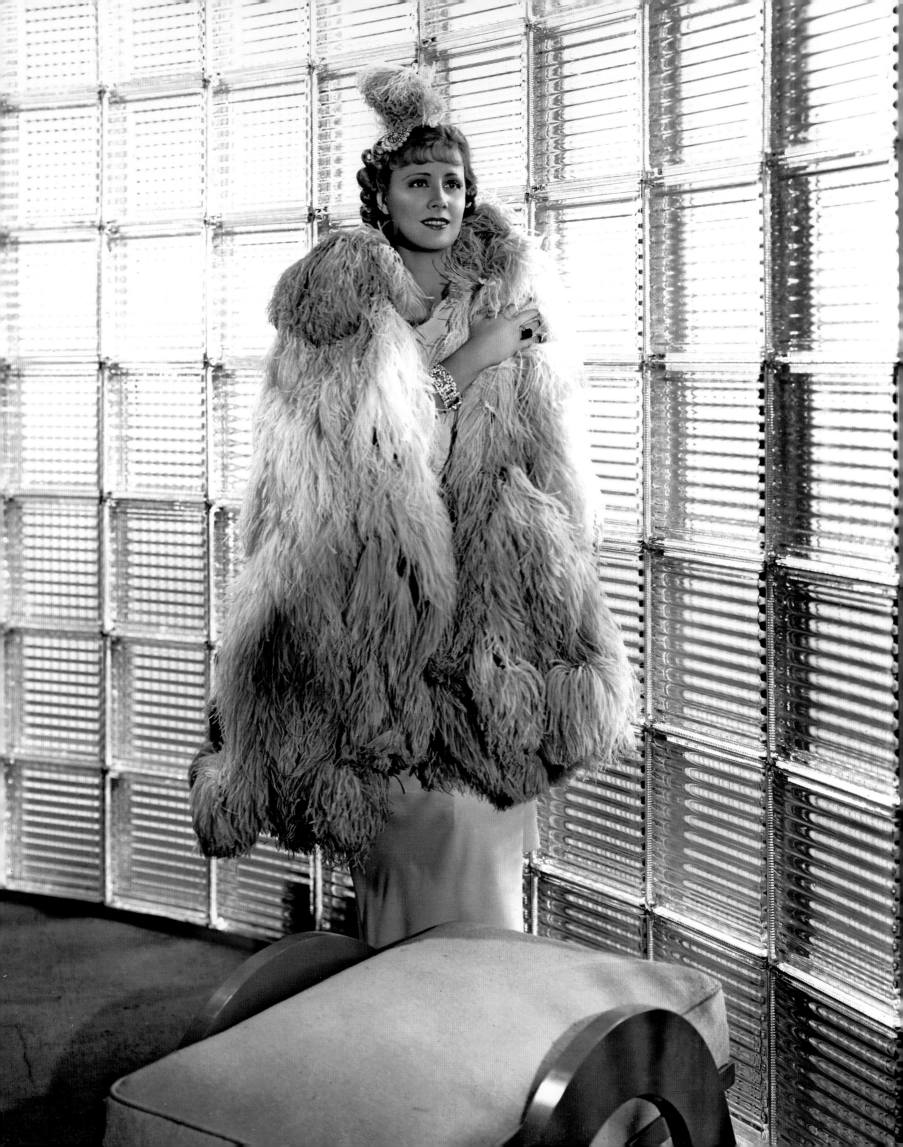

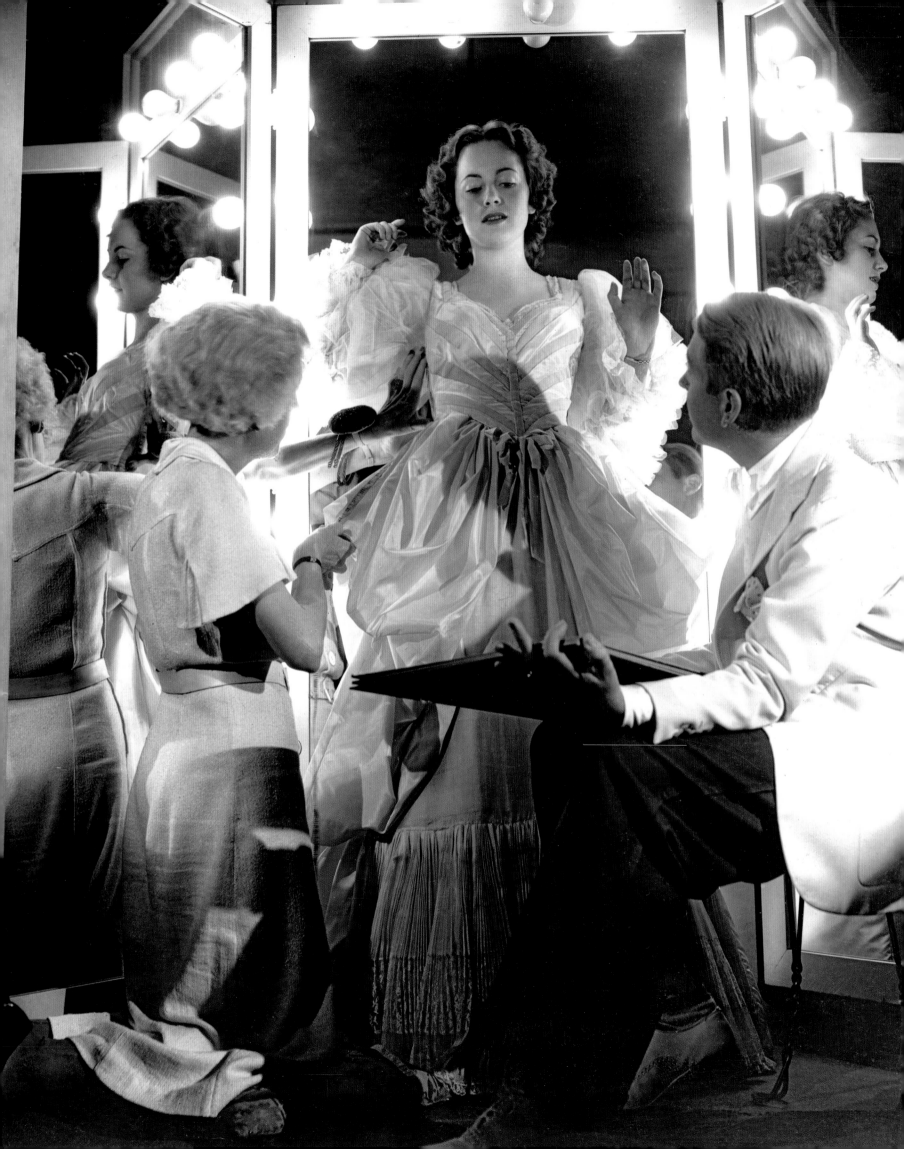

MILO ANDERSON

The distinction of dressing Joan Crawford for her Oscar-winning performance in *Mildred Pierce* went to Milo Anderson. It was an uphill battle for both designer and star from the start.

After a number of actresses, including Barbara Stanwyck, Ann Sheridan, and Olivia de Havilland, were considered for the lead in *Mildred Pierce* (1945), director Michael Curtiz reluctantly allowed Joan Crawford to test for the role. Crawford was coming off a string of flops at MGM. But that was not all that annoyed Curtiz. "She comes over here with her high-hat airs and her goddamn shoulder pads," Curtiz said. "Why should I waste my time directing a has-been?" Crawford's famed padded shoulder-look originated with MGM designer Adrian.

Aware of Curtiz's dislike for padded shoulders, Crawford wore a simple dress to the tryout that she bought at Sears, Roebuck and Company. During the test, Curtiz approached Crawford. As Crawford recalled, "He said, 'I hate you,' He tore the dress off me. Thank God I had a bra on. He said, 'My God, they're hers!' Not these," Crawford said pointing to her breasts. "These!" She pointed to her shoulders. "He was so embarrassed, he walked off the stage." When Curtiz subsequently watched the screen test, Crawford's performance won him over.

Throughout production, designer Milo Anderson found himself caught between Curtiz's hostility to Adrian's image of Crawford and the actress's desire to hold on to her signature MGM image. Although Crawford's character sported plain gingham dresses during the early part of the story, Anderson sneaked in toned-down shoulder-padded suits as the Mildred character became a successful businesswoman. *Mildred Pierce* earned six Oscar nominations, including Best Picture, but only Crawford brought home the statuette.

Anderson's ascent as a designer was phenomenal. As a teenager, he completed the wardrobe for *The Greeks Had a Word for Them* (1932) when Adrian was not available to take over for Coco Chanel. Yet he was anything but a Hollywood insider. He was

born Milo Leon Anderson on May 9, 1910, in Chicago, to butcher Alfred Anderson and his wife, Augusta. The Andersons moved to Hollywood when Milo was eight. While taking a course on set design during his freshman year in high school, Anderson realized that his true interest lay in costume design. Rather than risking the humiliation of taking the costume design course, which was regarded as a class for girls, Anderson began studying costume design informally on his own. For the school play *The Admirable Crichton* (featuring future star Sally Eilers), Anderson designed both sets and costumes. Through his sophomore and junior years, Anderson continued his independent costume design education by studying at the library. He got a summer job working in an art and interior shop owned by opera singer Alice Gentle. When Gentle was engaged to tour in *Carmen*, she had Anderson design her stage costumes.

Anderson's first encounter with the Hollywood film industry had nothing to do with costume design. He had a high-school

OPPOSITE: Milo Anderson (right) fits Olivia de Havilland.

ABOVE: Milo Anderson

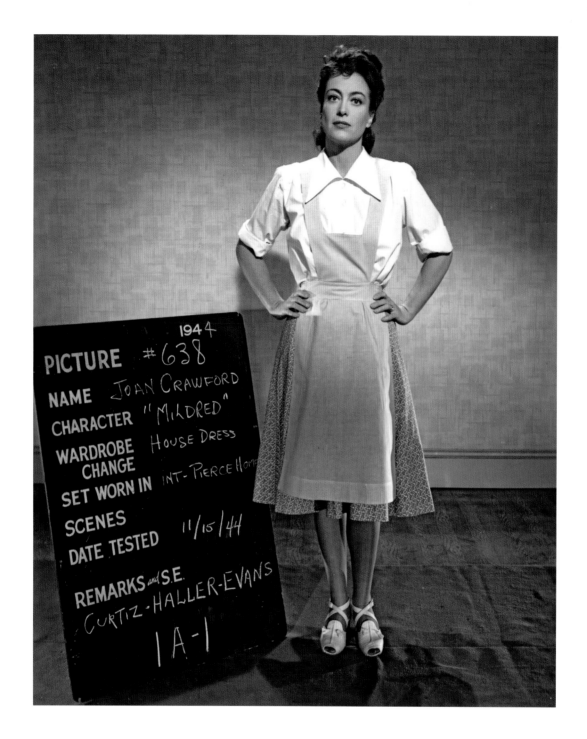

boyfriend, who also caught the eye of MGM designer Adrian. The young man ultimately preferred Anderson's affections, which did nothing to endear Adrian to Anderson. Nonetheless, when Coco Chanel's arrangement with Samuel Goldwyn began to unravel during *The Greeks Had a Word for Them*, and MGM refused to allow Adrian to finish the movie, Adrian recommended Anderson to Goldwyn as a joke. Though he likely expected the inexperienced Anderson to fail, the joke was ultimately on Adrian. Goldwyn took his recommendation, and the young man and his sketches, seriously. At seventeen, Anderson finished *The Greeks Had a Word for Them* and then designed all the costumes for Eddie Cantor in *The Kid from Spain* (1932). Anderson's first foray into

dressmaking so impressed Goldwyn that he offered Anderson a two-year contract and screen credit. Anderson dropped out of high school and permanently entered the working world.

Anderson designed for Crawford in *Rain* (1932), and Mary Pickford in *Secrets* (1933), though credited to Adrian, before moving to Warner Bros. Working at Warner alongside Orry-Kelly, who was known for his histrionics and acerbic demeanor, Anderson developed a reputation for being dependable and likeable. Some of his greatest successes at Warner Bros. included gowns for Olivia

ABOVE: Joan Crawford in *Mildred Pierce* (1945).

OPPOSITE: Doris Day in *Romance on the High Seas* (1948).

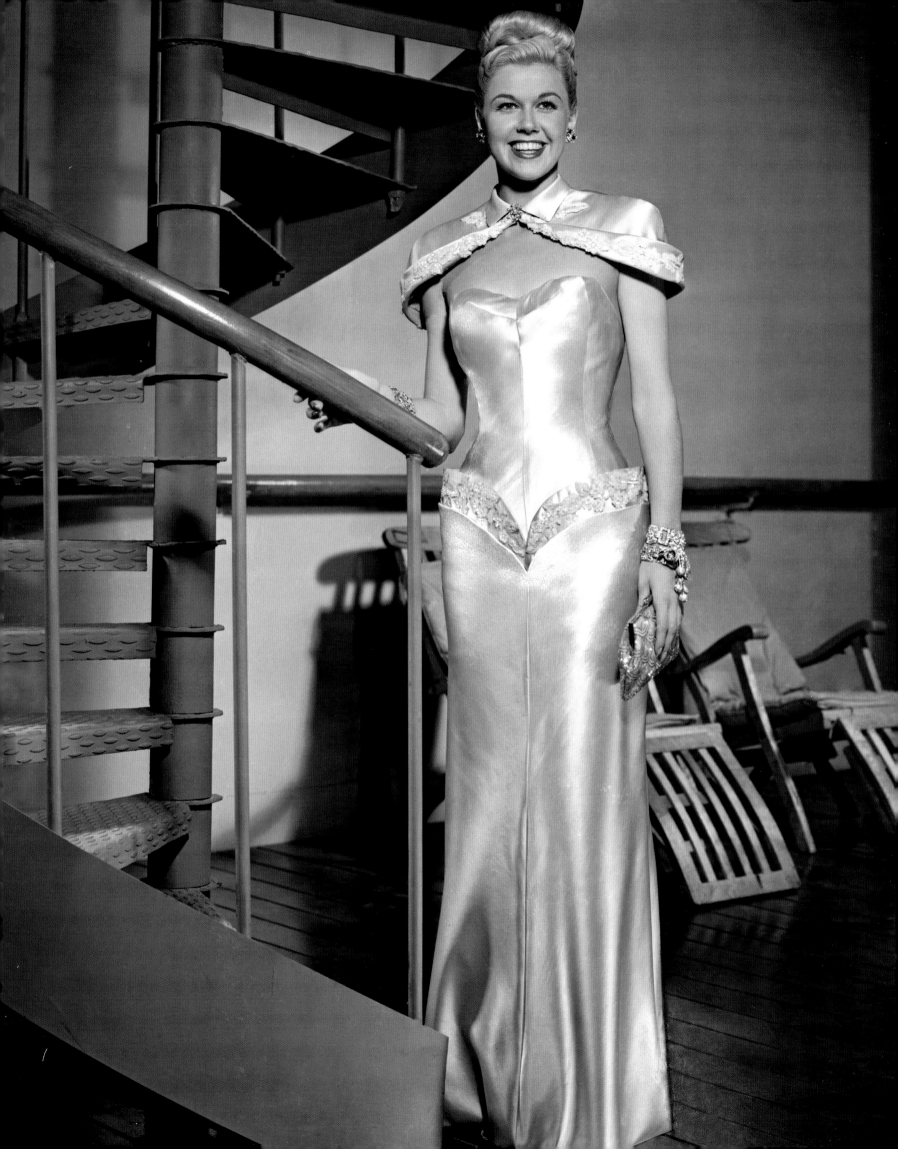

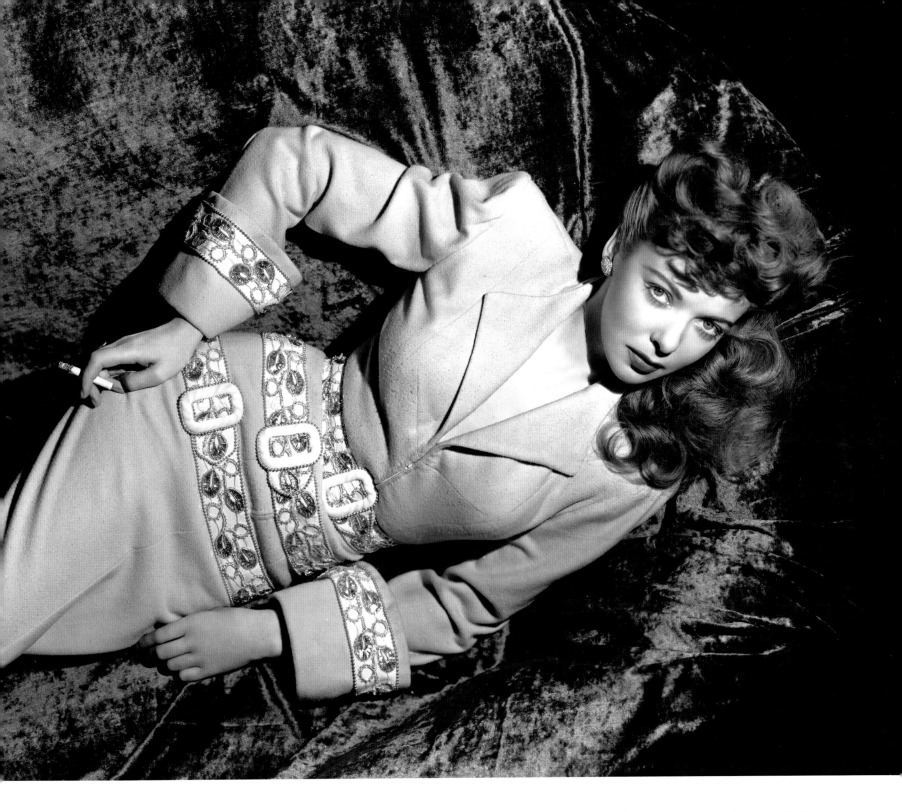

de Havilland in *Captain Blood* (1935), *Anthony Adverse* (1936), *The Charge of the Light Brigade* (1936), and *The Great Garrick* (1937).

Anderson left Warner Bros. in 1952 because he believed the studio was no longer willing to spend as much capital on wardrobe as his creations required. "I'd have a meeting with the producer, who'd tell me we couldn't afford to make a dress for a certain scene, that we should get something out of stock and change the collar," Anderson said. He resented the lower costume budgets and the speed with which films were beginning to be made, according to Chierichetti. "He only stayed on because of Jane Wyman—he adored her. In 1958, the studio offered him

Auntie Mame, but he wouldn't even come back for that. He felt the glamour was gone from the movies and he didn't want any part of it from then on."

In his later years, Anderson became a successful interior decorator in Los Angeles and taught at the Sacramento Art Centre. He died on November 3, 1984, at Hollywood Presbyterian Hospital of complications related to emphysema, at the age of seventy-four.

OPPOSITE AND ABOVE: A Milo Anderson design for Ida Lupino.

OMAR KIAM

When Hollywood reporters used to interview designer Omar Kiam, their first question was usually, "What is your *real* name?"

Certainly the six-foot-two, hazel-eyed, New York couturier with the ruddy complexion *must* have made up that sobriquet when he came to Hollywood to design for Goldwyn Studios in 1934. The fact was, he had not. He was born Alexander Omar Kiam Jr., in Monterrey, Mexico, on July 19, 1894. Though he went by "Alex" as a child, his schoolmates at Riverview Academy, a boys military school in Poughkeepsie, New York, preferred his middle name. From then on, the future designer was known as Omar.

He was born into a prominent Houston, Texas, family that had emigrated from Alsace, France two generations before. His mother, Maria, who was from St. Louis, married Alexander Sr. in Monterrey on July 20, 1893. She may have died giving birth to Kiam or soon thereafter, as Alex Sr. and his son returned to Houston without her soon after Kiam's birth. Kiam was sent away to be raised by his paternal aunt and grandmother in Connecticut, while Alex Sr. stayed behind in Houston to help manage Kiam's Mammoth Clothing Store, his brother Ed's haberdashery catering to Houston's upper middle class.

After completing his studies at Poughkeepsie's Riverside Academy in 1909, Kiam reunited with his father in Houston, where he got his first design job at his uncle's clothing store, designing caps for infants. Then he was off to the University of Texas, but Kiam lasted all of one week as a freshman. He took a job with a wholesale millinery house in St. Louis, and six months later, headed back to New York, arriving in 1914.

In 1918, Kiam was sent to Europe for a one-year tour of duty during World War I. He was wounded, though not seriously, on October 17, 1918, just three weeks before Germany surrendered. Within three years of returning to the United States in 1919, Kiam made what would be the first of several trips back to Paris, this time to study fashion and work in couture. Throughout the 1920s, Kiam apprenticed for design houses on both sides of the Atlantic.

In 1929, Kiam finally opened his own clothing shop on 46th Street in Manhattan. Soon he began designing for Broadway, though he would always say that he never sought a career as a costumer. Broadway came to him. During the next seven years, Kiam designed for several shows, including *Dishonored Lady*, starring Katharine Cornell, *Reunion in Vienna*, starring the husband-wife team of Alfred Lunt and Lynn Fontanne, and the original staging of *Dinner at Eight* in 1932.

In 1934, Kiam left New York to become head designer for Samuel Goldwyn. Although Kiam designed for all of Goldwyn's varied pictures for the next four years, he gained a reputation for his period costumes, which he especially enjoyed designing. Kiam took pride in getting every detail absolutely correct even though, in the end, it may not show on-screen. "It all goes to create in subtle ways the atmosphere you're after," he said. "For instance, all

the stockings in *Clive of India* were especially made of unusually heavy silk. They didn't have thin silk stockings in those days."

In designing modern clothes, Kiam strove for flair while still being pragmatic. In *These Three* (1936), Merle Oberon and Miriam Hopkins had a scene where their characters renovate an old house. Putting the pair in dresses would have been absurd, while shorts might have seemed inappropriately titillating. Rather than evade the dilemma with slacks, Kiam turned to traditional men's overalls for inspiration, designing feminine work clothes, complete with plaid gingham blouses.

In addition to Goldwyn, Kiam also worked for Hal Roach, and later, David O. Selznick, designing no fewer than twenty-eight changes for Janet Gaynor in *A Star is Born* (1937). For a man who seemed to enjoy costume design so much, Kiam's career was brief. *Wuthering Heights* (1939) was his last film. "There is a

great difference between designing clothes with no one person in mind and designing clothes for an individual," he once said. "I prefer to and find it more interesting to design for a great many women than just a few." He returned to New York and became chief designer for Ben Reig in 1941, creating elegant, simple, luxurious, and expensive couture for the women of Manhattan until his death on March 21, 1954. In the seven months prior to his death, he had attempted to recuperate from a heart ailment at the Ritz Tower Hotel, but he never rallied. He was fifty-nine.

OPPOSITE: Designer Omar Kiam fits Betty Thomas for *Vogues of 1938* (1937).

ABOVE: Laurence Olivier and Merle Oberon in *Wuthering Heights* (1939).

GWEN WAKELING

Though she designed for nearly 150 films, Oscar winner Gwen Wakeling's most memorable costume came from her brief foray into television, designing Barbara Eden's pink-and-ruby harem outfit for the pilot episode of *I Dream of Jeannie* (1965).

From robes for biblical epics to tailored business suits for 1940s films noir, Wakeling designed it all. And unlike many designers of her era, she dressed an equal number of men and women. "I'll tell you a little secret, men are vain creatures too," she once said. "In my work, I design for them quite as often as I design for women. They are not so unconcerned about their silhouettes as you might imagine them to be. It's fun to dress them up in a costume, because like the saying goes, 'there's something about a man in uniform,' and I say there's something about a man in a period or foreign costume, that is even more romantic." She dressed handsome English actor Robert Donat in *The Count of Monte Cristo* (1934) and designed for swashbuckler Tyrone Power in ten films, including *Son of Fury* (1942).

Gwendolyn Sewell Wakeling was born on March 3, 1901, in Detroit, Michigan, to Otty and Edith Gilmour Wakeling. Otty was an itinerant mining engineer, moving his family to Seattle, then Prescott, Arizona, and finally Los Angeles. Wakeling had no formal training in costume design and was entirely self-taught. Her first job after high school was making fashion sketches for a department store. She began her film career helping Adrian to design the wardrobe for Cecil B. DeMille's *The King of Kings* (1927). That same year, she married set designer Burgess Beall. In 1928, Wakeling worked at Pathé Exchange studio, continuing until it became RKO Pathé Pictures. There, she designed for stars Pola Negri in *A Woman Commands* (1932), Constance Bennett in *Lady with a Past* (1932), and Ginger Rogers in *Carnival Boat* (1932). She moved to Fox Film Corporation in 1933, where she helped shape Shirley Temple's image, designing for her in fourteen films. She also created wardrobes for *Drums Along the Mohawk* (1939), *The Grapes of Wrath* (1940), and *How Green Was My Valley* (1941).

Wakeling's husband died in 1940, and she became seriously ill the following year, when her appendix ruptured. Those stresses led Wakeling to leave 20th Century-Fox and open a salon with fellow designer Royer. She married writer Henry J. Staudigl in 1942. The two had worked together on *Drums Along the Mohawk* in 1939, when Staudigl consulted on color. Though their marriage lasted, her venture with Royer failed quickly. Wakeling returned to films as a freelance designer, working sporadically at first. She designed *Cover Girl* (1944) at Columbia before returning to work with Cecil B. DeMille on *Unconquered* (1947) and *Samson and Delilah* (1949). She received an Oscar for *Samson and Delilah*, shared with co-designers Edith Head, Dorothy Jeakins, Elois Jenssen, and Gile Steele.

In 1958, Wakeling worked with Temple again, designing thirteen one-hour episodes of *Shirley Temple's Storybook* for NBC. Because of small budgets, most costumes were rented from Western Costume, with adaptations improvised as needed. "I remember [director] Mitchell Leisen hand-stenciling things on clothes," costumer Margo Baxley remembered. During the 1950s and 1960s, Wakeling freelanced for RKO, Warner Bros., and Benedict Bogeaus Productions. In the late 1960s, Wakeling designed costumes for NBC and for the Los Angeles Civic Light Opera, including productions of *Kiss Me, Kate* (1964), *The Student Prince* (1966), and *Show Boat* (1967). Wakeling died on June 16, 1982, in Los Angeles. Staudigl died a dozen years later, on January 31, 1995.

OPPOSITE, CLOCKWISE FROM TOP LEFT: Rita Hayworth in a Gwen Wakeling costume for *My Gal Sal* (1942). • A Gwen Wakeling sketch for Virginia Mayo in *Pearl of the South Pacific* (1955). • Henry Fonda in *The Grapes of Wrath* (1940). • Gwen Wakeling (second from right) receives the silver trophy award given by the Associated Apparel Manufacturers of Los Angeles, 1936.

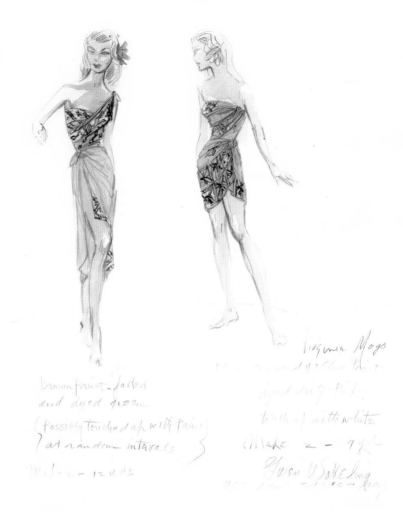

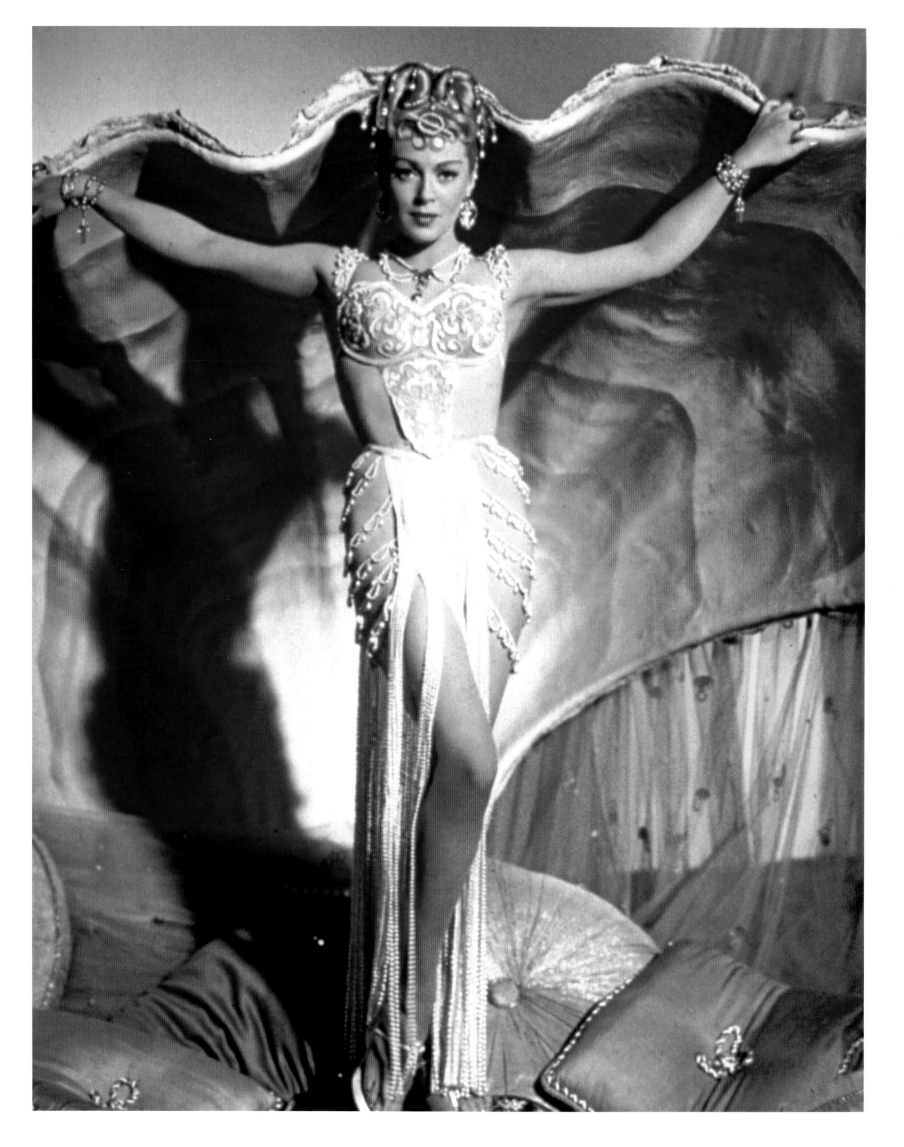

HERSCHEL MCCOY

Although Lana Turner was nominally the star of MGM's lavish *The Prodigal* (1955), pre-release press coverage focused almost exclusively on the real stars of the cheesy Bible epic: the 2,600 period costumes designed by Herschel McCoy.

The critical praise seemed to confirm that Herschel was poised to become a truly great costumer after having spent a decade designing for dozens of forgettable B movies. But the promise of a great career was never realized; Herschel died less than a year later from acute pancreatitis and pulmonary edema, following surgery at UCLA Medical Center for an intestinal blockage.

Herschel's interest in design dated back to his teen years in Mississippi. He was born there as Herschel D. McCoy on August 6, 1912. His father, William I. McCoy, was a hearing impaired accountant. His mother, Neva A. Burnett McCoy, worked as a milliner in a local shop. By the time Herschel and elder brother, Wilbur, were in grammar school, Neva had left the hat shop and was running a boarding house. Her earlier interest in apparel, however, had a lasting influence on Herschel. At fifteen, he persuaded his parents to let him quit high school in Meridian, Mississippi, and enroll in the New York School of Fine and Applied Arts (now Parsons The New School for Design). The school's Paris atelier, established by William Odom in 1921, enabled Herschel to study abroad. While in Paris, he researched peasant costumes, traveling to far out-of-the-way spots. He also spent several months apprenticing in the ateliers of Schiaparelli and Patou.

Herschel returned to the United States and went to work for 20th Century-Fox. While some sources state that he began at Fox in 1931, his earliest film credits are for 1936 releases. Herschel himself said he started his career "at the start of the Depression." Regardless of his start date, Herschel spent his years at Fox designing for serialized B movies, including the *Charlie Chan* and *Mr. Moto* series.

Herschel was a meticulous designer, often instructing his cutters in detail. For Tyrone Power's wardrobe in *Son of Fury* (1942), he researched men's clothes from 1790 and then did watercolor sketches for each of Power's twenty-seven costumes. In his instructions to the tailors, he specified: "Bottom buttons, seven inches apart. Second set, seven and a half. Belt, two and a quarter inches wide. Fob three inches." He included such instructions for each costume. The tailors cut and sewed, and then Power had to suffer through fittings for each of the costumes. And there were two copies of the suit he had to fight in—just in case he should split a seam before the scene was finished. There were six copies of a suit he had to swim in—just in case multiple retakes were needed. Two books were made for the wardrobe master, one of Power photographed in each costume, and one including continuity details. Because the movie was shot in several short sequences, detailed instructions were necessary so Power would not begin a scene in a tavern hanging up his derby, and five minutes later, leave with a topper.

While at Fox, Herschel often corroborated with Gwen Wakeling, with Herschel doing the men's costumes and Wakeling the women's. By the late 1930s, Herschel was financially comfortable. He moved his parents and brother from Mississippi to live with him in Westwood. A few years later, World War II ended Herschel's tenure at Fox. He enlisted with the Army Corps of Engineers in 1942. His brother, Wilbur, died that same year, and his father died before the war ended, leaving his mother to again run a boarding house, this time for UCLA students. Herschel joined his mother in managing the boarding house after the war ended, until 1951, when he joined MGM as a designer.

At MGM, Herschel graduated to A-list movies. *Quo Vadis* (1951) required a staggering 15,000 costumes. The space needed to house the costumes and sets was truly epic. Herschel and a staff of eight designed elaborate period garments for Robert Taylor, Deborah Kerr, and hundreds of other actors. One dress worn by Kerr required four thousand tiny beads, each one applied individually by hand. Another gown, worn by Patricia Laffan as the

OPPOSITE: Lana Turner in *The Prodigal* (1955).

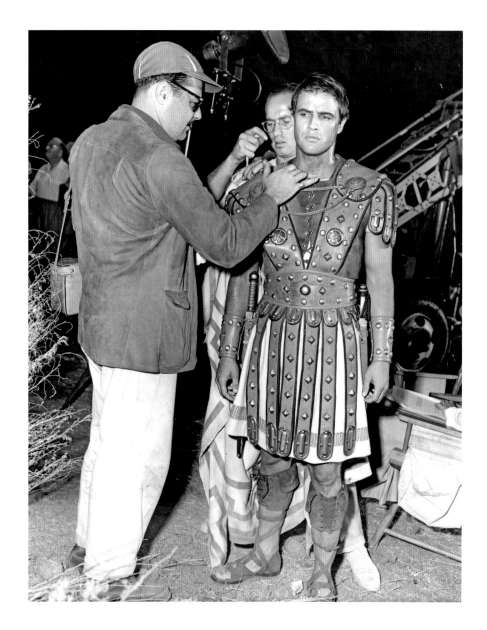

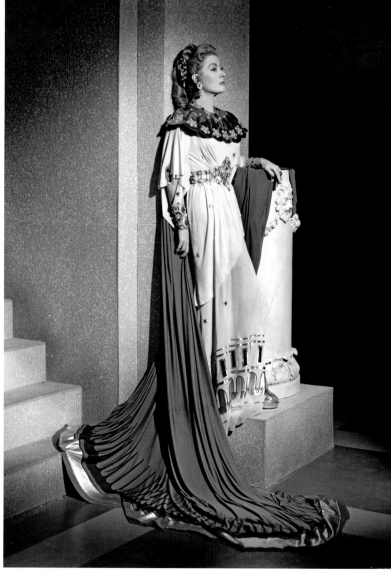

Empress Poppaea, was fashioned from a specially woven fourteen-carat gold lamé material. Studio underwriters insured that gown for $1,000. Herschel received his first Academy Award nomination for his efforts. The Oscar went to Orry-Kelly, Walter Plunkett, and Irene Sharaff for *An American in Paris*.

The following year, Herschel designed another period piece, *Julius Caesar* (1953), starring Marlon Brando, James Mason, Greer Garson, and Deborah Kerr. Although the Academy would pass over his work this time, the picture confirmed Herschel's status as the go-to designer for all things classically Greek or Roman, an informal honor that he appreciated, but considered a handicap at times as films requiring ancient style did not come around often.

The Prodigal (1955), based on the New Testament parable, required even more lavish costumes than *Quo Vadis*. Herschel designed more than 2,600 costumes, including 292 changes for the

principals alone. MGM spent $250,000 on wardrobe. One hundred people worked three months making Herschel's creations. Turner's $47,000 worth of costumes drew press attention as the "most revealing outfits" she had ever worn on film. Producer Charles Schnee insisted that the dresses Herschel had created for the platinum blonde were historically accurate re-creations of fashion circa 10 BC, based on then-recent archeological excavations near Persepolis, the ancient capital of Persia. Critics were not convinced. "One of the outfits has some beading on the top and a couple of scarves front and back," one fashion pundit wrote. "That's all, brother. The rest is all Lana."

Turner herself loved the attention. Just before *The Prodigal* was released, Dior announced that he would be bringing back the flat-chested modes of the 1920s. Turner predicted Dior's new line would bomb. "If a girl has 'em," she said, "she's not going to hide

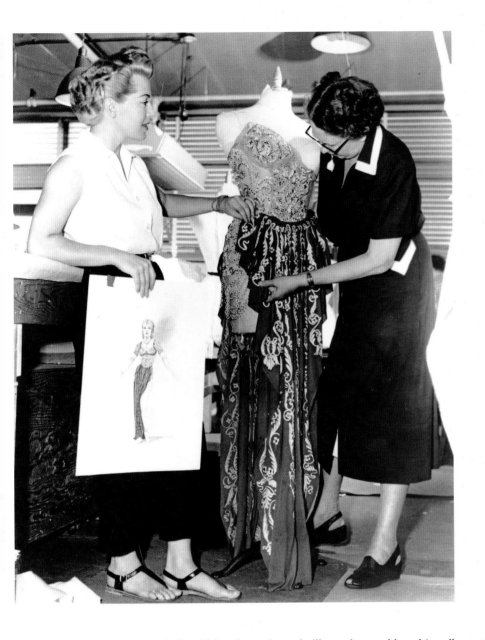

PETRONIUS

COSTUME #3 AND #7
BANQUET COSTUME

PETRONIO

COSTUMI N.3 E N.7
COSTUME DA BANCHETTO

'em. And if a girl hasn't got 'em, she'll use those rubber things."
As to her designer, Turner said, "He's great. He didn't mind a little
editing here and there." Turner explained that Herschel had agreed
to remove the heavier beads from her outfit after she complained
that the beading looked "big as a house."

Herschel had just started working on *Ben-Hur* (1959) when
he fell ill and was taken to UCLA. He died on February 3, 1956,
at age forty-three, leaving Elizabeth Haffenden to finish *Ben-Hur*
without him. Haffenden won the Oscar for her efforts at the 1960
Academy Awards.

OPPOSITE, LEFT TO RIGHT: Marlon Brando in costume for *Julius
Caesar* (1953). · Greer Garson in *Julius Caesar*.

ABOVE LEFT: Lana Turner checks on the progress of a dress for
The Prodigal in the workroom at MGM.

ABOVE RIGHT: A Herschel McCoy costume sketch for Leo Genn
in *Quo Vadis* (1951).

ROYER

Royer started out in 1933, creating wardrobes for B-movie serials at Fox Films, including the costumes for Warner Oland in his *Charlie Chan* series.

Eventually Royer moved up to A films, including *The Story of Alexander Graham Bell* (1939) with Loretta Young, *Rose of Washington Square* (1939) and *Little Old New York* (1940) starring Alice Faye, and *Jesse James* (1939) starring Tyrone Power.

Period pieces sometimes involved more than research and emulation of authentic past fashions. The historical film, *Lloyd's of London* (1936), comprised four distinct fashion periods between 1771 and 1806. The overflow work for the wardrobe department caused an annex to be appropriated to house the day and night shifts of eighty seamstresses each. For *Young Mr. Lincoln* (1939), Royer faced the challenge of making Henry Fonda's appearance match that of the sixteenth president. He gave Fonda footwear with three-inch heels and costumes with sleeves and pant legs intentionally too short for Fonda's build to imitate Lincoln's well-known gangly appearance.

Like Fonda, Royer was a native Nebraskan, born Lewis Royer Hastings on May 17, 1904, to Lewis and Eva Singleton Hastings, in North Platte, a Union Pacific Railroad town. Royer's father was a prominent figure as both head of the local union and a conductor for the Union Pacific, a position that afforded the Hastings family a comfortable lifestyle. Named after a fellow railroad employee and friend of his father, young Royer grew up with siblings John and Minerva in a two-and-a-half-story foursquare residence, complete with a sweeping front porch, square Doric columns, a porch swing, and a live-in maid. The Hastings children attended the University of Nebraska in Lincoln. During his freshman year, in 1922, Royer joined the Beta Theta Pi fraternity, where he was known as Pete. It was there that he met his future brother-in-law, George Luikart, who married Minerva in 1928.

While at the university, Royer was active in the theater department and appeared in a musical in Omaha in April 1924. Following his sophomore year, Royer persuaded his parents to allow him to move to New York City to study at the prestigious New York School of Fine and Applied Art (now Parsons the New School for Design). While studying, Royer also worked as an interior designer in 1925. A year later, Royer won a scholarship to study in France, concentrating on period design as applied to architecture, furniture, and costume. He studied abroad for two years, returning to the United States in 1928.

Royer never forgot his Nebraska roots. In the late 1930s and early 1940s, he returned to Nebraska where he lectured high school and college women on fashion. He also contributed costumes to a design exhibit mounted by the University of Nebraska and taught seminars there and at other local schools. In addition to designing costumes for studios, Royer worked as an interior decorator, maintaining a shop on Euclid Avenue in Pasadena in 1936 and 1937.

Between 1933 and 1947, Royer designed for more than a hundred films, most of them at 20th Century-Fox and United Artists. By the late 1930s, Royer became disenchanted with Fox because the studio was reworking and reusing costumes more than they were making new ones, even for the A pictures. Royer and Gwen Wakeling both left Fox in the early 1940s, and opened a salon together in Beverly Hills. Royer designed the 1940 fall line for the Maurice Rentner Company, a maker of finer gowns and suits for women. Rentner was later acquired by, and renamed after, Bill Blass. Also in 1940, Royer traveled to Mexico to design costumes for the dance tour of Margo, the singer, dancer, actress, and niece of bandleader Xavier Cugat.

Royer designed *The Shanghai Gesture* (1941) starring Gene Tierney with the actress's husband, designer Oleg Cassini, and worked briefly for Hal Roach Studios, but he never gained a foothold in the industry outside of Fox. When his couture shop with Wakeling failed in 1943, Royer moved to Mexico and designed for the film industry there. In Mexico, he became Luis Royer and designed for films starring Jorge Negrete, Carmen Montejo, and Gloria Marín, until 1952. He opened his own shop

OPPOSITE: Costume designer Royer confers with actress Elsie Larson.

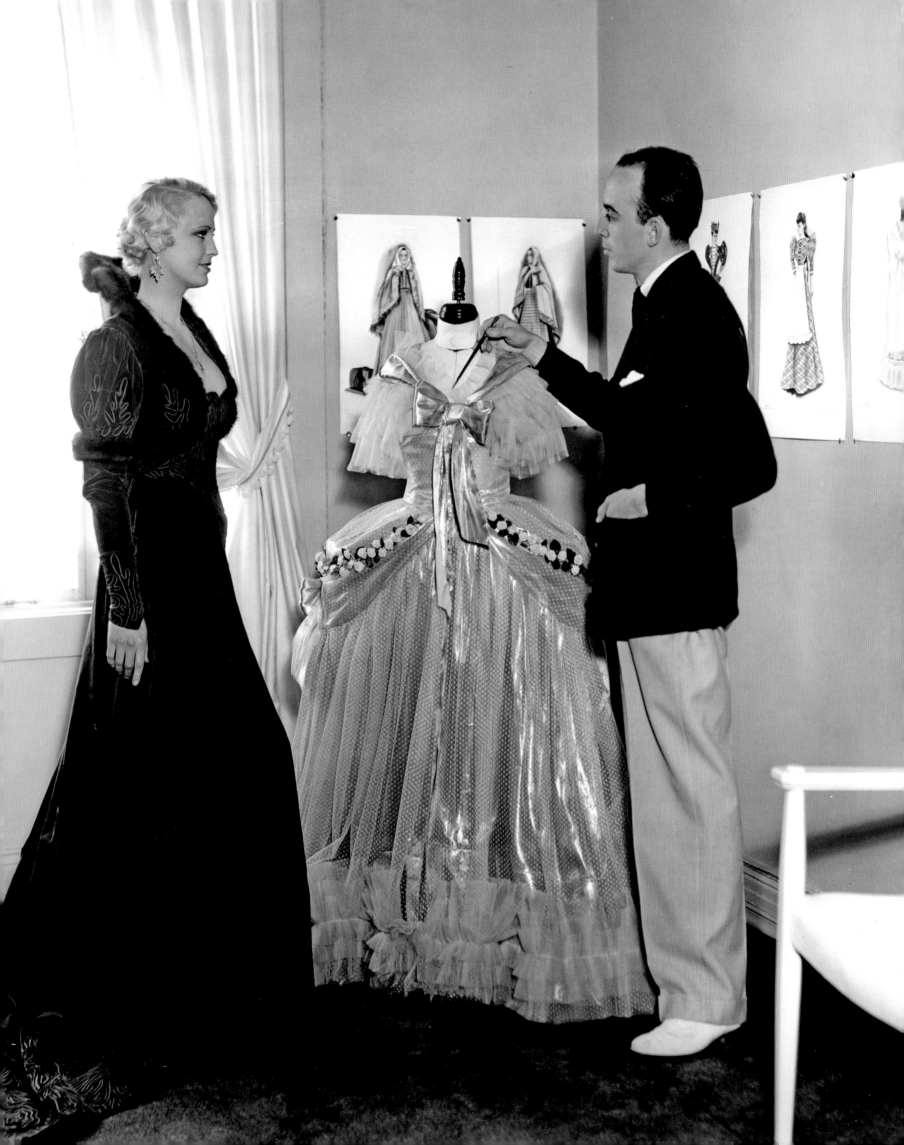

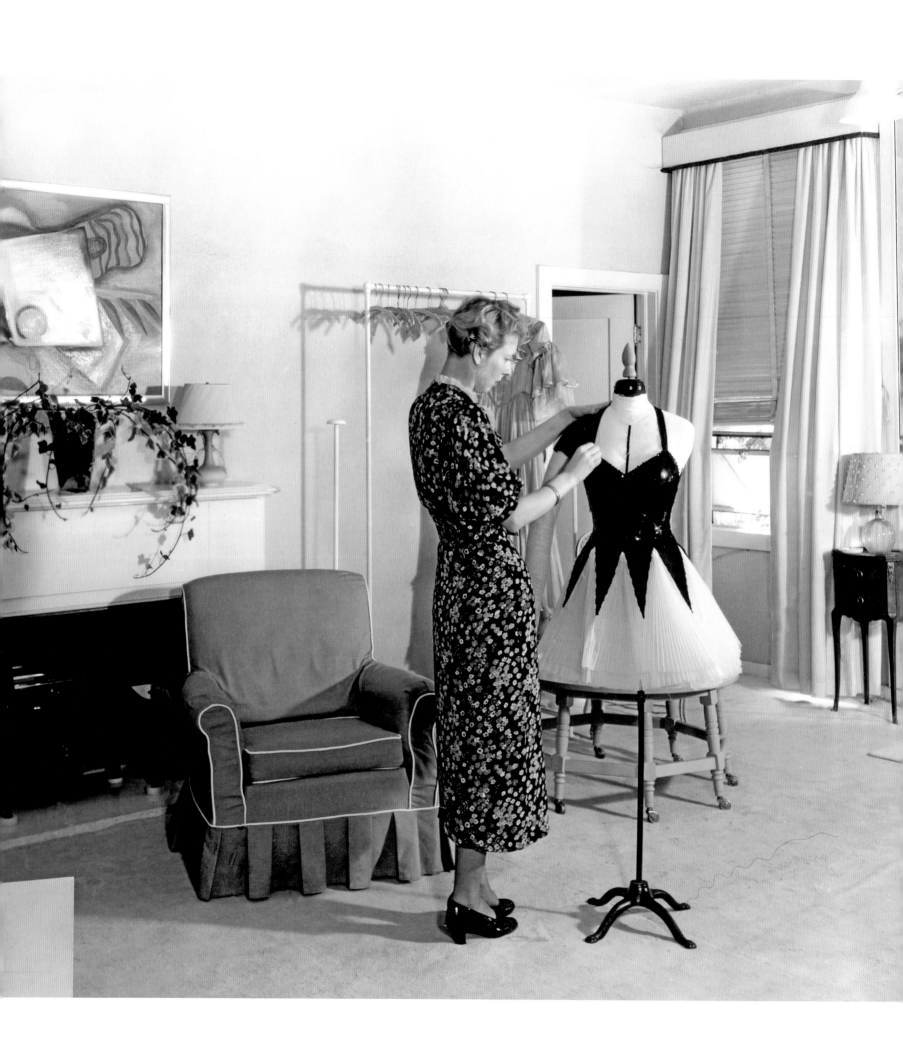

in Acapulco in the 1960s, which one writer described as "a handsome shop which dispenses frilly shirts for gents, turtlenecks in broad cloth (three buttons at the sleeve), and velvet espadrilles, some encrusted with gold. For the ladies, there is a whole meringue of organdy, long and short, black and white."

By 1980, Royer was back in the United States, living in Corona del Mar, California. In the late 1980s, he moved in with his nephew, John Loren Hastings Jr., in Laguna Beach. Royer died there on February 21, 1988, at the age of eighty-four.

OPPOSITE: A dress for Sonja Henie is constructed at 20th Century-Fox.

ABOVE: Henry Fonda in *Young Mr. Lincoln* (1939).

ADELE PALMER

When Hollywood designers formed their Costume Designers Guild in 1953, some organizers wanted to keep Adele Palmer out.

At that time, she had more than two hundred screen credits, including designing for classic films like *Wake of the Red Witch* (1948) and *The Quiet Man* (1952), both starring John Wayne. Excluders did not have anything against Palmer personally, but they disliked Republic Pictures, the studio where Palmer was in charge of wardrobe from 1938 to 1957.

Republic was a conglomerate of six "poverty row" studios—studios that cranked out ultra-low budget B films and serials. Eventually Republic expanded its budgets, and westerns with stars like Wayne and Gene Autry became its staple. Even then, because of quick turnaround times (production could be completed in as little as two weeks), Palmer had little time to make costumes. Generally she made just one or two dresses for the starring actress, more if the star was important. But usually Republic just rented wardrobe. On many occasions, Vivien Leigh's dress from her ride through shanty town in *Gone with the Wind* (1939) made appearances in Republic films because it was available for rent through Western Costume.

"She was a talent," said Helen Colvig of Palmer, who worked with her at Republic. "I think she was very fortunate to have that job. She had an office in a bungalow by herself where she did her own fittings with her seamstress." The studio could not afford to maintain a workroom, hence its reliance on Western Costume for most of its wardrobe needs. Insiders knew that Palmer worked magic with little time or resources, supervising costumes for hundreds of films during her nineteen years at Republic. Eventually the Guild founders relented and admitted Palmer as a member. But the Guild's resistance to her admission demonstrated how unfavorably Republic was viewed at the time.

Palmer was a Southern Californian, being born Eunice Adele Palmer to Theodore "Jack" Palmer and Rena C. Stafford Palmer, in Santa Ana on October 10, 1915, the eldest of five children. Her father was an orphan from Kansas who was stationed in California during his service in the U.S. Navy, where he learned to be an electrician. Following his discharge, Jack went to work as an electrician for the motion pictures studios, an occupation he followed for the rest of his life.

The future designer initially went to college to become a teacher but discovered she had more fun sketching her physics experiments than performing them. Education's loss became Hollywood's gain as she shifted her focus to theatrical costuming. She began as a sketch artist for Vera West at Universal. She then moved to MGM, where John Harkrider, then in charge of costuming, assigned Palmer the task of creating costumes for the animals in the circus number of *The Great Ziegfeld* (1936). She joined Republic the following year.

In 1957, Republic abandoned production of films for theaters. Palmer approached Charles Le Maire for a position at 20th Century-Fox. "Do you want me to save you?" Le Maire asked. "Save me," was Palmer's immediate reply. In two years, Palmer designed several highly respected films at Fox, including *Peyton*

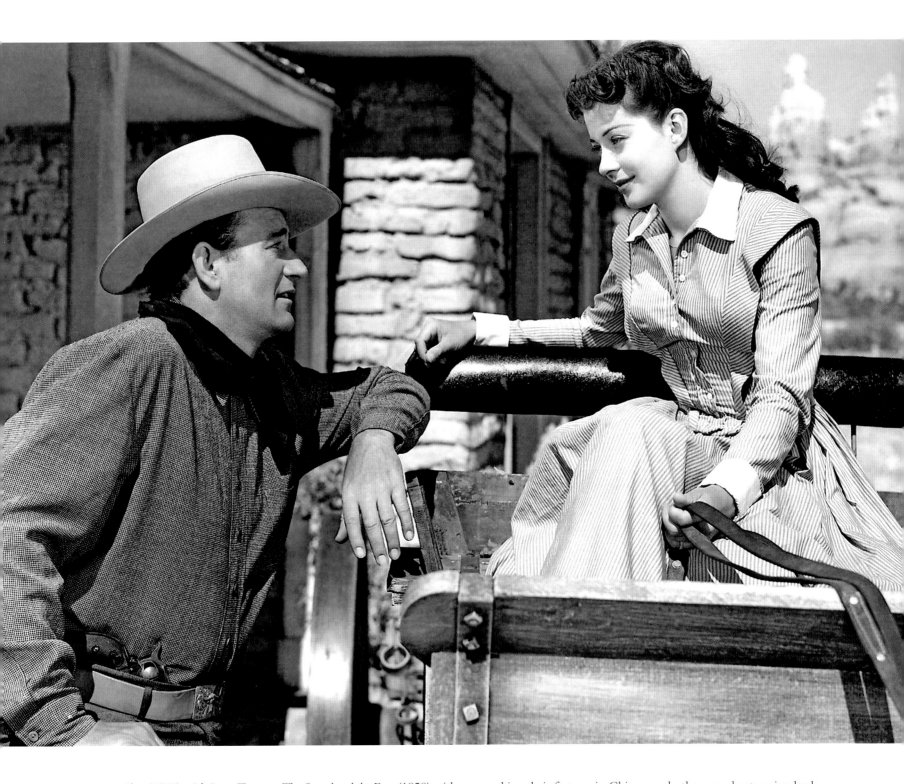

Place (1957) with Lana Turner, *The Sound and the Fury* (1959) with Yul Brynner, and *Compulsion* (1959) with Orson Welles. In 1959, she was nominated for an Oscar for *The Best of Everything* (1959), starring Joan Crawford, Hope Lange, Martha Hyer, and Suzy Parker. Being nominated must have succored the sting of being only begrudgingly admitted into the Costume Designers Guild just a few years earlier.

Having designed for nearly three hundred films, Palmer retired in 1960. She wanted to stay at home more with her husband and pursue her passion for painting. Palmer had married the dashing Thomas Patten Wilder in 1949. The Wilder family was wealthy—making their fortune in Chicago as leather merchants going back to the 1840s. Adele and Thomas traveled extensively and for a time lived in Newport Beach before settling in Santa Barbara in the early 1980s. Palmer stayed active in the arts and was involved in many charities. Wilder died in 2002, and Palmer died of natural causes on July 1, 2008, in Santa Barbara, at the age of ninety-two.

OPPOSITE: John Wayne and Maureen O'Hara in *The Quiet Man* (1952).

ABOVE: John Wayne and Gail Russell in *Angel and the Badman* (1947).

RENÉ HUBERT

When European designer René Hubert took refuge from World War II in Hollywood, he could not have been more pleased to have landed at 20th Century-Fox.

He instantly enjoyed autonomous creative control, designing wardrobes for *Sweet Rosie O'Grady* (1943) with Betty Grable and *The Song of Bernadette* (1943) with Jennifer Jones virtually unfettered. But that independence ended when Charles Le Maire became head of the wardrobe department at Fox in 1943. Hubert instantly resented being accountable to Le Maire, and the new department head knew it. Fortunately for both men, the script for *Wilson* (1944) gave Le Maire the opportunity to bring Hubert into his fold. Le Maire knew Hubert wanted the *Wilson* assignment, as he loved its period setting so much. Late one afternoon, after Hubert had left his office for the day, Le Maire piled on Hubert's desk a stack of research books related to the Wilson era that the studio librarian had pulled for him that afternoon. "What are these for?" Hubert asked Le Maire when he arrived the next morning. Le Maire handed him the script for *Wilson*. "I had been looking for a special project to give to you," he said. He joked with Hubert that Hubert so loved period costume that he probably considered the Wilson era to be modern. Hubert's icy disdain for Le Maire's authority instantly melted, and the two became friends.

Though sometimes described as a Frenchman, René Eugène Hubert was actually born in in Thurgau, Switzerland, on October 7, 1895. Throughout his life, he was a fervent admirer of French taste. His formal training in the arts began at the École des Beaux-Arts and the Académie Colarossi in Paris, where he studied painting. As a student, Hubert submitted sketches to managers of theaters in Paris. The Folies-Bergère hired him to do a series of costumes. Because of his flair for color and imaginative costumes, Hubert also found work designing for the Comédie-Française and other important Parisian theaters.

In 1921, Hubert came to New York to design costumes for the production of *June Love*. Hollywood noticed his work. He was commissioned to costume part of *Monsieur Beaucaire* (1924) with Rudolph Valentino. He executed part of the costumes in New York and part in France, though in the end, only Natacha Rambova and George Barbier received credit for the film. Hubert began a happy association with Gloria Swanson when Paramount assigned him to *Madame Sans-Gêne* (1925), which was made in France. Hubert became Swanson's personal designer, and created her wardrobes in *The Coast of Folly* (1925) and *Stage Struck* (1925). When his contract ended at Paramount in 1926, Hubert moved to MGM and designed for Norma Shearer in *After Midnight* (1927) and Marion Davies in *Quality Street* (1927).

In 1929, Hubert began designing for Universum Film in Germany, including *The Wonderful Lies of Nina Petrovna* (1929) with Brigitte Helm and *The Love Waltz* (1930) with Lilian Harvey. The political unrest on the Continent prompted Hubert to move to England to work for Alexander Korda on films such as the futuristic *Things to Come* (1936). War came to Europe when Hubert was in Switzerland producing a fashion theater tableau for the Swiss National Exhibition in Zurich. Unable to get back to England, he moved to Hollywood, where he initially freelanced for Samuel Goldwyn and Charles Rogers, and then joined the wardrobe department at 20th Century-Fox. Hubert became a U.S. Citizen, and never lived in Europe again.

During his tenure at Fox, Hubert's talent for period clothes was put to good use on *The Fan* (1949) with Madeleine Carroll and *That Lady in Ermine* (1948) with Betty Grable. Even for a modern film like *State Fair* (1945), Hubert designed clothes for Jeanne Crain that looked like peasant clothes in a fairy tale, with pink, lavender, and pale blue appliqué flowers.

When Darryl Zanuck brought Peggy Cummins from England to star in *Forever Amber* (1947), director John Stahl doubted that she could handle the role. Cummins was small in stature, but she

OPPOSITE: Marlene Dietrich in *The Flame of New Orleans* (1941).

OVERLEAF, LEFT TO RIGHT: René Hubert with Ingrid Bergman during the making of *Anastasia* (1956). · Ingrid Bergman in *Anastasia*.

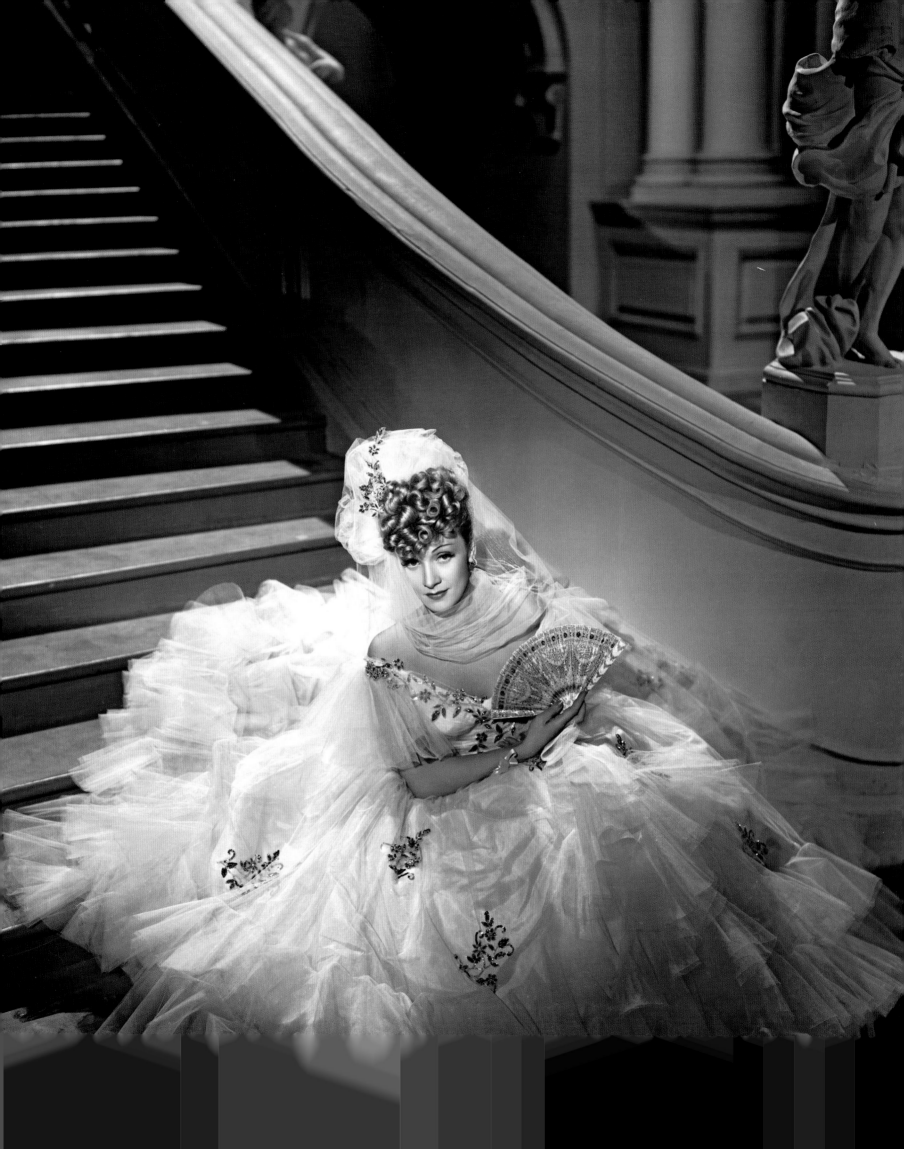

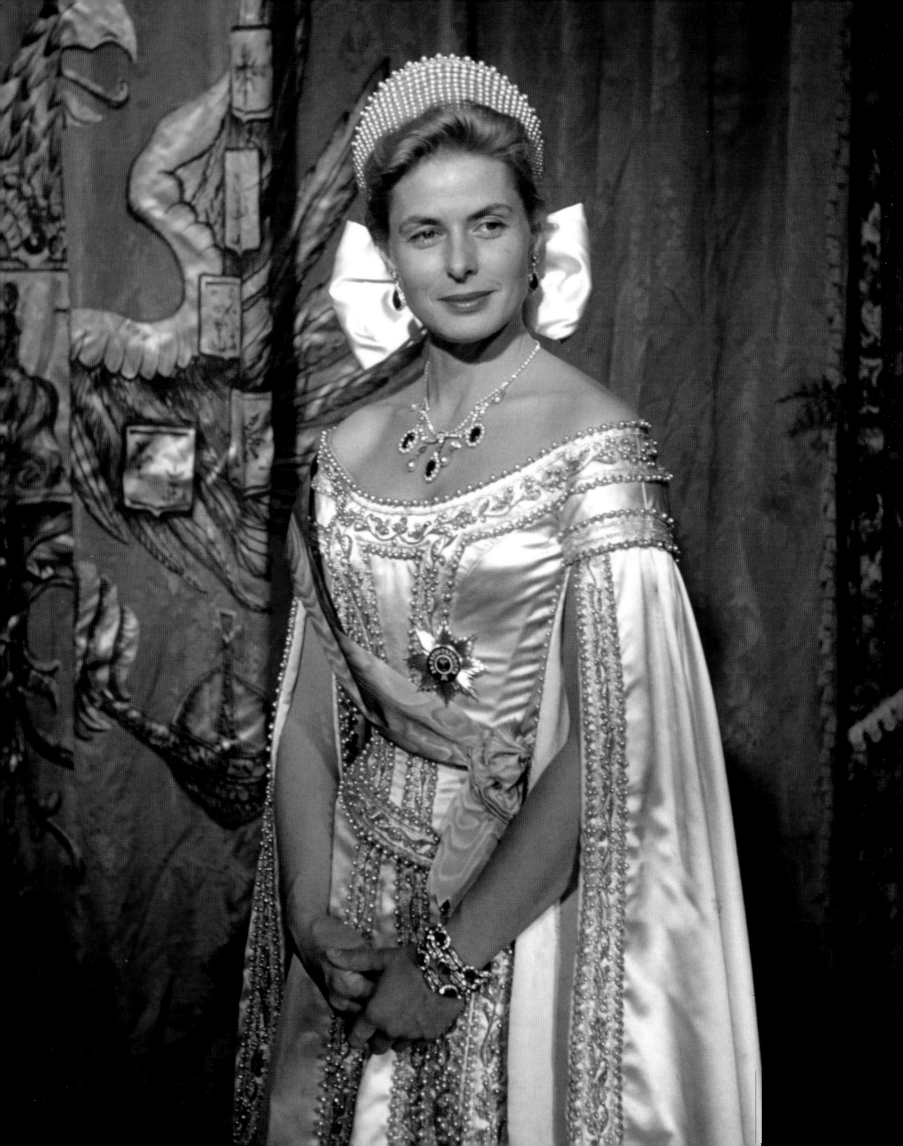

was a terrific actress and Zanuck found her dramatic and dynamic. Charles Le Maire shared Stahl's misgivings. He did not believe Cummins was feisty enough to play Amber. He assigned Hubert to do the many changes of expensive clothes that would be needed. The shooting schedule required five of the most important dresses to be filmed in the first two weeks of production. Le Maire soon discovered that Hubert shared his concerns about Cummins's viability in the part. In anticipation of a potential change in stars, Le Maire wanted to use oversize hems and seams in all the dresses, but Hubert feared the seams would show on the petite Cummins. To compromise, they limited oversize seams to the bodices.

The rushes made studio brass see that Stahl, Le Maire, and Hubert were right. Cummins was a fine actress, but failed to come across as a woman with the power to sway kings. Production was halted. Eventually Linda Darnell replaced Cummins. Despite his precautions in oversizing Cummins's costumes, Hubert still had to produce new designs for Darnell. Hubert had been designing Cummins's clothes to make her look bigger, and now he had to make Darnell look smaller. Other actresses wore the costumes intended for Cummins in the film.

A hefty $100,000 budget for costumes for *Désirée* (1954) did nothing to help Hubert reconcile the film production code with historical accuracy when he designed cleavage-revealing empire-period gowns. "In Europe, they're much more free when it comes to décolleté," Hubert said. "There they are their own judges of what's decent and what is not. We tried all sorts of things, but CinemaScope makes costuming more difficult than before since the actors' attire is constantly on view and close-ups are out." Hubert eventually settled on the simplest of design tricks—adding flowers and handkerchiefs to the tops of dresses. "It's odd but true, that were we to reproduce the actual costumes of the French postrevolutionary period on the screen, no censor in America would pass them."

For Marlon Brando in *Désirée*, Napoleon's uniform was surprisingly austere. "Napoleon was a little fellow with a big ego and a flair for showmanship," Hubert said. "So he dressed up everyone around him elaborately while he himself stuck to the simplest unadorned clothes. This automatically set him apart from his entourage."

Hubert designed Ingrid Bergman's wardrobe for her return to American screens in *Anastasia* (1956) before leaving 20th Century-Fox. He designed only two more films, *The Four Horsemen of the Apocalypse* (1962) with Glenn Ford at MGM, and another Bergman film, *The Visit*, in 1964. Hubert died in New York City in June of 1976.

OPPOSITE: René Hubert costume design for Linda Darnell in *Forever Amber* (1947).

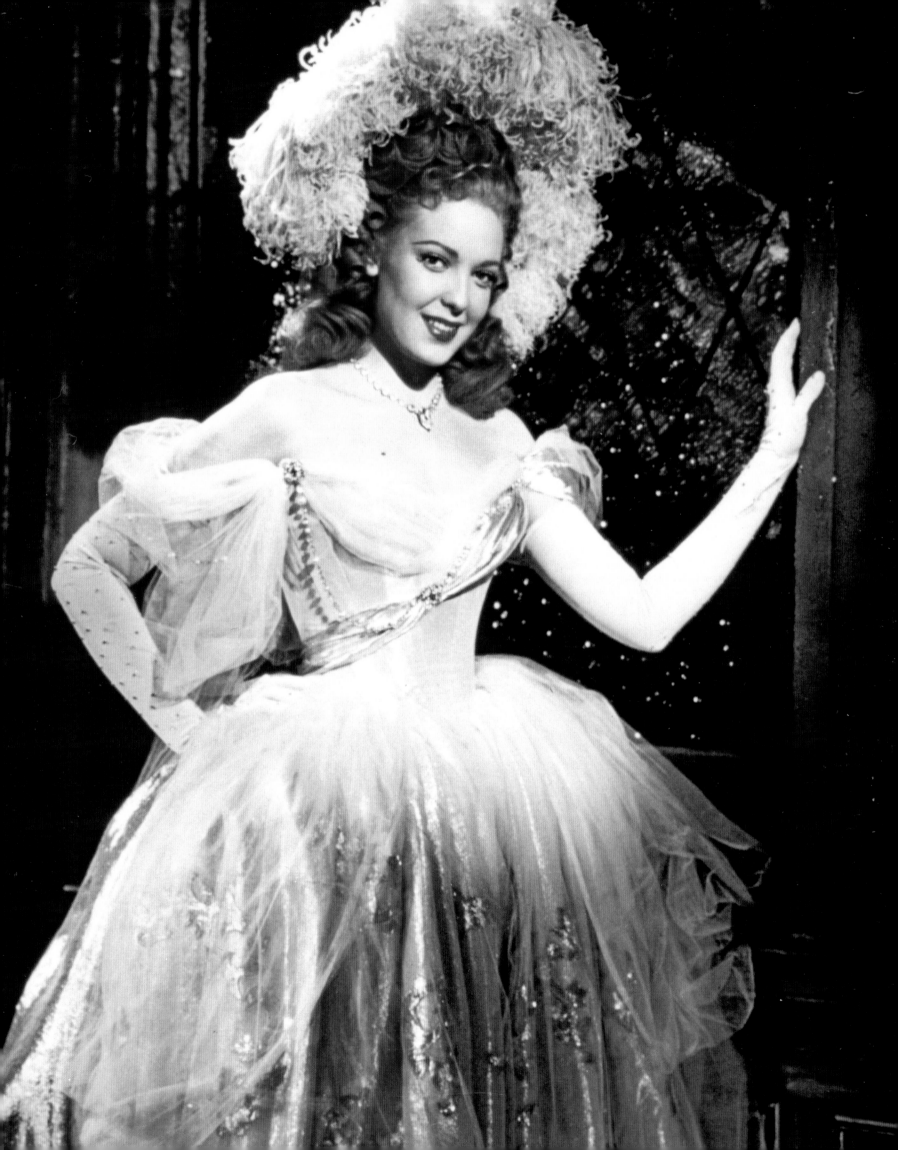

RENIÉ CONLEY

During her fifty-year career, Renié Conley designed simple clothes for blue-collar families, splendid robes for royalty, and everything in between.

And although she attired hundreds of stars in contemporary American styles too, her lifelong passion was what Conley called "ethnic" costumes—designs based on clothes from different lands and different times.

Her foray into ethnic design began in 1944 at RKO. "It started as a means of doing research for the films," Conley said. "During World War II, it was the Carmen Miranda era, and like every Hollywood designer, I was doing cute and not-at-all authentic Mexican and South American costumes for the musicals we were making." But that would change when Conley was assigned to *Pan-Americana* (1945), in which Eve Arden's character travels throughout South America. "The producer wanted me to dress all the natives correctly so viewers would notice the difference as Eve went from place to place," Conley explained. "Well, I did the best I could with the research I could find, but a lot of it I had to fake."

Although Conley was nominated for five Academy Awards during her career, her one Oscar win came, appropriately, for her stunning ethnic costumes in *Cleopatra* (1963). "It was a fascinating project," Conley said years later, "because there were so many ancient ethnic groups involved." While Irene Sharaff designed for Elizabeth Taylor, Conley designed for the other women, and Vittorio Nino Novarese designed for the men. "Cleopatra was Macedonian," Conley said, "so the lines of the gowns Irene Sharaff designed for her differed from those of her Greek and Egyptian handmaidens, which I designed. Francesca Annis, who portrayed a Greek girl, wore diaphanous, draped gowns exactly like the draped evening gowns we are seeing today. That is a true classic line."

Conley's interest in art and film started early. She was born Irene Rae Brouillet on July 31, 1903, in Republic, Washington, the oldest child of traveling salesman Ray P. Brouillet and his wife, Irene Belle Porter. Conley and her little sister, Helen, spent their early years in the Seattle area, where Conley helped design scenery for the drama club her sophomore year at Lincoln High School. The next year, her father moved the family south for his work, first to San Francisco and then to Los Angeles. Both Brouillet girls pursued postsecondary education in Los Angeles. Helen became a nurse. Conley attended the University of California and studied design at L.A.'s Chouinard Art Institute. Following graduation, she apprenticed as a theatrical set designer for Fanchon and Marco.

On May 18, 1927, Conley married silent film star Truman Van Dyke. Their son, Truman Jr., arrived seven months later. By the time Conley married Van Dyke, his film career was largely over. Having been raised in his native Mississippi, Van Dyke spoke with a heavy Southern drawl that ended his ability to land roles following the advent of "talkies." His marriage to the future designer was short-lived. Within two years of their son's birth, the Van Dykes split.

Conley landed her first costuming position, doing sketches along with Edward Stevenson for André-Ani, at MGM. She soon moved to Paramount, where she met Adele Balkan. "We weren't

assistants, we were just sketch artists," Balkan said years later. "We did things for Mitchell Leisen, for this musical, and for that. She sketched very nicely, and she was an attractive woman. She dressed well. She had a wonderful sense of humor. Everybody liked her tremendously. And the two of us lasted for quite a while. Everybody else disappeared and we were there, we became bosom buddies." The two would work together again at RKO.

Conley made the switch to RKO in 1936. The following year, she married Leland H. Conley, a career manager for a public storage chain in Los Angeles. That union lasted for fifty-five years, ending with Conley's death in 1992. She would stay at RKO for thirteen years, designing for both B-movie serials and big-budget blockbusters. She regularly designed for Ginger Rogers, dressing her in five films. "Ginger Rogers had the most perfect figure imaginable for clothes of the late '30s and early '40s," Conley recalled. "The fan magazines were always writing about her perfect legs and feet," she said. "Ginger had a tiny derriere, narrow hips,

and very broad shoulders. Her back was broad too, and yet it didn't look muscular." Conley was also careful to use small shoulder pads just to square the edges, not to add any more width.

"I remember when we were fitting the costumes for *Kitty Foyle* (1940), I gave Ginger a pair of sling pumps to try on," Conley said. "She kept walking back and forth across the room, becoming more and more upset. Finally she said, 'This is horrible. My heel bulges over the edge of the shoe.' I said, 'Everybody's feet do that. You have the best figure in Hollywood and you're not going to get any sympathy out of me!'"

While Rogers's movies usually required Conley to strive for elegance, her assignment in *The Long Night* (1947) required her to invent shop-girl chic. Conley had to design what was to look

OPPOSITE: Renié Conley

ABOVE: Costume designs reflect the multiple personalities of Eve (Joanne Woodward) in *The Three Faces of Eve* (1957).

 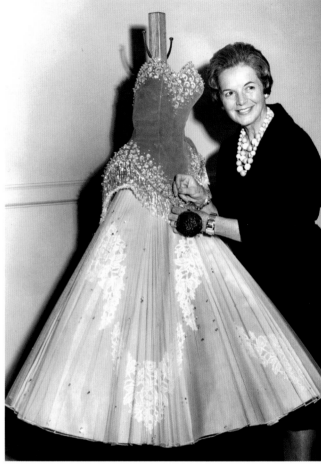

like a work dress for Barbara Bel Geddes, who starred opposite Henry Fonda as a florist's helper. Bel Geddes had to look like an underpaid salesgirl. But she had to look attractive enough to make Fonda fall in love with her. Renie shopped Los Angeles stores for the dress. "But Anatole Litvak, the director, said no to every dress," Conley said. "Barbara either looked too expensive or too cheap in store clothes. What Mr. Litvak had in mind, we finally discovered, was the effect of a peasant girl in a dirndl. Of course, he didn't know to say that. What man would? So we had to present Bel Geddes in a new dress every day for two weeks before we managed what he wanted. We had to design and make the $18 shop girl dress. It cost us $250."

In 1950, Charles Le Maire of 20th Century-Fox hired Conley. In her first year at Fox, Renie designed for Marilyn Monroe three times, for *Love Nest* (1951), *As Young as You Feel* (1951), and *Let's Make It Legal* (1951). Le Maire found Conley to be competent and dependable to do a good job, so much so that he was perfectly willing to take credit for her work before the Academy. Conley shared the Oscar nomination with Le Maire for *The Model and the Marriage Broker* (1951), even though Le Maire had done none of the

designs. "He didn't do a darn thing," Conley said. "People said I should take his name off of the nomination." She did not. And she was savvy not to. Le Maire continued to assign films to Conley, including *The President's Lady* (1953), which led to another Oscar nomination for Conley.

By 1954, Conley left Fox to become a freelance designer. For her first assignment, Walt Disney hired her to create 10,000 costumes worn by park personnel for the opening of Disneyland in 1955. "It's one of the wonders," Conley said, "because at times I wondered how it was going to be accomplished." Conley and her staff began making the costumes a year before the park opened, spending hundreds of hours on research for the conductors, boat captains, and cashiers that populated Fantasyland and Frontierland. "The personnel wasn't even hired yet to fit the costumes," Conley said.

Conley was an expert ice skater and at the same time she was working on the Disneyland costumes, she was also designing costumes for the Shipstead & Johnson's *Ice Follies*, for whom she became the exclusive designer. Conley also designed for ready-to-wear makers, but with limited success. "It's not easy for a designer in the studio to design for the public," Balkan said of Conley's attempts

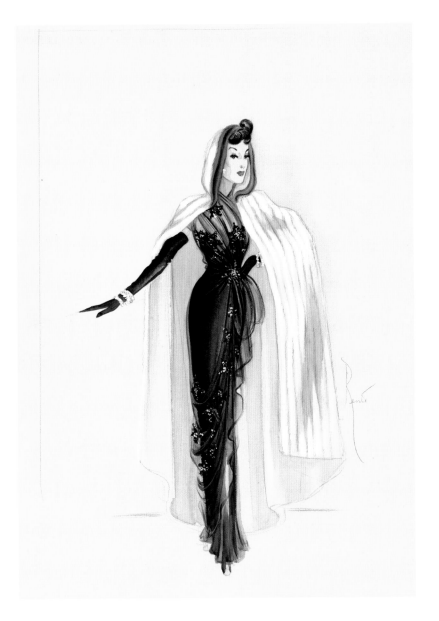

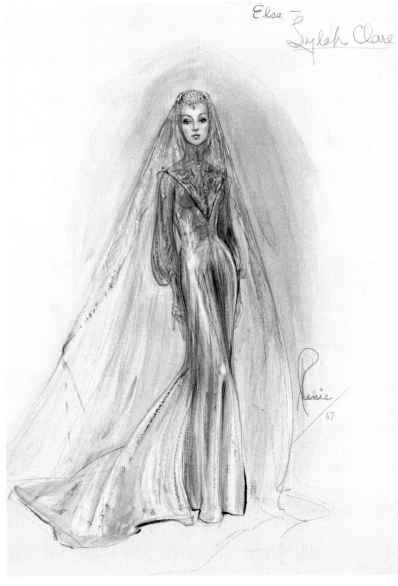

Elsa —
Lylah Clare

to design in the garment district of downtown Los Angeles. "It's a little hard to rein in that extra that you put in for films."

In 1953, Conley became a founding member of the Costume Designers Guild and served on its executive board. She was involved with the Costume Council and the Fashion Group, which worked hard to establish an adequate research center at the Los Angeles County Museum. She also taught about ethnic costumes at UCLA.

In *Body Heat* (1981) Conley successfully updated the 1940s film noir genre, adding a heightened sensuality to Kathleen Turner's Matty Walker. Although *Body Heat* proved Conley's skills were still relevant, that would be her last major film. She died on June 12, 1992, in Los Angeles, at the age of eighty-eight.

"If she eventually grew disenchanted with the direction the movie business was headed," *Hollywood Reporter* columnist Robert

Osborne said following Conley's death, "she was never less than enthusiastic about life or travel or adding to her extensive collection of ethnic costumes, which she shared with thousands when giving lectures throughout the world. She always had spirit and taste, and it always showed, on and off screen."

OPPOSITE, LEFT TO RIGHT: Renié Conley (second from left) consults with Jeanne Crain for *The Model and the Marriage Broker* (1951). · Renié Conley with a costume for Shipstead & Johnson's *Ice Follies*.

ABOVE, LEFT TO RIGHT: A costume sketch by Renié Conley for Tamara Toumanova in *Tonight We Sing* (1953). · A costume sketch by Renié Conley for Kim Novak in *The Legend of Lylah Clare* (1968).

BONNIE CASHIN

During her tenure at 20th Century-Fox, designer Bonnie Cashin hung a Hindu proverb over her drawing board: "He who arrives at perfection, dispenses with a vulgarity of clothes."

For Cashin, perfection in design meant functional clothes that reflected the way people actually lived. Although she designed wardrobes for more than sixty films, Cashin is popularly remembered for being the "Mother of Sportswear" and as the founding designer for Coach. Fashionistas also credit her with popularizing the "layered look," a pragmatic approach to dress that allows the wearer to adapt to changing situations.

Cashin's passion for clothing comes as no surprise, as her first playthings as a child were fabric scraps in her mother's dress shop. Cashin was born on September 28, 1915, in Oakland, California. Her father, Carl Cashin, was a less-than-successful photographer, and her mother, Eunice, supported the family with her dressmaking business. The family lived in several northern California towns before settling in Los Angeles. In each town, Eunice opened a shop. Cashin was constantly surrounded by patterns, fashion magazines . . . and those ubiquitous fabric scraps.

While attending Hollywood High School in the early 1930s, Cashin illustrated a fashion column for a Los Angeles newspaper. Her ambition was to become a writer, painter, or dancer. Being too short to become a dancer, at age sixteen she began designing costumes for the chorus of a Los Angeles dance troupe, produced by Fanchon and Marco. Designing for dancers, Cashin learned to be especially mindful of designing clothes for ease of movement.

Cashin moved to New York in 1934, where she attended Arts Students League of New York and became the costume designer for the Roxy Theater's "Roxyettes." She was still in her teens. *Variety* called her "the youngest designer ever to hit Broadway." With only a seven-woman staff and a small budget, Cashin designed three costume changes a week for each of the twenty-four dancers in the show. She worked at a frenetic pace, with her mother helping to make the costumes. In 1937, Cashin designed a fashion show number at the Roxy. The stage was transformed into a giant fashion magazine with models dancing from the pages in striking fashions

of the day. The showcase for Cashin's talent for couture did not go unnoticed by Carmel Snow, editor of *Harper's Bazaar*. Snow helped Cashin land a job in ready-to-wear with suit manufacturers Adler & Adler. Cashin designed for them in her off-hours from the Roxy. After the success of her first line of clothes, Cashin went to work full-time at Adler & Adler, and stayed until 1943.

As America geared up for war, Cashin became homesick for California. Producer William Perlberg helped her find a position at 20th Century-Fox with Charles Le Maire. At Fox, Cashin first learned how to design for characters and spent hours in the studio library researching period costumes. "It was exciting work," Cashin said in a 1956 interview. "I wasn't designing for fashion, but for characteristics, which is the way I still like to design clothes for daily wear. I like to design clothes for a woman who plays a particular role in life, not simply to design clothes that follow a certain trend, or that express some new silhouette."

Cashin designed *The Keys of the Kingdom* (1944) with Gregory Peck, *Laura* (1944) with Gene Tierney, and *Scudda Hoo! Scudda Hay!* (1948) with June Haver. Le Maire believed Cashin complemented the department and that her designs for *Anna and the King of Siam* (1946) had a more realistic period approach than did René Hubert's costumes for *Centennial Summer* (1946). In six years, Cashin worked on more than sixty films, doing historical, fantasy, and contemporary clothes. Cashin would travel in her mind, she said, by having lunch on a different movie set every day.

During her years at Fox, Cashin had honed her sense of practicality by designing clothes for her own personal wardrobe. For driving through the Hollywood Hills, she fashioned a coat out of a car blanket, which she later popularized as a poncho. When going into the hills to paint, she designed a "purse pocket"

OPPOSITE: Clifton Webb (left) and Gene Tierney (center) in *Laura* (1944).

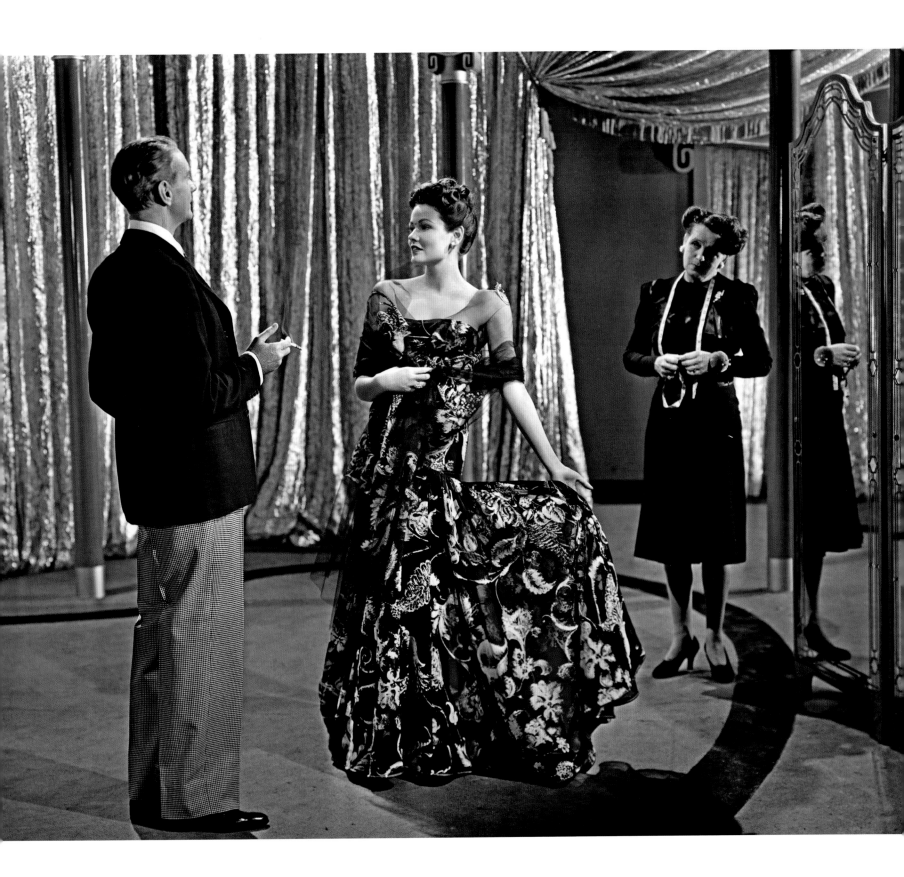

coat to hold art supplies and leave her hands-free. When Cashin returned to Adler & Adler in 1949, her "Hollywood ideas" shaped her future lines of clothing more so than her observations abroad.

In 1950, Cashin created her first layered ensemble for Adler & Adler, but soon found her creativity did not mesh with the company's profit-driven formula for success. In 1952, she left Adler & Adler to open Bonnie Cashin Designs, Inc. Having her own company allowed Cashin to do something no designer had done before, namely, work with diverse manufacturers to produce clothing lines at numerous price points, ranging from a simple vinyl jacket for a few dollars to a fur and leather coat costing thousands. For Sills & Co., Cashin produced innovative black leather coats and suits. The manufacturer initially rejected some of her leather mixed with tweed and denim combinations, believing that they could not be executed. Cashin's mother ultimately perfected the construction. Cashin's partnership with Sills & Co. lasted for twenty-four years.

In 1961, Miles and Lillian Cahn asked Cashin to design leather accessories for Coach, Inc., which they acquired in a buyout that year. Cashin spent two years rethinking the way modern women used handbags. She designed a leather version of a canvas bag that she had earlier made for herself, with a coin purse attached to the outside. These bags became known as "Cashin Carry," and were followed by a series of leather shopping bags and handbags. In 1964, Cashin began designing funnel-necked and hooded cashmere sweaters, skirts, and tights for Ballantyne of Peebles in the United Kingdom.

Cashin was inducted into the prestigious Coty Hall of Fame in 1972 and retired in 1985. She died on February 3, 2000, in New York City.

RIGHT: Rex Harrison (center) and Irene Dunne (right) in *Anna and the King of Siam* (1946).

LEAH RHODES

When Academy Award–winning designer Leah Rhodes took over stylist duties for Warner Bros. head designer Orry-Kelly in 1942, she doubted she could fill his shoes.

Orry-Kelly had enlisted in the army, and Rhodes, his assistant, suddenly found herself responsible for Bette Davis's wardrobe in *Old Acquaintance* (1943). "Leah said she thought she could never become a designer because she didn't argue like Orry-Kelly could," said David Chierichetti, a friend of Rhodes. But Orry-Kelly, with his volatile and abrasive personality, was anything but missed by Warner staff during his absence. When he returned from his one-year commission, Jack Warner had little patience for his antics and soon fired him. Rhodes went on to have a notable career, dressing many of the day's biggest stars, including Ingrid Bergman, Hedy Lamarr, Lauren Bacall, Doris Day, and Jane Wyman.

Rhodes started life as Leah Margaret Montgomery, born in Port Arthur, Texas, to Gulf Oil refinery stillman Frank Montgomery and his German immigrant wife, Katherine "Minnie" Layher. The Montgomerys married on January 28, 1901, in Port Arthur, and Leah, the first of their six children, was born the following year, on April 1, 1902. Leah and her siblings grew up in the gritty oil town, nestled on the Texas coast just miles from the Louisiana border. In her late teens, Leah apprenticed with a sign painter, then struck out on her own, designing windows for retailers in Port Arthur, and later in San Antonio. On May 4, 1921, she married Russell Spurgeon Rhodes, an auto mechanic. In 1926, the Rhodes moved to L.A.'s San Fernando Valley, where Russell managed an automobile dealership and Leah began her studio career in the wardrobe department of Warner Bros. Initially, Leah was a buyer and shopper for the workshop's designers. Eventually, she became head designer Orry-Kelly's girl Friday.

As her design career took off, Leah's marriage faltered. She divorced Russell in 1937. By 1940, she was living with thirty-two-year-old Charles Barnes, a metallurgist from Utah who had returned to America after working as a mining engineer in the Soviet Union. Their relationship may have been romantic, but Rhodes held him out to the public as her "brother." Whatever the nature of that relationship, Rhodes married U.S. Marine James C. Glasier within a couple of years. After the war, Glasier became a real-estate investor, and the two stayed together until his death in 1977.

Some designers, like Edith Head, preferred to dress modestly. Not Rhodes. She was known for her personal sense of fashion. "She always looked so nice," remembered designer Adele Balkan. "She was a spic-n-span kind of lady. She always looked like she came out of the bandbox." Rhodes did no less for her actresses. Her gowns for Lauren Bacall in *The Big Sleep* (1946) helped define the actress's image of effortless glamour. She dressed Bacall in five films, including her re-pairing with husband Humphrey Bogart in *Key Largo* (1948). Rhodes won the first Oscar for the Best Color Costume Design for her work in *Adventures of Don Juan* (1948), shared with Travilla and Marjorie Best. The film starred Errol Flynn.

Rhodes left Warner in 1952 to freelance. She had designed wardrobes for nearly sixty movies. "She told me she was doing

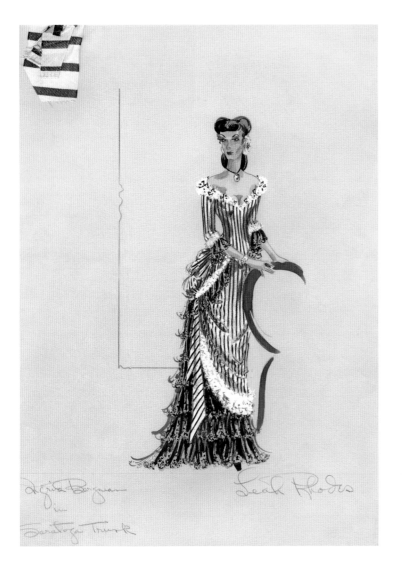

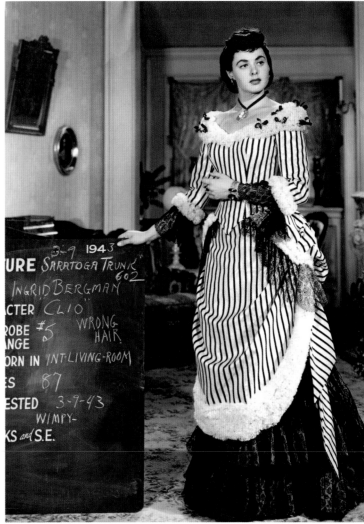

too many pictures. She wanted to do fewer and do them better," Chierichetti said. Rhodes freelanced for Universal and Paramount studios. She designed costumes for film, television, and occasionally for Las Vegas revues. In her later years, to accrue hours for her pension, she worked as a sketch artist for designers Burton Miller and Edith Head. "Edith was doing her a favor by hiring her to do that, because she could have anyone," Balkan said. "But I'm sure that Leah helped design, like we all did, but she wouldn't have gotten credit for it. But I don't think Leah was unhappy. I think she was pleased to do it." Her last film credit was for *Rio Lobo* (1970), starring John Wayne. Rhodes worked into her eighties, and died at the age of eighty-four, on October 17, 1986, in Burbank.

OPPOSITE: Designer Leah Rhodes (left) and actress Virginia Mayo.

ABOVE, LEFT AND RIGHT: A Leah Rhodes design for Ingrid Bergman in *Saratoga Trunk* (1945).

RIGHT: Leah Rhodes costume sketch for Lauren Bacall in *The Big Sleep* (1946).

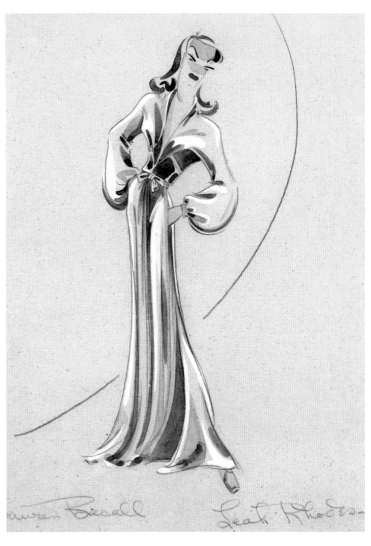

VERA WEST

Photographer Robert T. Landry returned home at 3:30 a.m. on June 29, 1947, to the guesthouse he rented from former Universal Studios costume designer Vera West. Vera and her husband, Jacques, lived in the main house at 5119 Bluebell Avenue—a beautiful Mellenthin residence that the couple had built just a decade before.

Landry, a thirty-three-year-old retired *Life* magazine photojournalist who lensed the famous World War II pin-up image of Rita Hayworth, was hoping to break into the movie business. As he carefully entered the property so as not to disturb the Wests in the wee hours of Sunday morning, he was surprised to find the Wests' beloved Scottish terriers, Duffie and Tammie, whimpering by the side of the swimming pool. In the pool, Landry found Vera's lifeless body floating, clad in a nightgown. "I always come in the back way," Landry told reporters, "But I heard the dogs fretting and I saw that all the lights were on in the house, so I started to investigate. The body was already floating."

The authorities were summoned. Investigators found two suicide notes, each cryptically referencing some mysterious blackmail. Vera addressed both notes to her husband, referring to him as "Jack Chandler." One note read, "This is the only way. I am tired of being blackmailed." The second, written on the back of a torn greeting card, said, "The fortune-teller told me there was only one way to duck the blackmail I've paid for 23 years. Death." An empty bottle of sleeping pills was found in the house. Vera and Jacques both habitually used them. The autopsy showed that Vera died of asphyxia "probably due to drowning."

Friends of the designer were shocked by her death. Actress Ella Raines had just seen West a short time before in New York. "She was very happy and didn't seem to have any troubles at all," Raines told a reporter. Jacques told police a different story. He was not home at the time of his wife's death, he claimed. The couple had a violent quarrel on Saturday night. Vera had threatened to consult a divorce attorney the following Monday, Jacques said, but that "she had threatened to do that many times before." Jacques left the house and began to drive to Santa Barbara, but ended up spending the night in his car, never arriving in Santa Barbara. The following afternoon, he returned to Los Angeles and checked into a hotel in Beverly Hills. He learned of his wife's death when he saw a newspaper headline while at the hotel and "almost collapsed," he said. Jacques said he believed that her suicide was prompted by their domestic difficulties. He also claimed his wife's health had not been good.

Years earlier, West had gained fame designing costumes for Universal's horror pictures. Within two years of arriving in Los Angeles in 1926, West began working at Universal and received her

OPPOSITE: Ava Gardner in *The Killers* (1946).

ABOVE: Vera West

OVERLEAF, LEFT TO RIGHT: Marlene Dietrich in *Destry Rides Again* (1939). • Deanna Durbin in *The Amazing Mrs. Holliday* (1943).

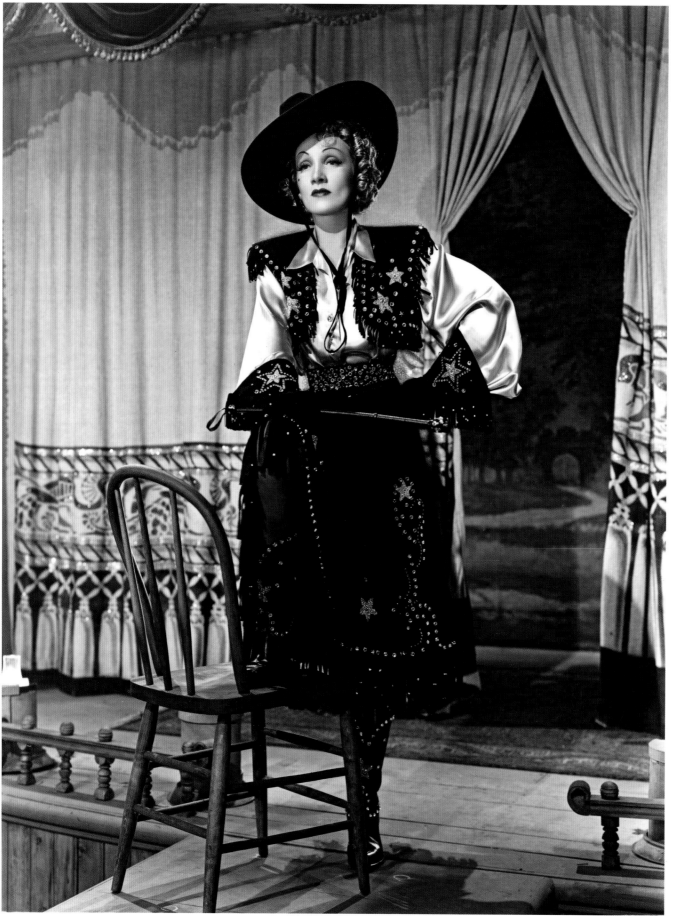

of Lillie's death, Emer married Clara Ringe, the daughter of a local candy maker. Emer and Clara had two children, Hazel and Emer Jr., though the baby boy died at ten months. When Emer Sr. died at forty-five, on January 14, 1917, West took on the task of supporting her stepmother and sister by working as a dressmaker at a local establishment in Philadelphia.

Vera attended the Philadelphia School of Design for Women (now Moore College of Art and Design). She grew up in Philadelphia and was working as a dressmaker there in 1920. She married Stephen D. Kille in 1924, and moved to Los Angeles two years later. West's marriage to Kille, who was employed in the restaurant business, did not last. Whether the couple ever divorced is not known, but when West moved to Hollywood it was *sans* Kille. By 1930, Vera had married fellow Philadelphian Jacques West, a salesman who eventually owned a cosmetics firm. If West did not divorce Kille, she was a polygamist, as Kille did not die until February 22, 1931, in Philadelphia.

In addition to designing for horror classics during her twenty years at Universal, West also dressed A-list stars. When Marlene Dietrich and Mae West came to Universal, West designed their costumes for *Destry Rides Again* (1939) and *My Little Chickadee* (1940), respectively. She dressed Ava Gardner in the Academy Award–winning film *The Killers* (1946). West's most successful elegant designs were for the teenage star who arrived at the studio in 1936, and whose films were so financially successful they are credited with saving Universal from bankruptcy: Deanna Durbin. "From the time when Deanna, at thirteen, came to Universal to make her first picture, *Three Smart Girls*—which was an instantaneous hit—until today, when that charming youngster has registered her fifth hit in a straight row with *Three Smart Girls Grow Up*, Vera West has designed and created everything which Deanna wears on the screen. In addition, she puts a stamp of approval on Deanna's personal wardrobe," *Photoplay* magazine proclaimed in 1939.

first film credit for *The Man Who Laughs* (1928), starring Conrad Veidt. Universal had been riding a wave of successful horror films that began in 1923 with Lon Chaney's *The Hunchback of Notre Dame*. West supervised the gowns for almost all of the classic Universal horror films, including *Dracula* (1931), *The Mummy* (1932), *The Son of Frankenstein* (1939), *The Wolf Man* (1941), and *Son of Dracula* (1943). She also designed for the female stars in Universal's B-movie thrillers, crime dramas, and westerns.

West was born as Vera Flounders to Emer Lovell and Lillian May Moreland Flounders, on June 26, 1898, in Philadelphia, Pennsylvania. Her father was a heating and sheet metal worker. Her mother died when Vera was two years old. Within a couple of years

West left Universal in early 1947. After having designed for four hundred films, West was perhaps ready for a change. Or maybe she was disillusioned with the new direction William Goetz, son-in-law of Louis B. Mayer, had decided to take Universal upon becoming head of production in 1946. Upon leaving Universal, West designed a spring collection for a fashion shop in the Beverly Wilshire Hotel.

Jacques told his lawyer, Lyman A. Garber, that his wife "hated the water" and had never learned to swim. She would only go in the water if he was sitting nearby, he claimed. As to the cryptic suicide notes, West told police sergeant R. P. Kealy that his wife suffered from a "persecution complex" and was not being blackmailed. Vera "was always imagining things like that," he said. "There was absolutely no blackmail involved. She just imagined it." West said he was well acquainted with his wife's financial matters and that there was no evidence she had been paying blackmail, but that her behavior had become more erratic. Police found two notes written by Jacques titled "gremlins of my wife's imagination."

Designer Yvonne Wood told friends various theories as to West's end. At times, Wood claimed that West had been murdered, and that her death was made to look like a suicide. But Wood could never identify a plausible motive for murder. "Nobody could understand why anyone would want to kill her. Nobody profited from it financially," Hollywood historian David Chierichetti said. Wood herself admitted that West was a kind soul and well liked, with no known enemies. At other times, Wood speculated that suicide was plausible, and that West's alcohol problem may have led her to take her own life.

Investigators concluded that the blackmail references were "hallucinations" resulting from West's supposed neurotic condition. But the investigation appeared superficial, at best, as evidenced by the lack of meaningful discussions in the press regarding West's mysterious pre-Hollywood history and the details suggested in her suicide notes. Did investigators know about West's previous marriage to Stephen Kille twenty-three years earlier, which corresponded exactly to the time West said the blackmail had begun? Many of West's claims regarding her past accomplishments appeared fabricated. Who knew that? And what would publicizing the falsehoods have meant to West, given her subsequent successful career at Universal? And was West's choice of suicide by drowning not shockingly improbable, given her morbid fear of water? Why did Jacques take an aborted trip to Santa Barbara, claiming instead to have stopped to spend the night in his car, an alibi that likely defied verification? Were earlier reports that Jacques was away on business at the time of the death a mistake by reporters, or a blunder that he abandoned when he realized that he could not manufacture evidence for such a trip? Did anyone review West's financial records to see if sums had mysteriously disappeared to hush a blackmailer, or did the police simply accept Jacques's word on the subject? Why were West's friends and colleagues unable to corroborate Jacques's claim that West was "always imaging things"? And no conclusion was ever drawn as to who the mysterious fortune-teller was who encouraged West to kill herself, if one actually existed.

Following Vera's death, Jacques West, who used aliases during his life, disappeared, but not before having the house on Bluebell Avenue where the death occurred demolished, and the land sold to a developer who subsequently built three new homes on the former West homestead.

OPPOSITE: A Vera West sketch for Maria Montez in *Sudan* (1945).

ABOVE: One of the suicide notes left by Vera West.

MARJORIE BEST

Though her Oscar win for *Adventures of Don Juan* (1948) did not make her the only Oscar winner from downstate Illinois, Marjorie Best was Jacksonville's most-nominated native, getting recognized by the Academy for her work in *Giant* (1956), *Sunrise at Campobello* (1960), and *The Greatest Story Ever Told* (1965).

It seems particularly surprising that the Morgan County newspaper serving the twenty thousand residents of Jacksonville did not even run an obituary for Best when she died in 1997, ninety-four years after being born there on April 10, 1903.

Best was respected for her knowledge in the field of costume design, even becoming an educator herself, but she never actively sought the spotlight. She moved to Los Angeles with her parents, Frank and Lizzie Osborn Best, in the late 1920s, where Frank worked as a real-estate agent. Best studied at the Chouinard Art Institute, intending to become a painter or a commercial artist, but changed her mind. "From the first time I visited a costume design class, I knew I had found the work that I wanted to do," Best said.

After graduation, Best took a position at United Costume, a large company that rented wardrobes of every type to film studio. Though not her first choice of employment, Best believed that the experience would prepare her for a studio job when one presented itself. At United, she designed both men's and women's costumes, but soon her assignments veered strongly toward male attire. "I suppose I did a good job once, and the others just naturally followed," she said. When Warner Bros. acquired United in 1943, Best finally landed that "dream position" she had waited for. The studio offered jobs to United's top designers. "I went along with the rest of the purchase—bag and baggage," Best said.

Designers for men's costumes were scarce. Creating wardrobes for men never brought the designer the prestige that designing gowns brought to her male counterparts. "The work was obviously more difficult than designing for women—and more limited in its scope," Best said. "I found each new problem fascinating." Besides specializing in men's costumes, Best worked on period films and designed many westerns, including *The Hanging Tree* (1959) with Gary Cooper and *Rio Bravo* (1959) with John Wayne. Best's roster of male stars included some of the biggest names then working at the studio—Errol Flynn, William Powell, Paul Henreid, Dennis Morgan, and Jack Carson.

When designing for men in the period before 1800, Best likened men's clothes to the natural coverings of male birds and animals. "[Men] led fashion, and women trailed far behind," Best said. "For generations, men wore the finest materials, the most jewels, the gayest colors. Then something happened, and for the past century-and-a-half, their clothes have remained much the same as they are today."

Of all the men she designed for, Errol Flynn had "the kind of physique I like to sketch when I make my designs," Best said. Flynn usually had ideas of his own. If an actor expressed any preference, Best tried to work it out. "Differences of opinion like that are natural because of individual interpretations of the character," she said. Flynn wanted low-cut vests for his suits in *Silver River* (1948) instead of the higher-buttoned-up style. Best agreed that his choice was more debonair than her original sketches.

Later in her career, Best returned to Chouinard and taught the history of costume design for many years. Best was also active in the Costume Designers Guild and the Costume Council of the Los Angeles County Museum of Art. She died on June 13, 1997, in Toluca Lake, California, of a heart ailment.

ABOVE: A Marjorie Best design for Audrey Hepburn in *The Nun's Story* (1959).

OPPOSITE: Gary Cooper in *The Adventures of Marco Polo* (1938).

MICHAEL WOULFE

Although he designed for more than one hundred films during his career, Michael Woulfe was always proudest of the black velvet dress he designed for Judy Garland's first television appearance, the premiere event for *A Star is Born* (1954).

Trimmed in white piqué and crystal beading with a matching white satin hat, the ensemble embodied Woulfe's skillful updating of traditional formal wear. While reporters raved that Garland looked radiant, no one in the television audience knew that she had instructed Woulfe to make the complementary black fur muff large enough to accommodate a flask of vodka, her self-prescribed cure for pre-show jitters.

Woulfe's favorite creation happened almost by chance. At the time, Woulfe was under contract to RKO, and it was Jean Louis who had dressed Garland for the Warner Brothers' musical drama. Months before the film's premieres, Garland had admired one of Jean Simmons's suits so much that she asked to borrow it. Sid Luft found out that Woulfe was the designer and invited him to their home to discuss designing a gown for Garland for the premiere. Because he was under contract, Woulfe needed RKO's permission not only to design the dress, but the complementary maternity version for the 1955 Oscars as well. Despite Woulfe's efforts, the latter gown was never worn. When Garland's third child, Joseph Luft, arrived a month premature, NBC sent a camera crew to Garland's bed at Cedars of Lebanon Hospital. Garland donned a peignoir and feathery bed jacket hastily purchased in Beverly Hills to give an acceptance speech that would never end up being given. The Best Actress Oscar went to Grace Kelly for *The Country Girl* instead.

Perhaps what Woulfe appreciated most about the Garland dress was the freedom he enjoyed in designing it. At times, Woulfe found studio demands frustrating and restricting. In later life, he believed he had been hampered in realizing the full extent of his creative potential because of the incessant demands of one man: Howard Hughes. Although Woulfe was adept at designing the classy and refined, catering to Hughes for nearly a decade unfairly gave him a reputation as a designer who pushed the censorship envelope relentlessly. That was never his goal.

Woulfe did not seek out Hughes; he was acquired by him when Hughes took over RKO in 1948. Woulfe had found his first Hollywood assignment designing for Sylvia Sidney in William Cagney Productions' *Blood on the Sun* (1945). Woulfe and Sidney enjoyed a long friendship. The two had much in common. Both were born in New York City—Woulfe on June 2, 1918, and Sidney on August 8, 1910. Both were first-generation Americans, each being born to Jewish immigrants from Romania. Both abandoned their birth names and assumed professional monikers—Woulfe was born Samuel Goldstein and Sidney started life as Sophia Kosow. And both had parents in textile-related industries. Woulfe's father was a life-long furniture upholsterer with a shop in Brooklyn, and Sidney's mother was a dressmaker from the Bronx.

Before his move to Hollywood, Woulfe had been a sketch artist and assistant designer in the New York garment industry. But thanks to the success of *Blood on the Sun*, Cagney Productions offered Woulfe a contract. He stayed for three years, though during his tenure, Cagney lent him to other studios, including RKO. In 1947, RKO put Woulfe on its regular payroll. Hughes's takeover of the studio the following year initially had little effect on Woulfe. During the entire time Hughes controlled RKO, he never once visited the studio in person.

With one exception, the absentee studio head largely left Woulfe alone. "The only time he ever gave me any instructions," Woulfe said, "was *always* on a picture with Jane Russell." Hughes's first missives regarding Russell came in 1948 during preproduction of *Macao* (1952). Hughes hired Josef von Sternberg to direct. Hughes wanted von Sternberg to work the same magic on Russell that von Sternberg had worked on Marlene Dietrich years before.

OPPOSITE: Costume designer Michael Woulfe with models wearing gowns from *The French Line* (1954).

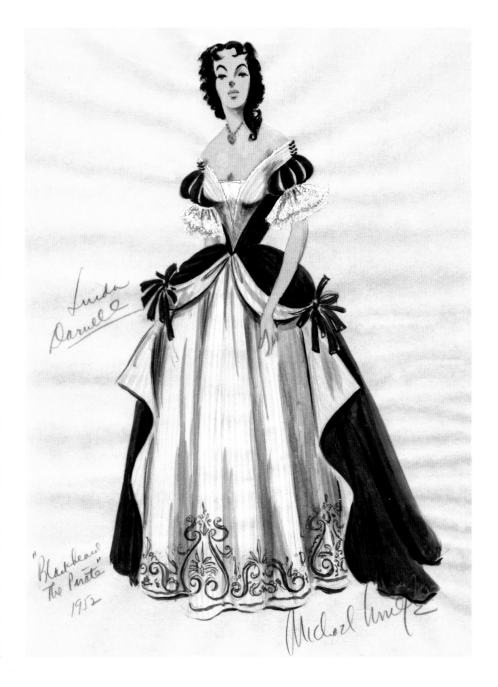

During preproduction, von Sternberg instructed Woulfe not to design any low-cut dresses for Russell, so Woulfe designed a series of elegant dresses that tastefully covered Russell's bustline. Howard Hughes saw the tests and was horrified. He could not see Russell's cleavage. He then had Woulfe redesign all the dresses, except for a chainmail dress. Despite its high neckline, Hughes liked it. The dress proved to be a bit of a mechanical miracle. The interlinking metal pieces were cut with tinsmith's shears and clamped together, and an inner belt helped distribute the hefty twenty-one pounds of links around Russell's hips.

"The clothes couldn't be terribly, what I would call, 'chic,'" Russell said of her costumes. "Michael could design beautiful things," she said, but "they always had to have the 'movie star'

image." Hughes's obsession with Russell's costumes was almost pathological. Hughes "drove us absolutely crazy," the actress said. But it was Woulfe who mediated between the two. Sometimes Hughes would call Woulfe at three in the morning to discuss Russell's dresses. "Now there are seven beads from below the bust up to the top of the bust," Hughes said on one occasion. "I think there should be six." He was *that* particular. "Then poor Michael would have to come and tell me," Russell said. "And then I would disagree, and I'd argue and holler and yell, and Michael would have go back and tell Mr. Hughes 'yes' or 'no' or what. So the argument went on. I hate to be any issue, but it was fun from where I was." *Fun?* Maybe not. Years later, Woulfe would recall Russell struggled with being true to herself while complying with Hughes's wishes. "She definitely separates Jane Russell private with the Jane Russell that is presented on the screen," Woulfe said. "She says, 'If that's what he wants, that's what he gets,' but she didn't like it."

After critics panned *Macao*, Hughes wanted to make a big splash with Russell in the musical comedy *The French Line* (1954). "Howard got the idea, since I had done *Gentlemen Prefer Blondes* (1953), he wanted to do a musical and have it outdo that," Russell said. "So he was going to have me in a bikini, and nobody wore bikinis in those days but the naughty girls in the south of France. It was just unheard of." Russell flatly refused to wear one, especially since the scene required her to do a dance number. "Even the camera guys (were saying), 'Oh, no, no, not that,'" Russell said. "So I just left and I went to the beach, and I said, 'I'm going to stay here until you come up with a one-piece bathing suit.'"

Woulfe was stuck in the middle again. His solution was a skimpy dance leotard with three large teardrop cutouts centering on Russell's navel, without actually revealing it. The cutouts were lined with nude-colored soufflé fabric. The costume's overall effect ignited the titillating thrill Hughes was hoping for while giving

ABOVE AND OPPOSITE: A design for Linda Darnell in *Blackbeard, The Pirate* (1952).

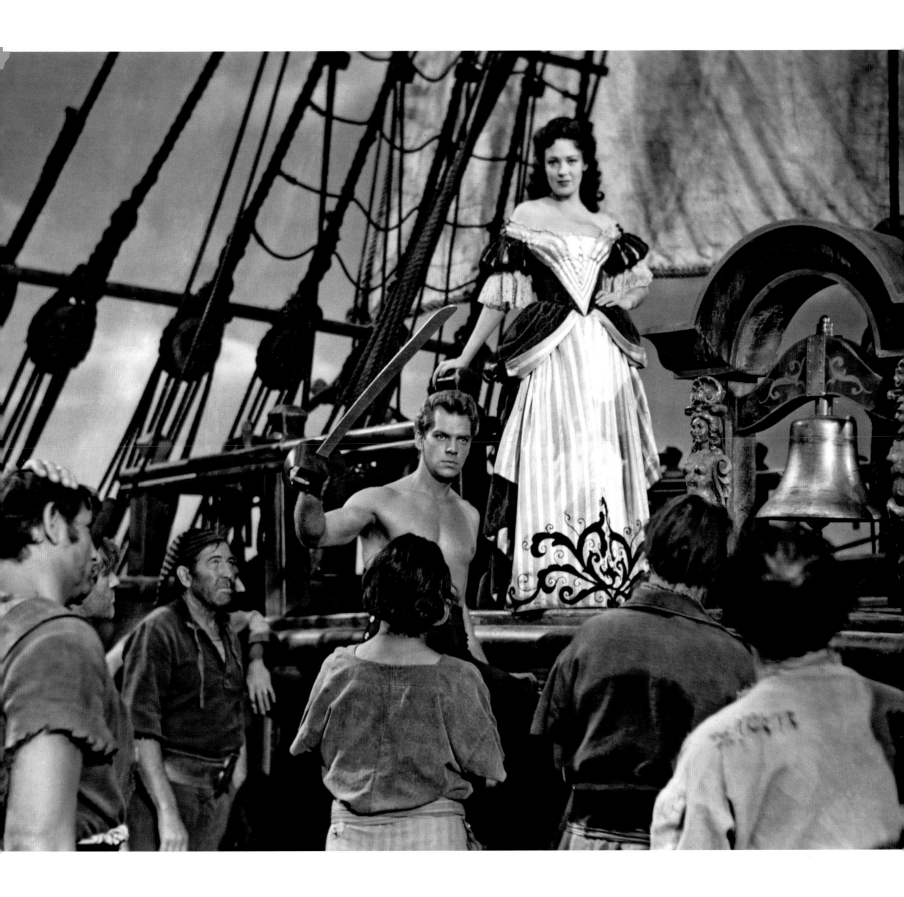

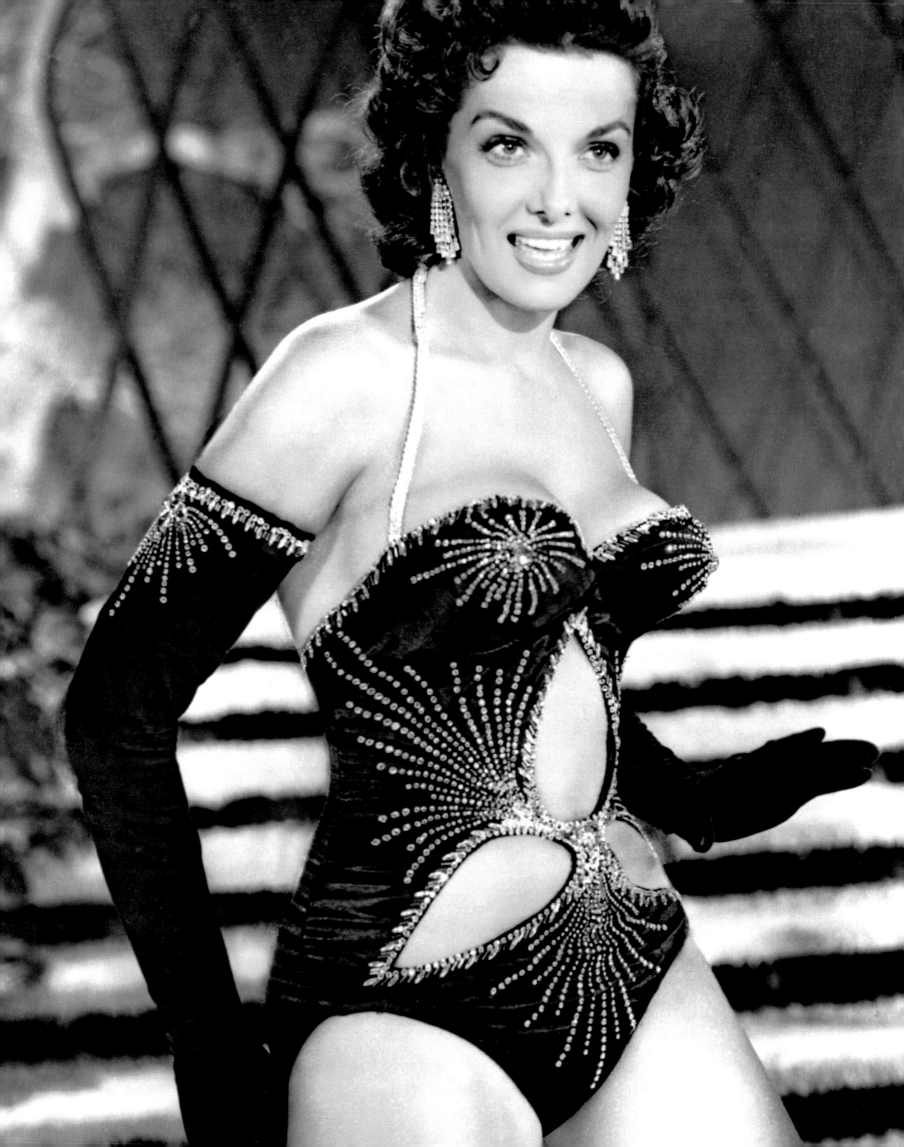

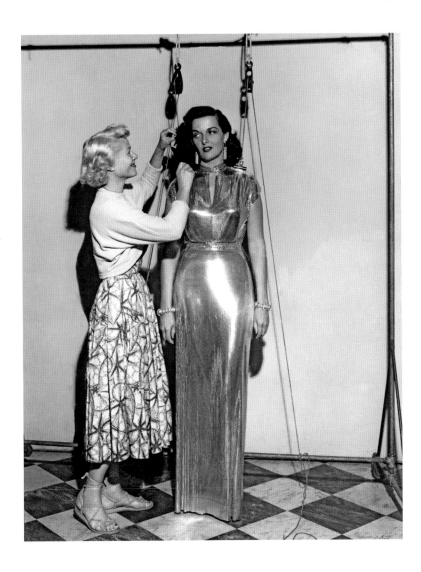

giving Russell the one-piece costume she demanded. Hughes shot *The French Line* in 3-D, then marketed the film with the tagline, "See Jane Russell in 'The French Line'—she'll knock BOTH your eyes out!" Censors across Middle America were outraged.

"You see a hundred-percent more skin at the beach every day of the week," Woulfe later said of the design. "But at that time, it was condemned by the Catholic Church and the Legion of Decency." Actual censorship varied from state to state. Censors in Kansas City noted, "Dance is obscene as it emphasizes lewd and indecent movements tending to stimulate impure sexual desire and lascivious thoughts." The dance sequence, along with Woulfe's costume, was deleted because of "obscene movements of body of the dancer. Her bathykolpian posing in a brief revealing costume accompanying lust-provoking words of her song all deliberately sexually suggestive."

Woulfe began designing for television in the 1950s, but his RKO contract prohibited him from claiming credit. His original designs for Marie Wilson, made when *My Friend Irma* (1952–54) transitioned from radio to the small screen, suffered subsequent alterations for the same reason his *Macao* designs had years before,

to show more flesh. Without Woulfe's knowledge, Wilson had a dressmaker cut down the necklines of the finished costumes. She still praised Woulfe in the press. "He made me sexy, but not censorable on television," Wilson said.

When Hughes sold RKO in 1955, he put Woulfe under contract to Hughes Productions. Woulfe continued to create personal wardrobes for Garland, Russell, and Jean Simmons. He designed the employee uniforms for four Las Vegas hotels and casinos owned by Hughes, as well as the costumes for the Las Vegas nightclub acts of Debbie Reynolds, Lena Horne, Betty Hutton, and Joey Heatherton. Working into the 1970s, Woulfe retired in West Hollywood, then later moved to the Motion Picture & Television Country House and Hospital in Woodland Hills, California, where he died at age eighty-nine, on August 30, 2007.

OPPOSITE: Jane Russell in *The French Line* (1954).

ABOVE: Jane Russell's mesh dress for *Macao* (1952) weighed twenty-one pounds and was suspended between takes to relieve Russell's shoulders.

HOWARD SHOUP AND
SASCHA BRASTOFF

Howard Shoup's studio biography stated that his interest in costume design began when Stanley Marcus of Neiman Marcus made a life-altering comment to him while he was studying to be a painter: "Clothes are a living art. Creating beautiful styles for beautiful women is an artistic expression well worth considering."

But Shoup would say later that he never *became* a designer, he was *born* one. That day was August 29, 1903, when Conway Howard Shoup was born in Dallas, Texas, to Frank E. Shoup, a professor and founder of the St. Matthew's School for Boys, and the former Mary Howard.

While not literally born a designer, Shoup exhibited an interest in little girls' clothes by age seven. In 1910, Shoup and his brother, Francis, went to visit his great aunt, Sarah Barnwell Elliott, a well-known writer who lived in Tennessee. "Howard too is making his mark," Elliott wrote to Shoup's mother. "The baseball team begged me to let him go away with them as their mascot. He knows them all, and goes with them to call on the young ladies. When he comes home, he can tell exactly what each girl had on and if her dress fit, or if the other colors suited each other and him."

Clearly Shoup was no typical seven-year-old. His father, Frank, was less than comfortable with his son's "artistic" leanings. And Aunt Sarah knew it. "Tell him that he is behind the times," she wrote to Howard's mother. "If he tries to warp or deflect that child's gifts, I'll never forgive him. In all life there is nothing so cruel as to put Pegasus to the plough, and it must not be done." So fierce was Aunt Sarah's protective stance, she actually threatened her niece's husband. "Tell him that if he does not allow Howard to develop along his natural lines, I shall take Howard away from him. The love of the beautiful, the artistic sense, is wonderfully visible in the child, and to twist it or quench it would be brutal cruelty."

Shoup graduated from Bryan High School in Dallas and studied art at the University of the South in Sewanee. He left college after two years and opened a dress shop directly across from Neiman Marcus in Dallas. Shoup believed that he needed to go to New York to make any sort of name for himself, and another

aunt paid for his tuition to Pratt Institute in Brooklyn, where he studied stage design and costume. Shoup struggled to find work in the fashion industry, and his parents sent him money to help make ends meet.

At twenty-one, Shoup found his first job with Hattie Carnegie, then one of the top designers in the country. Five years later, he moved to designing for Bonwit-Teller. In 1936, Hollywood agent Minna Wallis met Shoup at a party in New York, where she counted three Shoup gowns on the backs of other guests. Wallis suggested Shoup contact her when he vacationed in Los Angeles. He did, and within a few days, Wallis had him working at Warner Bros. designing for a Ruby Keeler film, *Ready, Willing and Able* (1937), among others.

In 1942, Shoup enlisted in the U.S. Army. He was stationed in Miami Beach, where he met Sascha Brastoff, a gay soldier who did not hesitate to put on a dress to get a laugh. Shoup performed in shows with Brastoff. "Sascha was a trained dancer and a natural comic," said Steve Conti, author of *Collector's Encyclopedia of Sascha Brastoff*. "He was overt enough to be known as gay, but not threatening, because the Army was just kicking people out left and right." While GIs were waiting for orders to deploy, Brastoff and Shoup put on these "rinky dink drag shows, men with mop heads on, that sort of thing," Conti said. "For one particular show, expecting it to be one time only, Sascha came up with a Carmen Miranda outfit, made up of pans and spoons, and things that were familiar to Army men. The headdress was made of a canteen and forks. He called himself 'The G.I. Carmen Miranda.'" Pulitzer Prize–winning playwright Moss Hart caught the act. He was in the process of writing *Winged Victory*, a show about recruits struggling through training. He wrote an entire scene at the end

of the play for Brastoff, which allowed Brastoff to leave active duty to act in *Winged Victory*, according to Conti. The production traveled all over the United States and raised $2 million for the Army Emergency Relief Fund.

When the tour was over, Shoup returned to Hollywood, where he resumed his design career, beginning with MGM's *Presenting Lily Mars* (1943). Brastoff reported to 20th Century-Fox, along with the rest of the cast of *Winged Victory*, to make the film version of the hit play. During filming, studio chief Darryl F. Zanuck purportedly saw Brastoff doodling in between scenes and invited him to design costumes for Betty Grable's "Acapulco" number in Billy Rose's *Diamond Horseshoe* (1945). "They gave Sascha *carte blanche*," says Conti. "His headdresses on the costumes were so elaborate that they actually had to raise the

top of the set to accommodate them because the women kept knocking the headdresses off. It cost them time and money, but they loved the effect."

Following *Winged Victory* (1944), Fox signed Brastoff to design for Carmen Miranda in *If I'm Lucky* (1946), owing to his GI Carmen Miranda routine during the war. Miranda had fun with the joke. "Soshint Braystuff," she said, butchering Brastoff's name, "who isss phony me. He is more like Miranda than I am!" Not only did Brastoff design the film for Miranda, but she asked him to do her personal wardrobe. They became friends and remained so until Miranda's death in 1955.

ABOVE: (l-r) Virginia Mayo, Moss Mabry, Sara Montiel, and Howard Shoup attend a Hollywood premiere in the 1950s.

Shoup and Brastoff remained lifelong friends and lived together later in life. In 1950, Shoup returned to Warner Bros. and did some of his most memorable film work there, including *A Summer Place* (1959), *Rome Adventure* (1962) with Suzanne Pleshette, and *Cool Hand Luke* (1967). Shoup and his colleagues petitioned the Academy to establish a costume design category in 1948, and he was the Founding President of the Costume Designers Guild in 1953.

Brastoff's friend, Filomena Bruno, met Shoup on a visit to Los Angeles, and they became instant friends. He hired her as a cutter/fitter at Warner Bros. and at his private design business. When Shoup encountered cashflow crunches, he asked Bruno to make collection calls regarding his outstanding accounts. That proved to be a bad idea. "Howard was contributing designs for the *Judy Garland Show* (1963–1964) on CBS," Conti said. Garland called the office about some outfits that Shoup was making for

her and Bruno took the call. "Oh, Miss Garland," Bruno said. "I was going to call you. We're sending out a late notice about some work that Howard had done for you." Garland came unglued. "*Nobody* sends Judy Garland a late notice!" she yelled at the stunned Bruno.

In 1953, Brastoff opened a business making high-end dinnerware, housed in a block-long showroom designed by A. Quincy Jones and Frederick Emmons and financed by Winthrop Rockefeller. Brastoff eventually expanded his lines to include lamps, ashtrays, lighters, and decorative objects. Brastoff had negotiated with Rockefeller to receive a salary instead of a cut of the profits. By 1961, Brastoff's boyfriend, Donald Sandow, urged Brastoff to demand a share of the profits, because Brastoff's name branded the business. Rockefeller agreed. Brastoff ceased to be an employee and became Rockefeller's partner instead. Six months later, expecting to receive his first partnership draw,

Brastoff instead received a long list of bills to pay. The business had never made money, and Rockefeller had been subsidizing operations. Shocked and humiliated, Brastoff had a breakdown and left the business. The company continued to operate, using older Brastoff designs and those of other artists who were brought in.

Eight years later, in 1969, Shoup and Brastoff opened up Esplanade, remodeling a dilapidated hotel on the border of Brentwood and Santa Monica. Shoup had his couture shop there and Sascha exhibited jewelry and sculpture. Shoup's clients included Debbie Reynolds, Peggy Lee, Joan Fontaine, and Natalie Wood, for whom he designed wedding dresses for her two marriages to Robert Wagner.

Shoup died in Los Angeles on May 29, 1987. During his film career, he designed for nearly 170 films and received five Academy Award nominations, though he never brought home the Oscar.

Shoup's death was difficult for Brastoff, and he designed less following the loss. In 1989, Brastoff was attacked outside of his home by an assailant under the influence of drugs. After the attack, Brastoff lost the will to draw, something he had always done for pleasure throughout his life. He died February 4, 1993, in Los Angeles, after a battle with prostate cancer.

OPPOSITE, LEFT TO RIGHT: Sascha Brastoff in *Winged Victory* (1944). · Judy Garland in *Presenting Lily Mars* (1943). Costume design by Howard Shoup.

ABOVE, LEFT TO RIGHT: In August 1956, Howard Shoup and actress Diana Dors were pushed into a pool by overzealous photographers during a Hollywood launch party. · A Howard Shoup costume sketch for Ann Blyth in *The Helen Morgan Story* (1957).

ELOIS JENSSEN

For a designer trained in the couture houses of Europe, Elois Jenssen had a surprisingly irreverent attitude toward fashion.

Although her costumes for Hedy Lamarr were as elegant as any Dior or Chanel creation, Jenssen believed that an actress should dress as she pleased offscreen, no matter how tasteless or over-the-top. "If she wants to wear beaded dresses and marabou and ostrich feathers, let her," the Academy Award–winning designer once said. "It's going to make her a lot happier than the latest creation and will get her the attention she wants. I don't know who started all this business about a star being well dressed anyhow."

Jenssen certainly knew about movie stars. She grew up among the privileged elite of Bel Air and Beverly Hills. She was born Elois Wilhelmina Jenssen at the start of the Roaring Twenties. Her father, Gunnar Darre Jenssen, a Norwegian immigrant, initially formed an engineering consulting firm with his brother in New York City. There he married Jenssen's mother, Elois Frances Collard, on December 24, 1919, before heading west. In the early 1920s, the Jenssens spent considerable time in the San Francisco Bay area, their base for several voyages to Asia, where Gunnar secured resources for his ink recovery and paper mill manufacturing business. Elois was born in Palo Alto on November 5, 1922.

By the mid-1920s, the Jenssens moved permanently to California, first residing in Oceanside. By 1930, the Jenssens moved to Los Angeles, living in a beautiful Mediterranean-style home in Beachwood Canyon and later moving to Holmby Hills. The Jenssens enrolled their future designer daughter in the Westlake School for Girls, a prestigious private institution in Holmby Hills.

At the age of thirteen, Jenssen enrolled in the New York School of Fine and Applied Arts (now Parsons The New School for Design). Her parents moved with her to Europe to enable Jenssen to study at the school's Paris atelier. The outbreak of World War II cut her studies short, but her time spent in Paris was invaluable, as visits to the great couture houses were part of the curriculum. Upon returning to Los Angeles, Jenssen completed a four-year course in design at the Chouinard Art Institute (now California Institute of the Arts). Years later, Jenssen would teach motion picture and television design at her alma mater.

Upon graduating in 1943, Jenssen presented herself to Hunt Stromberg, who had just left MGM to start his own production company. Natalie Visart had just signed with Stromberg and needed a sketch artist and assistant. Jenssen worked with Visart for three years. During Visart's tenure, Jenssen's sketches for *The Strange Woman* (1946) especially pleased star Hedy Lamarr. After Visart's departure, Lamarr asked Jenssen to design her clothes for the next Stromberg production, *Dishonored Lady* (1947).

After Stromberg closed his production company, Lamarr continued to require producers to hire Jenssen as a freelance artist. In *Let's Live a Little* (1948), Lamarr played a psychiatrist and author who falls in love with one of her patients. Arrayed in Jenssen's creations, Lamarr looked stunning, a fact even critics panning the film had to concede. At the end of 1948, five designers began work on the mammoth task of creating costumes for the Cecil B. DeMille's religious epic *Samson and Delilah* (1949). They included Edith Head, Dorothy Jeakins, Gile Steele, Gwen Wakeling, and, at the insistence of Lamarr, Jenssen.

Head was not particularly friendly toward Jenssen during production. She did not want the less-experienced Jenssen to do much of anything. Which costumes Jenssen actually designed is not certain. Some sources credit her with Lamarr's stunning peacock robe, famously decorated with feathers from DeMille's own flock on his ranch in Tujunga. Others claim that Head designed the flowing frock after researchers told her that ancient Minoans may have actually used peacock feathers in their designs. What is certain: all five designers shared the 1950 Academy Award for best color costume design. In later years, Jenssen lived near Head and frequently dropped in, though not always when Head wanted to see her. Head was not much of a drinker, but Jenssen, who developed a habit of calming her jitters with a cocktail before meetings with producers, was known to

OPPOSITE: Lucille Ball modeling an Elois Jenssen gown in "The Charm School" (1954) episode of *I Love Lucy*.

than designing for movies. "Nobody in television is telling us that we have to dress stars like every other woman," she said. Clearly television producers seemed less concerned about realism in wardrobe design, as evidenced by Jenssen's designs for Lucille Ball in *I Love Lucy*. Though playing an "ordinary" housewife, Ball's wardrobe had flair and sophistication, but still seemed appropriate for a middle-class homemaker. Though Jenssen could not design the elaborate gowns she had done in the movies, she said, "Still, all and all, we're getting a lot of zip and dash into their clothes. If I tried it in a movie, I'd have some producer yelling to keep it looking like a $5.98 dress and asking what was I trying to do—make the heroine look like a kept woman?"

During the next two decades, Jenssen designed for Ann Sothern in *Private Secretary* (1953–57), Lucille Ball in *I Love Lucy* (1951–57), Julie Newmar in *My Living Doll* (1964–65), and Evelyn Keyes in *Bracken's World* (1969). Jenssen largely retired by 1970, though she was only in her fifties. Drinking cocktails to cope with her nerves before job interviews no longer seemed to be working for her. She had increasing difficulty finding work notwithstanding her impressive portfolio. Jenssen came out of this quasi-retirement a few times in the 1980s. She received a special wardrobe credit for the Jack Palance-Martin Landau horror flick *Without Warning* (1980). In 1983, she was nominated for an Oscar for her work on the futuristic sci-fi film, *Tron* (1982). Her last project was an episode of *Designing Women* in 1986.

As she approached her eighties, Jenssen left her home and the neighborhood where she had once lived next to Rock Hudson and moved to the Motion Picture & Television Country House and Hospital in Woodland Hills, California. After suffering a series of strokes, she died in her sleep on February 14, 2004. She was eighty-one.

raid Head's bar during the day. During Head's terminal illness in 1981, Jenssen frequently took the ailing designer to the hospital for her blood transfusions.

The 1950s brought significant changes to Jenssen personally and professionally. On April 2, 1952, she married Thomas Jefferson Andre, an assistant director seventeen years her senior. Though their marriage was at first stormy enough to warrant mentions in gossip columns, the two stayed married until his death in 1983. Jenssen never had children, but was a stepmother to Andre's son from his first marriage.

With the advent of television, Jenssen left the movie wardrobe department. "The clotheshorse is returning and she's going to be on television," Jenssen said in a 1953 interview. Surprisingly, in some ways, Jenssen found designing for television less mundane

ABOVE: An Elois Jenssen sketch for Patricia Neal in *Diplomatic Courier* (1952).

OPPOSITE: Lucille Ball (left) and Elois Jenssen look over sketches for *I Love Lucy*.

CECIL BEATON

Cecil Beaton won awards for dressing both Hepburns.

He received the Tony for his costumes for Katharine Hepburn in Alan Jay Lerner's 1969 Broadway production of *Coco*, a musical based on the life of Coco Chanel. He won the Oscar for dressing Audrey Hepburn in *My Fair Lady* (1964).

Though undeniably talented, Beaton defined English snobbery. And he did so almost from birth. He was born Cecil Walter Hardy Beaton on January 14, 1904, to Ernest and Etty Sissons Beatty in the über-affluent Hampstead neighborhood of London, England. Though his family was upper middle class, Beaton longed for a more glamorous existence for himself and his siblings, Nancy, Barbara, and Reginald. As a young boy, he sent photographs of his sisters to the editors of London society columns. He was thrilled when they were published, not only because it pleased him as the photographer, but because it helped establish his family more firmly among society. His interest in theater purportedly started when he was four. Beaton's father took him to see theater legend Lily Elsie in a stage production of *The Merry Widow* (1908). The impression of Elsie performing in her Lucile gown obsessed him for life. At ten, Beaton constructed a miniature theater from his aunt's hat box. He cut out pictures of performers from *Play Pictorial* magazine to act on his makeshift stage, and voiced all the parts himself.

Beaton studied at Harrow and then spent three years at St. Johns College, Cambridge. There, he acted in *The Rose and the Ring* and designed for *Volpone*. He left Cambridge without a degree, and when he exhibited no talent for office work, turned to photography to earn his living. He eventually secured a contract with Conde Nast publications, and worked exclusively for them, photographing film stars and members of society on both sides of the Atlantic. He became the official photographer to the Court of St. James and took photographs of Queen Elizabeth and her family, as well as the wedding portraits of the Duke and Duchess of Windsor.

At thirty, Beaton debuted as a professional theatrical designer. Producer C. B. Cochrane hired him for the 1934 revue *Streamline*. He designed other revues for Cochrane, ballets for Osbert Sitwell, William Walton, and Frederick Ashton, and designed for West End theater productions. In 1938, he landed in hot water when he added an anti-Semitic phrase to an illustration he created for *Vogue*. Beaton claimed that he intended the remark as a prank, to go no further than the art department. Though he blamed a cold for his temporary lapse in judgment, Conde Nast was not persuaded and fired him.

In 1941, Beaton began designing costumes for British films. But his big break in film came when Alexander Korda hired him to design costumes for *An Ideal Husband* (1947), starring Paulette Goddard. *Anna Karenina* (1948) with Vivien Leigh followed.

Beaton did not design another major film until *Gigi* (1958) with Leslie Caron. Beaton sketched designs for two months at his country estate, Reddish House. He drew on early magazines *Les Modes*, *Femina*, *Le Theatre*, and *Cahiers d' Art* for inspiration. The principal costumes were made in Paris by Madame Karinska, and Beaton oversaw the making of the rest of the costumes at MGM. Hermione Gingold took exception with a black wool dress that Beaton had pulled for her to wear from the stock at MGM. She felt it looked shabby, "almost like a school mistress uniform," she said. But Beaton believed it perfectly suited her character, a conservative woman of economy. Director Vincente Minnelli backed his decision. "Leslie Caron is an example of a sensitive girl who, as a dancer, paid not too much attention to clothes," Beaton said of the film's star. "Now she has developed chic taste. As she has matured, her face has assumed a beauty it lacked years ago." Beaton won an Academy Award for his *Gigi* wardrobe.

Beaton designed the costumes for the 1956 Broadway and 1958 London stage productions of Alan Jay Lerner and Frederick Loewe's *My Fair Lady*. In 1962, when Beaton was signed by Jack Warner to do the costumes for the film, his designs were well reviewed. Fashion editors waxed on about Beaton's romantic vision of the past. "It's in the clothes that the romantic message is most significantly transmitted," wrote one. "Most of the 1,086 costumes Cecil Beaton designed for the picture—the exceptions are Eliza Doolittle's flower girl rags—are marvelously extravagant and

OPPOSITE: Cecil Beaton and Audrey Hepburn on the set of *My Fair Lady* (1964).

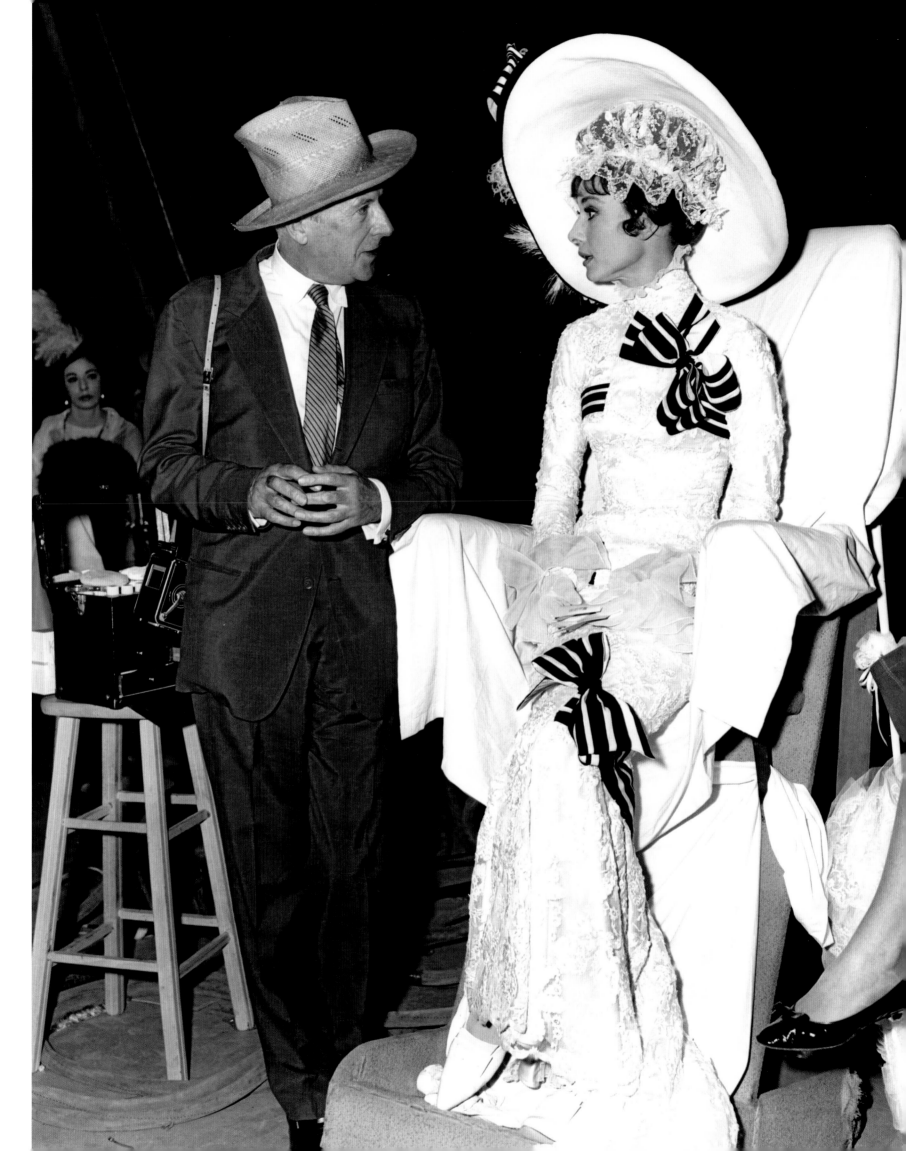

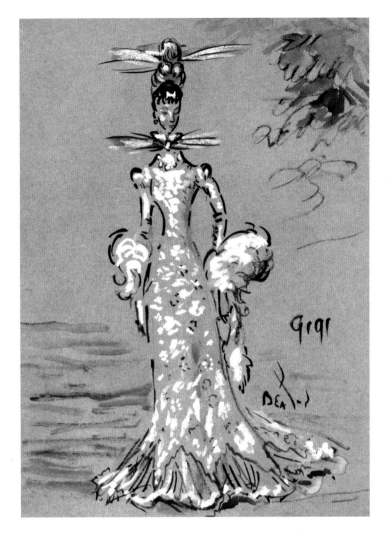

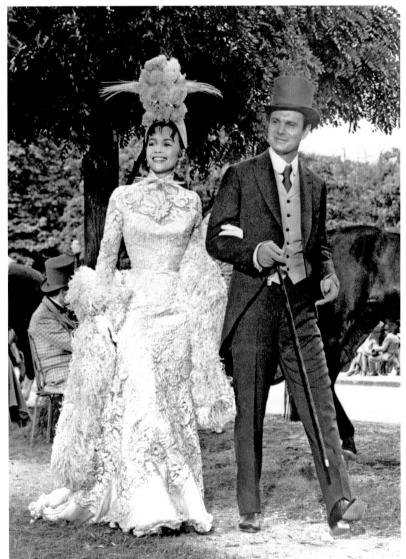

opulent in line, color, and fabric. They recall the heliotrope-scented world of whale-boned corsets, bustles, bows, long white kid gloves, aigrettes, and flirty sunshades. Femininity is rampant." For *My Fair Lady*, Beaton won two Oscars, one for costume design and one for art direction.

Director Vincente Minnelli brought Beaton back to Hollywood to design for Barbra Streisand in *On a Clear Day You Can See Forever* (1970), with Arnold Scaasi, the film version of Alan J. Lerner's Broadway musical. Beaton was appalled when entire scenes featuring his elaborate and expensive costumes wound up on the cutting-room floor.

During his life, Beaton had relationships with both men and women, including the fencer Kinmont Hoitsma and Adele Astaire, sister of Fred Astaire. He was knighted in 1972 by Queen Elizabeth II. Two years later, he suffered a stroke that paralyzed his right side. Beaton turned to writing and editing his diaries for publication, and arranged sales of his photographs at Sotheby's. He died of a heart attack on January 18, 1980, in England.

ABOVE, CLOCKWISE FROM TOP LEFT: Design for Leslie Caron in *Gigi* (1958). · A Cecil Beaton set design for *Gigi*. · Design for Leslie Caron and Louis Jourdan in *Gigi*.

OPPOSITE: Barbra Streisand in *On a Clear Day You Can See Forever* (1970).

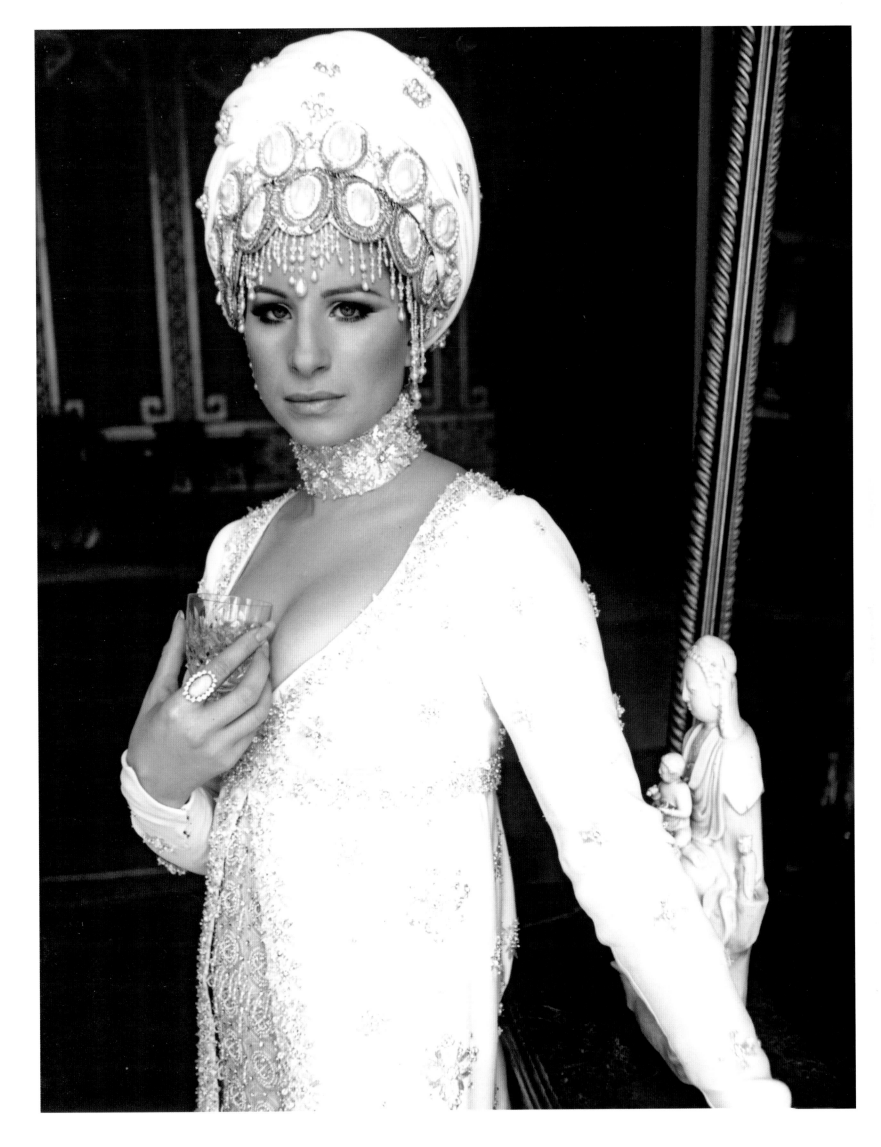

ADRIAN

While most parents would be thrilled if their preschooler demonstrated exceptional artistic skills, Gilbert and Helena Pollack Greenberg were frightened by their three-year-old son's first drawings.

"They were weird, imaginative things that terrified my mother," designer Adrian said years later. By age five, he was illustrating the works of Edgar Allan Poe, which did nothing to assuage his parents' concerns. Perhaps if they had known that thirty years later Adrian would design the wardrobe for Hollywood's adaptation of L. Frank Baum's beloved children's classic, *The Wonderful Wizard of Oz*, the Greenbergs might not have given their son's passing obsession with the macabre a second thought.

He was born Adrian Adolph Greenberg on March 3, 1903, in Naugatuck, Connecticut, to parents who dreamed of having a son attend Yale Law School. Nonetheless, when Adrian's artistic gifts began to emerge, Gilbert and Helena encouraged his penchant for drawing. Both had been interested in art themselves. Helena had been a painter before joining her family's millinery business. Gilbert had been a graphic artist before taking over his in-laws' shop upon marrying Helena in 1895. Growing up around his parents' hat shop gave Adrian a keen awareness of fashion and of the manufacturing process. He often glued together scraps in the shop to create miniature hats for imaginary patrons.

Helena's first attempt to provide formal art training for Adrian failed. For his first lesson, an elderly art instructor asked the seven-year-old to draw two stuffed sparrows. Seeing absolutely no point in copying lifeless forms, Adrian grabbed his hat and coat and left. Perhaps because their son obsessed on movement, or maybe because his older sister, Beatrice, became a dance instructor, the Greenbergs believed that a career in theater might suit Adrian best. At eighteen, Adrian enrolled at the New York School of Fine and Applied Art (now Parsons The New School for Design). Adrian set himself apart by preferring to draw animals rather than people. He loved to go to the zoo and stand in front of the lion cages and draw the great creatures.

At designer Robert Kalloch's recommendation, Florence Cunningham engaged Adrian to design costumes for the Gloucester Playhouse during his first summer vacation from school. Recognizing Adrian's potential as a theatrical costume designer, Cunningham encouraged him to assume his father's first name and call himself Gilbert Adrian. The following term, Adrian transferred to the school's Paris campus at Place des Vosges. Although his stay in Paris was brief—just four months—the art scene there had a profound effect on him, with Erté and Leon Bakst's designs for the *Ballet Russe* being his greatest influences.

For the annual *bal masqué* at the Paris Opera House, Adrian styled himself as an *art moderne* Scheherazade. His design for a fellow student, a beautiful young woman, won the evening's grand prize. While the two were dancing, Irving Berlin cut in and praised the young woman's costume. When she told Adrian of Berlin's praise, he left her mid-gavotte to seek out the composer. Berlin hired Adrian to design costumes for his upcoming *Music Box Revue* (1923) in New York. Charles Le Maire, Berlin's regular designer, found Adrian's costumes impractical for the stage and only included a few of them in the revue. Adrian never forgot the slight. When Le Maire arrived in Hollywood to work at 20th Century-Fox years later, Adrian, who was already working at MGM, gave him a chilly reception on the Hollywood social scene. Notwithstanding Le Maire's sparse use of Adrian's designs, *Music Box Revue* led to additional projects for Adrian, including John Murray Anderson's *Greenwich Village Follies* and George White's *Scandals*.

In 1924, Adrian came to Natacha Rambova's attention when she saw sketches he had left on the reception table of a costume house. At the time, Rambova and her husband, Rudolph Valentino, were readying their production of *The Hooded Falcon* (unmade), which Rambova had written and was producing. Rambova invited Adrian to join the pair in California. He

OPPOSITE: Joan Crawford in *Letty Lynton* (1932).

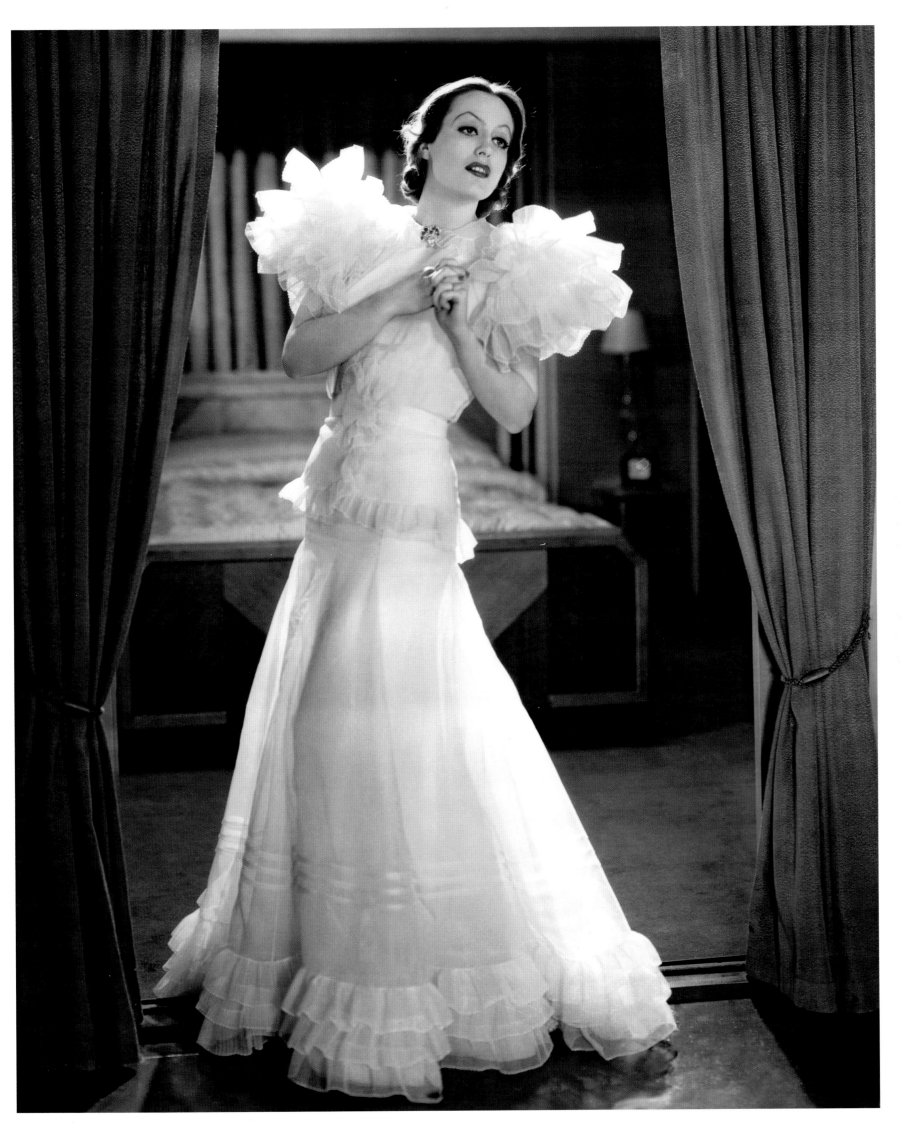

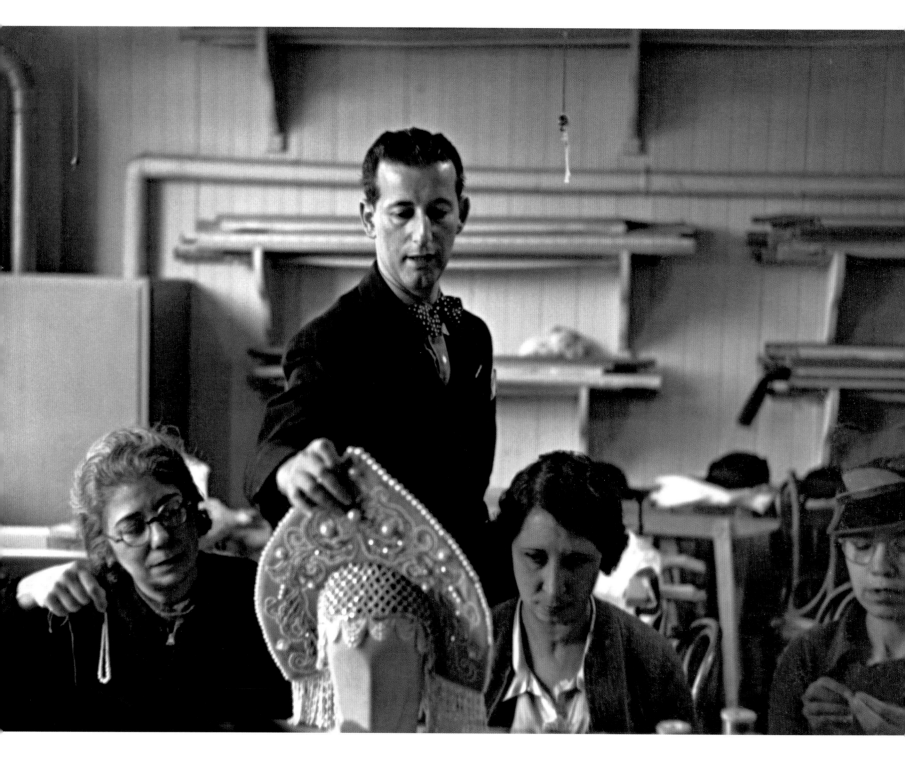

traveled west with their entourage on the Twentieth Century Limited passenger train.

Adrian rented an apartment on Highland Avenue and began work on the costumes for *The Hooded Falcon*. The press referred to Rambova's new discovery as "a youthful Poiret of films" and "the infant costume designer," because Adrian was only twenty-one. As in-fighting and budget overruns plagued *The Hooded Falcon*, Ritz-Carlton Pictures insisted that Valentino make *Cobra* (1925) while the problems with *Falcon* were resolved. *Cobra* gave Adrian his first film credit. After Ritz-Carlton ultimately pulled the plug on *Falcon*, Valentino and Rambova separated. Adrian worked for each on their subsequent productions. For Rambova, he designed

costumes for *What Price Beauty?* (1925), and he dressed Valentino as a Cossack in *The Eagle* (1925). That same year, Adrian also garnered notice when Sid Grauman showcased his designs in a prologue before Charlie Chaplin's *The Gold Rush* (1925) at the Egyptian Theater.

When Cecil B. DeMille's designer, Mitchell Leisen, did not have time to do both costumes and set designs for *The Volga Boatman* (1926), DeMille gave Leisen permission to hire Adrian, whom he had met in New York. Because Adrian still did not know enough about sewing, Leisen supervised the fittings. Adrian's style complemented DeMille's need to make the audience gasp at the sight of his players. "It is my pleasure to do something new if

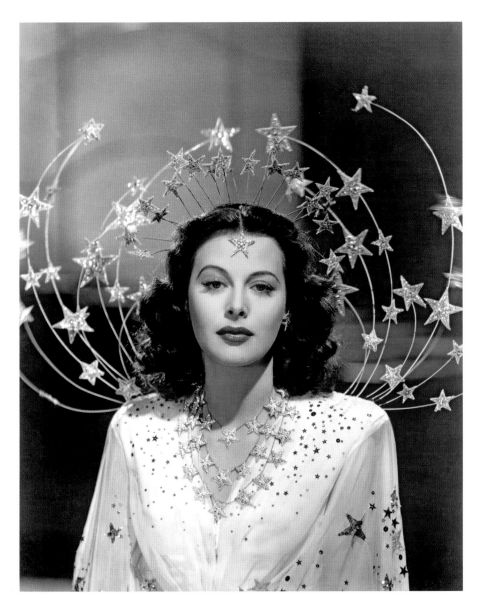

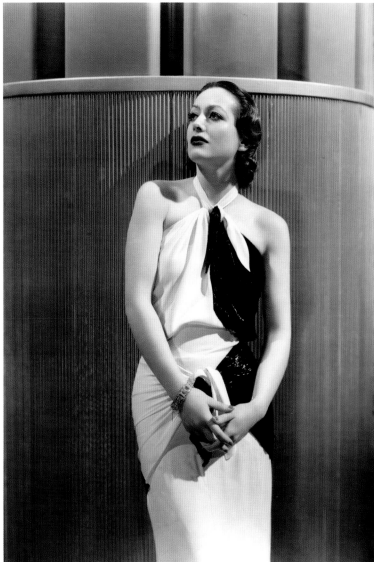

the picture will possibly permit it," Adrian said. "It is far more interesting to create than to advance a style already created." Adrian worked under contract for DeMille Pictures Corporation, designing for stars Leatrice Joy, Phyllis Haver, and working on DeMille's spectacle *The King of Kings* (1927). Adrian followed DeMille to MGM in 1928.

By this time, Adrian's success enabled him to move his parents to Beverly Hills. Aware and proud of his son's prestige, Adrian's father changed his name to Gilbert Adrian, Sr. Sadly, the elder Adrian would not live to see his son's greatest successes, as he died in 1931.

At MGM, Adrian met Greta Garbo, who became the designer's greatest muse. "Greta Garbo is responsible for invention," Adrian once said. "She has a great love of the unusual and startling. What the ordinary woman likes has no appeal for her. Because she is interested only in the purely creative, and is an eccentric in her lively curiosity, she is a fascinating woman to work with. Garbo's reaction to clothes, her individuality in spite of prevailing trends,

appeals to and fires the imagination of American women. Her influence on style has been more far reaching than that of any other actress."

In *A Woman of Affairs* (1928), Adrian began his tradition of emphasizing bad features to camouflage them. Where most designers tried to minimize a star's shortcomings, Adrian's designs overcompensated. Because Garbo's shoulders were broad, Adrian added width to the shoulders on her clothes so that the over breadth became unnoticeable. He covered Garbo's long arms with wide sleeves so the audience noticed the sleeves, not the arms. "I always emphasize the bad features of a woman to the point where they seemingly disappear," Adrian said. "It is foolish for a

OPPOSITE: Gilbert Adrian in the MGM workroom inspecting a headdress for Jeanette MacDonald in *Maytime* (1937).

ABOVE, LEFT TO RIGHT: Hedy Lamarr in *Ziegfeld Girl* (1941). · A Joan Crawford publicity still from *Letty Lynton*.

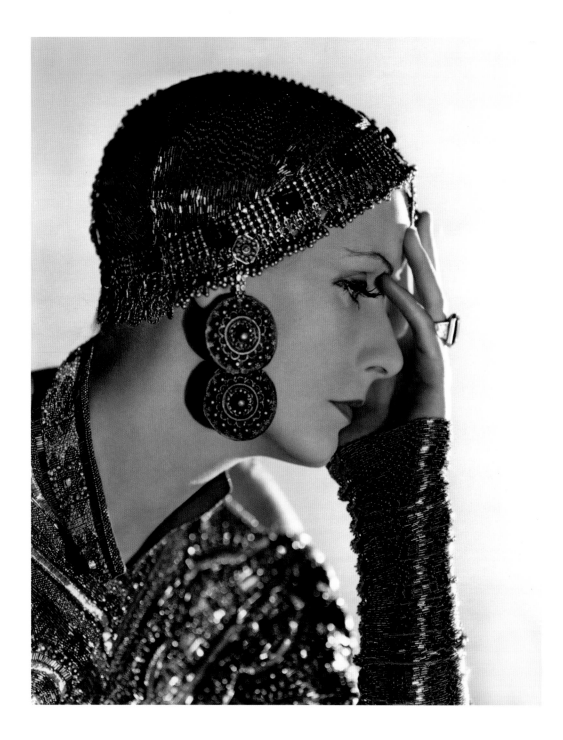

little woman to wear broad-shouldered effects, for it merely calls attention to her narrowness. Show the public your bad points and they won't notice them, particularly if another part of your dress holds their attention."

Adrian's costumes bore no resemblance to the simple, tailored clothes Garbo wore in real life. Her beaded dress in *Mata Hari* (1931) took fifteen seamstresses working for six weeks threading hundreds of crystal beads to complete, at a total cost of $3,000. "The whole thing weighs enough to stagger a strong man in a circus," one movie magazine writer claimed. "Thank heavens these Scandinavians are sturdy."

Adrian dressed Garbo in nineteen films, creating notably exotic costumes for her in some of her most memorable roles,

including *Queen Christina* (1933) and *The Painted Veil* (1934). Adrian's famously bizarre hat for Garbo in *Ninotchka* (1939), based on the actress's own sketch, was one of several eccentric headdresses the former hat model wore in her movies. "Garbo isn't fond of the fashionable hat of the moment," Adrian once said. "Nor is she fond of the fashionable hair dress. As she does not wear her hair in a way that suits the current hats and is very fond of personal-looking ones, they are apt to appear rather unusual to the eyes accustomed to the prevailing mode. The combination of individualistic hat and arrangement often gives

ABOVE: Greta Garbo in *Mata Hari* (1931).

OPPOSITE: Joan Crawford in *Dancing Lady* (1933).

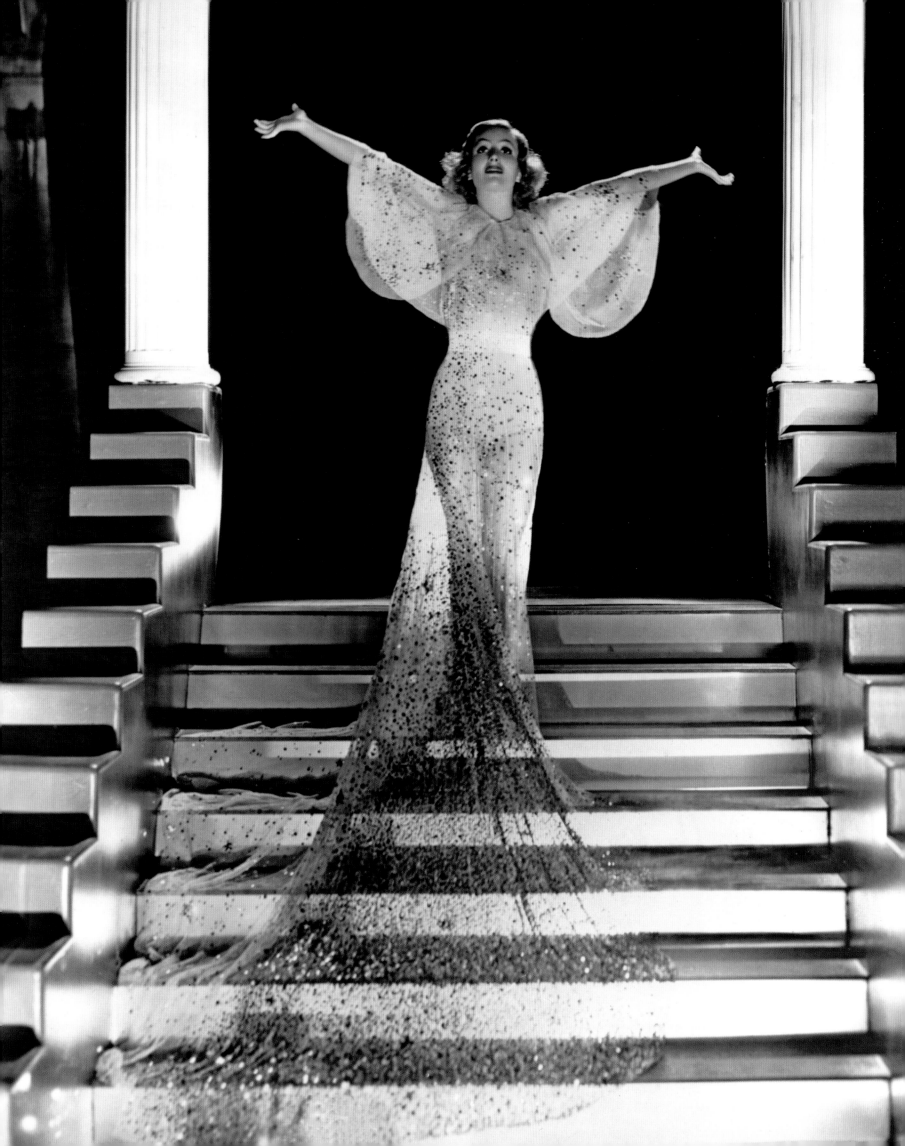

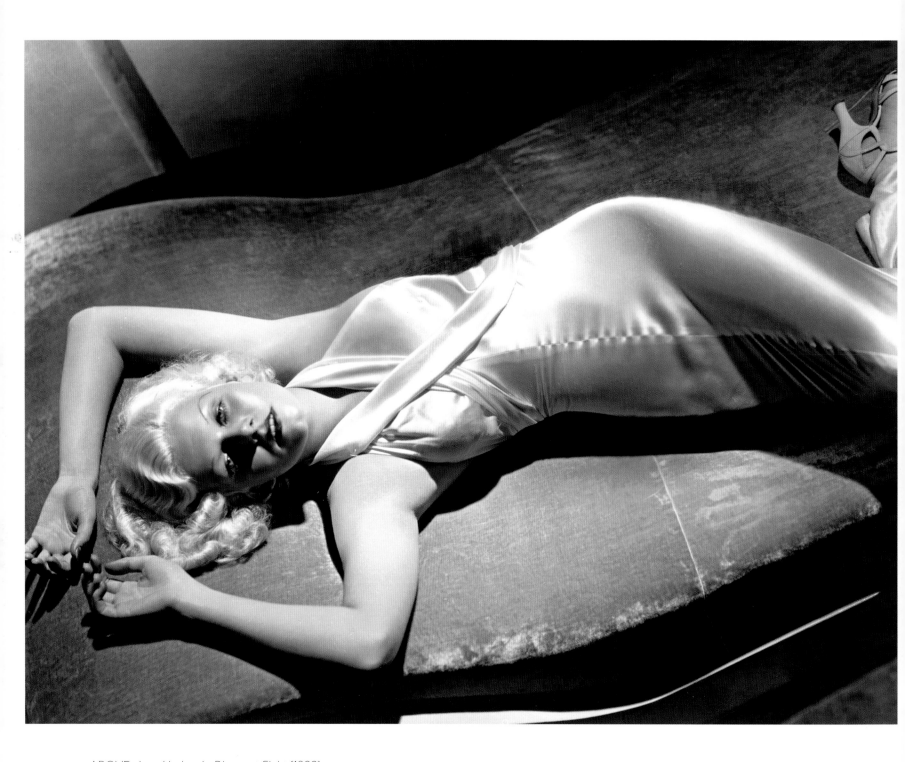

ABOVE: Jean Harlow in *Dinner at Eight* (1933).

OPPOSITE: Norma Shearer in *Riptide* (1934).

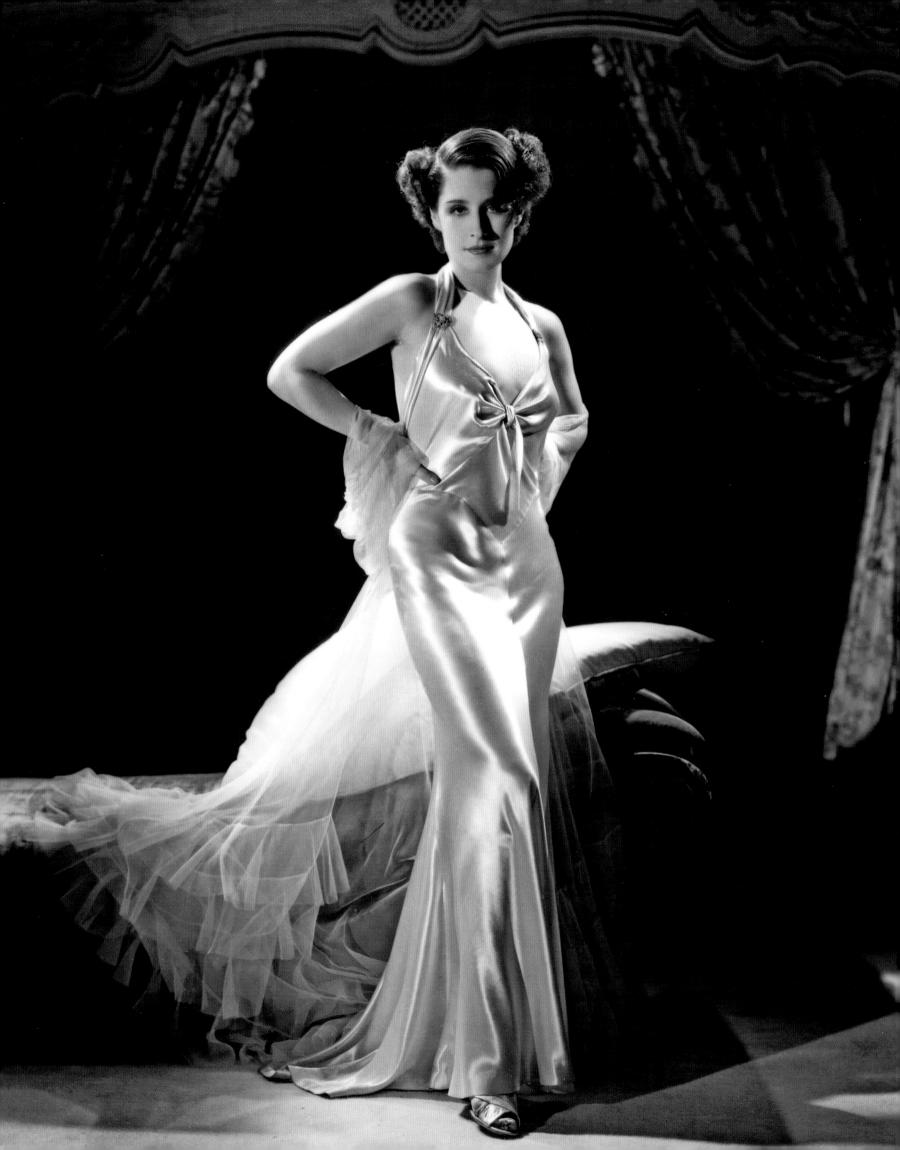

Garbo a rather extraordinary style effect, which in itself, is not really extraordinary."

Over time, Garbo's aversion to the limelight gave rise to the public perception of a reticent recluse. But Adrian remembered her differently. "I remember being particularly amused one day, after having shown her a sketch and taken a great deal of pains to explain why I had designed it for a certain scene—the colors, the materials, and various other reasons for its being used," Adrian remembered. "During all this time she had remained silent but interested. After I thought I had convinced her, she just said, 'Yes.' And then with a look of surprise, she said, 'Garbo talks!' (referencing the advertising campaign for her first talkie, *Anna Christie*, 1930) and laughed gaily."

The same year Adrian met Garbo, he designed his first film for Joan Crawford, *Dream of Love* (1928). He designed an additional thirty-two films for Crawford, and in the process, created the padded-shoulder silhouette that defined the 1940s. As he did with Garbo, Adrian accentuated Crawford's broad shoulders, rather than camouflaged them—only this time out of necessity as well. Crawford insisted on a free range of movement in her clothing. During fittings, she would rotate her shoulders with arms outstretched to ensure the fabric in her costumes could move with her. When Adrian was not designing in jersey or a fabric that stretched, he would let the clothes out across the back. He heavily padded Crawford's shoulders to take up the slack in the fabric. "More than any other designer in show business at that time, his influence on us and fashions in general was most pronounced," designer Irene Sharaff said of Adrian. "The Joan Crawford silhouette, exaggerating the shoulder pad in the '40s, is a case in point."

"She expresses a great deal of freedom in her dress," Adrian said of Crawford in 1933. "Young people copy her because she is youth. She is serious, nervous, terrifically active. She is constantly in motion. When she is in the fitting room, she is always walking around and swinging her arms above her head to be sure she has freedom. I rarely think of her in repose. In visualizing a costume for Joan, I think of something in movement. If I miss that quality, I miss the real Joan."

Adrian's gowns for Crawford in *Letty Lynton* (1932) were copied widely by clothing manufacturers. "The first time I became conscious of the terrific power of the movies was some months after *Letty Lynton* was released," Adrian said. "I came to New York

and found that everyone was talking about the Letty Lynton dress. I had to go into the shops to discover that of all the clothes I had done for Crawford in that film, it was a white organdie dress with big puffed sleeves that made the success. In the studio we thought the dress was amusing but a trifle extreme. The copies of it made the original Letty Lynton look very modest and shy."

Adrian's most spectacular period piece, *Marie Antoinette* (1938), was markedly continental. Starring Norma Shearer, the production required nearly 2,500 costumes and required fifty seamstresses to hand-embroider and sequin the gowns. Adrian visited France and Austria to research the period and literally copied embroidery patterns from paintings of the ill-fated queen. While the style of the eighteenth-century French court inspired Adrian's designs, his costumes were not entirely authentic historically. In particular, he exposed more of Shearer's shoulder and upper arm than the real Marie Antoinette ever revealed at court. Some of the gowns, which were literally wider than Shearer was tall, required rigid supports built in the studio's machine shop.

One of Shearer's last films with Adrian, *The Women* (1939), showcased Adrian at his best. Starring MGM's biggest stars—Shearer, Crawford, and Rosalind Russell—and set against the backdrop of New York society with no men in the cast, *The Women* envisioned a world of nothing but Adrian design. The studio even included a color fashion show sequence in the otherwise black-and-white film. Nonetheless, another film that year, *The Wizard of Oz*, remains Adrian's most enduring legacy. He showed great restraint to bring L. Frank Baum's four main characters—Dorothy, the scarecrow, the tin man, and the cowardly lion—faithfully to the screen. He made one notable exception to the book. Adrian feared the silver slippers would not translate well on-screen, so he changed the sequins to red, thus creating Hollywood's most iconic footwear—Dorothy's ruby slippers. For the munchkins and the citizens of Oz, Adrian was able to add his own touches—wide collars, stovepipe hats with buckles, and gowns of draped jersey. And although Adrian was known for designing costumes to flatter the feminine figure, Garland had to wear a restrictive and uncomfortable corset to flatten her breasts and make her appear younger.

With the outbreak of war costing the loss of movie rentals in Europe, MGM began slashing production costs by 1941. The

OPPOSITE: Gilbert Adrian (center) on the set of *Camille* (1936) with Greta Garbo and George Cukor.

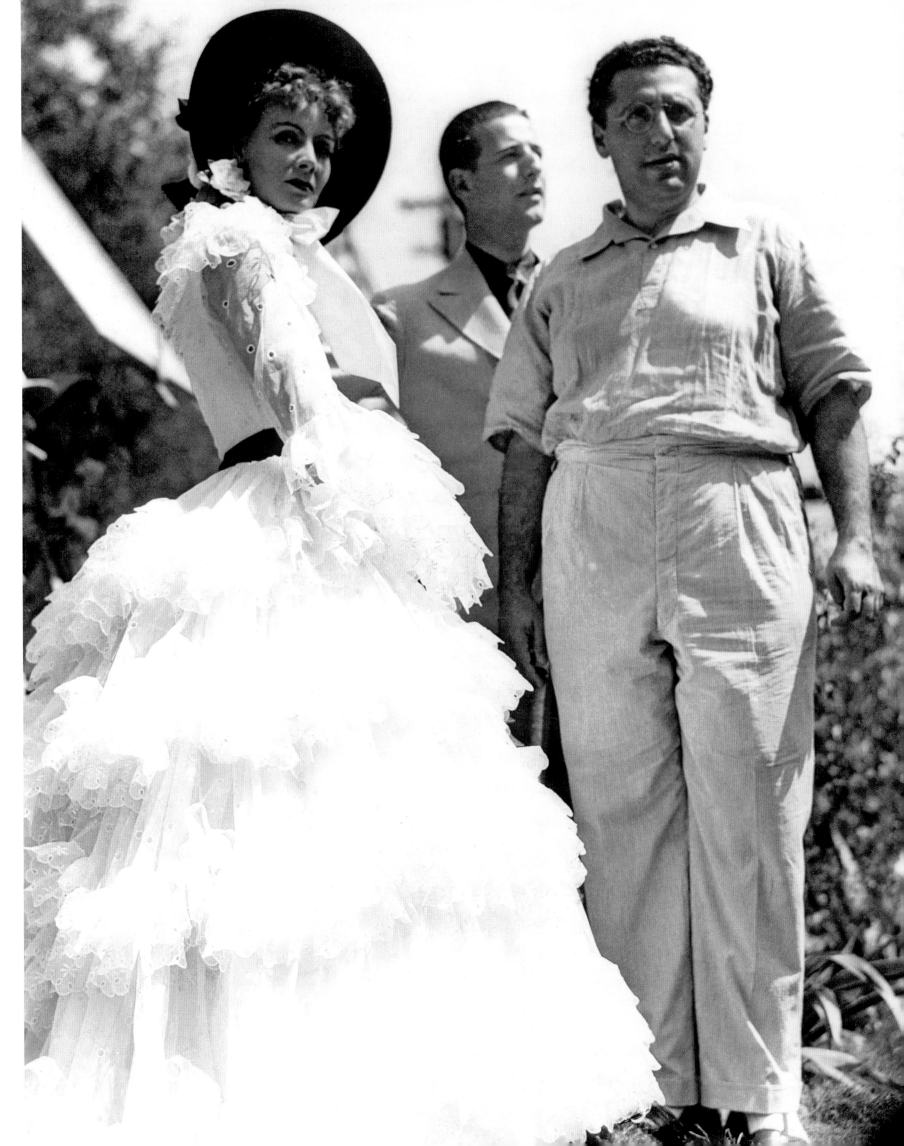

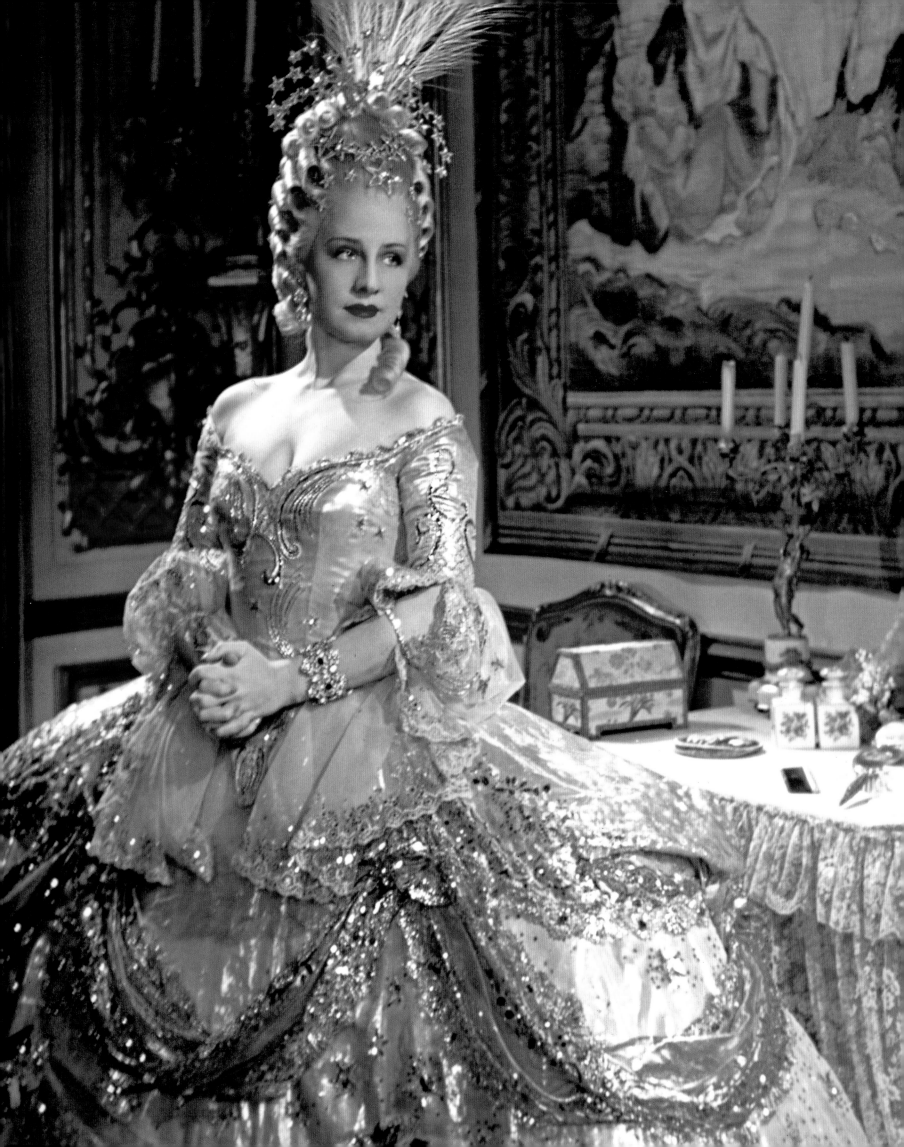

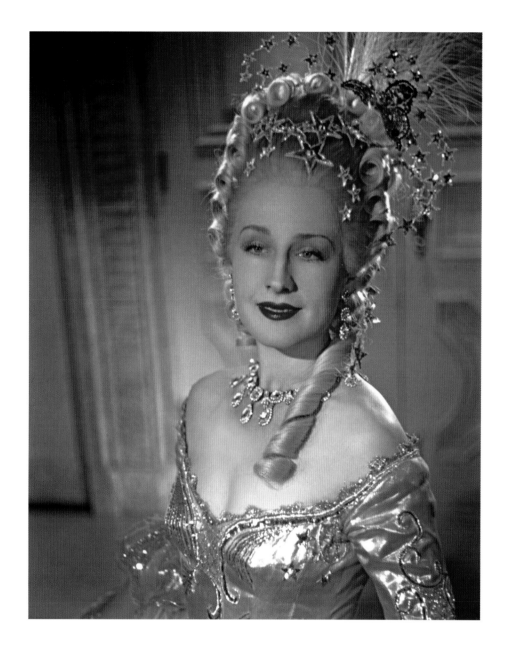

studio was no longer producing lavish spectacles on the scale of *Marie Antoinette* or *The Wizard of Oz*. The loss of the European audience also affected the approach to film content, including wardrobe. For Garbo's film, *Two-Faced Woman* (1941), Louis B. Mayer asked Adrian to make the Swede's image more accessible to Americans, since MGM could no longer rely on film rentals in countries where audiences had more of an appreciation for Garbo's mysterious qualities. Critics rejected Garbo as an "ordinary girl." She never made another film. "When the glamour ends for Garbo, it also ends for me," Adrian said later. "If you destroy that illusion, you also destroy her. When Garbo walked out of the studio, glamour went with her, and so did I." Adrian left MGM in September 1941, and opened his own couture house.

Two years before leaving MGM, Adrian surprised everyone by marrying actress Janet Gaynor on August 14, 1939. He was thirty-

five at the time, and had never hidden his homosexuality. Adrian had met Gaynor when he designed her wardrobe for *Daddy Long Legs* (1931). Gaynor was married at the time, but she had also had same-sex relationships. Adrian designed for her again in *Three Loves Has Nancy* (1938). In 1930s Hollywood, gay actors often entered "lavender" marriages to avoid discrimination or to placate nervous studio heads who believed the American public would not accept a gay leading man. Not being under the same level of public scrutiny as actors, gay designers did not experience as much pressure to marry. Why did Adrian and Gaynor marry? They genuinely loved each other. Their marriage lasted twenty years and produced one son. "When he [Adrian] met Janet Gaynor, it was one of the great romances of all time," said Sheila O'Brien, who

OPPOSITE AND ABOVE: Norma Shearer in rare color shots taken on the set of *Marie Antoinette* (1938).

worked in the MGM wardrobe department during production of *Three Loves Has Nancy*. "Let's go up to the dressing room and call A," Gaynor would say to O'Brien, referring to Adrian. "He'd come up and they would start in," O'Brien said. "They were the wittiest, most charming people. They adored each other and their conversations were funnier than anything the writers ever cooked up for Bill Powell and Myrna Loy."

On July 6, 1940, the couple had their son, Robin Gaynor Adrian. The three lived in Adrian's home in Toluca Lake in the San Fernando Valley, along with Adrian's collections of exotic birds and monkeys. Gossipmongers, who classified the Adrian-Gaynor union as just another "lavender" marriage, insisted that Robin was not the Adrians' biological child. "Robin, is absolutely *their* child," said family friend Leonard Stanley. "He looks just like the perfect combination of both of them. Adrian and Janet, it was a great love affair. They were inseparable." Even though they both had dalliances with members of the same sex before their marriage, Stanley believes that stopped. "I'm not pretending that

didn't happen," he says, "but I really don't think there were any extramarital affairs."

Adrian and Gaynor jointly financed their new couture business on Wilshire Boulevard in Beverly Hills. Hollywood continued to feature Adrian's clothes in films, though they were often only purchased from the salon. The notable exception is *Lovely to Look At* (1952), starring Kathryn Grayson and Howard Keel. A nod to the old MGM days, *Lovely*'s sets were designed by Tony Duquette, who had designed the interior of Adrian's Beverly Hills shop. *Lovely* was Adrian's last film. In 1952, he was stricken with a heart attack in his Wilshire Boulevard salon. He was kept there all night because his doctor did not want him moved. A hospital bed

ABOVE: Gilbert Adrian married actress Janet Gaynor in 1939.

OPPOSITE: Wardrobe test for Judy Garland in *The Wizard of Oz* (1939).

OVERLEAF, LEFT TO RIGHT: Rosalind Russell in *The Women* (1939). · Joan Crawford in *The Women*.

Oct 31
New dress
with hair
parted on side

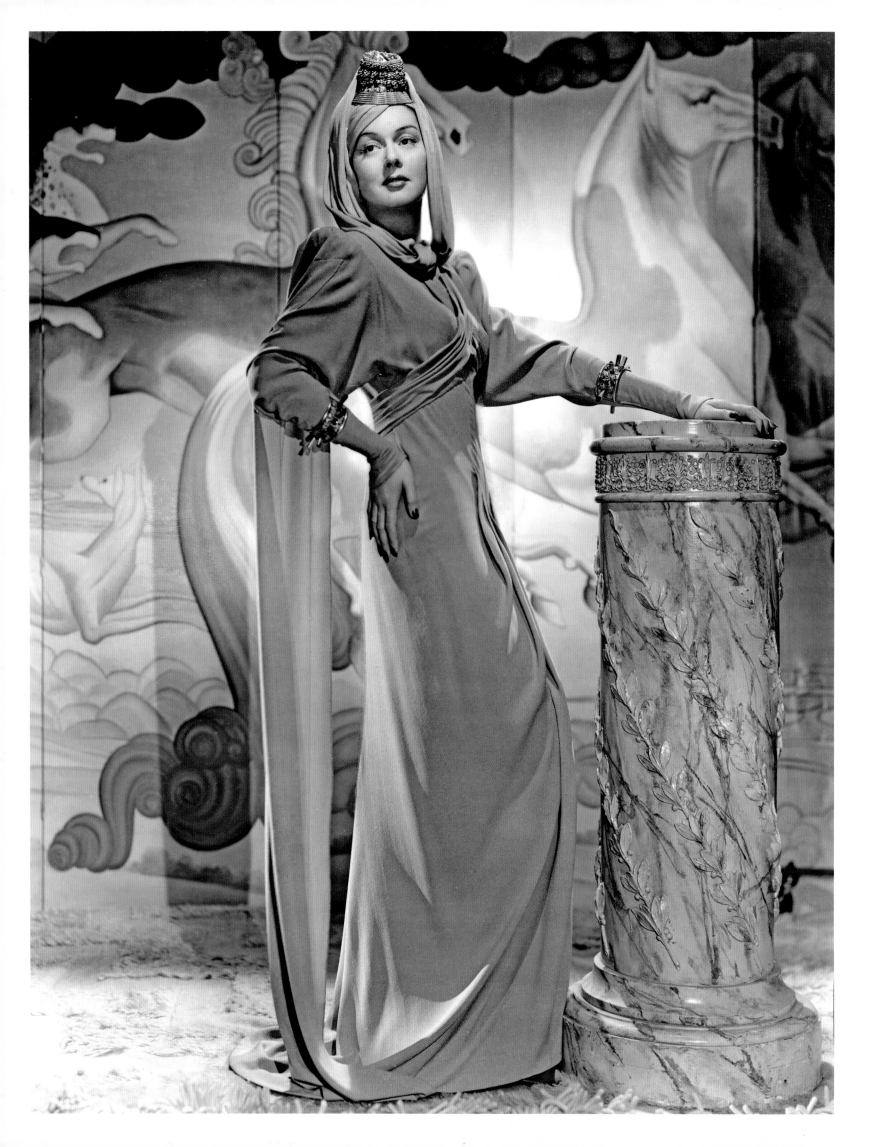

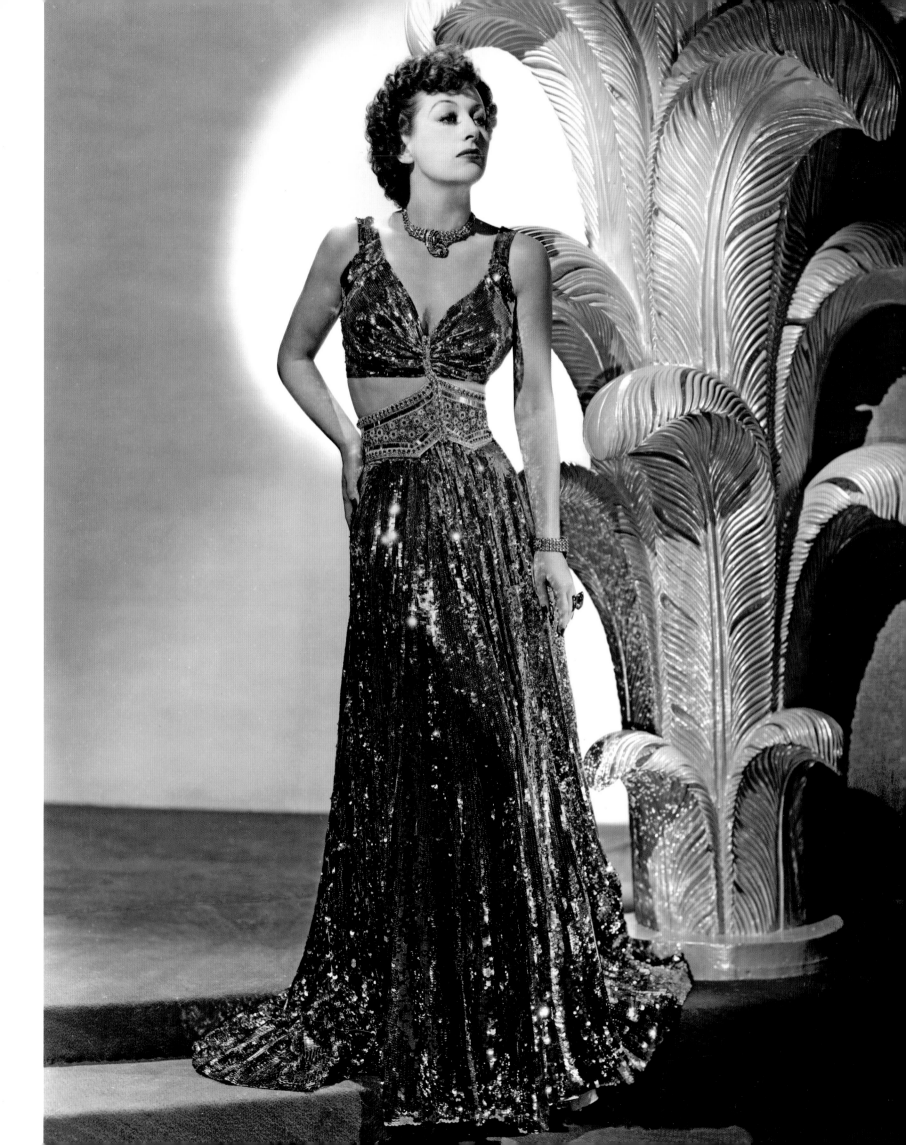

was brought in, and Gaynor and a nurse stayed with him. When Adrian recovered, he closed his shop and retired with Gaynor to a plantation in Brazil, near the ranch of close friends Mary Martin and Richard Halliday. There he concentrated on interior design and gardening.

In 1959, both Adrian and Gaynor made a return to Broadway, working on separate productions. Gaynor starred in *The Midnight Sun*, and Adrian began designing and executing costumes in Los Angeles for Lerner and Loewe's *Camelot*. On September 12, 1959, Adrian suffered a second heart attack at his home. He was hospitalized that evening, and Gaynor and their son boarded a flight from New York the next morning. Adrian died before they could reach him.

"Janet had a nervous breakdown six months after Adrian died, because it took that long for her to realize that she was never going to see him again," Stanley said. "She told me, 'Every time I open the closet, I cry,' because he had done all of her clothes. They had

been inseparable for twenty years, so her whole life was totally altered. She had a very hard time adjusting to that. She let him run the show, but she wanted it that way. And then that was all gone."

During his career, Adrian designed for more than 260 films. "I try to bring common sense to clothes," Adrian said in 1935. "I admit that some of my creations may have seemed mad at first, but they all had a definite idea of personality behind them. It is the *mind* of a woman that counts."

OPPOSITE: Gilbert Adrian and Joan Crawford look over sketches for *The Women* (1939).

ABOVE: A Gilbert Adrian design for Joan Crawford in *Susan and God* (1940).

OVERLEAF, LEFT TO RIGHT: Adrian's last film was MGM's *Lovely to Look At* (1952) starring (l-r) Kurt Kasznar, Zsa Zsa Gabor, Marge and Gower Champion, Kathryn Grayson, Howard Keel, Red Skelton, and Ann Miller. · Katharine Hepburn in a publicity still for *The Philadelphia Story* (1940).

TRAVIS BANTON

When Travis Banton met Marlene Dietrich in June 1930, the newly arrived German actress did not say more than four words to him.

His first fittings with her for *Morocco* (1930) had to take place after midnight because director Josef von Sternberg kept Dietrich working late on location. Dietrich would arrive, obviously fatigued, but she did not complain, nor would she accept any gesture of sympathy regarding her plight. In the still quiet of the wardrobe department in those early morning hours, Banton and his fitter would pin, measure, and adjust the gowns on Dietrich's figure while the actress stood in total silence. It was deafening. Banton wanted to yell, "Say something. Say *anything*. Tell me it's terrible, impossible, amateurish, but just say something." Years later, Banton came to realize that Dietrich's initial reticence was rooted in her discomfort with the language and her bewilderment by America's egalitarian society. Being mindful that she was no longer in Europe, Dietrich was uncertain how to treat the designer and his staff.

"I love making clothes for Marlene," Banton once said, "but sometimes her exotic personality leads me into certain excesses." Her obsession with feathers, for example, led Banton to design the iconic sleek, black-feathered vamp ensemble for *Shanghai Express* (1932). With its cascading sea of feathers swirling about Dietrich's shoulders and completely swallowing her neck, the design was an essay in overindulgent Hollywood fantasy that seemed too extreme to have any impact on real women's ready-to-wear clothing. But it did. "You can't imagine how many paradise birds you saw on American women," Banton said. "They put them everywhere." Ten years later, columnist Hedda Hopper was still talking about Banton's impact. "Travis did more than any single person to make Marlene Dietrich the clothes horse of the movies," she wrote. "When she arrived here, her afternoon gowns of black satin were trimmed with ostrich feathers. He taught her to wear the feathers where they'd do the most good."

Claudette Colbert did not believe she needed Banton's help to dress glamorously. At least not at first. She arrived at Paramount to film *Manslaughter* (1930) with a trunk filled with clothes from Saks Fifth Avenue. Colbert's mother had been a dressmaker in France, and if there was one thing Colbert believed she understood completely, it was clothes. Although his contract empowered Banton to control the wardrobe for every actress, he allowed Colbert to do as she pleased, which meant shopping at the finest retailers for her costumes. That ended with *The Man from Yesterday* (1932). Colbert's schedule left her no time to shop before filming was to begin. Banton showed her sketches for a chiffon gown, an afternoon outfit with a cape, and a street dress with a small bow. He quickly learned that Colbert hated three things—chiffon, capes, and bows. Or did she? Perhaps it was pride, or insecurity, or both, but Colbert seemed compulsively driven to prove her own design prowess by challenging all of Banton's choices. Over the next several months, Banton came to believe that Colbert was always going to quibble with him no matter what he designed for her.

Designing for Carole Lombard gave Banton needed relief from the quarrelsome Colbert. When Banton designed for Lombard in *Safety in Numbers* (1930), he was not forced to contend with the popular comedienne's fashion prejudices, because she did not have any. Trusting a designer was not an issue for Lombard because she was not terribly mindful of the impact a wardrobe could have. This is not to say that she did not appreciate beautiful clothing. She did. And Lombard loved to be surprised by Banton's designs. She met each viewing with great enthusiasm. "It's divine. It's too divine," she would say looking in the mirror. "I can't *stand* it. Teasie (Lombard's nickname for Banton), you're divine and the gown is divine, and I'm divine in it."

Banton's design savvy seemed almost innate, first revealing itself during his teens. Hollywood mythology sometimes portrays him as a rural Texan boy who inexplicably developed an uncanny *savoir faire* for fashion. And although he was born in Texas—in Waco, on August 18, 1894—Banton was thoroughly a product of the New York City art scene of the early 1900s. His parents, Rentfro and Margaret Jones Banton, moved to New York with Travis and little

OPPOSITE: Claudette Colbert in *Cleopatra* (1934).

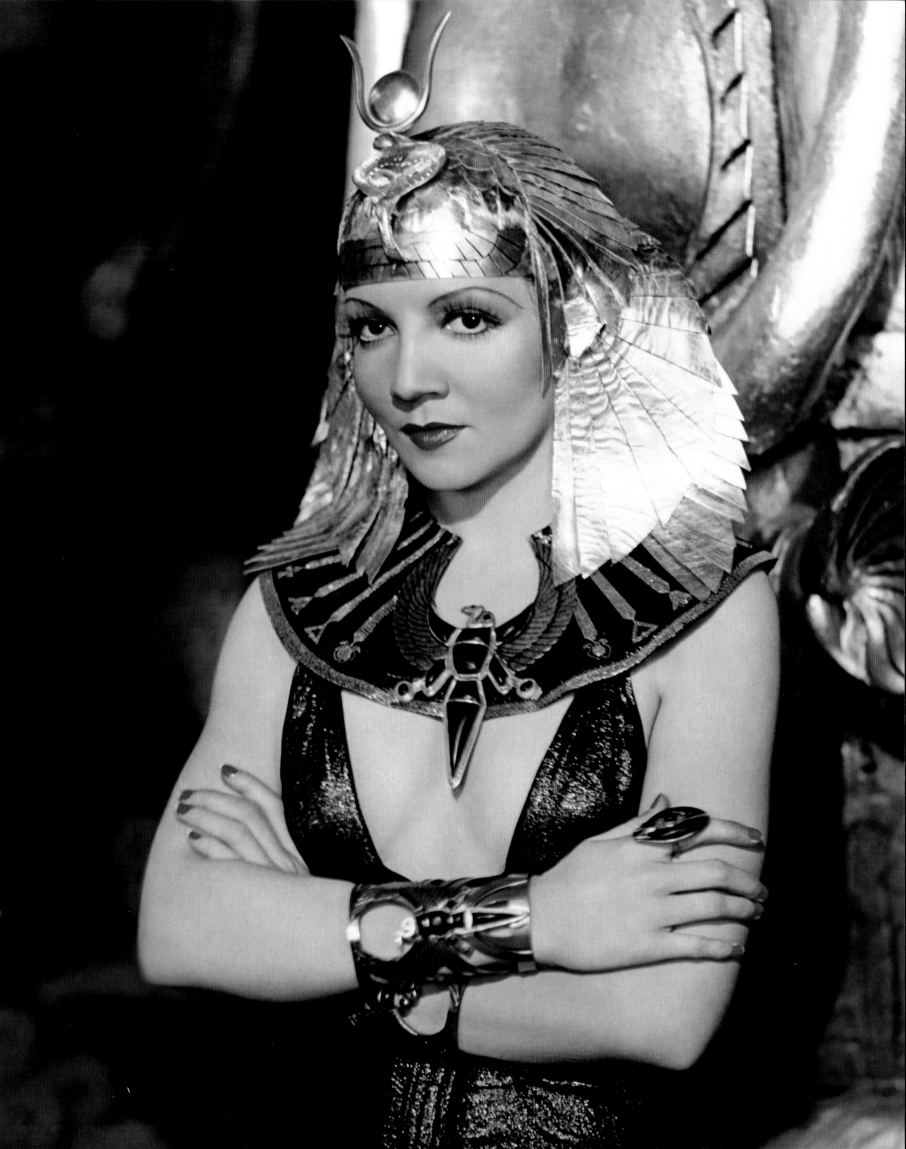

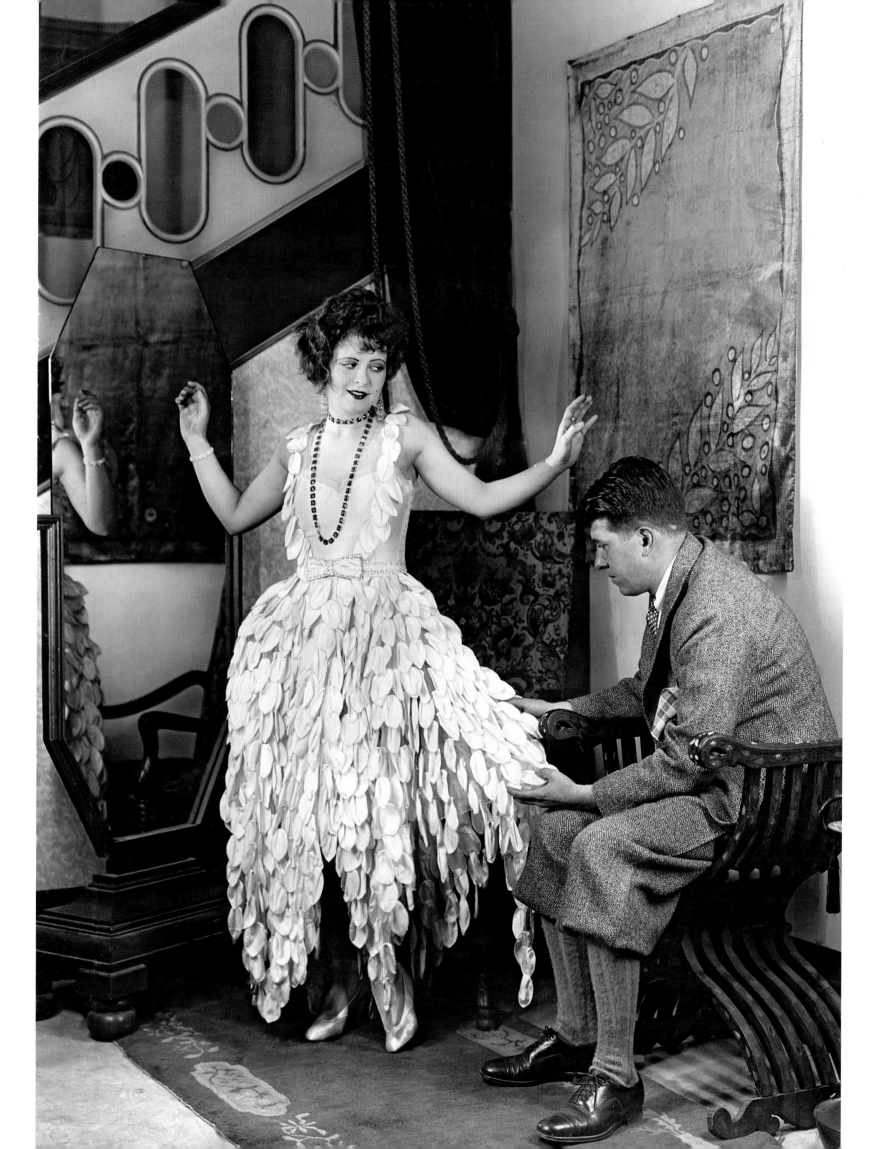

sister, Ruth, when the future designer was two. At an early age, Banton was exposed to the theater through matinee performances with his mother. As a teenager, he showed an aptitude for art. Rentfro, an accountant for most of his life, wanted a business career for his son. When Banton was sixteen, he enrolled in a course of business studies at Columbia University. He hated it, so his parents allowed him to transfer to the Art Students League.

When Banton began embellishing his drawings of nudes by adding gowns, jewelry, and other fashion accessories, his art school instructors encouraged him to take fashion design courses. In later years, Banton would say that the thought of a career in fashion design initially horrified him because it seemed like an unmanly

pursuit. That statement may have just been for the press. His mother certainly saw no shame in that profession. She encouraged her son to design, believing that he would probably be more apt to earn a decent living as a costume designer than as a painter or sculptor.

While a student, Banton met Norma Talmadge in 1916, when the star was at her zenith in popularity. She was in New York to make *Poppy* (1917), and expressed interest in Banton's designs.

OPPOSITE: Travis Banton and Clara Bow in the 1920s.

ABOVE: Lilyan Tashman, Travis Banton, and Carole Lombard at a party at Banton's home.

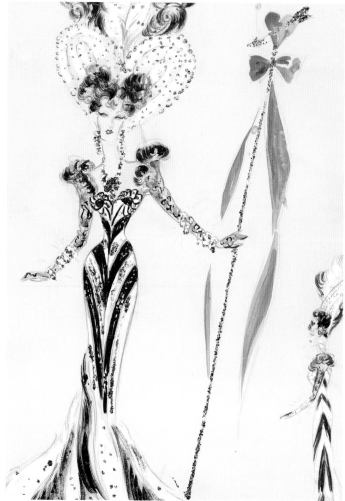

Being an art student with no real-world experience, Banton was awkward as he nervously showed Talmadge his sketches. She showed enthusiasm for each of Banton's designs and chose one for the film. Banton was undoubtedly honored and anxious when Talmadge asked him to supervise the fittings. He later said that the megastar demonstrated incredible patience with him, as he was sure the fittings took too long due to his inexperience.

After *Poppy*, the United States's entry into World War I landed Banton in the navy aboard a submarine. Returning to New York after the war, he finished his studies at the New York School of Fine and Applied Arts. Upon completion of his studies, Banton sold some sketches to *Vogue* and found full-time work with Madame Frances. Frances's clientele included New York society women and Broadway stars.

In 1920, the fashion world would focus on Banton suddenly, for something he designed without any particular client in mind. While working at the salon of Madame Frances, Banton designed a bridal gown of bouffant white net, a photo of which was published in a leading fashion magazine. The following day, a flurry of activity ensued at the salon, as a client requested to see the gown in the main fitting room. Though Banton was barred from the room, he could see the client reflected in a mirror when the door was held open for a minute. It was Mary Pickford, who bought Banton's gown for her wedding to Douglas Fairbanks, which was a few days later. Having a design selected for Mary Pickford's wedding sealed Banton's reputation as a designer. He went on to work for Lady Duff-Gordon and eventually opened his own salon. He was hired to design for theater, including *The Ziegfeld Follies*, *Little Miss Bluebeard* (1924), and *My Girl* (1924).

In March 1922, Banton was injured in a tragic car accident that killed his friend, Daniel J. Sullivan. As they were returning from Boston to Fall River, their car struck a street railway switch frog during a heavy snowfall. Banton was asleep in the rear seat at the time of the accident. Sullivan, the driver, was thrown from the car and suffered a crushed skull. Banton's parents came immediately from New York to attend to their son, who sustained serious injuries. Sullivan, an American vice consul, had served in the French Ambulance Corps during World War I. The twenty-five-year-old diplomat intended to continue on to Washington that evening, where he was to receive a promotion in the consular

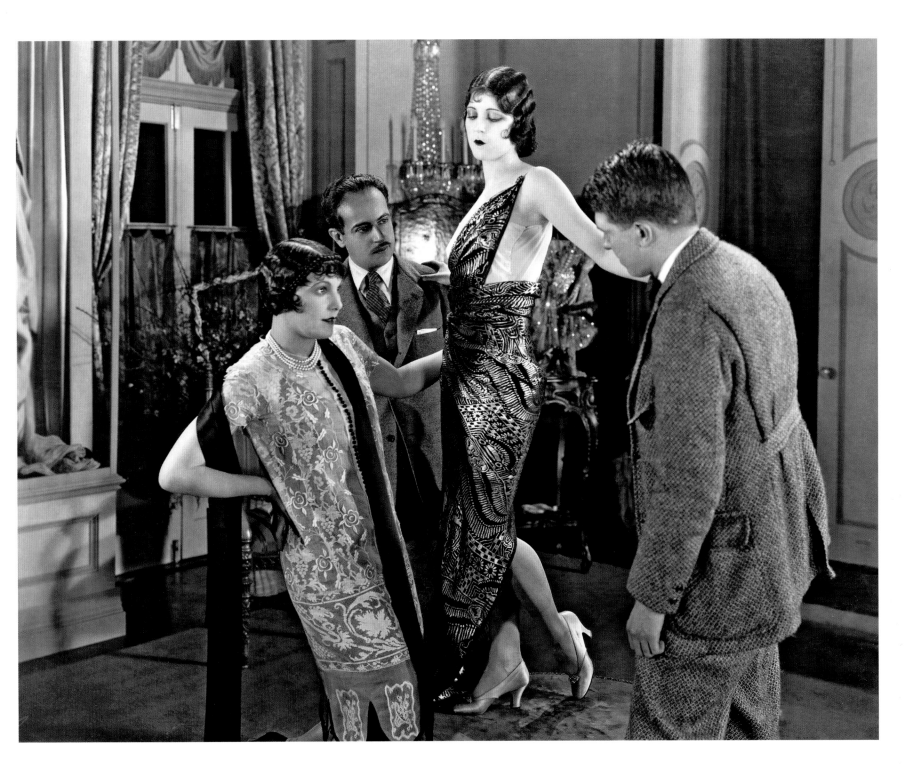

service. Following his recovery, Banton resumed designing in New York.

In 1924, producer Walter Wanger sought Banton's services for Paramount's *The Dressmaker from Paris* (1925) at the suggestion of his wife, actress Justine Johnstone, who was Banton's client. Banton received the offer during a telephone call on a cold, rainy New York day. Longing to escape the impending New York winter, he accepted the position so quickly that he nearly forgot to ask about the salary. Banton could not have hoped for a movie better suited to cut his film teeth on. Set in the world of Parisian *haute couture*, *The Dressmaker from Paris* ended with a parade of gowns in a fashion show.

After *Dressmaker*, Paramount offered Banton a contract at $150 a week. Howard Greer remained Paramount's chief designer, and Banton became his second. Rather than rivals, Greer and Banton became friends. Both were gay and enjoyed the nightlife of Los Angeles together. They were making more money than either

OPPOSITE, LEFT TO RIGHT: Travis Banton and Carole Lombard select fabrics. · A Travis Banton sketch for a Mae West costume.

ABOVE: Conferring with star Leatrice Joy and producer Paul Bern, Travis Banton (at right) fits an unidentified actress for *The Dressmaker from Paris* (1925).

of them had ever imagined. They spent lavishly on their homes and furnishings. Banton bought a hilltop home in Hollywood, with dozens of rooms that he decorated with murals of his own design.

When Banton first met Clara Bow in 1925, he found her luminous, and his designs for her in *It* (1927) dictated fashion for young women. But Bow's tacky penchant to over-accessorize Banton's designs with earrings or ankle socks forced Banton to watch her like a hawk. "Remember, dear, no earrings with this simple white crepe," he said to Bow at one fitting. "Two heavy ornaments hanging from either side of your head would ruin the effect, you know." She would agree, but when Banton saw the rushes, there would be an enormous earring dangling from her earlobe to her shoulder. "Why, Travis, darling," Bow said to him when confronted, "you said that two earrings were not right. Just to please you, I wore only one."

By 1927, Banton had established himself as an innovator. He became known for his new style of figure-hugging gowns, which were often heavily embellished with beading, sequins, or brilliants, or trimmed with fur. Stars began requesting him over Howard Greer. Greer did not mind, as he had never believed in his own ability to create clothes that translated well on the screen. He had been wanting to open his own salon and tendered his resignation. Paramount made Banton head designer.

When Paramount signed Mae West to make *Night After Night* (1932), probably no one imagined that Banton would dread meeting her. They shared one degree of separation in their not-too-distant pasts. West had caused a huge sensation on Broadway with her controversial plays like *The Wicked Age* (1927) and *The Constant Sinner* (1931), which dealt overtly with themes of sexuality. Her 1927 play, *Sex*, was raided by the police and West was sentenced to ten days in jail for "corrupting the morals of youth." The New York prosecutor who successfully put the controversial actress behind bars was none other than Joab Banton, the designer's uncle.

Upon their introduction, West asked, "Banton? Banton? Any relation to Joab Banton of New York?" Travis sheepishly admitted his relationship to the prosecutor. West surprised him. She broke out into a smile. "Hmmmmmm, wish I'd known you when the fireworks were going off," she said, using the same cadence made famous by her double entendre deliveries. "Might have had some say with that uncle of yours. But he was a fine gentleman and was only doing his duty. I don't hold any hard feelings."

Ironically, one of Banton's most famous form-fitting gowns, the heavily beaded gown and fur-trimmed stole that Dietrich wore in *Angel* (1937), is known for the amazingly intricate beading, which Banton did not design. "For the sample, I would do a little design, the beader would bead it, we'd use our own imagination," Banton's assistant, Adele Balkan, said of the gown's creation. "We'd bring it in to Dietrich and Banton. We did not stay in the room with them. And she would say whether she liked it or what she thought, whether there should be a pearl here instead of there, and she would send it back. And we must have done that three or four times." Instead of creating new beaded motifs on separate swatches, the beader simply kept adding to the initial piece of fabric. "In doing this," Balkan said, "it created a whole thing, and *that's* what Dietrich chose. She loved the conglomeration." Although Dietrich often personally acquired her wardrobe after filming wrapped, Paramount refused to part with the jewel-encrusted creation. With a price tag of $8,000 ($135,000 in 2015 dollars), it was the single most expensive design Banton ever created.

In 1937, Banton was making the handsome sum of $1,250 a week. Being *the* designer every Paramount star wanted, Banton believed himself indispensable to the studio. When his contract came up for renewal, his business manager advised him to ask for more money. The request was at odds with the studio's prevailing cost-cutting budgets for wardrobes. Executives were aware that Banton's drinking had increased over the years, though his assistant, Edith Head, tried to cover for him. The studio offered Banton a renewed contract at his current salary. Banton's business manager declined the offer, telling Paramount that Banton could get a better deal elsewhere. So Banton left.

Banton went to work at the salon of Howard Greer, his former Paramount colleague. The pair gave a joint collection show at their Sunset Boulevard atelier in 1939. Banton concurrently sought studio work. But he had trouble regaining his footing. He worked for United Artists in 1938 and 1939, and then at 20th Century-Fox from 1939 to 1941.

In July 1942, Hedda Hopper announced in her column that Banton had married Elizabeth "Biddy" Kleitz, whom he had met two decades earlier when they were students at Columbia University. "Travis and Biddy were in love when he was at Yale (sic)," Hopper wrote. "After graduation, he came here. Since he's back in the big town, they've renewed the old urge." Biddy was the daughter of Upstate New York architect and building contractor William Kleitz, and his wife, Albertina Isaksson. Following graduation from Columbia, Biddy had worked as a clerk for a publishing house and later went into advertising. The two were in their mid-forties at the time of their marriage, the first for both.

"They were trying to get him going again as a designer for retail and she tried to keep him away from all of his gay friends," David Chierichetti said of Biddy. "She felt that all these gay men, especially the other designers, were bad influences on him and encouraged him to drink. So if they called him, and she answered the phone, she wouldn't put him on."

OPPOSITE: Carole Lombard wearing a Travis Banton design in *My Man Godfrey* (1936).

ABOVE: "Leda and the Swan" costume created for Marlene Dietrich to attend a costume party.

OPPOSITE: Marlene Dietrich in *Angel* (1937).

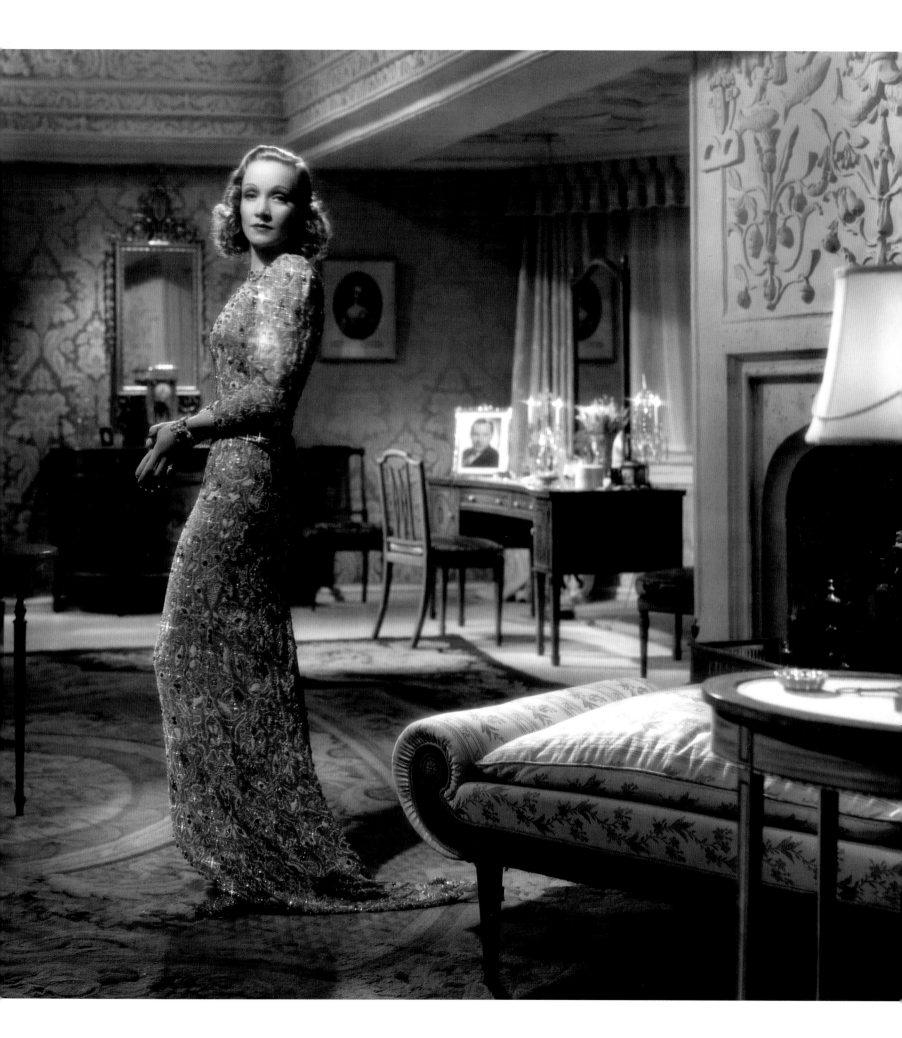

Biddy's marriage to Banton created new opportunities for the former advertising executive as well. Initially she played a supportive role, traveling with Banton as he promoted his ready-to-wear line. Her visibility with the press led to a position as West Coast associate for *Photoplay* fan magazine and, in 1946, Hollywood fashion editor for the *New York Times*. Biddy also took to the Hollywood social scene, often participating in celebrity fundraisers for charities, including the Christmas 1948 bash at Harold and Mildred Lloyd's Beverly Hills estate, where Biddy joined Frank Sinatra, Douglas Fairbanks Jr., and Esther Williams to raise $65,000 to build a new facility for the Blind Children's Center of Los Angeles.

Banton's first film assignments at 20th Century-Fox—for Betty Grable in *Down Argentine Way* (1940) and Grable and Alice Faye in *Tin Pan Alley* (1940)—did not require the level of sophistication that Banton was accustomed to at Paramount.

Banton designed four films for Columbia, including the modern clothes for *Cover Girl* (1944), though he refused to sign a contract with the studio. Rosalind Russell requested Banton when she made *Sister Kenny* (1946) for RKO. Banton went to work at Universal in 1945. "His strong design ties to the 1930s were the primary reason Banton was fired from working on *A Double Life* (1947)," David Chierichetti said. "George Cukor and Garson Kanin told him that they wanted him to do a dressing gown for Lili Palmer. They warned him that they didn't want one of these Carole Lombard numbers with some great big fur cuffs. He designed one like that anyway, and went ahead and ordered the fur. But he wasn't getting it done and they were just about to start in a week. So they put Yvonne Wood on it." Although Banton had been friendly to Wood initially at Universal—they would have lunch together occasionally—he never spoke to her again after *A Double Life*. "He'd pass her in the hall and would

look the other way," Chierichetti said.

Banton believed that he should have stopped designing for films around the time that Adrian resigned from MGM in 1942. Banton missed the theater, opera, ballet, and shops of New York and found the endless stream of Hollywood pool parties deadly dull. After *Valentino* (1951), Banton stopped designing for films and returned to work with Howard Greer for a while.

Although he never designed another film, Rosalind Russell asked Banton to design for her for the stage play *Auntie Mame* (1956). Banton swathed Russell in furs and sequined lounging pajamas for the play set from 1928 to the late 1940s. Banton collaborated with Marusia Toumanoff Sassi for *The Dinah Shore Chevy Show* in the mid-1950s. Together the designers formed the Marusia-Travis Banton label and showed their couture collection in early 1958.

In 1952, Biddy and Travis began living separately, though they would never divorce. Biddy returned to New York, and Banton moved back in with his mother in Los Angeles. He eventually moved to an apartment in Beverly Hills. In early 1958, Banton was hospitalized for throat cancer. He died on February 2, 1958, in Los Angeles. Biddy out-lived Banton by twelve years, dying on April 27, 1970, in Goshen, New York.

OPPOSITE, LEFT TO RIGHT: Dorothy Lamour in *Swing High, Swing Low* (1937). · Actress Anna May Wong and Travis Banton.

ABOVE, LEFT TO RIGHT: Susan Hayward in *Smash-Up: The Story of a Woman* (1947). · Joan Fontaine in *Letter from an Unknown Woman* (1948).

ORRY-KELLY

"You know, Tony's ass is better looking than yours," designer Orry-Kelly once told Marilyn Monroe about her *Some Like It Hot* costar Tony Curtis during a costume fitting.

"Oh, yeah?" the legendary blonde bombshell answered. "Well, he doesn't have tits like these!" Monroe pulled open her blouse, baring her breasts. Rarely had an actress so unequivocally won a one-upmanship contest with the Aussie designer. Orry-Kelly was as well known in Hollywood for his acerbic jibes as he was for his amazing costumes. "Hell must be filled with beautiful women and no mirrors," he used to quip.

Born in Kiama, sixty miles south of Sydney, on December 31, 1898, Orry-Kelly was openly gay. His father, William Kelly, was a tailor, and his stay-at-home mother, Florence Perdue Kelly, was a passionate carnation grower. Her son loved to say that he took Orry-Kelly as his professional name because his mother "always thought of me as her little flower." But on other occasions, the designer would claim that Orry Kelly was his birth name, and that studio publicists had added a hyphen to make him appear "more exotic." The truth was, he was born George Orry Kelly, and went by Jack. As far as hyphenation-happy publicists and carnation-breeding mothers, well, Orry-Kelly thought nothing of tweaking the truth, as long as it made an otherwise dull story seem clever.

In Kiama, the woman who ran the local theater took a liking to young Jack. At age ten, he began acting in plays and designing sets. Recognizing their son's flair for sketching and painting, the Kellys sent him to live with family friends in Sydney, where he studied art. He was quick to capitalize on the adventures afforded him by a local aristocrat who took the future designer under his wing. His mysterious benefactor dressed Jack in beautiful sailor suits and Lord Fauntleroy jackets with big lace collars and took him to the theater and the best restaurants. He later learned that his patron was actually a con artist, using him to distract his victims while he picked their pockets. Orry-Kelly never bore a grudge for the exploitation, he said years later. After all, he had a great time.

By 1920, Orry-Kelly was ready to leave Australia. His father gave him passage money to London. Armed with letters of introduction, experience in Sydney's theater district, and four years of working in his father's tailoring shop where he learned to hand-paint neckties, Orry-Kelly confidently believed he would make it big in London as a theatrical costume designer. He was soon dismayed after making the rounds with no one showing any interest at all. His Australian accent, which in 1920s London was considered déclassé, worked against him. As his money dwindled, he gave up, and set sail for New York. It was 1922.

While beating on doors of theatrical offices in New York, Orry-Kelly met a young struggling actor named Archie Leach. To save expenses, the future designer and the future Cary Grant decided to rent a loft together in Greenwich Village. The day they met, the duo ran into Charlie Phelps, a young performer who Orry-Kelly had known in Sydney. Phelps agreed to move in with the men, enabling them to split the bills three ways.

Orry-Kelly struggled at first. He worked as a waiter, a salesclerk, a hotel clerk, and even escorted ladies to tea dances in order to make ends meet. He also painted neckties, which Grant sold on the street. "Cary always said that he learned to act selling my ties," Orry-Kelly would later say. "If he sold a lot of them, he was doing a really good job acting and if he didn't sell many, then he wasn't acting very well." The third roommate fared better more quickly. Known on stage as Charlie Spangles, Phelps quickly booked work at a nightclub in Greenwich Village. His novel act included a routine where he donned a special costume split down the middle. When he turned in profile to the left, he appeared as a man, and to the right, as a woman.

Phelps's good fortune led to Orry-Kelly's. The owner of the club where Phelps worked hired the untested designer to redecorate another of his Greenwich Village locales. The re-designed room became a big hit. That small success led to assignments designing sets and costumes for a stage revue. He was hired to design for

George White's *Scandals* and for the Shubert Organization, and to paint borders for silent movie titles for Fox East Coast studios. But his costume design work for comedienne Nora Bayes, and actresses Ethel Barrymore and Katharine Hepburn in her Broadway debut, soon eclipsed his other talents. He found himself in demand as a costume designer.

Grant spent his first year in New York with the Bob Pender Circus, where he learned patnomine and acrobatics. "We had a marvelous time that year," Orry-Kelly remembered. "All of us

with our future in front of us like that, and we had already proved that we knew how to cope." The three made quite a trio. "Cary was straight and I was gay, and no one knew what Charley was," Orry-Kelly said.

By 1932, Grant had found success in Hollywood, appearing in five movies that year. Meanwhile Orry-Kelly was still back in New

ABOVE: Orry-Kelly (left) confers with Ruby Keeler (center) on the film *Go Into Your Dance* (1935).

York, but he was not getting any work because the Depression had devastated Broadway. Grant prevailed upon his agent, Minna Wallis, to find a designing job for his old roommate. She learned from her brother, Warner Bros. producer Hal Wallis, that his studio needed someone. Orry-Kelly was hired.

Orry-Kelly moved in with Grant, who was renting a beach house in Santa Monica. Actor Randolph Scott also moved in, though Orry-Kelly only stayed six weeks. To his disappointment, the jovial times he had known living with Grant in New York seemed oddly over, never to be revived.

The actual end to their friendship did not come until a decade later, during the war, according to Orry-Kelly. He had become a U.S. citizen and enlisted in the army. He urged Grant to "do his part," too. "But he was just starting to earn big money from the films and he begged off the whole issue," Orry-Kelly said. "Finally the studio had some American general with the USO contact Cary and suggest that he could best do his part by appearing at some canteens and USO shows from time to time. I was shocked by his behavior and told him so, and he tried to have me taken off the picture [*Arsenic and Old Lace*]. He called the head of the studio and told them I was never to do another one of his films again." Filmed in 1941 and released in 1944, *Arsenic and Old Lace* is the only film the former friends ever worked on together.

Who knows why Grant may have tried to boot Orry-Kelly off *Arsenic*, if it happened at all. Orry-Kelly's vitriolic indignation at Grant hardly seemed justified, given the realities. In fact, his artful omission of key facts calls the designer's whole story into question. Grant had become a U.S. citizen on June 26, 1942, a year *before* Orry-Kelly became an official Yankee on April 23, 1943. Grant had not returned to England to fight, but the British Embassy had instructed all Brits in Hollywood to stay put. Although Grant never put on a uniform, he donated his entire salary from *The Philadelphia Story* (1940) to the British War Relief Society and his entire salary from *Arsenic* to the U.S. War Relief Fund, making a combined contribution totaling nearly $4 million in 2015 dollars.

Even without the occasional support and friendship of big stars, Orry-Kelly had ensured his own success with the studios. When he first arrived in Hollywood, Orry-Kelly impressed the powers that be at First National Pictures/Warner Bros. almost immediately. In *The Rich Are Always with Us* (1932), Ruth Chatterton, one of

the reigning queens of the studio lot, was to play the young and sophisticated Caroline Grannard. At the time, the actress was nearly forty. The producer and cinematographer both worried that the wardrobe that the organza- and ruffle-loving Chatterton would be bringing from New York would be wrong for her character. Chatterton surprised both men when she arrived for her wardrobe tests sporting smart clothes that made her look both younger and thinner on camera. They wondered where she had purchased her new wardrobe. "Mr. Orry-Kelly, the new designer in wardrobe, made them especially for me," Chatterton answered. Simplicity instantly became the hallmark of Orry-Kelly's designs. His creations

OPPOSITE AND ABOVE: Orry-Kelly design for Kay Francis in *Stolen Holiday* (1937).

were fashionable yet did not exude the theatricality of Adrian, who was being widely copied by other designers at the time.

In addition to being Orry-Kelly's debut, *The Rich Are Always with Us* also occasioned his introduction to Bette Davis, who by her own account had arrived in Hollywood only the year before, "a mousy, twenty-two-year-old virgin with knobby knees, a pelvic slouch, and cold blue bug eyes that radiated intelligence." Davis credited Orry-Kelly's designs for giving her a certain amount of chic, a quality she did not feel she possessed. That film marked the beginning of a beautiful, albeit tempestuous, relationship between the actress and designer. During her eighteen years at Warner Bros., Davis came to rely on Orry-Kelly to help her build the characterizations for which she became so famous.

On *The Little Foxes* (1941), Orry-Kelly sided with Davis as she fought with director William Wyler about her excessively opulent wardrobe. Davis starred as Regina Giddens, a member of

the South's aristocracy who resented being denied the financial independence afforded only to men. Wyler instructed Orry-Kelly to dress Davis in the height of Gibson Era fashions, coinciding with the story's 1900 setting. Davis had already challenged Wyler's set designs as being too lavish, arguing that they should have been done in a style of decaying grandeur to reflect her character's diminished lifestyle after failing to inherit family wealth along with her brothers. Davis and Orry-Kelly were in accord that Regina's clothes would have, as Davis put it, "a certain worn-out look from a few years back." When Wyler would not compromise, Davis walked off the set in protest, a brave move given that Samuel Goldwyn had paid $385,000 to borrow her from Warner Bros. A week later, Davis relented.

In all, Orry-Kelly and Davis made an astounding total of forty-six movies together during a period of fourteen years. But surprisingly, the two did not like each other. Davis did not like

Orry-Kelly as a person, designer Milo Anderson once said. But they needed each other.

"I think of Bette Davis as a period piece," Orry-Kelly said. "She belongs in costume clothing. Working with Bette isn't easy, but she's worth it. She is honest and outspoken. She's one of the very few actresses I know who can look in the mirror and tell herself the truth. When I'm ready to give up and throw out a dress, she'll give it a hitch or a twist and turn it into something great."

Despite the personality clash, Davis ultimately trusted Orry-Kelly to design for her, no matter who she played. Her fearless choice of characters—sometimes playing unsympathetic, contemptuous, or aloof women—enabled Davis to gain acclaim in a range of genres, including historical films, comedies, dramas, romances, and crime tales. When Orry-Kelly left Warner Bros. in 1943, Davis seemed genuinely devastated. "Warner Brothers, for me, without Orry-Kelly was as if I had lost my right arm," Davis

said later. "His contribution to my career was an enormous one. He never featured his clothes to such a degree that the performance was overshadowed."

Although Orry-Kelly's name will always be linked to Bette Davis's, he also designed for some of Warner's classic films without Davis, including *The Maltese Falcon* (1941) and *Casablanca* (1942). In the latter film, producer Hal Wallis threw out half of Orry-Kelly's original designs for Ingrid Bergman before shooting even began. In *Casablanca*'s source material, an unproduced play titled *Everybody Comes to Rick's*, Bergman's character arrives at Rick's Café wearing "a magnificent white gown, and a full-length cape of the same fabric. Her jewels are fabulous." To Wallis, this made no sense. The

OPPOSITE AND ABOVE LEFT: Orry-Kelly design for Bette Davis in *Kid Galahad* (1937).

ABOVE RIGHT: Bette Davis in *The Letter* (1940).

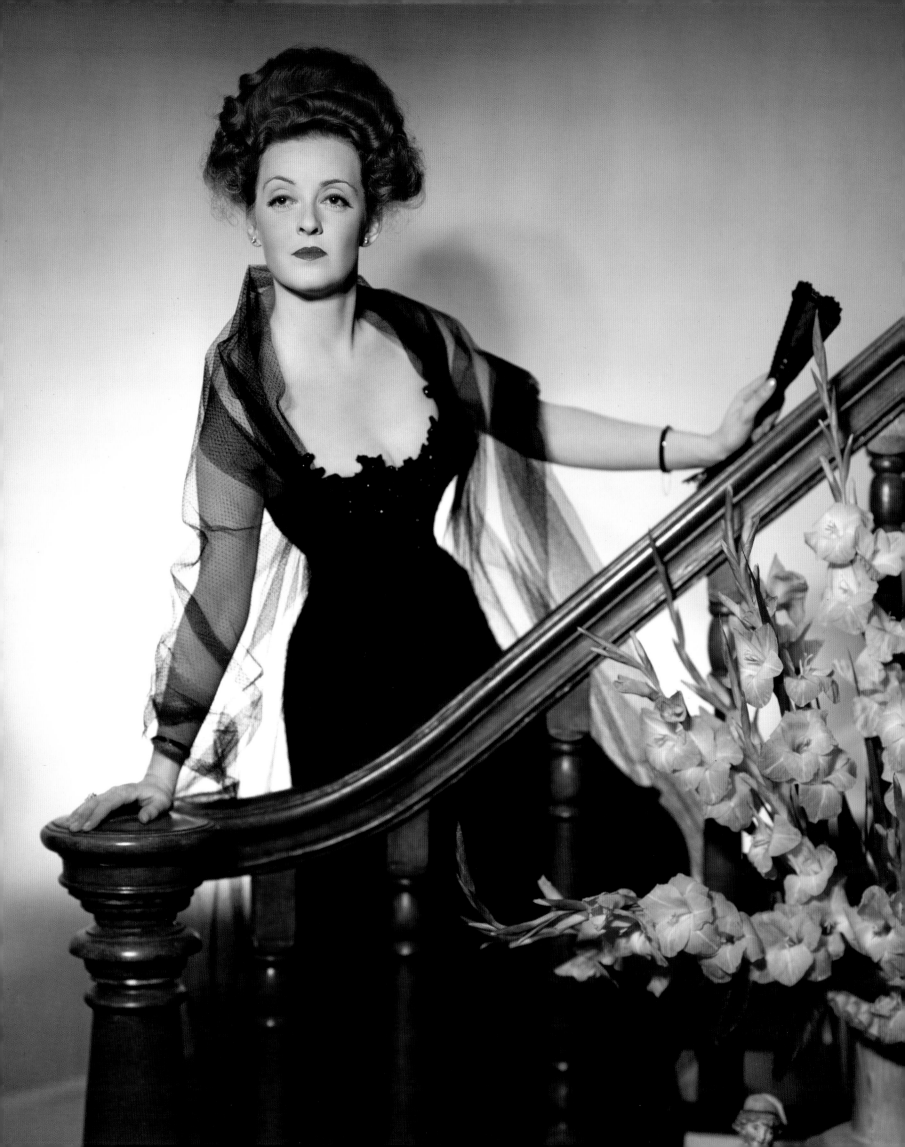

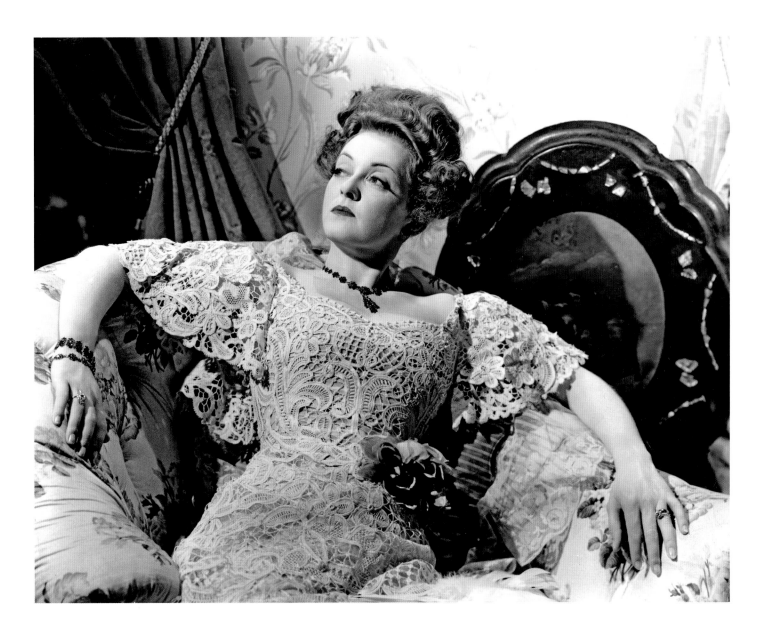

other characters had escaped Germany with just the clothes on their backs. How could Bergman's Ilsa Lund or Paul Henreid's Victor Laszlo have avoided the same misfortune? Orry-Kelly changed his original gown to a simple, white two-piece dress, which David O. Selznick, who was lending Bergman to Warner Bros., preferred. The scaled-down costume did not overshadow Bergman's beauty. In one of his famous memos, Selznick wrote, "In order for her to look smart, she doesn't have to be dressed up like a candy box."

Orry-Kelly was always an in-demand guest at Hollywood parties, noted for his witty stories and his ability to perform a soft-shoe routine if called upon. Also notorious were Orry-Kelly's fights with studio head Jack Warner. "I used to tell Orry-Kelly he should have been a prizefighter or gone into vaudeville," Warner said. "He could be trouble, loved the spotlight, and was stubborn as hell." The problem with Orry-Kelly was his drinking. "When he had too many drinks, he'd get mean, start swearing and throwing punches," Warner

said. "But he could be a damn nice guy when he wanted to be. His costumes had the one thing I always insisted on in everything—quality. There was quality there. No one else could touch him in that."

After completing *Mr. Skeffington* (1944), Orry-Kelly joined the army. Louella Parsons arranged for him to write a column for International News Service called "Hollywood Fashion Parade." After completing his one-year enlistment, Orry-Kelly returned to the studio to discover he was no longer the cat's meow. In his absence, Milo Anderson and Leah Rhodes had pleased everyone with their designs. Warner no longer needed to tolerate Orry-Kelly's outbursts. So when he refused to design for *The Doughgirls* (1944), Warner fired him. During a farewell drink at his home that evening, Orry-Kelly's dog bit fellow designer Milo Anderson on the nose. People who had seen the pair leaving the studio the

OPPOSITE AND ABOVE: Bette Davis in *The Little Foxes* (1941).

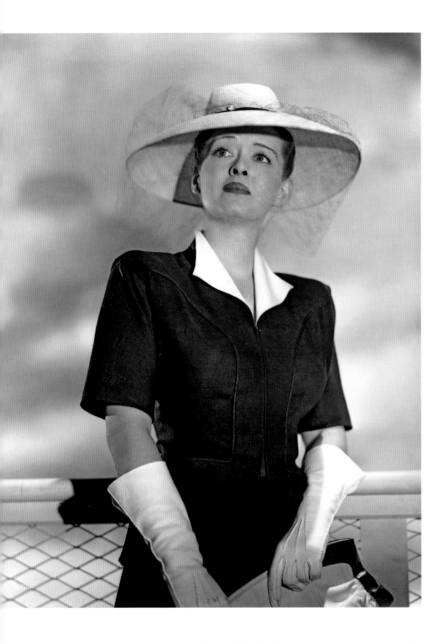

"He could do the wittiest, naughtiest costumes of anybody," said Margo Baxley, Orry-Kelly's driver and an employee of Western Costume. "In *Some Like It Hot*, they didn't shoot the full-length of the back of some of Marilyn Monroe's costumes because they were a little risqué for the times," Baxley said. "Her black dress had a jet butterfly that quivered right at the crack. Then on a white dress, there was a little open heart etched in blood red beads with a few drops of blood going down right on her shapely behind." Orry-Kelly's dresses of nude soufflé accented with only a minimum of sequins and beading, which made Monroe look nearly nude, resulted in *Some Like It Hot* being banned in Kansas and released unapproved by the production office. His designs precluded Monroe from wearing a bra, much to her approval. During fittings, Orry-Kelly used a string tied around Monroe's legs just under her buttocks to pinpoint exactly where the dress should cling. Monroe was pregnant when she began shooting the film (she later miscarried) and her figure was even more ample than usual.

Orry-Kelly had a trying time designing for Natalie Wood in *Gypsy* (1962). "What are you going to do for Natalie?" a reporter asked him, alluding to the challenge of designing costumes for a stripper. "What is Natalie going to do for me?" Orry-Kelly quipped. "Many people claim that Gypsy Rose Lee had no talent. I disagree. Becoming the greatest stripper of all-time with a shortage on the bust-line required nothing but talent. That's what Natalie's up against."

Around 1963, he began writing his autobiography, *Women I've Undressed*. The book, which was never published, was not actually about women. He mentions them, but mostly the book was about men. He would start a story about Bette Davis, but digress into a story about how much she hated Errol Flynn. "Orry-Kelly was one of the wittiest, funniest, most delightful men," Margo Baxley remembers from the three weeks she spent as his driver. "He was writing an autobiography, which for sheer libel possibilities, I'm sure it was burned before read. He would read to me from the proofs, and I was in hysterics. He was extremely indiscreet."

Women I've Undressed was rejected by the publisher because it did not contain enough scandal on Orry-Kelly's dealings with Marilyn Monroe, Cary Grant, and Bette Davis. Orry-Kelly explained to potential publishers that he was not a "scandal monger" and that the stories in his book were about *his* private

day before assumed Orry-Kelly had punched Anderson in the nose when he showed up at the studio the next day sporting a bandage.

Darryl Zanuck, head of 20th Century-Fox, told his costume supervisor, Charles Le Maire, to make a position for Orry-Kelly at Fox. Le Maire knew that Orry-Kelly had bullied his staff at Warner Bros. Dismayed at being forced to accommodate the cantankerous designer, Le Maire assigned Orry-Kelly to *The Dolly Sisters* (1945) with Betty Grable and June Haver. Le Maire considered Grable to be difficult, and he believed she and Orry-Kelly deserved each other. Orry-Kelly surprised Le Maire by doing well with the film. Though he returned to Warner Bros. briefly to design nine turn-of-the-century dresses for Davis in *The Corn Is Green* (1945), Orry-Kelly stayed at Fox until 1947, and then freelanced from 1950 onward at Fox, MGM, United Artists, and Warner Bros. He won three Academy Awards during this time for *An American in Paris* (1951), *Les Girls* (1957), and *Some Like It Hot* (1959).

ABOVE AND OPPOSITE: Bette Davis in *Now, Voyager* (1942).

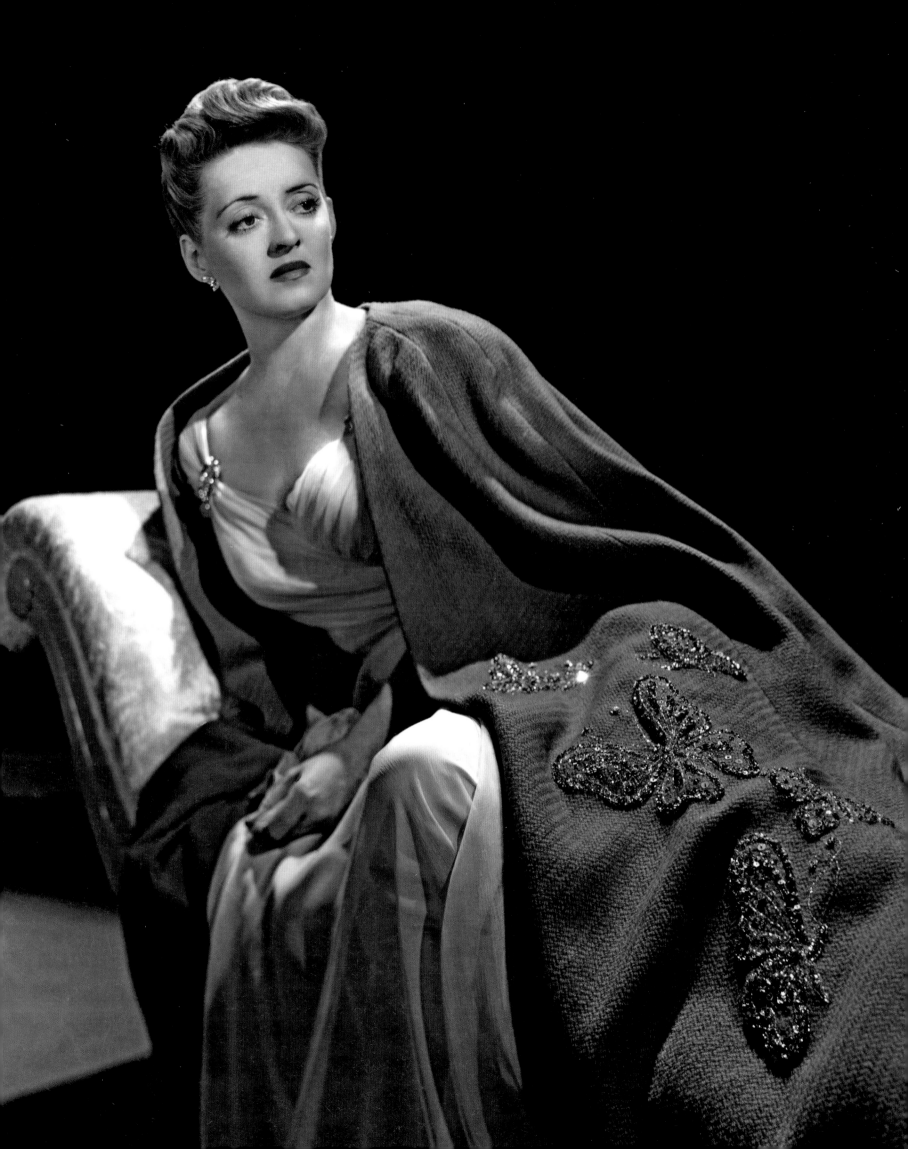

life. When Orry-Kelly refused to make additions, the publishers rejected the manuscript.

Orry-Kelly was designing for Kim Novak in *Kiss Me, Stupid* when he died in Hollywood on February 27, 1964, of liver cancer. In the days leading up to his death, his friend Ann Warner said Orry-Kelly was in a "blessed coma" and "talking to his old friends Fanny Brice, Ethel Barrymore, and Errol Flynn." Joan Blondell was one of his last visitors and Orry-Kelly called her by his nickname for her, "Rosebud."

"He made us all more beautiful than any of us had a right to be," Blondell told the press after his death. His pallbearers included George Cukor, Tony Curtis, Billy Wilder, and, in a last gesture of friendship toward the designer, Cary Grant.

ABOVE, LEFT TO RIGHT: Ingrid Bergman in *Casablanca* (1942). · Joan Fontaine in *Ivy* (1947).

OPPOSITE: Orry-Kelly fits Marilyn Monroe for *Some Like It Hot* (1959).

ABOVE: Tony Curtis and Jack Lemmon in *Some Like It Hot*.

OPPOSITE: Orry-Kelly confers with Natalie Wood during a fitting for *Gypsy* (1962).

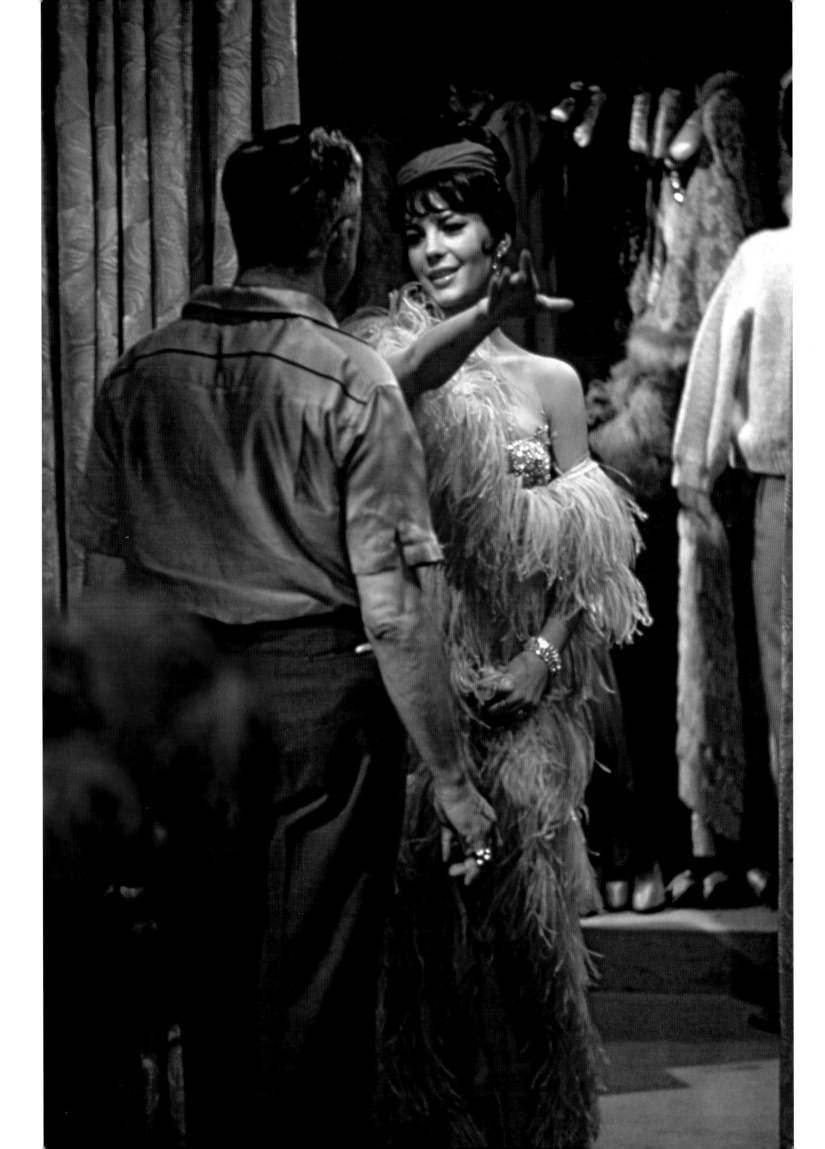

ROBERT KALLOCH

In the early morning hours of October 19, 1947, authorities were called to 4329 North Agnes Avenue, the North Hollywood residence of costume designer Robert Kalloch and his boyfriend, Joseph Demarais.

The latter had called for assistance, as his boyfriend of seventeen years had been suddenly stricken. Before he could be taken to a hospital, Kalloch died at 6:00 a.m. in his home. He was only fifty-four. Authorities responding to the emergency that morning had no way of knowing that they would be returning to the residence just a few hours later. At 3:15 p.m., Demarais also died in the Agnes Avenue home. He was forty-four.

The sudden and inexplicable death of Kalloch alone could have aroused some suspicion. After all, Demarais was the sole beneficiary of Kalloch's will. Kalloch had been the principle breadwinner, his salary as Columbia's head designer having financed the purchase of the residence in 1939, as well as the antiques and paintings that furnished it. Although Demarais had been on the studio's payroll as Kalloch's secretary, he had spent more time in rehab during the last few years than he had in assisting Kalloch. But any suspicions about Demarais's possible involvement in foul play disappeared upon his passing that afternoon. Still, a couple mysteriously dying on the same day seemed too improbable. The Los Angeles coroner ordered autopsies for both men. The results revealed that the simultaneous deaths happened purely by coincidence. Kalloch had been suffering from arteriosclerotic heart disease, triggering a fatal heart attack that morning. Today his condition could have likely been treated successfully with bypass surgery. Demarais, on the other hand, was found to be suffering from alcoholic fatty liver disease. He had simply drank himself to death.

While the timing of the deaths occurred by happenstance, the order of the deaths triggered a legal battle that would rage for four years. Kalloch's last will—a handwritten holographic document he had prepared without assistance of an attorney—left everything to Demarais. Because Demarais survived Kalloch, even for just nine hours, he inherited Kalloch's estate. Demarais had a will, but it was ineffective, as it left everything to Kalloch. With no contingent beneficiary named in Demarais's will, his estate, including the property he inherited from Kalloch, was postured for distribution to Demarais's heirs by law. Horrified at the specter of their nephew's estate passing to the family of his alcoholic lover, Kalloch's aunt and uncle filed a will contest, hoping to invalidate their nephew's will and to claim Kalloch's estate as his intestate heirs.

Like their deceased relatives, the competing families could not have been more different. Kalloch was born Robert Mero Kalloch III on January 3, 1893, in New York City, to Dr. Robert Mero

OPPOSITE: Irene Dunne in *The Awful Truth* (1937).

ABOVE: Robert Kalloch meets with Irene Dunne for *The Awful Truth*.

Kalloch II, a prominent dentist, and Emily Maguire. He enjoyed a thoroughly middle-class upbringing. He studied at Dwight School on the Upper Westside, and during his last three years there, also attended the New York School of Fine and Applied Arts. He passed the entrance examination for Yale University, but never attended. Instead Kalloch apprenticed as a dress designer at the New York branch of Lucile Ltd., where he began as a sketch artist in 1917.

In contrast to Kalloch, Demarais was born to dirt-poor French Canadian immigrants, Emile and Caroline Ouillette Demarais, in Tiverton, Rhode Island, on December 27, 1902. The youngest of five children, Demarais went by his middle name, Heliodore, as a youngster. Emile and Caroline worked in the local cotton mill. As soon as their children were old enough, they joined their parents at the mill as weavers. Eventually, Demarais left the looms to try to enter the New York City art scene, where he met Kalloch.

Being a decade older than Demarais, Kalloch was well established as a designer long before Demarais left the mill. Even before graduating from school, Kalloch was so confident in his artistry that he sought design work from his idol, Anna Pavlova, the famous Russian dancer. Because of his adoration for the artist, Kalloch waited night after night with his sketches at the stage door where Pavlova performed until he finally was able to make a presentation. Pavlova was impressed, and at age eighteen, Kalloch designed the costumes for an entire Pavlova ballet.

In 1919 and 1920, Kalloch worked at the London and Paris branches of Lucile Ltd., the couture house of British dressmaker Lady Duff-Gordon. Kalloch took his mother Emily abroad with him, "as otherwise his home life would be broken up," Lucile stated in her declaration in support of the Kallochs' joint passport applications. Emily had been widowed in 1915, and Kalloch maintained an unusually close relationship with his mother for the rest of her life.

During his year in Paris, Kalloch designed the costumes for the *Casino de Paris La Grande Revue* and studied the work of the city's great couturiers. After his year abroad, Kalloch returned to America and began working at the Madame Frances & Company Dressmakers in New York City. He worked for Frances for five years, during which time he and Madame Frances made twenty-eight trips to Europe to study fashion trends.

After leaving Frances, Kalloch worked for Hattie Carnegie for a year before Hollywood came calling in 1932. That year, Harry Cohn recruited Kalloch to become Columbia Pictures's first contract designer. Signing Kalloch was a great coup for the struggling studio. Since its founding in 1918, Columbia had been thinly capitalized and could only make low-budget pictures. The studio suffered from a small-time image, making it unable to attract any major stars for long-term contracts. To improve the image of Columbia, Cohn persuaded actresses like Irene Dunne, Nancy Carroll, Grace Moore, Lilian Harvey, and Fay Wray to star in his films. Kalloch was a double selling point for Cohn—the actresses he wanted to attract to the studio felt secure in having an accomplished New York designer dress them, and film magazines wanted to cover his sophisticated wardrobes for films.

Kalloch moved with Emily to 1355 N. Laurel Avenue in Los Angeles. Demarais followed Kalloch to Los Angeles and took an apartment a few miles away, on North Las Palmas in Hollywood. Although Kalloch and Demarais met in New York City, the timing of that first meeting is uncertain. By the late 1920s, Demarais was living in New York City, sharing an apartment with other struggling artists. He may have worked with Kalloch at Madame Frances, as his holographic will dated February 9, 1932, referenced his chattels stored at Madame Frances's salon on 54th Street in Manhattan. Whenever Demarais may have met Kalloch, by 1932 he was enamored of him enough to leave him his entire estate. Demarais wrote his will on stationery from the famous Westward Ho Hotel in downtown Phoenix while making his cross-country move to California. Although Demarais appears to have simply written his will while staying as a guest there, his will mentions leaving his entire estate "including real property here in Phoenix" to Kalloch.

During his first two years in Hollywood, Kalloch designed for nearly three dozen pictures, including Claudette Colbert's wardrobe for *It Happened One Night* (1934). After virtually sweeping the 1934 Oscars, *It Happened One Night* gave Columbia the respect that had eluded the studio for years and proved that Cohn's efforts to boost

Columbia's prestige and profits were working. Because of Cohn's dislike of period films, Kalloch was given plenty of opportunity to design sophisticated, contemporary wardrobes at Columbia, which always garnered publicity in the film magazines. Notwithstanding Kalloch's popularity with the press, Cohn insisted on checking his costume sketches for all his leading ladies to make quite sure that they were dressed "in good taste."

The blue-eyed designer was never seen without his round-lensed glasses and his silver cigarette case. He was rumored to suffer from phobias and neuroses, including the fear of riding seated upright in an automobile. To avoid panic attacks, he purportedly reclined in the backseat under a blanket. "Even Hollywood, which should be inured to idiosyncrasies, stands agape and agog," a reporter once wrote of Kalloch's peculiarities. That story focused on Kalloch's conversion of his spare room into a private home for his pet cat. "The walls are protected by ivy-covered chicken wire and the floor is covered with cushions designed for Tabby's comfort," the reporter wrote. "Tabby, by the way, is a very ordinary black alley cat—a stray that Kalloch picked up in Central Park. But she wears a solid gold collar now that would support the average family in comfort for many a week."

For all his quirks, Kalloch sounded amazingly "normal" when talking about his favorite actresses to dress. Take Carole Lombard. "Carole would look smart in a kitchen apron," Kalloch once said. "She has a way of wearing things that gives them style. She understands the value of line, and her clothes are always very, very simple, and correspondingly stunning. She loves daring clothes, cut so that people would gasp if that is in character with the part she is playing. She loves to shock people." Lombard not only liked to shock her audience, but her coworkers as well. "She says the most amusing things while being fitted," Kalloch said, "always a little naughty, and has us all in spasms of laughter. Risqué, of course, but very funny."

Just as Kalloch settled into his new career as costume designer, his mother died at their apartment on June 29, 1935. Perhaps because of her death, Kalloch returned to New York to rejoin Madame Frances for a year. Returning to Columbia after Madame Frances retired in 1936, Kalloch designed some of the studio's

OPPOSITE: Clark Gable and Claudette Colbert in *It Happened One Night* (1934).

OVERLEAF, LEFT TO RIGHT: Robert Kalloch fits actress Virginia Bruce. · Barbara Stanwyck in *Golden Boy* (1939).

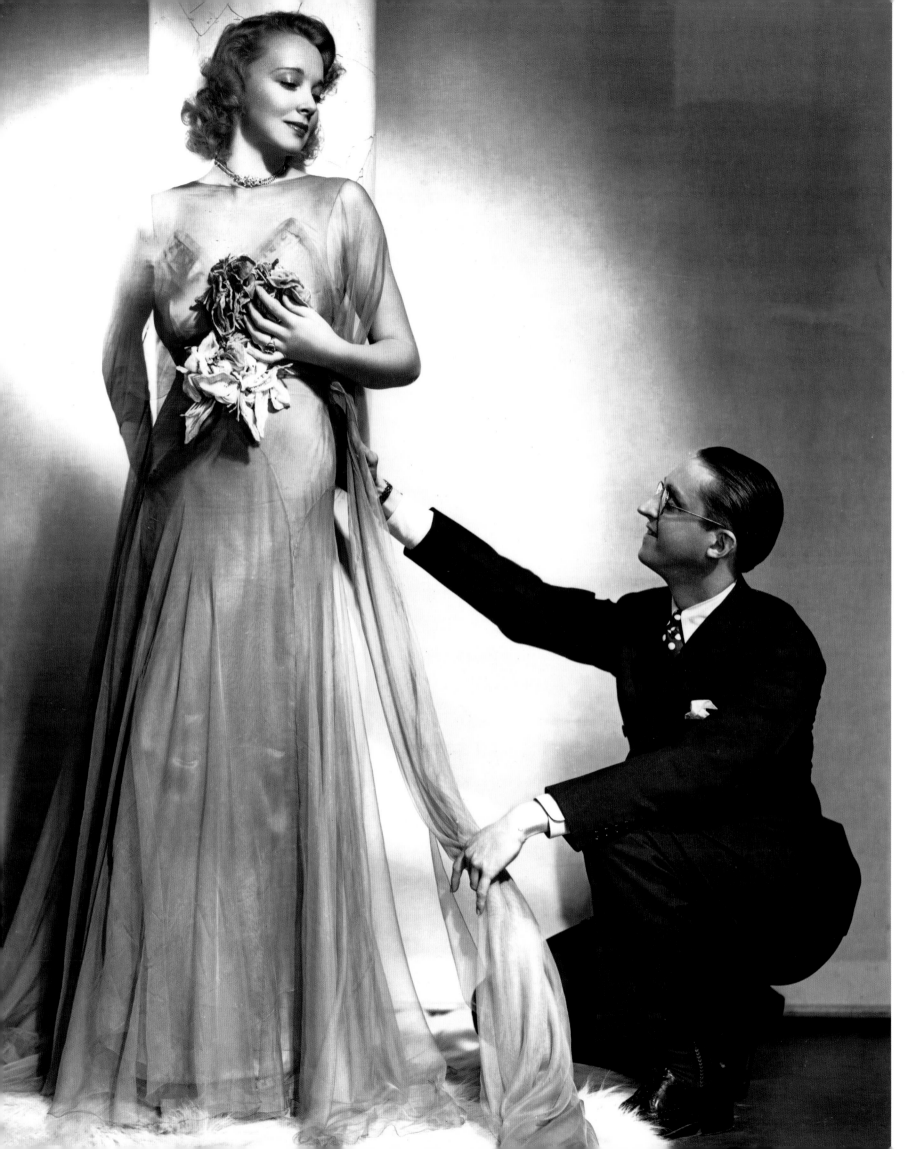

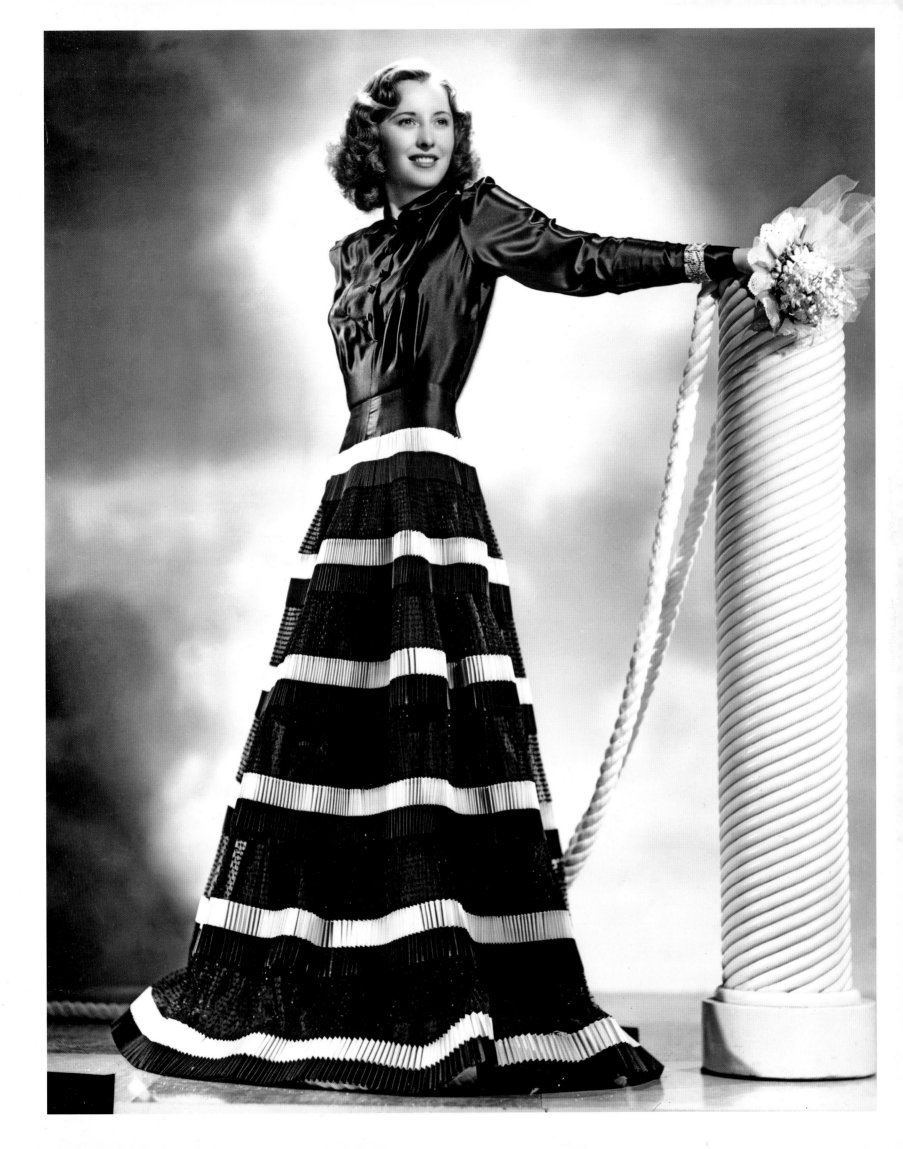

Ida Lupino
"Weather or No"

Dinner gown of garnet Lyons Velvet.
Skirt is thirty-five yards around at the hemline
Triple scallop edges low decolletage
Large puff sleeves - high back neck slashed from neck to waistline
Gold metallic ribbon bow on shoulder in place of flowers.
Gold kidskin sandals

Kalloch

most classic films, including *The Awful Truth* (1937), starring Irene Dunne and Cary Grant, *Mr. Smith Goes to Washington* (1939) with Jimmy Stewart, and *His Girl Friday* (1940), starring Cary Grant and Rosalind Russell.

Kalloch stayed at Columbia until 1941, when he left to replace Adrian at MGM. There, he designed costumes for Ann Sothern's character Maisie Ravier in *Ringside Maisie* (1941) and *Maisie Gets Her Man* (1942). That Brooklyn burlesque dancer character, originally intended for Jean Harlow, made Sothern a star. "Ann Sothern wants light colors and is always sure she doesn't look well if the dress is dark," Kalloch said of the comedienne. "She hates everything tight and won't wear a dress that binds her anywhere. She says she must feel comfortable or she can't work."

In October 1939, Kalloch and Demarais bought their Agnes Avenue residence. They paid $10,000 and took title as joint tenants. In the 1940 federal census, Demarais talked to the enumerator personally. He reported Kalloch's salary at "$5,000+," which was the highest income bracket used in the census that year. He listed his own salary as Kalloch's secretary at "$950." Demarais listed Kalloch as head of the household, and, surprisingly bold for the time, described his relationship to Kalloch as "partner."

Kalloch stayed at MGM for two years, designing for Judy Garland in *Babes on Broadway* (1941); Greer Garson in *Mrs. Miniver* (1942) and *Random Harvest* (1942); and Norma Shearer in *Her Cardboard Lover* (1942). After leaving MGM in 1942, Kalloch only designed two more films—*Suspense* (1946) for Warner Bros. and *Mr. Blandings Builds His Dream House* (1948) for RKO. The drop in Kalloch's professional productivity coincided with Demarais's personal decline. Beginning in 1941, Demarais was repeatedly placed in a convalescent home run by Georgia Anderson, in a quiet residential neighborhood in the Hollywood Hills. His stays were brief, lasting only three or four days at a time. If he finally did succeed in rehabilitating his drinking addiction during his last visit to Ms. Anderson's home in November of 1946, Demarais was never able to undo the damage to his liver, as his autopsy revealed eleven months later.

Within days of Kalloch's and Demarais's deaths, the Los Angeles Public Administrator opened probates for both men. At the time, no one in the Public Administrator's office knew the identity of Kalloch's or Demarais's heirs. Designer Travis Banton

stepped forward to advance more than half of the costs of Kalloch's funeral, an expense that Kalloch's estate never reimbursed. By May of the following year, Kalloch's heirs—Parker Kalloch and Anges K. Willis, who were the only surviving siblings of his now long-deceased father—filed a will contest, seeking to prevent their nephew's estate from passing to his boyfriend's brothers, Arthur and Emile Demarais, who had been found living in Rhode Island.

In a lapse of logical reasoning that seems risible today, Parker and Anges alleged in their pleadings that Demarais's relationship with Kalloch had done "great damage" to his reputation as a costume designer and concurrently argued that Kalloch had left his estate to Demarais solely because Demarais had "threatened to damage and impair" Kalloch's reputation—something they alleged had already occurred. Though Parker and Anges never expressly said that their nephew and Demarais had been lovers, the words they used in their pleadings to describe the relationship—a "strange attachment" induced by "unnatural flattery" that conferred upon Demarais a "strange power" over Kalloch—were unambiguous enough to keep the press from covering the dispute, as gay relationships were considered too obscene and immoral to be mentioned in newspapers of general circulation in the 1940s.

Negotiations continued for years. In a move that seems surprisingly progressive for the times, the Los Angeles Public Administrator opposed the contest, characterizing Kalloch and Demarais's relationship as one of "mutual trust, respect, and affection." Noting that the two men had mutual wills in place for nearly ten years prior to their deaths, the Public Administrator found no basis to invalidate Kalloch's last testament. Nonetheless, after four years of legal wrangling, Parker and Anges settled their contest out of court for a mere $750, which they divided among themselves and their attorney. Kalloch and Demarais's cumulative net estate—valued at $10,000 after taxes and creditors—was distributed to Demarais's two brothers. The two, who had labored in the cotton mill with their brother during their childhood, divided a sum valued in excess of $110,000 in 2015 dollars.

OPPOSITE: A Robert Kalloch sketch for Ida Lupino in *Let's Get Married* (1937).

WALTER PLUNKETT

Walter Plunkett, who will be forever remembered as the man who created more than five thousand designs for *Gone with the Wind* (1939), originally wanted to be an actor.

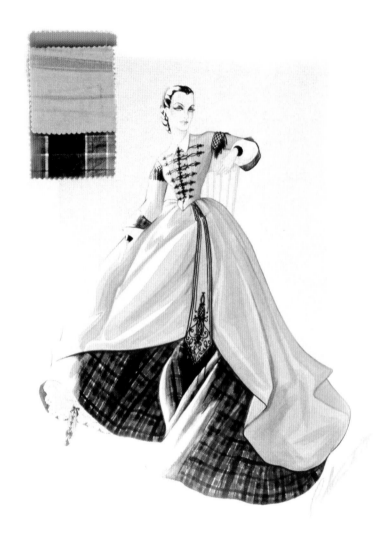

He discovered his love for the theater at an early age. He was born June 5, 1902, in Oakland, California, to James and Frances Plunkett. His parents took young Walter to stock company plays weekly. He never thought of acting himself until his high school English teacher encouraged him to try out for Oliver Goldsmith's *She Stoops to Conquer* during his senior year. Plunkett got the lead and that led to his entering a Shakespearean speech contest at Berkeley, where Professor Stanhope, university drama department head, signed him to do small parts in a Shakespearean repertory company.

Although Plunkett's parents fostered his love of theater, they never contemplated that he would seek a career in show business. Hoping that his studies would inspire him to enter law school, James induced his son to follow a pre-law curriculum. While studying, Plunkett acted in theater and did both scenery and costumes as well. Eventually, Plunkett found his legal studies "hopeless," and his father agreed that he should switch his major to English. During Plunkett's senior year, he signed with a local stock company, playing juvenile roles. Upon his graduation in 1923, Plunkett's father gave him a train ticket to New York. Unfortunately, the success Plunkett sought performing on Broadway eluded him. He returned to California in 1925, heading south to Hollywood.

Upon his arrival, Plunkett worked as an extra. He also did odd jobs in the arts, including advertising brochures for shops in Hollywood and costumes for dancers. He found one job particularly memorable. "A girl that I knew at the casting department at Fox said 'Walter, come to work tomorrow morning at women's wardrobe,'" Plunkett said. "She rather liked the way I doodled or something because I got there, and twelve perfectly beautiful girls who were all stripped to the waist came into the room. I was told that they thought it would be very vulgar to show them with their bare boobs, and they needed their nipples painted as roses."

Plunkett's fortunes changed when FBO Pictures tried to hire Howard Greer away from Paramount to organize its wardrobe department. Fortunately for Plunkett, FBO could not compete with Greer's Paramount salary. So Greer called Plunkett, and FBO offered Plunkett the position. The starting salary of $75 a week seemed like a tremendous amount of money to the young man, who had limited costuming experience.

"I worked on silent films trying to learn how to design costumes," Plunkett said. "I didn't know a thing about it. If I made a sketch of a pink costume, I went out and tried to find some pink

ABOVE: A Walter Plunkett costume sketch for Vivien Leigh in *Gone with the Wind* (1939).

OPPOSITE: Walter Plunkett and Olivia de Havilland on the set of *Gone with the Wind*.

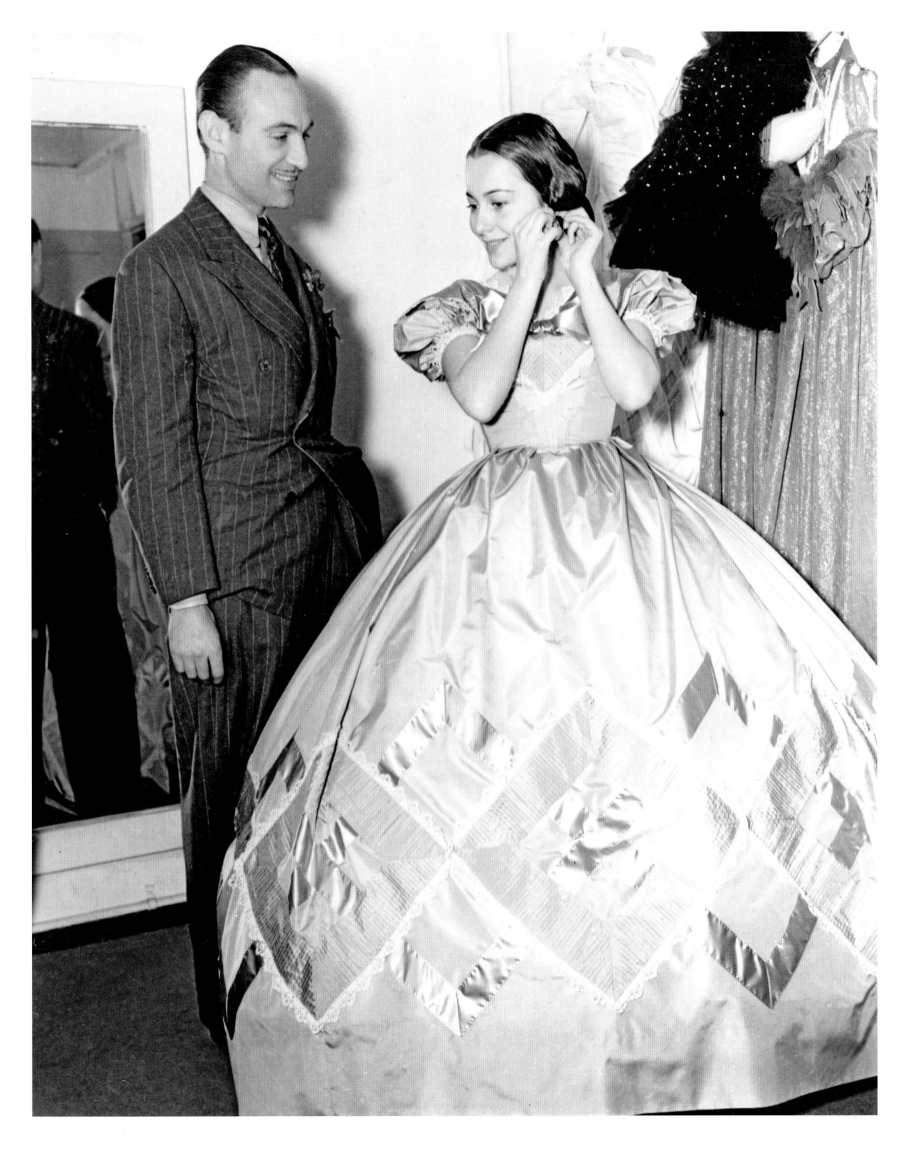

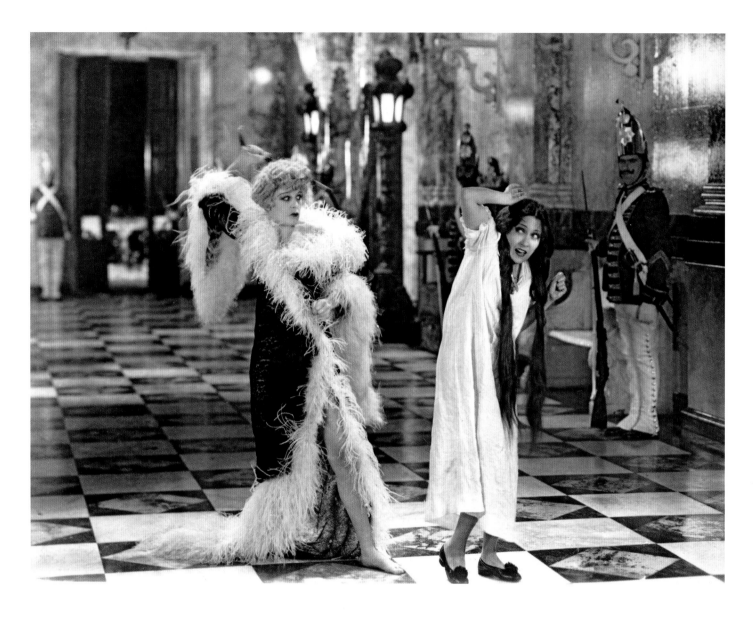

material. If it was oil cloth, chiffon, corduroy or felt, if it was the right shade of pink, I thought that would make the costume."

In 1926, Joseph P. Kennedy purchased FBO, and when sound came in, sold a major portion of the FBO stock to the Radio Corporation of America. In 1928, RCA merged FBO with Keith-Albee-Orpheum, and the studio became Radio-Keith-Orpheum (RKO).

Plunkett worked on Erich von Stroheim's *Queen Kelly* (1929), designing for Seena Owen, who played opposite Gloria Swanson. The film was made in the days before the Hays Code of censorship, and Plunkett put Owen in a transparent lace peignoir with nothing underneath.

After Plunkett's contract was assumed by RKO, he was introduced to Katharine Hepburn. "Right from the beginning, we seemed to click," Plunkett said. Plunkett's first design for Hepburn—the moth costume from *Christopher Strong* (1933)—was almost a disaster. Hepburn played an amateur aviatrix. "The natural thing for her to wear to a costume ball was to dress as a silver moth or something that would fly," Plunkett said. "I used little squares of metal. The seamstresses used pliers and screwdrivers and what not, instead of threads. It was fine in the fitting room. Kate adored it. It was beautiful. She got on the set and under the lights, the metal heated. The metal prongs dug into her flesh and they had to call off shooting. The costume came back and overnight we lined it with very, very thin soft silk velvet so that she could continue with it. Kate never held it against me."

Plunkett became more than a designer to Hepburn. He recalled helping her avidly research her character Jo for *Little Women* (1933). "She came to me and asked me for whatever information I could give her about the period," Plunkett said. "We read *Godey's* magazines together. She wanted to know what kind of poetry a girl at that period would read, what kind of recipes, what food would

she eat, what would amuse and entertain her. I made her a false little corset and hoop skirt so that she could get used to wearing the costume and pretend that she was in costume. One morning Kate phoned me and said 'Plunkett, my God, we've got it made. I went to the john this morning and forgot I had my hoop skirt on.'"

For *The Gay Divorcee* (1934), Plunkett was assigned to Ginger Rogers, who he would later say had "the worst taste" of anyone in films. Rogers had a tendency to add tacky things to her presentation, like an artificial flower pin in her hair or too many bracelets on her wrists. Even after getting Rogers's approval on his sketches, he had to check the costume on her each morning before she got to the set to confiscate any of Rogers's last-minute embellishments.

In 1935, Plunkett left RKO. Studio heads had refused to give him a contract with guaranteed screen credit. Instead, he was to remain relegated to asking each producer for credit on a film-by-film basis. Often his credit had been given to Max Ree, another

RKO designer. Further, RKO's best projects were then going to Bernard Newman, and the new contract did not even include a pay raise.

Plunkett went to New York to design a ready-to-wear collection on Seventh Avenue. But he would not be gone from Hollywood for long. Katharine Hepburn insisted that Plunkett design for her for *Mary of Scotland* (1936). Plunkett ended up staying in Los Angeles and worked on several films, including *A Woman Rebels* (1936) and *Quality Street* (1937), both with Hepburn.

OPPOSITE: Seena Owen whips Gloria Swanson in *Queen Kelly* (1929).

ABOVE LEFT: (l-r) Jean Parker, Joan Bennett, Spring Byington, Katharine Hepburn, and Frances Dee in *Little Women* (1933).

ABOVE RIGHT: A Walter Plunkett costume sketch for Ginger Rogers in *The Gay Divorcee* (1934).

If *Mary of Scotland* had not lured Plunkett back to Los Angeles, David O. Selznick's next project would have. Plunkett had first worked with Selznick in 1933 on *Little Women*. When Plunkett learned that the producer had obtained the rights to *Gone with the Wind*, he sought the wardrobe assignment immediately. "I wrote a note to David and said 'Please, when you are thinking of a designer, please consider me,'" Plunkett said. He got the job, but the script for *Gone with the Wind* still was not finished, so Plunkett worked on a few dresses for Carole Lombard in *Nothing Sacred* (1937), as well as clothes for *The Hunchback of Notre Dame* (1939), *Abe Lincoln in Illinois* (1940), and *The Story of Vernon and Irene Castle* (1939). Little did Plunkett know that the last of those films, a biopic about the famous dancing duo of the early 1900s, would give rise to a wardrobe clash that ultimately left him more amused than battered.

When he began designing the costumes for *Castle* star Ginger Rogers, no one told Plunkett that Irene Castle's contract had authorized RKO to make a film based on her life *provided* that Castle could be on-set at all times, have approval over all aspects of the film—even the final edit—and be allowed to design the clothes. When Castle arrived in Los Angeles at the start of production, she was outraged to find that Plunkett had already designed the costumes, though some were still in the process of being

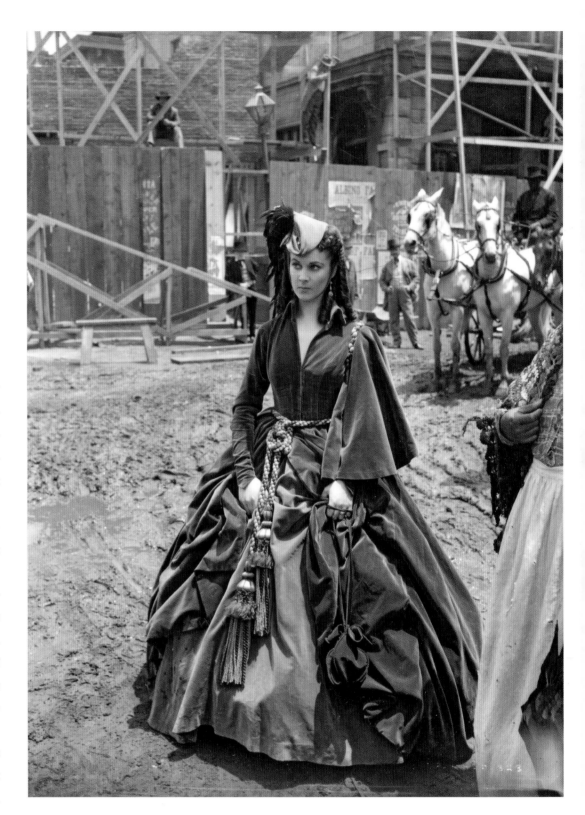

made. Castle took over costuming, insisting that she oversee the final fittings on every one of Rogers's dresses. Having no faith in Castle's design abilities, Plunkett and Rogers met in secret the night before Castle's fittings. Plunkett's fitters would mark the changes to be made, but not make the alterations. Rogers's secretary would take notes so that Rogers could suggest the same alterations to Castle during the final fittings.

RKO asked Plunkett to give up his design credit to Castle, and he agreed. But Castle was not appeased. She viewed Plunkett

as being in her way and took a dislike to him. "She hated me so much," Plunkett said, "that she invented a word for anything that was wrong in the shop: 'Plunketty, isn't it?'" Plunkett was actually amused; he would use the expression himself for the rest of his life. "Whenever I see anything that's dreadful," he often quipped, "I say, 'Oh my God, it's Plunketty, isn't it?'"

When *Gone with the Wind* went into preproduction, Selznick proved to be relentlessly difficult to please. Throughout production, he continually penned critical, demoralizing memos to Plunkett's

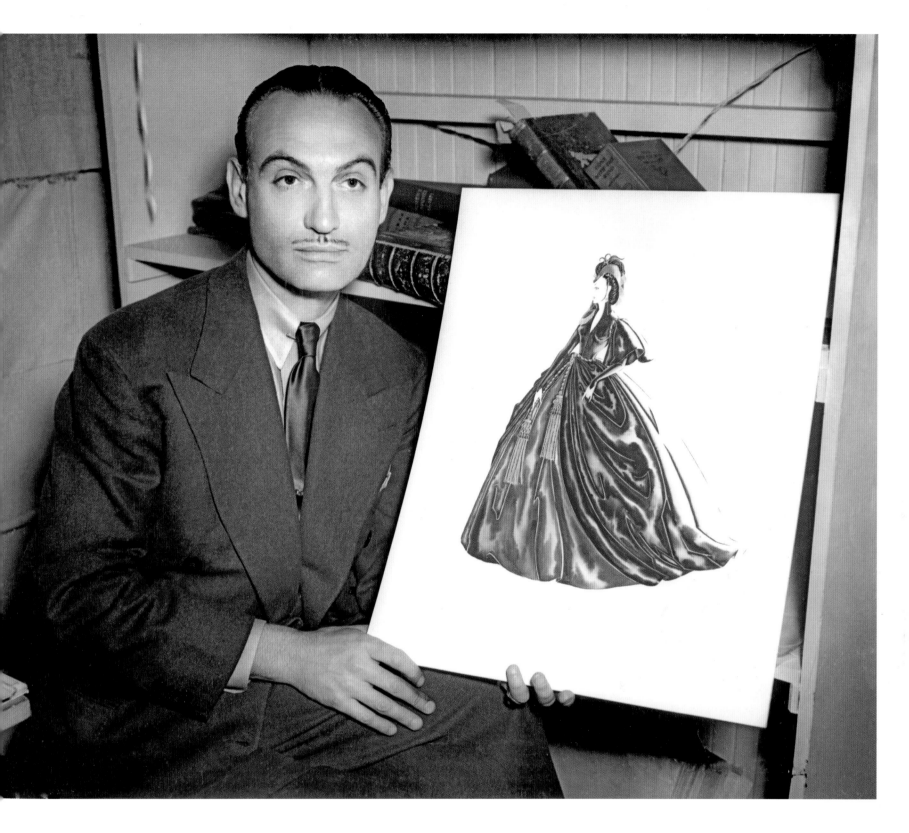

staff. Selznick's insulting tone astonished Plunkett, and to add to the injury, Selznick often sent copies to all department heads. When he threatened a re-shoot because of something Plunkett had designed, staff members would tell him they liked the design, and the re-shoot was soon forgotten.

When filming began on *Gone with the Wind*, Selznick was still searching for an actress to play Scarlett O'Hara. Paulette Goddard, Lana Turner, and many other actresses had tested for the role. Without the part cast, Plunkett had to design costumes with

no particular actress in mind. He relied on Margaret Mitchell's descriptions in her novel. When Vivien Leigh, then relatively unknown in the United States, was cast as Scarlett, Plunkett had his doubts. "She seemed like a sweet, demure, fragile woman," he

OPPOSITE: Vivien Leigh in the famous dress made from curtains in *Gone with the Wind*.

ABOVE: Walter Plunkett with the sketch of the green curtain dress from *Gone with the Wind*.

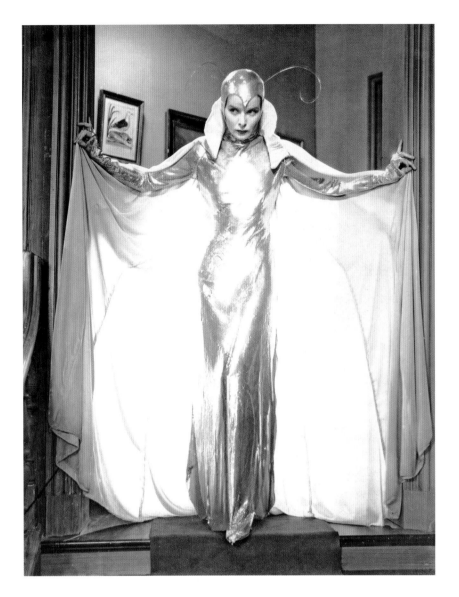

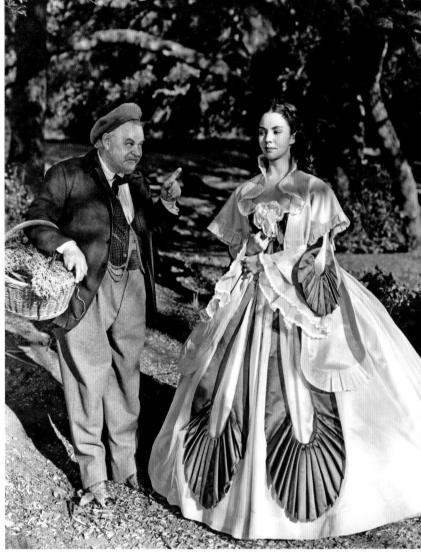

said. "But as soon as she stepped into the part, we realized that here was one terrific actress with the kind of temperament that almost uncannily matched that of Scarlett."

Plunkett initially believed, as did Selznick, that the audience would want to see the clothes on-screen as Mitchell had described them in the novel. But Plunkett's design instincts led him to abandon a strictly dogmatic approach. "Mitchell had said that when Scarlett went to Melanie's party, Rhett told her to wear her bright green dress," Plunkett said. "David [Selznick] had said, 'Don't change a thing from what Margaret Mitchell has written. It must be that way.' I said, 'She's been in green in almost every important sequence. This scene calls for a red dress and not a green one. It just cannot be green again.' So he said, 'Well, not without Margaret Mitchell's permission.' So we had to phone Margaret, and she said she didn't know that she'd always said she was in green. She said, 'My God, of course red would be better than that.'"

Ironically, the design restrictions imposed on Plunkett by the historical austerity of the Civil War resulted in one of the most famous dresses in film history—the green dress that Scarlett fashions from her mother's drapes. Plunkett sketched the design before Selznick fired George Cukor as director. While Cukor was emphatic about wanting something "unusual," Plunkett was required to make at least four sketches before he achieved the effect Cukor wanted. Selznick ultimately approved the design. That dress was "not the best costume of motion pictures, not by a long shot," Plunkett once said, "but I am very happy to think it is the most famous costume. There's hardly a day goes by that you don't hear somebody talking about pulling down the curtains to make a dress or something of that nature. So I'm proud that it was mine."

Selznick's enormous publicity machine to promote *Gone with the Wind* proved disastrous for Plunkett. "He thought it was to his

advantage to say that the clothes for *Gone with the Wind* were the most expensive clothes ever made for a film, and Plunkett was the most extravagant and costly designer," Plunkett said. "After we finished the film, I went out looking for a job, and nobody wanted to touch me. After quite a little while, Joan Blondell had a film coming up and she had control of who they hired, so she asked for me. She didn't care how expensive I was—which wasn't true by the way—Selznick had cut my salary."

According to Plunkett, Mae West gave him the most eye-popping introductory meeting of his career. West contacted Plunkett to design *The Heat's On* (1943). The diminutive star (barely five feet tall) had been one of the highest-paid actresses of the 1930s. Most of her fans did not know that she had short legs and always wore eight-inch platform shoes that created what Plunkett called the "Mae West walk." When he arrived for his first meeting, West's maid asked Plunkett to wait, as West was not quite ready.

"Pretty soon the maid came in again and said Miss West was ready to see me," Plunket recalled. West entered the room wearing long eyelashes, her trademark long blonde wig, her platform shoes... and nothing else! "I thought you'd like to see the lovely body you're going to have the opportunity of dressing," West told the stunned designer.

In light of Plunkett's rancorous experience with Selznick on *Gone with the Wind*, another collaboration seemed improbable. Seven years after *Gone with the Wind*, Selznick held a contest among Hollywood's top designers, to design *Duel in the Sun*

OPPOSITE, LEFT TO RIGHT: Katharine Hepburn in *Christopher Strong* (1933). • Jennifer Jones (right) in *Madame Bovary* (1949).

ABOVE, LEFT TO RIGHT: Walter Plunkett and Ginger Rogers attend the after-party for the premiere of *Gone with the Wind*. • A Walter Plunkett costume sketch for Ruth Gordon as Mary Todd Lincoln in *Abe Lincoln in Illinois* (1940).

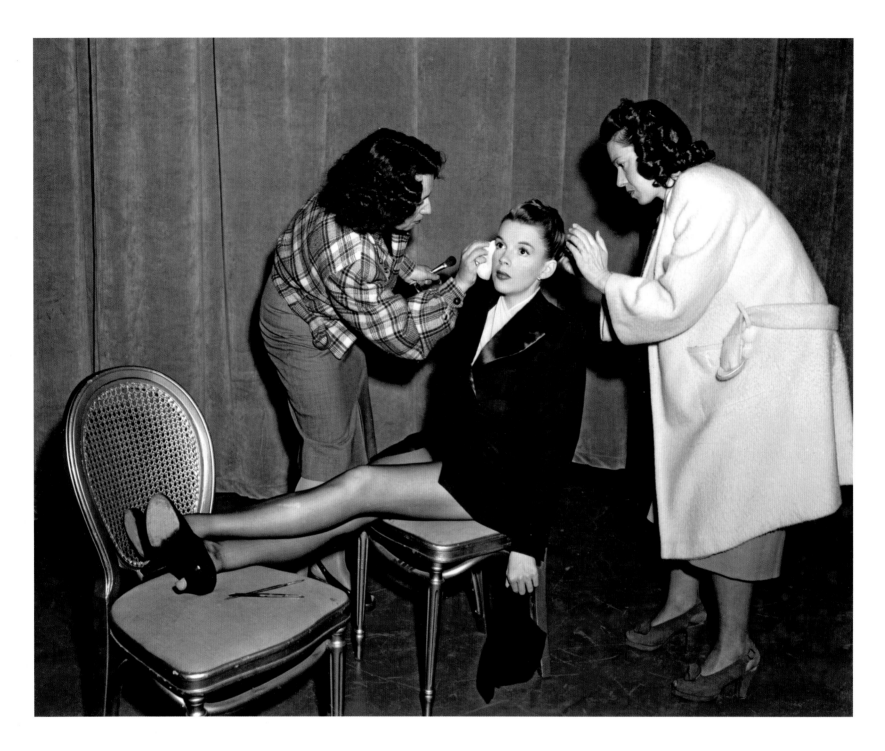

(1946). Designers were given a synopsis of the film and told to submit sketches. Plunkett was insulted by Selznick's invitation to compete. He had an established relationship with the producer and believed that Selznick should have instinctively known he would turn in good work. Plunkett sent Selznick a letter that Selznick had written at the end of production of *Gone with the Wind* stating that Plunkett's costuming had been one of the best jobs ever done for a film. With a copy of that letter, Plunkett included a note apologizing for not having time to create new sketches for *Duel in the Sun* and stating that the Selznick letter was his submission. The next day, Selznick gave him the contract to design the film.

Production on *Duel in the Sun* lagged on past its initial completion date, even though all of the costumes had been finished on time. Plunkett grew tired of working on the film, and became increasingly agitated by Selznick's incessant complaining about a white dress that Plunkett designed for Jennifer Jones's character to wear to a party. Selznick's memos repeatedly asked why the

ABOVE: Judy Garland (center) wears the tuxedo jacket for *Summer Stock* (1950) that Walter Plunkett resurrected from a deleted scene in *Easter Parade* (1948), originally designed by Irene.

OPPOSITE: Ava Gardner in *Show Boat* (1951).

designer could not create something that Selznick liked. Plunkett had already submitted twenty sketches, and Selznick narrowed his choices to two or three. Even after Selznick settled on a design, he sent out yet another memo to the entire production staff upbraiding the designer. Plunkett had enough. After offering Selznick some choice words, the designer left his employ for good.

After Plunkett left Selznick International, Irene Lentz offered him a position at MGM during a meeting over lunch. Initially Plunkett balked at the offer, because he enjoyed freelancing. Irene told him that he could stay at home when he was not working. She dangled the carrot of a steady paycheck and told him that working at MGM was "a lovely experience." Plunkett accepted her offer.

Plunkett first designed for Judy Garland in *Summer Stock* (1950). She proved to be a challenge on many levels. Her weight was on the upswing. She had no waistline, and her hips seemed to start just under her bustline. Camouflaging Garland's shortcomings with simple clothes needed for the farm setting was nearly impossible. Further, Garland was on the verge of an emotional collapse, often coming in late or breaking down in tears on the set. One day, she failed to show up on the set. The whole company waited through the morning. Around noon, Garland called, apologizing and explaining that she was in San Diego. She was making her way to the studio as fast as she could get there. When she arrived, she was shaking. Because Plunkett had developed good rapport with Garland, he was asked to go to her dressing room to speak with her.

Plunkett asked Garland why a woman who was one of the most beloved and talented entertainers in film and music was so troubled. Garland recounted the events of the morning. She had come to work that day at 8:00 a.m. to report for makeup. As she drove toward the studio, she saw the Metro-Goldwyn-Mayer sign, and thought to herself. "Today, they will find you out." She looked at the sign again, and this time the letters appeared to say "You are a Fraud." Startled, Garland screamed, turned her car around without going on to the lot, and instead started toward San Diego.

Every day she came to work, she was sure she did not have a voice, Garland confided to Plunkett. Everything she did she felt was pushed and fake, and she feared that the studio was going to find out. She feared that music department staff would come to the set and stop the number she was performing because they had found out that she really could not sing, and they would suggest

getting a real singer to dub her number. Plunkett was able to calm Garland down, and eventually he got her out to the set. As Plunkett was leaving the stage, Garland stopped the shoot.

"Hey, Plunkett, wait a minute," she called out to the designer. "Are you the best goddamned costume designer in the world?"

"Well, hardly," Plunkett answered.

"That's the way I feel, 'hardly!' Don't you try to tell me how to have confidence in yourself."

Then she went back to filming.

Garland managed to complete filming and then went away to recuperate. MGM brass later decided that *Summer Stock* still needed one great blockbuster number. When Garland returned to perform the new number, "Get Happy," she had a thin, lovely figure. The weight fluctuations caused continuity problems, but her slim figure allowed Plunkett to resurrect a tuxedo jacket costume originally designed by Irene for *Easter Parade* (1948), but later cut from that film.

Singin' in the Rain (1952) brought Plunkett full-circle back to the period when he began his design career—the advent of sound films in the late 1920s. Plunkett seized on the outlandishness of silent-era gowns, replete with yards of fur and scores of feathers, to bring out the humor in the clothes. His pale green dress with crystal beads and pale green fox fur cape for Jean Hagen's portrayal of silent-screen star Lina Lamont recalled Plunkett's own design years earlier for actress Lilyan Tashman. Debbie Reynolds's "Dream of You" costume was Plunkett's send-up of the absurd settings and clothes that chorus girls of the period had to endure, most notably girls dancing on the wings of an airplane in *Flying Down to Rio* (1933).

In 1951, Louis B. Mayer was forced out of MGM, and Nicholas Schenck took over. Schenck replaced MGM's romantic lush fare with more serious message pictures. The studio no longer wanted designers under contract, and Plunkett was asked to work freelance as needed, which he did.

Plunkett's last films were *7 Women* (1966) for MGM and *Marriage on the Rocks* (1965) for Warner Bros., which were done concurrently. Plunkett checked the workroom at MGM early mornings and took the freeway to Warner Bros. for late

OPPOSITE: Kathryn Grayson and Howard Keel in *Kiss Me Kate* (1953).

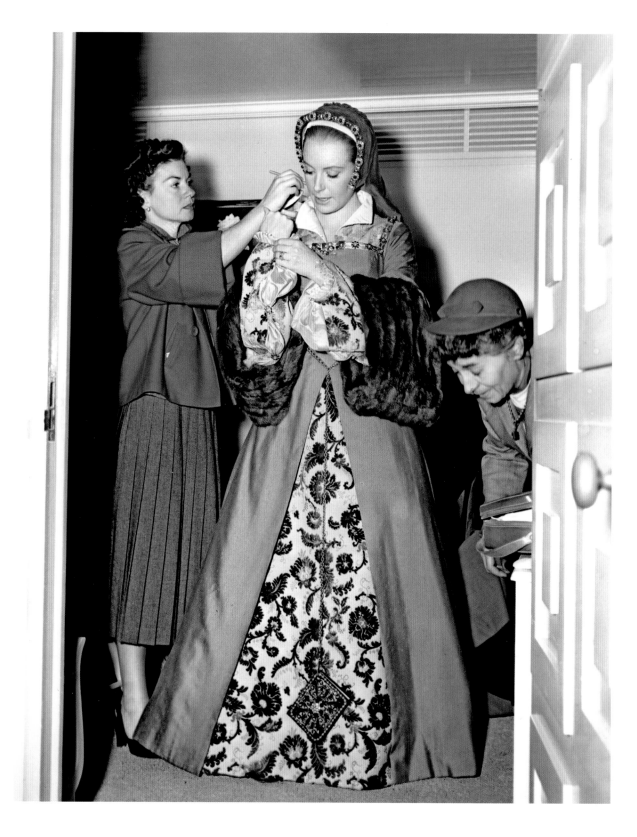

mornings. Then he would head back to MGM for the afternoons. In the middle of all that driving, Plunkett decided these would be his last two films. He told everybody on both sets, "This is it! Let's finish and then I'm going to go!"

Because of *Gone with the Wind*, Plunkett never faded into obscurity. He spent his later years traveling with his partner, Leigh, lecturing, giving interviews, and overseeing a retrospective of his work in Los Angeles. He repainted many of his costume sketches that had been lost over the years. In 1975, a set of lithographs of his *Gone with the Wind* sketches was published. Plunkett died March 8, 1982, in Santa Monica, California. He was eighty.

ABOVE: Deborah Kerr (center) is readied for a scene in *Young Bess* (1953).

OPPOSITE: A Wardrobe test for Leslie Nielsen in *Forbidden Planet* (1956).

WARDROBE STILL

PROD NO 1671 TITLE Forbidden Planet
ACTOR Nielson ROLE Adams
CHANGE NO_____ SCENE_____
SET_____

SYNOPSIS

Complete Space Uniform
Change #1

REMARKS

DESIGNER Plunkett COSTUMER_____
COLOR_____ B&W X DATE 3/3

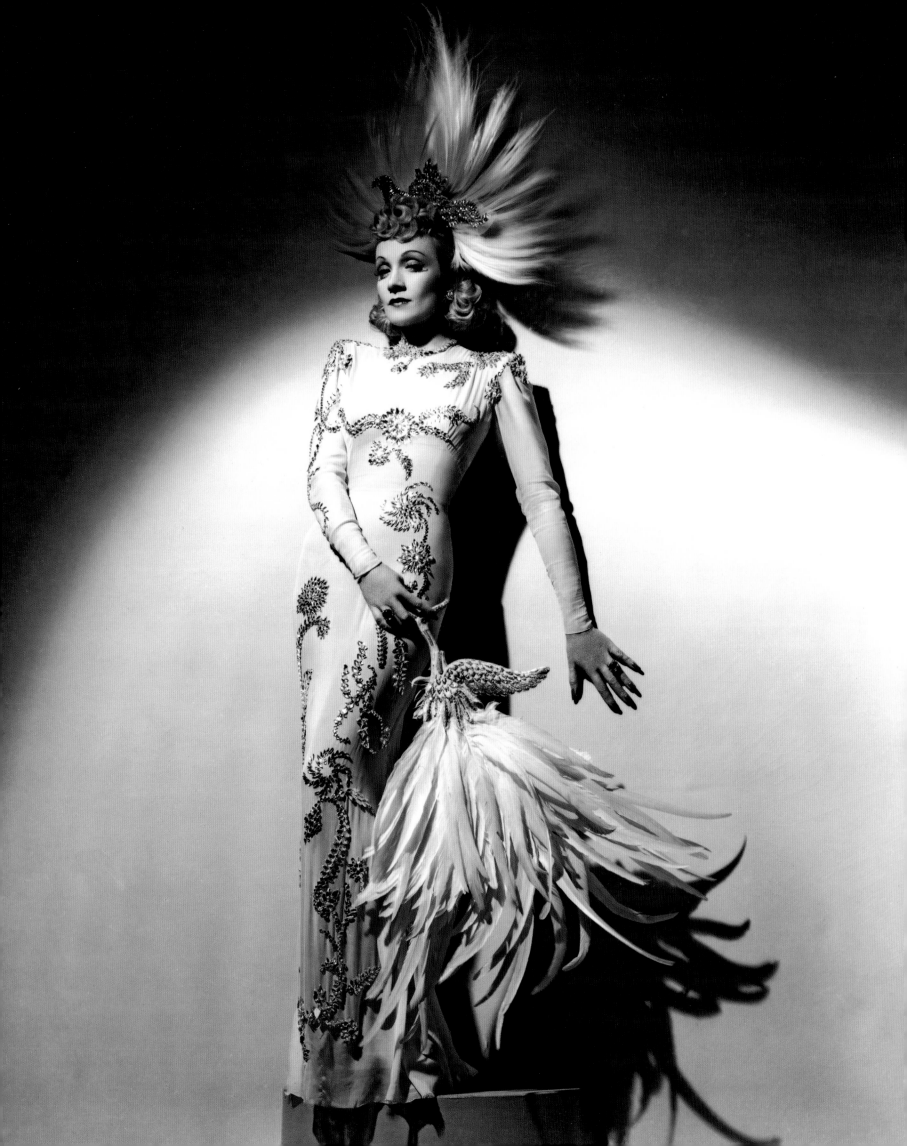

IRENE

On November 15, 1962, Irene Gibbons checked into the Knickerbocker Hotel, a hotspot where movie stars and Hollywood insiders alike hobnobbed regularly. She used a fake name and requested a room on the eleventh floor.

It was the Thursday of Fashion Week in Los Angeles, and her new collection had been well received just two days before. Soon after checking in, Irene opened the first of two bottles of vodka she had brought with her and began to compose two notes. "I am sorry to do this in this manner," she wrote. "Please see that Eliot is taken care of. Take care of the business and get someone very good to design. Love to all, Irene." In the second note, she tried to excuse her alcohol consumption to the other hotel guests. "Neighbors," she wrote, "Sorry I had to drink so much to get the courage to do this."

After almost finishing the second bottle of vodka, Irene removed the screen from her hotel bathroom window just after 3 o'clock in the afternoon. The sixty-one-year-old designer leaped from the eleventh floor of the hotel, landing on the roof of the hotel's extended ground floor. The coroner estimated that she lingered for several minutes before dying from "severe internal crushing injuries." Los Angeles police would later report that Irene had attempted to slash her wrists before jumping, though her death certificate makes no reference to such wounds.

The fashion world could not understand why the woman who had brought so much exquisite loveliness to the world had left it prematurely. But Hollywood insiders were less perplexed. "I knew it was coming," Irene's assistant, Adele Balkan, said. "Anybody who knew her knew it was coming. I don't think it was the first attempt. She wouldn't or couldn't help herself." During a forty-year career that most designers could only envy, Irene had her own salon in Los Angeles' top luxury department store, and dressed Hollywood's leading ladies in more than one hundred films. "She was a woman of great taste and great elegance and great talent," Balkan said, "and it all went down the drain."

She was born Irene Marie Lentz on December 15, 1901, in Brookings, South Dakota, to Emil and Maude Watters Lentz. Her family settled in Baker, Montana, in 1910, where Maude ran a general store and Emil dabbled in small-town politics. As a young girl, Irene dreamed of becoming a concert pianist; she mastered classical pieces by Debussy, Handel, Liszt, and Bach.

After high school graduation in 1919, Irene moved to Los Angeles with her mother and little brother, Kline. Her father also moved to Los Angeles, though he apparently never lived with the family again. Why the family moved west is uncertain. Irene later claimed that a drought had devastated her parents' cattle ranch, but this story contradicted her claim that she grew up in town working in her parents' general store. Upon their arrival in California, the Lentzes lived at 291 South Grand Avenue in downtown Los Angeles. Maude cleaned hotel rooms, and Irene worked as a saleslady in a drugstore. It was there in 1921 that she met handsome F. Richard Jones, a director at Mack Sennett's Keystone studio. The couple began dating. The initial romance ended quickly because Irene could not tolerate Jones's philandering. But he remained a helpful business contact. Because of Jones, Lentz worked as an extra at Keystone. A year later, Jones arranged for Lentz to work as a production assistant at Keystone, as well as to act in some films.

Still remembering her childhood dream of being a concert pianist, Irene enrolled in courses in music theory and composition at the University of Southern California. "Designing as a career never occurred to me then," she said. "I enjoyed planning my own wardrobes and helping with those of my friends, but making a business of it never did enter my mind. Instead, my entire ambitions were to be a concert pianist." A hometown friend persuaded Irene to take a class with her at Wolfe School of Design. "I agreed, not with a great deal of desire to be a designer, but simply to please her," Irene said. "After a few days, however, I was convinced that designing was the thing I wanted most to do."

OPPOSITE: Marlene Dietrich in *Seven Sinners* (1940).

Irene graduated from Wolfe in 1926, and with Jones's financial assistance, she opened a small dress shop near the University of Southern California. Her piano became part of the shop's decor. The store catered to students, and while the apparel was of good quality, Irene purposely eschewed expensive clothing. "The campus shop was a great success from the beginning," Irene said. "The dresses were cheap and I do think they had a certain flair." Irene would later claim, tongue-in-cheek, that her shop became a success because it was the only place on campus where girls could smoke. "Cigarettes were strictly against the rules everywhere else," Irene said. "So I always had a shop full of prospective clients, smoking. The place was so full of smoke so much of the time that my doctor would not believe it when I told him I did not smoke."

Soon ladies from the Wilshire District, Beverly Hills, and Hollywood were coming to her college shop. Dolores del Rio walked in one day and bought an evening gown for $45. "Many a woman would not have told a soul where she'd bought that dress," Irene said. "But Dolores told everybody she knew. After that, I got plenty of movie trade." Lupe Vélez soon became one of Irene's best customers. Consistent with her apparent innate drive to be in the spotlight, the "Mexican Spitfire" insisted on trying on dresses in the shop's main room, near the windows, rather than using a fitting room. "She always had a gallery," Irene said.

After the success of the first small store, Irene opened a larger salon on Highland Avenue in Los Angeles. A little over a year later, and after nearly a decade of on-again, off-again romance, Irene married Jones on September 20, 1929. With business at the store going well, a bright future seemed assured for the couple. Jones was becoming one of Hollywood's most successful filmmakers, directing Douglas Fairbanks in *The Gaucho* (1927) and Ronald

Colman in the early talkie *Bulldog Drummond* (1929). Tragically, and with little warning, Jones became ill and died of tuberculosis on December 14, 1930. His loss so devastated Irene that she never fully recovered emotionally. Even decades later, Irene would still openly lament his loss.

Irene closed her shop and went to Paris to visit her friend, actress Alice Terry. While there, Irene first learned about couture design by observing the local fashion houses. She returned to Los Angeles and opened a new shop on Sunset Boulevard in August 1931.

Ann Hodge, general manager at Bullocks Wilshire, the top luxury department store in Los Angeles, recognized the profit potential of bringing Irene's burgeoning celebrity clientele into her company. She orchestrated the opening of Irene's custom French-style salon in the store in 1933. Irene's clientele included some of Hollywood's biggest names—Irene Dunne, Helen Chandler, Dolores del Rio, Joan Bennett, Joan Crawford, Jeanette MacDonald, Norma Shearer, Jean Harlow, and Carole Lombard.

The local press was impressed. "Those of us who have watched Irene growing up, who have noted her progress each year, who have been amazed at her patience and diligence and energy, who have always believed in her artistry, are now pleased to make a low and sweeping bow before her upon her debut as one of the world's leading designers," one fashion critic wrote.

In 1934, Del Rio introduced Irene to her brother-in-law, Eliot Gibbons, a newspaper reporter and brother of MGM art director Cedric Gibbons. Irene and Gibbons shared a fondness of sports and flying, and Gibbons helped Irene obtain her pilot license. The couple married on September 27, 1935. That same year, Gibbons took a job as a screenwriter at MGM. The newlyweds had their challenges early on. Irene suffered a miscarriage in 1937 when she took a fall. Then in 1938, the couple made headlines when they were lost in deep snow drifts on the ski slopes of Badger Pass in Yosemite National Park for forty-eight hours. Fifty forest rangers and skiers searched for two days for the missing couple. The rangers found Eliot first, as he had set out for help. He led them back to Irene, who was found huddled at a campfire at the Bridal Veil Creek area. She had a sprained ankle, and rangers had to carry her out of the valley on a makeshift stretcher.

With Irene's customer base including actresses, the appearance of her gowns on-screen were inevitable. In 1932, they were featured in *The Animal Kingdom* with Ann Harding and Leslie Howard. Del Rio used her clothes in *Flying Down to Rio* (1933), and requested that RKO use Irene for all of her movies.

"When she has a showing of her creations, all of movieland is on hand," Jackie Martin wrote of one of Irene's 1939 showings at Bullocks Wilshire. "It was interesting to sit back and watch them arrive. First, the simply gorgeous Dolores del Rio. Then Paulette Goddard. Then quiet, unassuming Sandra Shaw—Mrs. Gary Cooper. Loretta Young. Oh oh—here comes La Dietrich. And Mrs. Leopold Stokowski, wife of the orchestra leader. Everybody was there but Garbo. While the models paraded around, the guests were served tea. Then, when it was over, what a rush down to Irene's beautiful salon! Glamour girls on the run—to reach Irene and get that simply divine creation before Marlene could!" Garbo had attended a fashion show the year before, concealed from the rest of the attendees by a door. The models paraded by for her exclusive view after they had exhibited their gowns for the rest of the patrons.

In the early 1940s, Irene was contributing gowns to nearly every film made by Marlene Dietrich, Rosalind Russell, and Claudette Colbert. So when Adrian left MGM and Robert Kalloch did not work out as his replacement, Louis B. Mayer's wife, Margaret, suggested that he consider Irene for the studio. Although Irene was unhappy with her financial arrangement with Bullocks Wilshire, Mayer's first offer in November 1941 did not impress her. After the attack on Pearl Harbor in December, Mayer felt his options narrowing. He met with Irene again. He agreed to her salary demands and allowed her to continue to design for a few private clients. Irene took six months to finish at Bullocks Wilshire and moved to MGM on July 1, 1942. "You're not going to like it because you're not going to be as independent as you are here," Balkan told Irene when she left Bullocks Wilshire. Balkan's advice was well informed; she had previously worked at studios.

Some wardrobe personnel instantly resented Irene, believing nepotism played a role in her hire at MGM, as her husband and brother-in-law both already worked there. Irene brought in

OPPOSITE: A young Irene Lentz appears with Ben Turpin in the Keystone comedy *Ten Dollars or Ten Days* (1924).

OVERLEAF, LEFT TO RIGHT: Loretta Young in *He Stayed for Breakfast* (1940). · Claudette Colbert in *Midnight* (1939).

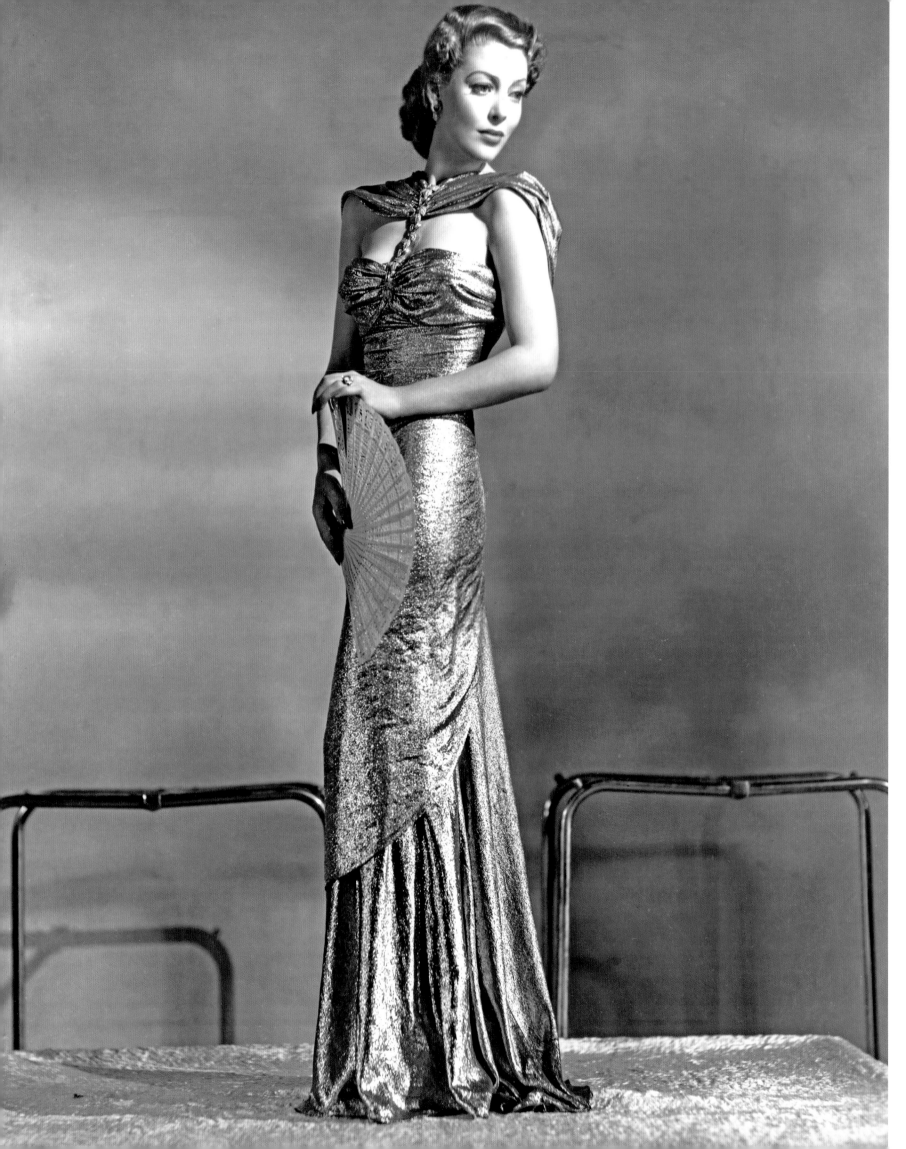

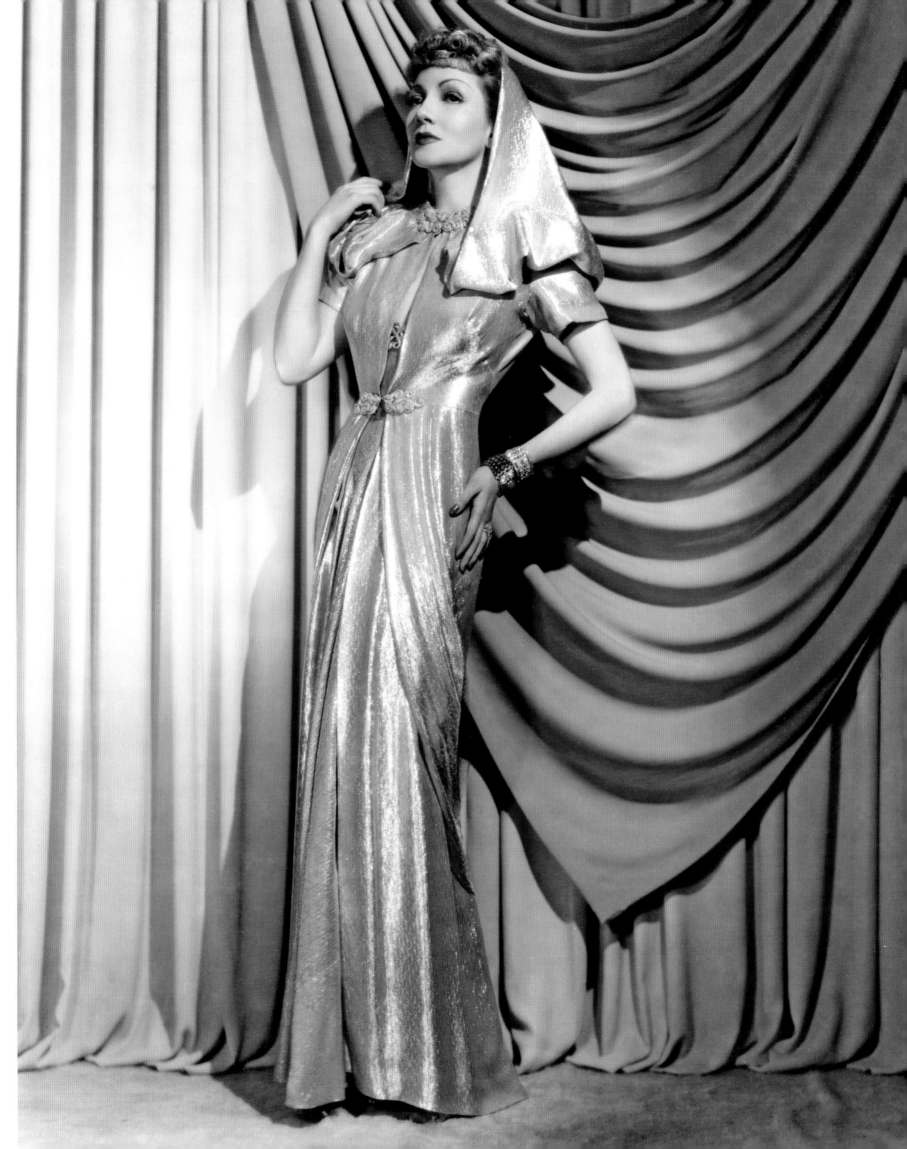

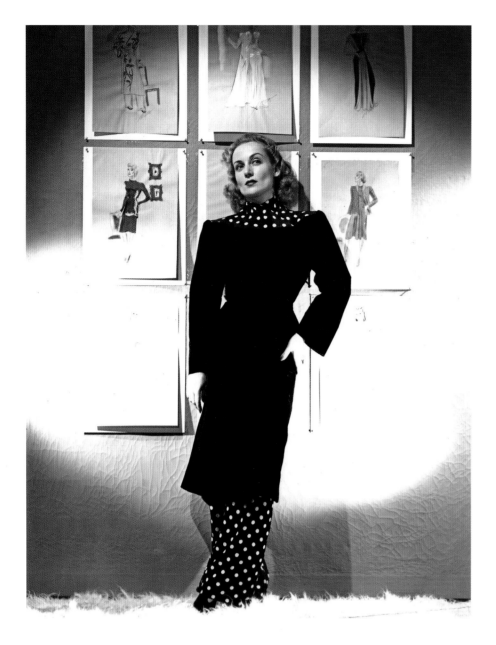

Irene a letter in May of 1944. "Dear Miss Irene," it read. "The other night I went to see *Gaslight*. I cannot tell you how much I enjoyed it, but most of all I want to tell you how wonderfully you have dressed Bergman. She was so superbly elegant—all the clothes, hats, details, were so perfect that I wanted to tell you, so that you would know how very much appreciated these clothes are as everybody that has seen the picture remarks about them and feels about them the same way I do."

As a designer, Irene found some actresses more desirable as a model for her creations than others. Joan Crawford and Esther Williams had broad shoulders and narrow hips and could wear Irene's suits better than, say, Donna Reed, who Irene assigned to her staff. "Those women had their own particular styles," Irene said. Irene assigned projects based on the script and which stars were involved in the project. She was proprietary over certain actresses, including Lana Turner and Barbara Stanwyck. The latter bestowed significant trust in Irene's style sense. Not until Irene urged her to do so did Stanwyck cut her long gray hair, even though long hair had been out of style for several years.

In September of 1946, Irene received the Neiman Marcus Award for Distinguished Service in the Field of Fashion. Receiving notification of the award early in the year may have rekindled Irene's desire to return to retail business when her contract with MGM expired. In January 1946, Irene asked Mayer if he would be willing to back her in the private venture. He refused, as she expected he would, but his refusal opened the way for Irene to approach investors elsewhere.

Irene secured financing for Irene Inc., from twenty-five department stores in exchange for the exclusive right to sell her clothes in their respective cities. She announced the news to the press before securing Mayer's permission. But the press reported that the venture was with Mayer's blessing, and that Irene would be cutting her studio design duties to eight to ten films a year. "This the kind of deal that Adrian wanted years ago," Hedda Hopper

Marion Herwood and Kay Dean to work on the period films. J. Arlington Valles and Gile Steele were already designing the men's costumes. Irene brought in Walter Plunkett because of his ability to design both period and men's costumes.

For *Gaslight* (1944), Irene lifted the period designs almost entirely from research, even posing with director George Cukor holding a copy of *Godey's Lady's Book*, documenting the source of the designs. "She's a person who cares nothing about clothes," Irene said of *Gaslight* star Ingrid Bergman. "She always dresses simply, and so she should. I wouldn't want to change her, not in any way. Everyone adores her. But when she stepped into the costumes of *Gaslight*, those lovely clothes of the 1880s, she looked as though she had always worn just such clothes. She was exactly right and so beautiful." Diana Vreeland, editor of *Harper's Bazaar*, was so impressed with the clothes from *Gaslight*, that she sent

ABOVE: Carole Lombard in *Mr. & Mrs. Smith* (1941).

OPPOSITE: Fred Astaire and Rita Hayworth in *You Were Never Lovelier* (1942).

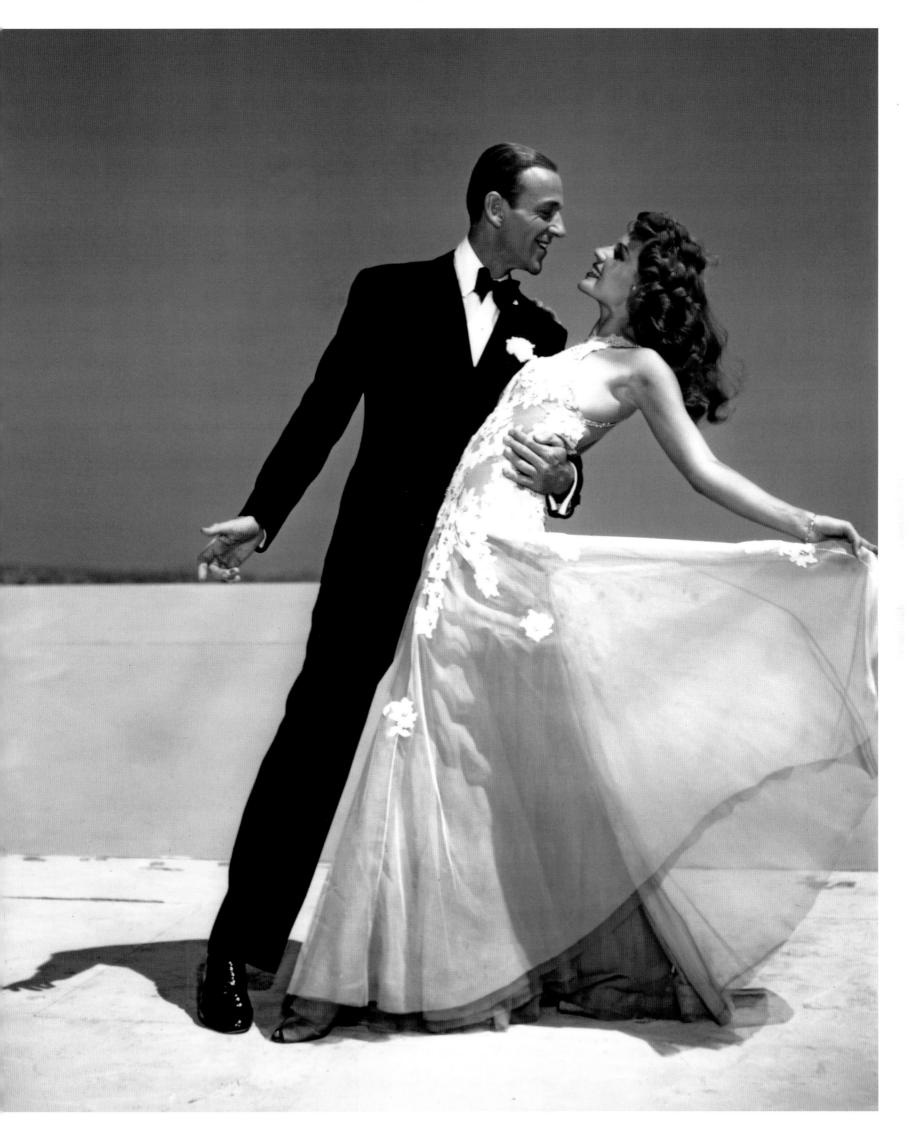

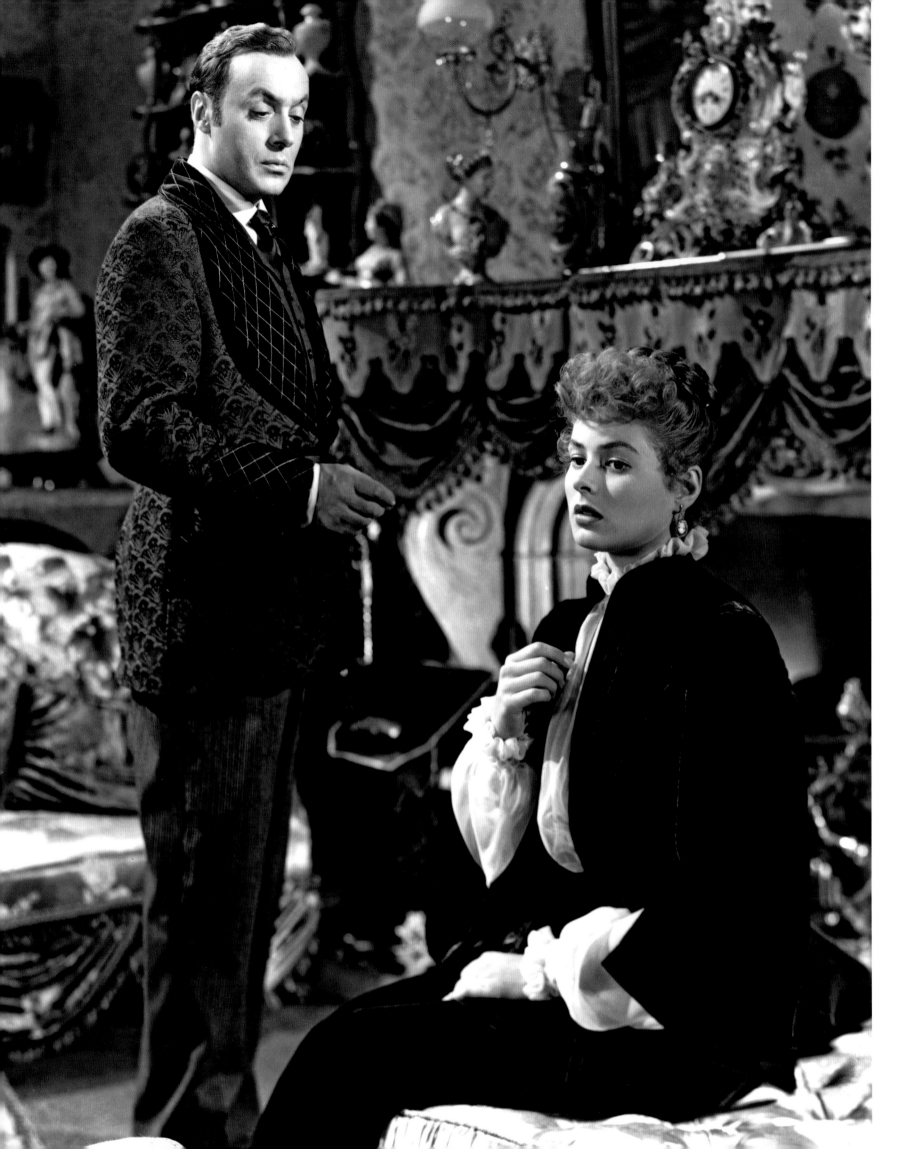

wrote, "but Metro wouldn't give. So he formed his own company, which has been a fabulous success."

Located at 3550 Hayden Avenue in Culver City, Irene Inc. was a three-minute drive from MGM's lot. Irene arrived at her factory at 7:30 a.m., and then commuted to MGM at 9:00 a.m. She took her lunch at the factory, then headed back to the studio to finish her day. During her tenure at MGM, Irene's long-hidden problem with drinking became more and more public. Irene had shown signs of alcoholism after the death of her first husband, and it remained an open secret among her friends and colleagues for years.

During World War II, Eliot Gibbons served as a captain in the U.S. Ferry Command. While Gibbons was absent on active duty, Irene took a small apartment in Westwood Village. Long periods went by when Irene had no idea where Gibbons was stationed. A chasm grew between them after he began an affair upon his return to Los Angeles. Irene's drinking increased, and late in 1946,

OPPOSITE: Charles Boyer and Ingrid Bergman in *Gaslight* (1944).

ABOVE: Director George Cukor and Irene look over a copy of *Godey's Lady's Book*, the inspiration for many of Irene's designs for Ingrid Bergman in *Gaslight*.

she was arrested for drunk driving. Mayer kept the incident out of the newspapers and ordered Irene into a clinic. The treatment had little effect.

In 1949, while working on *Adam's Rib* with Katharine Hepburn, tensions escalated quickly that resulted in Irene's dismissal from MGM. Hepburn and Irene had worked together previously on *Without Love* (1945) and *Undercurrent* (1946). Each time, Hepburn had rejected a great number of Irene's ideas and seemed hostile toward the designer. Irene never understood the actress's enmity. Hepburn even went so far as to hide Irene's designs when she appeared on-screen, covering one outfit with a bulky sweater and pulling a sheet up to her chin in another. When Hepburn arrived

for a fitting in May of 1949 and found Irene absent from her office, she complained to MGM's New York office. Irene's drinking and side business were preventing her from executing her job properly, Hepburn contended. The studio agreed. Irene's contract was terminated, with Mayer citing the morals clause, which allowed the studio to fire an employee for moral turpitude. Irene later told Travis Banton she had believed that going to MGM had been a mistake. "There was nothing I could say," Banton said. "She was right."

OPPOSITE: Marlene Dietrich and Irene on the set of *Kismet* (1944).
ABOVE: Lana Turner in *The Postman Always Rings Twice* (1946).

in a skilled nursing facility. Two years before her fatal plunge, Irene incurred permanent nerve damage to her face when she fell asleep against an electric blanket. A decade after the suicide, Day wrote in her autobiography that Irene had confided in her that she was in love with Gary Cooper. Day did not know whether the feelings had been returned or if the two ever had an affair. Irene had, in fact, been a close friend of the Cooper family and was devastated when he died of cancer on May 13, 1961.

Balkan blamed Irene Inc. for much of the designer's unhappiness. "The demands wore her down. The business wasn't what she wanted anymore," Balkan said. "The people who worked with her would scream at her when she'd get drunk because they were tired of it. They'd had enough of it too. She wouldn't go to Alcoholics Anonymous, naturally she just wasn't going to face it. She couldn't face the fact that she'd get up and tell people she was an alcoholic when the whole city knew it anyhow."

After her suicide, Alden Olds, president of Irene Inc., said the designer had been under "terrific strain" for some time. "She had been in ill health for about two years, and because of ill health, she did what she did, I'm convinced. She was a stalwart girl with a great deal of love for life, and this thing was just too much for her to bear."

"There is really nothing one can say about the sad end to the life of Irene, other than to repeat what many others have already said," a friend wrote to Alden Olds. "Unfortunately, in so many cases, it seems a truism that the tragedies of everyday life seem to haunt those whose basic qualities of character are above average. Somehow unhappiness in this sense rarely bothers the rogue and the opportunist. I guess this is just one of the paradoxes of creation. Yet, in a way, Irene, in spite of all the periods of depression, was an optimist and always looked to the future, perhaps at times with trepidation but always with hope."

ABOVE: An Irene sketch for Judy Garland in *In the Good Old Summertime* (1949).

OPPOSITE: Irene on the set of *In the Good Old Summertime* with a young Liza Minnelli.

Irene continued designing her collections for Irene Inc. and occasionally returned to films, designing for Doris Day in *Midnight Lace* (1960) and *Lover Come Back* (1961). Day had requested Irene for her films because of her great respect for Irene and appreciation of their friendship. Still, Day was anything but deferential to Irene. "Doris Day got her way, regardless," said Balkan, who returned to Irene to help her with the Day films. "Doris knew what Doris needed. Those were the days of the sleeveless dresses, and Doris knew that the sleeveless part should not be at the edge of her shoulder, but inside of it. It looked better. Doris was right, and Irene knew it in the end, but it's pretty hard to be the authority and then have it stepped on."

The 1960s brought nothing but heartache for Irene. Her estranged husband suffered several strokes, requiring his placement

CHARLES LE MAIRE

But for his passion to establish the Best Costume Design category for the Oscars, Charles Le Maire, supervising costume designer and head of the wardrobe department at 20th Century-Fox for sixteen years, would have never joined the Academy of Motion Picture Arts and Sciences.

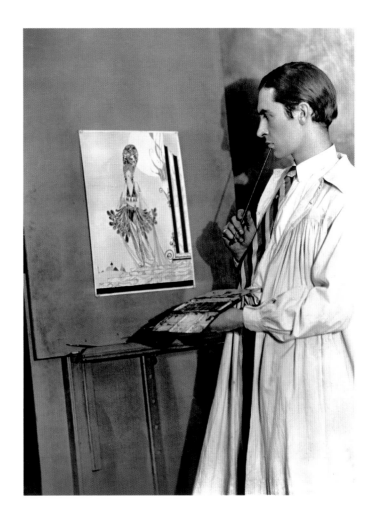

And given that he did not even like attending the Oscars ceremony, his quest seems all the more surprising. "I didn't want to go," Le Marie said of his first Academy Awards in 1946, "but I was a top executive at 20th Century [Fox], and I was supposed to be interested."

Following the ceremony, Le Maire approached Mervyn LeRoy, a member of the Academy. "Tell me, Mervyn," Le Maire began. "There were two or three pictures this year that were so beautifully costumed—God, they had such lovely clothes—and they didn't get anything at all. How come?"

"Now Charlie, don't start that," LeRoy answered. "We don't want any more classifications."

"What do you mean 'classification'?" Le Maire asked indignantly. "Costumes are not a 'classification.' Without costumes, you don't do pictures. If you stood a naked man on top of a hill and told him to open the Red Sea, who would know who he was if he didn't have a costume on?"

"Well, I know. I know," LeRoy conceded. Feeling trapped, LeRoy ended the conversation by telling Le Maire that he could not discuss the issue with a nonmember of the Academy.

"So I applied to be a member the next day," Le Maire said. "And that afternoon I got started. I got fourteen letters from stars and directors and people at 20th Century-Fox. The following day, I got twenty letters. Then I branched out to stars and people I knew, until I had something like 184 letters about how important costumes were to the industry." Le Maire put his pitch for the design category in a letter to Academy president Jean Hersholt. "I said to him that I insisted, as a member, that this letter be read at the directors' meeting," Le Maire said. "He read it, and without any trouble at all, they decided on it."

That was late 1946. Le Maire received his first Oscar five years after that in 1951, for *All About Eve* (1950). In all, Le Maire would garner three Oscars and thirteen nominations during his thirty-seven-year career.

Le Maire's journey to the top position in a major studio's wardrobe department was truly unique. Unlike many of his colleagues, Le Maire had no formal education in design. While many of his peers came to motion pictures as adventurous twentysomething upstarts, Le Maire was in his forties before he pursued a Hollywood career. And unlike most designers who

OPPOSITE: Jane Russell in *The Revolt of Mamie Stover* (1956).

ABOVE: Charles Le Maire as a young designer in New York in the 1920s.

695- Zoya
Slave Market.

June Whats

entered the industry somewhere near the bottom and worked their way up, Le Maire started at Fox as a top executive. This is not to say that Le Maire was unqualified for that position. He was, as evidenced by his success for sixteen years. But Fox executive William B. Goetz, who offered Le Maire the top spot, was not as interested in Le Maire's design portfolio as he was in Le Maire's willingness to solve a Goetz family problem, namely, what to do about Beatrice "Bee Bee" Goetz, the soon-to-be ex-wife of his brother, Harry. "Goetz wanted to leave her for a younger woman," designer Yvonne Wood told David Chierichetti, author and film historian. "She said she would go along with this if the studio found her an acceptable second husband that would be good enough to be a host at her parties—someone that could move with her in high society. So they gave Le Maire the job. He got the job at Fox because he married this woman."

Le Maire and the former Mrs. Goetz married in 1943, and Le Maire took the helm at Fox's wardrobe department that same year. The Le Maire marriage proved successful, lasting until Bee Bee's death in 1978. The couple enjoyed a mutual love of painting and held joint exhibitions in the later years. They built their Beverly Hills home to be a showcase for their own creations as well as the numerous pieces they collected during their thirty-five years together. All this stood in sharp contrast to Le Maire's humble beginnings. He was born on April 22, 1897, in Chicago, though

ABOVE, LEFT TO RIGHT: A Charles Le Maire sketch for Florenz Ziegfeld's stage production of *Rio Rita* (1927). · A Charles Le Maire costume sketch for *The Robe* (1953).

OPPOSITE: A wardrobe test for Anne Baxter in *All About Eve* (1950).

MANKIEWICZ A 597
ANNE BAXTER
AS "EVE"
CH #1
INT. DINING HALL
SARAH SIDDONS
SOCIETY — 1 to 40,
53 to 56, 80, 81, 135 to 145
EXT. PARK AVE — 146
INT. CORRIDOR OUTSIDE
EVE'S APT — 147
INT. EVE'S HOTEL
APT. — 148
3/5/50 DES
 LE MAIRE

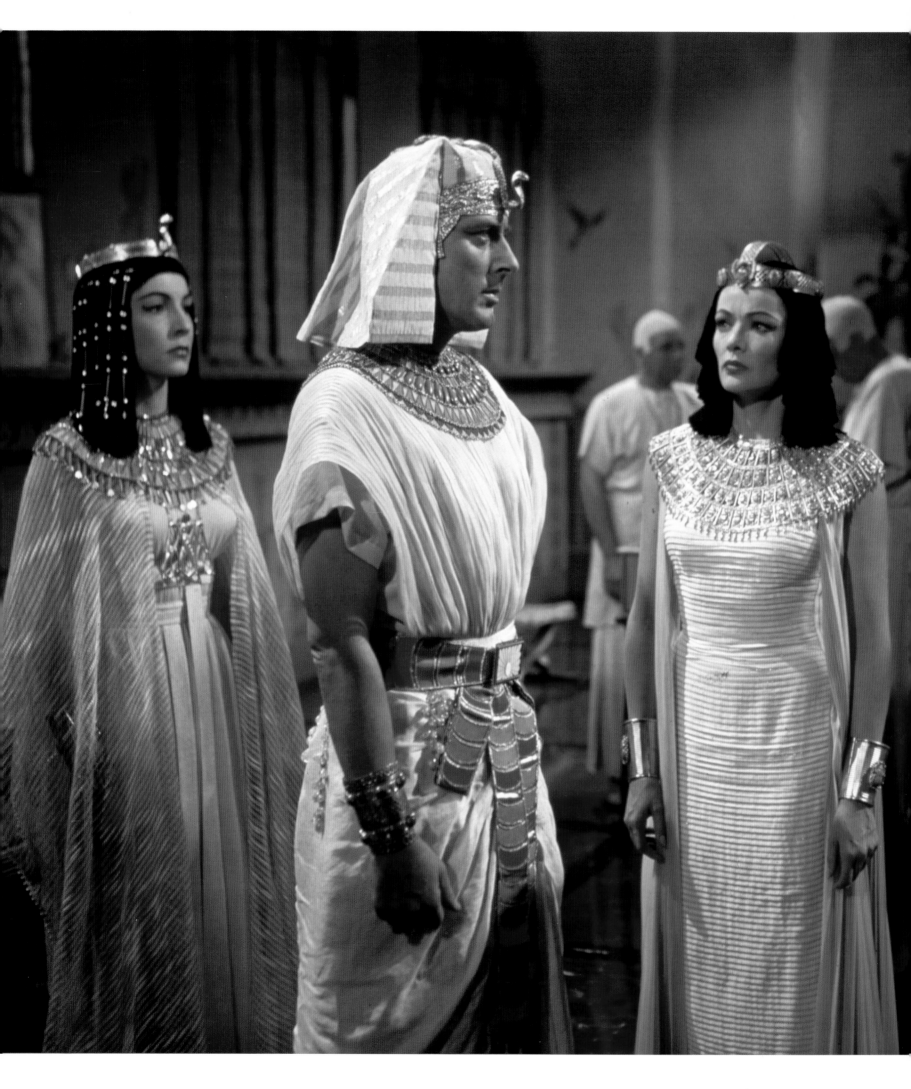

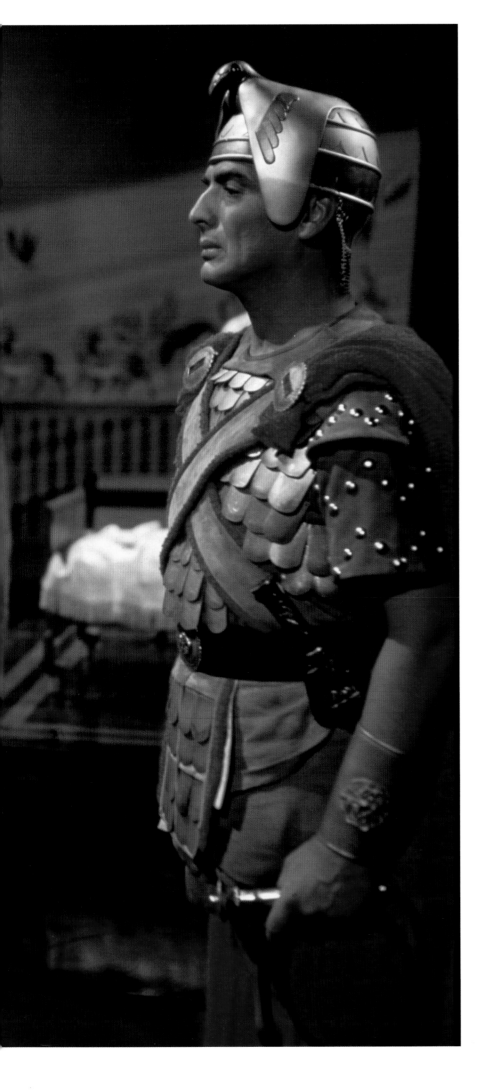

he did not grow up there. His working-class family moved often—first to St. Louis, then Denver, then Idaho Springs, Colorado, and back to Denver. Eventually the Le Maires settled in Salt Lake City. His father, Charles Sr., never made much money working as a head waiter at hotels, or later, managing restaurants. To make ends meet, Le Maire's mother, Lillie Vernier Le Maire, always took in boarders wherever the family lived. To do his part, young Le Maire worked at a soda fountain and gave dance lessons.

Early in 1919, Le Maire formed a duo with Walter Woolf King and began a tour of the Vaudeville circuit. When King was lured away with a better opportunity, Le Maire went to New York to perform as a juvenile in one of producer Boyd Wilson's acts. When that job ended and as the weather turned cold in November, Le Maire was running out of options. He had a small portfolio of what he called "awful little drawings" demonstrating how he could paint on fabric to simulate embroidery, a talent he had utilized on sachet pillows that his mother used to give as gifts. He made the rounds of potential customers in New York, but found few patrons interested in his services. Finally, Madame Sherri of Andre-Sherri, a theatrical costume company, recognized a spark of originality in his drawings. She offered Le Maire an apprenticeship. There, Le Maire designed costumes for the *Ziegfeld Follies*, George White's *Scandals*, and Earl Carroll's *Vanities*.

After moving to Brooks Costume Company, Le Maire received a telephone call from George White. White was in Fox producer Winifred Sheehan's office negotiating a contract for a film version of his *Scandals*. Although White had not spoken to Le Maire in months, he postured before Sheehan as if Le Maire had been waiting to get his call and was expecting the film assignment. Le Maire negotiated the contract on the spot. He obtained a terrific salary and was off to Hollywood to design *George White's Scandals* (1934). Le Maire returned to New York and designed both the stage and film versions of the Marx Brothers' smash-hit comedy *The Cocoanuts* (1929). In the early 1940s, as war clouds gathered over Europe, Le Maire enlisted in the army. He was assigned to Special Services, where he spent almost a year at Camp Kilmer in New Jersey decorating rooms and promoting entertainment to

RIGHT: (l-r) Michael Wilding, Gene Tierney, and Victor Mature in *The Egyptian* (1954).

lift the morale of the men. After his discharge, he got the call from Goetz at Fox.

Le Maire received a lukewarm reception from the Fox designers, including René Hubert and Yvonne Wood. He found the rumors about the department—poor organization, demoralized staff, employees drinking on the job—were true. After four weeks of observing operations, he called a staff meeting where he set down rules. No drinking on the lot. Punctuality and maintaining sanitary conditions were of the utmost importance. He invited any employee that could not comply with the rules to quit. Some did, which only helped Le Maire establish the order he sought.

Yvonne Wood was the first designer to depart under Le Maire's management. She simply did not like being told what to do, Le Maire said. He found René Hubert adept at costume pictures and musicals, but less strong in modern dress. His hires included

Bonnie Cashin, who brought a young attitude toward capes, coats, raincoats, and pocketbooks; William Travilla, who specialized in bombshells like Marilyn Monroe; Edward Stevenson and Renié Conley, both dependable designers who could do both modern and period clothes; Adele Palmer, who had handled westerns so adeptly at Republic; and Kay Nelson, whose strength was modern clothes.

Sometimes, to avoid allegations of favoritism among his staff, Le Maire assigned himself to a film if too many designers were expecting to get the job. That may have been why he assigned himself to *All About Eve* (1950), although Le Maire would later claim that Zanuck had simply asked him to do it. *All About Eve* led to Le Maire's first Oscar, which he shared with Edith Head. The two joining together to collaborate on the film was pure happenstance. Before filming began, Claudette Colbert, who had been cast as Margo Channing, was hospitalized with a ruptured

disk. When Bette Davis was chosen to replace Colbert, she was still shooting *Payment on Demand* (1951) at RKO. Davis suggested that Head do her clothes because RKO was right next to Paramount, and they could fit the clothes between filming scenes.

While Head dressed the screen veteran, Le Maire designed for the rest of the cast, including a then relatively unknown Marilyn Monroe. During casting, he got a call from Zanuck's office telling him that they were sending over a pretty blonde to test the next day for the part of Miss Caswell. Le Maire remembered Monroe. She had been an extra and chorine at Fox before going to MGM to take a small role in *The Asphalt Jungle* (1950). Le Maire did not have anything in stock that fit Marilyn physically or that fit her character. Because he believed Monroe was right for the part, he asked Zanuck for an extra day to design the dress that she would actually wear in the film, if she got the part. Zanuck agreed to wait.

"Marilyn could turn on the star quality like a switch," Le Maire once said. "And when she turned it on, there was nothing like it. I could show you a hundred actresses who were more beautiful, had better figures and always arrived on time, but none had a trace of what Marilyn had." One of Le Maire's favorite Monroe stories involved a gold lamé dress that he had lent her from her screen wardrobe for a special award function. "It was a very tight fit," Le Maire recalled, "and I told her to be sure to wear some underclothes so that the dress would look well." Monroe wore the dress, but without any undergarments. "Every bit of her was wriggling in different directions," Le Maire said. "She made quite an entrance." Later, when Le Maire admonished the megastar for not following his advice, Monroe said, "I'm sorry, Mr. Le Maire. It just wasn't comfortable with underwear on."

Le Maire won his next Oscar for *Love Is a Many Splendored Thing* (1955). His creations for star Jennifer Jones garnered the attention of more than just Academy voting members. When Le Maire threw a party for Pierre Balmain during his visit to Hollywood that year, attendees Hedda Hopper and Louella Parsons both scolded the French couturier for the recent French influence of straight dresses with no belts. Women of a certain age like to have belts, both columnists said. "Don't blame me for the trend," Balmain told Hopper, "blame the host of the party, Charles

Le Maire." When *Love Is a Many Splendored Thing* opened in Paris all the designers went to see it. They had been considering the Oriental and the relaxed look for a long time, Balmain explained, and the film swayed them to adapt the look in their collections. Both columnists later teased Le Maire that he should be ashamed of himself for this unwelcomed trend.

Le Maire's thirteen Oscar nominations were sometimes controversial. As department head, he was nominated alongside the staff member who actually designed the films. "Generally, you didn't fight it," said Adele Balkan. "If you were a big enough

OPPOSITE: (l-r) Virginia Leith, Emile Santiago, Charles Le Maire, and Gene Tierney at the 1954 Oscars ceremony. Le Maire and Santiago won for Best Costume Design for *The Robe* (1953).

ABOVE: Charles Le Maire sketches at his desk at 20th Century-Fox.

LADIES – WARDROBE
PICT.*
TITLE A·820· DATE 1-8-59
DIRECTOR N JOHNSON
ACTOR L. CARON
CHARACTER ANN
CHANGE 7
SET
SCENE 70-72
DESIGNER C. LEMAIRE

name as a designer, you could make those demands. If you were just on contract to the studio or something like that, you didn't." Renié Conley did not mind sharing her Oscar nominations with Le Maire for *The Model and the Marriage Broker* (1951) and *The President's Lady* (1953). "He was the one who hired us," she said, "and he was the one who would stand by us under anything."

Although Ava Gardner had a reputation for being difficult, Le Maire found her surprisingly accommodating. They worked together on *The Snows of Kilimanjaro* (1952). Gardner replaced Anne Francis just before shooting was to begin. A friend from MGM called Le Maire, warning him that Gardner could be a "bitch, bitch, bitch," and advising him to just "let her have her way no matter what." Zanuck, too, advised Le Maire not to press Gardner if she did not want to use any of the clothes that he had designed for Francis. Gardner was a great star and accustomed to great things, Zanuck said. That was all well and good, Le Maire thought, but shooting was scheduled to begin two days later. "I called her in to see what I could get together for the first day's shooting," Le Maire said. "She told me that she and Anne were about the same size and volunteered to try on her costumes to determine whether she could wear them." In the end, she used four of them in the movie. "It's a rare actress who is willing to do that," Le Maire said.

Le Maire found Susan Hayward to be surprisingly conflicted about juggling a career with traditional female roles. "Many people don't understand Susan," Le Maire said in 1981. "She was first and foremost a wife and mother. If she'd had a fight with her husband or if one of her little boys were sick, she'd be jumpy at work." When short hair came in vogue during the 1950s, Hayward honored her husband's preference and refused to cut her hair. "I told her she could get a wig," Le Maire said. "She cut her hair, but as soon as the picture she was making was finished, she let it grow out again." Le Maire noted that after she divorced Jess Barker, Hayward freely adopted shorter hairstyles. "She was a very aloof, determined, strong-minded person," Balkan said of Hayward. "I don't think she had too much to say about the clothes because she had great faith in him (Le Maire)."

When 20th Century-Fox began making fewer, but more expensive films in the 1950s, Le Maire predicted that the amount of work for designers would decrease. And when Buddy Adler replaced Zanuck, Le Maire also expected the quality of Fox's productions to decrease. Despite assurances by his agent, Charles Feldman, that his job was secure at Fox, Le Maire saw the writing on the wall. He decided it was time to try his hand at designing his own line of clothing. Bullocks Wilshire, Los Angeles' top luxury department store, hired him to design a ready-to-wear line and promised to buy everything that he designed. Back east retailers sought Le Maire as well.

"He didn't leave, they closed the gates," Balkan later said of the financial troubles that mired the studio around Le Maire's departure. "I think that was when they sold off a portion of the studio, and they just closed the gates."

Le Maire's last film was *Walk on the Wild Side* (1962), which he only agreed to do because his longtime agent Charles Feldman was the producer. During production, Le Maire experienced problems with his new ready-to-wear line. He did not have enough time to design, buy the materials, run a workroom, and keep up communications with buyers. He could not hire someone to represent his line, because the buyers wanted face time with the actual designer from 20th Century-Fox. After a year and a half, he abandoned the enterprise and moved to Santa Fe with his wife, Bee Bee. Le Maire was active in the Santa Fe community for years, staging several successful galas for the Mental Health Group, serving on two college boards and on the Executive Committee of the Museum of New Mexico Foundation. In the 1970s, the Le Maires moved to Palm Springs. Beatrice died in Laguna Hills, California on January 16, 1978. Le Maire continued to socialize in his later years in Palm Springs with old Hollywood friends like Alice Faye and Billie Dove. He died of heart failure there on June 8, 1985.

OPPOSITE: Leslie Caron in *The Man Who Understood Women* (1959).

EDITH HEAD

Edith Head received more Oscar nominations—a total of thirty-five—and Oscar wins—a total of eight—than any other designer in the history of Hollywood. Yet Head never thought of herself as a great costume designer.

She had an intelligent approach to design, she would concede. For her, the necessities of film came first. She was more interested in making sure that the actors had what they needed to get their job done, rather than creating something that would be a big coup for herself as a designer. Travis Banton, Adrian, and Irene may have had their distinctive looks, but Head believed there was no particular "Edith Head look." She prided herself that directors knew she could interpret a script without suddenly imposing a "great Edith Head dress" on them.

Head had the longest career of any designer of the Golden Age, working right up until her death in 1981. She never set out to be a costume designer or even to work in the motion picture business, though her father, Max Posenor, had been a haberdasher. He had emigrated from Prussia in 1876. Head's mother, Anna Levy, was born in St. Louis, Missouri, in 1874. Edith Claire Posenor was born on October 28, 1897, in San Bernardino, California, where Max had his men's clothing shop. The Posenor marriage ended so quickly that Head could not remember her parents being married. Anna married mining engineer Frank J. Spare on January 21, 1902, in Chicago. The family moved from mining town to mining town so often that, as an adult, Head could not recall all the towns in which she had lived, though she called Searchlight, Nevada, her hometown because she spent most of her childhood there.

Spare made a decent living, but the family was hardly well off. Still, Head's mother looked after the family, and Head was always well dressed. As a young girl, Head crafted dolls out of the pliable greasewood that grew in the desert. She constantly collected scraps of fabric to dress her dolls and to help decorate her makeshift dollhouse of old wooden boxes. Her bag of scrap fabrics was her most treasured possession.

Some of Head's front teeth did not grow in properly, and classmates nicknamed Head "Beaver." Head stopped smiling and became more introverted. Even after having her teeth fixed as an adult, she politely declined to smile for photographers.

In 1914, Anna decided the nomadic life was no place for her daughter, and brought her to Los Angeles to attend high school. Head went on to major in languages at the University of California Berkeley, and earned a master's in French from Stanford University. When a French teacher at the Bishop's School in La Jolla hastily returned to France due to a family emergency, Head accepted her first teaching assignment. Next Head taught art at the Hollywood School for Girls, where daughters of movie stars and industry personnel comprised almost the entire student body. She never considered herself artistic; desert mining towns had offered little opportunities for exposure to the arts. To stay one step ahead of her students, Head took art classes at night at Otis College of Art and Design and Chouinard Art Institute. While attending Chouinard, she met traveling salesman Charles Head, the brother of a classmate. They married in 1923. Although the marriage did not last, Head retained her husband's name professionally for the rest of her life.

As an art instructor at the Hollywood School for Girls, Head chaperoned students on field trips to Paramount, where they watched Cecil B. DeMille work on large-scale scenes. DeMille's daughters were enrolled at Head's school, and DeMille sat on the school's board of trustees. To supplement her income during the summer, Head responded to designer Howard Greer's ad looking for a sketch artist for a new DeMille film. Although her experiences as a field trip sponsor gave her the confidence to apply for the job, she lacked the confidence in her own artistic ability to submit an honest application for the position. Instead Head "borrowed" other students' drawings from Chouinard and presented them to Greer as her own. Had Head known just how

OPPOSITE: Betty Grable in an Edith Head design for *This Way Please* (1937).

frantically Greer needed designers, she probably would not have taken such a desperate tact. With the DeMille project requiring hundreds of costumes, Greer did not have the luxury of turning down any of the fifteen applicants.

Head's versatility immediately impressed Greer, so when he noticed that she seemed ill-at-ease at her drawing board, he tried to reassure her.

"Don't be upset," Greer said. "It won't take long to get the hang of things."

"I'm not worried about that," Head responded, "but I have the most awful confession to make. You see, when I was faced with my first interview, I was suddenly seized with panic. I was afraid that if I didn't have a lot of wonderful sketches, I'd never get the job."

"But they *were* wonderful. All of them!" Greer said.

"That's just it," Head confessed. "They weren't any of them mine! I just went through the art school where I've been studying and picked up everybody's sketches I could lay my hands on!"

Greer did not fire Head. "She might easily have saved her breath and her confession," Greer later wrote, "for her own talents soon proved she was more than worthy for the job."

Greer initially gave all of his new hires the same assignment. With all of his designers sitting together in one room, Greer explained that DeMille needed a woman's riding habit. But DeMille did not want just any riding habit that could be bought in a store. He wanted something that would make the audience gasp. Head's design, a gold riding habit with matching gold boots, pleased DeMille. She held on to her job, the only one of her group who did. Head may not have been the best artist in the lot, but she was older, better educated, better traveled, and had the real-world experience of teaching school. She also worked harder than most. If Greer asked for one sketch, she would do three or four. And as a skilled mimic, she quickly learned to sketch artistically like Greer. Because of Head's ability to speak Spanish, Greer came to rely on her help in the workroom.

After Walter Wanger brought Travis Banton to Paramount for *The Dressmaker from Paris* (1925), Head became both his and Greer's assistant. Banton and Greer split up the roster of Paramount stars between them, with Greer designing for Pola Negri and Banton taking Florence Vidor and Evelyn Brent. When Greer left Paramount in 1927 to open his own salon, Head was given more responsibility. Banton continued to design

for the films' stars, with Head dressing the other actresses in the films. She designed for Mary Carlisle, Leila Hyams, Joan Bennett, Gracie Allen, and Martha Raye.

Head was first assigned to design for Mae West in *She Done Him Wrong* (1933), when Banton was away in Paris. Head soon found herself designing *with* West, rather than for her. "Make the clothes loose enough to prove I'm a lady, but tight enough to show 'em I'm a woman," West told Head. West wanted tight black dresses, sequins, plumes of feathers, and lots of jewelry. For as often as West ran afoul of censors, she almost never showed cleavage or leg.

When Paramount did not renew Banton's contract in 1937, Head eventually assumed his position as head designer. Some stars believed that Head had sabotaged Banton and refused to work with her. That perception was unwarranted. Head had desperately

OPPOSITE: Claudette Colbert in *Zaza* (1938).

ABOVE: Edith Head and Dorothy Lamour during the making of *My Favorite Brunette* (1947).

OVERLEAF, LEFT TO RIGHT: Barbara Stanwyck in *Ball of Fire* (1941). • Veronica Lake in *This Gun for Hire* (1942).

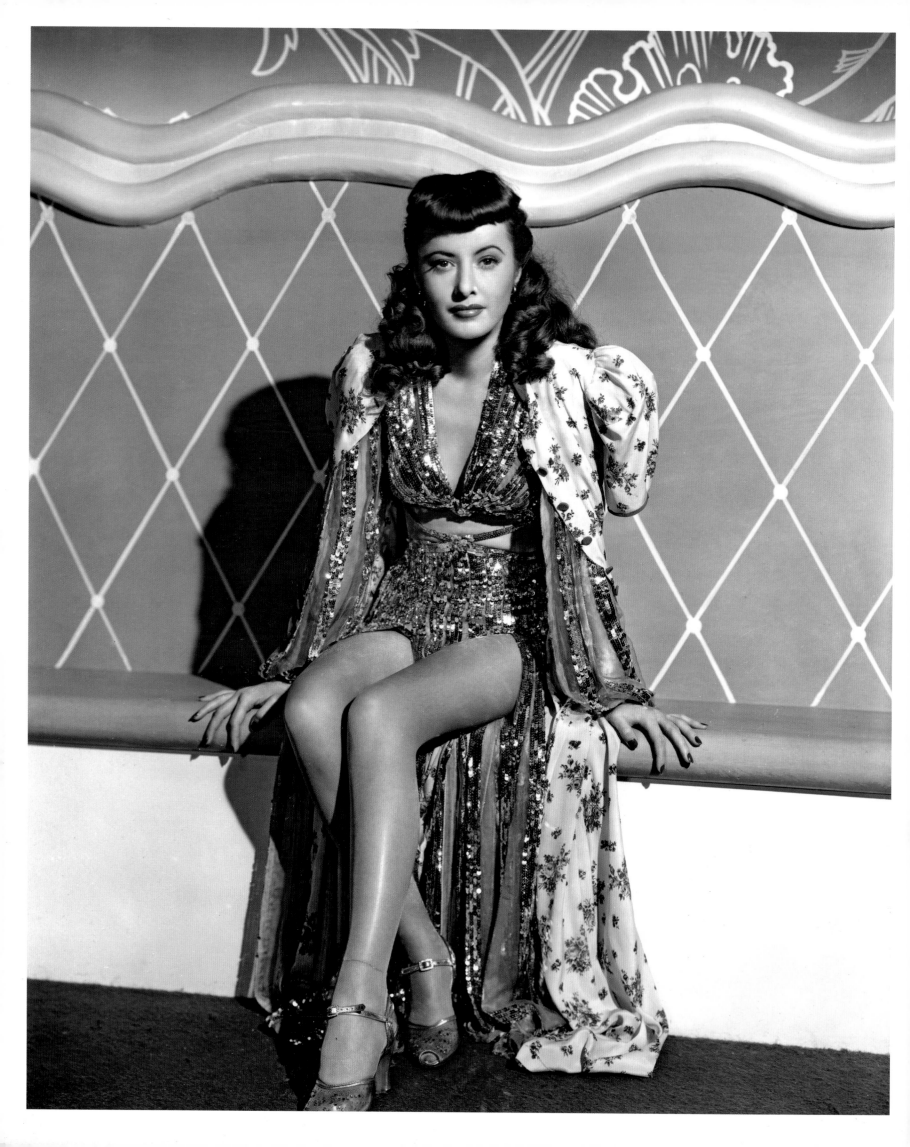

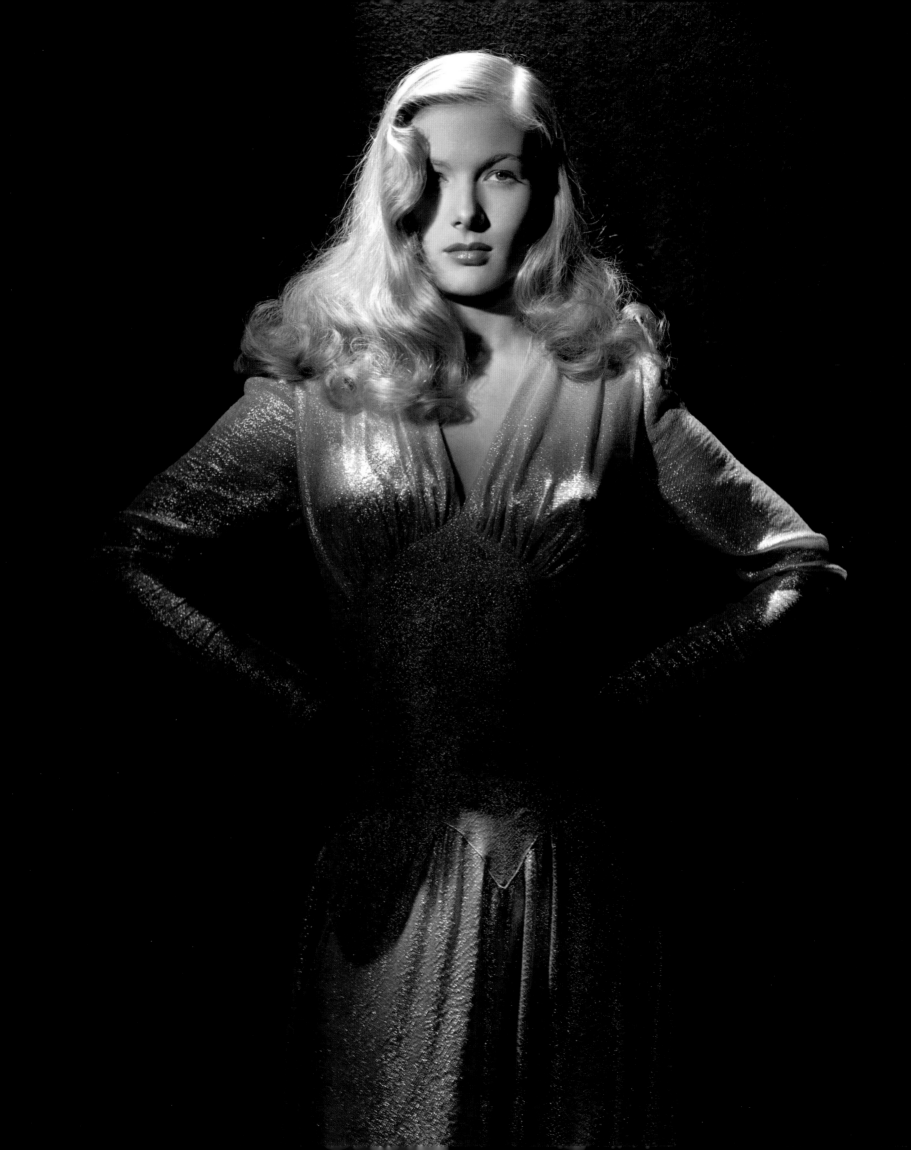

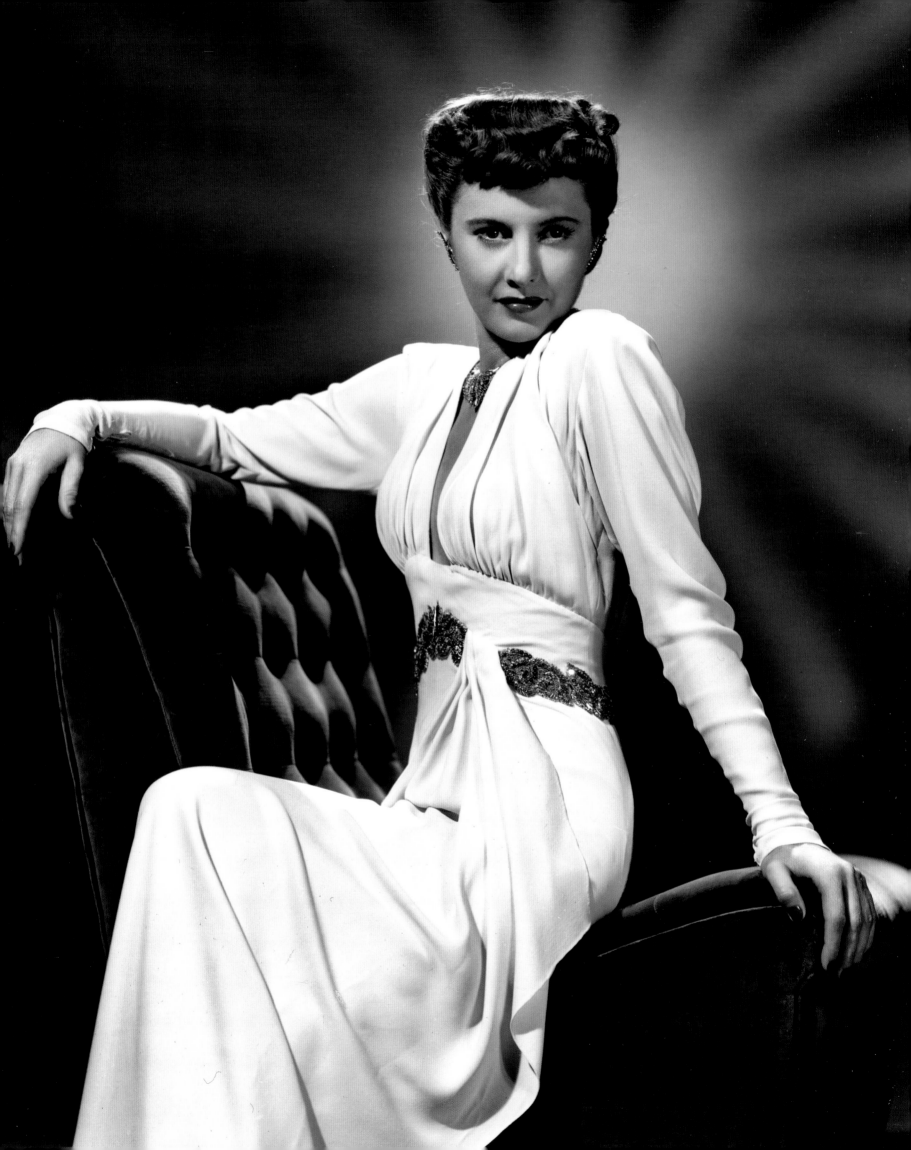

wanted Banton to stay, as he guaranteed her job security. She was not the obvious choice as a replacement. Paramount initially considered Ernst Dryden to replace Banton; Head did not assume the position for nearly two years.

In her new position, Head influenced fashion. She first wrapped a young Dorothy Lamour in a sarong for *The Jungle Princess* (1936). With the success of *Jungle Princess*, scriptwriters labored to find any excuse to keep Lamour in a sarong. During the rest of the 1930s and into the '40s, Lamour appeared in road pictures with Bob Hope and Bing Crosby, and sarongs and sarong-inspired clothing sold well across the nation.

For *The Lady Eve* (1941), Head corrected a figure problem that had plagued Stanwyck in previous movies and had kept her from making more high-fashion films. Head compensated for Stanwyck's long waist and low-slung rear by building her skirts high on her waist. Stanwyck's long waist was actually an asset, Head believed, and made Stanwyck look more elegant.

Head divorced Charles Head in 1938 and married art director Wiard "Bill" Ihnen on September 8, 1940. The couple eventually moved into a rambling Spanish-style house in Beverly Hills, which they called Casa Ladera. In the mid-1940s, Head joined the panel of Art Linkletter's *House Party* radio show on CBS. With an afternoon timeslot, the show sought to dispense helpful information to housewives. Naturally fashion played a part. Linkletter initially found Head painfully shy. "She came into my office," Linkletter said, "and I thought, 'Oh my, what are we going to do with this quiet, shy, reticent little woman wearing very unglamorous clothes and glasses and kind of a dull hat?'" With Linkletter's able coaching, Head became popular with listeners as she helped them simplify their look and dress well on any budget. When *House Party* made the transition to television, Head became the most recognized costume designer in the public eye. She appeared on the show for its entire fifteen-year run.

Head won her first Oscar for *The Heiress* (1949), in which Olivia de Havilland played an awkward young woman being courted by Morris, a handsome golddigger, played by Montgomery Clift. Director William Wyler insisted on historical accuracy in the costumes for the mid-nineteenth century tale. Head and de Havilland visited museums and studied original period clothing together. De Havilland's wardrobe expertly reflected the progression of her character, Catherine, throughout the story.

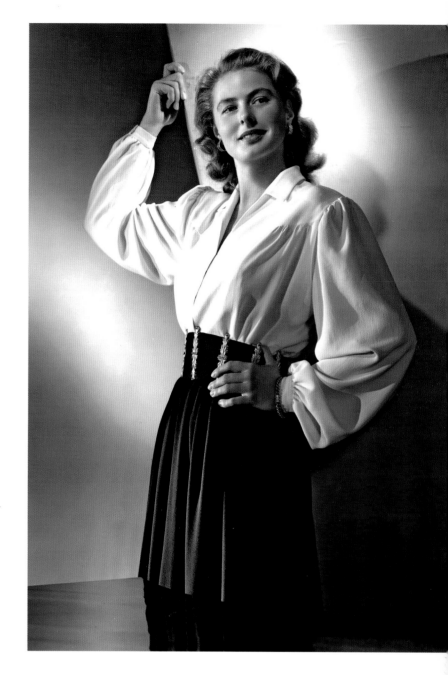

Head's second Oscar came for a movie that she would not have normally designed. *All About Eve* (1950) was a 20th Century-Fox production. The Paramount designer was brought on when Bette Davis replaced Claudette Colbert as Margo Channing. "Bette walks in here like a small, disciplined cyclone," Head said of the actress. "You don't discuss details with Bette. She shows you how she is going to do the part, how she is going to throw herself on the bed, sit on the desk, or whirl around and walk out in a huff. 'That,' says Bette, 'is the way I want the clothes to act.'"

OPPOSITE: Barbara Stanwyck in *Flesh and Fantasy* (1943).

ABOVE: Ingrid Bergman in *Notorious* (1946).

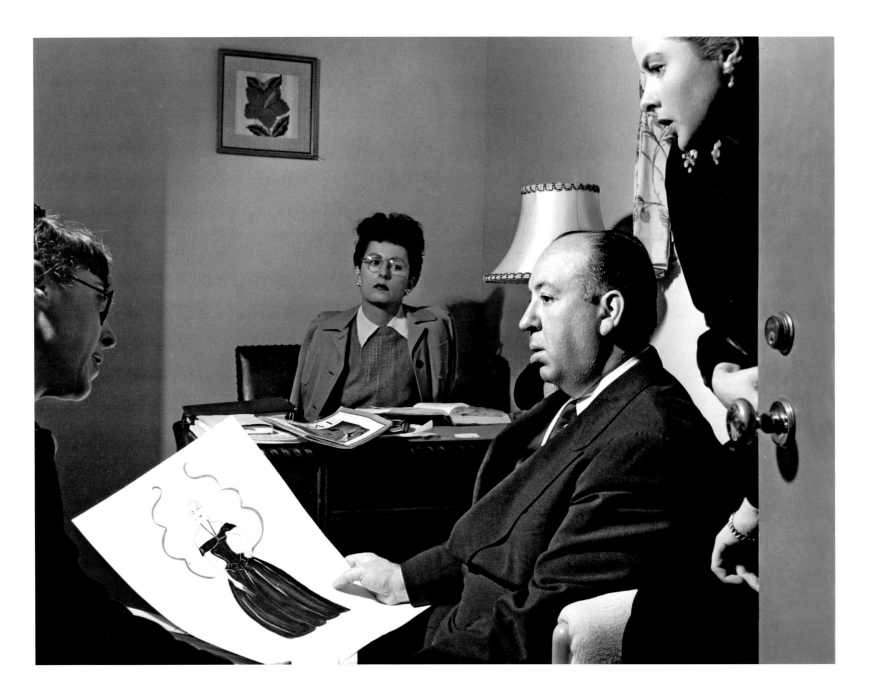

Davis's dress for one of her most famous scenes in *Eve* unintentionally deviated from Head's original design. For the party scene in *All About Eve*, Head designed a brown silk dress trimmed in sable with a squared neckline. Charles Le Maire had designed a similar dress for Anne Baxter for the same scene. On the day of filming, Head's dress slipped off Davis's shoulders when she tried it on. The dress had been measured incorrectly. As Head summoned her courage and prepared to tell director Joseph Mankiewicz that production would be delayed, Davis stopped her. Looking in the mirror, she asked Head if perhaps the dress was not better with the shoulders exposed. Head added a few stitches to keep the dress from slipping further, and off Davis went to utter the legendary line, "Fasten your seat belts, it's going to be a bumpy night."

Though Gloria Swanson had been one of Paramount's biggest stars when Head began working at the studio in 1924, Head did not design for her until *Sunset Boulevard* (1950). Even though Swanson's character, Norma Desmond, was a delusional has-been, director Billy Wilder did not want her to appear literally stuck in the past. Head gave Norma up-to-date fashions, but included a few touches demonstrating that Desmond had not entirely moved on from her silent-screen heyday. Head included oversize accessories and a silk lounging robe printed in leopard skin.

Director George Stevens told Head to strive for realism in *A Place in the Sun* (1951). He wanted the costumes to be true to

ABOVE: (l-r) Edith Head, Alma Reville, Alfred Hitchcock, and Ingrid Bergman discuss a design for *Notorious* (1946).

OPPOSITE, CLOCKWISE FROM TOP LEFT: A costume sketch for Hedy Lamarr in *Samson and Delilah* (1949). · Costume sketches by Edith Head for Grace Kelly in *To Catch a Thief* (1955).

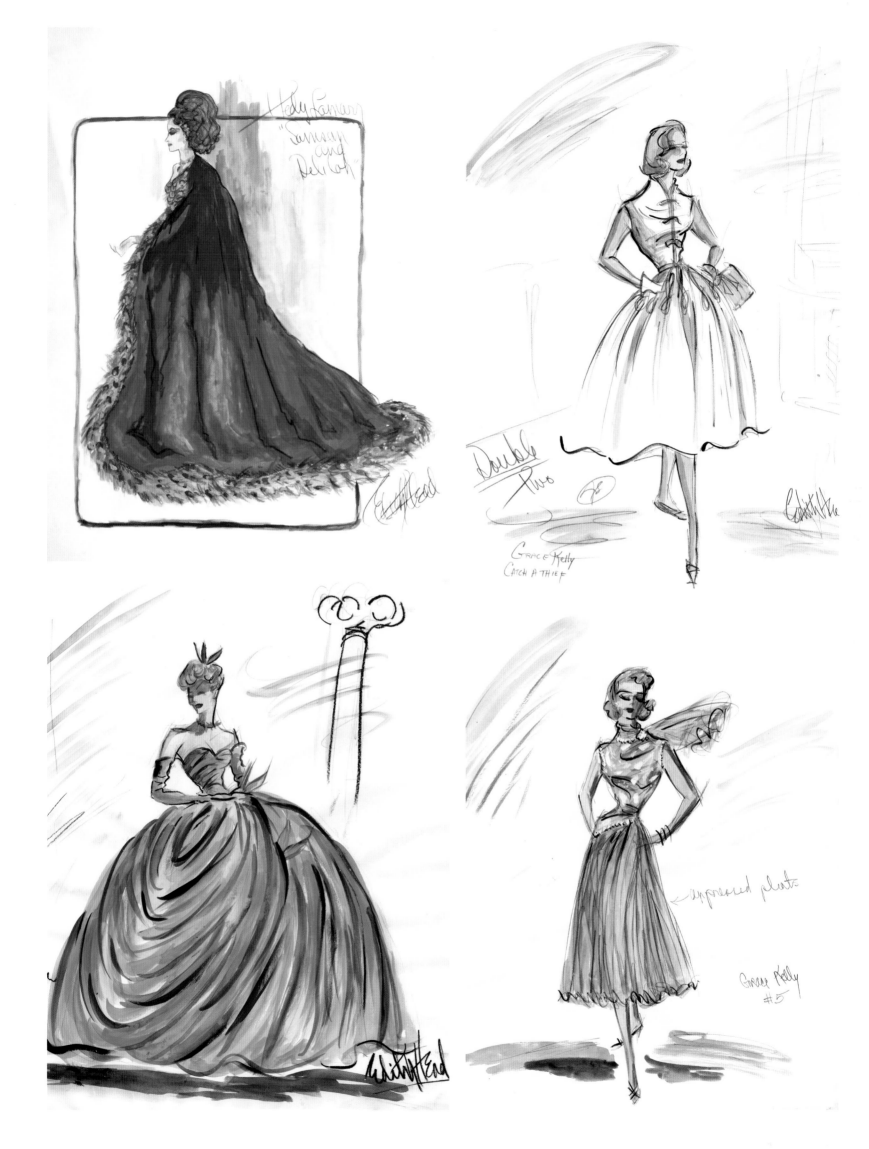

real-world people, rather than Hollywood's caricature of stereotypes. For Elizabeth Taylor, he challenged Head to design an honest look of a young, very wealthy girl, and for Shelley Winters, a convincing factory worker's wardrobe. Head's design for Taylor's gown, having six layers of white net over pale mint green taffeta, and a white velvet bodice covered in white velvet violets with green centers became the fashion hit of the season.

Audrey Hepburn's boyish figure defied America's prevailing view of beauty when she arrived in Hollywood. When she was cast in *Roman Holiday* (1953), she let Head know that she liked her long neck and had no intention of hiding it. Head used a long torso brocade ball gown with a wide off-shoulder collar to help the audience understand that Hepburn's character feels restricted by her royal duties. In Billy Wilder's *Sabrina* (1954), Hepburn asked that gowns from fledgling designer Hubert de Givenchy be used for her

character upon her return from Paris. At the time, Head was unhappy that Wilder indulged Hepburn and used Givenchy gowns. But in later years, she was more contrite, believing that ultimately it helped the film. Givenchy was not credited in the film, and Head won the Oscar for *Sabrina*, which resulted in much criticism for Head.

For *The Country Girl* (1954), director George Seaton liked to underemphasize clothes, so they only serve to build character.

OPPOSITE, CLOCKWISE FROM TOP LEFT: With George Burns behind them, costume designers Howard Greer, Edith Head, and Orry-Kelly discuss the length of the skirt Gracie Allen wears while recording a segment of the *Maxwell House Coffee Time Starring Burns and Allen* radio program in 1947. · Barbara Stanwyck in *The Other Love* (1947). · William Holden and Gloria Swanson in *Sunset Boulevard* (1950). · Olivia de Havilland in *The Heiress* (1949).

ABOVE: Gloria Swanson in *Sunset Boulevard* (1950).

"Though we often had to work hard with some stars to create an illusion of great beauty," Head remembered later, "I had to take one of the most beautiful women in the world and make her look plain and drab." Making Grace Kelly appear plain was not easy. "It was very difficult to dress down all her good points," Head said. "But I did even that. That's really illusion in reverse!" Head had worked with Kelly earlier, on *Rear Window* (1954). Kelly had been a model, and Head found her a woman of good breeding and taste. Kelly was partial to pastels and white. She abhorred strong colors, which was fortunate because director Alfred Hitchcock only liked them if they were part of the story. "Hitchcock is the only person who writes a script to such detail that you really could go ahead and almost make the clothes without discussing them," Head said. "It's so completely lucid, like, 'she's in a black coat, she has a black hat, and she wears black glasses.'"

Kelly proved to be Hitchcock's perfect muse. "I'm not interested in sharing a Marilyn Monroe-type," Hitchcock once said of Kelly. Hitchcock's mother, Emma, had been an impeccable dresser and had given the director strong Victorian sensibilities. He believed in letting the audience discover that there might be a volcano under a glacier. For *To Catch a Thief* (1955), Head accentuated Kelly's glacial qualities through a blue chiffon dress with spaghetti straps, and then a white chiffon dress. As Grace's character thaws, her clothes become brighter until finally at the end, she wears a gold ball gown, which Hitchcock had requested to make her look like a fairy princess.

OPPOSITE: Elizabeth Taylor in *Elephant Walk* (1954).

ABOVE: Grace Kelly arrives at the 1955 Oscar ceremony wearing an Edith Head ensemble. Edith can be seen in the background.

After Kelly married Prince Rainier of Monaco in 1956, Hitchcock vainly searched for a replacement. First came Kim Novak in *Vertigo* (1958). Hitchcock envisioned Novak's character in a severe gray tailored suit, just stepping out of a San Francisco fog, with her hairstyle twisted in a spiral forming a question mark. Novak felt restricted by the suit, and hated the outfit's black shoes. Novak was sensitive about the size of her feet and believed dark shoes emphasized them on camera. When Novak protested to Head, the designer suggested she speak to Hitchcock. The director held firm. Novak found that having her choice taken away actually helped her understand the character of Madeleine better, and she appreciated that Hitchcock let her come to that realization herself.

Hitchcock discovered his other attempt to replace Kelly, Tippi Hedren, in a diet soda commercial. Although Hitchcock signed Hedren to a seven-year contract, their relationship deteriorated as Hedren could not tolerate Hitchcock's obsessive control and advances. They only made two movies together. In the first one, *The Birds* (1963), Hedren arrives in a fur with out-of-place formality. For the scene where she is attacked by the birds, Head resurrected the *eau de nil* suit worn by Grace Kelly in *Rear Window* to give Hitchcock the chaste, cool quality he sought. In *Marnie* (1964), Hedren played a sexually frigid thief. Hitchcock instructed Head that he wanted no eye-catching colors that would detract

ABOVE, LEFT TO RIGHT: (l-r) Marla English wearing Audrey Hepburn's gown from *Roman Holiday* (1953), stands next to Edith Head and actress Gene Tierney. Edith is holding the Oscar she won for designing the film. • A costume sketch for Rosemary Clooney in *White Christmas* (1954).

OPPOSITE: Shirley MacLaine and Edith Head during a fitting for *Career* (1959).

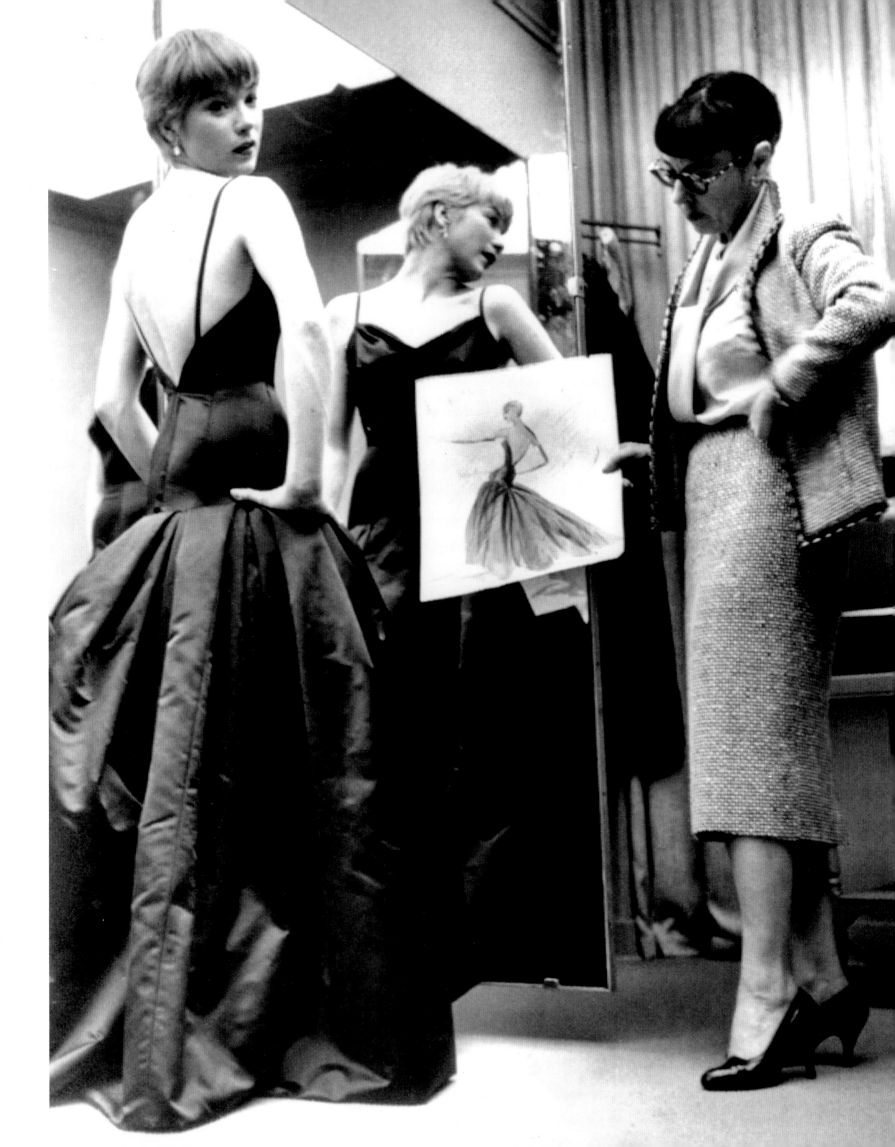

PARAMOUNT PICTURES CORPORATION
WEST COAST STUDIOS

5451 MARATHON STREET HOLLYWOOD 38, CALIF.
TELEPHONE CABLE ADDRESS
HOllywood 9-2411 "FAMFILM"

September 16, 1964

Mrs. E. R. Maelhorn
208 Kenmore Road
Havertown, Pa. 19083

Dear Mrs. Maelhorn:

Thank you so much for your nice letter.
I was pleased that you enjoyed my book
"The Dress Doctor", and find my appear-
ances on the Houseparty Program helpful.

As for my opinion about the ensemble
you wore to the wedding you attended --
from the description you gave me, it
sounds very appropriate, and I don't
think you should worry about it. It
was an afternoon affair, and I believe
anything dressier might have been <u>too</u>
dressy.

Cordially yours,

Edith Head

CLOCKWISE FROM TOP LEFT: A design for Lucille Ball from
the mid-1960s. · A letter from Edith Head offering advice to
a fan. · A costume sketch for Shirley MacLaine in *Sweet
Charity* (1969).

OPPOSITE: Shirley MacLaine poses with the extensive Edith
Head wardrobe created for her in *What a Way to Go!* (1964).

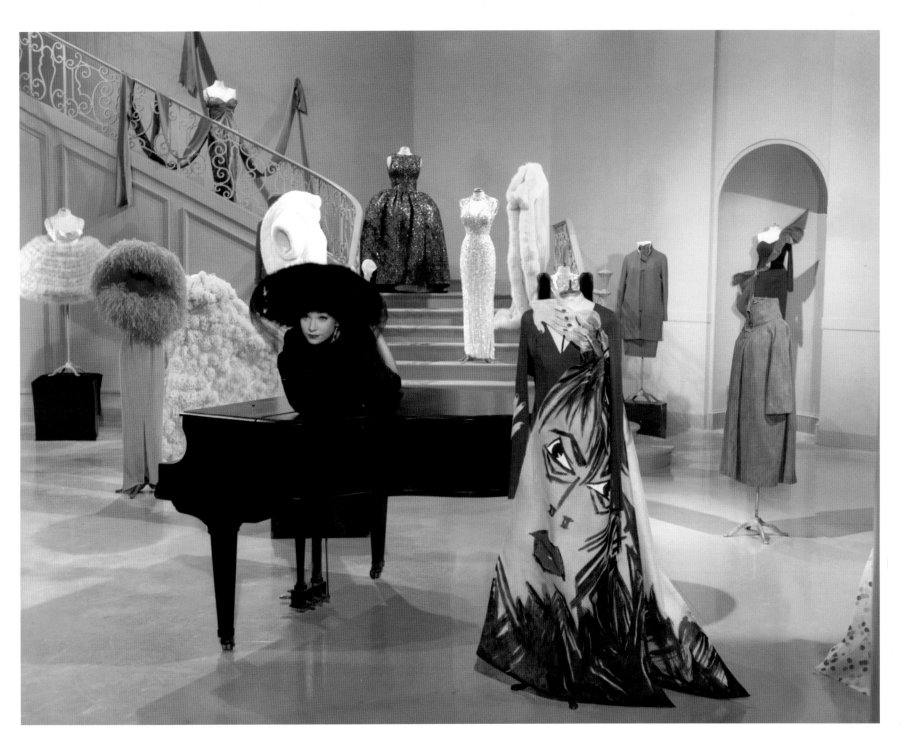

from the action and wanted to use warm colors to demonstrate that Marnie was, in fact, a warm person.

In 1966, when Gulf + Western bought Paramount, Head believed she would be forced out of the studio. She negotiated a contract with Universal, where Hitchcock was working. In the late 1960s, glamour was on the wane, but Universal was still producing films with opportunities for Head's skills as a fashion designer, including *The Oscar* (1966) and *Hotel* (1967).

In total, Head won eight Oscars, the last being for *The Sting* (1973). Though she did not design the wardrobe, the film carried her design credit. That win, her first in fourteen years, made Head a popular fashion adviser to a new generation. The *Sting* win boosted sales of her dressmaking patterns, marketed under the *Vogue* trademark, and brought fans to fashion shows, moderated by Head, featuring her old costumes. At Universal, she was more valuable for publicity purposes than for actually designing.

Late in life, Head suffered from myelofibrosis, an incurable bone marrow disease. On the evening of October 24, 1981, Head ruptured her esophagus during a hospital stay and died in Los Angeles, just four days before her eighty-fourth birthday.

JEAN LOUIS

Even prolific designers must consider themselves fortunate if they have created just one costume that becomes iconic during their careers. Jean Louis has the fortune of being remembered for at least three of his designs.

There was the black strapless dress Rita Hayworth wore in *Gilda* (1946), the sparkling gown Marilyn Monroe wore when she sang her "sweet, wholesome" rendition of "Happy Birthday" to President John F. Kennedy in 1962, and Marlene Dietrich's beaded nude illusion cabaret touring costumes.

Because of Jean Louis's long affiliation with Columbia and Dietrich's refusal to star in a Columbia picture, their collaboration almost never happened. Prior to Dietrich becoming a fixture on the Las Vegas stage, Columbia founder Harry Cohn had asked her to star in *Pal Joey* (1957). Insulted by her refusal, he swore she would never work for Columbia, an odd threat given her refusal to do just that. Little did Cohn know that he would soon get an opportunity for genuine payback. After Dietrich was offered a substantial contract to perform in Las Vegas, she wanted Jean Louis to make her gowns, as her favorite go-to designer, Travis Banton, had died a few years before. Aware of the tiff between Dietrich and his boss, Jean Louis refused. "I cannot even make a scarf without Harry's permission," he told Dietrich. So Dietrich supplicated herself before Cohn. With vengeful glee, the studio head turned the Hollywood legend down.

After Cohn's treatment of Dietrich purportedly displeased some Vegas casino owners, he reconsidered his position, then gave in, but not without setting petty conditions. Dietrich was never to use the front gate at Columbia. She could not be on the lot during normal business hours. She was limited to the wardrobe department for fittings and then was required to leave by the back gate. Dietrich so admired Jean Louis's abilities, she bore the humiliation and sneaked into Columbia through the back door for several weekends, standing for hours while Jean Louis fitted the bead-encrusted souffle creations in the deserted wardrobe department.

Born in Paris on October 5, 1907, Jean Louis would come to enjoy a well-earned reputation as a gifted Hollywood designer with the impeccable social polish one expected from a refined French gentleman. His first encounter with Marilyn Monroe certainly required his utmost *savoir faire*. He met Monroe in her Brentwood home to discuss her wardrobe for *The Misfits* (1961). He waited with his fitter in her living room for more than an hour. When they were about to leave, Monroe sauntered down the staircase. "Oh, I am sorry I am late," Monroe said. "But I am always late," she sighed. She wore a mink coat and high heels. "It's wonderful to meet you. I am so pleased you are going to design the costumes for *The Misfits*," Monroe said.

"With a sparkle in her eye, she dropped the fur to the floor," Jean Louis later recalled. Monroe was totally nude. "I thought you would like to see what you have to work with." She giggled. "But keep in mind that I never wear undergarments." Jean Louis was flabbergasted. "I kept looking at her directly in the eyes," he said. "Miss Monroe," he finally said. "I see you wearing hats. A lot of hats. Lots and lots of hats!"

Given his origins—the future designer grew up among the waterways of Paris, where his family worked in boats along the Seine River—a career designing for Hollywood's biggest stars may have seemed improbable for Jean Louis. But from a young age he had an interest in designing women's clothes. Born Louis André Berthault, the future designer studied art at L'École Nationale Supérieure des Arts Décoratifs in Paris. The school had no costume design course at the time, so in between his art classes, he taught himself about costumes and how to illustrate them. After school, he worked selling ties until he eventually found work as an illustrator at a traditional fashion house. Jean Louis was displeased with the old styles being shown and re-shown there. Paris was in the midst of a watershed moment—the Jazz

OPPOSITE: Jean Louis's design for Marlene Dietrich's night-club act.

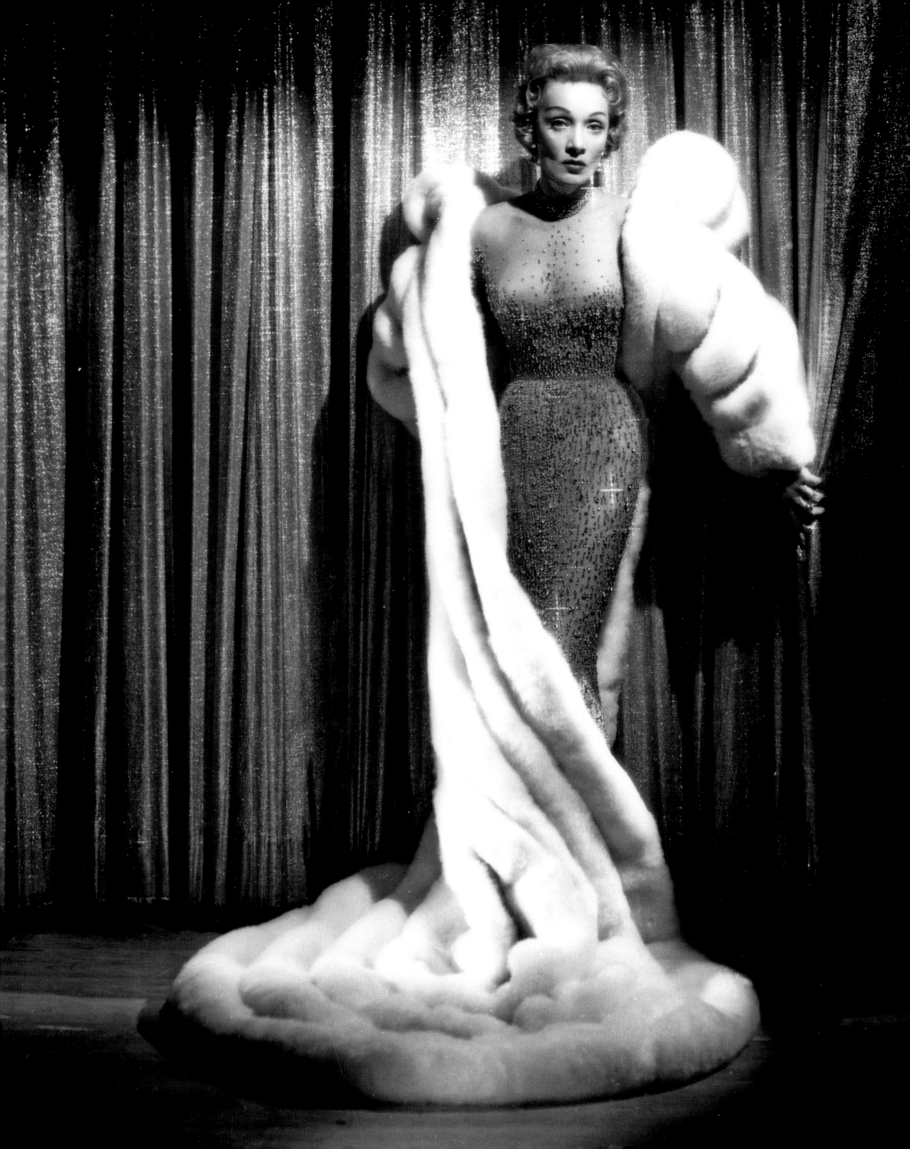

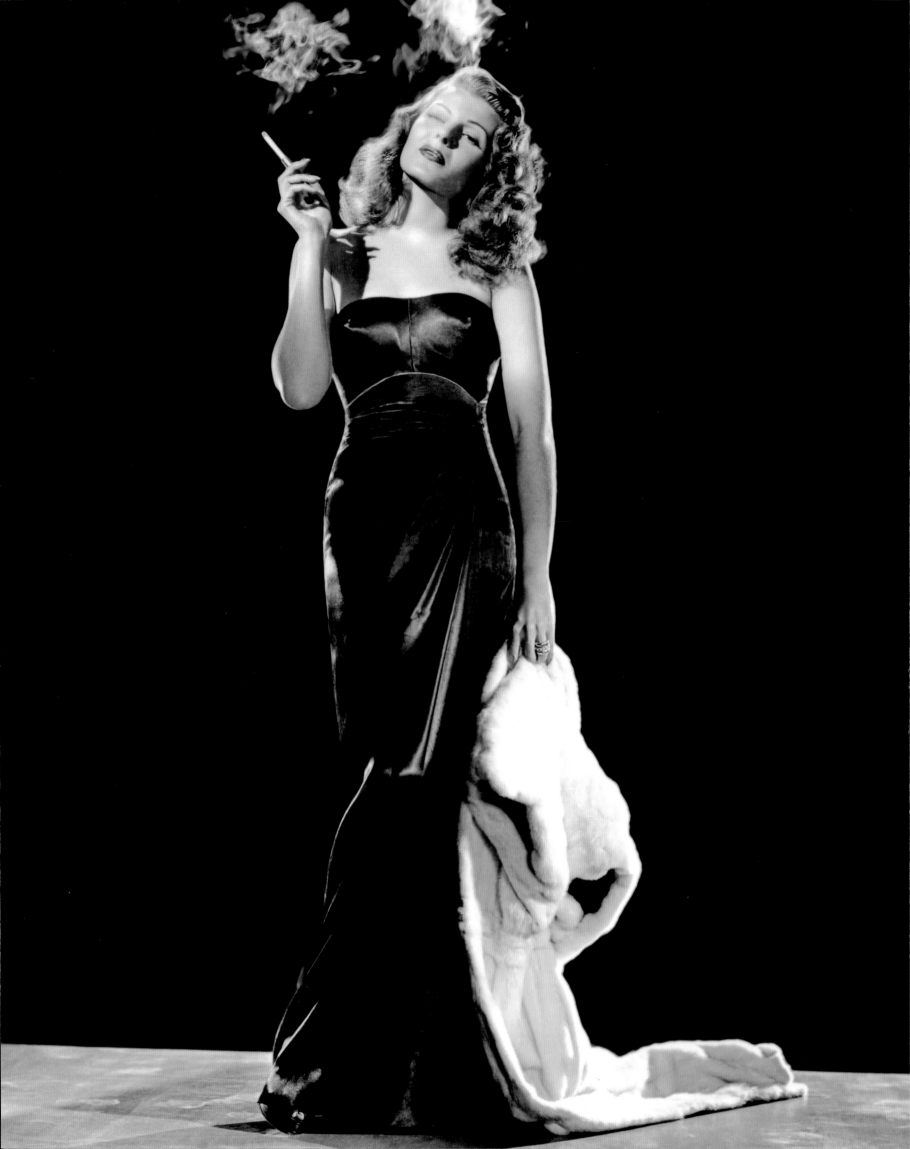

Age—and women were wearing new, less-constricted silhouettes. Wanting to help forge new trends, Jean Louis moved to a more modern house, Agnes-Drecoll, on the Place Vendôme, where he worked as a sketch artist for four years. At that time, Jean Louis found that Parisian designers were less inclined to take a risk on a young person, and he was frustrated at the slow pace at which his career was advancing.

In 1935, after he broke his arm in a taxi accident, Jean Louis purchased a round-trip ticket to America with the insurance money. He fell in love with New York, even though he spoke little English. The people with whom he was traveling suggested that he should try to stay. He took some sketches to Hattie Carnegie, and told her that he could drape and cut too. She offered him a two-week probationary position. His ship was set to sail in two days, so he cashed in his return ticket and began designing for Carnegie,

even though he had no work visa. U.S. Immigration ordered him to return to France.

Three months later, Carnegie navigated the hurdles of U.S. Immigration and brought Jean Louis back to New York. For the next seven years, Jean Louis worked for Carnegie. Designing for film never occurred to Jean Louis until Harry Cohn of Columbia Pictures, who was in New York looking for a new designer, paid him a visit at the recommendation of his wife, Joan, a Carnegie patron.

Jean Louis and Cohn came to an agreement. With the exception of Jane Russell, who requested her own designer when on loan

OPPOSITE: Rita Hayworth in *Gilda* (1946).

ABOVE: Jean Louis discusses the wardrobe for *Over 21* (1945) with actress Irene Dunne.

to Columbia, Jean Louis personally designed for all Columbia actresses, including Rita Hayworth, Jean Arthur, and Irene Dunne.

"Rita Hayworth was the most fun and so beautiful," Jean Louis said when assessing the Columbia stars. "There was nothing common about her. Her nose, her chin, were extraordinary—and those long, long legs." From the waist down Hayworth was thin—thin legs, no hips, and a small derriere. Jean Louis used certain design tricks, like tight belts, to give her an hour-glass shape. Her hips broadened a bit after her second daughter's birth, presenting some design challenges for *Affair in Trinidad* (1952) and *Salome* (1953). But for *Pal Joey* (1957), Hayworth's broader build was appropriate, as she was playing a more mature woman.

Jean Louis's most successful design for Hayworth was, without a doubt, the gown for her "Put the Blame on Mame" pseudo-

striptease in *Gilda* (1946). "When I did the *Gilda* dress, it was bolder and sexier than film designs of the time," Jean Louis said, "but on Rita, it was not vulgar." The *Gilda* dress was boned across the bodice, as might be expected. But the fitter also constructed a small strip of plastic across the bust. The plastic was heated with an iron and then bent to fit the exact shape of Hayworth's body. Because the number was filmed sooner than expected, Hayworth wore the dress without any test run. When *Gilda* was released, Jean

ABOVE, LEFT TO RIGHT: Jean Louis (left) and Elizabeth Courtney fit Rita Hayworth for *The Lady from Shanghai* (1947). • Ginger Rogers wearing a Jean Louis gown for *It Had to Be You* (1947).

OPPOSITE: Burt Lancaster and Deborah Kerr in *From Here to Eternity* (1953). Because the couple would be kissing on a beach, Jean Louis had to design a conservative swimsuit for Kerr.

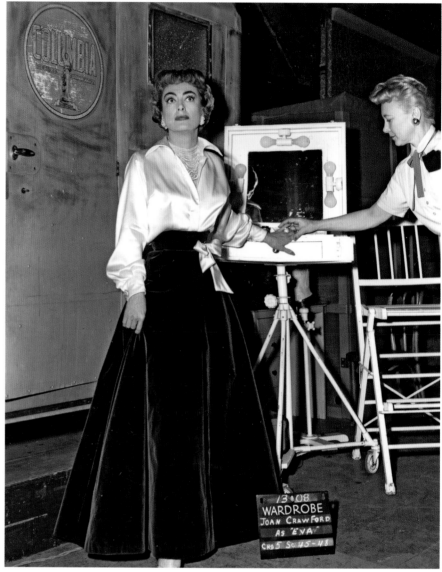

Louis received a telegram from fashion editor Diana Vreeland. All it said was "Superb."

When Betty Grable came to Columbia to make *Three for the Show* (1955), Jean Louis learned the woman with the million-dollar legs preferred pleasing fans over style. "I had designed a strapless dress and had shifted the darts above and below her bustline to give her a ladylike and seductive look," Jean Louis recalled. "At the first fitting, she eyed herself critically in the mirror and said to me, 'Remember, I am famous for two things—my bust and my legs.' With that, she pushed her breasts up until, to my shocked eyes, they seemed to be resting right under her chin. 'See,' she said, 'look how much longer my body looks now.'" Despite Jean Louis explaining to Grable that she had put herself and the dress completely out of balance, Grable was adamant. "What Betty wanted, Betty got," Jean Louis said. "So we added

some thin shoulder straps to support her high bust, slit the skirt almost to the hips to show off her famous legs, and that was that. She might not have had the greatest style sense, but to her, what her public wanted, her public got."

When Cohn signed Marilyn Pauline Novak to Columbia, he wanted to change her name to Kit Marlowe. Novak balked, and a compromise was reached—Kim Novak. Jean Louis found Novak cooperative, at first. When she first came to the studio, he put her in some of Hayworth's old clothes, letting the seams out in some and leaving the backs unzipped in others. For her debut at Columbia, *Pushover* (1954), Jean Louis did not put Novak in a bra. She approved. But when Cohn saw the rushes, he asked Jean Louis why Novak appeared to have no bustline. When Cohn insisted that Novak wear a bra, she cried. She hated wearing bras and argued with the studio chief. Although Novak did win some of

her battles with Cohn, this was not one of them. Novak appeared pushed-up in *Pushover*.

Novak developed a preference for gluing her dresses to her body, instead of having Jean Louis bone them. At the end of a day of filming, she had to rip the dress off of her body, usually ruining the dress and sometimes tearing her skin. Insecure about her legs, which she regarded as too thick, Novak insisted on wearing beige stockings and beige shoes to make her lower extremities look smaller. Later, she wanted to wear white shoes with all of her outfits because she believed white made her ankles look smaller. Because he understood that Novak's idiosyncrasies stemmed from her self-doubts, Jean Louis was able to look past them.

Jean Louis was vacationing in Paris when Dietrich contacted him about designing her Las Vegas nightclub costumes. After receiving Cohn's approval to work for the previously ostracized

actress, Jean Louis sent Dietrich five sketches of gowns of various modesties, and she settled on two see-through gowns. The dresses caused a sensation when the stage lights hit the performer because she appeared to have nothing on under them. To create the illusion, Jean Louis used tightly molded souffle material underneath a slightly looser dress on top. The audience appeared to see Dietrich's body under the dress, but they were actually seeing the souffle.

The mid-1950s brought significant changes in Jean Louis's personal and professional lives. The handsome Frenchman was the groom in two successive weddings back-to-back in 1954 and 1955.

OPPOSITE, LEFT TO RIGHT: Jean Louis with actress Kim Novak. · Joan Crawford in a continuity photograph for *Queen Bee* (1955).

ABOVE: Lana Turner in *Imitation of Life* (1959).

LADIES
WARDROBE

PICTURE A-955 Date 4-10-62
TITLE SOMETHING'S GOT TO GIVE
DIRECTOR G. CUKOR
ACTRESS M. MONROE
PART OF ELLEN
CHANGE No. #2 (ONLY ONE FITTING)
INT. HOTEL LOBBY - Sc 33
INT. ELEVATOR & CORRIDOR Sc 34-35
SCENE No. INT. SUITE "C" Sc 34, 34, 40
Designer J. LOUIS 8 X 10

A couple of years after Jean Louis wed Maggy, his boss at Columbia, Harry Cohn, died on February 27, 1958. Despite plenty of bad press over the years about Cohn's alleged difficult personality, Jean Louis never had a bad experience with him. When the new owner took over Columbia after Cohn's death, Jean Louis was told the studio would renew his contract, but at a reduced salary. Having been at Columbia for seventeen years, Jean Louis felt as if he was being told to start over. He chose to leave Columbia and began freelancing.

In 1960, Jean Louis signed to do a spring collection each year for New York fashion house Ben Reig. A clause in the contract promised Jean Louis time off between collections to make movies. After two months at Ben Reig, Jean Louis was asked to do *The Misfits* (1961). Even though Jean Louis had completed the first season's collection, Reig objected to Jean Louis leaving for California, claiming that the designer would be deserting his workroom staff. Reig insisted Jean Louis create a reserve line. Although not contractually obligated to do so, Jean Louis acquiesced so that he would be able to work on the film. Tensions between Jean Louis and Reig over the former's filmmaking eventually proved to be a deal breaker.

Following *The Misfits*, Monroe chose Jean Louis to design her wardrobe for her next film, *Something's Got to Give* (1962). Tensions between the actress and 20th Century-Fox were high; Monroe's frequent tardiness and absenteeism had studio heads seriously considering her termination. When she was invited to sing "Happy Birthday" to John F. Kennedy at Madison Square Garden, Monroe feigned illness and played hooky from the set. She secretly ordered a form-fitting gown from Jean Louis. Dubbed the "beads and skin" dress, the gown was made of nude marquisette fabric encrusted with

OPPOSITE: Marilyn Monroe in the unfinished *Something's Got to Give* (1962).

ABOVE: A costume sketch for Doris Day in *Send Me No Flowers* (1964).

On August 7, 1954, he married Marcelle Martha Martin, a fellow French immigrant twelve years his senior. They had met eighteen years before in New York, when she worked for Hattie Carnegie. They reconnected in California when Marcelle visited her sister in Los Angeles. Jean Louis and Marcelle married months later in Santa Barbara. Their happiness was short lived; Marcelle died within a year of cancer. Four months later, on November 26, 1955, Jean Louis married Maggy Fisher, an editor at *Radio and TV Daily*. She had also known Jean Louis for about twenty years, having met when he was studying art in New York and she was a model. Their marriage lasted nearly thirty-five years, ending with Maggy's death the day after her seventy-seventh birthday on September 27, 1989.

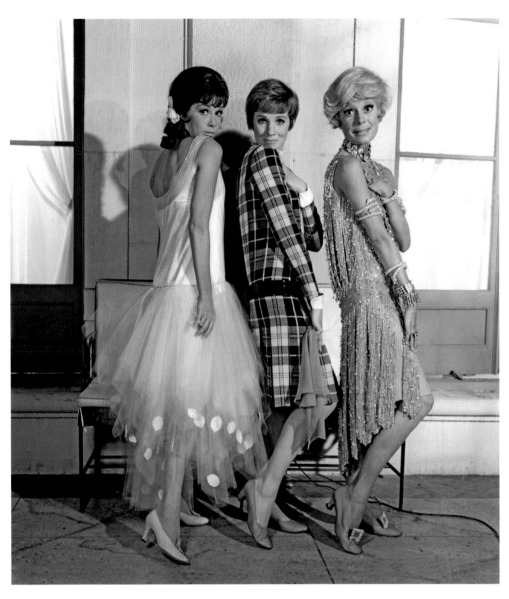

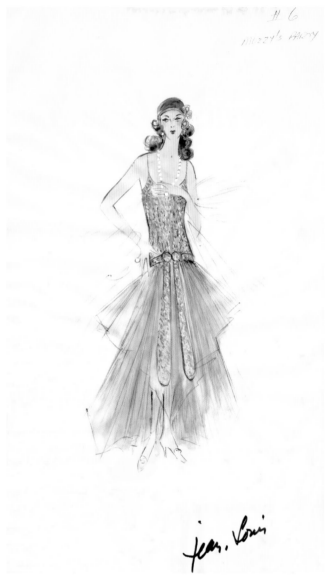

2,500 rhinestones. Monroe and the dress miraculously arrived in New York without studio heads catching wind of the clandestine trip. But after 20th Century-Fox saw clips of its AWOL star shamelessly vamping before the president at the Democratic fundraiser, Monroe was fired. Three months later, she was dead.

Jean Louis never believed that Monroe intended to kill herself on that fateful August night in 1962. Just a few days before, she had called the designer with a rush order for a dress. Because she did not wish to disturb him at home, she set up an appointment to come to his office the following Monday. "I was at church that Sunday when the priest told me of her death that weekend," Jean Louis said.

At the time he began designing for Monroe, Jean Louis was also pleased to begin his association with producer Ross Hunter at Universal, designing for Lana Turner in *Portrait in Black* (1960). Hunter was the only producer in the 1960s still interested in

making glamorous films. He was not always easy to please though, insisting that Jean Louis stick to pastels, which Hunter believed best flattered his stars.

When his collaboration with Ben Reig ended, Jean Louis opened his own ready-to-wear business. Surprisingly, his venture did not flourish as quickly as his design talents might have predicted. He was not a great businessman. The business did under $1 million annually. His lines were sold through department stores like Saks Fifth Avenue and I. Magnin & Co. His private client list for custom clothing included Nancy Reagan, Edith Goetz, and Lee Annenberg.

During the 1950s, Jean Louis and his wife, Maggy, became friends with actress Loretta Young. Their friendship was so well known that insiders referred to the trio as "The Three Musketeers." Jean Louis had even contributed designs to *The Loretta Young Show*,

which the actress wore as she famoulsy swept through the door at the opening of each episode. After Maggy died in 1989, Young looked after Jean Louis, who was becoming frail. The two surprised their fans when they wed on August 10, 1993. Jean Louis was just shy of his eighty-sixth birthday. Young was eighty.

Though Young did take care of Jean Louis at the couple's home in Palm Springs until his death, insiders believed love was not the primary impetus for their marriage. The year of the wedding, 1993, Young's adopted daughter, Judy Lewis, had written a book revealing that she was actually the biological daughter of Young, a product of her mother's clandestine affair with actor Clark Gable. Being a devoutly religious woman, Young strongly believed that

getting married at the time of the book's release would somehow help her image. Whether Jean Louis was cognizant of Young's motives is uncertain. Always the gentleman, he undoubtedly had no hesitation helping his friend. Jean Louis died at eighty-nine on April 20, 1997. Young died three years later, on August 12, 2000.

OPPOSITE, LEFT TO RIGHT: Mary Tyler Moore, Julie Andrews, and Carol Channing in *Thoroughly Modern Millie* (1967). • A costume sketch for Mary Tyler Moore in *Thoroughly Modern Millie*.

ABOVE: Actress Sally Kellerman and Jean Louis on the set of *Lost Horizon* (1973).

HELEN ROSE

More than one hundred reporters from the nation's metropolitan newspapers gathered in Beverly Hills in October 1969 to preview the spring collections of California's leading dressmakers, including Hollywood designer-turned-private-couturier, Helen Rose.

The Academy Award–winning costume designer presented her latest creations assisted by hostess Debbie Reynolds, who modeled some of the fashions personally. "At one time or another, I have influenced the fashion image of practically every glamour girl in Hollywood," Rose told the crowd as Reynolds modeled a yellow, floor-length chiffon gown. "Liz Taylor, Lana Turner, Marilyn Monroe, Marlene Dietrich . . . but the one I am most proud of is Debbie Reynolds," Rose continued. "I've watched her develop from a spindly kid in blue jeans on the movie backlot to a gracious lady with exceptional style and grace."

Reynolds thanked Rose for the compliment, then added, "But did you have to mention Liz?"

Realizing her *faux pas*, Rose hid her face. "Oh Debbie," she said, "I am sorry, I forgot."

"Well, I haven't," Reynolds quipped without hesitating, instantly reminding the crowd of Taylor's theft of Reynolds's husband, singer Eddie Fisher, a decade before. That scandal had resulted in one of the most publicized divorces in Hollywood history. Rose's slip not only gave Reynolds a comedic moment, but gave the actress an opportunity to show the press that she had truly moved on.

Perhaps more than any other designer of her era, Rose was known for her romantic creations, always soft, fluid, and exceedingly feminine ensembles. "A beautiful Helen Rose chiffon dress, a little Dom Perignon, some caviar, and damn it, you're married again," Zsa Zsa Gabor once said. Gabor was not the only woman to fall in love wearing a Rose creation—Grace Kelly did with Bing Crosby, Cyd Charisse with Fred Astaire, and Lana Turner with Fernando Lamas—even if only in the movies.

Creating romantic designs seemed like an improbable forte for Rose, who got her start designing burlesque costumes for strippers when she was a teenager. She was born Helen Bromberg

on February 2, 1904, in Chicago, to William Bromberg and Ray Bobbs. Younger siblings Shirley and Jack arrived in 1910 and 1914, respectively. Father William was a part-owner in a company that produced and retailed artwork reproductions. Mother Ray was a gifted seamstress, a talent she developed out of necessity during her own childhood. When Ray was eleven years old, her father was stabbed to death, leaving her mother alone with five children to feed. Ray's mother took in sewing, and Ray went to work in a garment factory, long before child labor laws had been enacted. "My mother sat at a sewing machine for ten to twelve hours a day," Rose said, "and as her body was not fully developed, her back grew curved and crooked. Since she made her own clothes, so she was able to disguise her disfigurement."

At an early age, Rose found her mother's vocation fascinating, and Ray fostered her daughter's interest. When Rose was six, her mother encouraged her to draw the fashions she saw around her as they visited the local park. Her father, cynical from profiting from lithographic reproductions of others' works, believed that "all artists end up drunk or starving in a garret." He insisted that Rose study typing and shorthand, which he believed would see her through in the business world. Only after she completed those studies did he give in to Rose's wishes to enroll in the Chicago Academy of Fine Arts. Although Rose could not relate to the style of Erté that dominated the approach at the Academy, her enrollment there led to her first job. During his annual recruitment visit, Lester Essig offered Rose 37½ cents an hour to design burlesque outfits for his costume company.

Rose's talent for turning burlesque beauties into sequined cupcakes and flowers attracted the attention of producer Ernie Young, who fancied himself the "Ziegfeld of the Midwest."

OPPOSITE: Elizabeth Taylor in *Cat on a Hot Tin Roof* (1958).

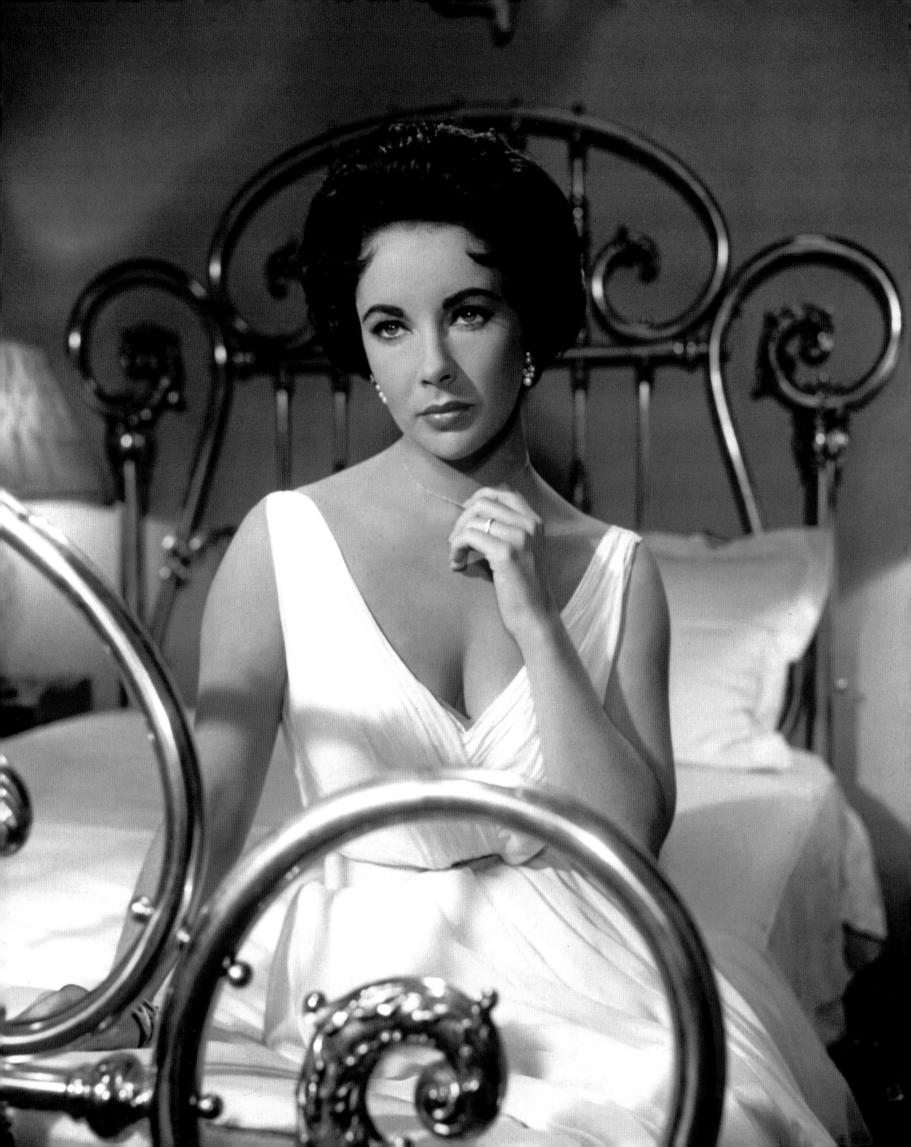

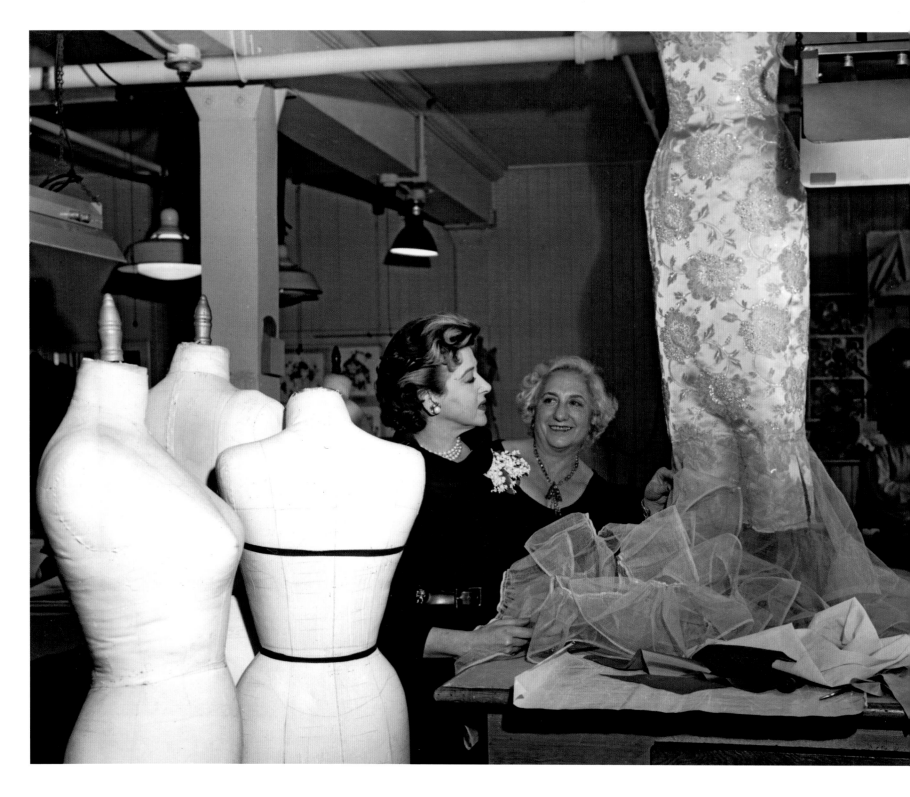

When Young opened a costume business, he offered Rose $50 a week, more than twice what she was making at Lester Costume Company. For three years, Rose worked for Young, honing her craft under the supervision of his wife, Pearl. But then came the stock market crash in October 1929, followed by Young becoming seriously ill. He was forced to shutter his business. Rose landed at a small costume house that specialized in chiffon ball gowns. There she learned how to work with chiffon so well

that that fabric would become one of her trademarks in her later design work.

Rose's new employer hated Young, and for this reason, made Rose's life miserable. When her parents decided to move to the West Coast, Rose had little incentive to stay in Chicago, and joined them. "The fact that I suddenly found myself living in the film capital did not impress me one bit," Rose said of her move to Los Angeles. "So the first thing I did when we were settled in Los

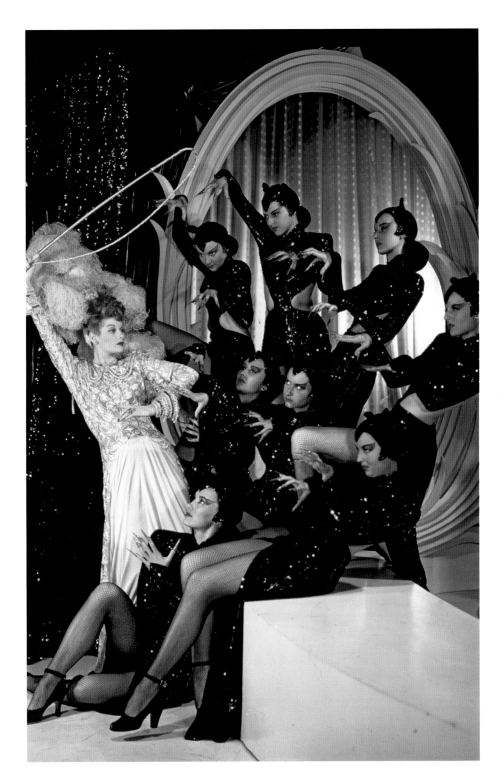

flamboyant," Rose said. "For a few months I floated on cloud nine. Then one morning when I went to the studio as usual, I found my sketches piled in the hall. 'Get your things and leave as quickly as possible,' I was told. 'You are no longer working here.' I had read about things like this, but I never believed them." Rose became a casualty in a purge when a new regime took over the studio. "Back at my old job with the costume company, I cringed when anyone mentioned motion pictures," Rose said. "It was a terrible experience for a young designer."

Rose moved on to design for Shipstad and Johnson Ice Follies. "I loved everything about the Ice Follies and the people who ran it," she said. "I was happy and content, and my designs improved with every show." When Rose's former collaborator, Fanchon Simon, became musical coordinator at 20th Century-Fox, she asked Rose to design for three pictures. "Fox! Oh, I couldn't!" Rose said in response to the offer. "But she promised to protect me and reminded me it would only be for four months," Rose recalled. She designed costumes for Lena Horne in *Stormy Weather* (1943), Alice Faye in *Hello, Frisco, Hello* (1943), and Betty Grable in *Coney Island* (1943). Then she returned to the *Ice Follies*. Rose's designs bucked the prevailing trend in film of using stiff evening suits of taffeta, satin, and faille. "I knew from my *Ice Follies* years with the skaters and dancers that nothing moves and picks up light like chiffon," Rose said. Her gold-and-chartreuse chiffon dress for Betty Grable caught the attention of studio head Louis B. Mayer, who offered her a position at MGM. Rose's reaction to a studio offer was, "Oh no!" When Mayer sweetened the deal by adding a six-week leave of absence each year to allow Rose to continue to work on the *Ice Follies*, she accepted.

Rose was brought on to work with Irene, who was then heading the design department at MGM. Irene did not embrace Mayer's new

Angeles was to get a job with a company that made costumes for stage shows."

Rose married Harry Rose in 1930, and became known professionally as Helen Rose. The couple had one daughter, Jode. In 1931, Rose began designing for Fanchon and Marco's "vest pocket" dance versions of popular musicals. Rose's portfolio impressed Rita Kaufman, the supervising designer at Fox studios, who offered Rose a job for $125 a week. "I was young and my sketches were

OPPOSITE: Helen Rose (left) inspects a dress for Ann Miller for *The Opposite Sex* (1956) in the MGM workroom.

ABOVE: Lucille Ball in *The Ziegfeld Follies* (1945).

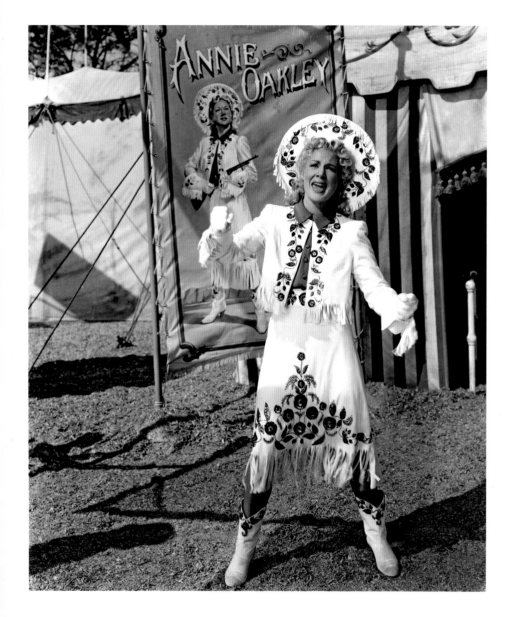

her in thirteen films. "Esther Williams has one of the greatest figures ever to grace films," Rose said, but surprisingly, she still "had to be very careful to design clothes that accentuated her beautiful figure and classic beauty." She has marvelous legs and perfect shoulders. "But perhaps due to her swimming, her waistline was not small," Rose said.

Rose dressed Judy Garland in six films, though Garland was fired before she completed the last one, *Royal Wedding* (1951). "Judy Garland was a marvelous talent," Rose said in 1981, "but she was always insecure about the way she looked, even though she was a small size six when we did *The Harvey Girls*. She needed a lot of attention, which was no problem at that point, since I was only doing one film at a time." By the time production began on *Royal Wedding* (1951), Garland's figure was not as good, and she was emotionally fragile. "She always had marvelous legs," Rose said, "so I made a black chiffon dance costume for her. When she came in for her final fitting, everybody was in my office to wish her well. When she walked out the door, the crew whistled and she was radiant."

At that moment, producer Arthur Freed arrived. He was in a bad mood. Instead of greeting Garland, he sniped at her, "What do you think you're made up for?" She burst into tears and ran from the studio. She attempted to commit suicide that evening.

That incident—including Freed's thoughtless comment—made it into Hedda Hopper's column. Studio heads were furious. Clearly, someone in wardrobe had spoken to Hopper. Freed confronted Rose in front of her staff the next day, though Rose believed Mayer was ultimately behind her thrashing. Feeling completely humiliated, Rose cleared out her desk, went home, and called her agent asking for his assistance in securing her release from her contract. Her agent advised her to return to the studio as if nothing had happened, which she did. Her colleagues gave her the cold shoulder for weeks, but Elizabeth

hire. Six months went by before Rose finally received an assignment for Lucille Ball's sequence in *The Ziegfeld Follies* (1945). Producer Joe Pasternak, who first encountered Rose on *Two Sisters*, became a big fan of her work. He requested her for his films. "Irene was an elegant, sophisticated woman who liked to design for women like herself," Rose said. "She preferred the Irene Dunnes or the Katharine Hepburns to youngsters like Elizabeth Taylor or Jane Powell. Irene had no feeling for this type of actress, so more and more frequently I was asked to design their pictures." In 1949, when Hepburn's clash with Irene resulted in her termination, Rose became the studio's chief designer. During the next decade, Rose dressed MGM's brightest stars, including Esther Williams, Grace Kelly, Lana Turner, Ava Gardner, Jane Powell, Deborah Kerr, and Cyd Charisse.

Esther Williams, queen of the MGM aquamusical, presented her own design challenges for Rose, who created wardrobes for

ABOVE: Betty Hutton in *Annie Get Your Gun* (1950).

OPPOSITE: Lana Turner in *The Bad and the Beautiful* (1952).

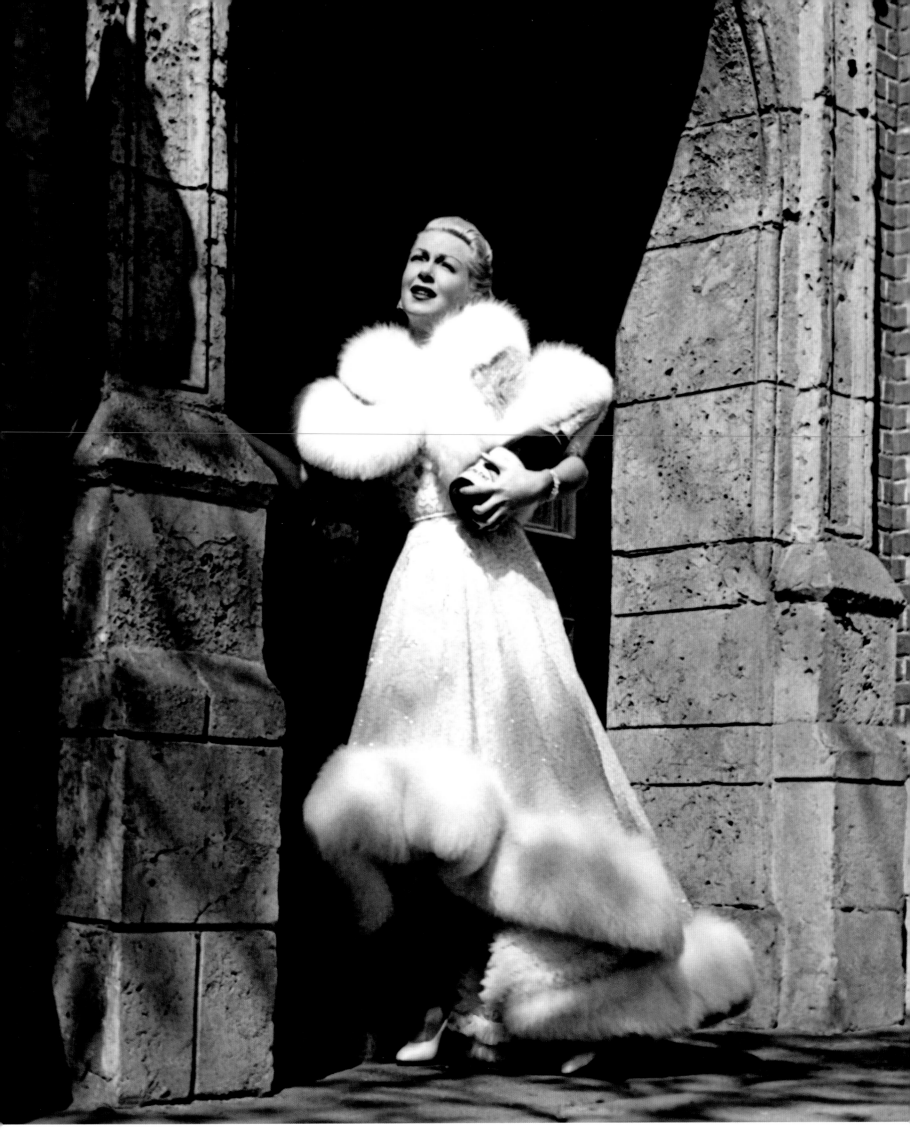

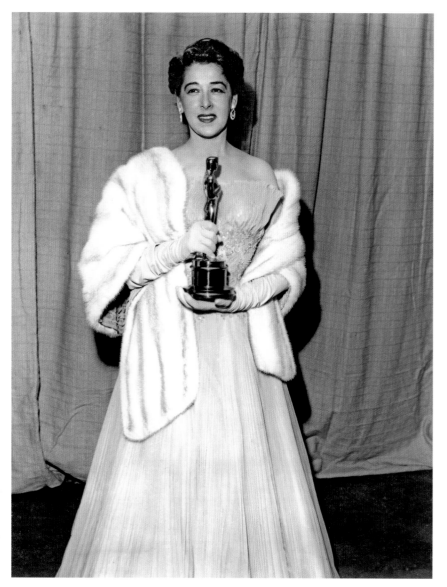

Taylor and Joe Pasternak stood by her, with Pasternak having Rose assigned to his next film, *Rich, Young and Pretty* (1951). Once she had his stamp of approval, life returned to normal at MGM. "The politics at MGM could kill you," Rose said of the incident.

Because of her position at MGM, Rose designed wedding gowns for some of the most famous stars, including Elizabeth Taylor, Grace Kelly, Debbie Reynolds, and Jane Powell. MGM was readying the film *Designing Woman* (1957) for Grace Kelly, which was based loosely on Rose's own life, when Kelly announced her engagement to Prince Rainier of Monaco. "Grace was radiant when she told me of her upcoming marriage, but I was saddened to think I wouldn't work with her again," Rose said. "Aside from being beautiful, she had a wonderful clothes sense that came from being a model. The studio asked what she wanted for her wedding present and she said she'd like

me to design her wedding dresses (one for the civil ceremony and one for the religious ceremony). That was quite an honor since every designer, every store, and every Paris couturier had offered to do it.

"We made the dresses in secrecy, and they cost so much, I was afraid I would be fired. But the publicity was worth it. The women in the workroom loved Grace, and they made her petticoats with such care those garments now could be worn as evening gowns. Grace later gave the wedding gown to the Philadelphia Museum [of Art], but she kept the pink chiffon wedding dress from *High Society* (1956) as part of her trousseau."

"Elizabeth (Taylor) had such a beautiful face that I knew I had to keep her clothes simple and dramatic," Rose said. "If you have a magnificent jewel, you put it in a simple setting—you don't distract from it with a lot of detail. On Elizabeth, I used velvets and chiffons in rich colors. I seldom gave her a print. For years I

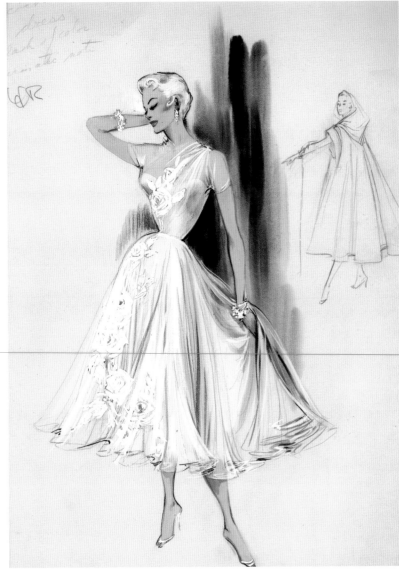

had been tempted to go into retail, because after every picture, I would get so many letters from girls saying they wished they could find dresses in the stores such as the ones Elizabeth or Janie Powell wore. By the late '50s, I could see the handwriting on the wall at the studio, as we were doing fewer and fewer pictures. I knew the time had come to start a business. I got MGM's permission and opened a factory near the studio.

"At the same time I was preparing *Cat on a Hot Tin Roof* (1958) for Taylor. Our director, Richard Brooks, wanted Elizabeth to wear a simple white shirtwaist through most of the film. I knew that if Elizabeth had been there, she would have objected; but she was touring Russia with Mike Todd and only got back the day before shooting started. She put on the slip, which was ravishing, fixed her hair and her makeup and then called for Brooks. After much mutual admiration, she said 'Oh, Richard, I can't wear that shirtwaist, it looks awful on me.' As tough as Richard is, he gave in

and let me design a draped, white chiffon dress with a V-neck and a wide satin belt. The crew worked all night to have it ready for shooting the next morning."

Rose put the chiffon dress she designed for Taylor in her first retail collection, which was sold in upscale department stores such as Bonwit Teller in New York and Joseph Magnin in San Francisco. When *Cat on a Hot Tin Roof* was released and the photos of Taylor wearing the dress began showing up in the fan magazines, Rose sold thousands of copies at $250 each. Elizabeth Taylor even ordered a few in different colors. "We kept that dress in the line

OPPOSITE, LEFT TO RIGHT: Helen Rose with her Oscar for *The Bad and the Beautiful*. · Joan Crawford in *Torch Song* (1953).

ABOVE, LEFT TO RIGHT: Helen Rose with actress Arlene Dahl. · A costume sketch by Helen Rose's longtime sketch artist, Donna Peterson, of Lana Turner in *The Rains of Ranchipur* (1955).

for three years, and then I only pulled it because the market was flooded with cheap copies."

In the early 1960s, Rose became disenchanted with designing for films. "With all the budget restrictions, with all the stars and producers and directors getting into the act, I just lost interest," she said. "Jane Fonda made so many changes in my designs for *Period of Adjustment* (1962) that I finally asked that my name be taken off the credits for the film. For me, it was like someone who's been feasting for years and then gets put on a very strict diet. Who needs it? I believe in getting out before you have to."

Rose left MGM in 1966. She and Harry moved to Palm Springs in 1970, where she continued to run her retail business. She wrote two books about her years as a designer. To promote them, she wrote fashion columns for newspapers and staged fashion shows of her Hollywood designs. Sara Sothern, Elizabeth

Taylor's mother, gave Rose a dress she had designed for Taylor in *A Date with Judy* (1948), and Debbie Reynolds and Cyd Charisse each contributed their original Rose gowns to the fashion show. When charity was involved, Princess Grace and Nancy Reagan both contributed gowns by other designers to be auctioned off at Rose's show. Rose died on November 9, 1985, in Palm Springs, California. Harry Rose died in 1993.

OPPOSITE: A costume sketch by Donna Peterson of Grace Kelly in *High Society* (1956).

ABOVE, LEFT TO RIGHT: Donna Peterson's sketch for Grace Kelly's wedding gown for her marriage to Prince Rainier of Monaco in 1956. · Actress Cyd Charisse and Helen Rose

IRENE SHARAFF

On a spring day in 1981, costumers Margo Baxley and Andrea Weaver drove Irene Sharaff to Los Angeles International Airport. Sharaff was eager to catch her flight back home to New York. "I won't be coming back," Sharaff told her colleagues.

"And she didn't," Weaver said years later. "She never worked on another film." Several months earlier, the Oscar- and Tony-winning designer had come to Los Angeles to design Anne Bancroft's wardrobe for *Mommie Dearest* (1981), the story of Joan Crawford's tempestuous relationship with adopted daughter, Christina. Many actresses had turned down the role of Joan, unwilling to bring an unsympathetic portrait of the Hollywood legend to the screen. Bancroft was willing, provided Frank Yablans deliver his promised script that "balanced the scales" by presenting Joan's perspective too, something missing from Christina's original work. The screenplay did not live up to Bancroft's expectations and she quit, opening the door for Faye Dunaway to star in the most badly reviewed movie of her career. While Dunaway's ability to portray Crawford was uncanny, the movie utterly failed to give the audience any insight into Crawford, her daughter, or anyone else unfortunate enough to be portrayed in the disjointed tale of child abuse.

"The acting community was not keen about making a film about Joan Crawford," said Weaver, who assisted Sharaff on the production. "They didn't want to denigrate her." By the time Bancroft departed, Sharaff had already finished the designs and was having the clothes made in England because Sharaff believed the better tailors were there. When Dunaway replaced Bancroft, she demanded an entirely new wardrobe. "I didn't design the clothes for Anne Bancroft, I designed them for Joan Crawford," she told Dunaway. "That was the beginning of the problems," Weaver said.

Trepidation permeated Sharaff and Dunaway's relationship throughout production. Most of the film's $9.4 million budget was spent on the lavish sets and costumes. "The people who were making these clothes were going berserk," Sharaff said. "I was going berserk too! I don't like making actors unhappy in what I design for them. If they dislike something violently, I'll do something else. I'm not despotic." But the animosity between Dunaway and Sharaff

defied belief. "[Dunaway] would stand for five hours measuring a shoulder pad in a suit, bringing it in a sixteenth of an inch and taking it out a quarter," Sharaff said. The constant tension week after week took its toll on the seventy-one-year-old designer. By the time Sharaff finished her work on *Mommie Dearest*, she was finished with Hollywood as well. Although she returned to her Broadway roots and designed for stage productions, she never worked in film again.

Sharaff's retreat was somewhat surprising. During her forty-three-year film career, she intimidated most everyone in Hollywood. "I liked her, but people were a little scared of her," colleague Albert Wolsky said. "Lily Fonda (a cutter/fitter) adored her, was scared of her, and respected her a great deal, because she knew she would be pushed into doing wonderful work." Known around Hollywood as the "Black Widow"—purportedly because she usually wore black—Sharaff left a wake of uneasiness wherever she tread. "People would whisper and get out of her way," Weaver said, "but she was a lovely person."

Perhaps Hollywood's uneasiness stemmed from Sharaff's thoroughly New Yorker quality. She could seem abrupt. Take her first meeting with Yul Brynner, when Sharaff was designing the wardrobe for the Broadway production of *The King and I* (1951). She met him as she was going to the Rodgers and Hammerstein office to show her sketches for the first time— "always a pretty frightening ordeal," Sharaff said. As Sharaff got out of her cab in front of the *Look* building with her portfolio in hand, Jerome Whyte, the production manager, introduced Sharaff to Brynner.

"What should I do about my hair?" Brynner asked Sharaff. He had a fringe of hair around his head and three strands across the top.

OPPOSITE: Irene Sharaff (left) fits a costume for the Broadway production of *Me and Juliet* (1953).

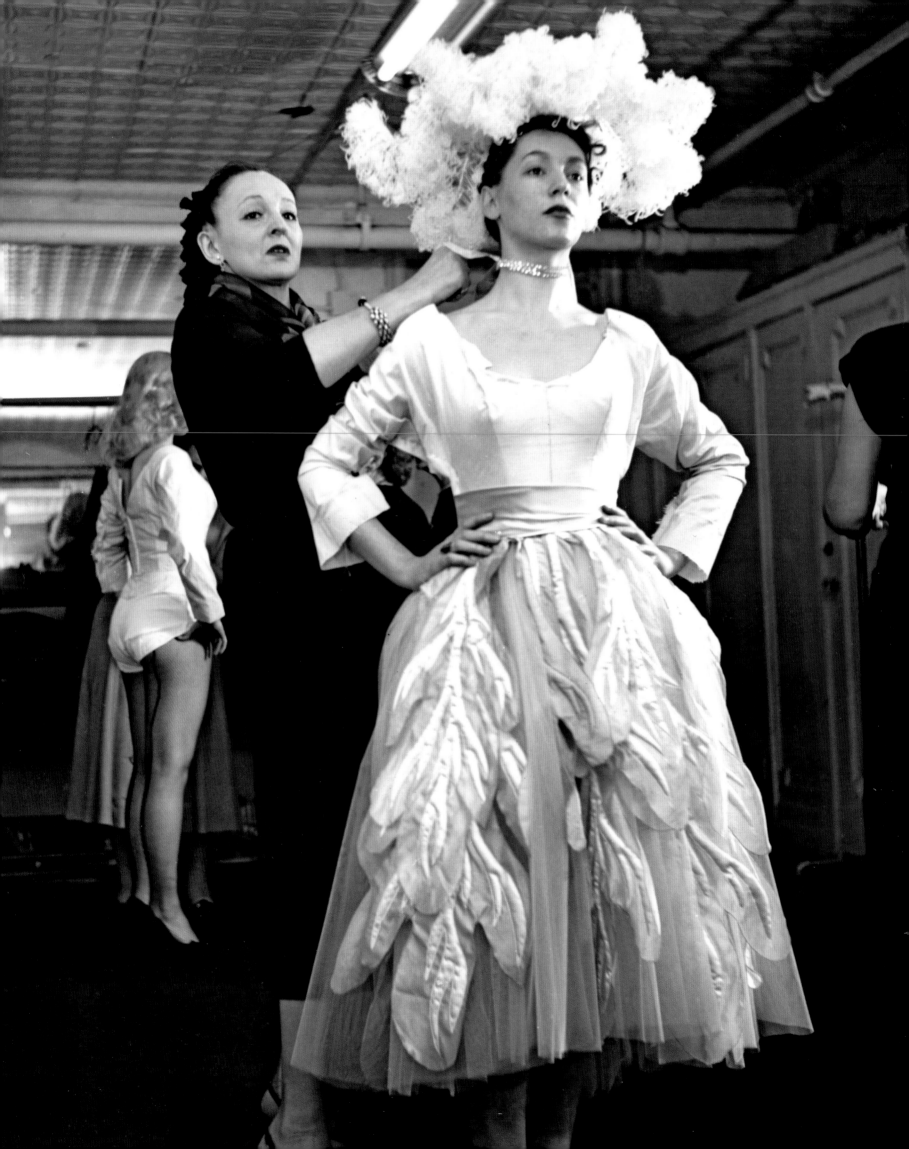

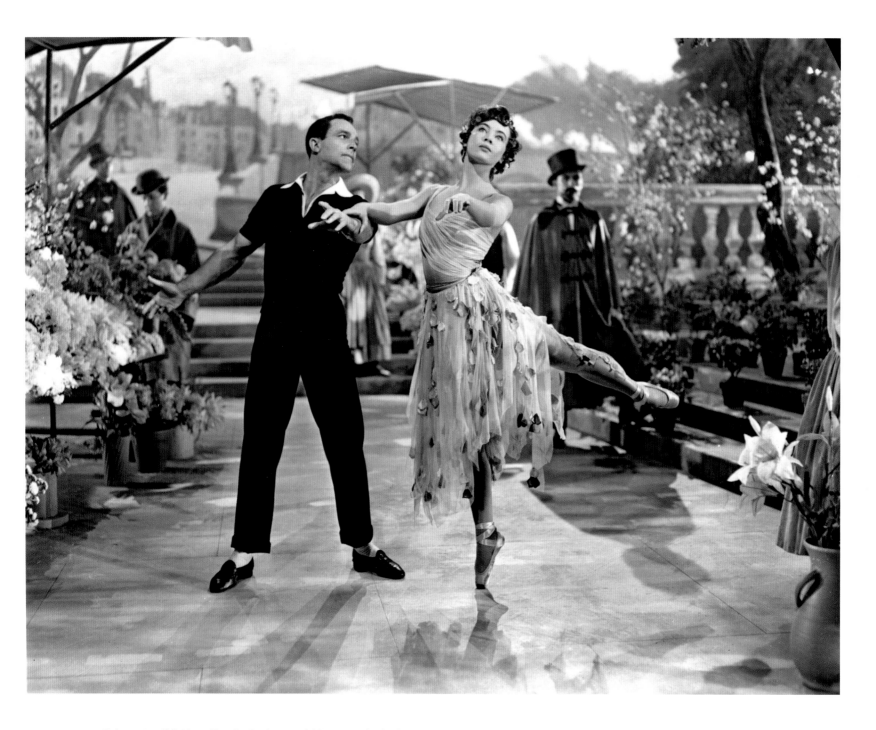

"Shave it off," Sharaff replied. She would later say she had no idea what prompted her brusque reply.

"I can't," Brynner said. "I have a bump on the top of my head."

"Look, it doesn't matter. You can't go on this way. I will have to get you a wig, so why not shave it off? And if you need a wig, we'll get you a wig. It's very easy."

And that was their first meeting. "So he left, looking at me as though I were a monster," Sharaff said. "I was taking away the last few hairs that he had on his head." According to Sharaff, Brynner was slow to accept her advice. "He came up for one fitting with Gertie Lawrence and I said, 'Yul, cut your hair off!' It wasn't until we opened in New Haven that he tentatively cut some of it off.

Then he finally shaved it all off. It became a ritual each night. He would take an electric razor and just go over his head. I don't think that *made* Yul, but it gave him a kind of logo."

Sharaff's life and career started and ended on the East Coast. She was born Irene Frances Sharaff on January 23, 1910, in Boston. Her father, Ralph Sharaff, emigrated from Russia in 1892. He married Rose Ethel Levy, a native New Yorker of Russian extraction, in 1900, and their first daughter, Adessa, was born a year later. Ralph spoke Yiddish and worked at a shirt waistcoat company. By 1915, he brought the family to New York, where he also worked in manufacturing. Young Irene grew up surrounded by dressmakers, including the family's next-door neighbor, and Ralph's sister, Ada Brenner.

Originally Sharaff wanted to be a painter. She studied at the New York School of Fine and Applied Arts and the Arts Students League of New York. In 1928, while she was still a student, Sharaff met actress Eva La Galliene, the founder of the Civic Repertory Theater in New York City. La Galliene arranged for Sharaff to meet the Civic's scenic and costume designer, Aline Bernstein. Sharaff was hired—though for the first six months she received no salary. The Civic had so little money that Sharaff had to be remarkably inventive with materials—discounted curtain and lampshade fabrics became pirate costumes in *Peter Pan*, and gold necklaces were fashioned from brass toilet chains from the hardware store.

In 1931, Le Galliene closed the Civic for a year. Sharaff spent the year-long hiatus in Paris, studying at the Académie de la Grande Chaumière and drinking in the theatrical designs of local artists Christian Bérard and Pavel Tchelitchew. She also studied the great designers working in Paris at the time, including Coco Chanel and Elsa Schiaparelli, to understand perfection in the design and finish of clothes. After five months, Le Galliene visited Sharaff in Paris and asked her to return for the 1932 season at the Civic, offering to let Sharaff design both sets and costumes for the upcoming production of *Alice in Wonderland*. Sharaff suspected Le Galliene had had too much wine at lunch, but realized she was serious when the script arrived the next day.

Sharaff spent her remaining seven months in Paris working on the designs, which she based on the illustrations from the original book. Although Sharaff's designs won the Donaldson Award, the revenue from the production was not enough to save the Civic. Sharaff was out of work after the production, but not for long. Irving Berlin, who had seen photographs of Sharaff's *Alice in Wonderland* designs, hired her to design a comic strip number and the "Easter Parade" scene in *As Thousands Cheer*. For the latter sequence, Sharaff chose an unusual palette of brown, sepia, umber, sienna, and taupe. The effect onstage was a fashion parade as it would have looked in

the rotogravure section of the *New York Times* in 1885. Opening on September 30, 1933, *As Thousands Cheer* ran for an impressive four hundred performances, and Sharaff became an in-demand theater designer. She would go on to design sixty Broadway and London theater productions—thirty-three of them musicals.

Sharaff was one of the few designers to work on the same production for both the Broadway and film versions, including

OPPOSITE: Gene Kelly and Leslie Caron in *An American in Paris* (1951).

ABOVE: An Irene Sharaff sketch for *Brigadoon* (1954).

OVERLEAF: Deborah Kerr in *The King and I* (1956).

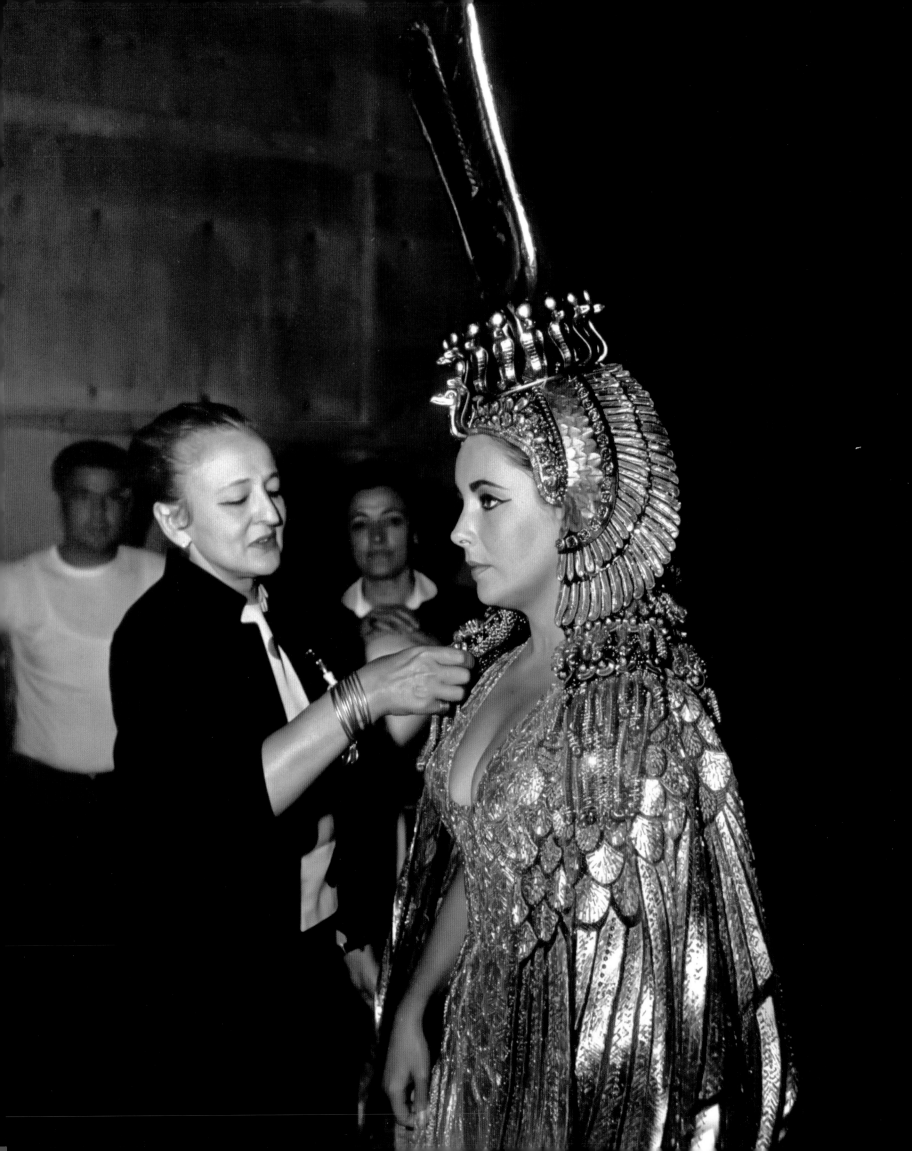

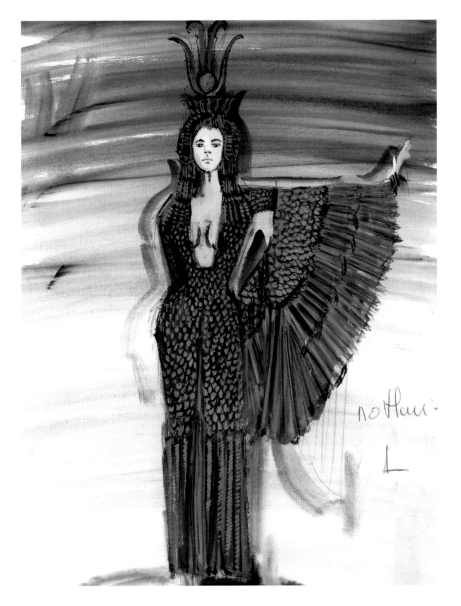

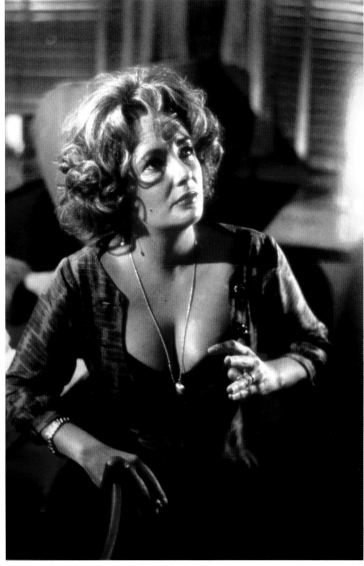

The King and I (1956), West Side Story (1961), Flower Drum Song (1961), and Funny Girl (1968). Working mainly as a freelance designer in Hollywood, Sharaff traversed studios including MGM, Samuel Goldwyn, and RKO. When she arrived at MGM, there was no musical in production, so she was assigned to Madame Curie (1943) with Greer Garson. Film was an entirely different discipline for Sharaff, so beginning on a black-and-white film that was not a musical was an ideal first assignment. Producer Samuel Goldwyn hired Sharaff to design for The Best Years of Our Lives (1946), Guys and Dolls (1955), and Porgy and Bess (1959).

Between 1943 and 1945, Sharaff worked with the Arthur Freed unit at MGM, designing Meet Me in St. Louis (1944) and Yolanda and the Thief (1945). She later contributed designs to An American in Paris (1951). An American in Paris was nearly finished by the time Sharaff reported for work in Los Angeles. Orry-Kelly had done all the contemporary clothes for the film, and Walter

Plunkett had done the Beaux Arts Ball sequence. Sharaff designed Leslie Caron's wardrobe for a series of short dances and the entire "An American in Paris" ballet. Design "a ballet about painters" was the only instruction Sharaff received as she began the sequence. George Gershwin had written the concert piece, but Sharaff was tasked with crafting the libretto. She chose painters who offered the best visual possibilities—Raoul Dufy, Toulouse-Lautrec, Utrillo, Rousseau, Van Gogh, and Monet. Kelly was keen to portray Chocolat, the well-known figure of Montmartre, as a dancer in the Toulouse-Lautrec sequence. Having lived in Paris, Sharaff knew

OPPOSITE: Irene Sharaff dresses Elizabeth Taylor for Cleopatra's entrance into Rome in Cleopatra (1963).

ABOVE, LEFT TO RIGHT: Irene Sharaff's costume sketch for the entrance into Rome in Cleopatra. · Elizabeth Taylor in Who's Afraid of Virginia Woolf? (1966).

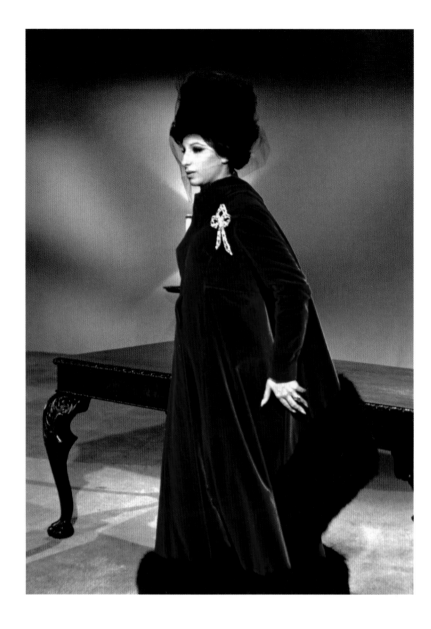

much of the city well. She immersed herself in Gershwin's music, listening to his score constantly as she worked on the sketches. She had just ten days to get her ideas down on paper. Once completed, her designs, as well as those of art director Preston Ames, were taken to Dore Schary's office for approval. With just slightly fewer than five hundred costumes, Sharaff likened the ballet sequence to staging a full-scale Broadway show.

In an odd encounter with body dysmorphia, Sharaff found one actress who did not desire a bigger bust, but had a yearning for a smaller neck. "Loretta Young had a perfectly beautiful swanlike neck, but she would have liked to have had two inches cut off of it," Sharaff said. Young's neck obsession became problematic during *The Bishop's Wife* (1947). "All the tricks of the trade that I could come up with to make her neck look shorter—ruffles or a scarf, even building shoulder pads—she said 'no' to. So the only solution was to have a whole body—a cuirass—made out

of foam rubber to change the proportions of her figure. Actually she had a good model's figure—she was very long-waisted and had long legs. I not only had to raise the neck about two inches, but the bosoms and the waistline also had to be raised. It was so unattractive to do that to an attractive human being, when it would have been so simple to do a double collar, a frill, or something. God knows, the clothes were nondescript enough in *The Bishop's Wife*!"

Sharaff was regularly requested by Elizabeth Taylor in the 1960s for films, including *Cleopatra* (1963), *The Sandpiper* (1965), and *The Taming of the Shrew* (1967). Sharaff designed the softly pleated silk jersey gown of primrose yellow in which Elizabeth Taylor married Richard Burton the first time.

Oliver Messel had originally been brought in to design the costumes for *Cleopatra*, but his authentic costumes did not flatter Taylor's figure. "A high waist, large bosom, short arms, wide hips

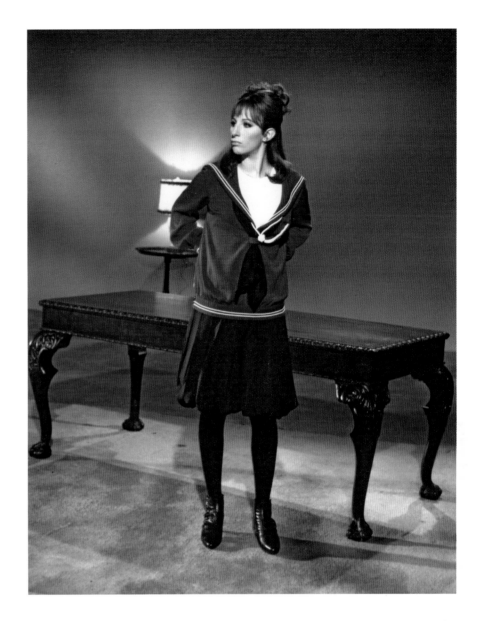

but no behind—difficult proportions to dress," Sharaff said of Taylor. "Our problem during *Cleopatra* was Elizabeth's gaining weight and taking it off very quickly," said Margo Baxley, who assisted Sharaff on the production. Director Joseph Mankiewicz also disliked Messel's designs for costar Rex Harrison. He turned to Sharaff for help. "Look, Irene," Mankiewicz said, "he looks absolutely ridiculous in these things." And he did, but it was not Messel's fault. Harrison usually appeared in beautifully tailored suits. "I don't know who tailored him in London, but it was always marvelous," Sharaff said, "but take that away and his arms were too thin. His legs were too bony. He had no chest. His shoulders were not broad enough."

"I remembered Loretta's cuirass and got a wonderful sculptor in Rome to make a cast of Rex's body, and we worked from that," Sharaff said. "I started to do some research, and I had read in *Suetonius*, 'Beware of the chap in the long sleeves!'—the loose

clothes—so that gave me a clue what to do." She built up and covered up Harrison, giving him long sleeves, brass breast plates, and thick flowing capes that hit the ground. "I did the equivalent of tights out of leather, and I designed a very long leather jacket for most of the military scenes in which he didn't wear his cuirass."

Taylor required sixty-five costume changes—a record at the time. For Cleopatra's entrance to Rome, Sharaff was expected to design something spectacular, and she did—a cape of twenty-four-carat gold cloth patterned after the wings of a phoenix. Producer Walter Wanger complained about the $2,000 price tag, but each time he told anyone how much it had cost, he inflated the number even higher. At lunch with the Baroness de Rothschild, Wanger

OPPOSITE AND ABOVE: Costume designs by Irene Sharaff for Barbra Streisand in *Funny Girl* (1968).

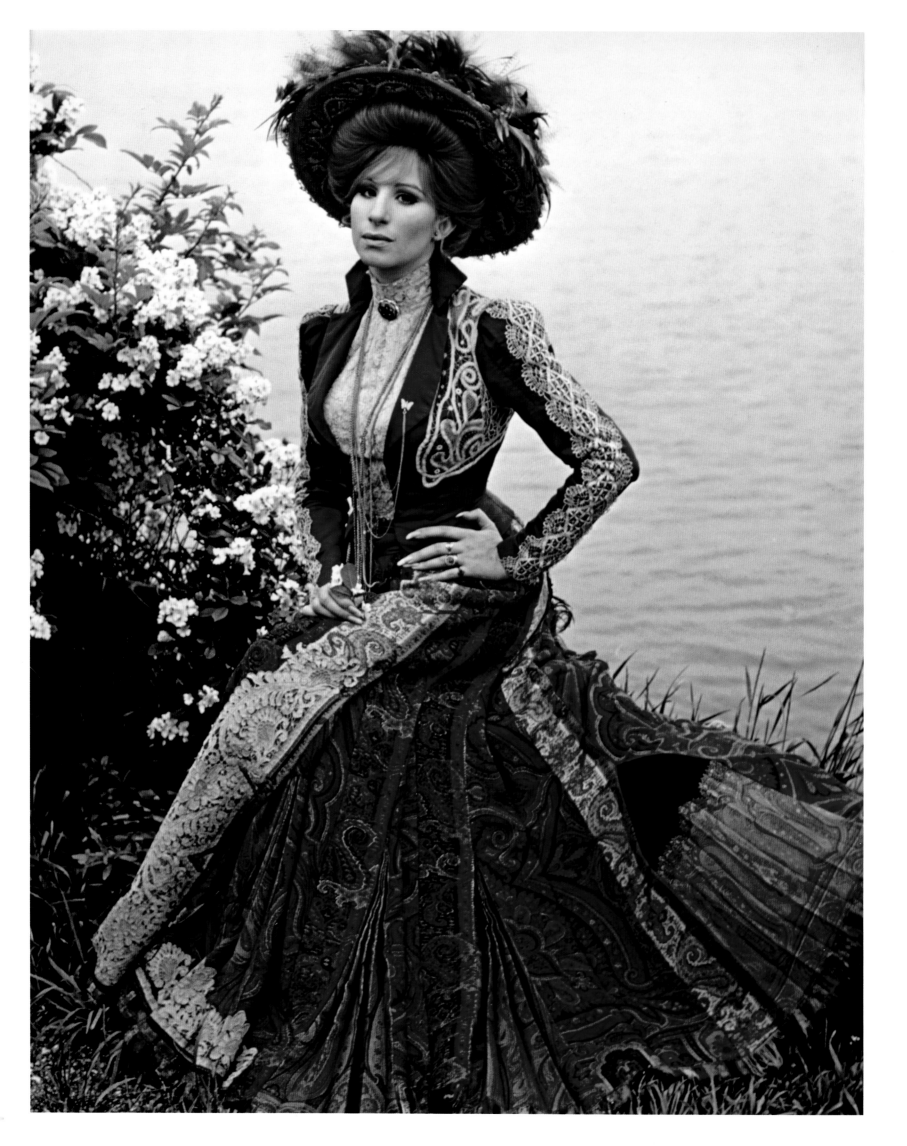

claimed that the costume cost $7,000, according to Sharaff. "Oh, that's nothing," the baroness purportedly exclaimed, "I can't even get a raincoat at Balenciaga for that!"

In contrast to the extravagant luxury of Cleopatra's garb, Taylor gladly eschewed glamour for the complex role of bipolar alcoholic Martha in *Who's Afraid of Virginia Woolf?* (1966). "Mike (Nichols) agreed with me that the character of Martha should look like a slob," Sharaff wrote in her autobiography, "her clothes so commonplace that at a glance she was the one with the disorder and sloppiness, and indifference that reigned in her house." Sharaff padded Taylor's hips to make her look more like an aging, unhappy Martha. "I chose suede for the dress that she first appeared in because it is a bulky material that tends to make a person appear heavier. Suede also soaks up the light on a set, so that on film the dress looks dull and tired."

Sharaff had a willing subject in Taylor, who embraced her character's wardrobe. "She went the whole way—she didn't care," Sharaff said. "This was one of those magic things about Elizabeth that I always remember. If an actress has a rapport with the camera, you can really feel it, and that's what happened when we did the costume tests for *Who's Afraid of Virginia Woolf?* Burton came on and went through the test halfheartedly. George Segal, who hadn't done many pictures, was very self-conscious, and Sandy Dennis was scared stiff. But Elizabeth came on—and remember, this was a great challenge for Elizabeth; here she was working with Burton in a very important, heavy role, and Sandy Dennis had gotten so many notices (in the play).

"When Elizabeth came on, everybody around the set— the stagehands, the cameraman, the wardrobe people—was absolutely hypnotized, and you felt it. The moment that camera started to buzz something happened between Elizabeth and that mechanical thing. Cukor said it once, 'It's the camera that chooses the star.'"

Sharaff designed the costumes for the Broadway and film versions of *Funny Girl*. Newcomer Barbra Streisand intrigued her. During fittings, Streisand impersonated stars like Greta Garbo when trying on the clothes. Streisand also seemed to exhaust herself attempting to micromanage every aspect of production, overthinking camera angles, lighting, and even the kind of film to use, Sharaff said. During their next collaboration, *Hello, Dolly!* (1969), Sharaff finally asked Streisand why she attempted to involve herself in so many aspects of production when she clearly found that process so stressful. She had "to be able to suffer to perform," the actress replied.

Sharaff was nominated for the Oscar fifteen times and won for *An American in Paris* (1951), *The King and I* (1956), *West Side Story* (1961), *Cleopatra* (1963), and *Who's Afraid of Virginia Woolf?* (1966). Sharaff maintained a long-term relationship with the Chinese writer and painter Mai-Mai Sze. Though Sharaff never publicly acknowledged that she was a lesbian, she lived openly with Sze and was frequently photographed with her. Costume designer Florence Klotz maintained a similar relationship with Ruth Mitchell, who was Hal Prince's producing partner. "It's a generational thing," costume designer Gary Jones said. "These women were together at parties, in that they were in the same room, together, but they couldn't operate the way they do now. In the 1960s or 1970s, I don't think they would have denied it, but I don't think the word lesbian would have come out of their mouths." (Klotz was described as Mitchell's companion in Mitchell's obituary in 2000.) Mai-Mai Sze died in New York in 1992, and Sharaff followed a year later, dying of congestive heart failure, complicated by emphysema, on August 10, 1993. Sharaff's obituary made no mention of Sze.

OPPOSITE: Barbra Streisand in *Hello, Dolly!* (1969).

WILLIAM TRAVILLA

Sometimes a costume becomes so unforgettably associated with an actress that the mere mention of her name brings the iconic outfit instantly to mind.

Can anyone say Marilyn Monroe's name without the image of her white cocktail dress fluttering over a subway grate in *The Seven Year Itch* (1955) inescapably coming to mind? The creator of that billowing dress, William Travilla, designed for Monroe in eight movies, but never so memorably as in that famous scene. Years later, Hollywood would learn that the designer was in love with Monroe at the time.

Their collaborations began early in each of their careers. The two met at Fox in 1950. At thirty, Travilla was a relatively young designer, though he had already won an Oscar for Errol Flynn's costumes in *Adventures of Don Juan* (1948). Monroe was a twenty-four-year-old starlet. She had asked to use the fitting area adjacent to Travilla's office to try on a bathing suit for a photo shoot. After putting the suit on, she asked Travilla's opinion. Before he could say a word, the shoulder strap broke, revealing one of Monroe's breasts. Whatever thoughts Travilla may have had about the bathing suit were instantly forgotten. As time went on, Monroe continued to seek Travilla's opinions about her clothes for photo shoots. When he did not like them, he would pull better choices from stock for her. As her popularity grew, and magazines and newspapers bombarded the studio for more and more photographs, Monroe requested that Travilla style her for all of her shoots.

Not until 1952 did Travilla actually design original clothes for Monroe. In *Monkey Business* (1952), he designed the wardrobe for both her and Ginger Rogers. Surprisingly, Monroe was unhappy with one of Travilla's designs, though it was not the designer's fault. Director Howard Hawks insisted that Monroe wear a full skirt for the roller skating scene with Cary Grant. Although Monroe wanted to don the hip-hugging tight skirts she always preferred, she lacked the clout to override Hawks. Travilla designed a jersey wool dress with a pleated skirt for Monroe. When he arrived on the set for shooting, he noticed the dress did not appear how he had designed it. The change confounded him—until—Monroe turned around. To get the skirt tighter around her hips, Monroe had surreptitiously tucked the pleats into the crack of her buttocks.

A year later, Travilla designed what would be the second-most famous gown for Monroe, after the *Seven Year Itch* white cocktail dress. The candy pink silk *peau d'ange* gown with the giant bow on the back for the "Diamonds Are a Girl's Best Friend" number in *Gentlemen Prefer Blondes* (1953) was actually Travilla's second design for that sequence. During production, a scandal had erupted when the press revealed that Monroe had once posed nude for a pin-up calendar, causing studio chief Darryl Zanuck to scrutinize Monroe's wardrobe carefully. For the "Diamonds Are a Girl's Best Friend" number, Travilla had originally designed a costume straight out of burlesque. The outfit, a body stocking covered in black fishnet with essentially a rhinestone-encrusted G-string and bra, was now deemed too revealing. His solution was a pink gown, full-length gloves, and multiple diamond bracelets. The effect of covering Monroe proved even more alluring than Travilla's original conception, and the gown became one of the designer's most identifiable creations. Madonna copied it for her "Material Girl" video in 1985.

Travilla was born William Jack Travilla on March 22, 1920, to John "Jack" and Bessie Louise Snyder Travilla, in Avalon, on Santa Catalina Island, just off the coast of Los Angeles. Bessie died when William was just two years old. Much of the Travilla family was involved in show business. William's aunt, Sybil Travilla, acted under the names Sybil Seely and Sibye Trevilla, often with Buster Keaton in his early two-reel comedies. William's father and uncles formed a vaudeville group, the Three Travillas. They performed stunt diving on Catalina Island. Jack's career came to a sudden and terrifying end when he suffered a severe head injury during a performance. He changed careers, operating a tire store in Los Angeles the rest of his life. When William was a grade schooler, his father married Ruth Calderwood, who gave birth to William's half sister, Joan Travilla, on April 11, 1929.

OPPOSITE: Tom Ewell and Marilyn Monroe in *The Seven Year Itch* (1955).

Travilla's stepmother recognized his interest in art and enrolled him at the Chouinard School of Art at age eight. The instructors found him so capable, they quickly advanced him into adult classes. When Travilla's grandmother learned that Chouinard's curriculum included sketching live nude models, the horrified matriarch purchased her grandson a violin, hoping that music could give the boy's creativity a wholesome outlet. Already impressed with her stepson's artistic aptitude, Ruth smashed the instrument over her knee, and Travilla continued his art studies without further interference from his grandmother. At fourteen, Travilla enrolled in the professional arts and design program at Woodbury College (now Woodbury University) in Burbank, graduating in 1941. While at Woodbury, William frequented burlesque clubs after class and sold sketches of costume ideas to some of the performers.

In 1941, when William was twenty years old, his maternal grandfather died, leaving his namesake a small inheritance. With that money, Travilla, along with his grandmother, and aunts, traveled to the South Seas, where he painted portraits of the natives of Tahiti. Upon his return to Los Angeles, he briefly sketched for Western Costume and then moved to Jack's Costume, a company known for providing wardrobe to ice shows and circus performers. There Travilla met ice skater Sonja Henie, who was dissatisfied with her current designer. Travilla soon showed that he could put more than flash in his clients' costumes, but actually make the performers more beautiful as well.

While still employed at Jack's, Travilla worked on movie assignments for Columbia and United Artists in 1942 and 1943. In 1944, he met exotic actress Dona Drake when she came to Jack's to have some costumes made. The couple married ten days after meeting. Six years Travilla's senior, Drake had been performing in show business since her early teens. Born Eunice Westmoreland, Drake first affected an exotic Latin heritage when

she appeared as Rita Rio in an all-girl orchestra and singing group in the 1930s. Drake successfully perpetuated her image as a Hispanic actress when she was under contract to Paramount, appearing in *Aloma of the South Seas* (1941) and *The Road to Morocco* (1942). In truth, Drake was African American and white mixed, and her family worked menial restaurant jobs. She hid her secret not only from the world, but also from her husband. Had she done otherwise, her 1944 marriage to Travilla would have been a legal impossibility. The California Supreme Court did not declare the state's anti-miscegenation law unconstitutional until 1948.

Hoping to garner more designing assignments, Travilla started a design business called The Costumer. He intended to collaborate with studio designers, but in the end, he tended to get assignments only when a designer was in trouble on a project. To earn extra money, Travilla recalled his South Seas trip by painting a series of semi-nude Tahitian women on black velvet. He sold them at Don the Beachcomber restaurant. Actress Ann Sheridan purchased several to decorate a boyfriend's apartment. Travilla met her one evening at the restaurant. At her request, Warner Bros. hired Travilla for ten weeks at $1,000 a week to design for Sheridan in *Nora Prentiss* (1947). The film turned out to be a great showcase for Travilla's designs, and the clothes earned favorable notices. His second film with Sheridan, *Silver River* (1948), was also well received. Travilla's success could not have come at a better time. Drake gave birth to the couple's daughter, Nia, on August 16, 1951.

OPPOSITE: William Travilla fits Ann Sheridan for *Silver River* (1948).

ABOVE: (l-r) Charles Ruggles, June Haver, Gordon MacRae, and Rosemary DeCamp in *Look for the Silver Lining* (1949). Costume design by William Travilla and Marjorie Best.

Because of her challenges with epilepsy and emotional problems, Drake preferred to focus on motherhood. She was relieved to have Travilla's income for the family's support.

After Travilla's success with Sheridan, Errol Flynn asked him to design his costumes for *Adventures of Don Juan* (1948). Marjorie Best had been brought on to design the costumes originally, but Flynn considered her designs too "true" to the period, which meant not manly enough for Flynn's tastes. Travilla replaced the ruffles with a slim-lined doublet and tights, still keeping with Flynn's swashbuckler image. Travilla found Flynn surprisingly obsessive about details, like the placement of seams and the fitting of collars. In the end, Flynn was pleased with Travilla's designs. At

the Oscars the following spring, Travilla, Best, and Leah Rhodes, who designed for Flynn's costars, took home the Oscar for color costume design.

ABOVE: William Travilla and Marilyn Monroe on the set of *Gentlemen Prefer Blondes* (1953).

OPPOSITE: A wardrobe test for Marilyn Monroe for *Gentlemen Prefer Blondes*.

OVERLEAF, LEFT TO RIGHT: The discarded outfit for the "Diamonds are a Girl's Best Friend" number, deemed too suggestive after Monroe's nude modeling came to light. · Marilyn wore a Travilla gown for a 1954 appearance on *The Jack Benny Show*.

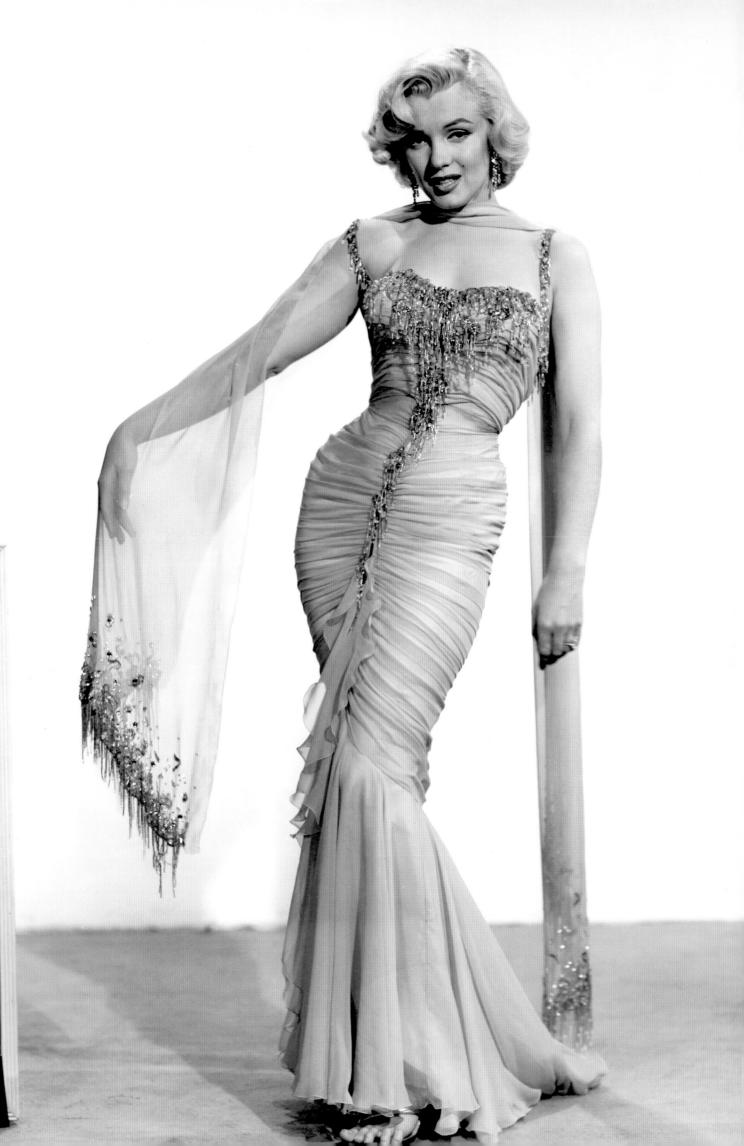

AWKS A678
RILYN
MONROE
S "LORELEI"
INING
ROOM SEQ.
OWN, BOY
UMBER

S. TRAVILLA
0/31/52

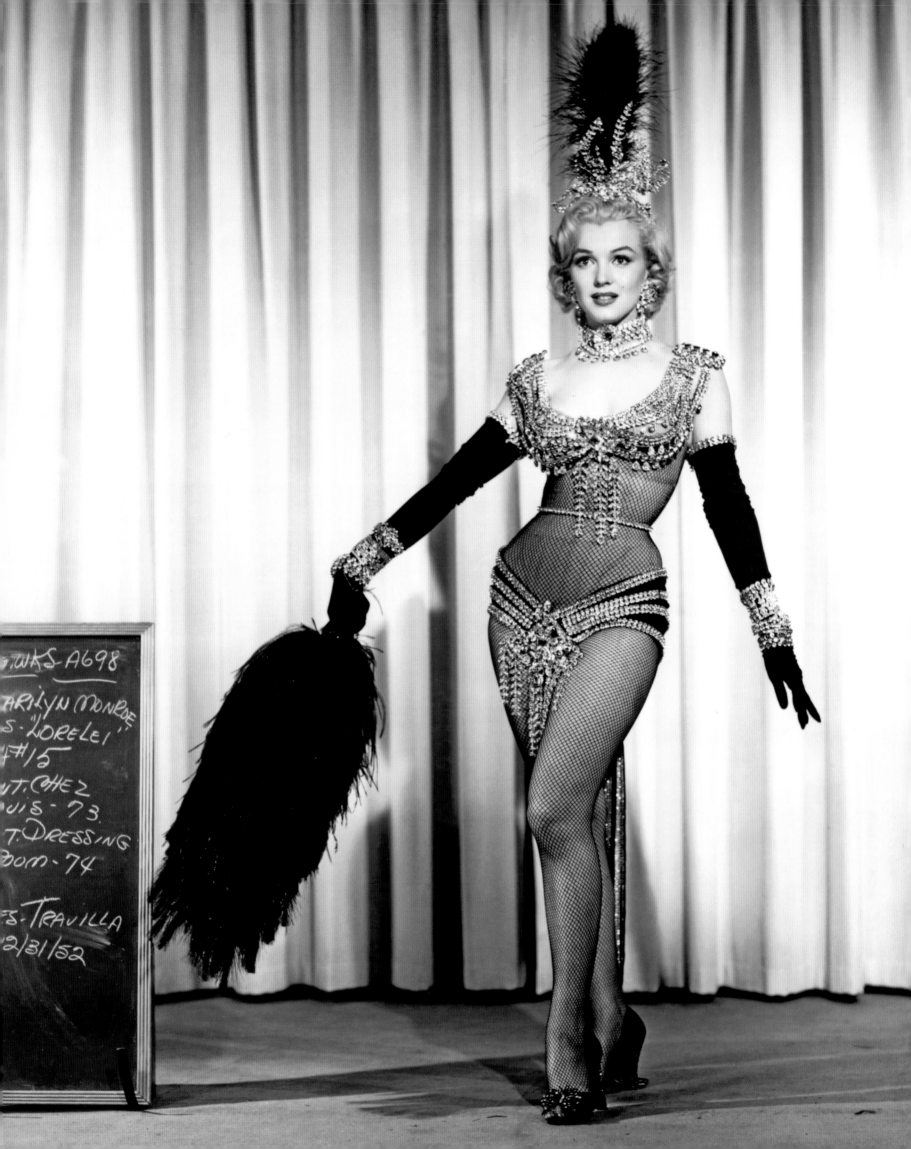

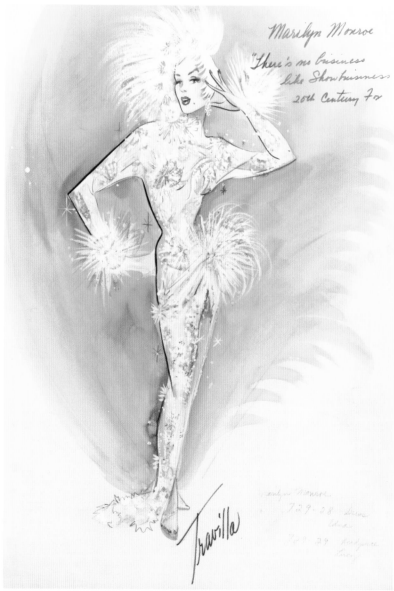

Another Hollywood player took note of Travilla's work for Sheridan. Charles Le Maire, costume head at 20th Century-Fox, found one of Travilla's creations for Sheridan the most beautiful suit he had ever seen. He offered Travilla a position at Fox. Right from the start, Travilla's designs pleased his new boss, although Le Maire found Travilla's fabric choices odd. They seemed too stiff for his designs. Le Maire taught Travilla to use chiffon instead of stiff taffeta or heavy satin, a lesson Travilla did not forget when he produced his ready-to-wear collection years later.

For *There's No Business Like Show Business* (1954), in the finale number, Monroe had difficulty keeping in step with the rest of the cast as they descended a staircase. After several failed takes, Monroe accidentally on purpose spilled coffee on the dress during a break. "This got back to Zanuck," said Hollywood historian David Chierichetti. The studio head's solution was simple. "I want you to make ten copies of that

dress tonight," he told Travilla, "and if she plays this game with us tomorrow, we'll just keep putting them on her." When Travilla told Monroe about Zanuck's plan, the star burst into tears. "Billy, every day a little piece of me breaks off and dies," she said, "and soon there won't be enough left, and when that happens, will you hide me?" This was in 1954.

Le Maire and the studio brass began to realize just how much the studio's most important star was relying on Travilla for emotional support. Monroe's boundless need for attention and reassurance consumed much of the designer's time. "Travilla would have to stay at the studio with Marilyn until late at night," Chierichetti said. "He had to be wherever Marilyn needed him, and he was relieved of all of his other duties on other pictures when Marilyn was shooting something. As talented as Travilla was as a designer, he was more important to the studio as Marilyn Monroe's confidante that kept her going."

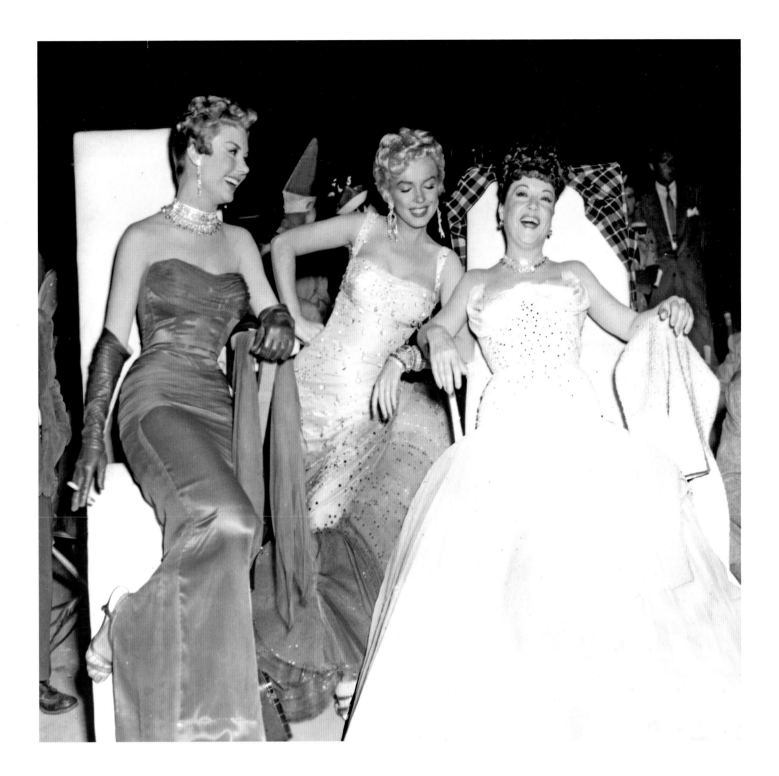

The two even went out on the town socially. On one occasion, Travilla took Monroe to the Tiffany Club to hear Billie Holiday sing. As Travilla passed the manager's office, he noticed Monroe's nude pin-up calendar on the wall. Because Monroe had never seen the calendar, the pair went back to get a glimpse. When they discovered the office door now closed, Monroe knocked. She told the man answering the door that she wanted to see the calendar. Through the door crack, Monroe and Travilla could see Holiday. The blues chanteuse took the calendar from the wall, crumbled it, and threw it out the door at Monroe, yelling, "Here you are, bitch!" Disgusted, Travilla complained to the manager, and the couple left. The reports of the incident in the rags the next day totally got the story wrong. The owner of the Tiffany Club erroneously told a reporter that Travilla had been offended by Monroe's nude calendar and had caused a fight at the club.

OPPOSITE, LEFT TO RIGHT: The replacement dress for the "Diamonds Are a Girl's Best Friend" number in *Gentlemen Prefer Blondes*. · A William Travilla costume sketch for Marilyn Monroe in *There's No Business Like Show Business* (1954).

ABOVE: Mitzi Gaynor, Marilyn Monroe, and Ethel Merman on the set of *There's No Business Like Show Business*.

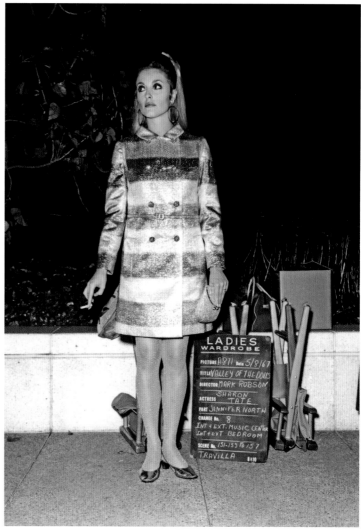

Drake was furious when she read that her husband had been out with Monroe. While the studio supported Travilla's relationship with the troubled actress, his wife certainly did not. Drake was jealous. She had suspected her husband of having affairs before. This time, Travilla's relationship did blossom into an affair with Monroe, though she was dating Joe DiMaggio at the time. The affair did not last. Not only was Travilla married, but he could not usurp DiMaggio in Monroe's affections. Monroe married DiMaggio in January of 1954, and shot *The Seven Year Itch* in the fall.

For the famous subway grate scene, Travilla selected white crepe for Monroe's dress to give her a clean contrast from the gritty streets of New York City. The halter bodice and sunburst pleated skirt completed the fresh feel he sought. The studio heads seemed to intuitively know that the scene was going to be memorable. The Fox publicity department invited dozens of freelance photographers to capture the scene as it was being filmed. Newspapers and magazines worldwide published thousands

of pictures of Monroe's dress blowing up in the train gust, not only generating heightened box-office interest, but helping to secure the scene's legacy as one of the most iconic images in the history of film. In 2011, Debbie Reynolds sold the dress for $4.6 million dollars when she liquidated her collection of Hollywood memorabilia.

As television began to overtake movies in popularity toward the end of the 1950s, Travilla became concerned as studios laid off staff and curtailed production. With an eye to his own financial survival, Travilla obtained Le Maire's permission to open his own retail business with his assistant, Bill Sarris, while the two continued at Fox. Together they started Travilla Inc., with the intention of selling their collections through upscale department stores.

Although Travilla promised Le Maire to be available whenever needed at the studio, the demands of his retail business prevented him from doing so. Le Maire and Travilla both agreed it was time for Travilla to leave Fox. Also around this time, Travilla separated from Drake, though the couple remained married until Drake's

INT - EXT Lyon's beach hou
148 - 150

Travilla

death decades later. Their daughter, Nia, came to live with her father in the mid-1960s, when Drake's emotional problems became severe.

During the 1960s, Travilla also worked freelance in television, contributing designs for Diahann Carroll in *Julia* (1968–71) and for Loretta Young in *The Loretta Young Show* (1953–61). He also worked on films as a freelance designer, including *The Stripper* (1963) and *Valley of the Dolls* (1967). Director Mark Robson even tried to convince Travilla that he should play the designer husband of Patty Duke in *Valley of the Dolls*, telling the designer it would be good for his business. "But it's the scene where she comes home and finds him naked in the swimming pool with a starlet, and I won't do that," Travilla told Robson. "The public will pay good money to buy my clothes. They don't need to see my bare ass running across the screen."

By 1971, Travilla found himself out of step with women's taste in clothing. Jeans and polyester had taken over women's wear, and they held no fascination for him. Travilla left Travilla Inc., and eventually moved to Spain. The country had a regenerating effect and he returned to the United States and reopened Travilla Inc. in the mid-1970s.

Beginning in the 1980s, Travilla's work in television gained recognition, earning him seven Emmy nominations and two wins. Although the television miniseries *Moviola* (1980) included a

OPPOSITE, LEFT TO RIGHT: William Travilla and his wife, Dona Drake. • Sharon Tate in *Valley of the Dolls* (1967).

ABOVE, LEFT TO RIGHT: A William Travilla costume sketch for Barbara Parkins in *Valley of the Dolls*. • Barbara Parkins dressed by Travilla in *Valley of the Dolls*.

featuring Marilyn Monroe's early years as an actress, Travilla won the Emmy for his costumes for the "The Scarlett O'Hara War" episode. His other Emmy was for costuming the Ewing family on *Dallas* (1978–91). He found the schedules challenging, and he was required to be on set constantly to curtail possible mistakes. Nonetheless, television was where Travilla found his most success later in life, including the television movie *Evita Peron* (1981) with Faye Dunaway; the miniseries *The Thorn Birds* (1983) with Barbara Stanwyck; and the series *Knot's Landing* (1979–93).

During his last decade, Travilla spent more time traveling, making trips to Africa, Egypt, Syria, and a return trip to the South Seas. He found influences for his ready-to-wear line everywhere he visited. A year after Drake's death on June 20, 1989, Travilla learned that he had lung cancer. He died on November 2, 1990, in Los Angeles. Talking about his penchant for pleating with a reporter, Travilla once quipped, "When I die, I don't want to be buried or cremated, just pleat me."

ABOVE: Costume design for Sharon Tate in *Valley of the Dolls*.

OPPOSITE: (l-r) Barbara Parkins, Sharon Tate, and Patty Duke in *Valley of the Dolls* (1967).

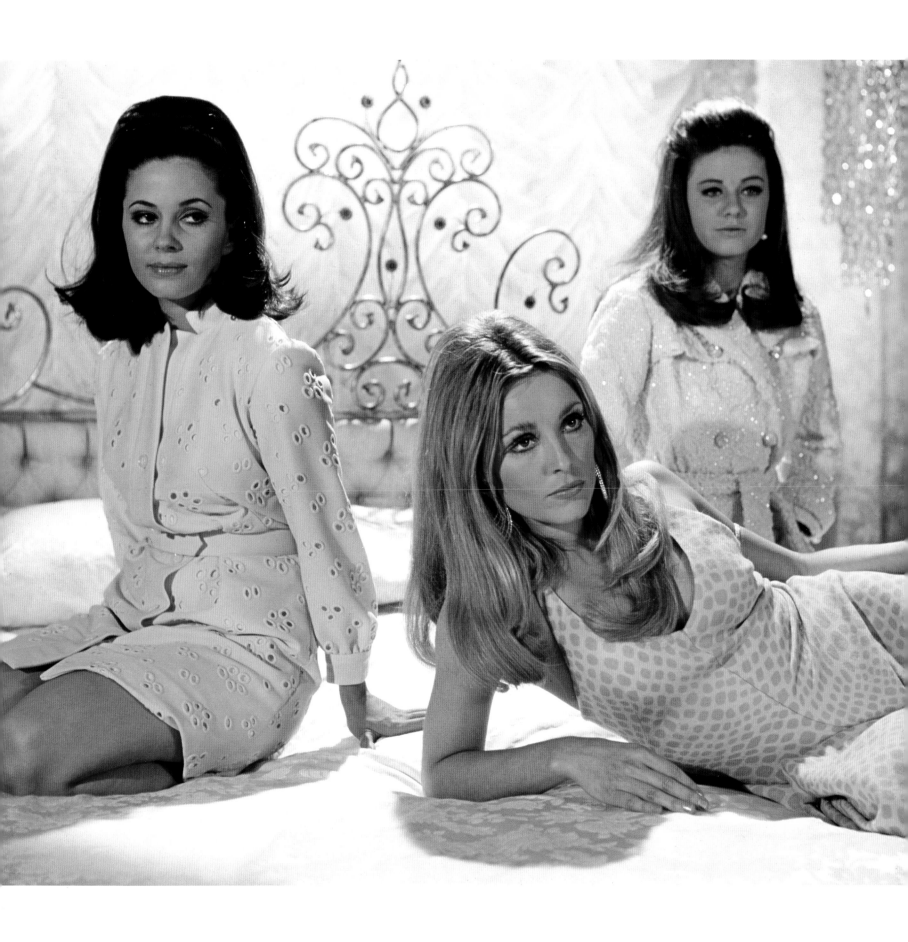

CHAPTER THREE
THE MODERN ERA

On February 12, 1947, French designer Christian Dior presented his first collection in Paris. The silhouettes of the dresses were unlike anything seen before—tiny waists, large busts, and volumes of fabric in the ankle-length skirts. It was dubbed the "New Look" by Carmel Snow, Editor-in-Chief of *Harper's Bazaar*. Although Hollywood had spent the prior two decades battling the dominance of Parisian designers, studios found themselves once again producing films with fashions that looked out-of-date by the time they were released. Costume designers raced to incorporate post-War European influences into their designs.

As Hollywood watched its box-office receipts shrink in the early '50s while families stayed home to watch television, it tried to give moviegoers what they could not get at home. New theatrical processes were invented, such as Cinerama, which used three synchronized projectors to create an illusion of depth in widescreen. Hollywood also attempted to lure patrons away from their televisions by ramping up the sexual heat in movies. When Joseph Breen retired from the Production Code Administration in 1954, censors began to wield less power. Further, studio personnel who had been released from their contracts in budget-saving moves found more personal expression out from under the thumbs of studio executives. Directors like Otto Preminger, not wanting to be restrained in the way they approached adult subject matter, released their films without the Production Code's approval. By the 1960s, the public once again clamored for effective regulation. On November 1, 1968, the Motion Picture Association of America film rating system took effect.

Meanwhile in fashion of the 1960s, Paris lost its stronghold to swinging London. For the first time, various skirt lengths all came into style at the same time. Pages of fashion magazines were filled with the battle between the mini, the midi, and the maxi skirt. A "new" modern era had emerged.

OPPOSITE: Lucille Ball in *Mame* (1974). Costume design by Theadora Van Runkle.

NORMA KOCH

Norma H. Koch was born on April 23, 1921, to Jules and Clara Mathy Koch, in Kansas.

She grew up in Kansas City, Missouri, where her father worked in her grandparents' grocery store. When Norma was five, the family relocated to California, first settling in the Mojave Desert. By 1930, the family was living in Los Angeles. Norma, who was an only child, taught herself costume design beginning when she was twelve years old by copying dress designs she found in newspapers.

Despite the lack of any formal training in costume design, Norma landed a position with Edith Head at Paramount by 1943. Her work on *Going My Way* (1944) so impressed star Bing Crosby that he encouraged Norma to strike out as a freelance designer. She was offered her first design job on the independent production *A Scandal in Paris* (1946) starring George Sanders. Though she began her career designing elaborate period clothes, Koch carved out a niche for herself in westerns, including *The Kentuckian* (1955) with Burt Lancaster, as well as gritty dramas such as *Marty* (1955) with Ernest Borgnine. In her films, Koch designed the men's clothes as well as the women's clothes.

In the 1960s, Koch often worked for director Robert Aldrich. Koch won an Oscar for *Whatever Happened to Baby Jane?* (1962) and was nominated for *Hush . . . Hush, Sweet Charlotte* (1964), both directed by Aldrich and starring Bette Davis.

The 1963 Oscar costume design awards were introduced by Audrey Hepburn. "This award is not only of great interest to every actress, who depends on the artistry of the designer to help her create her roles, but it is also important to women throughout the world," Hepburn said. "Historical or modern, every film with beautiful clothes launches some new trend in fashion." It would be impossible to imagine that any woman would have left the theater after seeing *Whatever Happened to Baby Jane?* and run to a store to emulate what they had just seen on-screen. Norma's acceptance acknowledged "all the Baby Janes, wherever you are."

On March 3, 1957, Norma married sound engineer Robert R. Martin. They worked together on *Taras Bulba* in 1962. Norma gave birth to her only son, Jules Martin, on January 23, just weeks before winning her Oscar in 1963. Her prolific career came to an abrupt end when she died at the age of fifty-eight on May 1, 1979, in Los Angeles.

TOP TO BOTTOM: Norma Koch's sketch for Bette Davis in *Whatever Happened to Baby Jane?* (1962). · Norma Koch in a costume consultation with Olivia de Havilland for *Hush . . . Hush, Sweet Charlotte* (1964).

OPPOSITE: Norma Koch makes an adjustment to George Sanders's costume in *A Scandal in Paris* (1946).

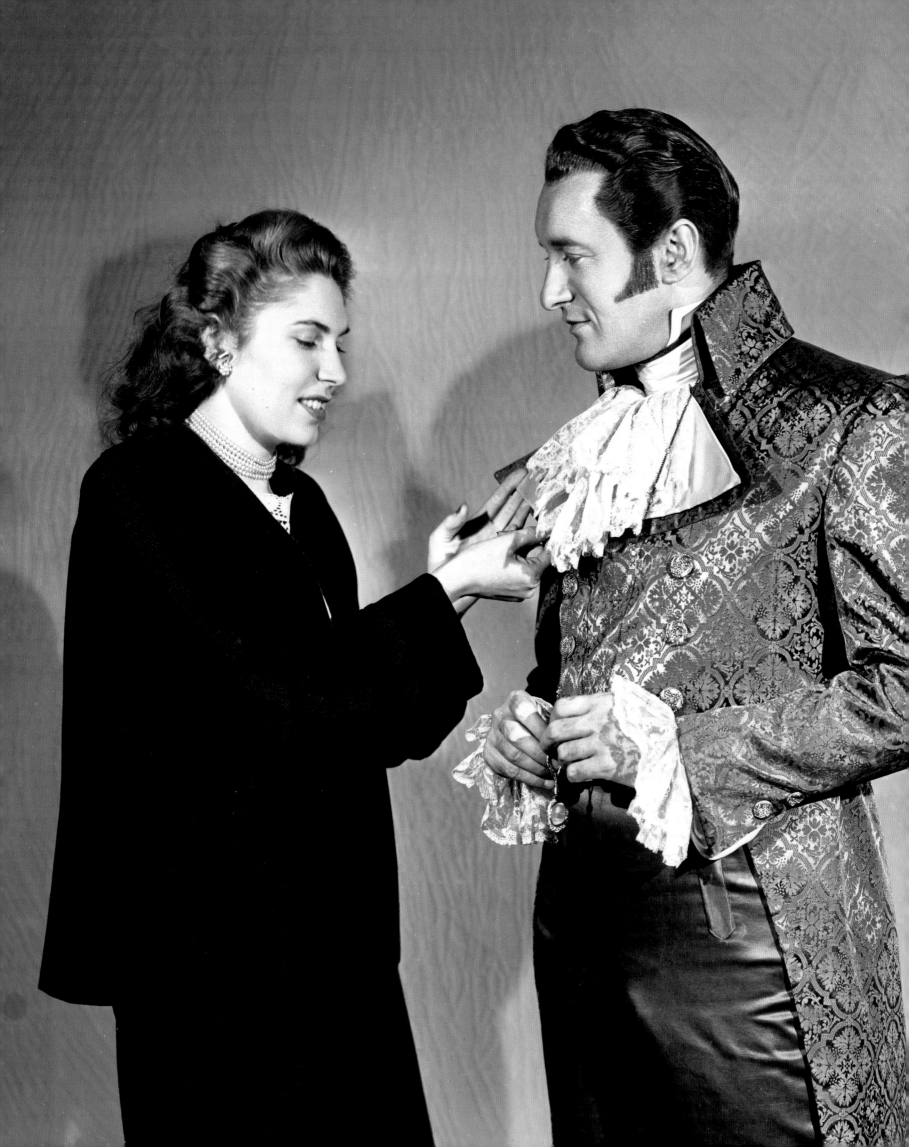

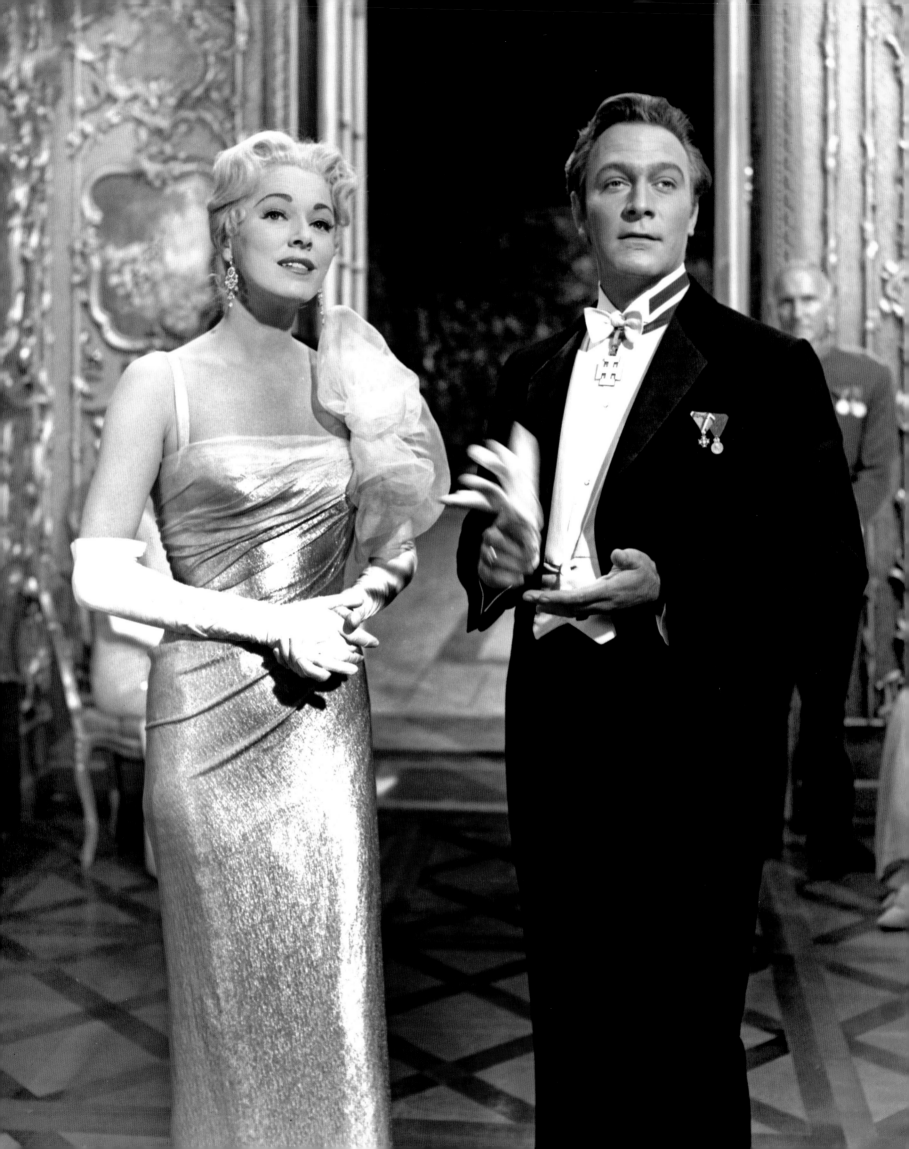

DOROTHY JEAKINS

In her later years, Dorothy Jeakins described her father as cruel man, who kidnapped Dorothy from her mother when she was five years old and hid her in foster homes.

She said she never knew who her mother was, but she did know she was a couturier who made tea gowns. Even more tragically, she said that her father left her brother with foster parents, and never went back for him.

In a *Los Angeles Times* interview, she referred to her youth as "a Dickensian existence, cringing with fear in the shadow of a foster mother who took her frustrations out on her with whippings and threats to send her to reform school." Dorothy would frequently be left alone, and at age seven, she would traverse Los Angeles on the city's Red Line trolley cars and beg for handouts. "I wondered why I was alive, but somehow I kept on living," she said. "I cried constantly, trying to comprehend who I was, and why fate had made me an unwanted child."

Public records tell a somewhat different story. Dorothy Jeakins was born Dorothy Elizabeth Jeakins in San Diego on January 11, 1914. Her mother, Sophie Marie von Kempf, was a Danish immigrant who had two children, Allen and Katherine Willett, from a prior marriage. Originally from Yorkshire, England, Dorothy's father, George Tyndale Jeakins, was a stockbroker who had immigrated to California in 1909. Soon after the birth of Dorothy's little brother, Robert, the Jeakins marriage fell apart.

In a 1964 interview with Betty Hoag for the Archives of American Art New Deal and the Arts Project, Jeakins described attending a Montessori School in San Diego. "I learned to read and write before I was six, and to draw also," Jeakins said. "And when I was in kindergarten I made a drawing of President Wilson, who had come to San Diego to speak at a war-bond rally, as I remember. Someone took me to see him and I made a drawing of him. They reproduced it in the newspaper. Someone showed me the newspaper, and I was astonished that it was good enough to be printed."

In 1920, according to the census, Dorothy and Robert were living with their father in San Diego. By 1930, Dorothy and her father had moved to Los Angeles, settling in Carthay Circle, a Spanish Colonial Revival development bordering Beverly Hills. It is possible that by 1921, George Jeakins could have put Dorothy in foster care in Los Angeles, and then was reunited with her by 1930. In the Betty Hoag interview, Jeakins described attending Otis Art Institute as a twelve-year-old in a Saturday children's class—not quite the stuff of Dickens. However, Robert W. Jeakins does disappear from the census. George never remarried and is not listed in any census as living with a woman.

"At Fairfax High I began reading plays, and it became a sweet escape into fantasy," Jeakins said. "Sympathetic teachers encouraged my interest in drama, and during preparation for one school play, I was taken along on a trip to a costume house. I'd never seen a costume before, let alone hundreds of them. It became the turning point in my life."

Jeakins won a scholarship to Otis Art Institute. She spent her weekends at the public library reading plays, and designing costumes for imaginary productions. "I'd take pencil and paper

OPPOSITE: Eleanor Parker and Christopher Plummer in *The Sound of Music* (1965).

RIGHT: Elizabeth Taylor presents Dorothy Jeakins with the Oscar for Best Costume Design for *Joan of Arc* (1948).

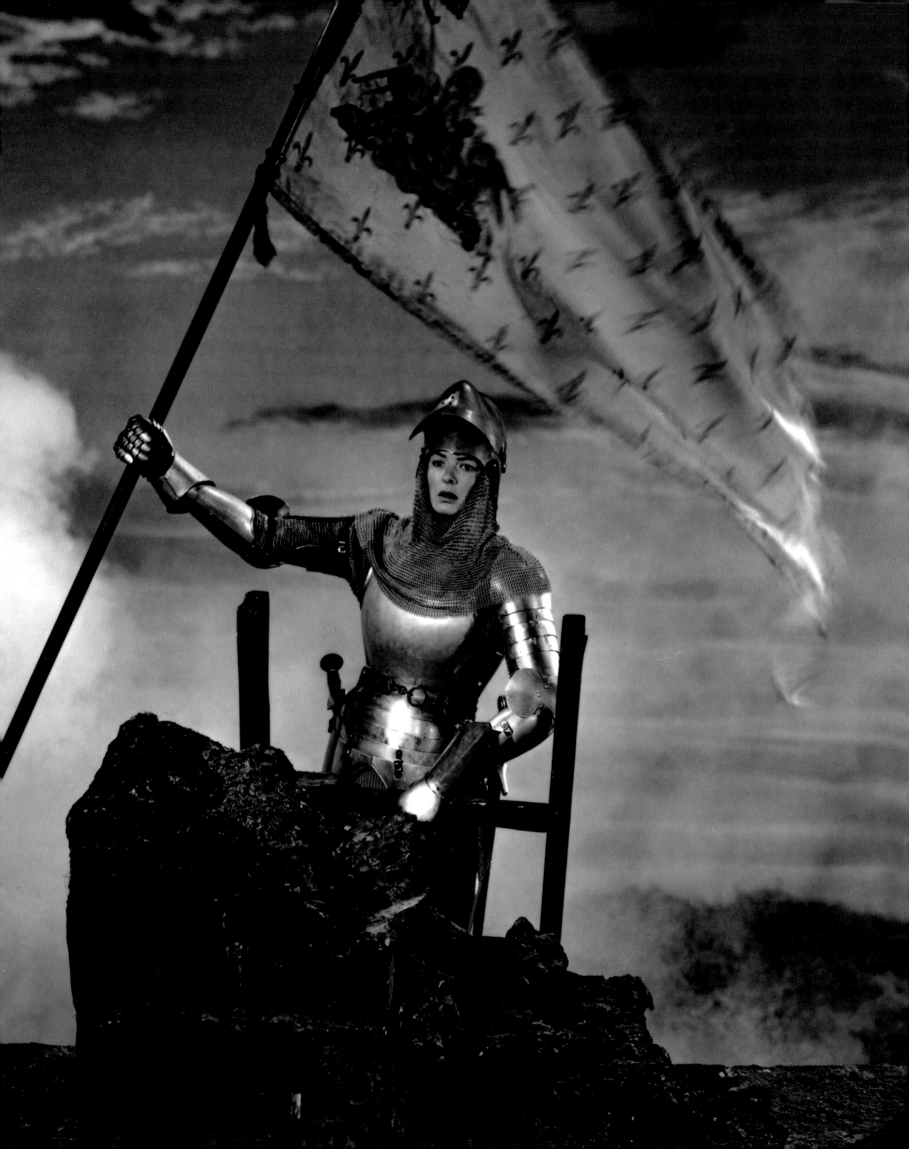

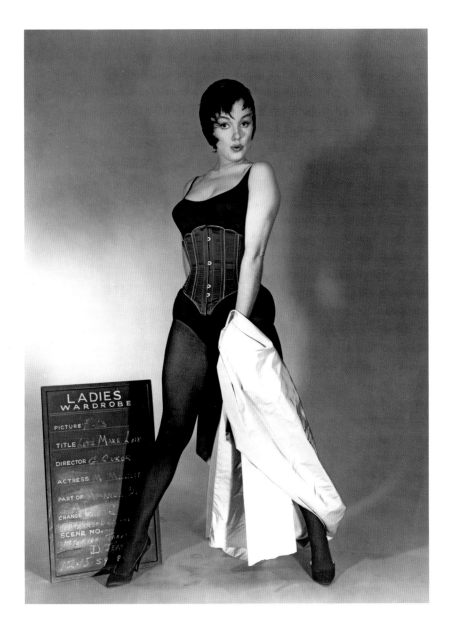

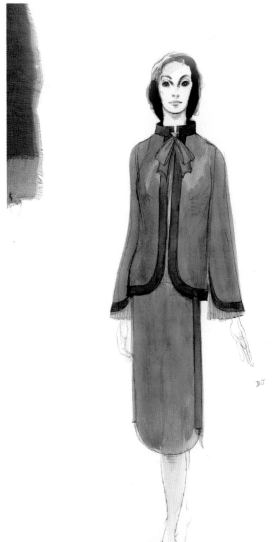

and draw complete wardrobes just by letting my imagination run wild," Jeakins said. At the same time, Jeakins worked painting cells and animated backgrounds for Walt Disney at his original Hyperion Avenue studio for $16 a week.

After leaving school, Jeakins worked doing illustrations for the Los Angeles City Planning Commission. Falling on hard times during the Depression, Jeakins worked for the Federal Art Project, painting for about a year before going into a division of lithography and printmaking. In 1937, Ernst Dryden hired her to work on costumes for *Doctor Rhythm* (1938). After Jeakins lost her studio position when the Federated Motion Picture Crafts went on strike, Jeakins went to work as a fashion illustrator at I. Magnin.

In 1940, Jeakins married Raymond Eugene Dannenbaum, the director of publicity for 20th Century-Fox. Dannenbaum changed his last name to Dane, and the couple had two sons.

Dane was stationed in Paris during the war and never returned to Los Angeles, leaving Jeakins alone with the children. She later claimed that Dane stayed in Europe because his family had a castle there. Her explanation seems unlikely. Dane was born in Vallejo, California, on December 11, 1905, and was not European.

Jeakins's layouts for I. Magnin caught the eye of 20th Century-Fox art director Richard Day. Day introduced Jeakins to director Victor Fleming, who hired her to sketch costumes for Barbara Karinska on his production of *Joan of Arc* (1948). Jeakins was shocked when Victor Fleming fired Karinska over the Fourth of July

OPPOSITE: Ingrid Bergman in *Joan of Arc*.

ABOVE, LEFT TO RIGHT: Marilyn Monroe in one of Dorothy Jeakins's designs for *Let's Make Love* (1960). · A Dorothy Jeakins costume sketch for Jean Simmons in *Elmer Gantry* (1960).

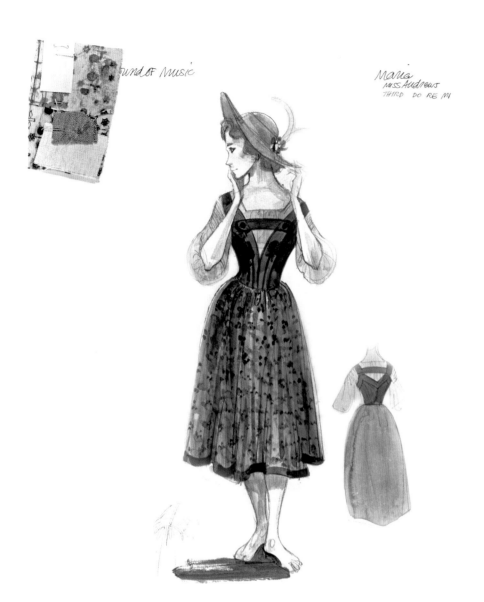

Sound of Music

Maria
MISS ANDREWS
THIRD DO RE MI

tempestuous. She described DeMille as "the most vicious man. He indulged in that awful process of making people appear to be naked in front of other people. At the end of the day I would end up in the men's wardrobe, sobbing." On the plus side, Jeakins said working with DeMille made her a perfectionist. "When you worked for DeMille, you became a perfectionist by necessity—unless you didn't need your job," she said. "It was the best training anyone could have. But it was far from sunshine and roses."

During a costume consultation, Adele Balkan witnessed a clash between DeMille and Jeakins. "He wanted the garment to look *identical* to the sketch," Balkan said. "You came as close as you could, but fabric and paper and paint are two different things, and he was not reasonable about that, or else he was doing it on purpose, I don't know."

Balkan accompanied Jeakins to the film's location in Egypt. "I don't think she really wanted to go to Egypt because of this, but she wasn't about to miss out on the trip." Jeakins left *The Ten Commandments* when the production returned to Los Angeles.

Jeakins made six movies with director John Huston and won her third Oscar for his *Night of the Iguana* (1964). Huston was the best director for using costumes as a tool for storytelling, according to Jeakins. For the tale of a defrocked minister leading a tour group through Mexico, Huston told Jeakins that "the tourists in the bus should look like they came from a mark-down sale at Orbach's" and that "Deborah Kerr must look virginal, a fastidious Pilgrim walking through the world clothed in raw silk."

Jeakins was one of the few Hollywood designers who worked freelance for her entire career. Occasionally she was left unprotected. For the classic film *High Noon* (1952), starring Grace Kelly and Gary Cooper, Jeakins received no screen credit. "The action all took place within an hour, a 'small' job, I suppose," Jeakins said. "I never thought to ask [producer] Stanley Kramer for screen credit for my work, therefore none was given—as it should have been. A lesson learned."

weekend. When Jeakins protested that she did not have the skill to finish the film herself, Fleming said that he believed that she could. "My life was altered in an instant," Jeakins said.

The designs for *Joan of Arc* were awarded the first Oscar for costume design. Jeakins won another Oscar the following year for Cecil B. DeMille's *Samson and Delilah* (1949). Jeakins believed that she did not deserve the Oscar for *Samson and Delilah*, because the costumes were done by what she described as a "costume congress of Cecil B. DeMille" including Edith Head, Elois Jenssen, Gile Steele, and Gwen Wakeling. She kept that Oscar in a closet.

Jeakins worked again on a team that included Edith Head, John Jensen, Ralph Jester, and Adele Balkan on DeMille's *The Ten Commandments* (1956). Jeakins found the experience

Jeakins successfully costumed Marilyn Monroe in *Niagara* (1953) as a vixen plotting her husband's murder. When Ray Cutler (Max Showalter) spies Rose (Monroe) in an eye-popping dress, he asks his wife, Polly (Jean Peters), "Why don't you ever get a dress like that?"

"Listen, for a dress like that, you've got to start laying plans when you're about thirteen," Polly tells him.

When Monroe and Jeakins collaborated again on *Let's Make Love* (1960), Monroe was unhappy with some of Jeakins's designs. Eventually, Marilyn replaced the outfits she did not like with pieces from her personal wardrobe. Jeakins and Monroe tried again on John Huston's *The Misfits* (1961), and nothing improved. "Although I really feel I should be replaced—I will continue with your clothes for *The Misfits* because they are under way and nearly ready to fit," Jeakins wrote to Monroe. "If you like them, I will see them through to completion. If you are disappointed, someone else can then take over. I am sorry I have displeased you. I feel quite defeated—like a misfit, in fact. But I must, above everything, continue to work (and live) in terms of my own honesty, pride, and good taste." Ultimately, Monroe chose Jean Louis to design *The Misfits*.

From 1953 to 1963, Jeakins designed productions for the Los Angeles Civic Light Opera Company. She was nominated for Broadway's Tony Award for Best Costume Design for *Major Barbara* (1957) and *Too Late the Phalarope* (1957) and for *The World of Suzie Wong* (1959). In 1962, Jeakins won a Guggenheim grant to study in Japan. She became interested in ethnic and tribal costumes and worked as a curator for the textile and costume collection of the Los Angeles County Museum of Art. In 1966, in addition to designing the film *Hawaii*, Jeakins also had a small role as Julie Andrews's New England mother-in-law. Jeakins believed she was cast because she had "a tired face." Jeakins's last film was John Huston's *The Dead* (1987).

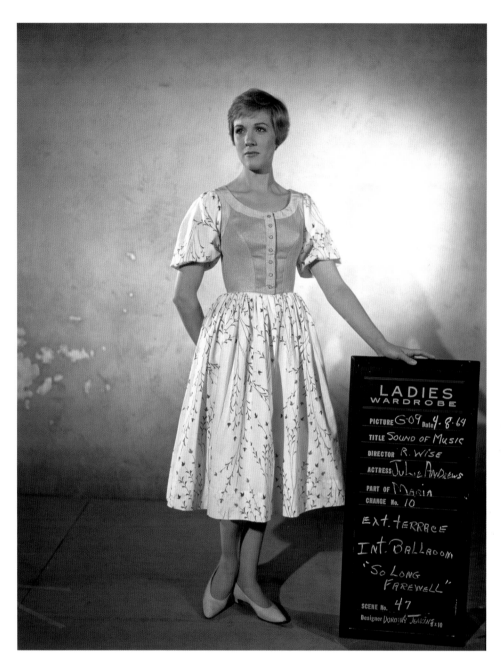

Even through a life of introspection and melancholy, Jeakins was able to see beauty. "In the middle of the night, I can put my world down to two words: make beauty. It's my cue and my private passion," she said. Jeakins died on November 21, 1995, in Santa Barbara, California. She was 81.

OPPOSITE: A Dorothy Jeakins costume sketch for Julie Andrews in *The Sound of Music*.

ABOVE: A wardrobe test for Julie Andrews in *The Sound of Music*.

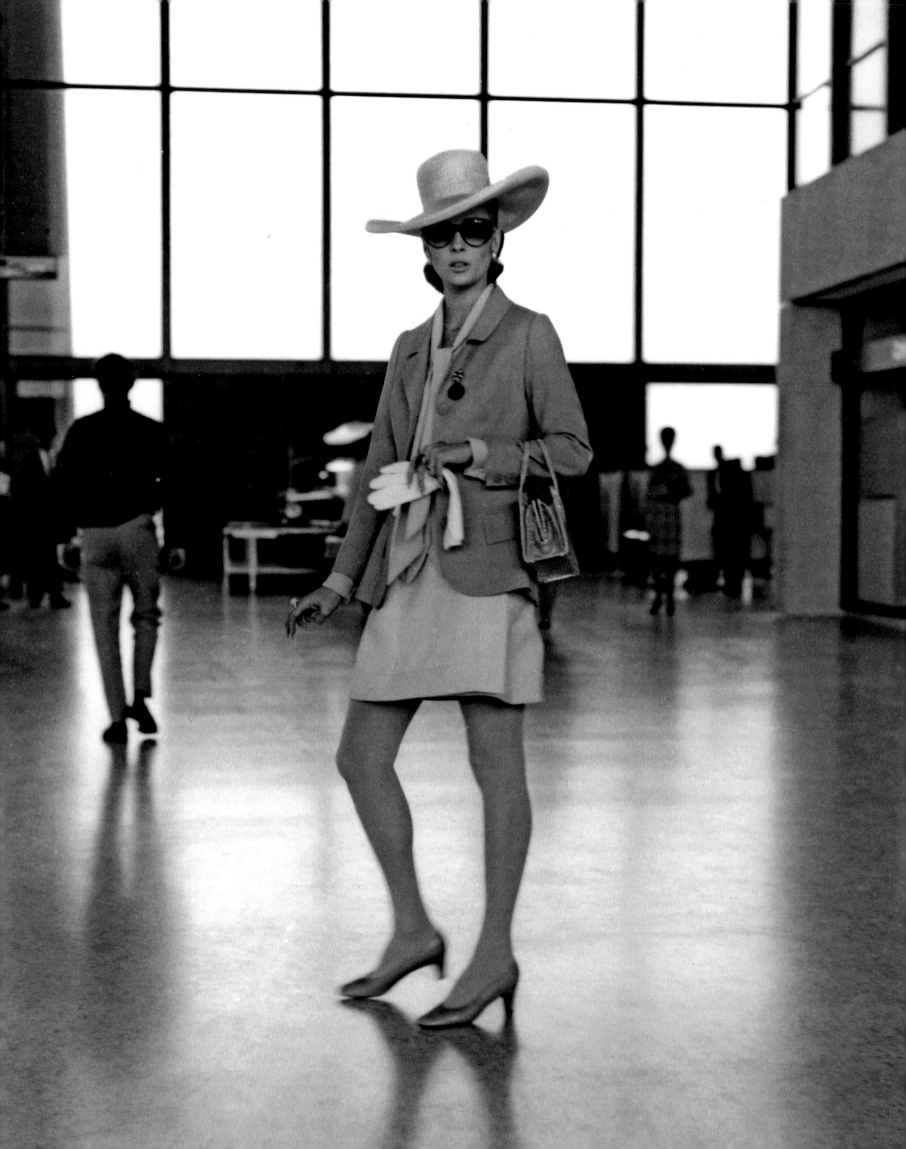

THEADORA VAN RUNKLE

Theadora Van Runkle came into the world on March 27, 1928, in Pittsburgh, Pennsylvania, as Dorothy Schweppe. She was the daughter of Eltsey Adair and Courtney Bradstreet Schweppe, a son of the Schweppes carbonated drink family.

Her parents, who were unmarried, did not stay together, and when she was two years old, Dorothy moved to California with her mother. She was raised in Beverly Hills, and later dropped out of Beverly Hills High School.

She married Robert Van Runkle when she was still in her teens. They had two children—Maxim and Felicity. Maxim's birth somehow caused Van Runkle to tap into her creativity. "The minute I got home from the hospital I started teaching myself to paint and draw," Van Runkle said. "Then I began going downtown and getting jobs as an illustrator. While I was freelancing, I always made my own clothes, and made clothes for friends, cut friends' hair in new styles, and just played at being a talent." During this time she changed her name to Theadora.

While drawing ads for I. Magnin one afternoon in 1964, Van Runkle decided she "was through with advertising," she said. "I was bored to tears with it and something else had to happen." Van Runkle met Dorothy Jeakins at a party, and Jeakins told her she needed a sketch artist. "The next day I went to work for her—for a month," Van Runkle said. "She let me go because I think she didn't like that I was such a good artist. She felt threatened."

But Jeakins was responsible for Van Runkle's big breakthrough from sketch artist to costume designer. Jeakins had designed *The Sound of Music* (1965) for director Robert Wise, and she believed she was going to be hired to design *The Sand Pebbles* (1966). Instead, Wise chose designer Renié Conley, whose specialty was ethnic costumes. Conley hired Van Runkle as a sketch artist and put her in a little office.

"One day Jeakins came to see Conley," David Chierichetti said, "and she saw Theadora at work. She walked up behind Theadora and made a motion as if she was going to hit her, since she believed Van Runkle had gone to work for the enemy. What Jeakins didn't realize was that Van Runkle had a mirror on her desk and that she saw Jeakins come up behind her with her hand raised. Van Runkle

ducked, and Jeakins was embarrassed. In order to sort of make it up to Theadora, she turned over *Bonnie and Clyde* (1967) to her."

"I'd never designed anything before," Van Runkle said of *Bonnie and Clyde*. "I never went to design school. I never went to art school. But I knew fashion. I knew style. I knew construction. I sewed by hand and by machine. I learned construction from *Vogue* patterns." Most of Clyde's suits—chalk-striped, double-breasted suits were patterned after archival footage of Pretty Boy Floyd. Dunaway was not convinced that Van Runkle's maxi skirts and berets were right for her. "Faye thought I didn't care," Van Runkle said. "Faye thought I was trying to make her ugly."

The "Bonnie and Clyde look" took the country by storm. Milliners became busier than ever making berets. Suddenly, the miniskirt was no longer the rage and the maxi skirt came in. Van Runkle's comments about her sudden success led to resentment from other costume designers, who had spent years working as costumers and assistants to learn their craft and work their way up. "I knew for all of my professional life I'd be doing this," Van Runkle said. "But I did nothing to get there. I knew it would happen by a miracle. It was written in the stars."

Bill Thomas, who was nominated for an Oscar for *The Happiest Millionaire* (1967) against *Bonnie and Clyde*, said of his contender in the press, "I expect *Bonnie and Clyde* to win the Oscar for Best Costume Design," Thomas said. "I'm not saying it's right, I am simply saying it's what will probably happen. You see, most people who vote aren't really students of design. They are in no position to judge. They've seen *Bonnie and Clyde*, know that the costumes are affecting the fashion scene today, and probably won't consider any more than that. It's unfair because kids are going out and buying Bonnie and Clyde costumes, not because they dig the designs, but because they want to emulate the lead

OPPOSITE: Faye Dunaway in *The Thomas Crown Affair* (1968).

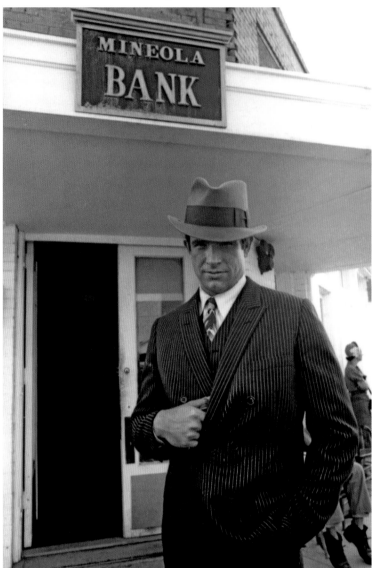

characters in the movie. Had Bonnie and Clyde lived a century earlier, you'd see teenagers going around dressed in bustles and long gowns now." Notwithstanding Thomas's prediction, John Truscott took home the Oscar for Best Costume Design for his work on *Camelot* (1967).

In *The Thomas Crown Affair* (1968), Van Runkle created twenty-nine changes for Faye Dunaway as a hip insurance investigator, playing opposite Steve McQueen as a wealthy businessman and bank robber. Van Runkle used what she called "method accessorizing" to help enhance Dunaway's character, who was trying to set a trap for McQueen. "It's an entire look," Van Runkle said at the time. "For one scene where Faye is obviously going to have a sexual encounter, I designed a dress of diaphanous flesh-colored chiffon with just one button at the neck. We worried about jewelry for a long time. Faye wanted to wear something that would symbolize control as a counterpoint to her passion. So

I finally got a massive antique cameo pin, and we combined that tremendously sensual dress with that in-control, almost puritanical piece of jewelry."

Van Runkle envisioned wide-brimmed hats and braided and upswept hairpieces for Dunaway in *The Thomas Crown Affair* and knee-length skirts. "But Faye wanted the skirts to be right up to her crotch. We got into a knock-down, drag-out over it and she won." In an interview a few years later, Van Runkle named Dunaway as one of the few in the industry who truly appreciated her work.

During the 1970s, Van Runkle's old Hollywood sensibility was showcased in *Myra Breckinridge* (1970) with Raquel Welch;

ABOVE, LEFT TO RIGHT: Faye Dunaway and Theadora Van Runkle during the making of *Bonnie and Clyde* (1967). · Warren Beatty in *Bonnie and Clyde*.

OPPOSITE: Steve McQueen in *Bullitt* (1968).

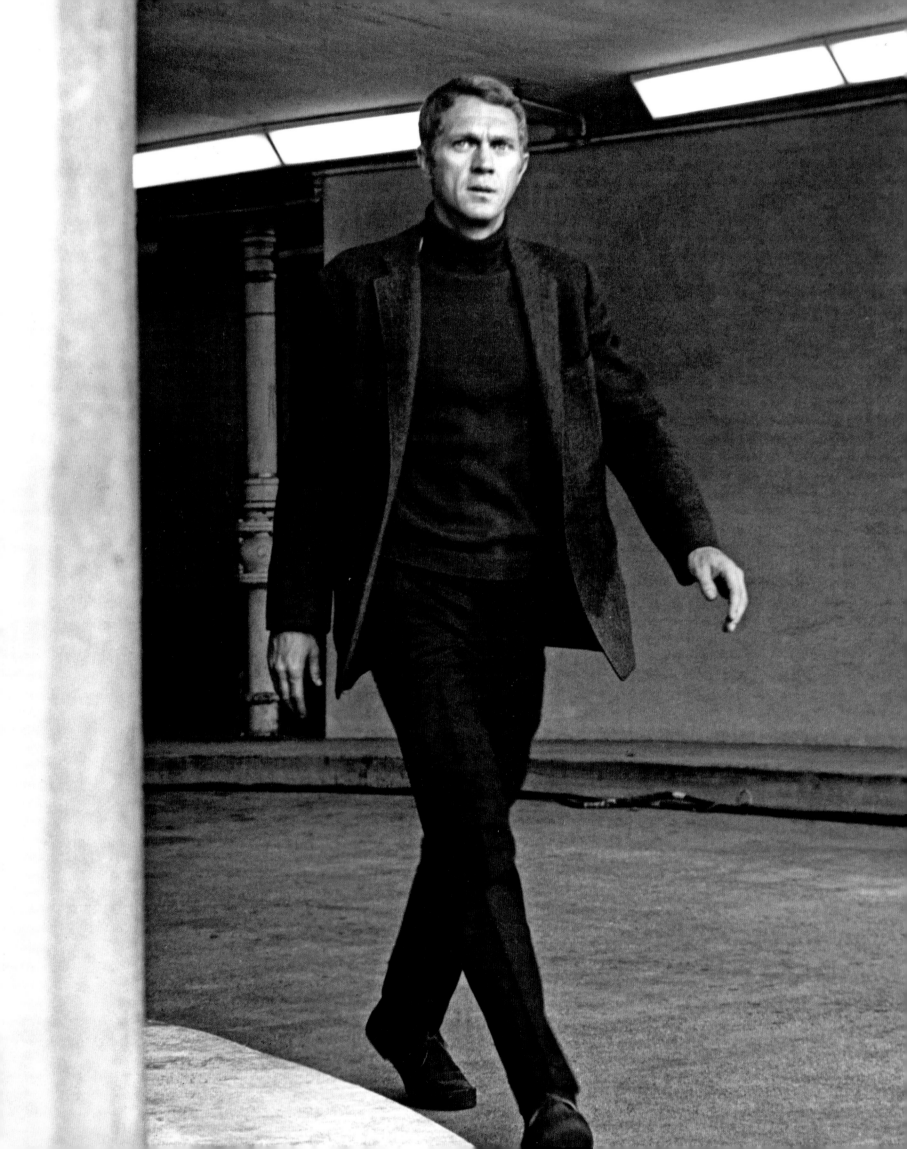

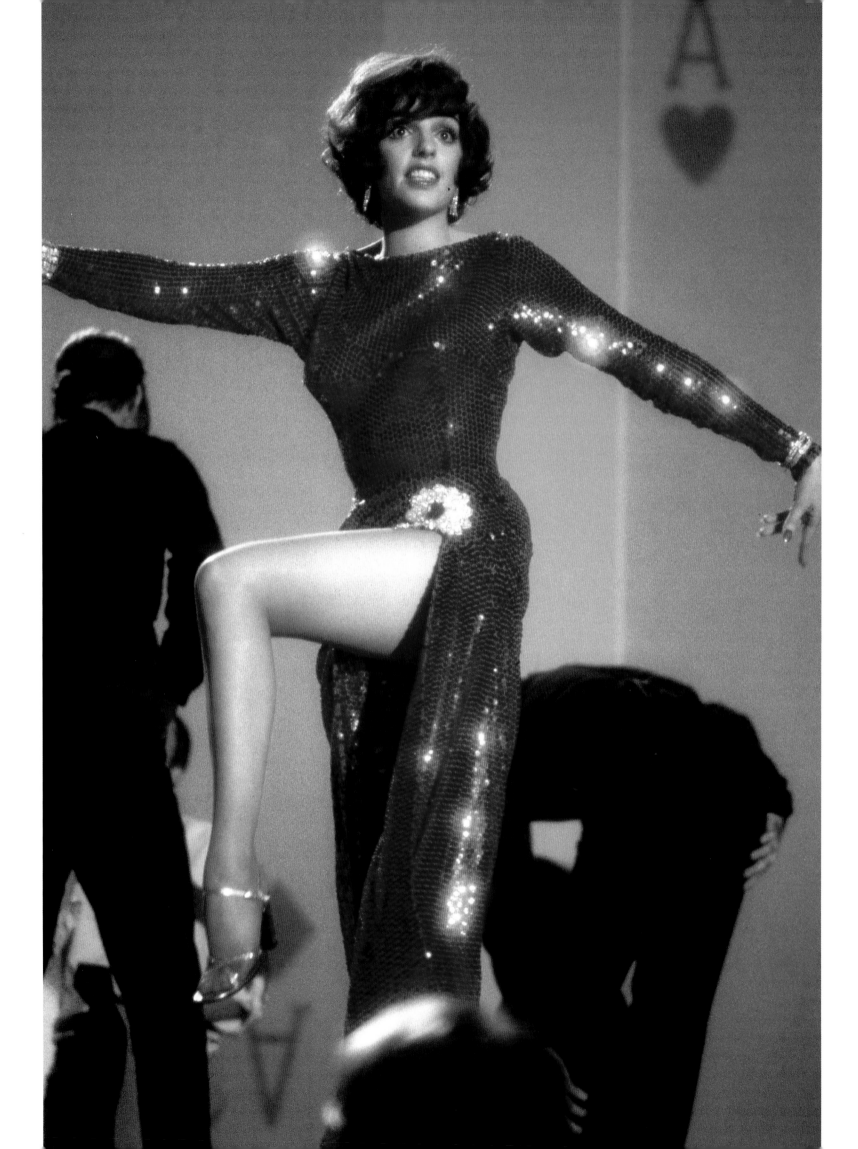

Myra Breckenridge
Sc: 107-108
Change # 22

Mame (1974) with Lucille Ball; and *New York, New York* (1977) with Liza Minnelli.

When the successful Broadway musical *The Best Little Whorehouse in Texas* (1982) was adapted for the screen, Van Runkle gowned Dolly Parton as the madam. Parton "knows she's got gifts," Van Runkle said, "and with her pale hair and white skin, she looks so wonderful in Dresden colors, in bisque. She's like ivory, pearl, crystal. She reminds me of all the great French beauties, of Du Barry and Marie Antoinette." For Parton's first number in the film, Van Runkle designed a gown that was an homage to Mae West. But after the costume tests were done, Van Runkle realized it did not make enough of an impression. She made a new sketch. "It's gorgeous," director Colin Higgins told her. "Do you want it? It's going to cost a fortune," she said. "Do it," Higgins told her. The low-cut red silk chiffon gown with thousands of tiny hand-stitched red, blue, and orange bugle beads made up $7,000 of the film's $60,000 costume budget. It was dubbed "Miss Mona aflame with passion."

Van Runkle spent her later years painting, attending art classes at UCLA, and doing sporadic work in films. When she made *I'm Losing You* (1998), a contemporary film by Bruce Wagner, Van Runkle lamented the changing role of costume designer. "Nowadays, movie makers want to spend no money on costumes and they want it to look like the great, golden age of costuming," she said. "I didn't have a concept for costumes because I didn't have any money." Van Runkle said she worked "with what I could cull from people's closets, my own closet, and bits of fabric to put things together."

Van Runkle married photographer Bruce McBroom on December 24, 1974, and the couple divorced December 29, 1982. She also taught at the Chouinard Art Institute and the Otis Parsons School.

"I know that everyone is supposed to fight, scream, and push to the top," Van Runkle said. "Be a winner, not a loser. But I've seen enough winners in the movie industry and I didn't like what I saw. I'm against the kind of thing where you are so ambitious that you lose out on becoming a person. I just want to grow old, wise, be domestic, cultivate my personal life, love my kids, try not to drop names, and get a little respect out of people for my designs." Van Runkle died of lung cancer on November 4, 2011, in Los Angeles. She was eighty-three.

OPPOSITE: Liza Minnelli in *New York, New York* (1977).

ABOVE: A Theodora Van Runkle costume sketch for Raquel Welch in *Myra Breckenridge* (1970).

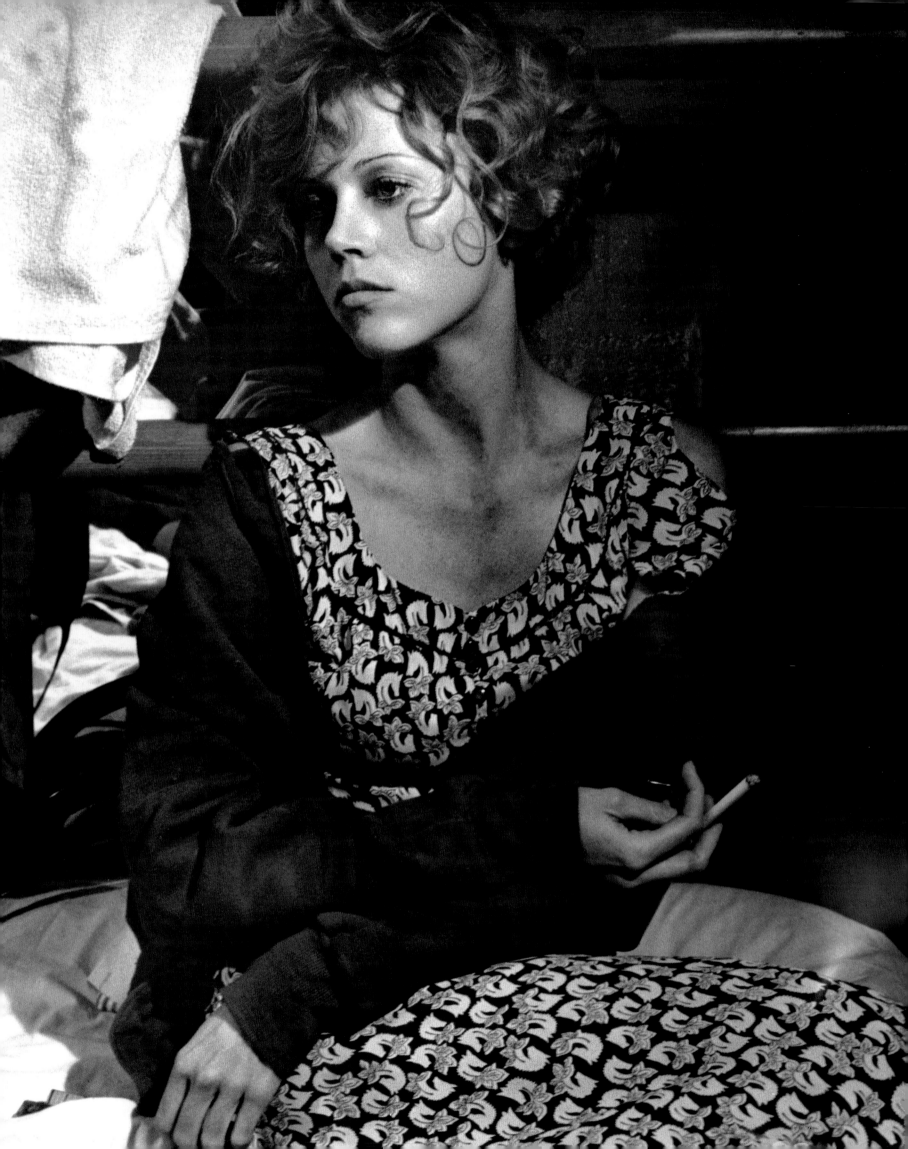

DONFELD

Donfeld was born July 3, 1934, in Los Angeles, California, as Donald Lee Feld. His earliest memories of drawing were in grammar school.

His teachers encouraged his artistic abilities through high school, but Donfeld planned to be a veterinarian. When a donkey Donfeld had nursed for two years died during a classroom experiment, he was crushed, and realized he did not have the courage to watch something he loved die.

Donfeld studied commercial design for two years at the Chouinard Art Institute, but became more interested in fashion. In 1953, an executive from Capitol Records was giving a lecture at Chouinard and saw Donfeld's work. He offered Donfeld a position as Assistant Art Director, and ultimately Donfeld designed the album covers for some of the most popular movie soundtracks of the day—*Oklahoma!* and *The King and I* among them.

"He was the new guy at Capitol Records coordinating the albums and the artwork, and nobody wanted to work with Frank Sinatra or Judy Garland because they felt they were so difficult," said Donfeld's friend Leonard Stanley. "Donfeld was not impressed by celebrity; he treated everyone equally. Judy and Frank adored him."

Donfeld had been at Capitol for several years when he found out that his assistant was making more money than he was. Donfeld approached his bosses and asked for a raise. They decided to let him go instead. Donfeld called Sinatra for help. The singer's secretary explained that he was in Las Vegas, but said she would give him the message. Donfeld was sure he would hear nothing. Within twenty minutes, Frank Sinatra called back and said "What's up kid?" "I've just been fired from Capitol Records and I don't know what I'm going to do with the rest of my life," Donfeld told Sinatra. "Give me a half an hour," Sinatra said. Half an hour later the phone rang and it was Sinatra. "You have an appointment with [producer] Arthur Freed at MGM at 12:30 and you have an appointment with [director] Vincente Minnelli at 1:30," Sinatra said. "Frank created Donfeld's entire second career, so you could

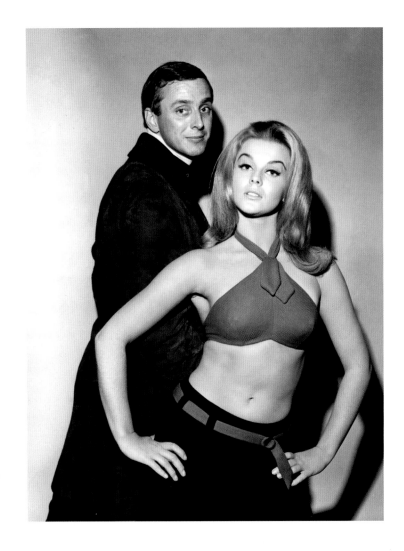

never say anything against Frank Sinatra to Donfeld," Stanley said. "For the rest of his life, Donfeld always referred to him as 'Mr. Sinatra' in front of other people."

Donfeld was hired as a sketch artist on *Spartacus* (1960) at MGM. Minnelli also put him to work as costume coordinator and assistant to the producer on a number being prepared by MGM for the Oscars that year—Maurice Chevalier singing "Thank Heaven for Little Girls." When Minnelli became ill, he asked Donfeld to take over production entirely, and the number was the highlight of the telecast.

Donfeld was hired by producer Jerry Wald at 20th Century-Fox as a special visual consultant to color consultant Leonard Doss on *The Best of Everything* (1959) and later, *The World of Suzie Wong* (1960). Costume designer Mickey Sherrard said

OPPOSITE: Jane Fonda in *They Shoot Horses, Don't They?* (1969).

ABOVE: Donfeld with actress Ann-Margret.

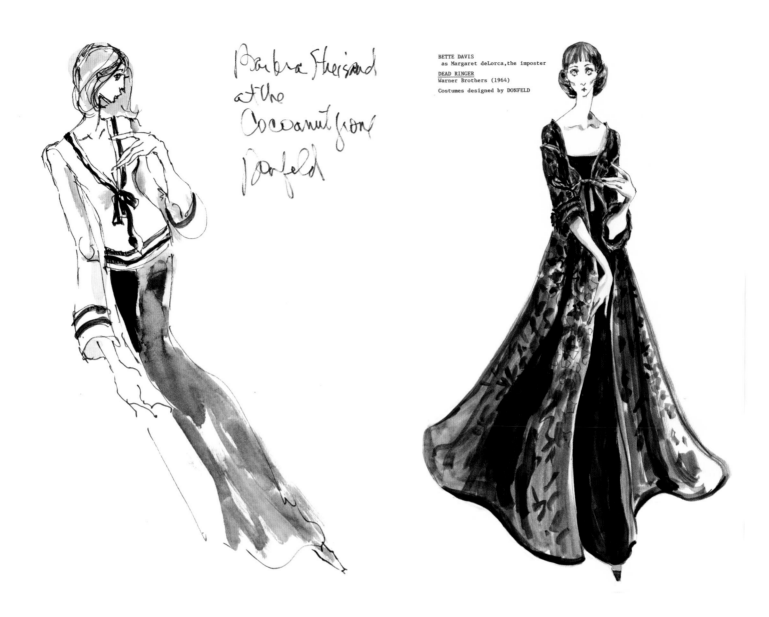

Barbra Streisand
at the
Cocoanut Grove
Donfeld

BETTE DAVIS
 as Margaret deLorca, the imposter
DEAD RINGER
Warner Brothers (1964)
Costumes designed by DONFELD

that Donfeld was fascinated with anything to do with wardrobe and quizzed costume designer Adele Palmer about how fabrics photographed.

Donfeld then signed a five-picture deal with 20th Century-Fox to design costumes. His first film was *Sanctuary* (1961) with Lee Remick, and by 1962, he received his first Oscar nomination for *Days of Wine and Roses*. Donfeld also carved out a niche for himself designing for television, cabaret, and Las Vegas appearances of Barbra Streisand and Nancy Sinatra.

For *They Shoot Horses, Don't They?* (1969), about a marathon dance in 1932, Donfeld decided the characters would not have had enough money to buy new clothes, so his designs started with clothes that would have been fashionable in 1929. Donfeld played authentic 1920s records during the fittings with Jane Fonda to help the actress find her character of Gloria. He even played an "If

Gloria . . ." game with Fonda. "If Gloria weren't a hooker, what would she be?" he asked Fonda. "A carhop," she answered. "If she were a singer, whom would she idolize?" "Ruth Etting," Fonda replied. Finally, one day Fonda looked in the mirror and said, "I *am* Gloria!" Donfeld's clothes received glowing notices from critics, who found them wholly authentic to the Depression era. "Not one costume sent people out of the theater wishing for one like it," Donfeld said. "But when those characters spoke, the audience listened. People who acted like slobs looked like slobs."

After ten years in the industry, Donfeld became the second-highest-paid costume designer in the business, after Irene Sharaff. Donfeld's fees for film work were $1,000 a week and up by 1970. That same year, Nancy Sinatra paid him $10,000 to design her wardrobe for her appearance at Las Vegas' International Hotel.

In his house in Benedict Canyon, Donfeld hosted a kind of

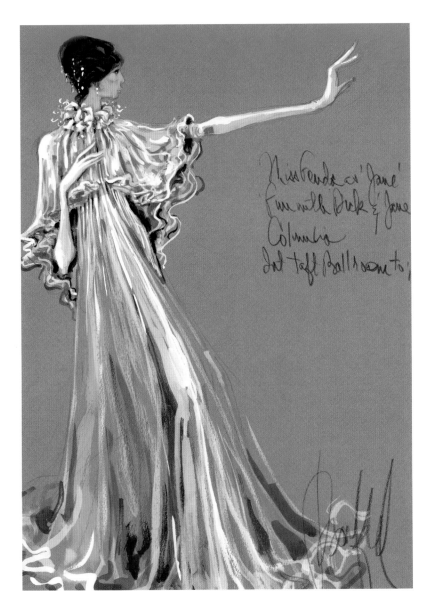

weekly salon for celebrities, including Tuesday Weld, Jacqueline Bisset, Michael Sarrazin, and David Hedison. "He was very good at making things quite comfortable and cozy," Jacqueline Bisset said. "His house was delightful. It was constantly changing. He made objects interesting. He always had big sheepdogs for as long as I knew him. He was so big and had such a physical presence. He was a little awe-inspiring, which I think he thoroughly enjoyed."

Bisset and Donfeld became good friends and collaborated on a number of films, including *Jules le magnifique* (1977), *Who Is Killing Great Chefs of Europe?* (1978), and *Class* (1983). "I asked for him to design for me in *The Grasshopper* (1970)," Bisset said. "He understood the body and he subtly used darts and the placement of seams to help it look better," she said. "My character in *The Grasshopper* changes from the beginning, when she is a little young woman from an average background, and she takes her chance

in Vegas. He did a really good job. I enjoyed working with him because he was such a colorful character. He could be terribly funny if he didn't like what you were wearing. He would throw his hands up in the air and gesticulate and make noises. There was no hiding his dislike of things."

Lamenting what had happened to the Academy Awards after he stopped coordinating the fashions, Donfeld was brutal. Of Barbra Streisand in 1969, he said, "Her dress looked like a pinball machine with all those dots on it, like you could put a quarter in her mouth and she'd light up." Some actresses in Hollywood did not forget his criticisms easily, especially when choosing or approving a designer for their next project. Donfeld's acerbic critiques cost him a number of projects.

"He adored Jane Fonda and thought she was a very important woman," Bisset said. "He was always going on about what a valuable person she was and how she didn't have an unimportant thought." But even Fonda could not escape Donfeld's ire when she did not request him for *Julia* (1977) after they had worked together on *Fun with Dick and Jane* (1977). Fonda wrote and explained to Donfeld that "The fact that Anthea [Sylbert] is doing *Julia* has nothing to do with me. It was a *fait accompli*. By the time I met with [director Fred] Zinneman to discuss such matters, he informed me that he had already engaged Anthea, as well as a hairdresser and that was that."

Bisset also saw the temperamental side of Donfeld when she was unable to get him hired for a job. "He got very grumpy," Bisset said. "I couldn't understand that because he must have known that one doesn't have the power to request people very often. And he was not a cheap person to employ, so there was the budget to consider. He got very upset with me. He didn't tell me directly, but he got very vicious, I was told. We managed to get through that."

Donfeld was nominated for an Oscar for *Prizzi's Honor* (1985), starring Jack Nicholson, Kathleen Turner, and Anjelica Huston. Huston "had a hand in many aspects of my work," Donfeld said.

OPPOSITE, LEFT TO RIGHT: Donfeld's sketch for Barbra Streisand's appearance at the Cocoanut Grove (1963). · Donfeld's sketch for Bette Davis in *Dead Ringer* (1964).

ABOVE: Donfeld's sketch of Jane Fonda in *Fun with Dick and Jane* (1977).

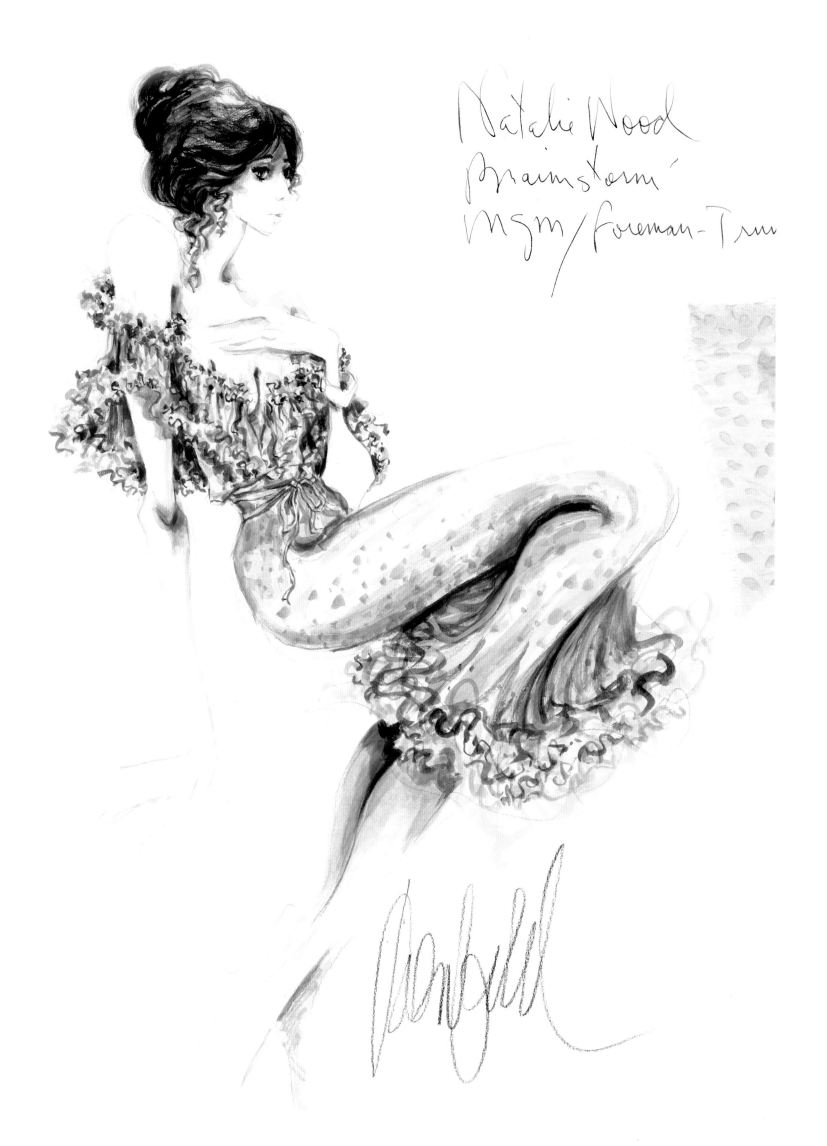

Natalie Wood
Brainstorm
MGM/Foreman-Tru

"I think I bewildered her a bit at the outset, but she never got in my way. She never resisted nor played the director's daughter." Director John Huston suggested a "Schiaparelli pink" swath of fabric across Anjelica's black taffeta dress. When the film was released, Donfeld received a note from designer Dorothy Jeakins. It read, "On the nose and all wonderful."

In the mid-1990s work slowed down for Donfeld and he began experiencing financial problems. "It's those damn business managers that everybody gets mixed up with," Stanley said. "Somebody took him to the cleaners. He thought he was making so much money, but couldn't understand why he was so broke."

"I think his life became very difficult for him near the end," said costumer Margo Baxley. "Unfortunately, Don was so bright and articulate with his pen. He would send notes, and sometimes he was not as discreet as he should have been, and I think it came back to cause him problems in the end. So I don't think his last few years were very happy."

"Somehow our relationship ended up in a kind of nondescript way, mainly because I was not able to request him and I was upset for myself, being told that he was angry," Jacqueline Bisset said. "He had some moments of financial problems that I tried to help him with. I was one of the few left after things got torn down and he became impossible." Donfeld died at the home of his brother Richard in Temple City, California, on February 3, 2007, at the age of seventy-two.

Though things went wrong later, Donfeld expressed a great optimism in the happier times of the mid-1960s. "In my work, I try to collect all my thoughts and say to myself, 'Be grateful for what you have and what you are and more than grateful to those who have helped you in difficult days,'" Donfeld said. "I keep reminding myself of the wonderful, encouraging people around me. Regret is something I don't have time to consider."

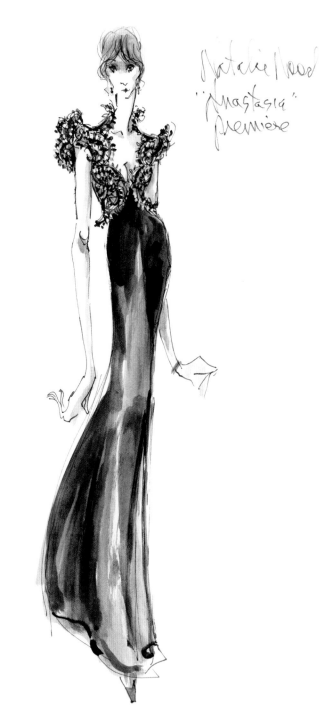

DONFELD

OPPOSITE: Donfeld's sketch for Natalie Wood in *Brainstorm* (1983), the actress's last film.

ABOVE: Donfeld's sketch for the dress Natalie Wood was to wear to the opening night gala of her stage debut in *Anastasia* in Los Angeles. Unfortunately, Wood died before the show opened.

THEONI ALDREDGE

In 1974, Theoni Aldredge was approached to design *The Great Gatsby*, starring Robert Redford and Mia Farrow.

"I went to meet [director] Jack Clayton," Aldredge said. "After I got over the shock of his offering me the job of costume designer, I told him I really didn't have enough time to do it properly. He told me the more I talked, the more time I was wasting because he knew I was going to do this film." Aldrege had only one and a half months before principal photography began. She began her research by looking at 1920s copies of *Vogue* magazine and the French magazine *Femina*. "The most helpful photographs were those picturing actual families, not just the models in '20s clothes," she said. Then she scoured the Paramount studio and textile mills in London to find the correct pure silk gauzes and the chiffons needed for the period.

Though the film received lukewarm reviews, it became an instant fashion classic. "Not only has she faithfully recreated '20s fashions for the Newport set, she has done so with such brilliance that you are never aware of the movie as a fashion statement," Mary Lou Luther wrote in the *Los Angeles Times*. "Daisy's clothes are Daisy's clothes, not Theoni Aldredge's imposition of a look on Mia Farrow." When people referred to the "Gatsby Look" upon the film's release, Aldredge was puzzled. "Gatsby didn't create an era," she said. "He just lived in one. He didn't create a look. I didn't create fashion here. I tried to service a piece of work." Aldredge won an Oscar for the film.

Theoni Aldredge was born on August 22, 1922, in Salonika, Greece, as Theoni Athanasiou Vachlioti. She was the daughter of a surgeon general of the Greek Army and a member of the Greek parliament. As a child, Aldredge collected dolls and was fixated on their clothes.

She graduated from the American School in Athens, Greece, in 1949 and decided on theater as a career. On her way to attend acting school in Chicago, Aldrege stopped in New York. There she attended a showing of the film *Caesar and Cleopatra* (1945). "A strange thing happened," Aldredge said. "I was overwhelmed by

the beauty of the flowing garments worn by Vivien Leigh. People can look so beautiful in clothes. I said to myself 'there is a mystery to costume,' and that's when it started."

Aldredge studied at the Goodman School of Drama in Chicago. There she met the actress Geraldine Page. Page told Aldredge to look her up when she came to New York, and Aldredge's first Broadway job was designing Elia Kazan's production of Tennessee Williams's *Sweet Bird of Youth* (1959) for Page.

On Broadway, Aldredge designed costumes for some of the most famous musicals of the modern era, including *A Chorus Line* (1975), *42nd Street* (1980), and *Dreamgirls* (1981). She won three Tony Awards, for her work on *Annie* (1977), *Barnum* (1980), and *La Cage Aux Folles* (1984). Aldredge was producer Joe Papp's

ABOVE: Theoni Aldredge

OPPOSITE: Bruce Dern and Mia Farrow in *The Great Gatsby* (1974).

20th Century FOX
"THE ROSE" "77"
MISS BETTE MIDLER
Rough Sketch

To Frank
My Friend
Love you
Theoni V. Aldredge

main designer at the New York Shakespeare Festival for more than twenty years. "Papp made me learn my craft, whether I liked it or not," Aldredge told the *New York Times* in 2001. "He paid me $80 a week. I'd say, 'Joe, that's not enough for my cigarettes.' He'd say, 'You have to stop smoking.'"

Aldredge began designing for films in Greece, with *Stella* (1955) starring Melina Mercouri. Aldredge continued designing for Mercouri films—including *Never on Sunday* (1960) and *Phaedra* (1962)—even as she was finding her footing on Broadway. Aldredge designed for Broadway and film concurrently. Her film credits include *Network* (1976), *Semi-Tough* (1977), *Moonstruck* (1987), *Ghostbusters* (1984), and *Addams Family Values* (1993).

"She didn't try to over-glamorize me, which I appreciated," Jacqueline Bisset said of Aldredge's designs for her wardrobe in *Rich and Famous* (1981). Bisset and Aldredge shared a similar view about what Bisset's character—a moderately successful writer—would wear. "The old tweed coat, a nice cashmere sweater, jumpers, and shirts. I was believably dressed," Bisset said. "I didn't feel my character was fashion-y; she was just okay with her clothes, but not more. The wardrobe looked like what my character would wear based on what she earned."

The designer married Tom Aldredge in 1953, and the couple was married until Theoni's death on January 21, 2011, in Stamford, Connecticut, at the age of eighty-eight.

OPPOSITE: Theoni Aldredge's costume sketch for Bette Midler in *The Rose* (1979).

ABOVE: Cher in *Moonstruck* (1987).

ANTHEA SYLBERT

Anthea Sylbert was born on October 6, 1939, in New York City. She studied art history at Barnard College, but decided not to go for a master's degree when she was hired to do research for a Broadway costume designer. "It occurred to me that this might be more interesting than twelfth-century manuscripts," Sylbert said.

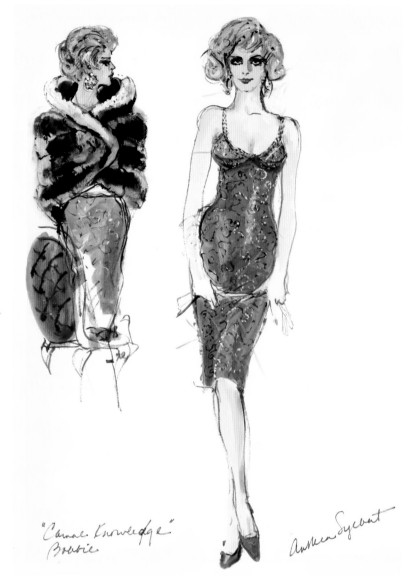

"Carnal Knowledge" Boobie

Anthea Sylbert

Sylbert began designing for off-Broadway theater productions, earning extra money designing shoes for Capezio. She was hired to design the 1967 film *The Tiger Makes Out* "because none of the successful Broadway designers would deign do such a small film," Sylbert said. There she met future husband Paul Sylbert, who was working as a production designer on the film. Through her brother-in-law, production designer Richard Sylbert, she met director Roman Polanski. Polanski was working on his first big Hollywood feature, *Rosemary's Baby* (1968), and hired Sylbert to design. Sylbert put star Mia Farrow in Peter Pan collars and baby-doll dresses. Because the film was set in 1965, the year that skirt lengths grew shorter every month, Farrow's dresses grow shorter as the film progresses.

For *Chinatown* (1974), Polanski wanted to dry out the color scheme, as the need for water was integral to the plot. Sylbert stuck to brown, black, and cream tones for Nicholson and Dunaway. "Jack Nicholson is the easiest to dress—not from the way he's built—but he's extremely open and free about trying anything. I liked working with Faye [Dunaway] because she's such an extreme fusspot and a challenge. I've always thought she has been overdressed in her movies. My feeling was that she's always about to show you her lining. Convincing her was extremely satisfying. Her way of describing my clothes is that they're 'clothes without any ego.'"

When designing for Warren Beatty in *Shampoo* (1975), Sylbert had to reach back to the night of and morning after the 1968 presidential election. "Men did, in fact, open their shirts down to the navel and hang seven thousand things around their necks, started to become peacocks, started in a funny way to become a sex object," Sylbert said. "So you say, 'okay, if I'm going to put him in a leather jacket, when you touch it, it should almost be a sexual experience.'" When Sylbert designed the jacket, she put zippers on it. She started to make it and realized zippers are not really sexy. "We laced the jacket, had fringes hanging, so there was movement when he wore it," she said. "Even the jeans—we started off by just buying jeans; after all, jeans are jeans. Well,

ABOVE: Anthea Sylbert's sketch for Ann-Margret in *Carnal Knowledge* (1971).

OPPOSITE: Mia Farrow in *Rosemary's Baby* (1968).

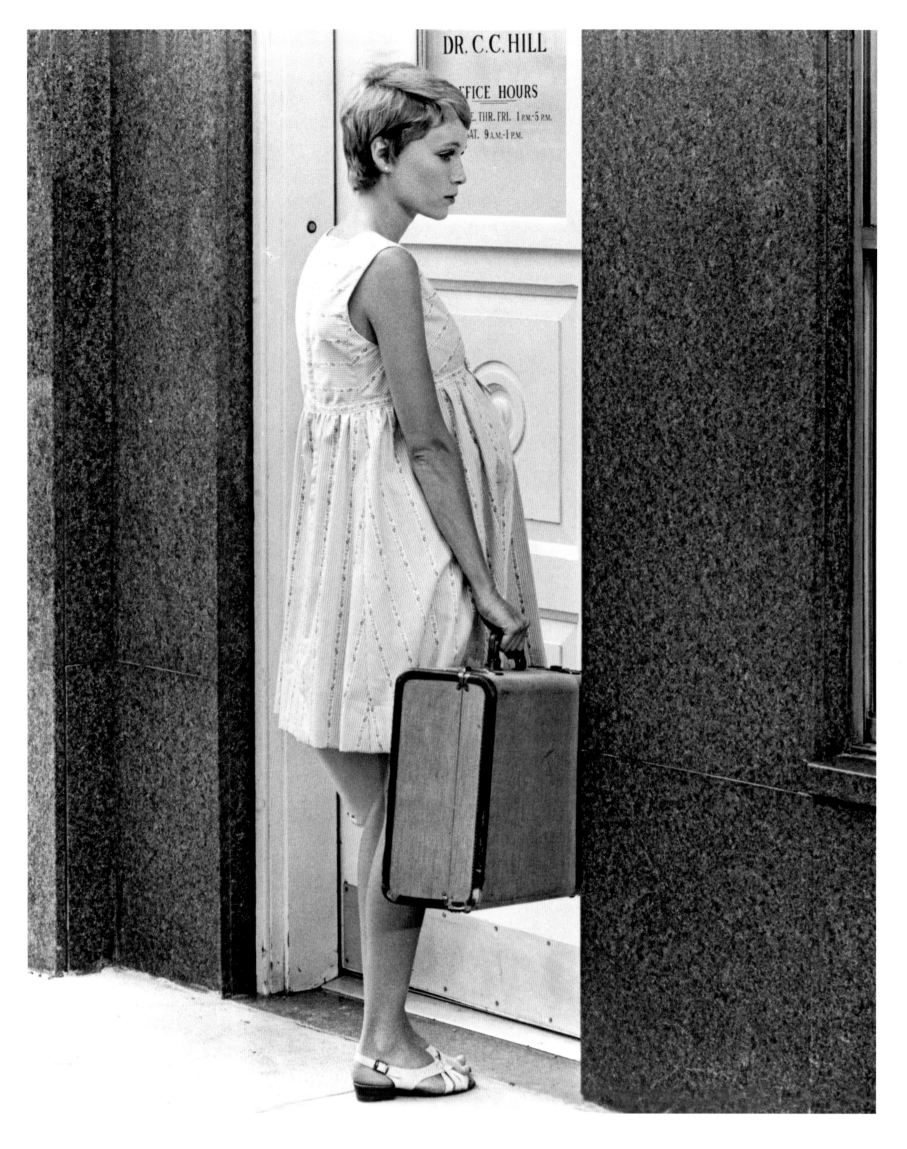

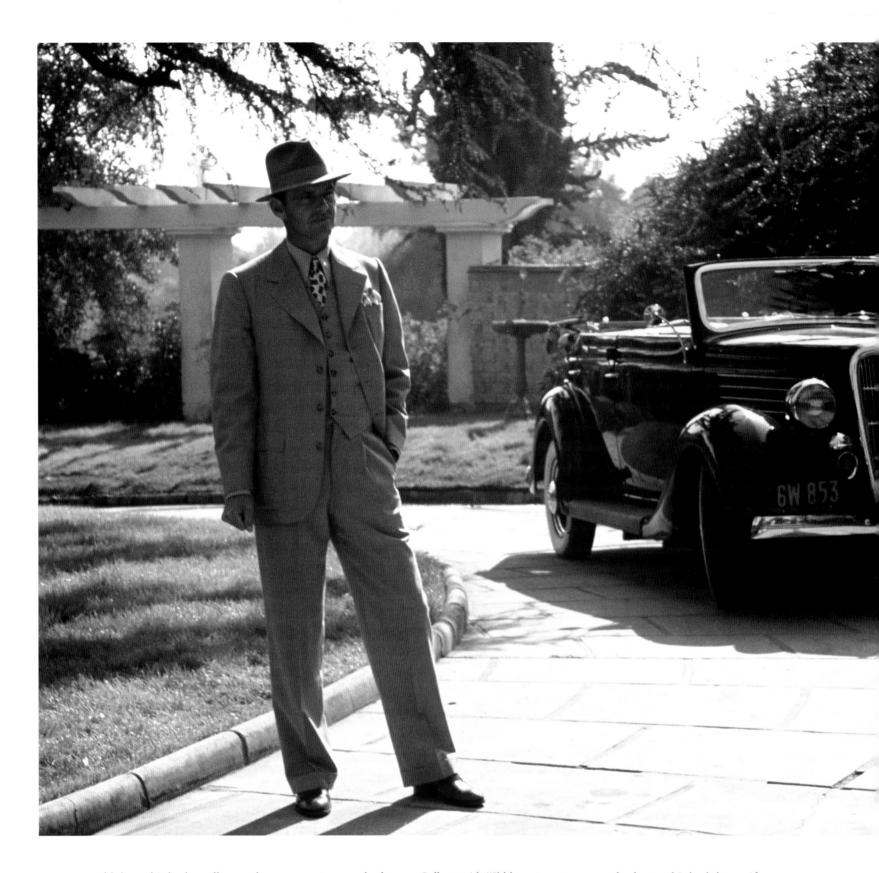

you couldn't see his body well enough, so we custom-made the jeans. His shirts were silk: everything he wore had some kind of sexuality to it."

In 1974, Robert Towne, who had written the script for *Chinatown*, tried to persuade Sylbert to become a film producer. At the time, Sylbert seemed disinterested. "If I were a producer,"

Sylbert said, "I'd have to cut my own budget and I don't know if that would work out." After a fight over the costumes on *F.I.S.T.* (1978), Sylbert decided to take the plunge into producing. John Calley at Warner Bros. offered Sylbert a job as vice president in charge of special projects in 1977. In 1980, she became vice president of production for United Artists, working on *Still of the*

Night (1982) and *Yentl* (1983). In the mid-1980s, Sylbert formed a production company with Goldie Hawn and produced *Protocol* (1984), *Overboard* (1987), and *My Blue Heaven* (1990), among others. In 1995, she dissolved her partnership with Hawn. She is married to actor Richard Romanus.

OPPOSITE: Jack Nicholson in *Chinatown* (1974).

ABOVE: Warren Beatty in *Shampoo* (1975).

PAUL ZASTUPNEVICH
AND BURTON MILLER

It seems unlikely that the two men who would define the fashion looks of the Hollywood disaster epic craze of the 1970s would grow up nearly side by side in Pittsburgh, Pennsylvania.

Paul Zastupnevich, the designer who worked for disaster impresario Irwin Allen and Burton Miller, who designed the Jennings Lang disaster films for Universal, both knew how to fan fashion flames.

Paul Dimitrovich Nicholiavich Ivanovich Fidorovich Gregorovich Zastupnevich, was known professionally as Paul DNIFG Zastupnevich, or as his friends called him, Paul Z. He was born on Christmas Eve in 1921 in the smoky town of Homestead, Pennsylvania, a steel suburb of Pittsburgh.

Zastupnevich began designing with the most important, and most available, of subjects—his mother. "My grandmother was a diva," said Zastupnevich's niece Marinka Sjoberg, "and she was the most important person in the family by far." Zastupnevich also turned to his sister, Olga, for inspiration. "He wanted to dress my mother up like a Hollywood movie star because that was the biggest 'movie star' in his life," said Sjoberg.

Zastupnevich studied at Carnegie Tech and earned a bachelor's degree from Duquesne University and a master's degree from the University of Pittsburgh. While in the Army, he helped found the Fort Benning Theatre Guild to put on shows for the servicemen, and designed costumes for their productions. He returned to Pittsburgh, and designed costumes for the Pittsburgh Civic Ballet. Relocating to Los Angeles, he spent six years at the Pasadena Playhouse as a student actor, costume designer, and director of stage productions, earning a degree in theater arts.

In the late 1950s, Zastupnevich starred under the name Paul Kremin at the Riverside Tent Theater in North Hollywood in the musical *Plain and Fancy*. His costar was Jeanne Cooper, who at the time was the wife of Rhonda Fleming's agent, Harry Bernsen. Fleming needed a gown for the Sportsman's Award Show and had tried to engage Edith Head to do it, but she was unavailable. Cooper suggested that Zastupnevich design the gown for Fleming.

Fleming was so pleased with the design that she asked Zastupnevich to design for her next film, *The Big Circus* (1959), for producer Irwin Allen. Zastupnevich got the script from Allen and created a group of sketches overnight. He made a red-and-white striped presentation folder with a clown's head and IRWIN ALLEN'S THE BIG CIRCUS emblazoned across the cover. Zastupnevich could not have known at the time how much packaging and presentation meant to Allen, who himself had to package proposals to investors. It was a large part of winning Allen over. Zastupnevich was hired.

"If there was ever an egomaniac, it was Irwin Allen," Zastupnevich said. "In many ways, he was a remarkable man. He was the ultimate salesman. I should know for I used to accompany him when he would make a 'pitch' presentation to the networks. I was his overworked, underpaid 'go-fer.'" After *The Big Circus*, Zastupnevich became Allen's full-time designer for all of his productions at 20th Century-Fox.

On December 16, 1967, Zastupnevich's brother-in-law, Charles Yurkew, was stabbed and killed in his Pittsburgh home by his own cousin. Zastupnevich's sister, Olga, and her daughter, Marinka, were home at the time. "Paul felt so responsible for my mother that he immediately flew out, swept us up, and flew us out to California," Sjoberg said. "He never let us out of his sight again. My mother was traumatized by the event, and he wanted her to know that she was protected. He became like a father to me. He sacrificed his entire life for family. Whatever relationships he could have had, he didn't. He didn't have time, he was always working.

OPPOSITE: The cast of the television series *Lost in Space* (1965–68). Costume design by Paul Zastupnevich.

MONICA LEWIS
NIGHT CLUB ACT '53

in. Out of the two types of suits that we featured in *Lost in Space*, I still like the first one, because they had more of a futuristic, spacey feeling. I just felt that the twenty-four-carat jerseys was almost going into musical comedy–type of costuming."

Because *Land of the Giants* involved a group of survivors of a suborbital passenger craft, the cast wore the same outfits for the entire first season. "When we started the thing, they only had one outfit, no doubles," Zastupnevich said. "They got sick of wearing the same thing. Finally, the whole cast said, 'For God's sake, we have luggage aboard!' And Don Matheson said, 'I've got so much money, and Deanna's [Lund] traveling around the world, and Heather [Young] should have a spare uniform somewhere along the way. So finally they convinced Irwin that they could have a change.'" The costume budget was so tight that Zastupnevich did not have enough money to have boots made to match Deanna Lund's outfit. So he took boots home and painted them. "I might have gotten into trouble with some local (union), but we got it on the screen and she was quite happy," Zastupnevich said.

"In *The Poseidon Adventure* (1972), Stella Stevens wore a Jean Harlow inspired gown," Zastupnevich said. "I had forewarned Stella that Irwin would be a prude about the cleavage she was exposing in the front. But I felt that since she was playing a retired hooker, married to a retired cop (Ernest Borgnine), we would brave his screams and bellows. When he carried on so that I knew he would throw out the dress if I didn't act quickly, I dashed over and withdrew a gaudy diamond beige clip and dropped it into the valley of cleavage. Irwin and Stella both shouted—one with approval and one with protest. I finally managed to placate Stella and I must say she served me smashingly in the white satin number. When Shelley Winters spied Stella wearing the dress, she bellowed, 'Gee, you're wearing the type of dress I always wore.' Stella, with her hands on her hips, whipped back, 'Yeah, dearie? What year was that?'"

In preparing Winters's New Year's dress for *The Poseidon Adventure*, "I created for her a smoke chiffon cocktail dress that any Yiddish matron would wear to her mitzvah. Shelley had gained some weight, but Irwin Allen wanted more poundage, so we had to improvise weight pads and even pad her out to a

Between locations and the studio, sometimes he worked on three or four shows at a time."

Some of Zastupnevich's most well-known work was for Allen's television shows. Zastupnevich won the Costume Designers Guild Award for "Best Dressed TV Series" in 1968 for *Lost in Space*, and again in 1970, for his work on *Land of the Giants*. "We went from the first year (where) we used a very heavy weight silver fabric, which was quite difficult to work with," Zastupnevich told writer Flint Mitchell about *Lost in Space*. "It was basically used in fire-fighting outfits with a heavy silver. The following year, when the twenty-four-carat silver jersey came out, we switched over to the suits, because (in) those you could bend over, and they wouldn't crack, and they wouldn't be stiff, and they wouldn't be difficult to work

zaftig matron. The only peril in this, we found out later, is when Shelley had to get into the water tank, she wouldn't sink. She merely dove to the bottom and popped up like a floating cork." Zastupnevich had to attach weights to her frame to make her submersible.

For *The Towering Inferno* (1974), Zastupnevich created a daring dress for star Faye Dunaway. "The dress was cut to here and slit to there and she would have fallen out of it, but we had her taped," Zastupnevich said. He told the director Dunaway should not sit in the dress and that she should stand or lean against a pole. "Whatever you do, don't have her bend over or you'll give us problems," Zastupnevich told him. "Would you know he double-crossed me and put her in a chair from the beginning! But she held herself up and the tape held."

"Just after the show came out, I began to read reviews, and one critic chastised me for putting Faye Dunaway in a dress for going to a fire," Zastupnevich said. "He wrote to me in the article, 'Why would she wear that kind of dress to a fire?' I was so furious, I sat down and wrote a scathing letter. I said, 'What makes you think she was going to a fire? She was going to a cocktail party to seduce her boyfriend on top of the Empire State Building, practically. She didn't know she was going to a fire! If she had known, she would have worn overalls that were fire retardant, not the chiffon dress!'"

After retiring to Palm Springs, Zastupnevich operated the clothing shop at the House of Z, his sister Olga's beauty shop and

OPPOSITE: A 1950s Burton Miller costume sketch for Monica Lewis.

ABOVE, LEFT TO RIGHT: Paul Zastupnevich • Deanna Lund in the television series *Land of the Giants* (1968–70). Costume design by Paul Zastupnevich.

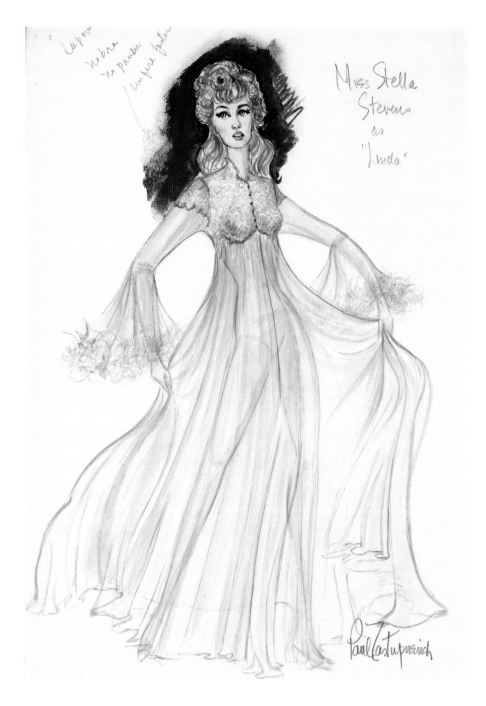

Miss Stella Stevens as "Linda"

Technology in 1949 and then attended Parsons School of Design in New York. His entrée into the design world came via another Pittsburgh native, Broadway singer Lisa Kirk.

Singer Monica Lewis discovered Miller's work when her brother, Marlo, was producing the television show *Toast of the Town*, and Kirk was a guest. "I called Burton and we made a date at a pharmacy that had a soda fountain," Lewis said. "We both ordered coffee and split a piece of pound cake. I figured he didn't have any money, not knowing that his family did. But I thought 'here's a kid hawkin' clothes' and I insisted we go dutch. And we never shut up. We talked and talked for hours."

From that point on, Miller designed all of Lewis's clothes for her nightclub and television appearances. Lewis did not know that Miller's father owned a large car dealership in Pittsburgh and his family was well off. "I didn't ask if Burton was gay, but I knew," Lewis said. "But who cares? My parents taught me tolerance about everything." One day Lewis received a call from Miller's father. "I know how much my son loves you and I have something to offer you," he told Lewis. "I know you're busy and I know you're working, but you could still do what you do. I would love it if you would marry my son because I know it would make him very happy and make us very happy, and I will give you a million dollars." Lewis was a little stunned, to say the least. "I said, 'Well, as much as I love Burt, I am in love with somebody else,'" Lewis said. "I thanked him very much and told him there was no need to give me a million dollars because there's nobody I'd rather spend my life with than Burton, as far as a pal, but I might become engaged soon. I made up a whole story on the phone and he was very disappointed."

Lewis hung up the phone and called Miller. At first he was furious when he heard what his father had done. Then he laughed and told Lewis that she should have taken the money. "I told Burton that money wouldn't last us three months," Lewis said, "and he agreed." Lewis still is not sure what prompted the proposal. "I'm sure his mother knew he was gay. His father may have had an issue with Burton being gay, but he still loved his son. He was trying, in his own way, to protect his son."

boutique. Zastupnevich died on May 11, 1997, in Rancho Mirage, California. "I heard jokes about his costumes—the silver suits on *Lost in Space*, or jokes about how Paul must have designed Irwin Allen's leisure suits," Sjoberg said. "But that was all cool during the time. Guys were wearing orange and pink and lime-green polyester leisure suits. Paul was well known for his velvet tuxedos. Ten years ago that was so out of style, but now today, it's cool again."

While Allen reigned as the king of disaster films at 20th Century-Fox, across town Jennings Lang was producing a string of disaster films at Universal. His costume designer was Burton Miller, who was born in Oakland, a suburb of Pittsburgh, Pennsylvania, on January 17, 1926. Miller graduated from Carnegie Institute of

After Lewis married Universal film producer Jennings Lang in 1956, she invited Miller to move out to Los Angeles. Miller closed up his New York apartment and lived with the Langs for nine months, until he could join the Costume Designers Guild. Miller was signed by Revue Studio, which was owned by Universal. Miller designed for Revue's shows, including *The Alfred Hitchcock Hour*; *The Investigators* with Mary Murphy; *Checkmate* with Julie London, Claire Bloom, Clair Trevor, and Joan Fontaine; *Thriller* with Judith Evelyn. He also designed a 1920s wardrobe for Maureen O'Sullivan to wear on an *Alcoa Hour* with Fred Astaire.

"Burton was very inexperienced. He learned by doing," said Helen Colvig, who worked at Universal with Miller. "I'm sure [wardrobe supervisor] Vincent Dee helped him a great deal because Vincent helped all of us. If we could fly on our own, he wouldn't interfere. But if we were having trouble getting things done, he always intercepted for us."

Miller dropped in on the Langs after a fitting with Ann-Margret for *Kitten with a Whip* (1964). The trio was having a drink before dinner, and Miller sat Jennings and Monica down and said, "I've got to tell you guys something you won't believe. I had a fitting with Ann-Margret, and I fell madly in love. It turned me on so much, I was blushing. It almost convinced me that I could be straight." Lang told Miller, "Well, that's the effect she has on the public."

Miller occasionally shared duties with Edith Head on Universal projects. When he was assigned to *Earthquake* (1974), he costumed all the stars except Ava Gardner, who had requested Head. "Ava just wanted to look as good as she could," Monica Lewis said. "She said to me, 'I'm not going on any diet. They can drape me or do something. It's too late.' And then we'd pull out the red wine and put on a Sinatra album. But Burton liked Edith Head and he certainly respected her."

The opposite happened when Head was assigned to design *Airport '77* (1977), dressing all the stars, including Olivia de Havilland and Brenda Vaccaro. Costar Lee Grant had seen Miller's costumes for a previous film and requested that he design her costumes. The split assignment caused *People* magazine to report

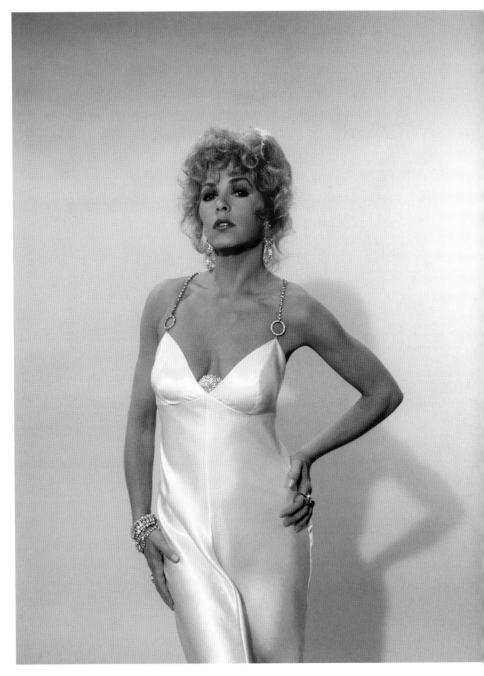

that a rift had developed between Head and Miller. Rather embarrassed, Miller called Grant to let her know about the item. Having studied at the Actor's Studio and considering herself a serious actress, Grant was not accustomed to seeing her name mentioned in gossip columns. But she squealed with delight, "It's a starlet item! At last! I love it!" she said.

The Pittsburgh newspapers had kept close tabs on Miller's career and he frequently gave interviews on all of his Universal

OPPOSITE: Paul Zastupnevich's costume sketch for Stella Stevens in *The Poseidon Adventure* (1972).

ABOVE: Stella Stevens in *The Poseidon Adventure*.

projects to columnist George Anderson. Anderson was especially shocked to report in March of 1982 that "the handsome and fit-looking Burton Miller complained of nausea and suddenly dropped over. His death was a shocker to his friends and coworkers who will miss him." He was only fifty-six.

"The night before he died, my husband was in New York," Monica Lewis said. "Whenever Jennings was in New York, Burton stayed with me and the kids, but that night he had to go home. He kissed me good night. He went home and the next morning, I get a call from our mutual doctor, telling me that Burt had an aneurysm and was dead. He was on the floor with a telephone in his hand. The clot had been in his leg, but it went to his heart. It was a shock."

Miller's body was sent back to Pittsburgh at the request of his mother. Actor Robert Wagner, whom Miller had costumed in *It Takes a Thief* (1968), paid for a memorial service in Los Angeles. "Burt was a staunch friend, loyal, no bullshit, funny," remembered Lewis. "He loved music and art. I could talk to him for hours. He was like a brother. He was a joiner. If we had a piano player at a party, which was often, he would sing all night. He knew every song."

ABOVE: Burton Miller, producer Jennings Lang, and actress Monica Lewis on the set of *Earthquake* (1974).

OPPOSITE: Burton Miller designs for Victoria Principal in *Earthquake*.

Victoria Principal
Rosa Amici

CHARA ACTER

SCEN ES

Dres s

Hat

Coat

Shoe s

Stoc ckings

Purs se

Glov ves

Fur

Jewe elry

Han d Props

Miscellaneous Miscellaneous

CHARA

SCEN.

Dress

Hat

Coat

Shoes

Stocl

Purse

Glove

Fur

Jewel

Hand

Misc

BOB MACKIE

"I grew up sitting on my sister or mother's lap, watching movies… when I was two or three years old because that's what we did," Bob Mackie said of his childhood.

"There wasn't anything else to do that was any fun. I liked the Technicolor ones. I liked the musicals because they were usually Technicolor. They had the most going on. They had the prettiest ladies and they went to the best places. It was certainly a lot nicer than where I lived."

Robert Gordon Mackie was born on March 24, 1939, in Monterey Park, California, to Mildred Smith and Charles Mackie. He and his half-sister, Patricia, were raised in Alhambra by his maternal grandparents, Herbert and Agnes Smith. "I didn't live with my mother as a child so [watching movies] was often our activity when she would come to visit me," Mackie said. "She was a divorced lady and working, and that was a little fantasy for her as well. On the way home in the streetcar, I would just have a million questions, 'Why did they do this?' and 'Why did they do that?' and 'Why did she wear those long dresses?' because I could never really understand period films. I didn't know what it was, but I knew it was different. And my mother would say, 'That's how they dressed in the olden days. That's an old-fashioned movie.'

"For me, the future was what was going on in these films. This was where I wanted to end up. It gave me an interesting direction that I'd never thought about really and all of a sudden one day [I thought] 'I could do that. I could design that. And it kind of came to me in a flash.'" The "flash" came after a showing of *An American in Paris* (1951). Mackie stayed for the credits to see who had designed the ballet sequence (it was Irene Sharaff).

While in high school, Mackie lived with his father in Rosemead. He designed costumes for school plays and musicals, and the mothers of the students would make the clothes from his

RIGHT: Barbra Streisand in *Funny Lady* (1975). Costume design by Bob Mackie and Ray Aghayan.

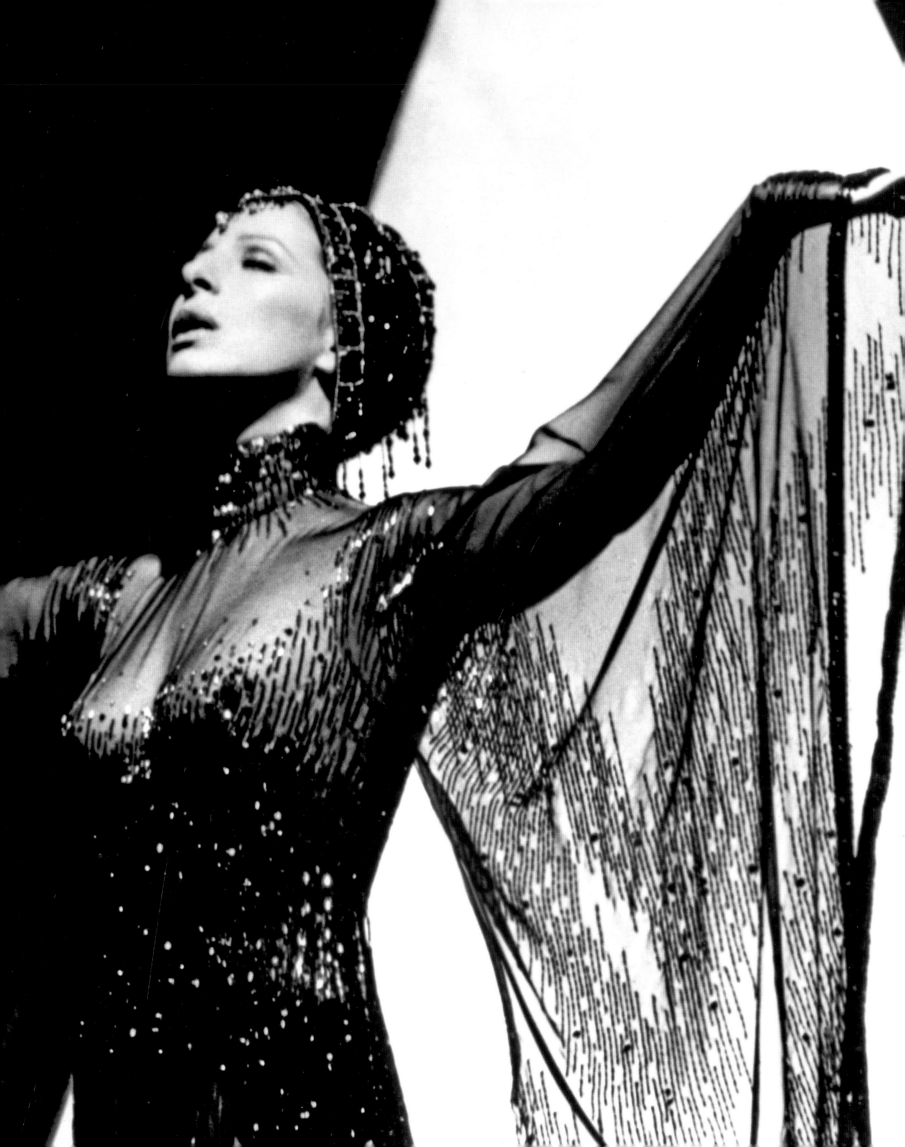

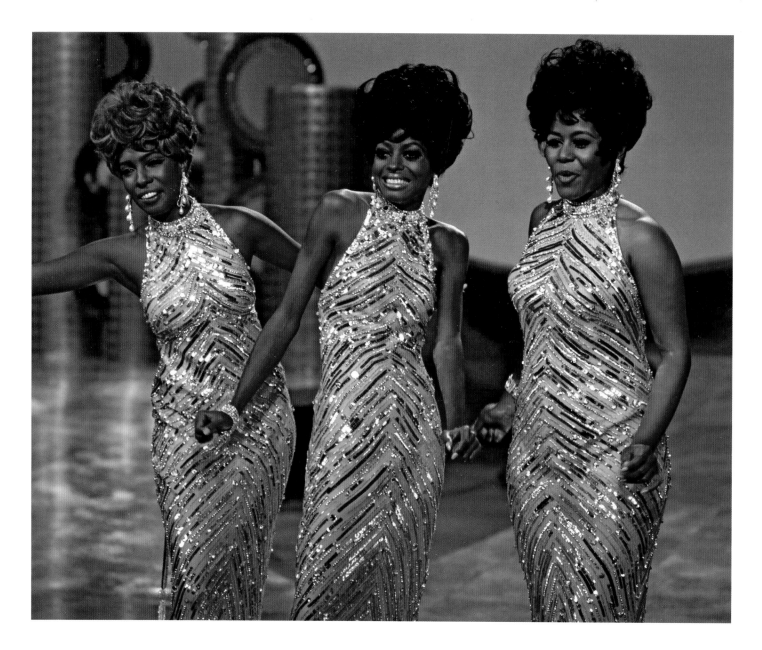

sketches. The mothers' finished clothes were usually a little more conservative than Mackie's original designs.

Mackie married actress Lulu Porter (real name Marianne Wolford) on March 14, 1959. The couple had known each other in high school, where they appeared in a production of *Anything Goes* together. The couple had a son—Robert Gordon Jr., known as Robin—who was born on October 15, 1959.

Mackie spent two years at Pasadena City College, majoring in advertising art and illustration and won a scholarship to Chouinard Art Institute. He only stayed a year at Chouinard, and got his first job sketching for designer Frank Thompson at Paramount. But sketching clothes for Glenn Ford in *Love is a Ball* (1963) was not the glamorous beginning for which Mackie had hoped. His next job was sketching Marilyn Monroe's wardrobe for *Something's Got to Give* (uncompleted) for Jean Louis. When Marilyn was suspended by the studio and production shut down, Mackie

returned to Paramount to sketch for Edith Head on *A New Kind of Love* (1963).

Mackie realized that the glamour he expected to find working in films had shifted to television. Mitzi Gaynor gave Mackie his first professional break, and he designed for her TV specials and live appearances. "I had very little experience, but Mitzi trusted me. She gave me a chance," Mackie said.

Mackie divorced his wife in 1963. That same year he met designer Ray Aghayan. Aghayan had been born into a wealthy Armenian family living in Tehran in 1928. Aghayan's mother was a designer for the family of Reza Pahlavi, then the Shah of Iran. Aghayan's fascination for American movies made him want to

ABOVE: Diana Ross and the Supremes in Bob Mackie designs, 1969.

OPPOSITE: John Travolta in *Staying Alive* (1983).

study in California. When Edith Head had been hired to design Judy Garland's costumes for her CBS television variety show in 1963, Aghayan was brought in for the remaining costuming needs. But after the first show, production was shut down for two weeks for some revamping. Head found that she had no time to design a weekly show, and producer George Schlatter asked Aghayan to submit some sketches for Garland, which Garland approved.

Mackie and Aghayan designed not only for Garland, but for her guests, which included Ethel Merman, Peggy Lee, and Barbra Streisand. "What he taught me about designing," Mackie said of Aghayan, "was that it was always about the stars, about making them look good—making the audience excited to see them even before the star opens her mouth."

"I thought all TV series would be as crazy as that one," Mackie said of *The Judy Garland Show*. "It was exciting, but totally unpredictable. You never knew what to expect from Judy—never even knew if she'd finish a song. At times, she was so warm and pleasant. And at times she could behave so badly. Yet Judy was Judy, and anyone who thought she could do a complete TV series and behave herself was crazy. It was a great relief for me to realize that all TV shows weren't like Judy's."

In 1967, Joe Hamilton was producing a one-hour variety show starring his wife, Carol Burnett, for CBS. When the Hamiltons were assembling key personnel, they saw Mitzi Gaynor's show in Las Vegas. Impressed not only with Mackie's glamorous costumes for Gaynor, but also with those for the comedy sketches, they asked for a meeting with the designer. They hired Mackie, who designed as many as fifty costumes per show for the *The Carol Burnett Show*'s eleven-year run. Burnett credits Mackie with helping to form some of her most memorable characters, including Mrs. Wiggins, Nora Desmond, and Eunice. For a *Gone with the Wind* parody, Burnett as Starlet O'Hara was supposed to have green curtains placed sloppily over her dress to lampoon the drapery dress from the original film. Mackie brilliantly had Burnett sport the curtain rod through the draperies as she uttered the side-splitting line, "I saw it in the window and couldn't resist!"

After she guest-starred on the *Burnett* show, Cher asked Mackie to design her costumes for her upcoming *Sonny and Cher Comedy Hour* (1971) with then-husband Sonny Bono. In Cher, Mackie found a perfect muse—a woman who moved easily between streamlined glamour and deadpan comedy. Cher could wear anything, and audiences tuned in every week to see what Mackie

had designed for her. In 1975, Cher was featured on the cover of *Time* magazine in a Mackie gown. "It really bugs me people say that if it weren't for her costumes, what would Cher be?" Mackie said. "They say I remade her, gave her a new glamour image. First of all, a woman is what she is. If she has to be 'remade' constantly, there's no lasting star quality to begin with. But besides that, Cher plunged into the glamour thing long before I started working with her."

Mackie's near-nude designs for Cher sometimes got the pair in hot water with the censors. A CBS affiliate in Cincinnati even dropped the show altogether. But the public stayed titillated. In 1986, after being snubbed for an Oscar nomination for *Mask* (1985), the Academy of Motion Picture Arts and Sciences asked Cher to present the Best Supporting Actor award. The Academy set down a list of rules about what could or could not be worn by presenters. For Cher, they had thrown down the gauntlet. She told Mackie to "really do something" and he designed a gown that could have been worn by an Indian warrior princess, complete with Mohawk headdress. When Mackie questioned Cher about the possibility of upstaging the winner in it, she thought, "Fuck it, this is what I want to wear." There was a media feeding frenzy the following day, asking how could Cher, now moving into the realm of being a serious actress, wear such a getup to the Academy Awards. But Cher had the last laugh. The dress has become one of the most iconic looks in Oscar history. When Cher accepted her Oscar for *Moonstruck* (1987) in 1988, Mackie dressed her in an embroidered gown embellished with crystal beads that was a throwback to 1915. While it still bared plenty of flesh and evoked Cher's style, the beauty of the gown won over critics.

Concurrent with his television work, Mackie occasionally designed for films. A costumer was originally hired to supply costumes for *Lady Sings the Blues* (1972), but Diana Ross wanted her own designer. Mackie had worked with Ross on a TV special and was asked to step in only two weeks before principle photography began. Mackie's vision for Ross was not to duplicate Billie Holliday's look—Holliday was a much larger woman than Ross. But Mackie and Aghayan settled on just doing beautiful 1930s clothes for Ross, and it garnered them (along with Norma Koch) an Oscar nomination.

OPPOSITE: A Bob Mackie costume design for Ann-Margret's Las Vegas nightclub act.

The 1975 film *Funny Lady* was a sequel to *Funny Girl* (1968) with Barbra Streisand reprising her role as Fanny Brice. Mackie and Aghanyan recreated some of Brice's most famous costumes, but Streisand put more emphasis on looking good than funny. As they had for Diana Ross, they chose beautiful clothes of the 1930s for Streisand's day and evening wear. "I was glad I was working with my partner, Ray, on that one," Mackie said. "Some days I'd have to say, 'I can't take it anymore. You'll have to take over for today.' It wasn't what you'd call a *bad* experience, but I don't like working with people who get themselves involved in all aspects of the production, who have to play boss. Barbra is definitely one of those women who get totally involved. And you accept from the start that you'll be working *with* her. But you soon begin to realize that, in her case, she's a pretty good judge. She's very critical of herself and has done a lot of self-study. She really knows, for example, which are her best colors. After awhile, you stop fighting and start listening. It makes the job easier—and in the long run, you improve upon your own work."

The film *Pennies from Heaven* (1982) starred Steve Martin and Bernadette Peters, and was based on a British miniseries of the same name. Mackie was able to design a wardrobe for big-budget musical numbers, the kind he dreamed of as a young boy. But the film also had a dark tone that those musicals never had, and it certainly was not what people were expecting from a Steve Martin film. "I loved doing Bernadette's drab, schoolmarm costumes," Mackie said. "In this town especially, you can get very typecast. People thought I could handle the fantasy parts of *Pennies*, but

they said, 'He can't do the realistic stuff.' I'm very thankful they gave me the chance to do reality costuming because I'd like to do more dramatic kinds of efforts rather than all this glitter and flash."

Mackie began his first ready-to-wear collection in 1982. His empire grew to include other products, including his signature fragrance, "Mackie," a series of collectible Mackie Barbie dolls, and the *Wearable Art* television program for the QVC network. Mackie has amassed thirty-one Emmy Award nominations and nine Emmy Awards. In 2002, he was inducted into the Television Academy Hall of Fame—the only costume designer to be honored there.

In 1993, Mackie's son, Robin, passed away from complications of AIDS. Mackie's life partner, Ray Aghayan, died October 10, 2011. Mackie's design house remains so busy that he has to turn work down, even from the women who helped to solidify his reputation. In 2014, Cher tweeted to her fans about her *Dressed to Kill* tour: "Telling you Something That Has BROKEN MY HEART, THE MAN WHO MADE ALL MY COSTUMES SINCE 1972 DECIDED HE COULDNT DO MY LAST TOUR." The diva continued, "NO MATTER HOW DISAPPOINTED ANY OF U ARE, YOU DONT KNOW MY GRIEF. IM SURE BOB CANT KNOW HOW MUCH I MISS HIM. FELT I HAD TO TELL U IM CRYING. I TRIED TO CONVINCE HIM TO END WITH ME, BUT HE HAD MANY REASONS As 2 Why He couldn't do it. 2 many obligations Not Enough Time EVEN 2 DO 1." (sic)

OPPOSITE: Bob Mackie and Cher

CHAPTER FOUR
CONVERSATIONS ON DESIGN IN THE MODERN ERA

The groovy fashion trends of Britain's Mod Movement ushered in the 1960s. The Vietnam War, race riots, and the new drug culture eclipsed them by decade's end. The hippie culture that replaced the Mods' was almost anti-fashion.

Out of the ashes of the old studio system came a new breed of director—the auteur—including Martin Scorsese, Stanley Kubrick, and Roman Polanski. Costume designers, no longer under long-term contracts to studios, began aligning themselves with directors to ensure future work. Savvy designers developed a keen appreciation of their directors' sensibilities, making them invaluable from project to project. The creative shorthand that arose between director and designer saved time and money as well.

The 1970s saw Hollywood bring gritty realism to the screen like never before in films like *The Godfather* (1972) and *Taxi Driver* (1976). That decade also included a wave of nostalgia that harkened back to an earlier day in films like *The Sting* (1973), *The Way We Were* (1973), and *The Great Gatsby* (1974).

In the 1980s, independent filmmakers such as David Lynch, Ismail Merchant, and James Ivory took moviegoers to worlds as varied as the planet Arrakis and Edwardian England. Hollywood surrendered, or at least shared, its influence on fashion with pop culture like never before as a young Madonna gyrated in her music videos sporting lingerie on the outside of her clothing.

The 1990s and 2000s saw the rise of digital filmmaking and the Hollywood blockbuster. Budgets soared, and designers moved into the role of managing large departments. In the era of the Internet, costumes could be created a continent away from a director, with camera phones making the approval process instantaneous. Costume sketches, once hand-drawn, could be rendered on computers, allowing for a more realistic interpretation of how an actor would appear on screen.

In this chapter, Hollywood insiders share their views on the state of movie design from the 1970s to the present.

OPPOSITE: Johnny Depp in *Pirates of the Caribbean: The Curse of the Black Pearl* (2003). Costume design by Penny Rose.

MAY ROUTH

Q: Tell me about your early life.

A: I was born in India, and I was there until I was twelve. Then I went back to England because of the war. It was so different going back to England because everything was so drab and gray. I thought when I went home I would be living in a palace. I didn't think I would be living in a red brick house without a stable for my own horse. But I went to boarding school, and became totally English.

Q: Did you want to be a fashion designer?

A: I went into fashion and in less than a year after school, I realized that most of the designs being done in the wholesale trade were just revamped versions of last season's best sellers. They would just put a different pocket on it or something, and it was really very boring. I was lucky that when I had been at art school, I had done some artist reference modeling for book jackets and things like that. If they were doing a cover of someone who'd been stabbed and lying on the floor, they would take a photograph of you in that pose and then draw from that photograph. I was earning about twenty pounds a week doing that, whereas I was earning six pounds a week as a fashion designer. So doing more modeling was a no-brainer.

Q: How did you transition to costumes?

A: One day I was modeling and the art director at the agency said, "You've been to art school. Bring me your portfolio." So I did, and he gave me my first drawing job, and I became a fashion illustrator. During the 1960s, I used to go to Paris and draw the collections. It was different than it is today. At that time, piracy was incredible and you weren't allowed to do drawings or take photographs of a collection. So you had to walk out of having seen a collection and sit down at the nearest café and try to remember what the clothes looked like and draw them. Then those sketches would be sent electronically to England, where they would then go in to the newspapers.

My ex-boyfriend, the photographer Brian Duffy, was doing very well. He produced a film called *Oh, What a Lovely War* (1969) with Len Deighton, who I had also gone to school with at St. Martins. They asked me to work on the costumes since Duffy knew that when I was at St. Martins, I had been into the period of 1914 and the magazine *Gazette du Bon Ton*. I started working with the

costume designer Anthony Mendleson, and he was very kind to me. But the wardrobe department decided that I was starting at the top and I had to be punished. So every day the guys in the department would find something wrong with my work. It was a challenge that I didn't really enjoy. So I thought, "Well, this is the film industry." I didn't like the whole unionization of it—the fact that everybody had to have a job, and you couldn't even move something that was someone else's job to move because you might take their job away. So I thought they were a whole lot of absolute assholes.

Q: But you stayed in the game?

A: Two years later, Anthony Mendleson recommended me to Yvonne Blake who was working on the film of *Jesus Christ Superstar* (1973). They had a problem in that they didn't know if they should do it as a historical film or as a contemporary film. Yvonne was doing the drawings of all the characters in biblical clothes, and she asked me to do drawings of all the characters wearing contemporary clothes. She suggested that I look at what was in the shopping malls at that time. Yvonne had a meeting with the art director, the production designer, the director, and me, and she talked them through the designs. They decided to go with the biblical look and not go with the modern. When Yvonne got *The Three Musketeers* (1973) and *The Four Musketeers* (1974), she asked me to work on those. My husband and I had split up and I got on a plane to Spain to work with Yvonne. The next day I met the production designer, Brian Eatwell, and the rest is history.

Q: Yes, you married Brian. How did that influence your work?

A: I am different from a lot of costume designers in that I lived with a production designer, and I was able to get all of his wonderful ideas. Coming from a fashion world, I had no idea about character. If he suggested something, sometimes my first reaction was "no," but then I realized he was right because he was coming from a theater background. He often pushed me creatively.

After we did the musketeer pictures, we went to New York and I took the exam for the costume design union in New York. Brian

OPPOSITE: Costume designer May Routh modeling one of her own designs in London in the 1960s.

and I decided to come to California. We were lucky that Brian had worked with Nicolas Roeg on *Walkabout* (1971) and *Don't Look Now* (1973). Nic was doing *The Man Who Fell to Earth* (1976) in New Mexico, which is a "right-to-work" state. It was one of the first times a whole British crew came to the United States, and I was allowed to work on that.

Q: What was that job like?

A: Nicolas Roeg told me that he wanted David Bowie's character, on the other planet, to wear his most precious possession, which is water. I designed his costume to be covered with see-through tubing. When the costume was constructed, it had far less tubing than I had drawn in my sketch. The costume also had these boxes on the back, which I had not originally designed and I was really pissed off. But they had to power the water somehow. The water had to be slightly pink so that you would be able to see it. Unfortunately, the minute the actors started moving, the joints between the tubing came apart. Luckily, the water was quite light so that you didn't actually see it on the clothes.

It was a total horror to me to have Candy Clark tell me what she wanted to wear because I hadn't ever realized that actors could do that. They were just people you put clothes on. Rather than saying, "I want to wear this," David would look at what I'd done and then suggest things to add. Once I'd gotten the suit right, then he might suggest a shirt. Once I started thinking about what kind of shirts he liked, when I found them, it gave me pleasure because I felt like I was on his wavelength. To someone like me who loved fashion, everything he did was chic. Candy, on the other hand, looked through a J.C. Penney catalog and chose a yellow jumpsuit that had black rickrack binding on it. She said that she'd spoken to Nic [Roeg] and that her wearing this would be perfect. I thought, "That's the ugliest thing I've ever seen in my life. Do you mean to say that on my first film as a costume designer, I'm going to put this on an actress?"

Q: How was working with Peter Sellers on *Being There* (1979)?

A: With all of the work I had done, Brian was always my production designer and he was always there to help me and give me support. *Being There* was the first time I worked with another production designer, and we were shooting on location in Washington, so I was really on my own. Peter Sellers had been on a radio show in England called *The Goon Show*, and when

somebody has made you laugh, they are very special to you. You have great affection for them. So somehow I thought Peter Sellers and I would become chums.

We made the clothes, and Peter was happy with them. Before I left for location, I received a call from my friend Sandy MacKendrick, who directed *The Ladykillers* (1955) and other Ealing comedies. He told me, "Whatever you do, don't become friends with Peter Sellers. Keep away from him. If you become friends with him, you will be fired within a week, and you won't know why. The producer will say he is firing you, but it won't be, it will be Peter Sellers." So after that, I stayed my distance. Peter had an English costumer/dresser who looked after him. I would put the clothes out with a choice of ties for them to discuss, and that was how it worked.

We had been told that Peter Sellers requested that the colors green and purple not be used anywhere on the set. We were on location and one of the second assistant directors came to me and asked me to check the clothes for the extras, including two gentlemen who were Indian. My wardrobe man said to me, "What are we going to do about their turbans?" I realized they both had on green turbans. I went to Peter Sellers's dressing room, and in my best Indian accent, I said, "Sab, I have a problem. Sab doesn't like the color green, and there are gentlemen with green turbans on and Sab, I don't know what to do." He asked if he had to speak with them in the scene, and I explained that they were only being used in the background, so he went with it. But you had to do that.

Q: His look as Chauncey the gardener, with the bowler hat, has become so iconic. How did that come about?

A: Peter Sellers was not wearing a bowler hat in my original drawing. We chose the bowler because the man who owned the house had been paralyzed in 1928. So I was looking for clothes that would have been worn in 1928—very much in the cut of the clothing. I put out hat shapes to see what went with the clothes and made Peter Sellers feel right. I think Peter may have even suggested the bowler. The pieces have to come together through a happy marriage. But when you're on the right path, and you're focusing on the character and the actor as that person, you can

OPPOSITE: David Bowie on the set of *The Man Who Fell to Earth* (1976).

deep at both ends. She had to learn to start swimming holding her breath so she would swim from one end to another and breathe in to a mask attached to a tank. She had to learn how to swim with her eyes open and look as if she could stand up in it underwater. The whole movie was a very happy experience. Tom Hanks was fun and Daryl was charming. Sandy Berg was a great wardrobe supervisor. After that I realized it was important to have a happy wardrobe department because it affects how you feel while you work on something for three to four months. You have to cast your wardrobe department with care and with people who are enthusiastic about the project.

Q: What has been one of the obstacles you have had to overcome in your career?

A: I was very lucky in that I got a lot of important films to start off with, including *Being There*, *Splash*, and *My Favorite Year*. Then Brian and I decided to move back to England and that was the worst thing that we could have done. I worked on something called *Morons from Outer Space* (1985), which wasn't really high on my list. We decided to move back, but at that point I had been out of Hollywood for two-and-a-half years and the first job I got was *Caddyshack II* (1988). After that I did television. But I ended up working with director John Frankenheimer, and that was one of the best things that could have happened. We did *Andersonville* (1996), *George Wallace* (1997), *Ronin* (1998), *Reindeer Games* (2000), and *Path to War* (2002).

John was fascinating to work with. It's so important to work with somebody who has an eye and knows that they want something of quality, and you want to give them that. A good director can make you thrilled by what you are producing for him, and the way it looks in the camera. Frankenheimer didn't suffer fools at all. People told me that I was very lucky to be working with him at that point in his career, because he had given up drinking. His daughter told that me he was very insecure and with people like that, if they ask you what you're doing, and you don't know, it can send them into a frenzy. So after that, when John would ask me if I'd taken care of something, I would just answer, "Yes, John." And then I'd go and make sure that it was done.

see what suits them and what doesn't. I won't say you become the character yourself, but you absorb the character's personality and you know what would be right for them.

Q: What was it like designing for Daryl Hannah as a mermaid in *Splash* (1984)?

A: I was asked to design the tail and the look of the mermaid. Originally I did the tail with scales and I showed the drawing to [director] Ron Howard. He said he wanted to do it much more like dolphin skin so that it would look as if it were more human than scales. I changed it to be almost like an orange peel. By adding the coloring of a goldfish, the look became more coherent and like a skin tone.

The fish tail was fabricated by the special effects department. It was a foam construction molded to her body and glued on to her. It had to be weighted down because a body wants to float to the surface. They trained Daryl in a swimming pool that was

ABOVE: Peter Sellers in *Being There* (1979).

OPPOSITE: Darryl Hannah in *Splash* (1984).

ALBERT WOLSKY

Q: You were a travel agent up until the time that you were about thirty. How did you move into costume design?

A: I was always interested in design, but not so much in costumes as in fashion. When I was going to college, over a couple summers I went to fashion houses. But I got so turned off by the whole process and by fashion itself, it kind of set me back and I just forgot about it. When I got out of the Army, I was kind of footloose and I didn't know what I wanted to do. My father had a very successful travel agency and that's why I became a travel agent. It was good for both of us, and we got to know each other. He loved what he was doing, but I felt like I couldn't spend the rest of my life there. Then one day, all of a sudden it came to me. I thought, "I don't like fashion, but I like theater and costumes."

A friend suggested I contact Helene Pons, who was a designer and also executed costumes for other designers. Three days later, I got a call from the friend who said that he had dinner with Helene the previous evening. She needed to go to Rome, but she couldn't get any space on a flight. I called her and she gave me the dates, and I found space for her. When I called her back she said, "I understand you want to speak to me." I told her I thought it could wait, but she said, "No, it can't wait, come right over." I was just going for some advice, but Helene was about to begin working on the Broadway production of *Camelot* (1960) and she offered me a job. I left the travel business that Friday and started with her on the following Monday.

When I first started, I was just thrown into it. I was so busy learning everything I had to learn, I didn't think about why she hired me. Only later did I realize that she understood that I had been running an office of about thirty people and she needed a manager. The product varied, but the skills of running an office were the same. Helene had one major flaw: she would go to any length to save on fabric. I knew after a couple months, you don't save on fabric, you save on manufacturing. You save on the time you spend making something. But I learned a great deal from her.

Q: How did your film work begin?

A: I met the designer Theoni Aldredge when I was assisting her on the production of *Ilya Darling* (1967). Theoni called me about working on a movie. I felt that I still didn't know enough about movies, and I was still working on a musical, so I turned her down. Weeks later, just as we were about to open for the out-of-town tryouts, they let all the assistants go. Theoni called again about the movie. I asked, "When do you need me?" She said, "Immediately." I said, "What is it you want me to assist you on?" She said, "I don't want you to assist me, I'm trying to get you this movie." I was dying. I met with the producers immediately and got the job on *The Heart Is a Lonely Hunter* (1968). Alan Arkin, who was in that film, recommended me later for *Popi* (1969).

Q: What were your experiences like working with director Bob Fosse?

A: *Lenny* (1974) was a period piece at the point that we made it, a film made in the 1970s, taking place in the 1950s. I tried to dress Dustin Hoffman as Lenny Bruce, but it didn't look right. What worked on Lenny Bruce were tight little suits, shirts, and ties. So little by little, I went away from that. There were elements I used. But it was an awakening that even though I was using a real person, who had died not that much earlier, I had to change it. There was one thing that Bob had in mind: having one of the nightclub routines being done in a raincoat. I don't remember seeing that in my research—that was something in Fosse's mind.

On *All That Jazz* (1979), we started production three months before shooting with Richard Dreyfuss. He was a wonderful actor, but he just wasn't right, and both Fosse and Dreyfuss knew it. So we closed down for a while, and they cast Roy Scheider. My job was to make Scheider look as much like Bob Fosse as possible to the point where we were testing the night before shooting, and his beard was so black, he looked like Othello. I recommended they bleach his hair, and he finally really looked like an essence of Bob Fosse. When I start with a real authentic figure, like a movie star, I start with total reality. But these are not documentaries, so you always have to find that middle ground. Fosse always wore black. It was a uniform. He wasn't trying to make a statement. That was what he was comfortable with, and he didn't have to think about what to wear in the morning. Fosse was never dogmatic about

OPPOSITE: Ann Reinking in *All That Jazz* (1979).

costumes. He would have some ideas and if he didn't like it, you would find out. But, otherwise, I was pretty free.

With most directors, you don't ask, "What do you want the character to wear?" I don't want to hear that anyway. I just want to hear about the essence of the character, I want to know why they're making the movie and what they think it's about. Then I want to come up with things and then we can talk about if it works or not. The beauty of when you work with someone a lot is that you can finish sentences for each other. Where Bob was wonderful was not telling you what to do, but he could see immediately if something was right or wrong, and he knew why.

Q: When you designed for Meryl Streep in *Still of the Night* (1982), was she comfortable being so glamorous? She seems like she is not as conscious about clothes in her personal life as she is about dressing her characters.

A: That's absolutely true. Off-camera, she couldn't care less. She's a very modest dresser. It's not her thing. Maybe now it is;

I haven't worked with her in some years. But when it came to the character, clothes were very important to her. She works like English actors do. They have to know what they're going to look like before they can develop their character. Laurence Olivier was like that. He really was concerned about the external look before he could do the internal part of the acting. When Meryl looked in the mirror during a fitting, she was looking for the character.

With a character like Sophie in *Sophie's Choice* (1982), I asked, "Where has she been? Where is she going? Financially, how did she afford her clothes?" She was a refugee and she lived in Brooklyn. Those are things that needn't be spelled out on the screen, but that's what you use to get to a look.

Q: As Sophie became more fragile, did her clothes become more fragile? Kind of like Blanche DuBois in *A Streetcar Named Desire*?

A: I think she was someone who, no matter what she wore, didn't know she was wearing it. Her entrance was very important

to me, when Stingo (Peter MacNicol) sees her for the first time, it was the middle of the afternoon. I had her come down the stairs in a slip and a peignoir to look like she just had sex. She liked the idea too because it sets up a "before." That's what clothes should do. Our job is to really tell a story and help the script as much as possible.

Q: Your beaded gown for Annette Bening in *Bugsy* (1991) was really a showstopper.

A: Film ratio changed and in most movies, they don't shoot costumes full-length, which I need to establish a period. I asked Allen Daviau, the cinematographer, "Am I ever going to see a full-length shot?" A couple days went by, and he said, "I have a gift for you." And it was a full-length shot of Annette's entrance in the beaded gown to Bugsy Siegel's house. He backlit her, so you could see right through the dress, and you could see her legs moving through the beads. It was totally unexpected and it was a gift.

Q: What was it like working with a blonde Barbra Streisand on *All Night Long* (1981)?

A: In those days, a lot of movies were being done by costumers and not costume designers. It was only later, little by little that it changed. Mostly it was the designers' fault. In the Golden Age, you saw in a film's credit "Gowns by" or "Designed by." They did the stars, but no one else. So the wardrobe department, more and more, took over. When I got in, I had to fight to be in control of the background actors, especially on *Grease* (1978). Even if I don't actually do it myself, I don't let anything go by without checking it.

All Night Long started out without Streisand. She was brought in to replace another actress. Then they needed a designer, so I was

OPPOSITE: Roy Scheider in *All That Jazz* (1979).

ABOVE: Jeff Conaway, Olivia Newton-John, John Travolta, and Stockard Channing in *Grease* (1978).

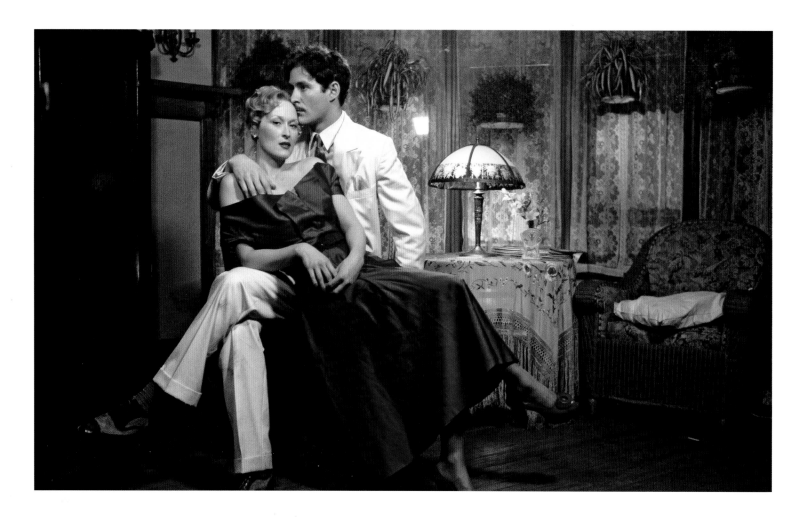

brought in. Barbra likes to be totally in control. She's opinionated. There's some street stuff about her, which I liked very much, and I responded to her. Even when she drove me crazy, I still liked her.

Q: But it's a positive thing when an actor cares so much about their character, isn't it?

A: Caring about your character is important. An actor looking in a mirror and giving no reaction is death to me. There's a difference between caring and controlling. You almost get the feeling that something has to come from them, or else it isn't important. Not necessarily with Barbra, but you could suggest something to an actor on a Monday and they don't like the idea. But on Wednesday they come to you with the same thing, and now it's their idea.

Q: Did you expect *Grease* to be such a big hit?

A: *Grease* was a very popular show on Broadway, but it was a mess. What I didn't realize until later, and I think the reason the movie was so popular, was we made a messy movie. None of us knew what we were doing. I did a show-and-tell for producer Allan Carr and he told me my concept was too real. He told me

I needed more color and to punch it up, and he was absolutely right. So I went back and I started using colors I'd never used before, or since. But I really credit that critique with giving me the edge of what I had to do because I couldn't figure out how to translate that stage material to the screen. You couldn't be realistic. Our actors that were playing high-school seniors, were dying out their gray roots. It was the kind of project that shouldn't have worked. All the creative people had their own problems they needed to work out with no guidance at all, except for Carr's mantra to make it colorful. We had to really push it, and make it almost surreal.

Olivia's last costume was based on drawings from Frederick's of Hollywood catalogs. She couldn't wait to get into it after wearing all these goody-goody clothes. She was sewn into it because there were no zippers. That tight black clothing was worn by, well, nice ladies *didn't* wear them.

ABOVE: Meryl Streep in *Sophie's Choice* (1982).

OPPOSITE: Annette Bening and Warren Beatty in *Bugsy* (1991).

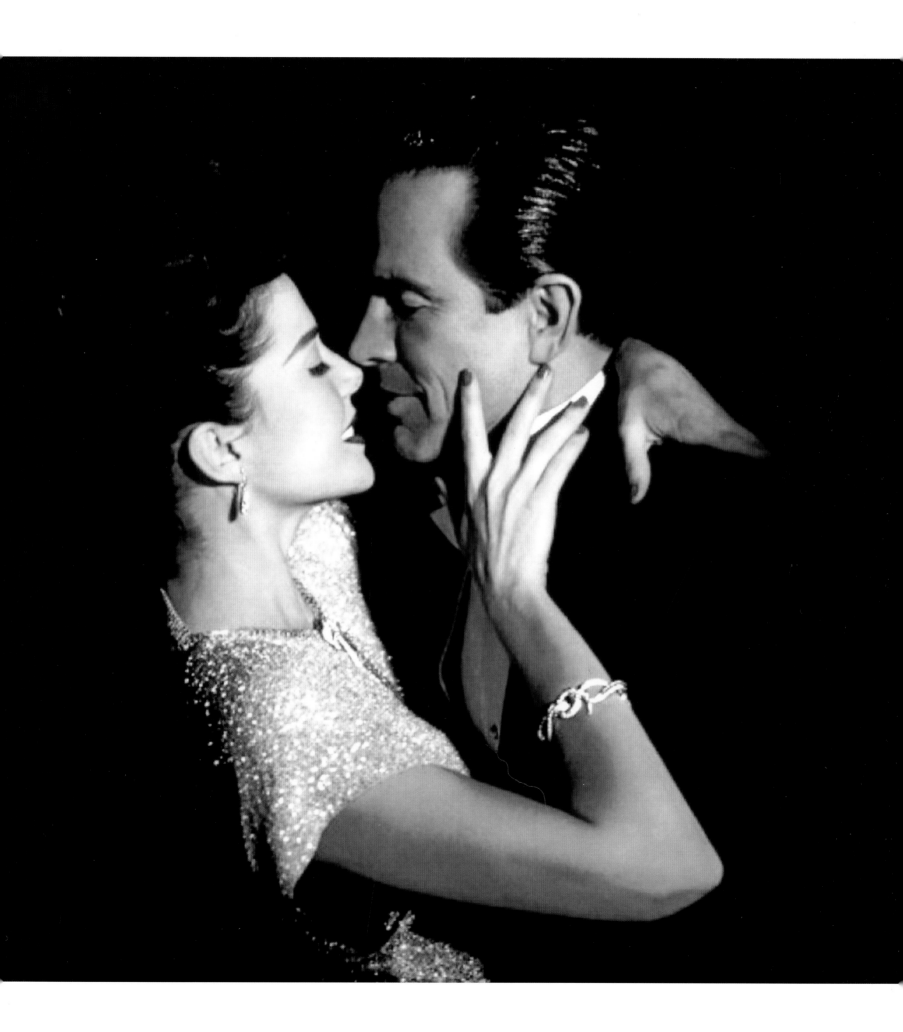

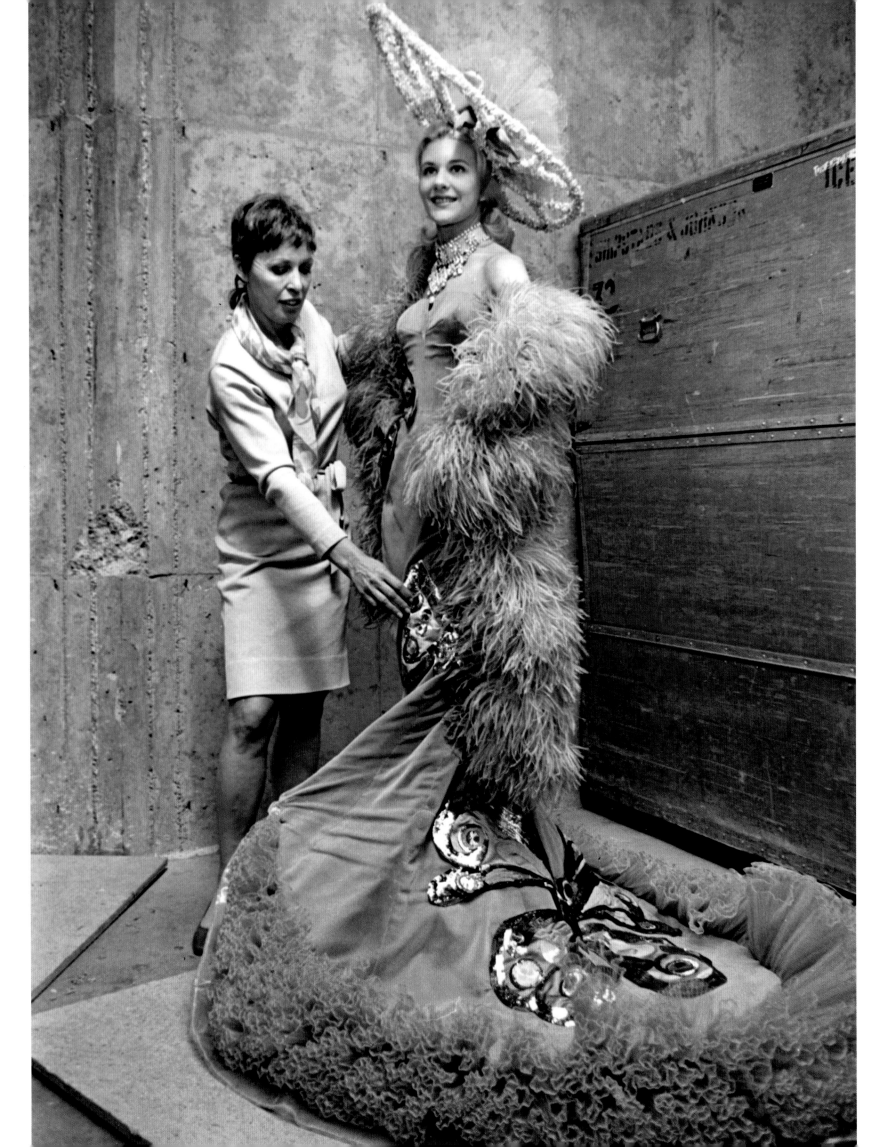

HELEN COLVIG

Q: How did you first become interested in design?

A: When I was five years old, I put my foot through a window, which caused me not to be able to walk. While I was bedridden, my mother bought fashion magazines for me. I would cut out figures from the magazines and then design makeshift paper clothes to put on them. I also developed a love for fabrics. Around the corner from my home was a dry cleaner that did pleating, and they would throw scraps of fabric away, which I would retrieve from their trash cans in the alley. I kept my treasures in a cigar box, and my dreams grew of becoming a costume designer. I carved a small dressmaking form for which I would make clothes.

Q: Where did you study?

A: At Chouinard Art Institute, and then I continued my studies at Otis Art Institute, studying sculpture. I married and had a son. With only some amateur dance work under my belt, I applied for a job at NBC, working in the costume department for live television. Knowing how to sew was a tremendous asset, and I worked as a costumer dressing performers in musicals and on *The Dinah Shore Show*. You had to work very fast, and this was in the days before Velcro. We used what we called "pie pans," which were the biggest snaps you could buy. I moved to CBS, dyeing shoes, assembling costumes, and assisting performers with their quick changes, often working in teams with other costumers. I thought I was going to have a heart attack sometimes.

Q: How did you make the transition to films?

A: I had gone to Disney to costume the Mouseketeers for *The Mickey Mouse Club*. In 1955, the Screen Actors Guild declared a strike. When everything got settled, all of a sudden everybody was busy, and they soaked up every bit of talent. There were no costumers left. Adele Palmer of Republic Pictures called my boss looking for a costumer for Patricia Medina for *Stranger at My Door* (1956). It was a chance to be an on-set costumer, instead of working in stock, so I seized the opportunity.

Q: How did you begin your association with Alfred Hitchcock?

A: I saw a Hitchcock show on TV one night, and I thought "Gee, those costumes look so real." They didn't look like costumes at all. I don't know what prompted me, but I called Revue Studios,

which was on the Republic lot, and asked to speak to the costume department. A man answered and I said, "I don't know who did the costumes on *Hitchcock* last night, but I just wanted to tell you and your department that it was so convincing and so good." He asked me who I was and I told him that I had worked for Adele Palmer. Though I wasn't actively looking for work, the man took my name and number in case he had a need for a woman costumer. The next day he called with a job offer. "Do you know what a Merry Widow is?" he asked me, "Well, Fay Wray wants one and I don't know what it is." I knew what it was, so he hired me as a costumer. After I completed an assignment to dress a ventriloquist's dummy for Claude Rains to use on Alfred Hitchcock's TV show, Revue began using me more as a designer than a costumer. Then MCA, owner of Revue Studios, acquired Universal and the staff moved to the Universal lot.

Q: How did Hitchcock use costumes to convey character in *Psycho*?

A: We didn't make clothes for *Psycho* because he wanted Marion (Janet Leigh) to wear what she could have afforded in real life. It was all off-the-rack. Hitchcock had an authentic real estate office photographed in Arizona. Then he went home with the employees and photographed their clothing in their closets. He showed us the photographs and said, "This is how I want my principals to look." In the beginning of the film, Janet Leigh wears a white bra and slip. But after she steals the money from her employer, Hitchcock wanted her in a black bra to show how she has fallen.

Q: What was it like working with Clint Eastwood when he directed *Play Misty for Me* (1971)?

A: Clint wanted Jessica Walter's character to look like a normal person, but she was a nut. Hitchock used to use the term "McGuffin," and that was a trickery—the thing that you didn't think was going to happen. You never suspect that person because they look so normal. But slowly, the characters got nuts or became murderers. Just like Tony Perkins wearing sweaters in *Psycho*—he looked like a nice, relaxed guy. But then when you start seeing the

OPPOSITE: Costume designer Helen Colvig (left) fits skater Carol Cooper for *Ice Follies* (1968).

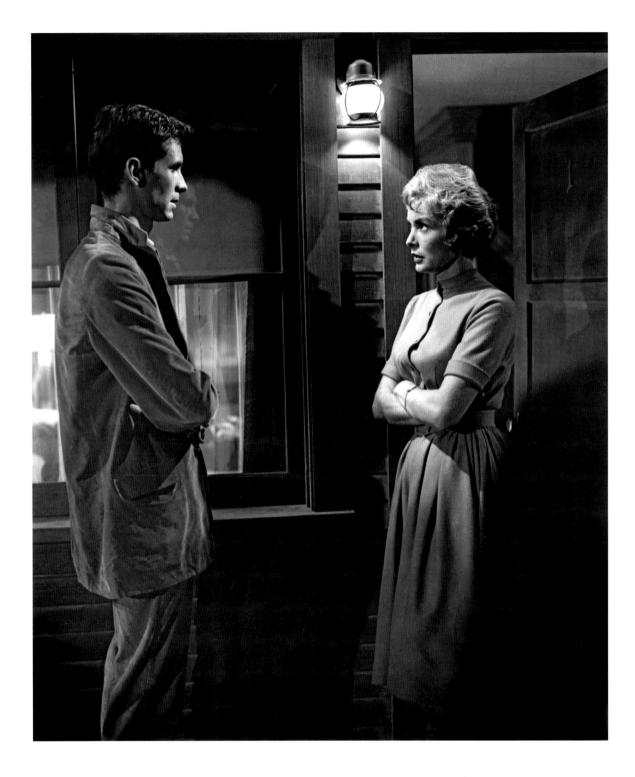

stuffed birds, you start saying, "uh, oh." The costumes were never to give anything away, but slowly the action and the story will explain what happens. The clothes had little to do with it.

Q: Was Marlon Brando a "method" actor about his costumes in *The Appaloosa* (1966)?

A: He is a tough man to work for. He provokes people. He put me through the wringer. He wanted this, he wanted that, and it wasn't right. I told him, "You're a peasant, you know. Mexicans don't wear royal blue." He said, "That's what I want." I told my boss, and he said "Make it." So I made this horrible blue outfit and

Marlon looked at it, and I said, "You're not even going to put it on, are you? I told you that we were going to do these white peasant outfits, but you didn't accept it. You wanted this one." And he said, "Well, I don't want it. I want the white outfit." Here we spent so much money on a whim of his, but he was just provoking. I made a serape for him, and it had color threads running through it. During production, he would sit on his horse with it on and he pulled all the color threads out of it. He's a fair guy, but when there's not enough amusement, he'll aggravate you.

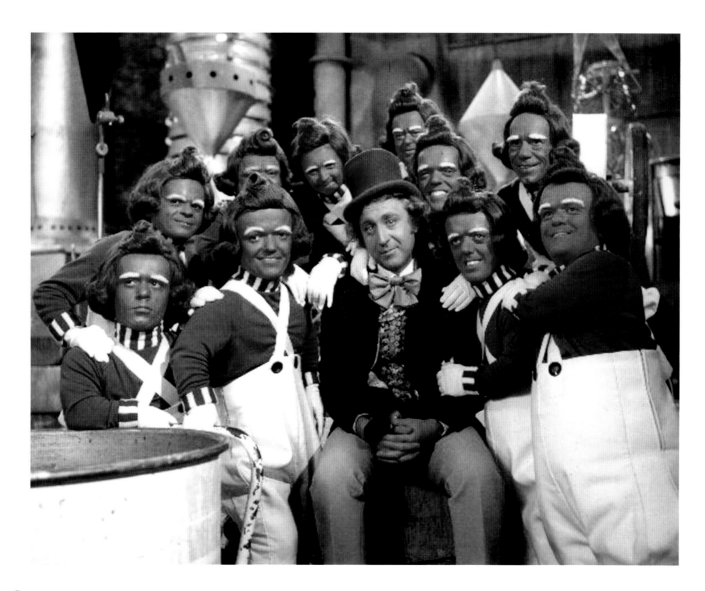

Q: Was working on *Willy Wonka and the Chocolate Factory* (1971) a kind of crazy experience, like the film itself?

A: I read the book and the script, and knew it was a fantasy. I talked to the producer and I met with Roald Dahl and they wanted to see what I was going to come up with. I made up the sketches, and they approved them. They didn't shoot the film in Los Angeles. It was shot in Germany because they got a tax break. All the clothes were made abroad from my sketches. I never saw any of the costumes until they were on the screen. It disappointed me terribly because I really wanted to supervise. I had worked on pictures before with [director] Mel Stuart, and he was such a difficult man. I learned on *I Love My Wife* (1970) that he was a screamer, and when he was displeased, he would just scream you down. When people start screaming, your first thought is that they must be so insecure to just blow up like that.

I didn't know how we were going to engineer Violet's expanding suit in *Willy Wonka*, and still to this day, I don't know how they did it. Mel didn't know what he was doing with the Oompa Loompas. They were supposed to look like candy. But he didn't want them to look like they were made out of chocolate because he didn't want them to look like they were in blackface. So he made them orange. What a crappy color. It could have been lavender. It could have been anything—pink, like a piece of candy. I hated it. He had me make sketch after sketch because he said, "It has to look like they're wearing candy," but it didn't come out that way. He was thinking of candy that he knew as a kid. But I didn't know that kind of candy because he was from New York and I was from California, and we had different kinds of candy.

OPPOSITE: Anthony Perkins and Janet Leigh in *Psycho* (1960).

ABOVE: Gene Wilder and the Oompa Loompas in *Willy Wonka and the Chocolate Factory* (1971).

RAQUEL WELCH

Q: In your autobiography, *Beyond the Cleavage*, you stated, "The doe skin bikini (in *One Million Years B.C.*) struck a chord. I became every male's fantasy." Was there ever a discussion with costume designer Sir Carl Toms about a more authentic costume, or was it always envisioned as a stylized sexy costume?

A: Sir Carl Toms was an absolute genius. He came to our first meeting with his design sketches in hand. He'd envisioned the design for Luana's character, completely on his own. He was, after all, a very gifted and accomplished designer for the British theatre and was knighted for his set design and costume work in the theater as well as on film sets. I expect that he conferred with the producer Michael Carreras in particular before he began sketching.

For my part, I couldn't imagine what on earth I would be wearing, and was wondering how in hell I could manage to survive this dinosaur epic. But Carl Toms came with a sketch, which looked amazing. It was an artfully draped animal skin—of chamois-like weight and pliability. And the finished product was very weathered. The edges of the skin looked like they'd been torn off an animal carcass and roughly cut with a piece of flint-like stone.

Q: You said you felt like you got no respect on the set of *One Million Years B.C.*, but while watching the rushes or working with the still photographers, could you envision at all how the way you looked in that film would alter your life?

A: There were no rushes on the Canary Islands. So I didn't see anything from the on-set photography while I was on location. Frankly, the only photographs were quickly snapped by the unit photographer at whatever point in the action the director called "cut." So basically, I would just repeat what I had done in the scene, mostly reaction shots to seeing a dinosaur or some prehistoric creature. I did not anticipate that my part in this movie would cause any stir, not even a ripple. So I was quite surprised that the production stills had somehow found their way to the London press by the time I got back from shooting in the Canary Islands. That was my best guess as to why there were so many photographers, who seemed to know me by name. They were all waiting for me at Heathrow airport by the time I landed there after returning weeks later from the shooting.

Q: Can you tell me about working with designer Ron Talsky and how he shaped your image at that time?

A: I worked with Ron Talsky for the first time on *Kansas City Bomber* (1972). He collaborated with the director and myself on creating my character of K. C. Carr, who was the single mother of a young seven-year-old daughter (Jodie Foster). She was a roller derby skater, who had a rough life and did not dress with glamorous style. So we went in the direction of very simple jeans and basic tops with jean jackets, a trench coat, and of course, the number 11 on her "Bomber" skating jersey. On only one occasion, Ron decided to fit me in a high-necked, but clinging knit dress, for a dinner date with Kevin McCarthy, who played the team owner.

On *The Last of Sheila* (1973), which was shot on a yacht in the South of France, I played a more glamorous character who was a successful actress. The key to her look was that she was trying to rise beyond her sexy image. Type casting, I guess. She was beautifully dressed but not in a flashy way. Herb Ross, the director, was expecting me to be a more obvious "babe." But I felt from personal experience that actresses who are considered sex symbols often want to be taken more seriously. So my interpretation of Alice was chic and tasteful but still beautiful. And Ron played a large role in choosing that direction, which I found refreshing. And the movie was very well received. Mind you, if the film had been a musical comedy, I could have had much more fun with my role.

Q: On *The Three Musketeers* (1973), Ron designed your costumes, but I believe other designers were overseeing the productions. Do you know how Ron worked with them? Did he have his costumes made in Los Angeles?

A: Yes, it was far more practical than flying to London. For *The Three Musketeers*, Ron designed my costumes for the role of Constance de Bonacieux, seamstress to the queen of Spain (Geraldine Chaplin). Constance was not—in any way—royalty, nor was she titled and would not have been in the same social stratosphere as either the queen or Milady de Winter (Faye Dunaway). Ron had all my *Three Musketeers* costumes made at

OPPOSITE: Raquel Welch in *One Million Years B.C.* (1966). Costume design by Sir Carl Toms.

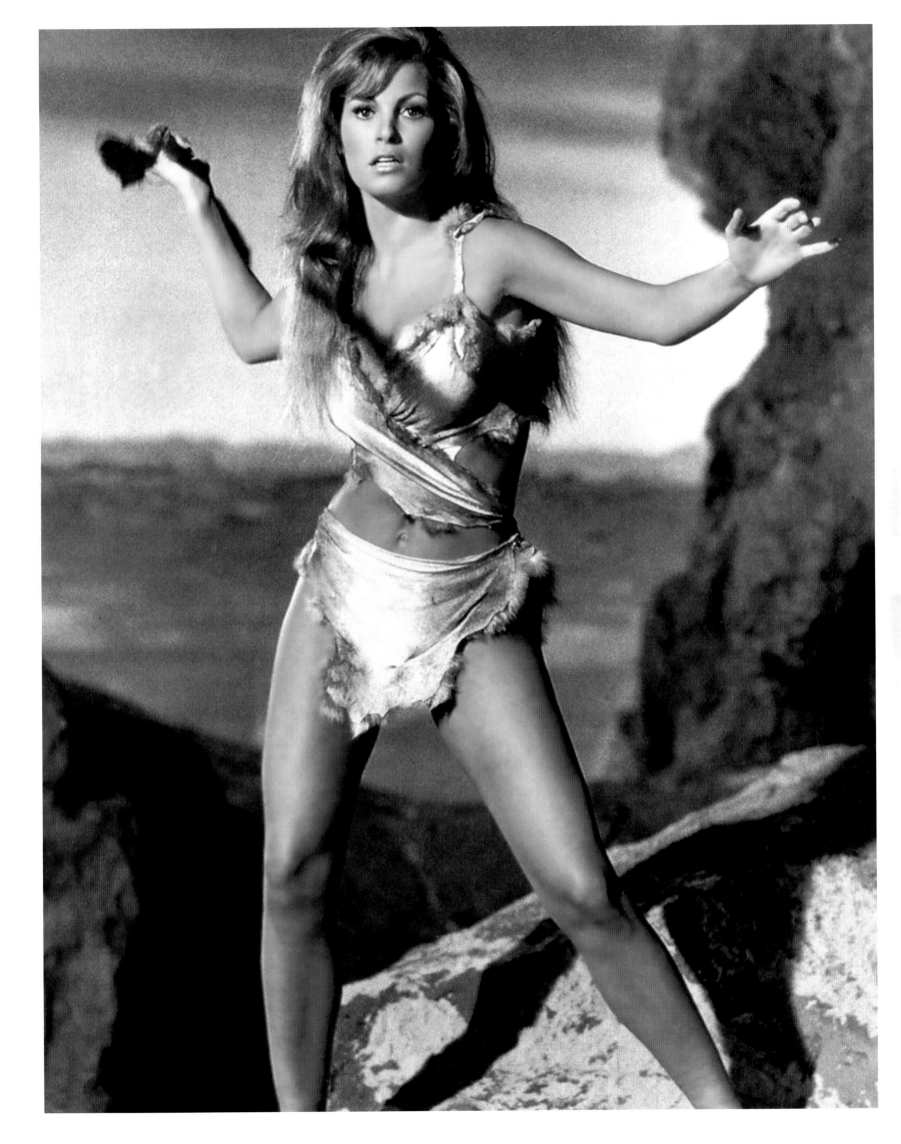

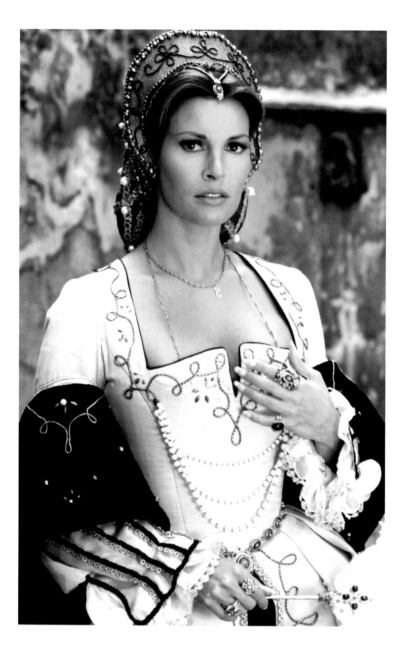

more vulnerable and also funnier than if I'd been all trussed up. The movie was a huge success and I won a Golden Globe for best actress.

One could say that Ron Talsky was helpful in three very pivotal movies in my career. *The Last of Sheila* was well received as a film with an all-star cast. My work on *Kansas City Bomber* received the best reviews of my career, so far, *The Three Musketeers* was a summer blockbuster, and winning a Golden Globe was pretty cool.

Q: How did you come to work with cutter/fitter Lily Fonda at Western Costume, and can you tell me about working with her?

A: I always felt that Lily Fonda was a force to be reckoned with. Her talent, her experienced eye, and her impeccable taste, were a gift to the movie industry, which she served and toiled in for most of her professional life. Lily was also great fun, and she possessed a wicked sense of humor. Of course, she was "the" master cutter—a kind of legend—at Western Costume Company all through the golden years of the movies. Most of the name actresses, through several decades, adored her and counted on her to make them look their absolute best. Lily always wanted any actress she worked on to look fabulous in perfect couturier clothes. I was happy to count myself among them. We really couldn't be in better hands.

I met Lily at the very beginning of my career. I was twenty-three at the time, when I was cast as the billboard girl on *The Hollywood Palace* (1964), which was a popular TV variety show. Though it was only a "walk-on," I was happy for the job as I had to pay the rent and had two small toddlers at home that needed looking after. I was just getting started in my career and was the new kid in town.

I was sent over to Western Costume to be fitted into a showgirl costume. My appearance, which would bookend the show, didn't have much to it, so the costume would have to do the talking for me. And I knew exactly which one I wanted. The fact that I knew the exact costume from *Guys and Dolls* (1955) made Ms. Fonda sit up and take notice. She loved that I had a frame of reference from all the movies I'd seen and loved as a kid. So we hit it right off, then and there.

As fate would have it, that very costume got me noticed when I opened and closed the show each week. The fan mail came rolling in and the producers took notice. As my star rose, Lily Fonda made my costumes for most of my movies, including *Myra Breckinridge* (1970). She and Theadora Van Runkle collaborated on the cutting and making of each design and the clothes were

Western Costume Company with Lily Fonda. In the fittings, we tried to fit me into the boarded front costumes of that fifteenth-century period, but the bust was pushed so high that it came bulging too obviously out of the top. So we took the liberty of allowing a bit more room in the bodice. My choice, granted. But I did not want to be a visual joke whenever I was on-screen. We also decided on fabrics that were not brocade or too rich looking, but more modest and less upper class. After all, Constance lived with her husband (Spike Milligan) in very modest almost farm-like circumstances.

Yvonne Blake designed the rest of the movie in London with Berman's Costume House. They were magnificent. I never heard anything about what she thought, and I could understand if she didn't like my choices. But I was happy that my character came off as

spectacular. Theadora's concept for my character stayed true to Gore Vidal's book, which adhered to the philosophy that the Golden Age of Hollywood was best represented by films from the era spanning 1935 to 1945. So Myra's clothes were copies of the silver-screen costumes worn by the likes of Constance Bennett, Rosalind Russell, Joan Crawford, Bette Davis, Dorothy Lamour, Myrna Loy, Rita Hayworth, etc. The clothes for *Myra Breckinridge* were of a quality far better than the finished movie itself, which ended up a mere shadow of Gore Vidal's novel.

Q: What are the demands on an actress for her personal wardrobe? Can you tell me about working with your stylist, Rob Saduski?

A: In contemporary movie making, an actress is often asked to bring clothes from her own personal wardrobe to a fitting and the costume designer may choose some of these outfits for use in the movie or television show. It sometimes works out well, but often the actress does not have the right look for the project in her closet. So then a costume either has to be made or the designer goes out and shops for the appropriate clothes for the character. In my heyday—the 1960s through the 1980s—actresses always had clothes designed and made for the Academy Awards or other red-carpet events and television appearances. Today, it's the custom to use a stylist who will call in clothes from various designers and the actress chooses the one that suits her best.

My friend, the costume designer and stylist Rob Saduski, can do whatever is called for. He has had gowns and dresses and suits made for me. He has also found gorgeous clothes for me for the red carpet. Some of the designers I have discovered through Rob are Roland Mouret, Jason Wu, and Elisabetta Franchi. I have also been a longtime patron of Dolce & Gabbana, Donna Karan, Michael Kors, Giorgio Armani, Elizabeth and James, Ralph Lauren, Roberto Cavalli, Versace, Alexander McQueen, Diane von Furstenberg, Hugo Boss, David Meister, and Tom Ford.

What I love about Rob is that he has a wonderful sense of the place and the event, so that he always directs me toward just

the right clothes to suit the occasion. But he also likes glamour and style in everything he chooses. I've been working with him for about ten years now and I have been greatly influenced in my personal and professional lives by Rob Saduski's sense of style. Someone once said, "Style is simply being yourself, on purpose." Though I've played a lot of characters from different time periods, from cowgirls to fifteenth-century royalty, I know exactly who I am, and so does Rob.

OPPOSITE: Raquel Welch in *The Three Musketeers* (1973). Costume design by Ron Talsky.

ABOVE: Raquel Welch with designer Ron Talsky.

BETSY HEIMANN

Q: When did you first consider costume design as a profession?

A: I was living in Chicago and working with an artists' collective. We were making one-of-a-kind clothing and having little art shows in eclectic places. That led to my being asked to have some of my clothes sold at local boutiques in Chicago. At that time, I was making jackets out of fabrics that were older and damaged. I would cut around the damaged parts and make something new out of something old. There was a movie filming in town and an actress bought one of my jackets and brought it to the set because the sleeves were too long. They made some inquiries because they thought it was unusual, and I was invited to the set. Theoni Aldredge was the costume designer on the film, and she asked me if I ever thought of becoming a costume designer. I said I hadn't thought of it, but the question seemed to resonate with me. I had been to art school at CalArts, I'd been to theater school at UCLA, and I'd been sewing since I was twelve years old. I told her I thought it was a fabulous idea. She suggested I work my way into the union as a seamstress and work my way up to costume designer, and that's what I did.

Q: So you had already studied in Los Angeles, but costume design hadn't entered your mind?

A: I had asked my mom for a sewing machine when I was twelve, and she couldn't figure that out. I just had this burning desire, but I never put the pieces together. It's funny how your life is just sitting there waiting for you to recognize it, and somebody else tips you off to what's going to happen in your life.

Q: How did your first film happen?

A: When I came back to Los Angeles to pursue this new career, one of the friends I had made while I was living here before said, "Oh, I'm producing a movie! Let me give you a job as a seamstress!" It was just sort of odd. All the pieces start to fit together when you're on the right path. In my life, I have chosen to go forward on my instinct—something pushes me forward. Then I find myself in a situation that seems practically impossible and I have to tackle the unknown.

Q: When you approach an article of clothing that seems simple, say, Uma Thurman's white shirt in *Pulp Fiction* (1994), what do

you factor in when making the decision to design it yourself or purchase it?

A: Sometimes what you want isn't out there, even if it's as simple as a white shirt. Maybe nobody is making a white shirt that is depressed at the waist. For Renée Zellweger in *Jerry Maguire* (1996), I had to find a black dress that tied at the shoulder so it could fall down and create a sexy moment onscreen. The line in the film was "That's not a dress. That's an Audrey Hepburn movie." There was the dress that Audrey Hepburn wore in *Sabrina* (1954) and my dress was an homage to that dress. There is a moment in the film where they are on the steps and he has to untie the dress. It's a cinematic moment written in the script. I could spend my life wandering around the universe looking for a dress that will do what's written in the script, or I can design one. If I want a jade-green blouse and that's not the color of the season, I make one. Now, I am a very good designer and I don't need to prove that every time. So I design the clothes that need to be designed to move the story forward and meet the needs of the director and the screenplay.

On *Almost Famous* (2000), I did such a good job of aging everything that people thought I got everything from a thrift store. When, in fact, every single thing in that movie, except for the blue jeans, was designed in my workroom—every T-shirt, every logo, every blouse. For the jeans, I went up to Seattle and dug through barrels of clothing like a mad woman to find the period blue jeans. Because of the way we treated the new clothes, the movie was overlooked for costumes, because people thought they came from a thrift store. It's a very high compliment, but it shows a lack of understanding for what we do.

Q: You helped to bring back the narrow silhouette in men's suits with *Reservoir Dogs* (1992).

A: [Director] Quentin Tarantino wanted to evoke the French New Wave films. He also wanted the characters to have a certain anonymity. With a $10,000 budget for costumes, I couldn't afford to buy new suits and all the multiples we would need. These guys had all just gotten out of prison, so I figured they probably bought their suits at a thrift store. Quentin's suit came from a warehouse downtown because he didn't need multiples, but for Tim Roth

and Steve Buscemi, I needed four suits for each of them. So I found a place that had old stock 1960s dark jackets.

Q: I understand you were instrumental in helping Paul Reubens's career along.

A: After seeing Paul do ten minutes of Pee-Wee Herman, I literally saw dollar signs jumping all around his head—like little cartoon dollar signs—it was kind of strange. We waited after the show to see him, and I said to him, "You are going to be very rich one day." He said, "Well, thank you very much, I wish I could

believe it. I have my own show that I am trying to do. I sent a few people to see him, but they didn't appreciate him." He said to me, "Why don't you produce my show? You understand it and have a passion for it." This was during an actor's strike and there was no work for me at that time, so I said I would do it.

Paul knew a woman who would do the publicity for the show and he borrowed $8,000 from his parents. We opened at The Groundlings, and we became popular. I felt like we needed

ABOVE: *Reservoir Dogs* (1992)

a bigger venue, so I went over to the Roxy on Sunset Boulevard. I waded through all the smoke and met Lou Adler. He said, "What do you want, kid?" I told him about the show, and he said, "No way, we don't want your show." So I asked what night was the worst for his business, and he said it was Tuesday night. So I suggested he just let us try the show on Tuesday nights. We ended up getting a few nights at the Roxy, and Marty Callner from HBO saw the show, and I sold it to them. We made a lot more than $8,000.

It was another one of those things like "How about being a costume designer?" I just did it and it was hard, but I was knee-deep in it. I paid everyone a salary from the money we took in, and it turned out great. The interesting thing is the difference in perception. We were quite the rage and after the show, people would come to talk to me and if they would ask, I would tell them that I was really a costume designer. "But you're the producer now," they would say. But I viewed it as a temporary job. I had told Paul, "All I want is for you to be famous and to send me a check every now and then." And that's exactly what happened. When I told people I was going back to being a costume designer, they would look at me like I was the stupidest person they ever met or I was no longer of interest to them. It was curious.

ABOVE: John Travolta and Uma Thurman in *Pulp Fiction* (1994).

OPPOSITE: *Almost Famous* (2000)

COLLEEN ATWOOD

Q: Do you remember your first thoughts about costume design?

A: As a child, I loved the costumes in *Snow White and the Seven Dwarfs* (1937). As an adult, *The Leopard* (1963) was the first movie that made me aware that costume design could be something spectacular. I was probably twenty years old and living in Seattle, Washington. I was just selling clothes at the time and not involved in this industry at all.

Q: When did you realize it could be a career?

A: There was a long period of having a child and having to make a living a different way—working in an Yves Saint Laurent boutique, selling clothes and fitting clothes. Once my daughter was out of high school, I decided I really wanted to work on films. I moved to New York and got my first break working in the art department on *Ragtime* (1981) for Patrizia von Brandenstein. I was doing everything I could to survive. I was basically starting over, sewing labels on at night in little designers' back rooms, and all kinds of stuff to make a living in New York.

Q: Was it sink or swim?

A: I was just excited by the prospect and the idea of doing it. I ended up making things by hand with Patrizia's daughter in their loft for set dressing for *Ragtime*, and became aware of the possibilities for design. I studied fine art in school, but not as it related to clothing or costumes.

Q: How did you break out to design on your own?

A: I was recommended by Patrizia for a job working for the film division of *Saturday Night Live*. It was for the little films they made that went with the show every week. Once I did that, I was recommended for my first design job. I got in the union, which in New York is not easy to shortcut, and then I was able to get my own work.

Q: What was your first meeting like with Tim Burton for *Edward Scissorhands*?

A: I lived in New York at the time and I was flown to Los Angeles for the meeting. I was very excited about the possibility of working with him. The meeting was so casual, we just met and had a cup of coffee. We only talked about the script a little bit and

who Edward was and the world Tim was thinking of creating. He asked me right then if I wanted to do it and I said, "Yeah!" I've had two jobs in my life where the directors actually said in the room, "Will you do the movie?" and that was one of them. Tim and I have had a very long collaboration and understanding of each other. I think we have similar taste in a lot of ways. After working with him, I know things he doesn't like, but he's always approachable for new ideas.

Q: Do you know what it was that made you both click from the start?

A: He liked my ideas, and I think he liked the fact that I didn't talk too much, to be honest. I'm a bit older than Tim, but we grew up in the same way—in very middle-class neighborhoods. We had a lot of experiences in common with life and who we were as artists, and I think that is really our connection.

Q: Would it be correct to say that Johnny Depp is your muse?

A: I think Johnny Depp is such a special artist and actor in his own way. We just get silly together and have a great time. If you fire off a little idea, Johnny takes it to another place. When I know I'm working with him, I always try to come up with little things and just lay them around to see if he picks up on them, and he always does. He is definitely an inspirational artist and muse that way, for sure.

Q: You went on from *Edward Scissorhands* to do *Silence of the Lambs* (1991), which are two radically different projects. What attracts you to a project?

A: It's a combination of things, but a connection with the director is the most important part for me. If I know a director and what excitement and energy they're going to bring to a script, it changes the aspect of what that script is to me. It's great to read a script that is just a good script and say, "Wow, I want to do this." But most of the time it, helps me to imagine what the director's take on the script will be.

Q: So even if there isn't a great opportunity for costuming, are you attracted to really good characterizations, as in *Silence of the Lambs*?

OPPOSITE: Johnny Depp as *Edward Scissorhands* (1990).

A: Those characters were so sparse and well drawn, and [director] Jonathan Demme connected with them in a great way. It was a very good script, but none of us realized it would be such a huge hit. We were just doing another movie with the Jonathan family. But then we would go to dailies and see the performances between Jodie Foster and Anthony Hopkins, and the tension of the way it was shot, and we felt like we were part of something.

Q: You used the word "sparse." So even if a character is sparse, you can still be drawn to costuming them?

A: What I like is that these projects are all so different. To me, that is the most interesting thing about my work. One-half of the year I can be working on a big-budget film with fantasy costumes, and the other half of the year, I can be working on a film with four costumes.

Q: When you work on musicals like *Chicago* (2002) and *Nine* (2009) with director Rob Marshall, how do you design in conjunction with the choreography?

A: It depends on the movie, and if it's a movie with a lot of choreography. In a perfect world of film, the choreography is designed in pre-production. Then I start my process of designing, measuring, and fitting the costumes. In the case of *Chicago*, when I met with Rob Marshall, I had just finished *Planet of the Apes* (2001). I brought my book from that film to the meeting. We talked about the difference between action and choreography and how it's closely related as far as costume functions and needs. So I knew a lot of things that dancers required. He told me he wanted me to do the movie and that he would call me in a few months. When production was starting, Rob called and he said he wanted to bring me in to see the choreography. Rob, John DeLuca, Joey Pizzi, Denise Faye, and Cynthia Onrubia performed the entire

ABOVE: Catherine Zeta-Jones and Renée Zellweger in *Chicago* (2002).

OPPOSITE: Charlize Theron in *Snow White and the Huntsman* (2012).

"Roxie"
Lead into 'Funny
Honey'

Colleen Atwood

Sketch artist Carlos Rosario

choreography for *Chicago* for me in an empty space using just chairs. It was the most impressive, inspiring thing I ever saw. It was amazing to see how the choreography was built to tell a story in a film, and to see all the movement, so you knew what the costumes were going to be doing before you built them.

Q: Can you give me an example of a costume that almost got cut from a film and why?

A: There's almost always one costume in every movie. In *Nine*, there is a costume that Judi Dench wore when she had a flashback. We were really struggling to make it work as a romantic costume on her in a number where she had to sit on a piano. I really wanted to make it look like an old cabaret tuxedo and I wanted it to be really sexy. We all had a moment over a weekend where Rob was saying, "I'm not sure this is right. I don't know if it's going to help her do the number." But I loved it, and Judi did, too. So when Judi came in on Monday for a fitting, we took the costume to Rob and John DeLuca. She sold it so well, they said, "It's great, she's going

to wear it. It's going to be fine. We just had a moment," which happens with people. Judi made it work in a great way.

Q: So the actors can really hit things home when they like it?

A: Yes, in both ways. They can also whine about a costume. It doesn't happen that often, but especially with young actresses who come from modeling, and not acting, it can happen. But they have to wear the costume and they have to feel the costume is their character. It is a real collaboration between the costume, the costume designer, and the actor. And if you're not helping them, then you're really not doing your job. It is really important to be able to move on if something isn't working for somebody. You have to have a vision, but you have to have more than one.

ABOVE: Carlos Rosario's costume sketch for Renée Zellweger in *Chicago* (2002). Costume design by Colleen Atwood.

OPPOSITE: Kate Hudson in *Nine* (2009).

ELLEN MIROJNICK

Q: Were you interested in costume design at a young age?

A: As a young girl, it wasn't about the costume design per se, it was about being swept off my feet by films—being taken in by stories, sitting in a dark theater, watching the magic happen. What happened over and over, though we don't talk about it as much as we did then, was that film influenced fashion. While designing junior sportswear, I had a book called *A Pictorial History of the Talkies*. Looking through that book and then watching current films that took place at different periods of time, whether it was *The Way We Were* (1973) or *The Great Gatsby* (1974), influenced my consciousness for designing. I used film continually as a source of inspiration when I designed ready-to-wear in my twenties. I did that for about seven years and then became a costume designer. It seemed to be a natural progression.

Q: Can you explain the approval process for a costume?

A: After 2000, when franchise films like *Pirates of the Caribbean* (2003) started to happen, the budgets soared. The source material for these films is usually from something else, like a comic book or a theme park attraction, and everybody, from the original creators to executives at companies that own the properties, has a say as to what a costume looks like. If it's a contemporary film, everybody thinks they know what a contemporary film should look like. Is it "cool" enough? Is it "hip" enough? They're looking to stand out or be noticed for something that might not have anything to do with the story you're trying to tell. I had to learn to be the translator of what was expected. The director and the producer want to make their statement, sometimes they're on the same page and sometimes not, and sometimes the studio differs from that statement. You have to determine very early on who has the power and what you are going to have to do to get everything you know is right for the story and characters. You have to translate what it all means in somebody else's vision, without alienating the others.

Q: Does the actor have any power in this process?

A: Every couple of years, the power shifts. There was a great deal of time that the actor had the power, then there was a time when the studio or the producers had the power. The actor has a say, of course, but you have to juggle who has the power—the studio, director, or producer. You have to relate it back to the actor and work with them. You have to give the actor the tools to create the character, but you have to keep it in balance as you listen to the other parties, if they are at odds with each other.

Q: The dress that Sharon Stone wears in the interrogation scene in *Basic Instinct* (1992) has become so famous. What were the considerations for that costume?

A: It needed to be elegant and beautiful and have the simplest of ease. It could not be suggestive or overtly sexual. It could not be anything that made the character of Catherine Tramell the black widow. It could not be obvious. The choice of that particular design came pretty naturally.

There were three parts to the design of that dress. The first was that Catherine had to change her clothes as Nick takes a peek at her changing. So she had to strip, she had to put a dress on very easily as we see the back of her nude body. The dress had to be easy to step into, easy to look perfect in one second as she turns because she knows he's looking at her, but it's not mentioned. She's done the first part of the seduction. She grabs her coat and goes down to the station. When she takes her coat off, which is the third part, her arms and legs needed to be totally free. Sharon requested a way in which she could be relaxed, as if she was a man sitting in an arm chair. So the costume had to serve all of those needs and be true to the integrity of the character as she is beginning the second part of her seduction.

Q: When designing *Behind the Candelabra* (2013) with Michael Douglas, did you base your designs on things that Liberace actually wore or did you act as though you might have been designing for Liberace at that time?

A: It was both. Having a lot of research was extremely helpful. I also had the great fortune of going through the show costumes at the Liberace Museum, which is now closed to the public. The story is not a biography of Liberace, it is a story of Scott Thorson's relationship with Liberace from 1977 to 1982. Liberace was all

OPPOSITE: Sharon Stone in *Basic Instinct* (1992).

about presentation and extravagance and having whatever he wanted. He was called Mr. Showmanship for a reason. By the time we meet him in the movie in 1977, he is extremely glittery. But Steven Soderbergh was the director, and the story that he wanted to tell was not a Ross Hunter glittery Hollywood film.

Steven is a very naturalistic director, so the question becomes: what will the actors be able to handle so you're not just looking at the flamboyance of a costume? You're really inside the characters and who they are, as opposed to what they're wearing. It's a difficult line to walk. I was very nervous and insecure from the beginning until the end. Was this going to be enough or was this going to be too much? If it was too much, what would be the right balance for Michael Douglas and Matt Damon? I didn't want it to be a caricature.

The show clothes for both of them were interpretations of what really existed. Liberace's show clothes at that time could cost $1 million an outfit and they weighed tons because of the amount of rhinestones and crystals that were used. We replicated an iconic white virgin fox coat trimmed with rhinestones with a sixteen-foot train using fake fur. Howard Cummings, the production designer, and I decided which of the other pieces I interpreted would go with which songs, based on what the show would look like, the pianos, and where we were in the story. It was great fun and I think we did great costume design by giving Michael, Matt, and the other actors' tools to become these characters. The costumes really helped them transform.

Q: You had to win over director Oliver Stone to create a power look for the characters in *Wall Street* (1987), didn't you?

A: I had only read about fifty or sixty pages of the script of *Wall Street* when I met with Oliver Stone, but I was fascinated by the themes of money and power and seduction. If you look through my résumé, you'll find that in a lot of the films I've done. I am fascinated by how Gordon Gekko (Michael Douglas), this self-

made man became the shark that he did, and how he lured Bud Fox (Charlie Sheen) to the table.

I wanted Gordon to be a powerfully seductive fellow. I had just worked with Michael Douglas a few months before on *Basic Instinct* and he was in suits and ties, but it couldn't be ordinary this time. He had to have the romance and the seduction of Cary Grant—because that's what he does subliminally with Charlie Sheen. Oliver, at one point, said, "Nobody looks like this on the street," and I said, "I don't care, this is what Gordon looks like, and it will look like that eventually." That was a brazen remark at the time but that's what I really felt. We're not making a documentary. Oliver's movies were very rough at that time. There was no slickness. He had made *Salvador* (1986) and *Platoon* (1986), both based in reality. *Wall Street* was based in reality, but it needed to have its own heightened level of money, power, and seduction. I don't know if that was right or wrong, but it just resonated inside of me about who Gordon Gekko was and what this world looked like. It needed to look luscious and as an outsider, you wanted into it so much.

Oliver was kind of mad at the time, but then he was perfectly thrilled later, and said to me, "You were robbed of an Academy Award." He realized what influence it had on the street; it changed men's fashion at the time. It gave men permission to be powerful looking, in their own interpretation. We were all shocked because Gordon is really the villain, but people are attracted to the dark.

OPPOSITE: Michael Douglas as Liberace in *Behind the Candelabra* (2013).

ABOVE: Michael Douglas in *Wall Street* (1987).

GARY JONES

Q: How did you become involved in costume design?

A: I grew up on a farm in Swanton, Ohio, which is about twenty miles west of Toledo. Around the time I was nine or ten, I saw a live production of *Holiday on Ice*. The first "a-ha!" moment was a Scheherazade number. There were eight ladies in sheer pantaloons and each had her own downlight which changed, and the effect of the light on the costumes changed the color. It was magic. Then there was a "Showboat" number, where a paddlewheel steamer rolled out onto the back of the ice, and out of it came the same eight ladies in antebellum dresses that had lights inside them. They floated across the ice and got into position, the house went black, and the lights inside the dresses illuminated as they skated around. I couldn't believe my eyes.

In high school, I worked on school plays, and I made Roman armor for the Easter morning sunrise service at my church. In college, I started in the economics department, but I had no idea what I was doing in those classes. I met an actor there who told me I should come to the theater department. I went, and never left. After college, I had an offer to assist a designer at the New York Shakespeare Festival. I arrived in New York with $500 in my pocket, and discovered that the man who had offered me the job was in the hospital having the cartilage replaced in both of his knees and wasn't doing any designing that summer.

I explained what happened to a friend of mine. The friend said, "Come to dinner tonight, there is someone I want you to meet." That person was screenwriter Anita Loos. She said to me, "I know exactly who you should meet, and I'll make arrangements." She sent me to Stanley Simmons, who designed costumes for ballet and theater. Stanley arranged for me to meet Milo Morrow, who was the head of the costume design shop for the New York Shakespeare Festival. He took me on as an apprentice for $35 a week. The very first costume I made was for Judy Collins, who was playing opposite Stacy Keach in *Peer Gynt* (1969). Raul Julia, James Earl Jones, and Estelle Parsons were there. It was an extraordinary time, and I worked there for almost ten years. After working with Theoni Aldredge on the Shakespeare Festival's original production of *A Chorus Line* (1975), I went to work at Barbara Matera Ltd.

Years later, I sent a letter to Anita Loos and told her that she had been the *raison d'être* for the "whole mess." I think she got a kick out of it. Stanley Simmons told me that Anita had said she was "glad to be the *raison d'être* for anything!"

Q: How did you meet the costume designer Ann Roth and begin your collaboration with her on the film *Hair* (1979)?

A: I was working at Brooks Van Horn Costumes for John David Ridge, and Ann was coming in to do a Broadway show called *Do You Turn Somersaults?* (1978) with Mary Martin. John was working on circus costumes, which were the bread-and-butter for the company. I had never met Ann, but John assigned me to her, saying, "Give her whatever she wants." She came in and showed me the drawings for her show and told me what colors and fabrics she wanted to use. While I'm sure I was very nervous, I was also very comfortable. There was some chemistry going on. After she left, I went out to the fabric stores by myself, and by the end of the day, I had found 85 percent of the fabrics for Mary Martin's costumes. Sometime after the costumes were completed, as Ann and I were coming back from the dress rehearsal in Tennessee, she said, "I know that you know the musical *Hair* very well because you were at the Shakespeare Festival. I've been asked to do the film. I've never liked that musical, but I really want to work with [director] Milos Forman. If you think we can do it together, let's do it." And that was that.

Q: Was everything designed for *Hair* or did you use vintage clothing?

A: We purchased things, but in film, one of everything won't do because you need multiples of most costumes in case one gets ruined. And, usually, one was what you had if you went to a thrift shop. So we copied and reworked pieces. Ann says she was one of the first designers to use vintage clothing when she made *Midnight Cowboy* (1969), and in the way she used them, I think she's right. What set the clothes apart was the way things were aged. When we made Treat Williams's old beaten-up leather jacket or his vest,

ageing was the only way to accomplish what we needed. At one point, Ann went out to Barstow and she and [choreographer] Twyla Tharp worked out the way everything was going to look at the rally in Washington. They started out with the drawings of the Twyla Tharp dance company, and then added to it. The jeans became a joke, because if you could find vintage ones, they weren't quite right. So we took them apart and started all over and did the embroidery.

Q: Did you collaborate on Geraldine Page's characterization in *The Trip to Bountiful* (1985)?

A: There was a collaboration, although at that point in Geraldine Page's career, she didn't spend a lot of time discussing. We had three fittings. During the first, I showed her research and a drawing of a collar that I had done. Geraldine said, "The only thing I ask is that there be flowers somewhere for her." In my head, I immediately knew what she was talking about. I knew the sort of gray fabric with flowers that ladies like that wore. We didn't find it gray, but we made it gray. It had small boutonnières, and the collar we used was the one we talked about. She was very aware of who this character was, so we made sure we accentuated her lowered bosom. We shortened her dress a little bit because she still had great legs and it was just prettier. That film was just a gift given to me, because I knew everyone of those characters. In my life, they weren't southern, but they lived in Ohio. We copied some of the favorite things that I remember from my childhood—the green jacket worn by Rebecca DeMornay, the floral print Geraldine wears, the men's clothes. It was like someone had said to me, "Pick out all your favorite stuff from your childhood and put it in a movie."

Q: In doing films like the remake of *Sabrina* (1995) or *Oz, the Great and Powerful* (2013), you reinvented looks for characters with whom audiences are familiar. Do you have to clear your mind of those past projects before you start designing?

A: For the remake of *Sabrina*, and I don't mean this in an unkind way: Julia Ormond is a totally different kind of woman than Audrey Hepburn. I don't think we worried about repeating because there wasn't any way to really do that. So, yes, you try to clear your mind from trying to force anything, but you have to deal with the shape of the different actors who will be doing it. It puts different requirements on your designs, and you find your characters in a different way.

When I came on to *Oz, the Great and Powerful*, production designer Robert Stromberg and character designer Michael Kutsche had already been working with director Sam Raimi on the characters. They were not only developing the costumes, but their eye makeup, and everything that related to the CGI. So we had Michael's drawings, and I made drawings for the other characters which had not been imagined at that point. In the first meeting, the production design department was literally wallpapered with the various worlds that we were going to be living in for the next year. It became about making costumes that would be believable, but that would fit into the four worlds—a turn-of-the-century sideshow in the middle of Kansas; the enchanted forest; the world of the Winkies; and eventually we get to Oz. The witches each had their own essence, both as real people, and then as witches. Sam had fallen in love with the computer-generated drawings, and we had to make them a reality.

As we go forward in digital filmmaking, you really need a strong director who knows what he can and can't do, which is certainly the way Sam is. As a designer, you have to be willing to do things you might not ordinarily do, because your designs will be manipulated—colors can change dramatically under digital-lighting conditions.

OPPOSITE: Lindsay Lohan and Chris Pine in *Just My Luck* (2006). Costume design by Gary Jones.

KYM BARRETT

Q: How did you decide on costume design as a profession?

A: I was studying English and classical literature at university. I was required to work in plays, and I didn't want to act, so I chose to do sets. Traditionally sets and costumes are split up, but when you learn them at university, you learn them as a whole. Even during my theater days, until I moved into a realm with bigger budgets, I still had to do both. I spent a couple of years in charge of the whole vision of smaller productions. Once I started working at Belvoir St. Theatre or Sydney Theatre Company, all of a sudden the workload was separated, because the shows were bigger and I don't think they felt designers had enough time to do both. I had a mentor at school named Brian Thomson, who was scenic designer of the original Australian and London productions of *The Rocky Horror Show* (1973). He asked me to do a musical with him, and that was the first time I did costumes exclusively. Once people see the show, and you do publicity, that is how people start to identify you. So it wasn't that I particularly decided that was what I wanted to do; I was equally comfortable in either area. Occasionally I'll do set designs for commercials because I enjoy it, but my career has gone down a costume path by serendipity.

Q: You went to school with costume and production designer Catherine Martin, and began your film career working with her and her husband, director Baz Luhrmann.

A: Catherine was a year ahead of me in school, and we were friends. I did *Romeo + Juliet* (1996) with Baz and Catherine. She felt her strength was more on the side of production design, and she wanted to spend more time on that. So my doing the costumes was kind of completing the team. Because we were reinterpreting our time, a parallel universe where the characters are speaking early modern English, I think it was important that the visual of the character set up their trajectory. I mapped a visual path for each character, taking a lot of clues from what Shakespeare said about them. He may have put so much information about the characters in his play because when it was originally performed, perhaps they didn't have heaps of elaborate costumes. So I feel like he was doing in words, what I was trying to do with the costumes, so it reinforced the whole visual narrative.

Q: When you've described your first meeting with Lana and Andy Wachowski, directors of *The Matrix* (1999), I heard you use a word that I do not usually associate with Hollywood meetings—laughter. Are meetings with directors intimidating?

A: It depends on the people. Most of the time I get called for meetings for films based on original scripts. A director who is willing to work with an original script is a particular type of person. Sometimes the directors are also the writers, and there's a natural openness. You have to just unfurl your ideas and see what sail catches the wind. If the director has had that same thought, it *is* fun. I first read the script for *The Matrix* a few years before I met the Wachowskis. I was living in my garret on Wilcox Avenue in Hollywood, and I asked my agents to just send me any scripts so I had something to read because I couldn't afford books. I loved the script, but my agent wasn't sure it would ever be produced because they felt no one would understand it.

When I met the Wachowskis, they were with their wives, who I believe have a bearing on what kinds of people they want to spend time with. I brought up some references that they liked. I had grown up on westerns and Chinese Kung Fu movies, because where I lived that was all there was. There are a lot of themes in those films that they are drawn to. And I love beautiful clothes and beautiful things, but something doesn't have to be beautiful or expensive for it to be good. They're the same way. They would never say, "Give me five racks of Prada for the fittings." But some people do, they say, "Listen, you can only show them Givenchy, Prada, and Armani." I don't do that. Quite often I'll take the labels out of things and try to mix it in to find what's right.

Q: Do labels have a psychological effect on choosing a wardrobe?

A: There are certain actresses that you can't please unless you get a rack of clothes from Prada.

Q: Neo's coat in *The Matrix* has a monk-like quality to it. Was the intent to fuse design with religion?

OPPOSITE: Keanu Reeves in *The Matrix* (1999).

A: I wanted to combine East and West. Our main goal was the movement through space. We knew we wanted him to fly and we didn't want it to look cheesy. *Superman* (1978) got away with it brilliantly, but that's a special type of suspension of disbelief. One of the hardest things was how do you make a coat that can withstand having rain poured on it all day, that someone can fight in, and is not too heavy. You cave into a lot of practical things, and since it was black, I had to rely on a silhouette. The lighting was very dark most of the time. It was important to me that it shape-shifted between a Mandarin-collared Asian silhouette and a Western-type cleric look. I also had to consider the stunt work that would be done on wires, so the coat had to be tight to the torso and keep its silhouette when it moved. Keanu is very tall, and he didn't want to slouch or be laconic. So I felt the high collar and a coat that was buttoned up quite tight across his chest gave him that extra reminder to stand up straight. In many ways, Keanu does have a monk-like sensibility. He speaks softly. If you visit him in his hotel room, there are books everywhere. He is rigorous in his training. He doesn't smoke or drink when he's working.

OPPOSITE: John Malkovich in *Eragon* (2006).

ABOVE: Carrie Anne Moss in *The Matrix* (1999).

PENNY ROSE

Q: How did you become interested in costume design?

A: I was given a sewing machine when I was twelve. My mother wouldn't buy high-street fashion clothes in the 1960s because she thought they were horrible. She was a conservative, elegant lady, and she expected me to be the same. So the thought of the miniskirt, or anything from Kings Road, was just not allowed. So I made my own. Though nobody approved of them because they were considered to be inappropriate, my father was rather impressed that I'd made them.

In my school holidays from age fourteen onward, I worked in our local theater, which was in Windsor. The day came when they said, "We want you to help in the costume department." I thought it was great fun. However, I ended up attending drama school on a general theater course.

Because I speak fluent Italian, I got a job with Fiorucci in Milan when I was twenty-one. He taught me all the rudimentary skills of fashion buying, and I was his buyer for a year. Then I met a girl at a dinner party who asked me to help on a commercial, and I accepted. The girl who asked me to help her got another job. I was left stranded, but people were incredibly helpful. The director was Adrian Lyne. His company didn't know that was my first commercial, so they rang me up and said, "Would you come and do another one?" So I made that split-second decision, should I tell them I don't know what I'm doing or should I go in there and wing it? Guess which one I chose.

I was in the right place at the right time. In the early 1970s, everybody I worked for subsequently became a famous film director—Alan Parker, Ridley Scott, Tony Scott, Hugh Hudson among them, and some of them brought me with them. So I am just one lucky gal.

Q: How do you approach a costume?

A: Most of my work is period. I don't really draw first. I get an actor into a room and I start to put shapes on them. I start to see what works with their body shape. During that process, we can decide that the woman should have an enormous bosom, which she may not actually have, or if the man should have a paunch, which the actor may not have. The character could be round-shouldered because he sits at a computer all day. There are a myriad of things that come into the decision-making process, but if you work with me, it all takes place in the dressing room. I don't really invite directors into that first session. I ask them to let us have a play first, and when the actor and I feel that we have something, we'll invite them in. This takes a little time, because we are working out shape, color, texture, and fabric. Then I will make a first sample, or maybe two or three. I've made up to six samples, so that everybody gets a chance to discuss their favorite. The actor and I always come to an agreement, so that I am never showing the director or the studio something that the actor does not want to wear.

Over the years I have discovered that when people look at a drawing, which is one-dimensional, they don't really see the costume. It is always more powerful to put something on a human being who walks and talks. Then I make maquettes of the costumes because the studio loves them. It's not a regular stand that the dressmakers use, but a little miniature one about eighteen inches high. We make mini versions of the costumes we are going to create. It's on something. It's in front of you. You can touch it. You can feel it.

Q: What makes a successful costume designer? Is it talent?

A: I don't know about talent. What I have definitely is a way with people. I know that because they call me "Marmite." Marmite is a horrible English spread, like Vegemite. You're either a match for me, or you can't take me at all. There's nothing I can do to make you like me if you don't. I can just be as professional as possible. But actors come to work every day and spend all day being someone else. How bizarre is that? So I think the combination of makeup, hair, and costume department really needs to give them everything we've got, because what they're about to spend all day doing is really hard. Someone with raw talent is [costume designer] Sandy Powell, who draws beautifully, and comes up with wacky, unexpected, and very original designs. I think she used denim in *Gangs of New York* (2002). Who would think of putting denim on people in 1900? She really has an instinctive, God-given talent.

Q: Some of your first work in films was for director Gerry O'Hara, including the *The Stud* (1978) and *The Bitch* (1979), starring Joan Collins. What were those like to work on?

A: The most interesting were the ones with Joan Collins, because she was already very well known. She'd been to Hollywood when she was eighteen. She knew how to—and did—behave like a movie star, big time. Joan taught me all there is to know about dealing with big stars. She was demanding, but in a very pleasant way. I felt that I was duty-bound to give her what she wanted. We were sitting in a taxi one day, and we drove past Harrod's. She said, "There you are, that's the mink coat I want to wear in the film!" I said, "We can't afford that!" She said, "Oh, don't be so defeatist." And she rang the man who owned Harrod's, and he lent it to us.

Now I wouldn't have had the clout for that. I was just a kid. She taught me a lot about getting something for nothing. She was fearless.

Q: Did you collaborate on the character of Jack Sparrow with Johnny Depp for *The Pirates of the Caribbean: the Curse of the Black Pearl* (2003)?

ABOVE: Geoffrey Rush, Keira Knightley, and Johnny Depp in *Pirates of the Caribbean: At World's End* (2007).

A: Johnny arrived at the fitting with the character of Jack Sparrow in his head. He wanted Jack to be a "rock 'n' roll" pirate, and I worked out that he had Keith Richards in mind. I had six styles of hat made for our initial fitting—one of them a tricorn made in leather. That was the one he picked up. He doesn't deliberate long. Once he thinks we've found the shape, he stops.

Q: How do you keep your work on the subsequent *Pirates of the Caribbean* films fresh?

A: When we did *Pirates of the Carribean: On Stranger Tides* (2011), I didn't know who was going to play the villainous pirate. I kept nagging, "Can you cast him?" Then I heard it was Ian McShane. I didn't know him, but I saw a picture. He looks like he's had a party on his face and I just woke up one morning and thought, "Ah, biker pirate. We haven't done one of those!" Then I met with Ian with some shapes in leather. I said, "Look, you don't have to commit to this. I think it would look fabulous, but we're going to be in 110-degree heat in Hawaii. You will never be able to take this off. Having established this as your look, you can't walk around in a shirt." And being British, and a fine actor, he looked at me and said, "It's not going to be a problem."

ABOVE: Toby Kebbell, Richard Coyle, and Jake Gyllenhaal in *Prince of Persia: The Sands of Time* (2010).

MARK BRIDGES

Q: When did you first become aware of fashion?

A: When I was five years old, I would go and shop for my mother. I think there was an element of dress-up that I always liked. Halloween was a big deal for me, even when I was very small. There was the doctor get-up, a cowboy, and an Easter outfit when I was about four with a vest that my grandmother made, and a watch chain and little fedora. At six or seven, during the British Invasion, I had a Carnaby Street cap with brushed denim shirt and shorts, and I would talk in a cockney accent. I guess I always liked the idea that clothes make a character. On TV, there were variety shows like *The Carol Burnett Show* (1967–78) and *The Sonny and Cher Show* (1976–77) that had sparkly costumes. The witty, showy, and glamorous things that Bob Mackie designed on both shows had an influence on me. I still love things that sparkle. You'll see that in *The Artist* (2011). Part of it was technical because in black and white, it read better.

Q: How did you meet your mentor, Richard Hornung, and can you tell me what you learned from him?

A: I knew him from the 1980s, when I worked as a shopper at Barbara Matera Ltd., and he was assisting Santo Loquasto, Patricia Zipprodt, and any number of other people. He needed someone to size clothes for a week. I was just going in as another assistant, but I was very ambitious and tried to go that extra mile for them. Later, Richard asked me to come out to Los Angeles to assist him on *The Grifters* (1990).

Richard hired me again to assist him on *Barton Fink* (1991) for the Coen Brothers. He had already done *Raising Arizona* (1987) and *Miller's Crossing* (1990) for them. I think the Coens are very visual, but I don't know how costume-savvy they were in those early years. Richard brought so much to the table. He delighted in menswear and had a huge vintage necktie collection. So for something like *Barton Fink*, he knew how to carve out a character in the language of menswear. John Mahoney's character, based on William Faulkner, succumbed to the style of Hollywood, so he would be a little snappier but still a Southern gentleman. Richard's idea was that the first time we meet that character, Barton hears barfing in a bathroom, and the guy had been kneeling on a handkerchief in the stall. All those little details like the two-tone shoes and the Panama hat really flesh out a character. Richard could explain all this to the Coens, and he knew how to talk to actors.

I was happy to be working on something kind of quirky and interesting. It had the same kind of trajectory as *The Artist*, an independent film made on a shoestring budget, and you're not sure who is going to like it, but it debuts at Cannes and everybody raves about it. Richard got an Oscar nomination for it. For such a short career, it was a gift that he was able to get a nomination before he passed away.

Natural Born Killers (1994) was Richard having free reign. Oliver Stone gave him so much latitude and was like, "Dazzle me. Do what you think is right." We prepped the show in L.A., but we shot in New Mexico and Arizona. We went to a place down in South Central that had a lot of back stock—1970s underwear, socks, belts, mesh shirts. Richard bought hip-hugger jeans for Juliette Lewis. Now this was 1993, and if you look at jeans from that period, they're really at the waist. So for her to wear hip-huggers was really retro, and we slimmed them out because they were supposed to be bell-bottoms. People have been wearing them for the last twenty years and I can't help but think that somewhere there is a grain of *Natural Born Killers* influencing that look. It was sexy, but it didn't seem '70s, and I think Richard was really cutting edge on that.

Q: What is it like working with director David O. Russell on films like *I Heart Huckabees* (2004) and *The Fighter* (2010)?

A: With David, I sketch it all in, and he will ask for things. He is very creative on the spot. It can be stressful, especially if we are on location. For *Silver Linings Playbook* (2012), when you go to a place like Philadelphia, there aren't seamstresses hanging around waiting for work. For Jennifer Lawrence's dance costume we had to work around the schedule of the woman who was the cutter for the local opera. We were in a town that is not accustomed to movie deadlines, combined with David's impromptu creativity. We lucked out because the movie came out well and it looked good. No one would ever see that it was fraught with complications.

Q: You said earlier that you were ambitious. Yet *The Artist*, which brought you so much acclaim and an Academy Award must have just looked liked another small independent film from the outset.

A: Maybe the word "ambitious" doesn't apply to *The Artist*. It appealed to me more on an artistic level. I choose things now because I love them. Because I was a kid who grew up loving movies, I was going to do that film no matter what. The crew asked [director] Michel Hazanavicius, "How are we going to see this when it's finished?" We thought the movie was just going to go back to France and end up on DVD on a shelf in some store.

It was something that nobody else was doing. In this age of CGI and 3-D, we just keep getting more entrenched in computer-generated stuff, which is beautiful to look at, but rather soulless. I felt like maybe we need to go back to simple storytelling. Let's start over. The first way to start over would be to go to a silent, black-and-white film. You tell a story and then get the CGI in perspective. And look what happened, people fell in love with *The Artist* and pooh-poohed *John Carter* (2012), which was all computer.

As a designer, you're constantly looking for things that will pull your string. It was a challenge to do that movie on such a shoestring budget, but luckily I have good relationships with the vendors in town. I respect their property and they respect my

work. Also, I love the thrift store, so I felt I could do it. Was I lucky to get it? Yes. Opportunity met preparedness.

Q: You've worked with Mark Wahlberg four times—*Boogie Nights* (1997), *The Italian Job* (2003), *I Heart Huckabees* (2004), and *The Fighter* (2010). What is he like to work with?

A: I have had the benefit of working with him from the early days. He was very open and he was game for all those high-waisted tight pants in *Boogie Nights*. Some actors don't like to sit in a chair and have their tattoos covered up with makeup, so they just want something with long sleeves. I needed to mix it up enough that at some point he needed to wear a tank-top, because it was the 1970s. On the night of the premiere, he came up to me afterward and said, "I didn't understand at the time, but I understand now what you were doing." He was smart enough to let me do what I wanted, and then see the final product and appreciate that I was only acting in his best interest and in the best interest of the film.

I have often thought about what makes a costume work for an actor. You'll get an actor to approve a costume if they look

good, but it makes them feel like somebody else. It's an elusive combination. I don't think anybody goes into a fitting saying, "Make me look horrible" unless you want to do *The Elephant Man* or something. They know they're going to be forty feet tall on the screen and they're worried about the size of their ass, no matter how famous an actor they are. There is probably more to it, but those seem to be the two special traits.

OPPOSITE: Jean Dujardin and Bérénice Bejo in *The Artist* (2011). Costume design by Mark Bridges.

ABOVE: Woody Harrelson and Juliette Lewis in *Natural Born Killers* (1994). Costume design by Richard Hornung.

LIZZY GARDINER AND STEPHAN ELLIOTT

When the film *The Adventures of Priscilla, Queen of the Desert* debuted in 1994, moviegoers embraced the story of two drag queens and one transsexual on a road trip across Australia. The film won an Oscar for Best Costume Design for Lizzy Gardiner and Tim Chappel. When the film was turned into a Broadway musical, the designing duo won the Tony for their stage designs. *Priscilla* director Stephan Elliott has continued to work with costume designer Lizzy Gardiner on subsequent film projects.

Q: Lizzy, what were your first thoughts about costumes in films?

LG: My mother was incredibly beautiful and used to wear Valentino in the 1970s. I was always around fashion. I loved storytelling as well, and I used to watch movies that were completely inappropriate for my age. *The Graduate* (1967), *The Getaway* (1972), and *Bonnie and Clyde* (1967). Those films still inspire me.

I became obsessed with filmmaking and fashion at the same time. I went to the Academy of Arts in France and studied fashion design, but majored in costume. I don't know where it came from, but I was very sure that costume design was what I wanted to do. The thing about fashion is that it lacks the storytelling. Stephan Elliott and I were friends since we were kids, and he had this film called *Priscilla*, and then it began.

Q: How did you meet your *Priscilla* co-designer, Tim Chappel?

LG: I was designing a soap opera in Australia and I needed an assistant, and he came on to the show. We were both only twenty-one or twenty-two. Then we went straight into doing films. We couldn't have been luckier.

Q: Where did the over-the-top ideas for costumes for *Priscilla* come from?

LG: From childhood cartoons, from our mothers, from our grandmothers. Tim and I have a similar sense of humor. We just made ourselves laugh and laugh and laugh. There was no one to say stop laughing, so we didn't. We just had a ball doing what we wanted to do, with no boundaries.

Q: Stephan, is there a level of trust a director has to have with his crew?

SE: There are two ways of doing it. One, you can become a bastard control freak. You can carry on about anything. Or, if you have a relationship with someone you trust, you can actually let them do their job. If Lizzy puts a foot down and says this is what I think is right, then it probably is right. A director's job is not telling people what to do; it's to keep everybody going in a direction. I work out a goal post, and I have to make sure everybody moves within that. You are basically giving people within that space the license to do whatever they want because you trust them.

Q: Lizzy, how are you usually brought on to a project?

ABOVE: Tim Chappel's sketch for Guy Pearce in *The Adventures of Priscilla, Queen of the Desert* (1994). Costume design by Lizzy Gardiner and Tim Chappel.

OPPOSITE: Hugo Weaving, Terence Stamp, and Guy Pearce in *The Adventures of Priscilla, Queen of the Desert.*

LG: A lot of times it is my agent who introduces me to someone through my body of work. There is always someone who says, "Oh, I remember she did *that* film." A film can be held for you or against you. *Priscilla* has been held for and against me. You try not to get typecast. If I only did films of drag queens, I would only work every ten or fifteen years. You'd be surprised how many people see the film or the live show of *Priscilla* and think, "She does drag queens, how could she do fashion?" You spend a lot of time almost apologizing for some of your best work so that you don't get pushed into a corner. I also do big period films, but often people don't realize that. The people who have done their homework know what I've done.

Q: What do you bring with you to a meeting?

LG: In the case of a meeting for the Marvel Comics genre, a lot of the work is already done before you walk into the meeting. They've had conceptual artists and designers and illustrators working on the films for years sometimes. So you walk into a job where you're given the vast body of what they want and they don't really want you to upset the apple cart too much. There are other films that are an open slate and no one has put any thought into the costumes at all. Then when you go into the meeting you have to be very careful that you don't start pitching something that is completely the wrong image for what they want. I do a lot of research before I have a meeting. You need to understand who the director and the producer are as filmmakers. You have to find out what it is that they are looking for. They have to understand that your ego is not so big that you aren't going to be a collaborator. You can't be someone who has only one vision—your own.

I find that with actors you need to do as much research as they have about their character. You need to help by coming in with ideas about back story—where was a character born, where did they go to school, did they go to college or drop out, what kind of family did they come from? You want to hear what the actor has thought about, or what they haven't thought about. You have to become enveloped in that character in order to design for them, and steer them away from, "Does my bum look big in this?" But at the same time, you do have to be incredibly sympathetic to the fact that these actors are up there on the big screen, and they're putting it out there in such a big way. I think they are so brave doing what they do. The best thing I can do for them is be honest and try to make them look good and look right. When you work with a really good actress like Nicole Kidman, she will do anything. She is not a vain person at all. She will go anywhere with her character and doesn't necessarily have to look beautiful, as long as she trusts you.

In *The Railway Man* (2013), Nicole plays a middle-aged, working-class English woman and she really wanted to be true to the character. She didn't want to wear Burberry from head to toe. It was a period film and she wanted period and she wanted dowdy. Maybe it's her maturity, and maybe she knows that to be a great actress she must transform herself. She always has the red carpet to look glamorous, so she doesn't have to do it in the movies.

Q: Stephan, do you always have a vision when you approach a film?

SE: As a writer, there is always an image in your head. I'll discuss what I think that image is and then hand it over and say, "Now you add to it. You bring what you can bring to the table." It also comes with being older and wiser that when someone has had a better idea, you acknowledge it and say, "Yeah, that's a better idea, do it." A lot of people are very frightened on a set of being trumped or someone having an idea that's better than theirs. Rather than saying, "No, I hate it," which is what the majority of people will do when they are challenged, they should reward someone and say in front of everybody, "Better idea. Let's go with it." You should see what that does to a crew. They feel rewarded, not just for the person who had the idea, but for everybody else. They see that the director's ego is not getting in the way of a better idea.

Q: Lizzy, when you come into a franchise like the *Mission: Impossible* films, and design the second film, do they want to keep things or change things?

LG: They wanted to change it at that stage. Tom Cruise wanted to try something completely different. Everyone was on pretty much the same page. That film was incredibly difficult because of how long it took to get all the stunt work done. Tom tries very hard not to come into the room with his huge body of work behind him. He wants to be open to a new designer and a new direction. He doesn't want to keep creating the same character. Tom had a lot of physical things that he needed to do in the film, so he made me aware of that. Once I understood that, I was able to make him look like the movie star he is, but still be able to do

the stunts. Learning all about the harnesses used in stunt work is another education.

Q: Can we talk about the famous dress made of Gold American Express cards that you wore to the Oscars the year that you won for *Priscilla*? It is one of the most controversial moments of Oscar fashion history.

LG: It was one of the many ideas that got thrown around for *Priscilla*. It wasn't something we put an enormous amount of focus on because we knew that American Express would never agree to it.

Q: Was your original idea to construct it like a Paco Rabanne dress, connecting the cards with metal wire?

LG: It's the only way you can construct it with credit cards. But had we even considered that construction for the film? I don't think we even got that far because we didn't think it was ever going to happen. But then the Academy Awards came, and literally a few days before, I was still looking for something to wear. I just couldn't wear one of *those* dresses. It just seemed ludicrous to go in some big gown. It just felt so wrong. Back in those days, when you drove to the Academy Awards, you went through one of the worst parts of Los Angeles. In your limo, in a $35,000 dress, you pass homeless people that have slept on that road for most of their lives. The whole thing struck me as being quite bizarre. Of course, it really is much more complex than that.

At the very last minute, I thought I'm just going to wear the American Express dress. I thought I would never get permission from them, but I was going to do it anyway. We may have changed the cards or something. But then at the very last minute, they agreed to it. With a security guard, they sent hundreds of American Express cards that had my name on them. They arrived the day before the ceremony. I told a few people I was going to do it, and the vast majority said, "Don't do it." But it was too late and I didn't have anything else to wear. If I'd had something else in my cupboard I probably would have pulled that at the last minute. I had put all my eggs in that basket. I thought there was no chance in the world we were going to win.

Q: Even if you didn't win, you would have made the fashion pages the next day.

LG: As many people loved it, that many people hated it. That hurt my feelings a bit. They really misunderstood it or they took it

too seriously. How could you take that seriously? They wondered what I was doing—was I insulting the Academy Awards? There were quite a few actresses that felt I was insulting them. If anything, I was insulting myself by wearing the thing. But if you pull a stunt like that, you have to expect that you're going to upset people, and I was a bit too young to understand that. Now I do. I understand that I did upset some people. And I really inspired some other people. It became really controversial, but that wasn't what I set out to do. The Academy Awards are an incredible part of filmmaking and I never meant to insult them.

Q: But you were trying to make a statement about the commercialization of Oscar fashions. Did you think everyone was going to be in on that statement?

LG: They didn't realize that and they didn't see it that way. And, of course, now it's gotten much worse. I believe now it's more about the dress on the red carpet than it is about the film. I don't know what you do about it. But then in focusing on the dresses, it's also put more focus on costume design.

ABOVE: Colin Firth in *The Railway Man* (2013). Costume design by Lizzy Gardiner.

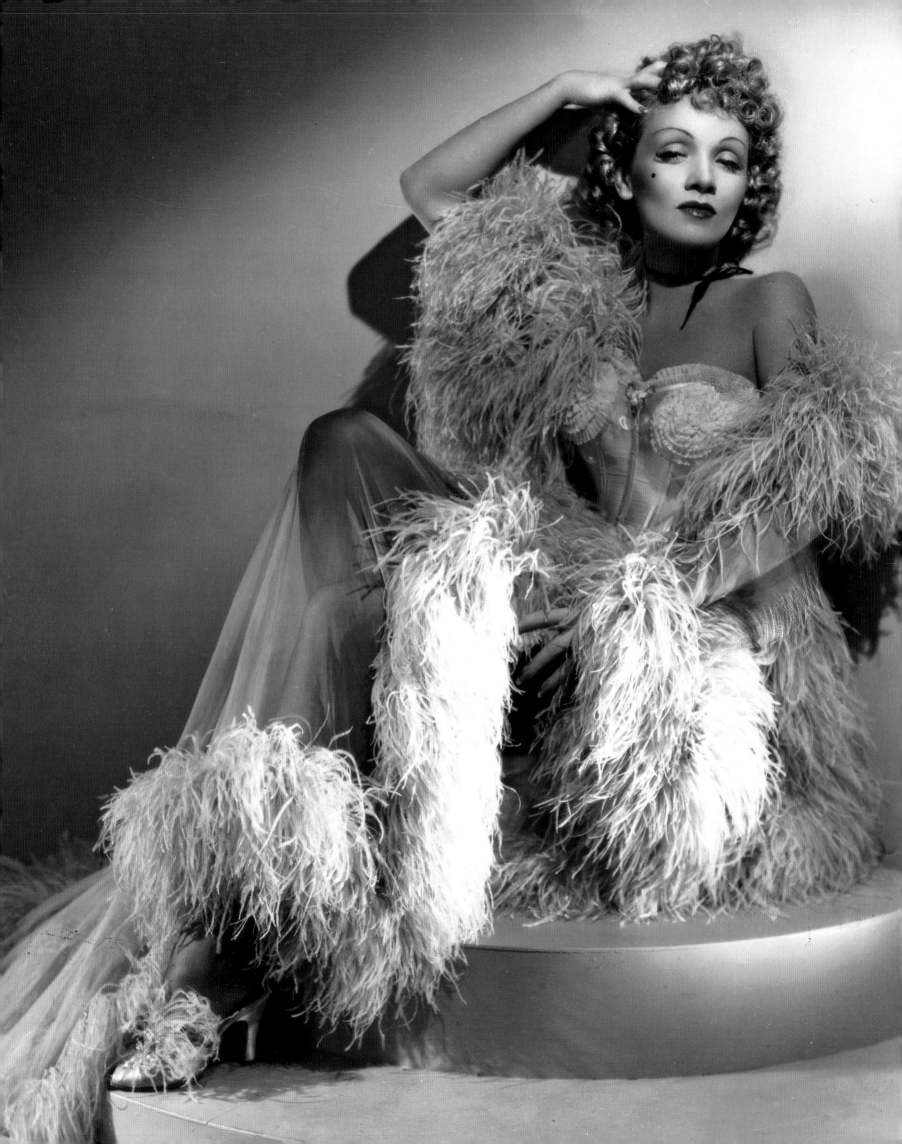

SELECTED BIBLIOGRAPHY

BOOKS

Billecci, Frank and Fisher, Lauranne. *Irene: A Designer from the Golden Age of Hollywood—the MGM Years 1942–49.* Atglen: Schiffer Publishing Ltd., 2014.

Chierichetti, David. *Hollywood Costume Design.* New York: Harmony Books, 1976.

Chierichetti, David. *Mitchell Leisen: Hollywood Director.* Los Angeles: Photoventures Press, 1995.

Conti, Steve; Bethany, A. DeWayne & Seay, Bill. *Collector's Encyclopedia of Sascha Brastoff.* Paducah: Collector Books, 1995.

Curtis, Tony. *The Autobiography.* New York: William Morrow and Company, Inc., 1993.

Davis, Ronald L. *The Glamour Factory.* Dallas: Southern Methodist University Press, 1993.

Day Iverson, Stephanie. *Bonnie Cashin: Practical Dreamer.* New York: The Fashion Institute of Technology, 2000.

Erté. *Things I Remember.* London: Peter Owen Limited, 1975.

Esquevin, Christian. *Adrian: Silver Screen to Custom Label.* New York: The Monacelli Press, 2008.

Greene, June. "Designer Lives in Feminine Paradise but Film Cutting Provides Many Headaches." *The Pittsburgh Press,* July 25, 1940, §2, p. 17.

Greer, Howard. *Designing Male.* New York: G. P. Putnam's Sons, 1951.

Gutner, Howard. *Gowns by Adrian: The MGM Years 1928–1941.* New York: Harry N. Abrams, Inc., 2001.

Hansford, Andrew with Homer, Karen. *Dressing Marilyn.* Milwaukee: Applause Theatre & Cinema Books, 2012.

Head, Edith and Calistro, Paddy. *Edith Head's Hollywood.* New York: E. P. Dutton, Inc., 1983.

Jorgensen, Jay. *Edith Head: The Fifty-Year Career of Hollywood's Greatest Costume Designer.* Philadelphia: Running Press, 2010.

La Vine, W. Robert. *In a Glamorous Fashion.* New York: Charles Scribner's Sons, 1980.

Leese, Elizabeth. *Costume Design in the Movies.* New York: Dover Publications, Inc., 1991.

Lewis, Monica with Lamanna, Dean. *Hollywood Through My Eyes.* Brule: Cable Publishing, 2011.

Mann, William J. *Behind the Screen.* New York: Viking, 2001.

Morris, Michael. *Madam Valentino: The Many Lives of Natacha Rambova.* New York: Abbeville Press, 1991.

Reilly, Maureen. *Hollywood Costume Design by Travilla.* Atglen: Schiffer Publishing Ltd., 2003.

Rose, Helen. *Just Make Them Beautiful.* Santa Monica: Dennis-Landman Publishers, 1976.

Sharaff, Irene. *Broadway & Hollywood.* New York: Van Nostrand Reinhold Company, 1976.

Tolini Finamore, Michelle. *Hollywood Before Glamour: Fashion in American Silent Film.* London: Palgrave MacMillan, 2013.

Vaughan, Hal. *Sleeping with the Enemy: Coco Chanel's Secret War.* New York: Alfred A. Knopf, 2011.

SIGNED ARTICLES

Adrian. "Do American Women Want American Clothes?" *Harper's Bazaar,* February 1934, p. 135.

Alden, Alice. "Movie Colony Awaits Mme. Chanel's Nomination to Sartorial Hall of Fame." *Shamokin (Pennsylvania) News-Dispatch,* March 28, 1931, p. 3.

Anderson, George. "Stage and Screen: Pittsburgher Helps Stars Look Like Stars." *Pittsburgh Post-Gazette,* May 31, 1973, p. 8.

Anderson, George. "The Triangle Tattler: In Memoriam." *Pittsburgh Post-Gazette,* March 9, 1982, p. 24.

Arne, Sigrid. "Movie Wardrobe Department Brings Gwen Plenty Gray Hair." *Reading (Pennsylvania) Eagle,* December 13, 1941, p. 3.

Astor, Mary. "Talkies? 'They Can't Last.'" *New York Times,* October 15, 1967, Arts & Leisure section, p. 117.

Banton, Biddy, "A Century of Fashion." *New York Times,* June 10, 1951, p. SM-11.

Banton, Biddy, "California Sun Fashions." *New York Times,* November 7, 1948, p. SM-52.

Benningtonm, Arthur. "The Last Word in Daring Gowns." *The Milwaukee Sentinel,* December 18, 1922, p. 10.

Blank, Edward D. "Pittsburgh's Burton Miller Amused at Report of Rift: Designer Finds Fabric of Hollywood in 'Feud,' Torn Costumes." *The Pittsburgh Press,* October 26, 1976, p. 27.

Blank, Edward D. "'Rollercoaster' Designer Suits Costumes to Performers, Roles." *The Pittsburgh Press,* April 21, 1977, p. C-6.

Brand, Harry. "Biography of René Hubert." 20th Century-Fox studio biography, n.d., Academy of Motion Picture Arts and Sciences, Margaret Herrick Library (Beverly Hills).

Brody, Meredith. "Costume Drama." *Interview,* August 1989, p. 126.

Bullitt Lowry, Helen. "High Art Home-Made, or Paris Robbed of Her Prey." *New York Times,* November 9, 1919, p. SM3.

Byrne, Julie. "How Bonnie, Clyde Designer Does It." *Los Angeles Times,* September 10, 1968, part IV: page 1.

Campbell, Lillian. "Achieves Ambition as Screen Designer." *The Hammond (Indiana) Times,* December 6, 1937, p. 12.

Carroll, Harrison. "Hollywood." *The (Massillon, Ohio) Evening Independent,* December 15, 1947, p. 4.

Cartnal, Alan. "Bonnie, Clyde Style Creator Concentrates on Elegant Look." *Los Angeles Times,* April 1, 1970, part IV: page 1.

Chierichetti, David. "Charles Le Maire: 40 Years of Creating Costumes for the

OPPOSITE: Marlene Dietrich in *Destry Rides Again* (1939). Costume design by Vera West.

Stars." *Los Angeles Times,* August 29, 1981, p. C9.

Chierichetti, David. "Cinematic Realism Replaces Fading Images of Glamour." *Los Angeles Times,* December 14, 1984, p. L27.

Chierichetti, David. "Edith Head: An Enigmatic Life and Legend." *Los Angeles Times,* October 21, 1983, pp. F12–F16.

Chierichetti, David. "Ethnic Costumes: A Tale of 200 Cities." *Los Angeles Times,* April 2, 1982, p. K6.

Chierichetti, David. "Fashion." *Los Angeles Times,* February 17, 1984, pp. F1–F3.

Chierichetti, David. "Fashion." *Los Angeles Times,* August 23, 1985, pp. E1–E3.

Chierichetti, David. "Helen Rose Remembers." *Los Angeles Times,* December 11, 1981, pp. L8, SF8.

Chierichetti, David. "How they Dress the Hollywood Heroes." *Los Angeles Times,* April 4, 1980, pp. I2–I3.

Chierichetti, David. "Juggling Movie Figures." *Los Angeles Times,* August 22, 1980, p. I1.

Chierichetti, David. "Milo Anderson: Quiet Man with Resounding Talent for Costumes." *Los Angeles Times,* August 19, 1983, pp. G1–G3.

Chierichetti, David. "Star Style: Hollywood's Legendary Fashion Firsts." *Los Angeles Times,* October 27, 1978, p. H6.

Curtis, Charlotte. "Anything Goes in Acapulco—Except the Lilly." *New York Times,* March 12, 1968, p. 38.

Dale, Eleanor. "The Film Forum." *The Deseret News,* Salt Lake City, Utah, February 14, 1921, p. 6.

Davis, Leah R. "The Man is Known by the Clothes They Wear." *The Family Circle,* Vol 7, No, 1. July 5, 1935, p. 14.

Deutsch, Linda. "Bonnie, Clyde Designer Reached Success After Being Fired." *The Kansas City Times,* March 19, 1968, p. 8.

Dunning, Decla. "Californians Success Story." *Script* Magazine. March, 1949.

Durham, Walter A. Letter to Alden Olds, n.d. (c. 1962). Academy of Motion Picture Arts and Sciences, Margaret Herrick Library (Beverly Hills), Special Collections.

Foley, Barbara. "Jean Louis and His First Ladies." *W* Magazine, March 27–April 3, 1981, p. 10.

Gatlelain, Jacque. "Frenchman Interviews the Designers of Movie Modes." *The Milwaukee Journal,* February 7, 1935, p. 12-M.

Garner, Ruth Dennen. "Gowns to be Two-Sided." *Los Angeles Times,* November 8, 1925, p. B-5.

Garrison, Maxine. "Retail Fashion Designer Makes Filmland Sit Up and Take Notice." *The Pittsburgh Press,* January 17, 1945, p. 15.

Garson, Greer. Letter to Marjorie O. Best, March 13, 1961. Academy of Motion Picture Arts and Sciences, Margaret Herrick Library (Beverly Hills), Special Collections.

Greer, Howard. "I've Dressed Them All." *Modern Screen,* Volume 7, No. 1, December 1933, p. 44.

Haber, Joyce. "Costume Designer Gives the Stars a Dressing Down." *Los Angeles Times,* April 19, 1970, Calendar Section, p. 9.

Hall, Barbara. "Oral History with Adele Balkan." n.d. Academy of Motion Picture Arts and Sciences, Margaret Herrick Library (Beverly Hills). Oral Histories.

Hammond, Fay. "Society and Film Notables Open Hearts and Pocketbooks to Raise $150,000." *Los Angeles Times,* September 8, 1947, p. A1.

Hampton, Mary. "Fashion Famous Dolly Tree Tells of Smart Movie Costumes." *The Modesto (California) Bee and News-Herald,* June 7, 1939, p. 8.

Harmetz, Aljean. "Designer with an Affinity for the Past." *New York Times,* March 13, 1988, p. 23.

Harrington, Lisa. "From Rags to Riches." *California Monthly,* June–July 1981, p. 15.

Harrison, Paul. "Her Suit May Suit Men." *The Ottawa (Canada) Citizen,* April 16, 1942, p. 15.

Hoag, Betty. *Transcript of Oral History Interview with Dorothy Jeakins.* June 19, 1964, Archives of American Art, Smithsonian Institution. http://www.aaa.si.edu/collections/oralhistories/transcripts/jeakin64.htm, accessed May 12, 2015.

Hopper, Hedda. "Hedda Hopper's Hollywood." *Tucson (Arizona) Daily Citizen,* May 8, 1951, p. 13.

Hopper, Hedda. "English Duo Seeks Comedies." *The Salt Lake Tribune,* Salt Lake City, Utah, December 30, 1948, p. 10.

Hopper, Hedda. "Hedda Says—Powell-Loy Film Needs Revisions." *The Pittsburgh Press,* April 6, 1945, p. 27.

Hopper, Hedda. "Travis Banton, Designer for Films, to Wed." *Los Angeles Times,* June 20, 1942, p. A7.

Houston-Montgomery, Beauregard. "Travilla." *Interview,* August 29, 1981, p. 100.

Howe, Herb. "Her Years as Valentino's Wife." *The New Movie Magazine,* Volume 1, No. 3, February 1930, p. 32.

Hutson, John and Cashion, Duny. "Put the Blame on Jean Louis." *Palm Springs Life.* Volume 39, No. 8, April 1997, p. 48.

Jefferson Doepken, Kitty. "Paul Zastupnevich, Pittsburgh Native, in Oscar-Running with 'Poseidon' Designs." *Wheeling (West Virginia) News-Register,* March 11, 1973.

Johnson, Erskine. "In Hollywood: on TV." *Redlands (California) Daily Facts,* November 12, 1953, p. 10.

Jungmeyer, Jack (NEA). "Costuming Gives Films Personality." *The (St. Petersburg, Florida) Evening Independent,* January 12, 1924, p. 6.

Kawatzky, Vivian. "Irene's Show Her Last." *The Milwaukee Sentinel,* November 17, 1962, part 1, p. 4.

Keavy, Hubbard (Associated Press). "Screen Life in Hollywood." *Bluefield (West Virginia) Daily Telegram,* September 15, 1936, p. 6.

Kerr, Deborah. Letter to Irene Lentz-Gibbons, June 21, 1947. Academy of Motion Picture Arts and Sciences, Margaret Herrick Library (Beverly Hills), Special Collections.

Krier, Beth Ann. "Costume Designer for the Famous." *Los Angeles Times,* August 4, 1974, pp. M1–M2.

Laird, London. "About Town." *Kansas City Times,* April 13, 1963, p. 37.

LaPrise, Ray. "So His Wife Goes to His Competitors." *Daytona Beach (Florida) Morning News,* October 6, 1958, p.3.

Lane, Lydia. "LeMaire's Clothes Flatter, Not Disguise, The Figure." *Mansfield (Ohio) News-Journal,* September 22 1958, p. 8.

Lang Hunt, Julie. "Trials and Triumphs of a Hollywood Dress Designer." *Photoplay,* Vol. 49, No. 4, April 1936, p. 23.

Lentz Gibbons, Irene. Scrapbooks (1932–1962). Academy of Motion Picture Arts and Sciences, Margaret Herrick Library (Beverly Hills), Special Collections.

Lindstrom, Jan. "Material Girl." *Variety,* February 9, 2005, p. A2.

Luther, Marylou. "'74 Gatsby Look Dim Reflection of the Past." *Los Angeles Times,* April 5, 1974, pp. G1–G2.

Manning, Maybelle. "Fashion Capitals of World Started in Same Way as Miami—Style History Made with Dress Creations." *The Miami Daily News,* October 27, 1941, p. 7A.

Markel, Helen. "Adrian Talks of Gowns—and of Goats." *New York Times,* May 29, 1945, p. 14.

Merreck, Molly. "Hollywood in Person." *The Milwaukee Journal,* December 12, 1932, p. 5.

Mitchell, Flint. "Interview: Paul Zastupnevich." *LISFan 6,* Vol. 1, No.6, Summer 1990.

Neville, Lucie (NEA). "Designer Revolts Against Calendar's Dictatorship." *The (St. Petersburg, Florida) Independent,* August 8, 1940, p. 7.

Osborne, Robert. "Hollywood style lost one of the best friends" *The Hollywood Reporter,* June 24, 1992.

Othman, Frederick C. "Venus De Milo Figure Adopted by Hollywood." *Nevada State Journal,* Reno, Nevada, September 1, 1937, p. 5.

Palmborg, Rilla Page. "The Private Life of Greta Garbo." *The Lincoln (Nebraska) Evening Journal,* published in installments, October 19, 1931, p. 7, October 20, 1931, p. 6, October 21, 1931, p. 11, October 23, 1931, p. 5, October 26, 1931, p. 10, October 27, 1931, p. 8, October 29, 1931, p. 8, October 30, 1931, p. 6.

Page, Eleanor. "Ask Sloan About Acapulco." *Chicago Tribune,* August 14, 1967, §2, p. 6.

Parnell, Dorothy. "Greer Tells of his 'Designs' on Women." *Milwaukee Sentinel,* September 12, 1959, §2, p. 5.

Parsons, Louella O. "Paris Styles Will be Worn by Stars: Mme. Chanel Going to Hollywood to Give Actresses Latest Fashions." *The St. Petersburg (Florida) Times,* February 27, 1931, p. 8.

Pasik, Herb. "Mr. Z Has Dressed Many a Star." *Weekend Desert Post,* August 7, 1987, p. 4.

Percy, Eileen. "Well-Dressed Stars Certain: Mlle. Chanel to See to That at Goldwyn Studio." *Pittsburgh Post-Gazette,* March 25, 1931, p. 18.

Quintanilla, Michael. "Dressing for an Affair." *Los Angeles Times,* July 30, 1999, p. E1.

Ramsden Frances. "Stitches in Time: Those Fabulous Designers of the Silver Screen." *Motion Picture,* Vol. 66, No. 791, January 1977, p, 28.

Riding, Alan. "Erté, a Master of Fashion, Stage and Art Deco Design, Is Dead at 97." *New York Times,* April 22, 1990, http://www.nytimes.com/1990/04/22/obituaries/erte-a-master-of-fashion-stage-and-art-deco-design-is-dead-at-97.html, accessed May 16, 2015.

Riordan, Betsey. Letter to Alden Olds. n.d. (c. 1962). Academy of Motion Picture Arts and Sciences, Margaret Herrick Library (Beverly Hills), Special Collections.

Rogers, Ginger. Letter to Irene Lentz-Gibbons. n.d. (c. 1948). Academy of Motion Picture Arts and Sciences, Margaret Herrick Library (Beverly Hills), Special Collections.

Rose, Helen. "I'm a Designing Woman." *Coronet,* March 1967, p. 142.

Rose, Helen. "Movie Bridal Paths Cut High-Fashion Trail." *Los Angeles Times,* November 19, 1982, part V, p. 26.

Sabol, Blair. "The Master of Cinderella Makeovers." *Los Angeles Times,* January 19, 1975, part VIII, p. 1.

Sanello, Frank. "Gift wrapping the Stars." *After Dark,* December 1981, p. 36.

Scott, Vernon (United Press International). "Wardrobe Expert LeMaire has Dressed Most Beautiful Women." *The Elwood (Indiana) Call-Leader,* May 31, 1961, p. 10.

Seder, Jennifer. "Adrian Remembered." *Los Angeles Times,* September 7, 1979, p. H2. http://www.iann.net/paul_zastupnevich/voyage_94.htm

Shoup, Donald C. "Eulogy for Conway Howard Shoup." Academy of Motion Picture Arts and Sciences, Margaret Herrick Library (Beverly Hills).

Spence, Betty. "Theadora Van Runkle: The Gift of Garb." *Los Angeles Times,* July 18, 1982, Calendar section, p. 8.

Thomas, Dan. "Hollywood Letter." *Kentucky New Era,* September 20, 1934, p. 3.

Tildesley, Alice L. "Where Women Really Reveal Themselves." *The Lincoln (Nebraska) Star,* January 27, 1935, p. E3.

Tildesley, Alice L. "Back Come the Curves!" *The (San Mateo, California) Times,* March 21, 1938, p. 11.

Tildesley, Alice L. "Famous Hollywood Designer says 1925–28 was the Ugliest in the History of Fashions—Women Wore "Barrel" Clothes Then and Stars Refuse to Re-don Them for Period Pictures." *Sarasota (Florida) Herald & Tribune,* August 24, 1938, p. 8.

Tschorn, Todd. "Theadora Van Runkle dies at 83; noted Hollywood costume designer." *Los Angeles Times,* November 8, 2011, http://articles.latimes.com/2011/nov/08/local/la-me-theadora-van-runkle-20111108?_r=1&ref=obituariesm, accessed May 15, 2015.

Watrous, Valerie. "Meet Your Neighbor." *Los Angeles Times,* March 28, 1927, p. A8.

Vreeland, Diana. Letter to Irene Lentz-Gibbons. May 24, 1944. Academy of Motion Picture Arts and Sciences, Margaret Herrick Library (Beverly Hills), Special Collections.

Winchell, Walter. "Notes of a Roverboy." *The Scranton (Pennsylvania) Republican,* June 19, 1936, §II, p. 1.

Woulfe, Michael. "Letter to Fashion83." *Los Angeles Times,* November 4, 1983, part V: p. 1.

Young, Marian. "Hollywood's Young Designers Threaten Supremacy of Paris, New York Stylists—Main Job is to Create Glamor." *The Pittsburgh Press,* October 1, 1935, p. 25.

Young, Marian. "Movie Stars Drop Their Glamour When Cameras Stop." *The Milwaukee Journal,* October 4, 1935, p. 3.

Zastupnevich, Paul. Speech at the Voyage '94 Convention. Transcribed by Carole Whittaker, courtesy of Jeanette Georgali. http://www.iann.net/paul_zastupnevich/voyage_94.htm, accessed May 12, 2015.

Zastupnevich, Paul. Notes for planned autobiography, May 1993, courtesy of Marinka Sjoberg.

Zehms, Mary Lou. "Haut Couture Showings by Marusia, Werle, Greer, Irene, Rex, Highlight Press Week." *Long Beach (California) Independent,* November 19, 1956, p. 12.

UNSIGNED ARTICLES

"Actor Held in Crash Inquiry." *The San Bernardino County (California) Sun,* January 15, 1942, p. 11.

"Actors at Warner Studios Garbed by Marjorie Best." *The Shawinigan (Canada) Standard,* April 20, 1955, p. 16.

"Adrian Answers 20 Questions on Garbo." *Photoplay,* Vol 48, No. 4, September 1935, pp. 36–37, 76–77.

"Approaching the Stars in Fall Beauty; Designer Irene's New Creations Will Make Dreams Come True." *The Milwaukee Journal.* September 12, 1948, §7, p. 9.

"Annual Report 2012/2013." Blind Children's Center, Los Angeles, California, n.d. http://www.blindchildrenscenter.org/annual1213_75.html, accessed May 12, 2015.

"Biography of Charles Le Maire, Head of 20th Century-Fox Wardrobe Department." 20th Century-Fox publicity department release, n.d. (c. 1945). Academy of Motion Picture Arts and Sciences, Margaret Herrick Library (Beverly Hills).

"Blackmailed Film Stylist Kills Herself." *Los Angeles Daily News,* June 30, 1947.

"Bonnie Cashin." *Current Biography,* May 1970, p. 9.

"Burton Miller, Movie Costumes Designer." *Pittsburgh Post-Gazette,* March 9, 1982, p. 29.

"Charles Le Maire, Designer in Movies." *Sun-Sentinel* (United Press International), Ft. Lauderdale, Florida, June 11, 1985, http://articles.sun-sentinel.com/1985-

06-11/news/8501230396_1_monsieur-le-maire-costumes-broadway, accessed May 15, 2015.

"Cost of Gowns High In Films." *The Wichita (Kansas) Beacon*, July 17, 1921, p. 3.

"Couturier to Join Films; Madame Chanel to Design Fashion in Hollywood." *The (Montreal, Canada) Gazette*, January 31, 1931, p. 11.

"Daniel J. Sullivant dies in Auto Wreck." *New York Times*, March 13, 1922.

"Death Takes Travis Banton in Hollywood." *Long Beach (California) Independent*, February 3, 1958, p. 16.

"Death Threatens Studio Veteran." *Los Angeles Times,* October 20, 1936, p. A2.

"Deaths: Banton—Biddy" *New York Times*, May 2, 1970, p. 34.

"Designer and her Creation; Dress Genius Gauges Lure of Sex in Fashion." *The Milwaukee Journal*, December 17, 1921, Final, p. 1.

"Died, Andreani." *Oakland (California) Tribune*, May 9, 1903, p. 3.

"Divorce Rolls List Notables." *Los Angeles Times,* December 30, 1940, p. 4.

"Dorothy Jeakins." *Toledo (Ohio) Blade,* November 29, 1995, §2, p.13.

"Dorothy Jeakins." *Los Angeles Times Home Magazine*, July 1, 1947.

"Early Day Film Actress Passes." *Los Angeles Times*, August 24, 1939, p. A8.

"Effective today is a new contract between Irene and MGM." *California Apparel News*, June 4, 1947.

"Elois Jenssen." *Variety*, March 29, 2004, http://www.highbeam.com/doc/1G1-115490975.html, retrieved May 15, 2015.

"Elois Jenssen." *Pittsburgh Post-Gazette*, April 3, 2004, p. 40.

"Error in Bridge Culminates in Divorce Decree." *Los Angeles Times*, July 2, 1931, p. A15.

"Erté." *The Times* (London). April 23, 1990.

"Fashion Designer Gilbert Adrian Has Heart Attack." *Times Daily* (Associated Press), Florence, Alabama, May 1, 1952, §2, p. 4.

"Famed Dress Designer Travis Banton Dies.*" Los Angeles Times,* February 3, 1958, p. B2.

"Fashion Forecast: Mlle. Chanel Returns." *The Lewiston (Maine) Daily Sun*, July 23, 1931, p. 3.

"Fashion Flashes: America's Foremost Designers Present Evening Clothes Plans." *The Lincoln (Nebraska) Star*, March 6, 1941, p. 4.

"Fashions Salon to be Opened." *Los Angeles Times*, July 22, 1930, p. A3.

"Film Fashion Features." *New York Times*, December 2, 1923.

"Film Mode Show for East." *Los Angeles Times,* January 8, 1927, p. A8.

"Film Stars' Duds Slay Good Taste." (Associated Press) *The Spokesman-Review*, November 6, 1935, p. 1.

"Friend of Hollywood Film Beauties Dies." *San Bernardino County (California) Sun*, October 26, 1936, p. 2.

"Gaynor Elopes with Fashion Designer." *The Morning Herald* (Associated Press), Uniontown, Pennsylvania, August 15, 1939, p. 1.

"Gilbert Adrian, Designer, Dies." *The Bend (Oregon) Bulletin*, September 14, 1959, p. 8.

"Gilbert Adrian Sick, Kept in Dress Shop." *Miami Daily News*, May 1, 1952, p. 9A.

"Glamorous Styles of Lean Years Now Sought by Women." *Pottstown (Pennsylvania) Mercury*, May 11, 1937, p. 6.

"Gloria has New Gowns by Chanel." *The Brownsville (Texas) Herald*, March 6, 1932, p. 10.

"Gowning of Fox Film Stars One of Important Details of Work." *The Daily Notes,* Canonsburg, Pennsylvania, April 18, 1930, p 6.

"'Greeks' Word: Lowe's." *Reading (Pennsylvania) Eagle*, March 1, 1932, p. 16.

"Herschel McCoy." *Los Angeles Times*, February 6, 1956, p. 33.

"Hollywood Fashion Center? Designer not so Sure." *Los Angeles Times*, May 13, 1937, p. 16.

"Hollywood is the Style Setter for the Nation, In the Opinion of Royer." *Lincoln (Nebraska) Sunday Journal and Star,* July 28 1940, p. D-3.

"Hollywood Selecting Big Hats, Black Dresses, Handsome Accessories for Fall." *The Milwaukee Journal*, September 12, 1943, §VII, p. 8.

"Leah Rhodes." *Variety*. November 19, 1986.

"Lina Basquette Sued over Furs for Style Shop." *Los Angeles Times,* June 8, 1931, p. A8.

"Kathleen Kay Assumes Charge of New Fox Films Wardrobe." *Fox Studio Mirror.* December 7, 1926.

"Margaret Whistler." *Motion Picture Studio Directory and Trade Annual*, New York Motion Picture News, Inc., October 21, 1916, p. 99.

"Marjorie O. Best; Movie Costume Designer Won Academy Award." *Los Angeles Times*, June 19, 1997, Metro section, p. 10-B.

"Matthew O. Hunley *(sic)*." *Los Angeles Times*, December 21, 1990.

"Miss Swanson Wears Dozens of New Gowns in 'Tonight or Never.'" *The Florence (Alabama) Times*, June 6, 1932, p. 4.

"Mother Coulter of Screen Fame Reported Dying." *Los Angeles Times*, October 19, 1946, p. A1.

"Movie Stars Dress to Suit Personality." *Alton (Illinois) Evening Telegraph,* November 26, 1926, p. 21.

"Moving Pictures Teach Psychology of Dress, Says Designer of Stars' Gowns." *Fayetteville (North Carolina) Observer,* January 27, 1921, p. 5.

"Orry-Kelly was in a blessed coma." *The Hollywood Reporter*, February 28, 1964.

"Pacific Coast News." *The (New York) Morning Telegraph,* June 22, 1922.

"Pair's Deaths Same Day Set Off Estate Battle." *Los Angeles Times,* May 21, 1948, p. A1.

"Paris Comes to Hollywood for Advice Says Designer." *The Milwaukee Journal,* October 3, 1938, p. L-2.

"Period Clothes Prove Problem to Movie Men." *The Miami Daily News*, April 16, 1939, p. 2-D.

"Period Design for Film Reflect Early Fashions." *Beverly Hills Shopping News*, February 15, 1954.

"Renie." *Variety*. July 13, 1992.

"Rites Slated for Fashion Stylist Greer." *Los Angeles Times,* April 20, 1974, p. C7.

Robert Kalloch biography, Columbia Pictures Publicity Department, September 1937. Academy of Motion Picture Arts and Sciences, Margaret Herrick Library (Beverly Hills).

"Royer to Speak Here this Week." *Nebraska State Journal,* Lincoln, Nebraska, February 19, 1941, p. 18.

"Royer Talks to Girls' Assembly." *Nebraska State Journal,* Lincoln, Nebraska, February 22, 1941, p. 2.

"Screenwriter, Wife Rescued." *Los Angeles Examiner*, March 1, 1938.

"Setting Styles Through the Stars." *Ladies Home Journal,* February 1933, p. 10.

"Sleep Pills New Mystery Clues in West Suicide." *Los Angeles Herald-Express,* June 30, 1947, p. 1.

"Suit Asks $131,624 in Realty Deal." *Los Angeles Times*, October 29, 1945, p. A3.

"Tales Out of School." *Pictures and Picturegoer*, July 1925, p. 40.

"Theadora Van Runkle Dies." *Variety.* November 7, 2011.

"Tirtoff-Erte Quits Movies; Designer Finds Hollywood and Screen Stars Too Exacting." *New York Times,* November 4, 1925.

"Travis Banton, Gown Designer, Describes Ten Steps Taken in the Creation of Screen Costumes." *Texas Daily Herald,* June 19, 1933.

"Sophie Wachner Semi-Annual Sale." Display Ad. *Los Angeles Times,* October 18, 1931, p. B-8.

"The Story of Irene." *McCall's.* June 1947.

"That Octopus Gown." *Photoplay.* September 1921, p. 20.

"Vera West, Designer, Takes Life Hinting at Blackmail." *Los Angeles Times,* June 30, 1947, p. 2.

"Vera West Did Not Pay 'Blackmail,' Mate Says." *Los Angeles Times,* July 1, 1947, p. 2.

"Vera West's Death Probed." *Hollywood Citizen-News,* June 30, 1947.

"Wardrobe Woman at Big Studio Has Wide Variety of Duties; Makes Pajamas for Elephants." *The (St. Petersburg, Florida) Independent,* August 2, 1935, p. 6.

"West Quarrel Told by Mate." *Los Angeles Examiner,* July 1, 1947.

AUDIO AND VIDEO RECORDINGS

The Hollywood Fashion Machine. American Movie Classics and Marcia Ely Productions, 1995.

Hollywood Fashion Machine. World of Wonder, 1999–2000. Episodes: "Edith Head," 1999, "Starmakers," 1999, "Paris Goes to Hollywood," 1999; "Dressed to Thrill," 1999; "Fashion Duos," 1999; "Studio Style Wars," 2000; "Fashion of Fear" 2000.

Hollywood the Golden Years: The RKO Story. British Broadcasting Corporation and RKO Pictures, 1987.

Plunkett, Walter, audio recording. January 30, 1980. Accession Number: 4000-01-351. Pacific Film Archive Audio Recordings Collection, University of California, Berkeley Art Museum and Pacific Film Archive.

ARCHIVAL RESOURCES

Akron Official City Directory. Akron, Ohio: The Burch Directory Company, 1899, 1903, 1904, 1907–1912.

Ancestry.com. Public Member Trees (Provo, Utah, Ancestry.com Operations, Inc., 2015), www.ancestry.com.

Arnold, James Newell. *Rhode Island Vital Extracts, 1636–1850.* 21 volumes. Providence, R.I.: Narragansett Historical Publishing Company, 1891–1912. Digitized images from New England Historic Genealogical Society, Boston, Massachusetts.

Boston, Massachusetts. *Passenger Lists of Vessels Arriving at Boston, Massachusetts, 1891–1943.* Micropublication T843. RG085. 454 rolls. *Passenger Lists of Vessels Arriving at Boston, Massachusetts, 1820–1891.* Micropublication M277. RG036. 115 rolls. National Archives, Washington, D.C.

Census Returns of England and Wales, 1901. www.1901censusonline.com. Kew, Surrey, England: The National Archives, 1901. Data imaged from the National Archives, London, England.

Commonwealth of Kentucky. *Kentucky Birth, Marriage and Death Records - Microfilm (1852–1910).* Microfilm rolls #994027-994058. Kentucky Department for Libraries and Archives, Frankfort, Kentucky.

Commonwealth of Massachusetts. Department of Public Health, Registry of Vital Records and Statistics. *Massachusetts Vital Records Index to Births [1916–1970].* Volumes 92-160, 162, 168, 175, 212–213. Facsimile edition. Boston: New England Historic Genealogical Society, Boston, Massachusetts.

Commonwealth of Massachusetts. *Massachusetts Death Index, 1970–2003.* Boston, Massachusetts: Commonwealth of Massachusetts Department of Health Services, 2005.

Commonwealth of Massachusetts. *Massachusetts Vital Records, 1840–1911 & Massachusetts Vital Records, 1911–1915.* New England Historic Genealogical Society, Boston, Massachusetts.

Commonwealth of Pennsylvania. Death Certificates, 1906–1963. Series 11.90 (1,905 cartons). Records of the Pennsylvania Department of Health, Record Group 11. Pennsylvania Historical and Museum Commission, Harrisburg, Pennsylvania. http://www.phmc.state.pa.us.

Compendium of History Reminiscence and Biography of Western Nebraska Containing a History of the State of Nebraska. Chicago, Illinois: Alden Publishing, 1909.

Costumer Designers Guild Directory of Members, Los Angeles: Costumer Designers Guild Local 892, 1988, 1990–1992, 1994–1998, 2009.

Dodd, Jordan R, *et al. Early American Marriages: Texas to 1850.* Bountiful, Utah: Precision Indexing Publishers, *Hunting for Bears, comp.* Texas marriage information taken from county courthouse records. Many of these records were extracted from copies of the original records in microfilm, microfiche, or book format, located at the Family History Library. Texas Department of State Health Services. Texas Marriage Index, 1966–2011. Texas Department of State Health Services, Texas.

Dodd, Jordan, *Liahona Research, comp.* from county marriage records on microfilm located at the Family History Library in Salt Lake City, Utah, in published books cataloged by the Library of Congress, or from county courthouse records.

England & Wales, National Probate Calendar (Index of Wills and Administrations), 1858–1966. Principal Probate Registry. *Calendar of the Grants of Probate and Letters of Administration made in the Probate Registries of the High Court of Justice in England.* London, England © Crown copyright.

Find A Grave. http://www.findagrave.com.

Florida Marriage Collection, 1822–1875 and 1927–2001. Florida Department of Health. *Florida Marriage Index, 1927–2001.* Florida Department of Health, Jacksonville, Florida. Records from various counties located in county courthouses and/or on microfilm at the Family History Library.

Husted, F.M. *Oakland, Alameda & Berkeley Directory for the Year 1902,* Oakland, California, 1902.

Internet Broadway Database. www.ibdb.com.

Internet Movie Database. www.imdb.com.

JewishGen, Online Worldwide Burial Registry (JOWBR). www.jewishgen.org.

Los Angeles (California) Superior Court. Probate court files. Los Angeles: Superior Court Archives, microfilm, 1910–2004.

Los Angeles Directory Company, *Los Angeles (California) City Directory,* Issues: 1923, 1926, 1927, 1929, 1932, 1936, 1938–1942.

Mecklenburg-Schwerin, Germany, Census, 1900. Mecklenburg-Schwerin (Großherzogtum), Volkszählungsamt. *Volkszählung am 1. Dezember 1900.* Landeshauptarchiv Schwerin. 5.12-3/20 Statistisches Landesamt (1851–1945).

Mexico. *Mexico Marriages, 1570–1950.* Salt Lake City, Utah: Family Search, 2013.

Philadelphia, Pennsylvania, Marriage Index, 1885–1951. Philadelphia County, Pennsylvania Clerk of the Orphans' Court, Philadelphia, Pennsylvania.

Research Publications, An Imprint of Primary Source Media. *City Directories of the United States 1882–1901*. Filmed from the Holdings of the Boston Public Library. Woodbridge, Connecticut, n.d.

Reports of Deaths of American Citizens Abroad, 1835–1974. http://www.archives.gov/research/vital-records/american-deaths-overseas.html. *Reports of the Deaths of American Citizens, compiled 01/1835-12/1974*. Publication A1 566. ARC ID: http://research.archives.gov/description/613857. Record Group 59. National Archives at College Park, Maryland. *Record of Death Notices of U.S. Citizens Aboard, 1835–1855*. Publication A1 848, ARC ID: http://research.archives.gov/description/1227672. Records of District Courts of the United States, RG 21. The National Archives at College Park, Maryland. *Notices of Deaths of U.S. Citizens Abroad, 1857–1922*. Publication A1 849, ARC ID: http://research.archives.gov/description/1227673. Records of District Courts of the United States, RG 21. The National Archives at College Park, Maryland.

State of Alabama. *Alabama Deaths and Burials, 1881–1952*. Family Search. Salt Lake City, Utah, 2009, 2010. Index entries derived from digital copies of original and compiled records.

State of California. *California Birth Index, 1905–1995*. Sacramento, California: Department of Health Services, Center for Health Statistics.

State of California. *California Death Index, 1940–1997*. Sacramento, California: Department of Health Services, Center for Health Statistics.

State of California. *California Divorce Index, 1966–1984*. Sacramento, California: Department of Health Services, Center for Health Statistics.

State of California. *California Marriage Index, 1949–1959*. California Department of Health and Welfare. California Vital Records, Vitalsearch, http://www.vitalsearch-worldwide.com. The Vitalsearch Company Worldwide, Inc., Pleasanton, California.

State of California. *California Marriage Index, 1960–1985*. Sacramento, California: Department of Health Services, Center for Health Statistics.

State of California. *Great Register of Voters 1900–1944*. California State Library, Sacramento. Riverside, California: Custom Microfilm Services, Inc., 1986.

State of Illinois. *Cook County Birth Certificates, 1878–1922*. Family Search, Salt Lake City, Utah, 2009. Illinois. Cook County Birth Certificates, 1878–1922. Illinois Department of Public Health. Division of Vital Records, Springfield. *Illinois. Cook County Birth Registers, 1871–1915*. Family Search, Salt Lake City, Utah. Illinois. Cook County Birth Registers, 1871–1915. Illinois Department of Public Health. Division of Vital Records, Springfield.

State of Illinois. Cook County Marriage Index, 1930–1960. *Cook County Clerk Genealogy Records*. Cook County Clerk's Office, Chicago, Illinois, 2008.

State of Illinois. *Cook County Marriages, 1871–1920*. Family Search, Salt Lake City, Utah, 2010. Illinois Department of Public Health records. *Marriage Records, 1871–present*. Division of Vital Records, Springfield, Illinois.

State of Illinois. *Illinois Deaths and Stillbirths, 1916–1947*. Family Search, Salt Lake City, Utah, 2010. Index entries derived from digital copies of original records.

State of Maine. *Maine Birth Records, 1621–1922*. Augusta, Maine: Maine State Archives.

State of Maine. *Maine Marriages 1892–1996 (except 1967 to 1976)*. Index obtained from Maine Department of the Secretary of State, Maine State Archives, http://www.state.me.us/sos/arc/files/dbinfo.htm.

State of Minnesota. *Minnesota Birth Index, 1935–2002*. Minneapolis, Minnesota: Minnesota Department of Health.

State of Missouri. *Missouri Marriage Records*. Jefferson City, Missouri: Missouri State Archives. Microfilm.

State of Montana. *County Marriages, 1865–1950*. Salt Lake City, Utah: Family Search, 2013.

State of New Hampshire. *New Hampshire Marriage and Divorce Records, 1659–1947*. Online index and digital images. New England Historical Genealogical Society. Citing New Hampshire Bureau of Vital Records, Concord, New Hampshire.

State of New Hampshire. *New Hampshire Marriage Records 1637–1947*. Family Search, Salt Lake City, Utah, 2011. *Marriage Records*. New Hampshire Bureau of Vital Records and Health Statistics: Concord, New Hampshire.

State of New York. *Index to New York City Marriages, 1866–1937*. Indices prepared by the Italian Genealogical Group and the German Genealogy Group, and used with permission of the New York City Department of Records/Municipal Archives.

State of New York. *State population census schedules, 1915 & 1925*. Albany, New York: New York State Archives.

State of Tennessee. *Tennessee State Marriages, 1780–2002*. Nashville: Tennessee State Library and Archives. Microfilm.

State of Texas. *Texas Birth Index, 1903–1997*. Austin: Texas Department of State Health Services. Microfiche.

State of Texas. Death Certificates, 1903–1982. Austin: Texas Department of State Health Services.

State of Vermont. *Vermont Marriage Records, 1909–2003*. Vermont State Archives and Records Administration, Montpelier, Vermont. *Vermont Marriage Records, 2004–2008*. Vital Records Office, Vermont Department of Health, Burlington, Vermont.

State of Washington. Marriage Records, 1865–2004. Olympia: Washington State Archives.

State of Washington. *Washington, Death Certificates, 1907–1960*. Salt Lake City, Utah: Family Search, 2013.

State of West Virginia. *West Virginia Marriages, 1853–1970*. Family Search, Salt Lake City, Utah, 2008, 2009. Digital images of originals housed in county courthouses in various counties throughout West Virginia.

State of Wisconsin. *Wisconsin Births and Christenings, 1826–1926*. Family Search, Salt Lake City, Utah, 2009, 2010. Index entries derived from digital copies of original and compiled records.

Statistics Canada. *Census of Canada, 1891*. Ottawa, Ontario, Canada: Library and Archives Canada. Series RG31-C-1. Statistics Canada Fonds. Microfilm reels: T-6290 to T-6427.

Summit County, Ohio, Marriage Records, 1840–1980. Akron, Ohio: Summit County Court of Common Pleas: Probate Division. Digital Publication, 41 rolls.

Trow General Directory of New York City. New York: R.L. Polk & Co., Inc., 1915–1919.

United Kingdom Incoming Passenger Lists, 1878–1960. *Board of Trade: Commercial and Statistical Department and successors: Inwards Passenger Lists*. Kew, Surrey, England: The National Archives of the UK (TNA). Series BT26, 1,472 pieces.

U.S. Census Bureau. *1860 U.S. census, population schedules*. NARA microfilm publication M653, 1,438 rolls. Washington, D.C.: National Archives and Records Administration, n.d.

U.S. Census Bureau. *1870 U.S. Census, population schedules*. NARA microfilm publication M593, 1,761 rolls. Washington, D.C.: National Archives and Records Administration, n.d. Minnesota census schedules for 1870. NARA microfilm publication T132, 13 rolls. Washington, D.C.: National Archives and Records Administration, n.d.

U.S. Census Bureau. *Tenth Census of the United States, 1880*. (NARA microfilm publication T9, 1,454 rolls). Records of the Bureau of the Census, Record Group 29. National Archives, Washington, D.C.

U.S. Census Bureau. *Twelfth Census of the United States, 1900*. Washington, D.C.: National Archives and Records Administration, 1900. T623, 1854 rolls.

U.S. Census Bureau. *Thirteenth Census of the United States, 1910*. (NARA microfilm publication T624, 1,178 rolls). Records of the Bureau of the Census, Record Group 29. National Archives, Washington, D.C. For details on the contents of the film numbers, visit the following NARA web page: http://www.archives.gov/research/census/publications-microfilm-catalogs-census/1910/index.html.

U.S. Census Bureau. *Fourteenth Census of the United States, 1920*. (NARA microfilm publication T625, 2076 rolls). Records of the Bureau of the Census, Record Group 29. National Archives, Washington, D.C. For details on the contents of the film numbers, visit the following NARA web page: http://www.archives.gov/publications/microfilm-catalogs/census/1920/part-07.html. Note: Enumeration Districts 819-839 are on roll 323 (Chicago City).

U.S. Census Bureau. *Fifteenth Census of the United States, 1930*. Washington, D.C.: National Archives and Records Administration, 1930. T626, 2,667 rolls.

U.S. Census Bureau. *Sixteenth Census of the United States, 1940*. Washington, D.C.: National Archives and Records Administration, 1940. T627, 4,643 rolls.

U.S. Customs Service. *Passenger Lists of Vessels Arriving at New York, New York, 1820–1897*. Microfilm Publication M237, 675 rolls. Records of the U.S. Customs Service, Record Group 36. National Archives at Washington, D.C. *Passenger and Crew Lists of Vessels Arriving at New York, New York, 1897–1957*. Microfilm Publication T715, 8892 rolls. Records of the Immigration and Naturalization Service; National Archives at Washington, D.C. *Passenger Lists, 1962–1972, and Crew Lists, 1943–1972, of Vessels Arriving at Oswego, New York*. Microfilm Publication A3426. ARC ID: http://research.archives.gov/description/4441521 National Archives at Washington, D.C.

U.S. District Court. *Petitions for Naturalization from the U.S. District Court for the Southern District of New York, 1897–1944*. NARA Microfilm Publication M1972, 1457 rolls. Records of District Courts of the United States, Record Group 21. The National Archives at Washington, D.C.

U.S. Immigration and Naturalization Service. *Records of the Immigration and Naturalization Service, RG 85*. Washington D.C.: National Archives and Records Administration.

U.S. National Cemetery Administration. *U.S. Veterans Gravesites, 1775–2006*. Washington, D.C.: National Cemetery Administration.

U.S. National Homes for Disabled Volunteer Soldiers, 1866–1938. Historical Register of National Homes for Disabled Volunteer Soldiers, 1866–1938; (National Archives Microfilm Publication M1749, 282 rolls); Records of the Department of Veterans Affairs, Record Group 15; National Archives, Washington, D.C.

U.S. Naturalization Records: Original Documents, 1795–1972. *Naturalization Records of the U.S. District Courts for the State of Alaska, 1900–1924*. NARA Microfilm Publication M1539, 5 rolls. *Records of District Courts of the United States, Record Group 21*. National Archives, Washington, D.C. *Naturalization Records for the U.S. District Court for the Eastern District of Washington, 1890–1972*. NARA Microfilm Publication M1541, 40 rolls. *Records of District Courts of the United States, Record Group 21*. National Archives, Washington, D.C. *Naturalization Records for the U.S. District Court for the Western District of Washington, 1890–1957*. NARA Microfilm Publication M1542, 153 rolls. Records of District Courts of the United States, Record Group 21. National Archives, Washington, D.C.

U.S. Passport Applications. *Passport Applications, 1795–1905*. NARA Microfilm Publication M1372, 694 rolls. General Records Department of State, Record Group 59. National Archives, Washington, D.C. *Passport Applications, January 2, 1906–March 31, 1925*. NARA Microfilm Publication M1490, 2740 rolls. General Records of the Department of State, Record Group 59. National Archives, Washington, D.C. *Registers and Indexes for Passport Applications, 1810–1906*. NARA Microfilm Publication M1371, rolls 1–2. General Records of the Department of State, Record Group 59. National Archives, Washington, D.C.

U.S. Quartermaster General. *Applications for Headstones for U.S. Military Veterans, 1925–1941*. Microfilm publication M1916, 134 rolls. Records of the Office of the Quartermaster General, Record Group 92. National Archives at Washington, D.C.

U.S. Social Security Death Index, 1935–Current. Social Security Administration. *Social Security Death Index, Master File*. Social Security Administration.

U.S. World War I Draft Registration Cards, 1917–1918. United States, Selective Service System. *World War I Selective Service System Draft Registration Cards, 1917–1918*. Washington, D.C.: National Archives and Records Administration. M1509, 4,582 rolls. Imaged from Family History Library microfilm.

U.S. World War II Draft Registration Cards, 1942. United States, Selective Service System. *Selective Service Registration Cards, World War II: Fourth Registration*. Records of the Selective Service System, Record Group Number 147. National Archives and Records Administration.

White, Lorraine Cook, Ed. *The Barbour Collection of Connecticut Town Vital Records*. Vol. 1-55. Baltimore, Maryland: Genealogical Publishing Co., 1994–2002.

Wikipedia. www.wikipedia.org.

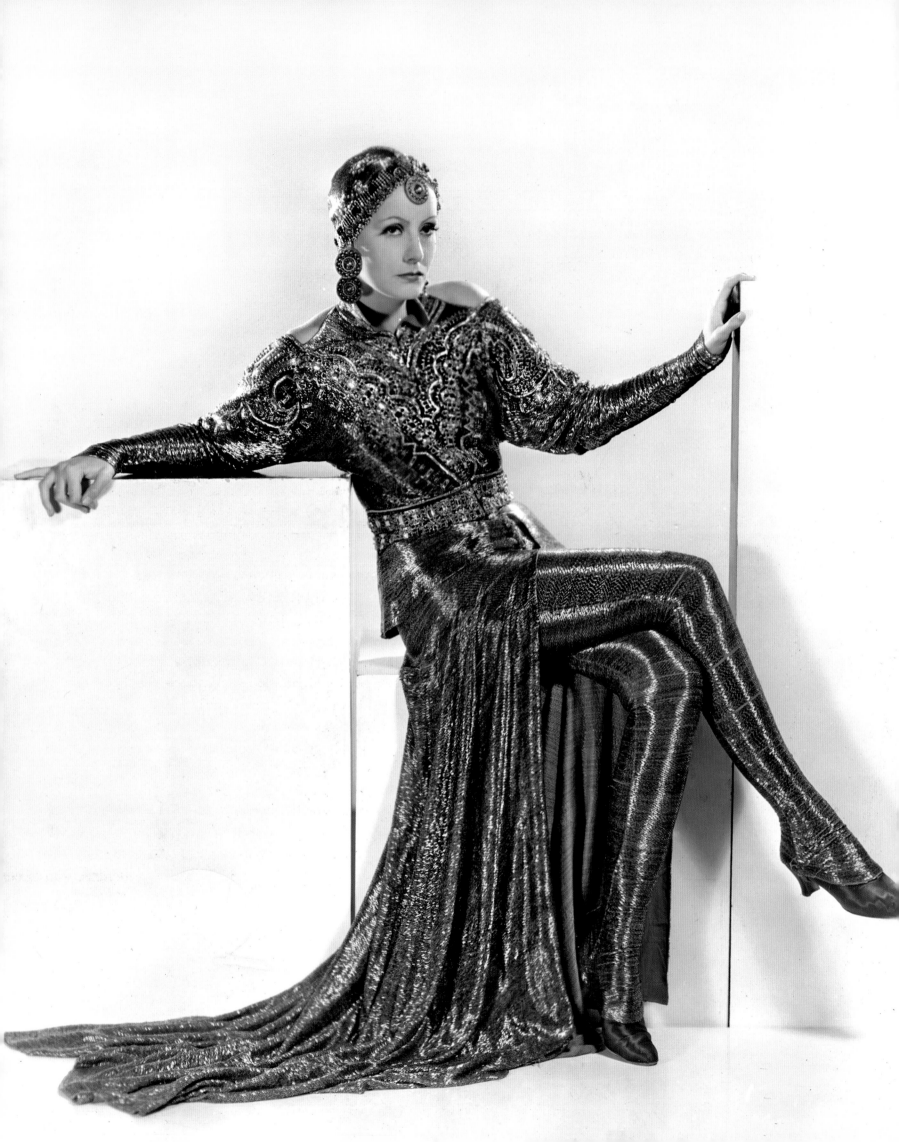

PHOTO CREDITS

Pages 1, 2, 5: Photofest; page 6: Mark A. Vieira collection; pages 8, 11: Photofest; page 12: Mark A. Vieira collection; pages 14, 15: Donald L. Scoggins collection; pages 16, 17: Photofest; pages 19, 20, 21, 22, 23: Seth Carriere and Clarissa Carriere Abbott; page 24: Independent Visions; pages 25, 26, 27, 29: Photofest; page 30: Independent Visions; page 31: Photofest; page 32: David Chierichetti collection; pages 33, 34, 36, 37, 39, 40, 41: Photofest; page 42: Mark A. Vieira collection; pages 44, 45: Photofest; page 46: Donald L. Scoggins collection; page 47: Photofest; page 48: Independent Visions; page 50: Photofest; page 51: David Chierichetti collection; page 52: Photofest; page 53: David Chierichetti collection; page 54: Jay Jorgensen collection; pages 57, 59, 60, 61: Photofest; page 62: David Chierichetti collection; pages 63, 64: Photofest; page 65: Mark A. Vieira collection; page 66, left: Mark A. Vieira collection; page 66, right: Jay Jorgensen collection; page 68, 69: Photofest; page 70: David Chierichetti collection; pages 71, 72, 73, 74, 75: Photofest; page 76: Jay Jorgensen collection; pages 77, 78, 79: Photofest; page 81, top and bottom left: Photofest; page 81, top right: Jay Jorgensen collection; page 81, bottom right: Independent Visions; pages 82, 84, 85, 87, 88, 89, 90, 91, 93, 94, 95, 97, 98: Photofest; page 99: Independent Visions; page 100: Photofest; page 101: Jay Jorgensen collection; page 103, pages 104–105, 106: Photofest; page 107: David Chierichetti collection; pages 108, 109, 110, 111: Photofest; page 112: Jay Jorgensen collection; page 113: Photofest; page 114: Jay Jorgensen collection; pages 115, 116: Photofest; pages 118, 119: Tom Culver collection; pages 120, 121, 123, 124, 125, left: Photofest; page 125, right: Tom Culver collection; page 126: Photofest; page 128: Tom Culver collection; pages 129, 131, 132, 133, 134, 136, 137, 138, 139, 140: Photofest; pages 141, 143, 144, 145: David Chierichetti collection; page 146: Photofest; Page 147: Independent Visions; pages 148, 149, 150: Photofest; page 151, left: Jay Jorgensen collection; page 151, left, pages 152, 153: Photofest; pages 155, 156, 157, 158, left: David Chierichetti collection; page 158, right: Jay Jorgensen collection; page 159: David Chierichetti collection; page 160, 162, 163, 164, left: Photofest; page 164, right: David Chierichetti collection; page 165, 167, 168: Photofest; page 169: Jay Jorgensen collection; page 170: Photofest; page 171, left: Jay Jorgensen collection; page 171, right, pages 172, 173, 174, 175, 176, 177: Photofest; page 178:

Independent Visions; page 179, 180: Photofest; page 181: David Chierichetti collection; pages 182, 184, 185, 186, 188: Photofest; page 189: David Chierichetti collection; pages 190, 191, left: Photofest; 191, right: David Chierichetti collection; pages 192, 193: Photofest; page 194, left: Mark A. Vieira collection; page 194, right, page 195, left: Photofest; page 195, right: Jay Jorgensen collection; pages 196, 197, 198, 200, 201, 202, 204, 206, 207, 208, 209, 210, 211, 212, 213: Photofest; page 214: Jay Jorgensen collection; pages 215, 216, 217, 218, 219, 220-221, 222, 223, 224, 227, 228, 229, 230: Photofest; page 231: David Chierichetti collection; pages 232, 233, 234, 235, 236, 238, 239, 240, 241, 242, 243, 245, 246: Photofest; page 247: David Chierichetti collection; pages 248, 249: Photofest; page 250, left: David Chierichetti collection; pages 250, right, 251 Photofest; page 252: Greg Schreiner collection; page 253: Jay Jorgensen collection; page 254, left: Photofest; page 254, right: Jay Jorgensen collection; page 255: David Chierichetti collection; pages 257, 258, 259, 260, 261, 262, 263, left: Photofest; page 263, right: David Chierichetti collection; page 264: Jay Jorgensen collection; pages 265, 267, 268, 269, 270, 271: Photofest; page 272: Independent Visions; pages 273, 274, 275, 276, 279, 280: Photofest; page 281: Donald L. Scoggins collection; pages 282, 283: David Chierichetti collection; page 284: Greg Schreiner collection; pages 285, 286, 287, 288: Photofest; page 289, left: Jay Jorgensen collection; page 289, right: Photofest; page 290, left: Jay Jorgensen collection; page 290, right: Photofest; page 291: Independent Visions; pages 292, 294, 295, 296: Photofest; page 297: Independent Visions; page 298: Photofest; page 299, left: David Chierichetti collection; page 299, right: Jay Jorgensen collection; page 300: Photofest; page 301: Independent Visions; Pages 302, 304: Photofest; Pages 305, 306: Independent Visions; page 307: Jay Jorgensen collection; pages 308, 309: Photofest; pages 310, 311, 312, 313: Jay Jorgensen collection; pages 314, 315: photofest; page 316: Jay Jorgensen collection; page 317: Independent Visions; pages 318, 319: Photofest; page 320: Independent Visions; pages 321, 323: Photofest; page 324: Monica Lewis collection; page 325, left: Jim Avey collection; Page 325, right: Photofest; Page 326: Robert Mycroft collection; page 327: Jay Jorgensen collection; pages 328, 329: Jim Avey collection; pages 330-331, 332, 333: Photofest; Page 334: photo by Harry Langdon, Jay Jorgensen collection; pages 337, 338, 341, 342, 344,

OPPOSITE: Greta Garbo in *Mata Hari* (1931).
Costume design by Adrian.

345, 346, 348, 349, 350, 351, 352, 354, 355, 357, 358, 359, 361, 362, 363, 364: Photofest; pages 366, 367: Independent Visions; page 368: Jay Jorgensen collection; pages 369, 370, 372, 373, 375: Photofest; page 376: photo by Barry Wetcher, courtesy Regency Entertainment and Monarchy Enterprises S.a.r.l.; pages 379: Photofest; page 380: photo by David Appleby, courtesy Twentieth Century Fox; pages 381, 383: Photofest; page 384: photo by Andrew Cooper, SMPSP, courtesy Disney Enterprises Inc. and Jerry Bruckheimer, Inc.; pages 386, 387: Photofest; Pages 388, 389, 391: Photofest; page 392: Mark A. Vieira collection; page 396: Mark A. Vieira collection.

INDEX

ACKNOWLEDGMENTS

We would like to thank the many people who were kind enough to speak with us about their knowledge of the costume design industry: Colleen Atwood, Kym Barrett, Margo Baxley, Jacqueline Bisset, Mark Bridges, Seth Carriere, Clarissa Carriere Abbott, Helen Colvig, David Chierichetti, Tom Culver, Stephan Elliott, Joan Evans Weatherly, April Ferry, Lizzy Gardiner, Betsy Heimann, Anne Jeffreys, Gary Jones, Jerome Kay, Willa Kim, Kevin King, Monica Lewis, Ellen Mirojnick, Penny Rose, May Routh, Greg Schreiner, Marinka Sjoberg, Leonard Stanley, Jack Taggart, Mary Vogt, Andrea Weaver, Raquel Welch, and Albert Wolsky.

For many years, Hollywood's precious history was discarded all too easily. Photographs and negatives, held together with silver and gelatin, rotted away because of improper storage. Costume sketches and wardrobe records were tossed in the waste bin as new studio regimes arrived. Costumes themselves met an inglorious fate most of the time when they were reworked for other productions until they finally wore out. We would like to thank a group of individuals whose expertise in their fields saved a great deal of Hollywood history. The late Robert Cushman, photograph curator for the Academy of Motion Picture Arts and Sciences' Margaret Herrick Library, and Manoah Bowman have rescued millions of negatives and film stills from obliteration. It is because of the dedication of photo preservationists like them that we are able to see film history in a new light. For their kindness in offering images and sketches from their private collections, we would like to thank Tom Culver, David Chierichetti, Jim Avey, Bill Sutton, Robert Evanko, Forest Paulette, Greg Schreiner, and Mark A. Vieira.

This book would not be possible without the aid of archivists who work to preserve Hollywood's history. Jenny Romero, Special Collections Department Coordinator, and the staff of the Academy of Motion Picture Arts and Sciences' Margaret Herrick Library were always of great assistance. We are also very grateful for the help of Robert Daicopoulos and Robert Vaughn of the Louis B. Mayer Library at the American Film Institute. All quotes from Adele Balkan are from the Academy of Motion Picture Arts and Sciences oral history with Barbara Hall.

Thank you to those who offered special assistance: Ali MacGraw, Dean Lamanna, Rob Saduski, Michael Childers and Laurie Baccaccio. Many friends and associates made themselves available for help in invaluable ways, including Gene Snook, Robert Mycroft, Michael Giammarese, Jeff Roberts, Mark Mayes, James Radford, Tim Jenkins, Lisa Malec, Tim Waller, and Marissa Vassari.

Putting a book together takes many talented people, and we were so lucky to have a fantastic group of people working with us. We are especially grateful to our editor, Cindy De La Hoz, at Running Press for her guidance and patience. Thank you to Chris Navratil and Allison Devlin, the publishers at Running Press, for their belief in this project. Thank you to Jennifer K. Beal Davis and Joshua McDonnell for their beautiful design and for bringing these pages to life. Mark A. Vieira also gave new life to the many historical images in the book. Thank you to Stacy Schuck, Susan K. Hom and Kendra Bean for helping to give us the best product possible and to Seta Zink for making sure people know about it. Thank you to Heather Margolis, John Malahy, Jennifer Dorian, Genevieve McGillicuddy, Shannon Clute, and Kristen Welch of Turner Classic Movies, and Aaron Spiegeland and John Parham of Parham-Santana.